THE MAKING OF *Gone with the Wind*

THE MAKING OF

Gone WITH THE Wind

by Steve Wilson

FOREWORD BY
ROBERT OSBORNE

HARRY RANSOM CENTER | UNIVERSITY OF TEXAS PRESS, AUSTIN

The exhibition
The Making of Gone With The Wind
and this companion publication
were made possible
through the generous support
of Turner Classic Movies.

Copyright © 2014 by the University of Texas Press
Foreword copyright © 2014 by Turner Classic Movies
Printed in China
Fourth printing, 2019

Requests for permission to reproduce material
from this work should be sent to:
Permissions
University of Texas Press
P.O. Box 7819
Austin, TX 78713-7819
utpress.utexas.edu/rp-form

♾ The paper used in this book meets the
minimum requirements of ANSI/NISO Z39.48-1992
(R1997) (Permanence of Paper).

LIBRARY OF CONGRESS CATALOGING-IN-PUBLICATION DATA

Wilson, Steve, July 8, 1957–
The making of Gone with the wind / by Steve Wilson ;
foreword by Robert Osborne. — First edition.
pages cm
Companion publication to the Harry Ransom Center's
exhibition, September 9, 2014-January 4, 2015, marking
the seventy-fifth anniversary of the film's release.
Includes bibliographical references and index.
ISBN 978-0-292-76126-1
1. Gone with the wind (Motion picture : 1939)—
Exhibitions. I. Harry Ransom Center. II. Title.
PN1997.G59W55 2014
791.43'72—dc23
2014007088

doi:10.7560/761261

This book is dedicated to my mother,
who shares my love of the movies.

CONTENTS

FOREWORD

I don't think anyone would argue that the greatest professional achievement in the career of producer David O. Selznick was *Gone With The Wind*. Not only was it a phenomenal achievement as a film, but if one adjusts for inflation, it remains the highest-grossing motion picture of all time. We're such fans of it here on TCM that it's the first film we showed when we launched the channel nearly twenty years ago, on April 14, 1994. But it is a surprise to learn that on July 30, 1936, when Selznick's company purchased the screen rights to Margaret Mitchell's recently published novel, David O. wasn't even present. Instead, he was on an ocean liner sailing to Hawaii. And it was while he was on that voyage that he picked up the novel for the first time and actually read it. It's true. His only prior knowledge of the book had come from reading a plot synopsis and from the advice of a trusted employee that he should buy it and make a film based on it.

Within months of its publication, *Gone With The Wind* had sold millions of copies, making it one of the most successful publications up to that time. As one of Selznick's biographers, David Thomson, noted, Selznick "soon realized that he owned not just the best of properties but the heaviest of responsibilities." Selznick himself was an avid reader and made a point when he adapted popular novels into movies to always stay as true to the source material as possible. *Gone With The Wind* was not going to be an exception to that rule. He knew fans of the book would insist upon it.

That made it incumbent upon Selznick to get everything right: the screenplay, the casting, the costumes, sets, and props. Across the board, every aspect of his adaptation needed to honor the novel itself, as well as the high expectations of the book's millions of enthralled readers. So Selznick made the film the only way he knew how—his way. He hired the best people possible and worked tirelessly, scrutinizing every detail of their work, demanding perfection from everyone involved.

And that is what this fascinating exhibition celebrates: the meticulous attention and devotion David O. Selznick, as the hands-on producer and relentless cheerleader, put into the making of what had early on been referred to as "Selznick's Folly." Among the many treasures you'll find in this catalog and the exhibition itself is the first Teletype sent to him about the novel from his New York representative, Kay Brown, who first suggested Selznick consider purchasing the film rights. You'll also find a confidential memo from Selznick discussing several leading men being considered to play Rhett Butler, including Gary Cooper, Ronald Colman, Errol Flynn, and the man who eventually was cast, Clark Gable. You'll see storyboards and concept art for the spectacular "Burning of Atlanta" sequence, and even a memo detailing the number of protest letters Selznick received when he announced that British-born Vivien Leigh would play Scarlett O'Hara, the definitive southern belle. But that barely scratches the surface of the many treasures and pleasures that await you.

I'm betting you'll enjoy it nearly as much as you do *Gone With The Wind* itself.

ROBERT OSBORNE
Film historian and host of Turner Classic Movies

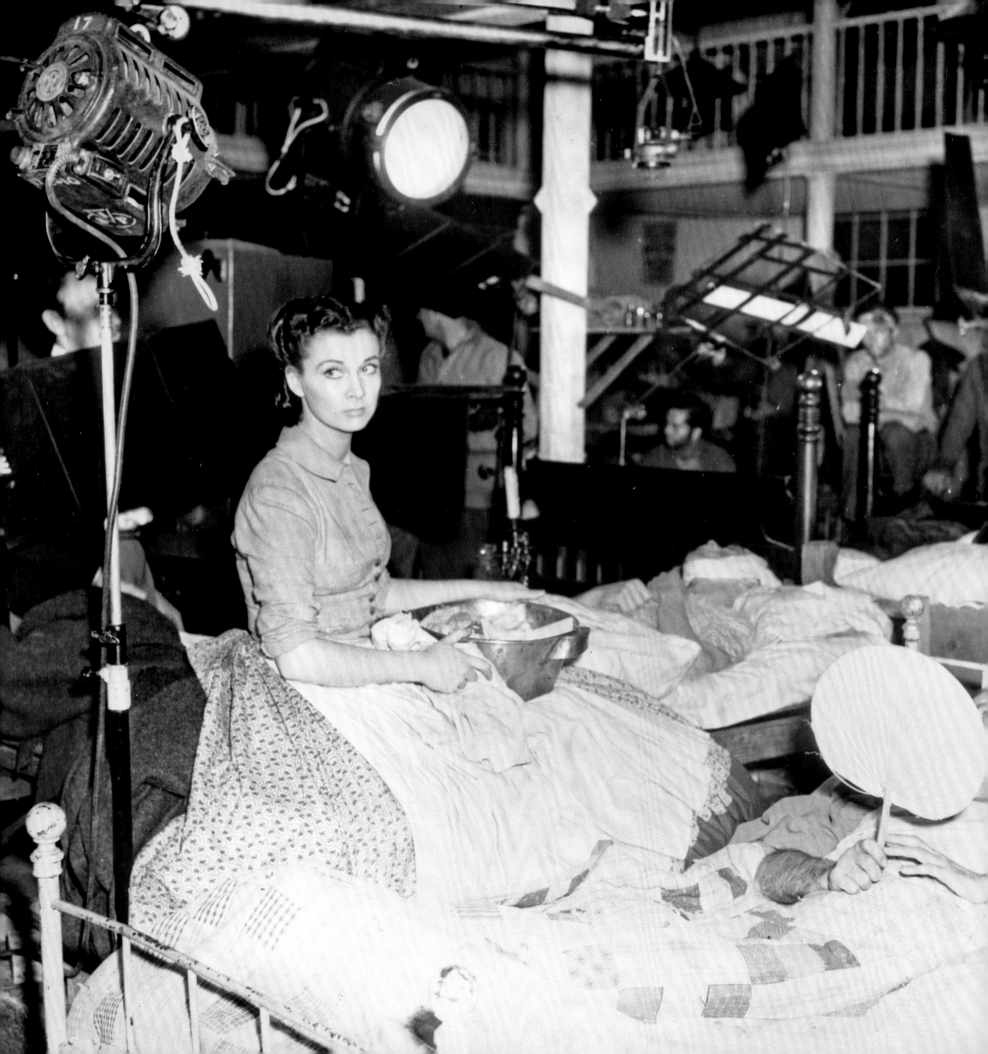

INTRODUCTION

Scarlett O'Hara, the protagonist of *Gone With The Wind*, was introduced to the American public in the middle of the Great Depression. It was a time when hunger was a fact of life for many and the hardship and sacrifice caused by war was both a recent memory and an imminent threat. And as the population shifted from rural to urban areas, disconnection from the land came to be considered a profound loss. Scarlett's resourcefulness and resiliency in facing these same difficulties, as well as her failures and foibles, all set against the epic backdrop of the Civil War, made *Gone With The Wind*, the novel, an instant best seller that resonated with the general public like few stories before or since.

Producer David O. Selznick's purchase of the film rights to *Gone With The Wind* was announced just as the novel appeared in bookstores. His reputation for producing large-scale "prestige pictures" was well known, so from the beginning, everyone reading the novel was excited about the prospect of a major motion picture adaptation and was trying to guess who would play Rhett and Scarlett. Thousands of people wrote letters recommending their favorite stars—or themselves—for roles in the film. Others wrote to Selznick about various aspects of the production. Southerners encouraged Selznick to present a "true picture of the South" and cautioned him to be careful with the southern accent. Many readers of the novel expressed serious apprehension about its portrayal of African Americans. The Hays Office, the film industry's censor, advised Selznick to exercise restraint in the depiction of violence, race, sex, childbirth, and profanity. Everyone, it seemed, understood the potential of this motion picture to influence America's understanding of history, race, and culture.

The Harry Ransom Center's exhibition, which marks the 75th anniversary of the film's release, examines these pressures and influences as it tells the story of David O. Selznick's three-year struggle to bring *Gone With The Wind* to the big screen. From the nationwide search for a new "personality" to play Scarlett O'Hara to the challenge of adapting a sprawling thousand-page novel into a manageable screenplay, the artistic choices involved in the design of sets and costumes, the grueling film schedule, the portrayal of a divisive event in American history, and the occasional clash between historical accuracy and breathtaking spectacle, it is a story as epic, vital, and revealing as *Gone With The Wind* itself.

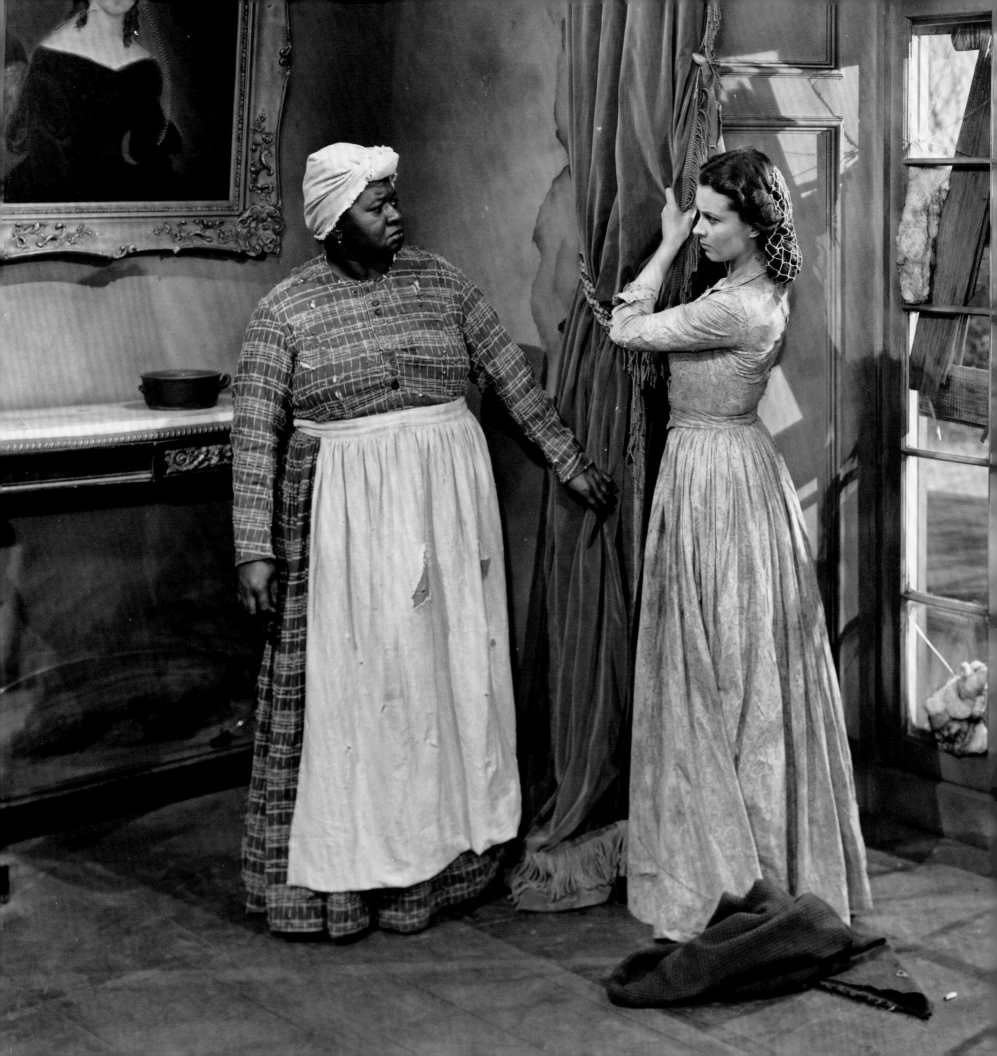

THE MAKING OF

Gone WITH THE Wind

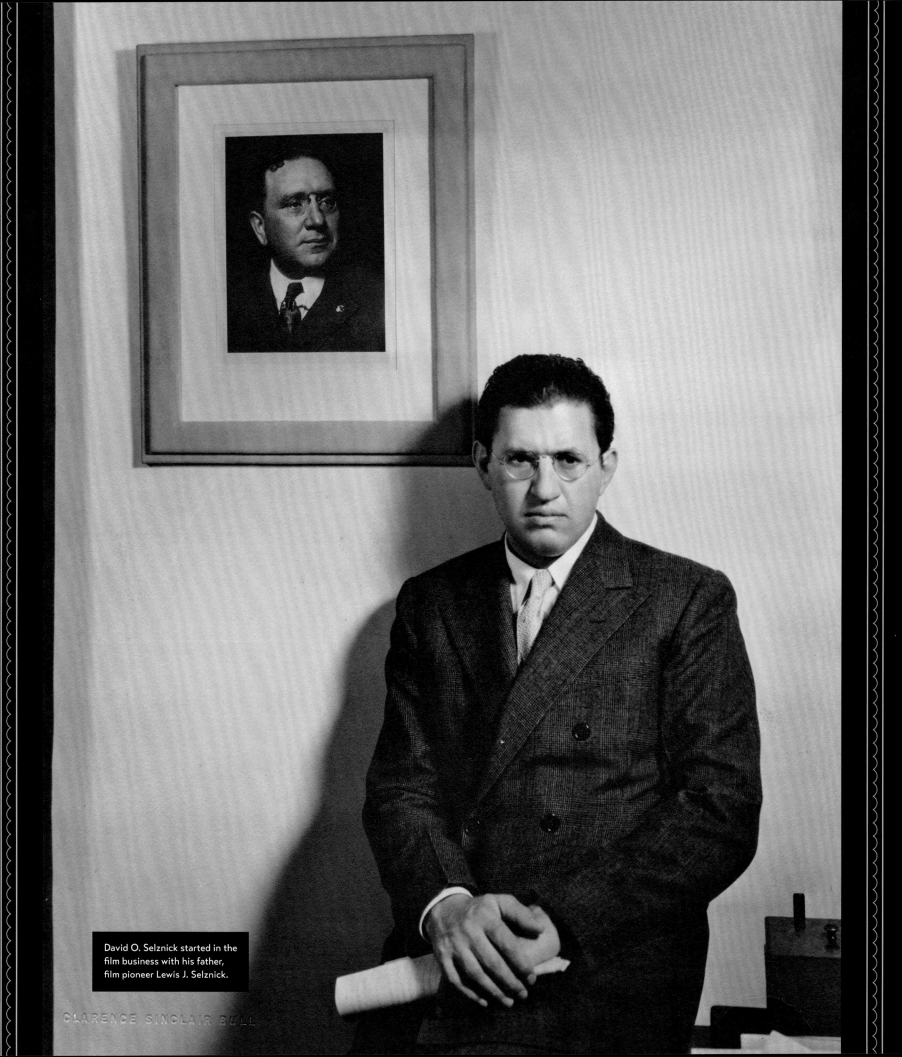

David O. Selznick started in the
film business with his father,
film pioneer Lewis J. Selznick.

CLARENCE SINCLAIR BULL

SELZNICK INTERNATIONAL PICTURES

In late spring 1936, when David O. Selznick first learned of Margaret Mitchell's novel *Gone With The Wind*, his new production company, Selznick International Pictures (SIP), was not quite a year old. He had started his own company on his departure from Metro-Goldwyn-Mayer (MGM) as one of its most successful producers. There, he had made a name for himself by producing "prestige pictures," films with high production values, often adapted from literary classics like *Anna Karenina*, *David Copperfield*, and *A Tale of Two Cities*. He had also met and married Irene Mayer, daughter of Louis B. Mayer, the head of MGM. Their son, Jeffrey, was four years old. A second son, Daniel, had just been born. David O. Selznick was 34 years old and the most exciting and promising producer in Hollywood.

Selznick had established SIP with his close friend, John Hay "Jock" Whitney, founder of Pioneer Pictures, which was formed to make films using the new, improved Technicolor Process No. 4, or "three-strip Technicolor." Pioneer had contracted with Technicolor to make nine feature films in color, the first being *Becky Sharp*, based on the classic novel *Vanity Fair*, which was soon followed in 1936 by *Dancing Pirate*. *The Garden of Allah*, starring Marlene Dietrich, was being produced in Technicolor by SIP under Pioneer's contract. *Little Lord Fauntleroy*, however, SIP's first picture, was in black and white and had just been released.

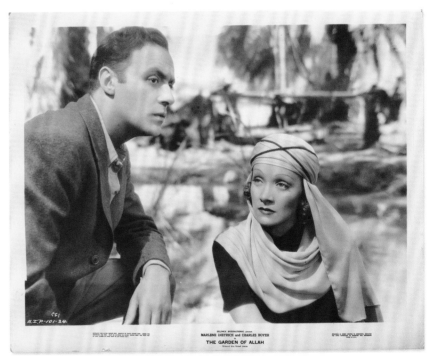

(ABOVE) Charles Boyer and Marlene Dietrich in *The Garden of Allah* (1936). Selznick was preoccupied with the production of *The Garden of Allah* when Kay Brown first told him about *Gone With The Wind*. *The Garden of Allah* was SIP's second film and its first in Technicolor under Pioneer Pictures' contract.

(LEFT) Freddie Bartholomew and Dolores Costello in *Little Lord Fauntleroy* (1936). *Little Lord Fauntleroy* was Selznick International Pictures' first production.

George Cukor was a longtime friend and collaborator of Selznick's and was his first choice as director of *Gone With The Wind*.

Much of SIP's staff consisted of people Selznick had worked with at RKO and MGM. Val Lewton, Franclien Macconnell, and Barbara Keon signed on to SIP's story department. Hal Kern would be Selznick's head of film editing, and William Wright joined as an associate producer. Selznick's secretary at this time was Silvia Schulman, an aspiring writer.

Katherine "Kay" Brown was a petite woman in her midthirties who had valuable connections in the New York publishing and theater worlds. Selznick had worked with her at RKO. Now, she split her time between SIP and Pioneer, identifying and signing both story properties and talent for the two companies. It was Kay Brown who first told Selznick about *Gone With The Wind*.

Among the "talent" Selznick had under contract for SIP was director George Cukor, a longtime friend and collaborator. Cukor had begun his career in the theater and made the move to Hollywood with the advent of talkies. He quickly became one of the most sought-after directors for his ability to elicit strong performances from his actors, women in particular. Working with Selznick, Cukor made such films as *A Bill of Divorcement* (1932), *Dinner at Eight* (1933), *Little Women* (1933), and *David Copperfield* (1935) before he was appointed to direct *Gone With The Wind*.

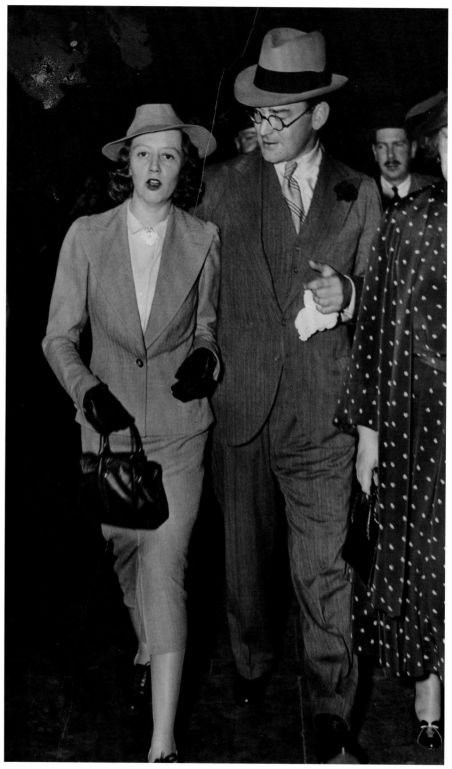

Katherine "Kay" Brown was Selznick's East Coast story editor and chief talent scout. She split her time between Selznick's company and Pioneer Pictures, owned by Selznick's friend and financial partner, John Hay "Jock" Whitney (right). Photo by Leo Lieb for the *Daily Mirror*, May 21, 1937.

THE BOOK DEAL

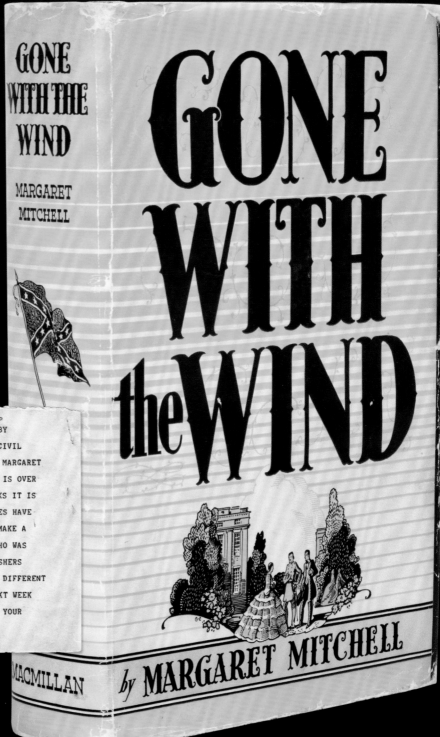

On May 20, 1936, Selznick, Kay Brown, and Val Lewton were busy registering titles with the Motion Picture Producers and Distributors of America, also known as the Hays Office, a relatively straightforward process, still performed today, intended to prevent public confusion over films with similar titles. Selznick claimed titles like "Antony and Cleopatra," "The Pickwick Papers," and "Florence Nightingale," and he was in negotiations with the Mark Twain estate for the motion picture rights to *Huckleberry Finn* and *The Adventures of Tom Sawyer*. He was also looking for a project for his main star, Ronald Colman, and a project to produce in Technicolor for SIP's sister company, Pioneer Pictures, possibly "Rip Van Winkle" or *The Prince and the Pauper*.

When Brown's Teletype about *Gone With The Wind* arrived, it had an urgency not typical of her other communications about story properties. In quick, broad strokes, she described an epic story set against the Civil War that features a woman as the main character. The first two actresses to come to Brown's mind, Miriam Hopkins and Margaret Sullavan, were immensely popular and known for

```
TO DOS FROM KB                                          5/20/36
WE HAVE AIRMAILED DETAILED SYNOPSIS OF "GONE WITH THE WIND" BY
MARGARET MITCHELL AND ALSO COPY OF BOOK TO VAL STOP THIS IS CIVIL
WAR STORY AND MAGNIFICIENT POSSIBILITY FOR MIRIAM HOPKINS OR MARGARET
SULLAVAN STOP IT WILL BE THE JULY BOOK OF THE MONTH CLUB AND IS OVER
A THOUSAND PAGES LONG AND I GUESS THAT IS WHY EVERYBODY THINKS IT IS
GOING TO BE ANOTHER ANTHONY ADVERSE STOP ALL PICTURE COMPANIES HAVE
DEFINITELY REGISTERED THEIR INTEREST ONE GOING SO FAR AS TO MAKE A
25,000 OFFER ON HEARING THE STORY TOLD TO THEM BY A PERSON WHO WAS
GOING TO DO ITS REVIEW STOP WE HAVE TOLD MACMILLAN THE PUBLISHERS
THAT YOU HAVE BEEN LOOKING FOR A CIVIL WAR STORY TOLD FROM A DIFFERENT
ANGLE AND ASKED THEM TO DO NOTHING ON IT BEFORE MONDAY OF NEXT WEEK
THEREFORE WOULD APPRECIATE IT GREATLY IF YOU WOULD GIVE THIS YOUR
PROMPT ATTENTION
END
```

(ABOVE) Kay Brown's first teletype to Selznick regarding *Gone With The Wind*. For transcriptions of documents, please see the appendix.

(RIGHT) First edition of Margaret Mitchell's *Gone With The Wind*.

```
     PIONEER SELZNICK
     TO KB FROM SS
     JULY 7,1936
     DOS ON SET  FOLLOWING HIS REPLY
     IF YOU CAN CLOSE "GONE WITH THE WIND" FOR 50,000 DO SO STOP ALTERNATE
     PROPOSITION 5500 AGAINST 55,000 FOR 90 LOR 60 DAY OPTION STOP I
     REALIZE THERE IS NOT MUCH CHANCE OF YOUR BEING ABLE GET THIS ON
     OTPIONAL BASIS BUT YOU MIGHT MAKE A STAB AT IT AS I WOULD PREFER THIS
     IN ORDER TO HAVE OPORTUNITY DETERMINE HOW COULD CAST IT ET C STOP
     ON OUTRIGHT PURCHASE REGRET INABILITY TO PAY MORE THAN 50,000
     BUT I FRANKLY THINK THIS, WHICH IS MUCH HIGHER PRICE THAN HAS BEEN
     APID FOR ANTHONY ADVERSE AND OTHER IMPORTANT BOOKS, IS AS HIGH ZAS
     WE SHOULD GO IN VIEW OF FACT THAT EVEN IF BOOJK JUSTIFIES THE
     HIGHEST HOPES THAT ARE HELD FOR IT IT COULD NOT BRING MUCH MORE MONEY
     AND 50,000 WOULD BE EXCELLENT PRICE VEN IN SUCH CIRCUMSTANCES
     THEREFORE IN ADVACNCE OF PUBLICATION I CANNOT SEE MY WAY CLEAR TO
     PAYING ANY MORE THAN 50,000 STOP KNOW HOW HARD YOU HAVE WORKED ON
     THIS AND HOPE THIS WILL NOT MEAN OUR LOSS OF PROPERTY BUT IF IT
     DOES IT JUST CANT BE HELPED STOP YOU MAY ASK WHAT DIFFERENCE AN
     EXTRA FIVE OR THEN THOUXXXTEN THOUSAND DOLLARS WOULD MKE ON A PROPERTY
     LIKE THIS BUT THE POINT IS THAT I FEEL WE ARE EXTENDING OURSELVES
     CONSIDERABLY EVEN TO PAY SUCH A PRICE FOR IT IN VIEW OF FACT THAT
     THERE IS NO CERTAINTY WE CAN CAST IT PROPERLY
     END DOS SS
     MIN
     OK WILL CALL YOU BACK IN ABOUT FIFTEEN MINS
     EKB
```

```
     SIP LA
     JULY 7,1936
     IS SYLVIA THRE
     HEQEOL    HOLD YOUR SEAT   IVE CLOSED FOR FIFTY THOUSAND
     MARVELOUS    THRILLED TO DEATH    WAIT TILL DOS HEARS IT
     WHO IS CHECK PAYABLE TO AND WILL YOU TAKE CARE OF ALL THIS AFROM
     YOUR OFFICE
     WILL TAKE CARE OF EVERYTHING   PLEASE TELL MR SELZNICK HOW
     IMPORTANT IT IS THAT WE DO NOT TELL THIS PRICE  DORIS WARNERS WIRE
     WHICH I HAVE JUST READ CLEARLY INDICATES SHE WOULD HAVE PAID FIFTY
     AND SO THAT NO ONE CAN SAY THAT WEXXXXX  AGENT PLAYED FAVORITES
     LET IT BE KNOWN IT WAS ABOUT FIFTY TWO THOUSAND   AM O  SO PLEASED
     DO YOU WANT TO TELL DOS BEFORE RINGING OFF
     END KB
     CANT  HE IS ON SET WATCHING REHEARSAL OF LAST SCEEN OF PICTURE AND
     CANOT DISTURB HIM BUT IF HE WANTS WIRE YOU FURTHER AM SURE MORNING
     WILL BE TIME ENOUGH OR WE CAN ALWAYS PUT THRU CALL TO YOUR HOME
     STOP  MAY I PLEASE HAVE NUMBER AGAIN
     END  YOU ARE SURE THERE IS NO MISTAKE IN MY AUHXXX AUTHORIZATION TO
     CLOSE AS I HAE WORKED MY G D HEAD OFF ON THIS    THERE IS NO REASON
     FOR YOU TO BABY ME AND SAY HOOP LA AND NO REASON TO TELEPHONE ME
     IF YOU ARE SURE EVERYTHING IS ALL RIGHT    IM IN SUCH A DITHER I WAS
     AFRAID I DIDNT READ ENGISH    FLAGG AND I OUT TO GET DRUNK   WILL NOT
     BE HOME UNTIL ELEVEN OCLOCK AS THERE IS NO TRAIN TILL NINE TWENTYONE
     FROM NEWYORK
     END KB
     ABSOLUTELY CERTAIN YOUR AUTHORITXATIN CLOSE FOR 50,000 STOP  I STILL
     SAY HOOP LA AND HAVE A DRINK FOR ME
     END
```

portraying strong women. Sullavan had recently starred in *So Red the Rose*, another Civil War story that had performed so badly at the box office that Selznick would use it as an argument against purchasing the rights to *Gone With The Wind*.

Brown pointed to the promise of strong sales of the book due to its pre-selection by the Book-of-the-Month Club. She indicated the size and scope of the story by comparing it to *Anthony Adverse*, a sprawling historical novel by Hervey Allen, famous as much for its considerable length as for its prodigious sales.

Her final attempt at piquing Selznick's interest was to suggest that he was already late to the game, that all the other film companies were aware of the story and that one had even made an offer. The situation would turn out to be more complicated than she realized.

Selznick stalled for more than a month. At one point Brown spoke of a $75,000 to $100,000 asking price, and although it soon settled to the $50,000 to $65,000 range, it would still be one of the highest prices asked for a story property.

But the problem was not just the price. By July 7, 1936, Selznick was enthusiastic about the story. As early as May 26 he said, "The more I think about it the more I feel there is an excellent story in it." But he couldn't settle on a cast. His initial thought for the role of Rhett Butler was Ronald Colman, whom he had under contract. But Colman did not seem right for the part and was unenthusiastic about the role. At one point Selznick said that if he were still working at MGM he would buy the story for Clark Gable and Joan Crawford. Selznick and his staff also discussed Bette Davis, Tallulah Bankhead, and Jean Arthur, all of whom would play a part in the drama surrounding the production of *Gone With The Wind*.

Kay Brown had been negotiating with Annie Laurie Williams, Margaret Mitchell's agent, and got on well with her. Furthermore, Williams represented a number of important writers, including John Steinbeck, so Brown wanted to maintain good relations. Williams was committed to getting the best price she could for her client, but all things being equal, she would rather Selznick win the bidding. He had a reputation for faithful adaptations and quality productions.

Teletype messages between Silvia Schulman and David O. Selznick in Los Angeles and Katherine Brown in New York City as they close the deal for the film rights to *Gone With The Wind*.

On the morning of July 7, Kay Brown sent a telegram from New York to Selznick that would have reached his home on Summit Drive in Los Angeles before sunrise. "Do hope this doesn't wake you," she wrote, "if we do not close at three o'clock this afternoon Tuesday this will be the situation…."

It was the last day of filming for *The Garden of Allah*, and Selznick was supervising the rewriting of the final scene. Brown had Williams in her office and did not want to let her go. She suspected Warner Brothers was trying to reach Williams with an offer, and she was determined to hang on to her until she heard from Selznick. Silvia Schulman, Selznick's secretary, suggested Brown take Williams out to eat. They went out for a drink instead.

Early in the afternoon in California, but well after five o'clock in New York, Selznick finally authorized Brown to close for $50,000 but asked her to try again for a 60- or 90-day option at a much lower price. He still wanted to settle on a cast before he committed so much money.

After a long, tense afternoon, Brown closed the deal for $50,000. Schulman was elated. "Marvelous. Thrilled to death. Wait till DOS hears it." But Brown had one more point she needed to get across. The other bidder was not Warner Bros. It was Doris Warner, wife of Mervyn LeRoy, one of the top directors at MGM, who had contacted Williams earlier with an offer. Brown wanted Williams protected from embarrassment and asked Selznick not to reveal how he had made the deal.

Brown had also learned over drinks with Williams that it had been Darryl Zanuck who had, a month earlier, obtained a report on the novel through a bootleg galley and made an offer.

As the events of the day sunk in, Brown asked Schulman, "You are sure there is no mistake in my authorization to close? There is no reason for you to baby me and say hoop la and no reason to telephone me if you are sure everything is alright." She said she was taking her secretary, Harriett Flagg, out to celebrate.

"I still say hoop la," Schulman replied, "and have a drink for me."

David O. Selznick's secretary, Silvia Schulman, met her husband, Ring Lardner, Jr., at Selznick International Pictures. He worked in the publicity department of SIP and worked on the screenplay of *A Star Is Born*. Associated Press photo, February 6, 1937.

WHO SHOULD PLAY SCARLETT?

Less than two weeks after its publication, *Gone With The Wind* was at the top of every best-seller list in the country. And since news of Selznick's planned film production was announced days later, most people who read the book speculated about who would be cast in the film. This guessing game would become a national obsession. Letters began coming in to the Selznick office—so many, in fact, that Selznick assigned Lydia Schiller and Dorothy Carter, two of SIP's secretaries, to keep a tally of the votes for the various stars. Louella Parsons, the gossip columnist, sent Selznick a sample of the letters she received, adding that there were so many she simply threw them away. By the end of 1936, Russell Birdwell, Selznick's head of publicity, claimed he had received more than 75,000 letters.

Many readers suggested Margaret Mitchell herself play the part of Scarlett. And naturally some established actors, including Katharine Hepburn and Joan Crawford, dropped hints that they might be interested in the role. Although Selznick worried about overexposure, the public's interest in who would play Scarlett O'Hara remained strong.

(RIGHT) Selznick assigned Lydia Schiller and Dorothy Carter the task of reading all the fan mail that came into the SIP offices and preparing a weekly tally of the votes for various actors for roles in *Gone With The Wind*.

(BELOW) Katharine Hepburn expressed an interest in the part of Scarlett O'Hara soon after the book was published.

INTER OFFICE COMMUNICATION

SELZNICK INTERNATIONAL PICTURES, INC.
CULVER CITY, CALIF.

TO Mr. David O. Selznick (copy: Mr. George Cukor)

SUBJECT "GONE WITH THE WIND" - #2

FROM L. Schiller DATE Nov. 14, 1936

Total compilation to date:

Role	Artist	For	Number of Votes Against	2nd Choice
SCARLETT O'HARA	Miriam Hopkins	24	4	4
	Margaret Sullavan	6	4	2
	Katharine Hepburn	4	7	1
	Tallulah Bankhead	0	5	-
	Bette Davis	5	2	-
	Joan Crawford	11	-	3
	Norma Shearer	1	-	-
	Luise Rainer	2	-	-
	Claudette Colbert	1	-	-
	Constance Bennett	0	2	-
	Olivia de Havilland	-	-	1
	Myrna Loy	1	-	1
	Barbara Stanwyck	-	-	1
RHETT BUTLER	Ronald Colman	6	9	-
	Clark Gable	22	9	2
	Warner Baxter	8	1	-
	Fredric March	2	3	3
	William Powell	3	-	-
	Franchot Tone	1	-	-
	Randolph Scott	1	-	-
	Cary Grant	2	-	1
	Henry Hull	1	-	-
	Ian Hunter			
	John Boles	2	1	1
	Henry Fonda	-	1	1
	Basil Rathbone	1	1	-
	Melvyn Douglas	1	-	-
	Noel Coward	1	-	-
	Sidney Blackmer	2	-	-
	Leslie Banks	1	-	-
	Alan Mowbray	1	-	-
	Alan Marshal	-	-	1
	Errol Flynn	1	-	1
	Spencer Tracy	-	-	1
	C. Henry Gordon	1	-	-
	John Mack Brown	1	-	-
	Preston Foster	-	-	1
	Richard Dix	1	-	-
	Laurence Olivier	1	-	-

CROSS REFERENCE SHEET

Name or Subject "GONE WITH THE WIND" File No.

 Scarlett

Regarding Telegram to DOS from SS: Date 8-7-36

"Hepburn crazy about "Gone with Wind"-Hayward suggest waiting your return before doing anything about this."

SEE HONOLULU * DOS general files

Name or Subject File No.

"WITH NEW PEOPLE OR WITH STARS"

To be in charge of his own production company and control his own productions within the Hollywood studio system of the time, Selznick would need financing, space to build sets, lights, cameras and other equipment, a crew, distribution channels, and, of course, actors. Most established actors were under contract to one studio or another. Selznick had a few of his own—Ronald Colman, for instance—and George Cukor was his director of choice. But to truly make it in the studio system, Selznick felt he would have to develop his own talent pool.

Initially, Selznick thought he would have to cast established stars in *Gone With The Wind*, but as domestic sales of the novel soared and interest in who would play the two leads became a national obsession, he realized that anyone cast in these parts would become instantly famous and a great asset to his studio. If he could depend on the strength of the novel to drive ticket sales, especially in the all-important foreign markets, he could afford to cast at least one of the main parts, Scarlett O'Hara, with a newcomer.

OK READY WITH NY 1-1366

SEPT 25 1936 · *Distribution*

MESSRS WHITNEY WHARTON AND MISS BROWN FROM DOS

I AM ANXIOUS TO KNOW PROBABILITY FOR SALE OF GONE WITH THE WIND ABROAD AND ESPECIALLY IN ENGLAND AND TO CONTINUE TO BE KEPT ADVISED ON THIS BECAUSE I FEEL THAT OUR DECISION AS TO WHETHER TO CAST THE PICTURE WITH NEW PEOPLE OR WITH STARS SHOULD BE LARGELY DEPENDENT ON THE SUCCESS OF THE BOOK ABROAD STOP OBVIOUSLY THE PICTURE IS GOING TO BE ENORMOUSLY EXPENSIVE AND EQUALLY OBVIOUSLY WE WILL HAVE TO GET A LARGE RETURN FROM EUROPE. IF THE BOOK IS NOT IMPORTANT ABROAD WE WILL CONSEQUENTLY HAVE TO PROTECT OUR INVESTMENT WITH ONE OR TWO STARS IN THE PICTURE. IF, ON THE OTHER HAND, IT IS AN EQUAL OR COMPARABLE SUCCESS ABROAD, WE CAN ATTEMPT TO FIND NEW PEOPLE FOR DEVELOPMENT INTO STARDOM FOR CERTAINLY AS FAR AS THIS COUNTRY IS CONCERNED, THE PICTURE REQUIRES NO STARS TO MAKE IT AN OUTSTANDINGLY IMPORTANT ATTRACTION.

Gone With The Wind was an immediate best seller in the United States, but Selznick's casting decisions would depend on whether or not foreign markets would have the same enthusiasm for a Civil War story that the United States did.

Who Should *Play* Scarlett?

And What Film Actor Is Best Suited to the Role of Rhett Butler? Atlanta Is Particularly Interested in How the Movies Will Answer These Questions in Filming "Gone With the Wind"

By Frank Daniel

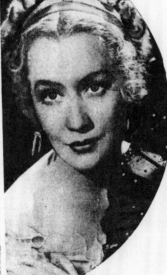

Bette Davis

Miriam Hopkins

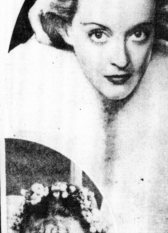

Katharine Hepburn

Margaret Sullavan

ATLANTA takes a proprietary pride in "Gone With the Wind," its immense success and its fidelity to the section and the sentiments of the Civil War Era it reflects, and one manifestation of this interest is the general speculation about the forthcoming film version of the novel.

There might be more trepidation about the outcome if Hollywood had not learned a great deal about making historical novels, and novels about the south, since talking pictures arrived. In early films—Mary Pickford's "Coquette" remains unforgettable—players attempted to talk the synthetic southern accent which passed unchallenged on Broadway. The chief difficulty with this dialect was that southerners couldn't understand it at all, so gradually Hollywood learned to abandon southern accent almost entirely.

When Paramount undertook to film "So Red the Rose," the producers assembled a cast of players from various parts of the south. But it was the quality of their voices, rather than the accents, that lent conviction to the dialogue in this film. Even when people as colloquial as those in "The Trail of the Lonesome Pine" were presented on the screen, the diction of the players was not indigenous to the Kentucky mountains. Colloquialisms conveyed the atmosphere effectively.

THERE are several reasons why southern is a dangerous dialect to attempt on the screen. One is that magnolia talk and the machine age are inharmonious—as is immediately apparent when a radio speaker palatizes his vowels too noticeably. Mechanisms seem to exaggerate these qualities disproportionately.

Another reason is that no actor seems able to talk southern without immediately going into caricature. Jack Oakie can talk a highly amusing southern, because he is a fine comedian, and Una Merkel can talk another sort, because she is southern-born and knows its intonations at first hand. But Gary Cooper and Marion Davies and other serious actors have achieved some extraordinary vocal effects in the interest of sectional authenticity. And, of course, the strangest southern, to southern ears, ever to emerge from the sound horns is that spoken by John Mack Brown, of Alabama and Georgia.

Perhaps another important reason against the use of southern dialect indiscriminately is that the southern people who say "impawdunt" for "impor-

tant" and "twinny" for "twenty" and "say-ing" for "sing," are not aware of it. To their own ears their speech sounds Oxonian, and when they hear similar sounds under stress of screen dramatics, they are offended. Even the type of southerner who says "Sarrowday" and "Lilly Whi-ut wuz a ri-ut ni-us go-ul" isn't conscious of his variations from the norm.

In "Gone With the Wind," Margaret Mitchell managed to convey the quality of her characters' speech with uncanny accuracy. Readers are usually aware that Scarlett O'Hara's voice is more high-pitched, and her speech more careless, than the voice of Melanie Wilkes, which is cool, accurate, and well-placed. How Miss Mitchell managed to achieve this effect, not for only two characters, but for many, is one of the mysteries which make her novel so impressive.

With some of these ideas in mind, at dinner parties, or where two or more "Gone With the Wind" readers are gathered together, the conversation is likely to turn to the projected filmization, and then someone will inquire, "Who do you think should play Scarlett?" and almost equally important, "What actor would you like to see play Rhett Butler?"

THE romantic renegade Rhett Butler apparently captures feminine interest as effectively in 1936 as he did in the sixties, and nine ladies out of ten will assure you that Rhett isn't really as bad as he is painted. Some are even inclined to blame Miss Mitchell for some of the less decorative qualities she attributed to Rhett. After all, there's no reason to go around spreading scandal about an obviously well meaning, unfortunate and VERY handsome young man.

Almost everybody has his or her chosen Scarlett and his chosen Rhett. Meanwhile Miss Mitchell herself is uncommunicative.

"When I sold the screen rights to 'Gone With the Wind' I sold them outright, and I have no part in the film adaptation," she declares. "I don't want to go to Hollywood, and if I went I don't think I'd be able to help anybody make a moving picture.

"I did tell the representative of Selznick International that I hoped a southern actress would play Scarlett. I haven't any other preference about who should play it. I haven't followed the movies very closely of late. For one thing, I've been busy with the book, and for another, my eyes have been troubling me.

"I've said I thought the girl who played David Copperfield's mother (Elizabeth Allan) would represent my conception of Melanie Wilkes, but probably there are others who will do so as accurately."

HOLLYWOOD has at least three scenarists from Georgia—Laurence Stallings, Lamar Trotti and Nunnally Johnson—who might be available if their services are required in the adaptation.

Actresses most mentioned for the film role of Scarlett are Miriam Hopkins (from Bainbridge and Savannah), Margaret Sullavan (from Virginia) and Katharine Hepburn and Bette Davis (both from New England).

Nominations for the screen Rhett Butler have ranged from Basil Rathbone to Edward Arnold, with Clark Gable and Ronald Colman most often mentioned. Everybody seems to concur that Leslie Howard is the man to represent Ashley Wilkes, unfortunately secondary to Rhett Butler.

Miss Davis' work in "Dangerous" and in several other roles makes her a promising Scarlett. She is expert at characterization, as expert perhaps as any actress in Hollywood, and would combine the apparent charms and the shallowness and selfishness of the character in her impersonation.

After seeing and hearing Katharine Hepburn in "Spitfire," in which she represented a southern mountain girl, most southerners will probably prefer to see her

as Scottish Queens and Louisa M. Alcott heroines.

Margaret Sullavan conveyed the celebrated "southern charm" of the heroine of "So Red the Rose" effectively, but Miss Sullavan is a lighter actress than will be required for Scarlett. She plays most often in comedies, and would probably not undertake the "Gone With the Wind" role.

Miriam Hopkins knows Georgia, having been born here, and she is an actress who doesn't demand entirely "sympathetic roles." Her performance as Becky Sharpe was conspicuously fine, even in a film chiefly concerned with exploiting the marvels of colored movies, and reviewers have often compared Scarlett to Becky (though Miss Mitchell says she didn't read "Vanity Fair" until after her book was written).

SCARLETT will be a demanding role, one for a dramatic actress of unusual abilities, of qualities which can range from the sinister to the alluring. She must be young enough to play the early scenes, in which Scarlett is an adolescent coquette, and mature enough as an actress to lend dignity and conviction to Scarlett's later experiences.

Where this actress will be found remains to be seen.

The film version of "Gone With the Wind" will probably deal in more detail with the episodes during and after the Civil War. The antebellum scenes will no doubt be used, dramatically, for contrast, to present the prosperity and graciousness of a doomed civilization, as against ensuing deprivations. Scarlett will be introduced as the flirtatious girl who seeks to attract most men, but who is herself most attracted by the gentlemanly Ashley Wilkes, affianced to Melanie. Her principal scene, in the early part of the film, will surely be that in which she avows her feeling to Ashley, while Rhett Butler unintentionally overhears. That's a scene for an intensely dramatic actress, as are most of the scenes thereafter—when Scarlett watches Atlanta and the Confederacy waste away to defeat and starvation, when she begins her fight for financial security, when she eventually marries Rhett Butler, when she learns that the man she loved so long is no longer lovable, and when at last she is financially and socially secure—and alone and unloved.

"Who Should Play Scarlett?" *Atlanta Journal*, September 20, 1936. Just weeks after the publication of the novel and the announcement of Selznick's acquisition of the film rights, the *Atlanta Journal* published this story. Speculation about who would portray Rhett Butler and Scarlett O'Hara became a national obsession.

TALLULAH BANKHEAD

SELZNICK INTERNATIONAL PICTURES, INC.
NEW YORK CITY

Inter-Office Communication

TO Mr. David O. Selznick DATE September 23, 1936

FROM Miss Katharine Brown

SUBJECT TALLULAH BANKHEAD *xfiled*

Dear Mr. Selznick:

I went to see REFLECTED GLORY last night and laid out the red plush carpet for Miss Bankhead who is, so happy to be in my most capable hands!

It doesn't seem necessary to me to shoot more than one talking sequence with Miss Bankhead and therefore I am selecting the scene with Ashley. It is my opinion that she could play the last part of the book magnificently and our biggest worry is how she will look and play the earlier scenes.

I told her I would go over to Eaves with her and get her a perfectly divine costume for the party sequence and also a velvet costume with hat for silent close-ups.

There is no mistaking the fact that Miss Bankhead wants this part and what will happen to me the day that she hears other people are making tests for it in New York is something else again.

 Cordially yours,

 Kae
 KATHARINE BROWN

kb*f

Kay Brown worked with Tallulah Bankhead for three months to prepare her for her screen test. Brown was also working with several other possibilities, including Louise Platt, who would eventually star in *Stagecoach* (1939).

Tallulah Bankhead was the first established actress to make a serious effort to win the role of Scarlett O'Hara. The Alabama native was a bona fide star of Broadway and London's West End, but her few movie roles to date had been disappointing at the box office. Bankhead prepared for the screen test for three months. Kay Brown believed that the 34-year-old Bankhead would have to prove that she could appear young enough for the early scenes of the film. So Bankhead went on a diet, had her teeth capped, and began going to the Elizabeth Arden salon for a regular regimen of facial treatments. She even quit drinking.

Selznick and Brown took her quite seriously, giving her time to prepare and securing for her the best available hair and makeup artists and the right wardrobe for her test. They planned for George Cukor, Bankhead's old friend from the theater and the director of *Gone With The Wind*, to direct her screen test.

Because all of her plans for theater roles revolved around whether or not she would be cast as Scarlett, she told Selznick she needed to know if she had the part within two weeks of the test. On Christmas Eve Selznick wired Bankhead, "The tests are very promising indeed. Am still worried about the first part of the story and frankly if I had to give you an answer now it would be no but if we can leave it open I can say to you very honestly that I think there is a strong possibility."

Bankhead replied the next day. "... As I see it, your wire to me means one thing—that if no one better comes along, I'll do. Well, that would be all well and good if I were a beginner at my job.... I realize your feeling of responsibility and the desire for the perfection of the production of '*Gone With The Wind*,' and I also know how harassed you must be by the many conflicting opinions and suggestions which you receive daily, but if you were to abide by them all, poor '*Gone With The Wind*' would never see the light of day."

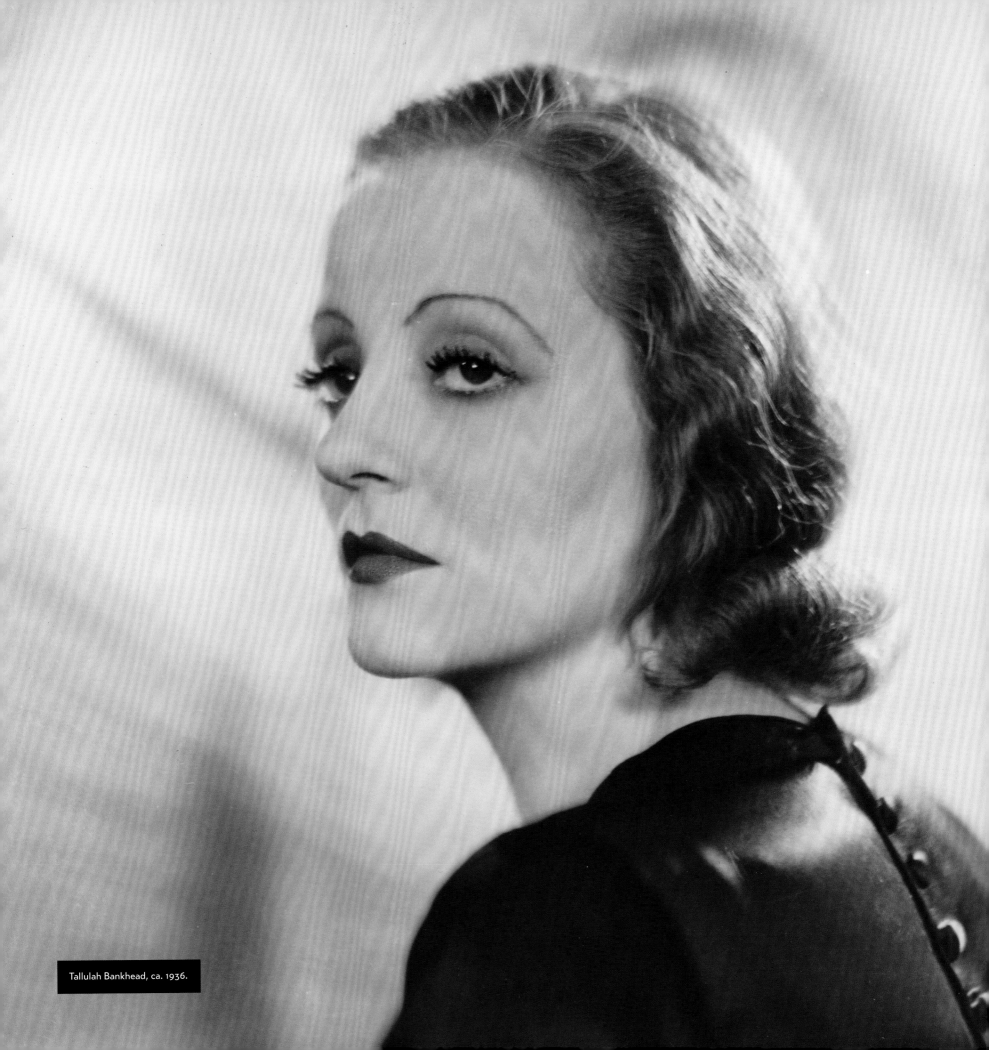

Tallulah Bankhead, ca. 1936.

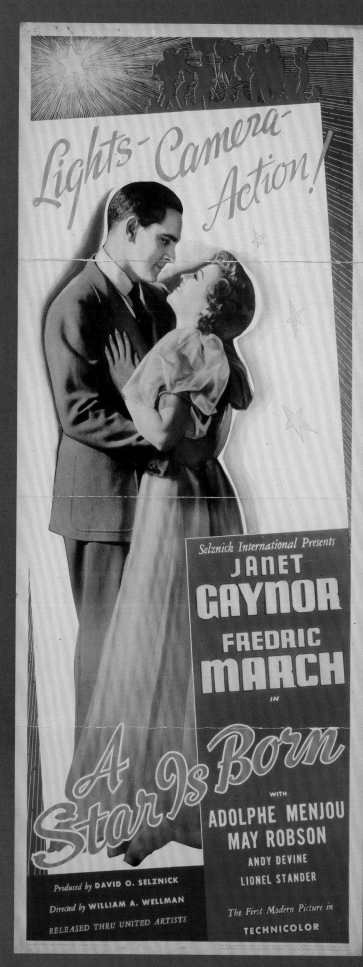

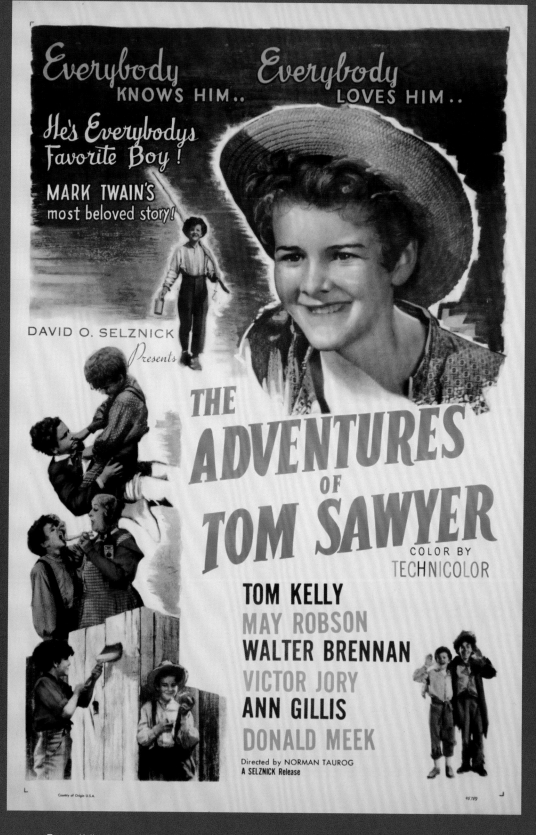

(ABOVE) Tommy Kelly, the star of *The Adventures of Tom Sawyer* (1938), was found in the Bronx after a long, nationwide talent search. The problems Selznick and Brown encountered during that search, from overwhelming responses to casting calls to correcting the accent of the actor they eventually chose, would reappear in their search for an unknown to play Scarlett O'Hara.

(LEFT) Insert poster for *A Star Is Born* (1937). Gaynor and her costar, Fredric March, were Selznick's early favorites for the parts of Melanie and Ashley in *Gone With The Wind*.

OTHER FILM PROJECTS

If Selznick's new studio were going to survive, it would have to produce income. So even as he was producing *Gone With The Wind*, Selznick was making other films. Often these other films influenced or were influenced by *Gone With The Wind*.

For some time Selznick had been talking about a story he called "The Truth About Hollywood." He was frustrated, though, because no one seemed to share his enthusiasm for the story of the rise of one star and the fall of another. For some, it seemed too close to Selznick's earlier film, *What Price Hollywood?* He eventually hired Dorothy Parker and Alan Campbell to flesh out William Wellman and Robert Carson's outline. Once they had a title, provided by Jock Whitney, *A Star Is Born* went into production in Technicolor under Pioneer's contract. It was completed early in 1937. The film starred Janet Gaynor and Fredric March, who, at this early date, were also Selznick's favorites for the roles of Melanie and Ashley.

The Prisoner of Zenda, based on the 1894 novel by Anthony Hope, was a starring vehicle for Ronald Colman, Selznick's main contract star. Selznick signed Colman with his new company after having worked with him on *A Tale of Two Cities* at MGM. At SIP, Selznick worked for months to find a suitable film for Colman after deciding he was not right for the role of Rhett Butler.

Both Selznick and Colman pushed for *The Prisoner of Zenda* to be made in color, but Pioneer Pictures had the contract with Technicolor, and cash flow problems prevented them from doing so. Selznick was under pressure to produce films more quickly to bring in revenue, so production proceeded in black and white. The film is still considered the definitive version of the classic novel.

Nothing Sacred, starring Fredric March and Carole Lombard, was produced in the second half of 1937 in Technicolor. The script was written by Ben Hecht, another old friend of Selznick's and a writer who would be of tremendous help in producing the final screenplay of *Gone With The Wind*. The film included a small comic bit starring Hattie McDaniel who would eventually play Mammy.

Unlike these other films, which were conceived, written, produced, and released within a few months, *The Adventures of Tom Sawyer* took a year and a half to reach theaters. Selznick wanted a complete unknown to play the part of Tom. A nationwide search was held, and thousands of boys were interviewed. At one point, Selznick instructed his staff to search orphanages, thinking that a rags-to-riches story would benefit the publicity for the picture. Selznick and Kay Brown would have very similar problems and results in their search for an unknown to play the part of Scarlett O'Hara.

Fredric March and Carole Lombard were both under contract to Selznick when they starred in *Nothing Sacred* (1937), one of Selznick's few comedies. The screenplay was by Ben Hecht, who would later do last-minute rewrites for *Gone With The Wind*.

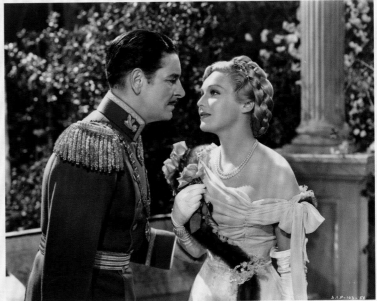

Ronald Colman and Madeleine Carroll in *The Prisoner of Zenda* (1937). After deciding that Colman was not right for the part of Rhett Butler, Selznick struggled to find a suitable starring role for his main contract star, finally settling on the romance/adventure story by Anthony Hope.

SIDNEY HOWARD

TO KB FROM DOS

ON SIDNEY HOWARD MY SUF SUGGESTION IS THAT YOU ADVISE HIM THAT I WOULD
LOKE VERY MUCH TO HAVE HIM COME OUT AND DO A SCRIPT WHENEVER HE IS
AVAILABLE AND IF HE DOES NOT O LIKE THE ONE I HAVE FOR HIM RIGHT NOW
PERHAPS I WILL HAVE SOMETHING ELSE TO OFFER HIM. AT ANY RATE I
THINK BEST PROCEEDURE IS TO DETERMINE WHEN HE WILL BE CLEAR OF PRESENT
PLAY TROUBLES. PLEASE FOLLOW THIS UP IN A WEEK OR TEN DAYS, OR WHENEVER
YOU THINK HOWARD WILL BE CLEAR AND AT REGULAR INTERVALS IF HE DOES
NOT SEEM TO BE FREE THEN. ALTHOUGH HE NEED NOT KNOW THIS I FEEL THAT
HE AND HECHT ARE PROBABLY THE TWO BEST WRITERS FOR PICTURES WHO ARE
NOT TIED UP WITH STUDIOS AND THEY ARE BOTH RARE IN THAT YOU DONT HAVE
TO COOK UP EVERY SITUATION FOR THEM AND WRITE HALF THEIR DIALOGUE
FOR THEM. THEREFORE I DONT WANT THERE TO BE ANY SLIP ABOUT GETTING
THEM WHENEVER HOWARD IS AVAILABLE STOP HECHT I DONT FEEL LIKE GLI
GOING AFTER IN VIEW OF HIS BEHAVIOR TOWARD THE CHAIRMAN ALTHOUGH JOCK
HAS BEEN GOOD ENOUGH TO INDICATE THAT HE WOULD NOT STAND IN THE WAY
IF WE REALLY NEEDED HECHT.

TO KB FROM DOS

I THINK WE COULD DO A LOT BETTER THAN HELEN CHANDLER AS MELANIE AND
DONT THINK YOU OUGHT TO TEST HER IN THE ROLE UNLESS YOU NEED SOMEONE
TO PLAY WITH PLATT. INCIDENTALLY COLONEL MERIAN CALDWELL COOPER NOW
EN ROUTE TO NEWYORK WILL BITTERLY RESENT THE SUGGESTION OF ANYONE BUT
A GIRL HE KNOWS BY THE NAME OF DOROTHY JORDAN FOR THE ROLE OF MELANIE
SO I PUT YOU ON YOUR GUARD AND I MUST SAY I THINK DOROTHY IS A VERY GOOD
POSSIBILITY FOR IT.

HAVE RECEIVED YOURS AND JOCKS WIRES ABOUT "SEEN BUT NOT HEARD" AND WILL
WIRE YOU ABOUT THE PLAY TOMORROW. WE HAVE HEARD ABOUT THE BOY NAMED
RAYMOND ROWE AND IF EITHER HE OR THE OTHER KIDS ARE POSSIBILITIES FOR
TOM, HUCK, OR JOE, OR ANY OTHER ROLES IN SAWYER, URGE YOU TO TEST THEM
IMMEDIATELY, PARTICULARLY IF THE PLAY LOOKS AS IF IT IS GOING TO L CLOSE
THEREBY MAKING THEM AVAILABLE.

(ABOVE) When Kay Brown told Selznick that Sidney Howard was available for screenwriting assignments, Selznick said he wanted Howard for an original story, "Man with a Young Wife," but a week later, when Brown mentioned Howard's interest in *Gone With The Wind*, Selznick jumped at the chance to hire him for the project.

(RIGHT) Sidney Howard in February, 1936. Photo by George Brown for *New York Journal American*.

esides casting, the other challenging task at this stage was preparing the *Gone With The Wind* screenplay. The novel was more than 1,000 pages long, covered a period of decades, and was set against a backdrop of the nation's bloodiest and most divisive conflict. Developing the right screenplay—the foundation of the entire project and the blueprint from which all the actors, designers, and technicians would work—proved to be an enormously difficult task and one that would vex Selznick throughout the production.

Selznick's initial choice for screenwriter was Jane Murfin, with whom he had worked on *What Price Hollywood?* and *Little Women*. However, after Kay Brown told him that Sidney Howard might be available, Selznick hesitated. Howard was a Pulitzer Prize-winning playwright who was also known as one of Hollywood's best screenwriters, nominated for Academy Awards for screenwriting for *Arrowsmith* and *Dodsworth*. Within days of learning of Howard's availability and interest in *Gone With The Wind*, Selznick fired Murfin and hired Howard.

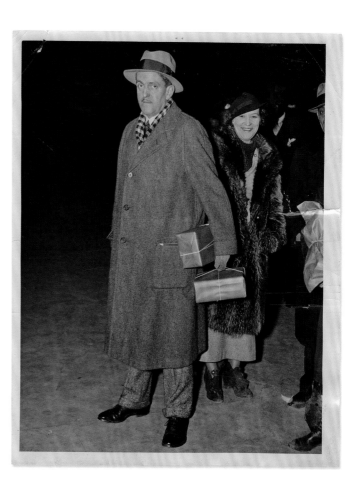

"STOP PLANTING STORIES ABOUT HEPBURN"

In the fall of 1936 and well into 1937, it was becoming apparent to Selznick that *Gone With The Wind* was going to be expensive and was going to take some time to produce. Worried that the public would lose interest in the story, Selznick authorized various activities to keep public interest in the film production high. He tried unsuccessfully to acquire rights to serialize the novel in a magazine and authorized a radio play based on a chapter in the novel to be sponsored by Sears Roebuck and Co.

Selznick assigned Russell Birdwell, his head of publicity, the task of keeping the public interested in *Gone With The Wind*. Birdwell, sometimes referred to as "the mad Birdwell" by Kay Brown and Silvia Schulman, was a former reporter for Hearst Newspapers. Knowing that Katharine Hepburn had hinted at her interest in the part of Scarlett, Birdwell began planting stories about her in the press. Public interest in who would play the part was so intense, however, that such stories became a nuisance.

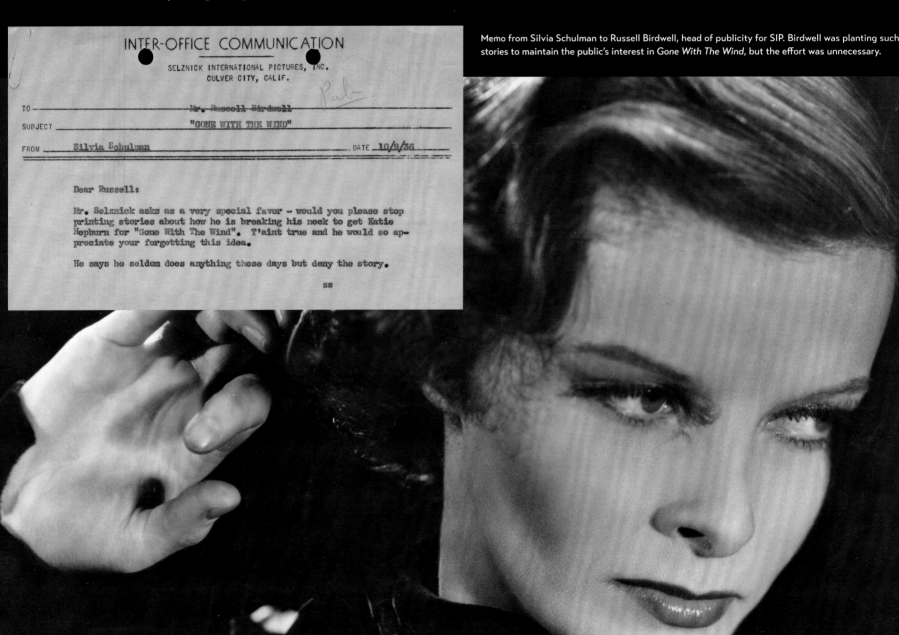

Memo from Silvia Schulman to Russell Birdwell, head of publicity for SIP. Birdwell was planting such stories to maintain the public's interest in *Gone With The Wind*, but the effort was unnecessary.

INTER-OFFICE COMMUNICATION

SELZNICK INTERNATIONAL PICTURES, INC.
CULVER CITY, CALIF.

TO — Mr. Russell Birdwell

SUBJECT — "GONE WITH THE WIND"

FROM — Silvia Schulman DATE 10/9/36

Dear Russell:

Mr. Selznick asks as a very special favor — would you please stop printing stories about how he is breaking his neck to get Katie Hepburn for "Gone With The Wind". T'aint true and he would so appreciate your forgetting this idea.

He says he seldom does anything these days but deny the story.

SS

THE INVASION OF THE SOUTH

Despite being asked repeatedly, Margaret Mitchell refused to work on the screenplay of *Gone With The Wind*. She was quite happy, however, to meet and talk with the writer, director, and anyone else from Selznick's company. Selznick planned to send George Cukor and Sidney Howard to Atlanta to meet with Mitchell, scout locations, and audition some young actors.

Kay Brown was to organize and supervise the entire enterprise. Her plan was to contact colleges throughout Georgia and neighboring states and, if they had a drama department, ask if they would consent to an open audition for parts in the film. She would also contact Junior Leagues and Little Theater groups. Along with Anton Bundsmann and her secretary, Harriett Flagg, Brown would select the most promising candidates to meet with Cukor. Cukor never made the trip, however. He stayed in Hollywood editing and shooting retakes for *Camille* with Greta Garbo.

Everyone involved severely underestimated the response their invitations would receive. In Baltimore, the first stop, "the belles turned out in droves," but "it was all very social and very General Lee." However, "Washington was different." Brown's report began, "There is no reason to bore you with long reports on our activities. Just know a day in New York is child's play [compared] to this mad house."

Charleston and Atlanta were even more chaotic. The trio quickly realized they could not communicate with Selznick by telephone because the switchboard operators in their hotels would leak news of their plans and movements. Many of the colleges Brown had contacted closed for the day so students could attend the auditions. Where Brown thought dozens of people might show up, hundreds descended on them. Some came wearing full antebellum costumes; a few came in blackface. For many it was an event, a chance to be part of the story that had taken the country by storm. But

Kay Brown and her secretary, Harriett Flagg, handled the logistics of the open auditions in the South while Anton Bundsmann rehearsed with the actors and directed their performances. Publicity for the talent search, which Brown facetiously called the "Invasion of the South," was intended to attract suitable talent and promote interest in *Gone With The Wind*. The public's response, however, overwhelmed the three talent scouts. Anton Bundsmann later changed his name to Anthony Mann and became one of Hollywood's top directors. Photo by Winn for the *Atlanta Journal*.

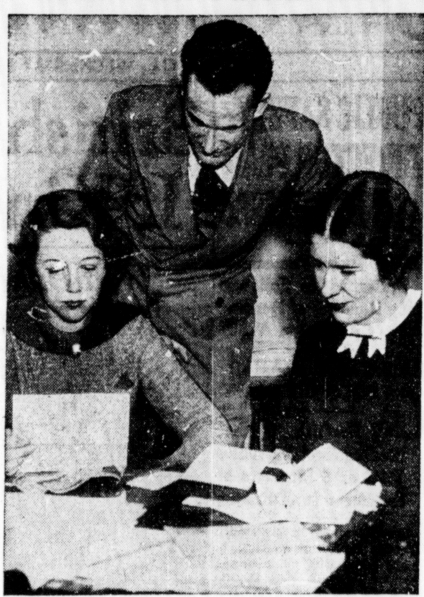

Seek Film Talent Here

THREE HOLLYWOOD SCOUTS, advance guards of a company of film officials who will come here to seek talent for roles in the screen version of "Gone With the Wind," pictured as they arranged their schedule for interviews Wednesday. They are Anto Bundsmann, who will direct tests for prospective Scarlett O'Haras; Katherine Brown (left), studio representative, and Harriett Flagg, a secretary.—Staff photo by Winn.

for Brown it was a disappointment. As with the talent hunt for *The Adventures of Tom Sawyer*, almost no one they talked to had either training as an actor or any natural talent.

Out of the hundreds of people interviewed, only a small handful showed any promise. The standouts from the "Invasion of the South," as Brown called it, were three young women, Louisa Robert, Susan Falligant, and Alicia Rhett. Brown sent photographs to Selznick for his reaction. Because Cukor had been unable to attend any of the open auditions, Selznick and Brown decided to invite the most promising Scarlett "hopefuls" to New York to shoot screen tests. Alicia Rhett, who impressed everyone from Hollywood with her charm and authenticity, would eventually be cast in the film as Ashley's sister, India Wilkes.

On his way to Europe, Cukor stopped in New York to work with the young women as well as several stage actors Brown had lined up for him. He also met with Sidney Howard, who was becoming increasingly concerned about arranging a conference with the director.

(ABOVE) Kay Brown said of Alicia Rhett, "This is one of the sheltered Southern types, as you can see from her haircut. Incidentally, this hair is a most magnificent red and her eyes are dark brown. She gave a lovely reading of Melanie, insofar as any amateur can read Melanie." Indeed, Rhett was seriously considered for the role of Melanie for months but was eventually cast as Ashley's sister, India.

(RIGHT, TOP) Character description of Scarlett O'Hara distributed to women auditioning for the part at casting calls in the South in 1936–1937. See appendix for remaining text.

(RIGHT) Kay Brown's report on the open auditions in Charleston was typical of their experiences. Her next report from Atlanta began, "I shall refrain from detail about this harrowing experience." Brown persuaded Selznick to let her use an approach that targeted cities with Little Theater groups and colleges with drama departments rather than public auditions that only attracted "the curious who are completely devoid of talent and assume proportions that are impossible for the three of us to handle."

GONE WITH THE WIND....

SCARLETT O'HARA....

Daughter of Gerald O'Hara and Ellen Robillard O'Hara. Sister of Suellen and Carreen O'Hara. 1861...at sixteen...married to Charles Hamilton of Atlanta. 1865... at twenty...married to Frank Kennedy. 1868...at twenty-three...married to Rhett Butler. Mother of Wade Hampton Hamilton, of Lorena Ella Kennedy and of Bonnie Blue Butler. At sixteen Scarlett is the belle of North Georgia. She has had proposals from practically every man in the countryside. Outwardly demure with all the graces of a southern gentlewoman, she is, under the surface veneer, a woman vain, obstinate, self-willed, passionate. Her face, arresting if not beautiful, is a blend of the delicate features of her mother, a coast aristocrat of French descent, and the heavy ones of her florid, Irish father. Her eyes are a clear, pale green above which black brows slant upward. Her lashes are a bristly black, against skin of magnolia petal white. Curly black hair is neatly parted, smoothed and netted into a lady-like chignon. Above a seventeen inch waist, firm but mature breasts are emphasized by tightly pulled stays. Her hands are tiny, slender, and very white. Her feet are small and graceful. Her dimpled face is schooled to a modest sweetness that belies the turbulent, willful eyes, lusty with life. Her airs are for men...women are her natural enemies.

At twenty Scarlett has been matured by hard work and suffering. She has been hardened; her temper sharpened, her hands roughened. Greed and ruthlessness show through the veneer more often. Only two weak spots in her armor...her love for Ashley Wilkes and her passionate love for Tara, her home plantation...for the land.

As wife to Frank Kennedy she is alternately sweet and teasing, and a raging wildcat, with the temper of a tartar. When she is angry, black brows meet in a sharp angle above blazing eyes. As a business woman she is alternately a brave but timid lady, helpless and dependent, and a cold, greedy, businesslike and unscrupulous harridan.

TO SS FROM DM 12/2/36
KB CALLED FROM ATLANTA TO SAY THAT ALL HER MESSAGES WOULD HAVE TO BE
SENT OUT ON THE TELETYPE AS EVERYTHING PERTAINING TO GONE WITH THE WIND
IS NOBODYS BUSINESS BUT THE SOUTHS AND EVERYTHING SHE DOES IS IMMEDIATELY
BROADCAST TO THE WINDS AND PUBLISHED POST HASTE HENCE THE RELAY OF HER
REPORTS.

TO DOS FROM KB IN ATLANTA
WE ARE BARRICADED IN OUR ROOM HAVING ARRIVED THIS MORNING FROM
CHARLESTON. WAS OFFERED SEVERAL ELEVEN MONTHS OLD BABIES AND IF YOU
NEED A COOK SAY THE WORD AS ALL THE MAMMIES WANT TO COME NORTH. WE
HAVE BEEN PHOTOGRAPHED FROM EVERY POSSIBLE ANGLE INCLUDING REAR VIEW.
CHARLESTON WAS MARVELOUS. ONE PARTICULAR YOUNGSTER, ALICIA RHETT,
HAS DEFINITE QUALITIES FOR MELANIE. DONT WORRY ABOUT TEST SITUATION.
NO COMMITTMENTS HAVE BEEN MADE WHATSOEVER. THE RICH JUNIOR LEAGUE
FROM BALTIMORE OFFERED TO PAY THEIR OWN FARE TO CALIFORNIA. REGARDING
PEOPLE IN WHICH WE ARE DEFINITELY INTERESTED HAVE FULL KNOWLEDGE OF
FINANCIAL SITUATION AND AM IN A POSITION TO MAKE SPECIFIC RECOMMENDA-
TIONS TO GEORGE ON THIS POINT. BY THE WAY, WHERE THE HELL IS GEORGE
AND WHEN DOES HE ARRIVE. MARGARET MITCHELL GOT UP EARLY THIS
MORNING AND IS ABSOLUTELY MARVELOUS. WANTS TO PUT ON A DISGUISE
AND COME TO THE FRIDAY AUDITIONS WHICH ARE OPEN TO THE PUBLIC. FIVE
OTHER DAYS OF AUDITIONS HAVE BEEN SCHEDULED INCLUDING VARIOUS COLLEGE
GROUPS, JUNIOR LEAGUES, LITTLE THEATRE GROUPS WITHIN A RADIUS OF 100
MILES. SORRY THIS IS SUCH AN INCOHERENT WIRE. IT SHOULDNT BE AS WE
ARE IN A DRY STATE BUT THE MARSHS ARE EXPOSING US TO A LITTLE
CORN TONIGHT.

Hollywood Glamour Fails to Blind Her

Hollywood may have its eyes on MISS ADELE LONGMIRE, daughter of Mr. and Mrs. John P. Longmire of 1260 Esplanade avenue, but this daughter of an old New Orleans family certainly hasn't her eye on Hollywood. A wire from the casting director of "Gone With the Wind," saying he would be here and wanted to see "Billy" Longmire again left this young New Orleans girl as disinterested today as she was when she ignored Selznick's recent $100-a-week proffered contract for a part in this forthcoming picture. Miss Longmire has had important parts in three Little Theater productions.

WO ALLEGED RUNK DRIVERS JAILED HERE

Police made two arrests for drunkdriving during the early hours of iday morning.

John Cassreino, 28 years old, of 913 urth street, a clerk in the assoc

MAY OFFER N. O. GIRL ROLE IN 'WIND' FILM

MOTHER, YOUN SON ARE SLAIN; MAN SLASHED

(By The Associated Press)

Lynchburg, Va., April 2.—Lock in their apartment only a few f away from friends, Mrs. William Craghead and her 10-year-old so

THE "CREOLE GIRL"

Kay Brown's experiences during the "Invasion of the South" convinced her that open auditions were a waste of time and energy. Their best bets, she concluded, were university drama departments and Little Theater groups. Following their tour, Brown, Bundsmann, and Flagg visited the Vieux Carré theater, a well-known Little Theater group in New Orleans. There they found a young woman who, more than any other amateur actress they met, made them think of Scarlett O'Hara. Her name was Adele "Billie" Longmire, and they referred to her as the "Creole Girl." Selznick, Cukor, and Whitney were all intrigued.

For months Kay Brown tried to arrange a trip for Longmire to New York or Los Angeles for a screen test. Her parents opposed the trip, however, despite Brown's offer to cover expenses for both Longmire and her mother. They objected primarily to the long-term contract, which was an obstacle to signing for many of the amateur actors that Selznick's scouts found in the South.

In mid-April 1937, during a cross-country trip by train, George Cukor stopped off in New Orleans to meet her. After working with Longmire for an hour, he decided she "has a great intensity and real acting talent," and that although he felt she wasn't right for the part of Scarlett, Selznick should definitely sign her. Longmire was more interested in a career in the theater, however, and resisted signing with Selznick or with MGM or Warner Brothers, who had become interested in her as well.

A year later, in the summer of 1938, Adele Longmire took part in the Central City Play Festival near Denver, Colorado. She was in *Ruy Blas* by Victor Hugo, and on the last night of the play's run, the playwright Elmer Rice was in the audience, probably at the suggestion of Kay Brown and his friend, Jock Whitney. Rice asked to meet Longmire after the performance and after a brief conversation, offered the part of Ann Rutledge in the play he was directing, Robert Sherwood's *Abe Lincoln in Illinois* on Broadway.

Longmire enjoyed a long career in the theater and later became a literary agent. In 1942, she starred opposite Regis Toomey and Howard Da Silva in *Bullet Scars* for Warner Brothers and in later years occasionally appeared in small roles in film and on television.

(FACING) Less than two weeks after this newspaper story, George Cukor traveled to New Orleans to interview Adele Longmire. Although she was ambivalent about acting in films, she eventually moved to New York to pursue a career on the stage. *New Orleans States*, April 2, 1937.

(RIGHT, TOP) Longmire's parents objected to the long-term contract, which they felt gave almost unlimited power to the producer and none to the actor. Many other amateur actors discovered during Kay Brown's talent search in the South voiced the same concerns.

(RIGHT, BOTTOM) After Cukor's meeting with Adele Longmire, Selznick and Brown tried for months to sign her to a long-term contract. Bernard Szold, the director of the Vieux Carre theater in New Orleans, tried to interest MGM in her as well.

FEBRUARY 15, 1937

TO KB FROM HF

FOLLOWING WIRE RECEIVED FROM SZOLD...."TERRIBLY SORRY BILLIES PARENTS UNWILLING TO ALLOW HER GO NEWYORK FOR TEST STOP DO HOPE YOU FIND POSSIBLE CONSIDER ONE OF OUR OTHER GIRLS AS THEY MOST ANXIOUS TO COME STOP BILLIE HEARTBROKEN SENDS MANY THANKS AND REGRETS."

ALICIA RHETTS SIGNED CONTRACTS ARRIVED TODAY. NO WORD FROM OTHERS AS YET.

TO DOS FROM KB APRIL 14, 1937

HAVE JUST HAD LONG TALK WITH GEORGE AND THIS IS HIS OPINION ON BILLIE LONGMIRE, THE CREOLE GIRL, AND HE BASES THIS ON HAVING WORKED WITH HER FOR AN HOUR. HE FEELS THAT SHE HAS A GREAT INTENSITY AND A REAL ACTING TALENT. SHE WOULD BE USEABLE IN THE YOUNG EMOTIONAL ROLES LIKE SILVIA SIDNEY PLAYS. SHE IS NOT A POSSIBILITY FOR SCARLETT IN GONE WITHE THE WIND. WE HAVE DISCUSSED THE PROBLEMS OF THIS YOUNG LADY AND WE BOTH FEEL THAT THERE IS A GOOD CHANCE BERNARD SZOLD WILL DOUBLECROSS US AND SELL HER TO METRO FOR HIGHER MONEY THAN WE ARE OFFERING AND IF UPON READING GEORGES OPINION AS TO HER ABILITY YOU WANT HER I BELIEVE THAT IT WILL NECESSITATE MY GOING TO NEW ORLEANS AND SEEING THE FAMILY AND GETTING HER SIGNED UP RIGHT THERE.

THE FIRST PROTEST

In late October 1936, Selznick began receiving cards and letters protesting the production of *Gone With The Wind*. At first the protests came from Brooklyn, then Philadelphia. Almost all were simply addressed to Selznick International Productions, Hollywood, California. As William Wright wrote in a November 5, 1936, report to Selznick, the writers were "protesting against the filming of GONE WITH THE WIND on the grounds that it is un-American, anti-Semitic, anti-Negro, Reactionary, pro-Ku Klux Klan, pro-Nazi and Fascist." He recommended "we ignore the whole matter and not even answer the letters unless they continue to come in in much greater volume."

Silvia Schulman, Selznick's secretary, answered Wright, saying that she had brought the letters to Selznick's attention and that he had instructed her to inform John Wharton. She added, "It looks like a very local project between the Negroes and the Jews, and all the other isms in Brooklyn."

William Wright noted that one protester identified herself as being affiliated with the Wynnefield Branch of the League Against War and Fascism. Wright believed the organization had "some sort of publication which started the crusade, such as it is."

John Wharton agreed that they not reply because "we would only be dignifying a situation which does not call for any such action on our part."

By the end of January 1937, many more cards and letters had arrived, and some, as William Wright noted, included "threats of definite and specific action." Selznick sent a selection of the letters to Jock Whitney with the suggestion that they "get up a form letter (separately typed because a printed or mimeographed letter might be a confession of the number of these letters we have received) stating that we think complaints against the picture, in advance of the production, are unfair and that they may be sure we feel as keenly as they do about picture material that would carry with it any propaganda of antagonism and that the negro will be treated with the greatest respect in the picture."

Jock Whitney suggested they consult the Hays Office, which agreed that a reply was in order. Subsequently, anyone protesting the production of *Gone With The Wind* received the following reply, tailored to his or her specific comment:

> We are in receipt of your letter addressed to ******** concerning our imminent production of "Gone With The Wind."
>
> We urge you to believe that we feel as strongly as you do about the presentation to the public of any material that might be prejudicial to the interests of any race or creed, or that might contain any un-American material.
>
> We respectfully suggest you suspend judgment until the completion of the picture, which we can assure you will contain nothing that possibly could be offensive to you. In particular, you may be sure that the treatment of the negro characters will be with the utmost respect for this race and with the greatest concern for it sensibilities.

The first cards and letters protesting the production of *Gone With The Wind* were sent from Brooklyn in late 1936. The writers were concerned that the treatment of African Americans in the novel would be amplified in the mass medium of film. Although his advisors suggested he ignore the protest, Selznick insisted the letters be answered with individually tailored responses.

THROUGH SCARLETT'S EYES

Excerpt - (Original filed GONE WITH THE WIND - Casting - Southern Talent Search)

Wind - Sets

Mr. David Selznick
Culver City, Calif.

Dear David:

Dec. 11, 1936

Memo III - Macon

...Your suggestion of Hobe Irwin is, I think, absolutely perfect. The problem, as I see it, is to get Peggy's permission to take license with the settings in the book. The book, she says, is projected through Scarlett's eyes and as Scarlett saw 'Tara' it was beautiful but in reality it was an ugly place, in keeping with the architecture of the period and from what I saw of these houses they were an absolute horror. I pictured 'Twelve Oaks' as a beautiful plantation, such as the Louisiana plantations. This is inaccurate. It was beautiful to Scarlett because it was Ashley's home. The mistake I made is a common one. In every city we visited they wanted us to go to a beautiful plantation "just like Twelve Oaks and Tara". In Louisiana they picture their own lovely places as the ones described in the book and the majority of people are going to be very disappointed if we portray these places as ugly buildings. I'm sure there is a compromise with complete authenticity which will be beneficial to all concerned but it will have to be handled intelligently and with diplomacy. Mitchell worked ten years not seven on the background to make it completely authentic so it is somewhat of a problem to discuss changes. Both she and her husband know intimately what you stand for in pictures and are counting on you to film the book so the South will have its first real Southern picture. All the South will have its different ideas and it will be no cinch to lick this problem in a commercial as well as artistic manner.

Kay Brown

From New Orleans, Brown returned to New York. Cukor was still planning to come, but decided to take his vacation in Europe first. In the meantime, Brown scheduled New York actors for him to meet and organized screen tests for the young women they had invited on their southern tour.

Selznick still wanted Cukor to visit Margaret Mitchell in Atlanta, accompanied by Hobe Erwin, a highly respected interior designer and art director who had worked with Selznick on a number of films, including *Topaze* (1933), *Little Women* (1933), and *Dinner at Eight* (1933). In addition to consulting with Mitchell, Selznick wanted them to scout locations, do background research, and possibly audition more Scarlett candidates.

Margaret Mitchell's comment that *Gone With The Wind* was "projected through Scarlett's eyes" and Kay Brown's observation that southerners wanted their region depicted as beautiful and genteel greatly influenced Selznick's conception of the film, as much as the many letters and comments urging him to be historically accurate and to present a "true picture of the South." Indeed, the conflict between beauty and historical accuracy would come up constantly throughout the production.

(ABOVE) While Selznick wanted *Gone With The Wind* to be completely authentic, he was a showman who looked for every opportunity to depict beauty and create spectacle. The question of how much artistic license he should take with the story would come up again and again as the production progressed.

(RIGHT) Lillian Deighton, the head of Selznick's research department, compiled volumes of photographs and accounts of events for use by the production team.

FIRST DRAFT

Throughout the fall of 1936, Sidney Howard had been busy with the screenplay. He delivered his fifty-page "Preliminary Notes on a Screen Treatment of Gone With The Wind" on December 14, 1936. Selznick went through it carefully and although he agreed with most of Howard's thoughts on how to shape the story into a manageable screenplay, replied on January 6, 1937, with eight pages of his own notes. Selznick regarded the process as an "enormously difficult editing job" that involved decisions about what parts of the story could be cut and what parts combined. Howard was happy to go along with Selznick's idea to cut out the Ku Klux Klan entirely, for example, but other cuts and changes would prove to be much more difficult to agree on.

With Selznick's notes in hand, Howard began work on the final screenplay. He felt he could work on the "most obvious scenes" and complete "almost three fifths of the first rough dialogue draft" on his own, but he felt strongly that he would need face-to-face meetings with both Selznick and Cukor in order to work out some of the more difficult parts of the screenplay. Scheduling these face-to-face meetings proved difficult. Cukor's trip east was rescheduled several times before he finally arrived in New York in early January. Howard would not get to work with Selznick until later that spring. Nevertheless, he delivered his first draft on February 12, 1937. It was 250 pages long, twice the length of the usual screenplay. Howard said that as he and Cukor worked through the story, they decided "the most practical course was to proceed regardless of length." Howard added, "It is obvious that some radical amputations of book material will be obligatory."

In this letter to Selznick, Sidney Howard mentions Selznick's reaction to his "Preliminary Notes on a Screen Treatment." Selznick had suggested, among other things, eliminating all mention of the Ku Klux Klan, adding that he had "no desire to produce [an] anti-Negro film." Howard agreed, but other cuts and transitions between plot points would be much more difficult. Selznick, Howard, and a number of other screenwriters would struggle with this problem throughout the production.

SIDNEY HOWARD
157 EAST 82ND STREET
NEW YORK CITY

January 11th, 1937.

Dear David:-

Thank you for mailing me your reactions to the treatment. It was a good idea for you to do so because, believe it or not, Cukor had lost his. I don't think that there is much of any value in any treatment, beyond that of forcing a writer to do some initial planning and discover for himself where the most obvious snags are going to come.

George and I are spending every afternoon together. He has already had script on the first two sequences and I can come pretty close to giving him most, if not all, of the first draft before he sails on Saturday. I was very pleased indeed that you felt as I do about the Klan and if what George and I worked out on Saturday holds water for us today, we have licked that problem and all its present day unpleasant implications by a great big, clean omission, which would almost certainly have been necessary in any event.

You don't have to worry about actual changes. There is ample material in this book without adding anything new of our own. The tough nut is the arrangement of the material. The book is written in a series of islands: good enough novel technique, but you have to produce a picture, not an archipelago. Where the islands are big enough, as, for example, the whole passage beginning with Melanie's baby and ending with the flight from Atlanta, we encounter no trouble. Where they are small, as, for example, Belle Watling's attempt to give money to the hospital, they can be fairly fussy. My object in this first draft is to get the story on paper structurally for picture purposes and largely in master scenes, and I am going through to the end even though I am already conscious of some rather brutal transitions. Almost all of those, I think, will be taken care of in the revision one expects to do with the director. I have learnt from experience that a writer can waste a lot of time by getting his wires crossed and writing his first draft as though he were himself directing the picture. My plan is to push this first draft right through and get it in the mail to you as soon as possible.

affection

David Selznick, Esqre.

SELZNICK'S THEORY OF ADAPTATION

Inter-Office Communication

SELZNICK INTERNATIONAL PICTURES, INC.

9336 WASHINGTON BOULEVARD CULVER CITY, CALIFORNIA

OFFICE OF THE
PRESIDENT

To: Mr. Ring Lardner, Mr. Russell Birdwell

Subject: "GONE WITH THE WIND" – Woollcott Broadcast

Date: January 7, 1937

I can't think of any new angles for Woollcott's "Gone With The Wind" broadcast – much as I would like to. However, perhaps he can do something with the following:

Cukor is about to make a trip through the South, accompanied by Sidney Howard and Hobe Erwin, the famous interior decorator. Cukor will not merely look for talent, but together with Erwin will make a detailed study of Southern interiors and furniture, to make sure that the picture is accurate in these respects.

With further reference to the accuracy of atmosphere and casting, you need only refer to Cukor's work on "David Copperfield", "Little Women" and "Romeo and Juliet" and my own work on "Copperfield", "Fauntleroy", "Tale of Two Cities", etc.

It may be of interest to Woollcott to know I have a theory of adapting successful novels, which I do not apply to unsuccessful novels or to originals, and which theory I do not think is followed by other producers.

It is that I make no attempt to correct seeming faults in a successful novel but to include these seeming faults of the novel with its seeming successes. I feel one never knows what chemicals have gone to make up success and that a successful adaptation is obtained by the most conscientious effort to recapture these chemicals.

In the picturization of a long novel, cuts are obviously necessary because of length. However, in making these cuts, I try my best to make block cuts so that the scenes we retain can be done as fully as possible and as closely as possible to the original scenes in the book. I do not share the general motion picture theory that the screen is a different medium and because of that necessitates a different approach. I feel that the screen is much closer to the novel in form than it is to the play and that its latitude is at least that of the novel.

I see no reason at all for the wide departures in adaptations of successful novels. I have followed the approach, of which I speak above, in the picturization of "David Copperfield", "Anna Karenina", "Tale of Two Cities", "Little Lord Fauntleroy" and "The Garden of Allah" and am now following it in the production of "The Prisoner of Zenda".

As to the casting of "Gone With The Wind", I feel that new personalities are preferable – first, selfishly because of my belief the roles of Scarlett and Rhett will make stars for us; and second, from the standpoint of illusion created by the picture itself: wellknown personalities are liable to be identified with their previous roles, whereas a new personality will be accepted, provided they are sufficiently talented and properly cast as Scarlett and as Rhett.

DICTATED BUT NOT READ BY
DAVID O. SELZNICK

Selznick's memo to his publicity men, Russell Birdwell and Ring Lardner, Jr., about an upcoming radio broadcast on Alexander Woollcott's program *The Town Crier* mentions Cukor and Erwin's upcoming trip to the South and his desire for accuracy in *Gone With The Wind*. Written the day after his eight-page response to Sidney Howard's "Preliminary Notes on a Screen Treatment," Selznick's memo more succinctly explains his "theory for adapting successful novels." He felt that the key to a successful screen adaptation was to stay faithful to the source material, making "no attempt to correct seeming faults in a successful novel but to include these seeming faults of the novel with its seeming successes." Selznick's determination to follow this system would create conflicts throughout the production.

David O. Selznick's reputation as a filmmaker was built on a long line of film adaptations of classic novels such as *David Copperfield* and *A Tale of Two Cities*. In the course of making these films, he developed his "Theory of Adaptation," briefly described here, which he applied to *Gone With The Wind*.

CUKOR'S TRIP SOUTH

After many false starts and schedule changes, George Cukor finally arrived in New York on March 15, 1937. Two days earlier, three of the young women invited for full-costume screen tests, Louisa Robert, Susan Falligant, and Alicia Rhett, had arrived with their chaperone. Cukor met with them and saw their tests. Of the three, only Alicia Rhett impressed Cukor. He felt she had a "fine quality" but worried that the role of Melanie might be beyond her talents.

During her trip south, Kay Brown had become doubtful the studio would ever find a Scarlett from the general populace. To satisfy the intense interest from the public and the press, she proposed casting one or more of the young women for the movie's barbeque scene and Selznick agreed.

After reading Kay Brown's "Invasion of the South" report, Cukor wanted to go to Atlanta without fanfare. Although both Selznick and Margaret Mitchell agreed at first, Sidney Howard objected, making the point that they would necessarily be taking some liberties with the story and settings and would therefore be vulnerable to criticism if the director of the film didn't make a public visit to the city where the story takes place. Selznick, Mitchell, and Cukor were persuaded, and Brown agreed to accompany Cukor and Erwin to Atlanta, but wanted it "clearly and distinctly understood that I am being a complete martyr and that nobody shall say I am doing this because it will be fun to be there."

Cukor's visit to Atlanta went well. Mitchell arranged a press gathering and introduced Cukor to two people who became technical consultants on the film, Wilbur Kurtz, a noted Civil War historian, and Susan Myrick, a newspaper reporter and old friend of Mitchell's.

George Cukor and Hobe Erwin in Atlanta. Margaret Mitchell gave the pair a tour of Atlanta, including a trip along the road that Scarlett took to Jonesboro and Tara. Staff photo by Winn for the *Atlanta Journal*, March 29, 1937.

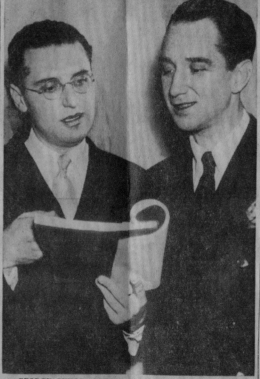

The Atlanta Journal

ATLANTA, GA., MONDAY EVENING, MARCH 29, 1937

'Gone With Wind' Director Really Seeking Atmosphere

GEORGE CUKOR (LEFT), NOTED MOTION PICTURE DIRECTOR, and HOBE ERWIN, prominent designer, compare notes on Atlanta following a tour of the city and its environs with Margaret Mitchell, whose 'Gone With the Wind' will be screened by Mr. Cukor. He said he would reproduce Peachtree Street as it appeared in the Sixties, in Hollywood.—Staff photo by Winn.

Journal Reporter's View Changed After a Talk With George Cukor

BY HARRY WILENSKY

George Cukor, noted Hollywood director, who will make the movie version of "Gone With the Wind," is in Atlanta in search of atmosphere—and strange as it seems, it isn't a publicity stunt.

Making his first trip south, the film director came here to see about looking for talent and atmosphere in Atlanta is merly an attempt to arouse interest in the forthcoming movie, a Journal reporter went out in cynical mood to interview Mr. Cukor. But the film director lost no time in unconvincing him.

Mr. Cukor has three telephones in his hotel suite, but he answered none of them Sunday night. "Your party isn't in," chirruped the telephone operator.

"Oh, yeah?" retorted the reporter and went to the room clerk

MARCH 16, 1937

GEORGE ARRIVED AND IS TELEPHONING YOU LATER THIS MORNING. HE WAS SO
NICE ON THE PHONE AND COMPLETELY COOPERATIVE ABOUT SOUTHERN GIRLS.
HE IS MEETING THEM THIS AFTERNOON AT THREE, SEEING THEIR SILENT TESTS
AND AUDITIONING THEM AND THEY WILL GET AWAY EITHER TONIGHT OR TOMORROW,
UNLESS GEORGE DECIDES HE THINKS ONE OR TWO OF THEM HAVE REAL ABILITY
AND KEEPS THEM OVER FOR FURTHER TESTS. FOUR NEWSPAPER CAMERAMEN
WERE ON THE SET DURING ENTIRE DAY. THE PUBLICITY BREAKS LOOK AS
THOUGH THEY WILL BE TREMENDOUS OUTSIDE OF NEW YORK. GEORGE IS BEING
PHOTOGRAPHED WITH THE GIRLS THIS AFTERNOON AND THIS SHOULD HIT THE
NEWYORK PAPERS BIG. WILL AIRMAIL SILENT TESTS TOMORROW.

BRIEFLY DISCUSSED WITH GEORGE HIS SOUTHERN TRIP AND HE MOST ANXIOUS
TO MAKE IT. HE WILL ADVISE YOU ALL DETAILS.

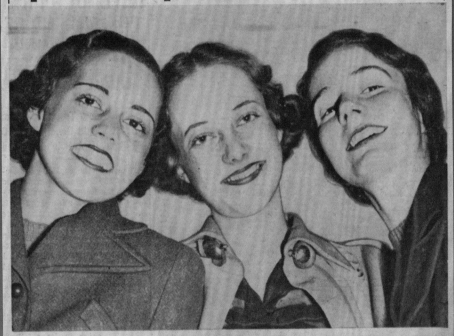

NEW YORK AMERICAN—*A Paper for People Who Think*—MONDA

Sylvia Sidney's Rivals for Film Role

LOUISA ROBERT, LEFT; SUSAN FALLIGANT, CENTER, AND ALICIA RHETT
*In City for Screen Tests for Role, in Movie Version of 'Gone with the Wind,' for
Which Sylvia Sidney Is Being Considered* N. Y. American Staff Photo.

SELZNICK INTERNATIONAL PICTURES, INC.
NEW YORK CITY

Inter-Office Communication

TO Mr. David O. Selznick DATE March 29, 1937

FROM Mr. George Cukor - in Atlanta SUBJECT GONE WITH THE WIND.
Second Talent Search

Dear David:

Will you have somebody in your office look this girl up. She seems
definitely interesting. (Betty Barney)

We arrived yesterday with a great fanfare. Margaret Mitchell was
absolutely divine with us, helpful, cooperative, very intelligent
about the whole thing. Yesterday, she took Hobe and me up and down
the city, showing us where she imagined various houses to be; then
we followed the road that Scarlett took to Jonesboro and 'Tara',
looking at houses, etc. I found it enormously helpful.

In the afternoon, we went to a meeting of the Atlanta Historical
Society where I was my usual gracious self and made a very good im-
pression for Selznick International - which was not difficult for me.
We have made all arrangements with the Historical Society to photo-
stat their records and pictures; have had long lists of reference
books, some of which we will buy locally, so we will be as completely
equipped as we were for COPPERFIELD.

Kay and Darrow and Miss Flagg arrived today and we are organizing
the talent bureau and giving a big tea for the press tomorrow. Kay
and Miss Mitchell and I have been looking for suitable technical
advisors. One is a Wilbur Kurtz who is regarded as the great
authority on architecture, military movements, Civil War, etc. in
Atlanta. For the social customs, women's costumes, general behavior,
there is a very intelligent friend of Miss Mitchell's who is very
well born - Miss Myrick - who has lived both in Atlanta and in the
country outside Atlanta who would be ideal. Kay is talking to them
both about money. I should imagine you would get them very inex-
pensively. With them I feel we can make no glaring mistakes and they
will be of enormous help to us.

After all my gracious promises, I forgot that I did not have Garbo's
telephone number. I am getting it and will call her one evening,
either today or tomorrow.

Can you do something about Time Magazine - current issue? I suppose
you read the item in which it said that I said that I will select Scarlett,
I want her to be this and I won't have this - all of which you know
with my usual tact and modesty I did not say - and then after making
fun of me they make me still further a fool by saying that the part
had been filled three days before.

After we finish here we are going to Savannah, Charleston and New Orleans,
combing the country quite thoroughly for talent, etc. I think I want to
go back to California and then go East with you, if you want me to.

Affectionate regards,
George (under contract
to Selznick International)

(ABOVE, TOP) After completing *Camille* with Greta Garbo, George Cukor traveled
first to New York, where he worked with the three young women Kay Brown had
discovered during her talent search in the South: Louisa Robert, Susan Falligant,
and Alicia Rhett. From there he traveled to Atlanta to meet Margaret Mitchell.

(ABOVE) Of the three women tested, only Alicia Rhett impressed Selznick with her
screen test, but Kay Brown's suggestion that he cast several young southern women
in the barbeque scene to justify the extensive talent search and garner publicity
appealed to him. *New York American* staff photo, March 15, 1937.

(RIGHT, TOP) George Cukor's report to Selznick about his trip to Atlanta includes
the recommendation that Selznick hire Wilbur Kurtz and Susan Myrick as technical
advisors to ensure he made "no glaring mistakes" on *Gone With The Wind*.

(RIGHT) Wilbur Kurtz (cutting cake) and Susan Myrick (looking over Kurtz's
shoulder) at Kurtz's birthday party.

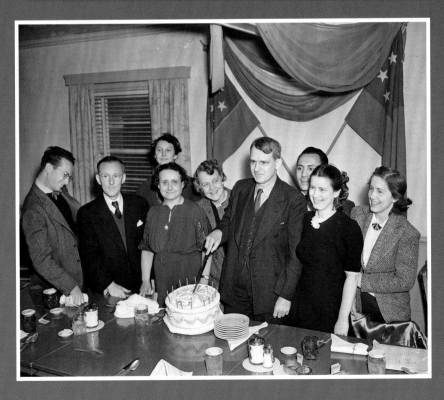

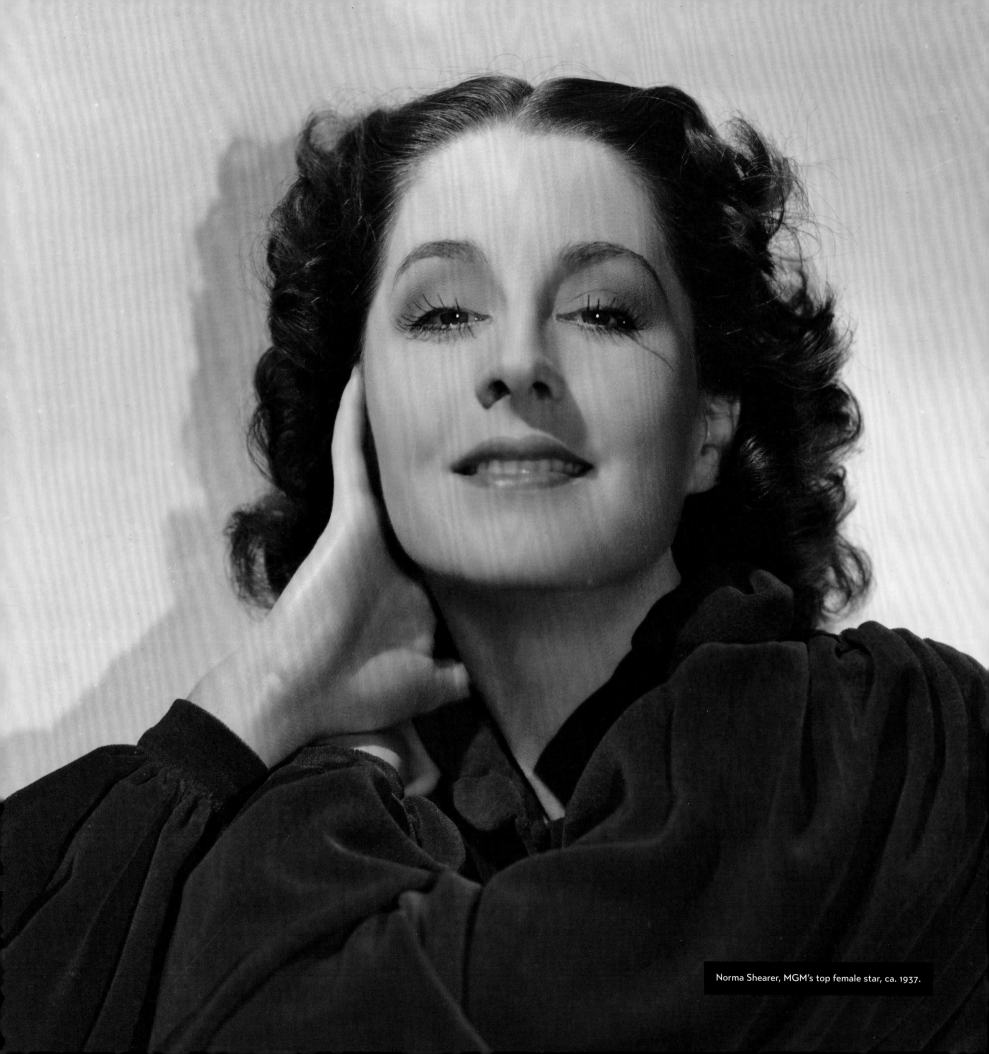

Norma Shearer, MGM's top female star, ca. 1937.

NORMA SHEARER

On March 21, 1937, Walter Winchell, the American newspaper and radio gossip commentator, reported that Selznick was desperately trying to get Norma Shearer to play Scarlett O'Hara. The public response was quick, harsh, and overwhelmingly against Shearer for the part of Scarlett. Some said she might be right for Melanie, perhaps, but not Scarlett.

Shearer was one of the top stars at MGM. Her husband, Irving Thalberg, had been head of production at MGM and had died, tragically, at the age of 37 less than a year earlier. Selznick had been talking to MGM about casting Clark Gable as Rhett Butler. With Gable as Rhett, Shearer would seem a natural for Scarlett because Gable and Shearer had costarred successfully in two films together and were planning a third. Furthermore, Shearer and Thalberg had been the first to invest in Selznick's new production company. But MGM would not let Selznick have Gable unless they distributed the film, and Selznick was not ready to make that commitment.

Selznick sent a long letter to the *Hollywood Reporter* on March 23, 1937, in which he said, "My conversations with Miss Shearer have been most informal," adding that the studio intended to cast an unknown in the part. A week later, Selznick and Shearer issued an unusual joint denial of Winchell's announcement.

The public's reaction to Walter Winchell's gossip column announcing Selznick's selection of Norma Shearer for the part of Scarlett was so overwhelmingly negative that Selznick persuaded Shearer to join him in issuing this joint statement denying the story.

PAULETTE GODDARD

Paulette Goddard was a former Ziegfeld Girl who played uncredited bit parts in films until Charlie Chaplin cast her in *Modern Times*. Goddard, under contract to Chaplin, was romantically linked with him as well. Concerns about how the public might respond to her cohabitation with Chaplin and her difficult and demanding behavior toward Selznick's staff would work against her as she aggressively pursued the part of Scarlett O'Hara.

Selznick and Chaplin were partners in United Artists, which was the likely distributor of *Gone With The Wind*. Goddard made more screen tests for the role of Scarlett O'Hara than any other established actress and eventually signed an option agreement with Selznick in anticipation of getting the part. During this period, Selznick cast her in his production of *The Young in Heart* (1938).

```
TO OSHEA FROM DOS                              MAY 10, 1937
PAULETTE GODDARD HAS FOR A LONG TIME BEEN CAMPAIGNING FOR THEROLE
OF SCARLETT.  RECENTLY SHE HAS TELEPHONED GEORGE A COUPLE OF TIMES.
I HAVE EXPLAINED TO GEORGE THAT WHILE I AGREE SHE IS AN EXCELLENT
POSSIBILITY THAT WOULD BE WELL WORTH TESTING, THERE IS NO POINT IN
EVEN MAKING A TEST UNTIL AND UNLESS WE CAN DETERMINE THAT WE CAN
SECURE HER AT REASONABLE TERMS AND WITH THE USUAL LONG TERM OPTIONS.
CERTAINLY I HAVE NO INTENTION OF MAKING A STAR FOR CHAPLIN ALTHOUGH
I WOULD BE AGREEABLE TO LET CHAPLIN HAVE HER FOR ANY PICTURES HE
PERSONALLY WANTS TO MAKE WITH HER, NOT TO EXCEED ONE YEARLY AND TO
MAKE SURE HE DOESNT SPEND A WHOLE YEAR ON THE PICTURE AS HE IS WONT.
I SUGGEST YOU CONTACT CHAPLIN THROUGH ARTHUR KELLY IFHE ISSTILL ON
THE COAST BECAUSE I EXPLAINED OUR POSITION TO KELLY AND HE UNDER
TOOK TO SECURE HER ON THIS BASIS.  IF KELLY HAS LEFT SUGGEST YOU
CONTACT CHAPLIN THROUGH DR GIANNINNI ALTHOUGH YOU MAY CONSIDER IT
PREFERABLE TO CONTACT MISS GODDARD DIRECT IN VIEW OF WHAT I CONFI-
DENTIALLY LEARNED IS AN IMMINENT SPLIT BETWEEN CHAPLIN AND GODDARD.
YOU CAN REACH HER THROUGH CHAPLINS HOME, THE TELEPHONE NUMBER OF
WHICH YOU CAN GET OVER AT MY HOME OR FROM THE UNITED ARTISTS STUDIO.
PLEASE KEEP ME ADVISED.
```

Selznick made more screen tests of Paulette Goddard for the part of Scarlett than of any other actress. Her complicated romantic and business relationship with Charlie Chaplin prevented Selznick from completely committing to giving her the part.

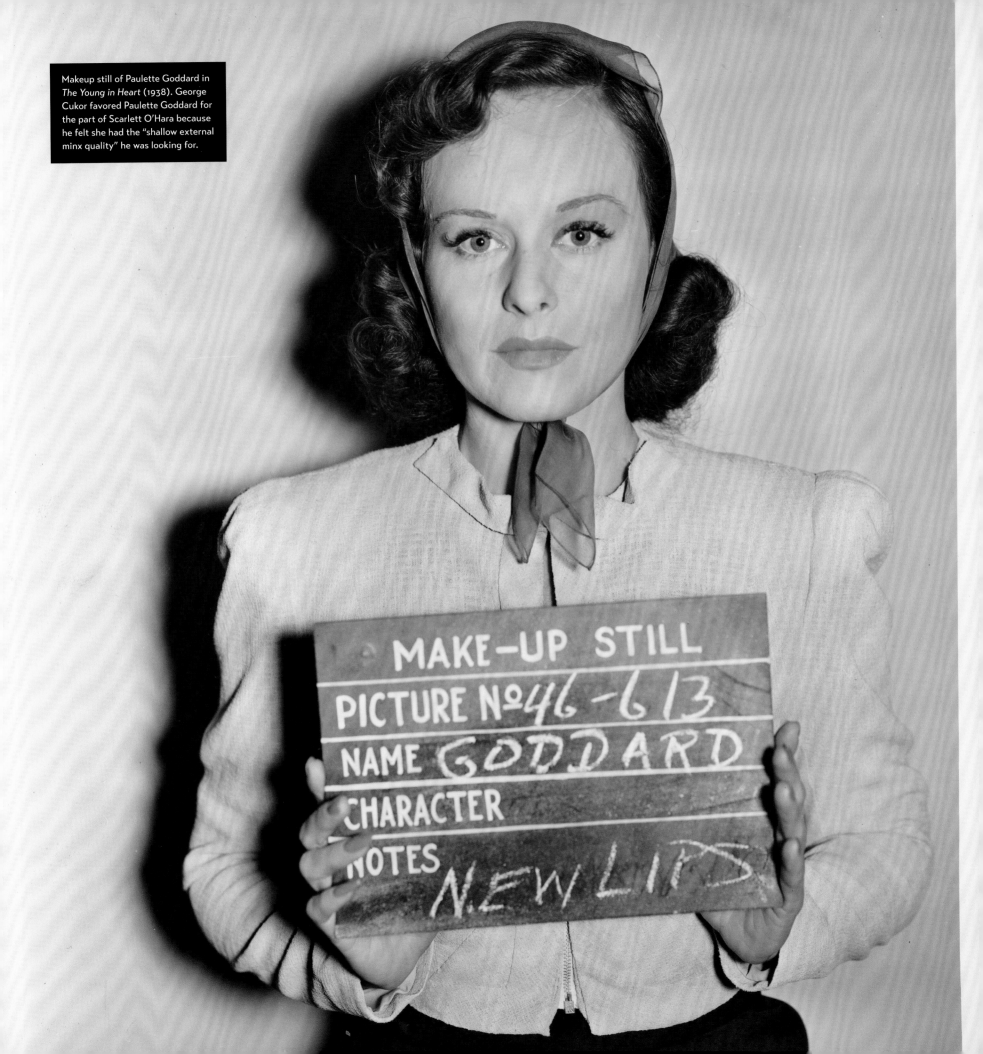

Makeup still of Paulette Goddard in *The Young in Heart* (1938). George Cukor favored Paulette Goddard for the part of Scarlett O'Hara because he felt she had the "shallow external minx quality" he was looking for.

MAKE-UP STILL
PICTURE №46-613
NAME GODDARD
CHARACTER
NOTES NEW LIPS

THE BIGELOW TWINS

The parts of the Tarleton Twins proved particularly difficult to cast. Selznick simply could not find any twins who could also act. Several people suggested Selznick make them brothers rather than twins, but Selznick insisted on remaining faithful to the novel. Hugh and Albert "Bert" Bigelow, twin brothers from a prominent family in Brookline, Massachusetts, were the front-runners for the parts, but scheduling and contract negotiations proved difficult. In earlier versions of the script, the Tarleton Twins appeared in several scenes over the course of the story. Scheduling the filming of these scenes close enough together to mitigate the cost of carrying two bit players proved impossible.

Selznick considered using one actor and a double exposure special effect, but his production staff talked him out of it. He then began cutting scenes in which the Tarleton Twins appeared and seriously considered cutting their parts altogether.

```
FOUND ANOTHER SET OF TWINS FOR THE TARLETONS - 6 FEET, BLONDE, EDUCATED
DUKE UNIVERSITY, ACCENT WOULD BE EASY, RIDE LIKE MONKEYS.  SPENT THE
LAST TWO SUMMERS LIFEGUARDING AT JONES BEACH.  WILL AIRMAIL PICTURES
FOR YOUR APPROVAL.  THIS IN POSSIBILITY OF DIFFICULTY WITH BIGELOW
TWINS.
```

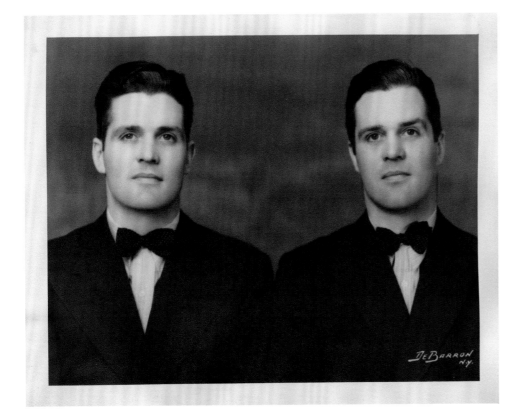

(ABOVE) Finding a set of twins who fit the description of the Tarleton Twins in the novel, who could ride horses, speak with acceptable southern accents, and play the parts believably proved to be enormously difficult.

(LEFT) Hugh and Bert Bigelow of Brookline, Massachusetts, were Selznick's choice for the parts of the Tarleton Twins. Their salary demands and the difficulty of scheduling the men, each of whom had a job back home, forced Selznick to consider other options. Photo by DeBarron.

CASTING AFRICAN AMERICANS

THE COTTON CLUB
Special Rental Rates to Clubs and Private Parties

MONROE KENNEDY, MANAGER
322 NORTH 17TH STREET · PHONE 7-8996
BIRMINGHAM, ALABAMA

June 21
1937

Exploitation Department,
Selznick-International,
New York City

Dear Sirs:

 We had planned a contest for the right
to go to New York and take a screen test for possible
selection of the winner for a part in "Gone With The
Wind."

 There will be many Negro characters
in the play and we thought that we might give the
screen play a great deal of publicity and at the same
time conduct a stunt of mutual benefit.

 Our proposal is to conduct the contest
for the best Negro performer and actor, pay all
expenses to and from New York, if Selznick-International
will agree to give the winner a screen test, with no
obligation on their part unless screen test merits your
further attention.

 Negroes of Birmingham are very talented
and there is no doubt but what we could build real
interest in the film with the contest.

 We await your further ideas and
wishes,

 Martel Brett
 president,
 Cotton Club.

On June 21, 1937, the Cotton Club of Birmingham, Alabama, offered to host a contest for "the best Negro performer and actor" and pay the winner's expenses to travel to New York for a screen test. Selznick had Kay Brown reply that he did not want to participate because he simply did not know the starting date of the production. The real reason was that he did not like casting contests. If he did not cast the winner of the contest, he risked alienating everyone involved. But it was true that he didn't have a firm starting date.

Selznick himself was actively working on casting the African American roles. Brown and Bundsmann in New York were auditioning actors daily. One standout was Rex Ingram, who had recently appeared in *The Green Pastures* with Oscar Polk and Eddie Anderson after years of uncredited bit parts. He was the favorite for the part of Big Sam, but opted for the part of Jim in *The Adventures of Huckleberry Finn* (1939) opposite Mickey Rooney. Georgette Harvey had appeared in the original Broadway cast of *Porgy and Bess* and was seriously considered for the role of Mammy. And Elizabeth McDuffie, Eleanor Roosevelt's maid, had asked to be considered for the part. Often referred to in SIP memos as "Whitehouse McDuffie," she was given serious consideration for the role out of respect for her employer. Ultimately, Selznick asked Kay Brown to let her down "diplomatically."

Letters from African Americans requesting auditions for these roles arrived at the Selznick offices, too, and were answered with form letters similar to those sent to aspiring Scarlett O'Haras.

Kay Brown answered Martel Brett's letter on June 25, 1937, "Due to the fact that at the present time we have no definite starting date on the production of *Gone With The Wind*, we feel it inadvisable at the present time to have any contests for screen roles."

Most African Americans who wrote to Selznick requesting auditions for parts in *Gone With The Wind* were answered with individually tailored form letters. The casting department decided to cast only experienced actors in the African American roles.

SELZNICK INTERNATIONAL PICTURES, INC.
NEW YORK CITY

Inter-Office Communication

TO Mr. George Cukor DATE April 27, 1937

FROM Tony Bundsmann SUBJECT TUESDAY APPOINTMENTS

These are the colored people we lined up in Harlem:

3:00 J. Louis Johnson Uncle Peter Pork
3:00 Wilhelmina Williams Dilcey
3:05 Ollie Burgoyne Dilcey
3:10 James H. Dunmore Jeeves
3:15 Alex Lovejoy Pork
3:20 Edgar Martin Pork
3:25 Marie Young Dilcey
3:30 Leona Hemingway Dilcey
3:35 Abner Dorsey Pork Jeeves
3:40 Richard Huey Big Sam
3:45 Fred Muller Uncle Peter
3:50 Floretta Earle Dilcey
4:00 Rex Ingram Big Sam
4:15 Georgette Harvey Mammy
4:20 Greenleaf - 5 people
4:25 Jack Carr

Gerald Gooding - Dilcey
Tony Padlues
Sally Ellis - 2432 7th Ave Apt 5.
Light Chairs - Tables - Sofa - Ashtrays -

LIST -

Tomorrow's appts.

(ABOVE) Anthony Bundsmann's report to George Cukor on the audition schedule for African American actors in New York includes actors with a wide variety of experience. J. Louis Johnson, James H. Dunmore, and Richard Huey were seasoned New York actors. Huey formed the Richard Huey Players, which was active in Harlem in the 1930s. Ollie Burgoyne had a long career as a dancer, most notably with the New Negro Art Theater. Alec Lovejoy made several films with the African American filmmaker Oscar Micheaux. Rex Ingram had recently appeared on Broadway in *The Green Pastures*, and Georgette Harvey originated the role of Maria in *Porgy and Bess*.

(RIGHT) Rex Ingram (left), who portrayed the Lord in *The Green Pastures*, and Oscar Polk (right), who played Gabriel, talk to Dr. Christian Reisner (center) about their experiences making the film. Ingram was Selznick's choice for Big Sam in *Gone With The Wind*, but Ingram opted for the role of Jim opposite Mickey Rooney in the 1939 film *The Adventures of Huckleberry Finn*.

Coleman

Twenth Century Fox
Director Selznick

Dear Sir,

I understand that you are in the thrives of the casting of "Gone With the Wind"

I have read the book and am interested in the portrayal of "Prissy" If you recall Prissy was the frightened, vain, hardly efficient little negro maid given by her mother to Scarlett: and she follows the heroine throughout the book

Now, I feel that I understand Prissy and am more capable of making her live on the screen than anyone else.

Inclosed are a couple of rough, unfinished pictures. I am twenty-two five-three and weight 107 lbs.

I would have been a actress if the field for negroes were wide enough. as if it is I have spoken lines for many of the studios.

Mr. Selznick I am counting on your considerate nature and your desire to cast truly,

Sincerely
Elizabeth Coleman
1380½ E. Adams
Ce. 24484

HITCHCOCK

Alfred Hitchcock, the English film director and producer, visited the United States in 1937 to negotiate a deal with MGM but also with an eye to working with Selznick. He made it plain to MGM that he wanted to make at least one picture a year with Selznick. Although the MGM deal had gone cold by Thanksgiving, Hitchcock maintained contact with Selznick and eventually signed a seven-year contract with SIP that began in March 1939. Hitchcock's first film for Selznick, *Rebecca*, went into production just as *Gone With The Wind* was wrapping up. Selznick would occasionally ask Hitchcock to comment on aspects of the screenplay of *Gone With The Wind*.

Teletype from Kay Brown to Selznick about meeting with Alfred Hitchcock. Jock Whitney was unimpressed with Hitchcock's most recent film, *Sabotage* (1936), and recommended that Selznick pass. But Selznick thought Hitchcock had potential since he was not only a director, but a producer and writer as well.

```
A(

GA
                                                              8/23/37
HYX3  TWS PAID AUG 23
SELZNINK INTL PICTURES
                   WUX CULVER CITY CALIFORNIA
TO DOS FROM KB
ALFRED HITCHCOCK IS IN THIS COUNTRY FOR TEN DAYS.  IT IS
MY UNDERSTANDING HE HAS NO PICTURE COMMITMENT.  I HAVE BEEN
ASKED TO MEET HIM BUT THINK THIS UNNECESSARY UNLESS YOU
ARE INTERESTED IN HIM AS A DIRECTOR.  PLEASE ADVISE.

TO VL FROM KB
HAVE AIRMAILED BENSON SCRIPT WITH NOTE TO KATE CORBALEY.
SELZNICK INTL PICTURES..
```

David O. Selznick and Alfred Hitchcock on the set of *Rebecca* (1940). Hitchcock's first film for Selznick was to be "The Titanic," but the project was abandoned due, in part, to the difficulty of obtaining releases from the survivors of the shipwreck.

COLOR

The production of *Gone With The Wind* was growing in size and expense. Sidney Howard was finding it impossible to bring the screenplay down to the length of a normal motion picture. Selznick proposed to his colleagues at United Artists releasing it as two pictures instead of one, and they said they thought it would work. Selznick also debated whether to make *Gone With The Wind* in black and white, the norm at that time, or in color under Pioneer's contract with Technicolor. Jock Whitney and Selznick liked the idea of shooting in color, but others argued against it. Color would add tremendously to the cost of making the film because of the need for special cameras that exposed three strips of film, each of which was exposed through a different filter—red, blue, and green. Because the light coming through the lens passed through a beam-splitting prism and the color filters, the process required an immense amount of light to achieve an acceptable picture. So, larger and brighter lights were necessary, not to mention the electricity to power them. The cost of processing the film, cutting the negatives, and making projection prints was also much higher and had to be done at Technicolor. All this added expense, however, was seldom recouped at the box office. Although categorizing *Gone With The Wind* as a "super picture" (thus counting it as two pictures for purposes of the Technicolor contract) would finish out Pioneer's contract, earn stock options for the company, and help justify the extra expense, no one was sure if making *Gone With The Wind* in color would bring larger audiences to the theater.

Inter-Office Communication

SELZNICK INTERNATIONAL PICTURES, INC.

9336 WASHINGTON BOULEVARD CULVER CITY, CALIFORNIA

OFFICE OF THE PRESIDENT

To: Mr. Ginsberg

SUBJECT: *notes on Mr. Ginsberg's letter to Mr. Wharton*

DATE: August 26, 1937

Wind - Tech.

Dear Henry:

Please advise me if my notes are in any degree liable to misinterpretation.

Incidentally, I have another thought which is the possibility, which I think SIP and Pioneer might secure if a deal were refused on any other basis to make "GONE WITH THE WIND" in color, of "GONE WITH THE WIND" being considered two pictures under the Pioneer-Technicolor contract. This would mean that the whole Pioneer deal would be completed with the production of "GONE WITH THE WIND" in color, and that we might secure 30,000 options. Certainly it would be worthwhile for Technicolor to have "GONE WITH THE WIND" in color instead of two other pictures. From Pioneer's angle it would relieve them of the financing of a second picture, and from SIP's angle it would justify the extra cost. Again, from Technicolor's angle, the actual dollars and cents business on negative and on prints would undoubtedly be equal on "GONE WITH THE WIND" to what it would be on two other pictures. And certainly from the standpoint of its value to color, it would be equal to four other pictures.

If you like this idea I suggest you take it up at once with Kalmus and Wharton.

DOS.

dos:bb

DICTATED BUT NOT READ BY
DAVID O. SELZNICK

Through his partner, Jock Whitney, and Pioneer Pictures, Selznick had access to Technicolor and had made several films using the color process. But unless he could get concessions from the Technicolor company, he would have great difficulty justifying the added cost of making *Gone With The Wind* in color.

CHOOSING RHETT

From the outset, Clark Gable was the overwhelming popular choice for the part of Rhett Butler. Gary Cooper was also a compelling option, but neither MGM nor Samuel Goldwyn were eager to loan their top male star. Warner Brothers was willing to loan its top star, Errol Flynn, for the role, but Selznick was not sure he was right for the part. Selznick's negotiations with the three companies would drag on for almost a year.

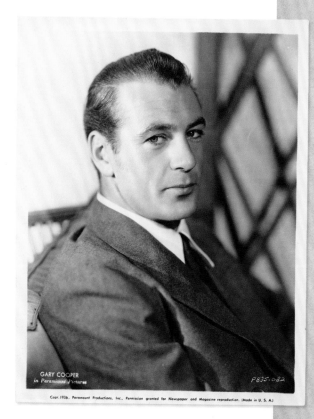

(ABOVE) Gary Cooper, ca. 1936, at Paramount Pictures, shortly before he signed with Samuel Goldwyn. Cooper was Selznick's choice if he couldn't get Clark Gable for the part.

(RIGHT) Selznick was just as concerned about casting the role of Rhett Butler as he was about casting Scarlett O'Hara. In this confidential memo to John Wharton, SIP's vice president, Selznick explains his options.

Mr. John F. Wharton

September 20, 1937

CONFIDENTIAL

Dear John:

Replying to your memo of September 16, I shall number my answers to your questions in accordance with the numbers you have given to the questions:

1. I think we have no alternate but to assume that we definitely cannot get Gable unless M.G.M. releases the picture.

2. I am in hopes that fatherhood has softened Gary Cooper's heart and bolstered his judgment – and that he might be persuaded to play the part. More importantly, I think that if Goldwyn agreed to give him to us, he could deliver. I now feel that he would in many ways give an interest to the role that would compensate for other superior qualities that Gable has, and I would be equally happy with either Gable or Cooper.

3. I think Colman is an extremely bad third and that it would be difficult to get out of him the virility and bite that are so essential to a satisfactory Rhett. (Incidentally, all of these opinions are of course subject to complete right about faces if and when we find that we can't get who we want – so please do not quote me on any of these opinions to anybody).

4. The only other man that we have thought of as a possibility is Errol Flynn.

The worries about Scarlett are different than those about Rhett. We feel definitely that we must find a new Scarlett, and it may be that this week's tests will reveal her; but we feel equally definitely that it is hopeless to expect to find a new Rhett, hence our anxiety to get either Gable or Cooper.

We are probably testing Margaret Sullavan for Melanie. Hepburn is anxious to test for Scarlett but I think she's all wrong for it.

I hope this gives you the information you want. For the love of Pete don't permit this letter to be seen by anyone.

DOS

dos/cl

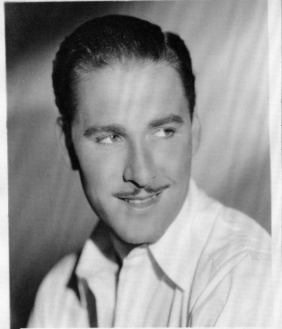

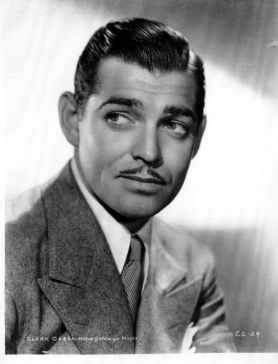

ITEM	METRO GOLDWYN MAYER	WARNER BROTHERS
RHETT	Gable	Flynn
SCARLETT	None	Bette Davis, if we wish. (?)
OTHER PLAYERS	None obligatory	Entire stock company available, including de Havilland if desired.
COST OF RHETT	$150,000.	$50,000.
TIME OF STARTING	Feb. 15th, if Gable sells his vacation time, which is unlikely; otherwise Apr. 1st guaranteed.	October, or any time on 10 wks. notice.
FINANCE	50-50 up to $2,500,000.	$400,000. SIP. Up to $2,100,000. W.B.
RISK OF LOSS	50-50	Identical
OVERAGE COST	Advanced by SIP and recouped by SIP only out of its own profits.	Advanced by W.B. up to $250,000. on same basis as $2,500,000. limit, and recouped out of 82½% of gross; beyond $250,000. overage, identical with MGM.
COST OF DISTRIB.	20%	17⅞%
PROFITS	50%	40% of gross beyond cost to include profit and distribution; equivalent of 27 7/10% of profits.
ROAD SHOWS	Gross computed after deduction of cost.	Identical.
BILLING	Joint presentation SIP and MGM	SIP picture.
CONTRACT APPROVAL	None. Protective clauses only.	Complete approval as under UA contract.
ADVERTISING	Consultation, but final MGM approval.	Complete approval as in UA con.
TRAILERS	Pays for cost and retains profits	SIP pays cost and retains profits. (?)
PRINT COST	Entirely out of SIP's share.	Out of SIP's share up to limitation, then paid partially by WB as in UA contract.
TECHNIC. OPTIONS	All remain with SIP	Identical.
NEW TALENT	Remains with SIP (not yet agreed to by Schenck and Mannix)	Remains with SIP except one picture to WB if use new personality as Rhett or Scarlett.

Handwritten pencil notations (Selznick's hand): "who pays for trailers? yes" (top), "NMS" (beside SCARLETT), "no unknown Sullavan", "no trace", "accepted", "cost?" (circled, beside COST OF RHETT), "NMS" (beside TIME OF STARTING), "thereafter", "November 1-15?", "(but 3 yrs. later than M.G.M.) S.I.P.", "is", "over number of A pik.", "billing", "probably, ok"

(ABOVE, TOP) Errol Flynn made a name for himself at Warner Brothers in swashbuckling action films like *Captain Blood* (1935) and *The Adventures of Robin Hood* (1938). Flynn was Selznick's least favorite on his short list for Rhett Butler.

(ABOVE) Selznick negotiated with MGM for months trying to get Clark Gable. Gable was unenthusiastic about the part, feeling he would not be able to live up to the public's expectations.

(RIGHT) Selznick had this chart drawn up comparing the possible deals with MGM and Warner Brothers. Selznick's objective was to cast Clark Gable, the public's clear favorite for Rhett, but Selznick had to decide how much he was willing to give up to get him. Pencil notations are in Selznick's hand.

CENSORSHIP

William Harrison Hays was the first president of the Motion Picture Producers and Distributors of America, later renamed the Association of Motion Picture Producers, Inc. The organization was formed to clean up the image of the motion picture industry after a series of scandals in the 1920s. The "Production Code," a self-imposed code of behavior for the motion picture industry, was nicknamed the "Hays Code." In 1934, Joseph Breen took over the office that enforced the code.

The Production Code of the late 1930s laid out broad principles governing what was and was not acceptable in motion pictures. In the interest of efficiency and economy, it was decided that producers would submit their screenplays to the Hays Office in advance of filming so that any objectionable material could be identified and changed before it was committed to film.

Val Lewton, the head of Selznick's story department, was the chief liaison with the Hays Office and kept in close contact as changes were made to the screenplay of *Gone With The Wind*. While he negotiated a number of concessions and compromises, there were some lines and scenes that Selznick was forced to change. Melanie's childbirth scene, for example, and references to Belle Watling's profession had to be toned down. Joseph Breen also warned Selznick to be careful that battle scenes not be too gruesome and to avoid offensive language.

MOTION PICTURE PRODUCERS & DISTRIBUTORS OF AMERICA, INC.
28 WEST 44TH STREET
NEW YORK CITY

WILL H. HAYS
PRESIDENT

CARL E. MILLIKEN
SECRETARY

October 14, 1937

Wind - Censorship

Mr. David Selznick
Hotel Sherry-Netherland
Fifth Avenue and 59th Street
New York, New York

Dear Mr. Selznick:

This goes to you in the nature of a follow-up of our discussion on Monday afternoon with Messrs. Cukor, Howard and yourself concerning the first draft script for your proposed production titled GONE WITH THE WIND.

There are four, or five, major difficulties suggested by the present script, all of which, however, may, we feel, easily be changed in order to bring the basic story into conformity with the Production Code, and, likewise, to make it generally acceptable from the standpoint of political censorship.

There ought to be at no time any suggestion of rape--or the struggles suggestive of rape; Rhett should not be so definitely characterized as an immoral, or adulterous, man; the long scenes of childbirth should be toned down considerably; Scarlett should not offer her body to Rhett in the scene in the prison; and the character of Belle should not definitely suggest a prostitute.

In the hope that a page-by-page discussion of details may be helpful in the rewriting of this present script, we respectfully direct your attention to the following:

Page 2: We suggest a check with your Research Department concerning the suggestion that there was a college in the city of Atlanta in 1861.

Scene 9: Because there is considerable discussion throughout this story regarding childbirth, babies, pregnancy, etc., we recommend that you consider deleting Ellen's line in scene 9, and Gerald's line in scene 11, suggesting that Wilkerson is the father of the illegitimate Slattery child.

Scene 11: In the recitation of the prayers known as the "Rosary," it is our thought that the opening prayer should be the "Credo"--"I believe in God, the Father Almighty," etc.--and not the "Confiteor."

Scene 12: Please be careful in this, and all other scenes of

Film producers submitted their screenplays to the MPPDA, also known as the "Hays Office," in order to identify and alter or eliminate any objectionable material. Selznick routinely pushed the limits of what the Hays Office would accept. But with *Gone With The Wind*, the depiction of painful childbirth, in particular; suggestions of rape, prostitution, and gruesome wartime surgery; and strong language provoked serious disagreements between the producer and the Hays Office.

undressing, that there be no <u>undue exposure</u> of the person of Scarlett.

<u>Scene 20</u>: We question Scarlett's use of the line, "Did the girl have a baby?" in this place because of the frequency with which such references are repeated throughout the story. It is also our judgment that Cathleen's line, "She was ruined, though," will be deleted by political censor boards.

<u>Scene 25</u>: We recommend, again, that you exercise the greatest care in this scene in order that there be no <u>undue exposure</u> of the persons of the girls.

<u>Scene 26</u>: Gerald's expression, "God's nightgown, man," is likely to be deleted by political censor boards.

<u>Scene 30</u>: The same thing needs to be said with regard to Scarlett's expression, "damned to you."

<u>Scene 36</u>: There should be no suggestion of rape in shooting these Menzies scenes. <u>This is important</u>.

<u>Scenes 39 et sec</u>: Belle Watling's "establishment" should <u>not</u> be characterized as a <u>bawdy house</u> or <u>house of assignation</u>. This, too, is <u>important</u>. Can it not be suggested that it is a drinking, or possibly, a gambling establishment?

In this same connection, Belle should <u>not</u> be characterized as a prostitute. It might be well if she were suggested as, possibly, a loose character operating a drinking saloon or gambling joint. We direct your particular attention to the suggestion at the bottom of page 35 regarding the "gilt mirrors and bar room art."

<u>Scene 39</u>: We suggest that you delete Rhett's line, "If I feel inclined," and substitute, possibly, the word "maybe."

<u>Scene 115</u>: The observations set forth above regarding scene 20 apply to the lines of Scarlett and Miss Pitty in this scene.

<u>Scenes 163 et sec</u>: We urge and recommend that you change the expression, "Fo' de Lawd," to possibly the expression, "Lawsy," or "Law-see."

<u>Scenes 168 et sec</u>: Please be careful that these scenes showing the dead or wounded, be not <u>too realistically gruesome</u>. There is danger here of such scenes being eliminated <u>in toto</u> by political censor boards.

<u>Scenes 187 et sec</u>: For your British print, we recommend that you shoot a protection shot of scenes showing the characters making the sign of the cross. The action is acceptable pretty generally throughout the world <u>except</u> with the British Board in London.

<u>Scene 190</u>: With a view to cutting down much of the broad detail of the dialogue and action suggesting the birth of Melanie's child, we recommend that you endeavor to delete, wherever you can, such action and dialogue which <u>throws emphasis upon the pain and suffering of childbirth</u>. This, likewise, is of <u>very great importance</u>. To this end we recommend that, in scene 190, you rephrase Melanie's line, "It began at daybreak" to "I have known since daybreak," and that you also delete from Melanie's line, at the end of the scene, the phrase, "she'd know when to send for him."

<u>Scene 191</u>: We suggest that you eliminate Scarlett's speech at the top of the page, "Miss Melly's baby's coming," and Prissy's reply, "Oh, Lawd!" This, of course, will make it necessary for you to rewrite Scarlett's next speech in this scene.

<u>Scene 193</u>: We suggest that you eliminate the word "bad" from Scarlett's speech at the beginning of the scene, making the line read, "<u>How</u> do you feel?" We further recommend that you eliminate Melanie's speech, "How long did it take" etc.; Scarlett's reply; Melanie's line, "I hope I'll be like one of the darkies," and Scarlett's line, "We've still got plenty of time."

<u>Scene 202</u>: The girls who "reel drunkenly" out of the door of the saloon should <u>not</u> be suggestive of prostitutes.

<u>Scene 203</u>: Again we ask that you be careful that these scenes of the dead and dying be not shot as <u>too realistically gruesome</u>.

<u>Scene 204</u>: Please delete the expression, "Oh, God," from Dr. Meade's line.

<u>Scene 209</u> (page 102): We ask that you amend Scarlett's line, "....You've got to bring the baby," making it read, "You've got to superintend things." In this same scene we recommend that you amend Prissy's expression, "Fo' de Lawd," used twice.

<u>Scene 209</u> (page 103): Please do not over-emphasize the anguish in Melanie's voice. There should be no <u>moaning</u> or <u>loud crying</u> and you will, of course, eliminate the line of Scarlett, "And a ball of twine and a scissors."

Note: Beginning with scene 210 down to the end of scene 227: We urge and recommend that these scenes of childbirth be cut to <u>an absolute minimum</u>, in order merely to suggest Melanie's suffering. We think, for instance, that you might well delete showing her teeth "biting her lower lip till it bleeds;" her holding on to Scarlett's hands in desperation; all of the business of tying the towel to the foot of the bed, and the dialogue accompanying such scenes.

Scarlett's line in scene 218, "She can't stand many more hours of this;" Melanie's line, "I can't stand it when you're not here;"

Prissy's line, in scene 219, "Miss Meade's Cookie say effen de pain git too bad, jes' you put a knife unner Miss Melly's bed an' it cut de pain in two," and Scarlett's line at the bottom of the page, "I think it's coming now,"--these scenes, together with all the business set forth on page 107, are enormously dangerous from the standpoints of both the Production Code and of political censorship.

It seems to us that you may carefully <u>suggest</u> these scenes of childbirth without <u>over-emphasizing the distress</u> and <u>pain attended thereto</u>. It may be possible to do this effectively by playing the camera on Scarlett's face, or, possibly, on the faces of some of the other characters. As now written, however, the scenes are hardly acceptable and should be <u>materially toned down</u>.

Scene 252: Political censor boards everywhere will delete the business of Rhett kissing Scarlett's body as set forth in the script. The words "I want" and "wanted" are dangerous, too. It would be well to substitute some other words for these.

Scene 260: We question the suggestion on page 122 showing Melanie's "blood-stained lips."

Scene 268: We recommend that you merely <u>suggest</u> the body of the dead Confederate soldier and <u>not</u> actually photograph it.

Scenes 277 et sec: Here, and elsewhere throughout your script, we urge and recommend that you have none of the white characters refer to the darkies as "niggers." It seems to us to be acceptable if the <u>negro characters</u> use the expression; the word should <u>not</u> be put in the mouth of <u>white people</u>. In this connection you might want to give some consideration to the use of the word "darkies."

Scene 291: Please delete the line by Dilcey, "An' whut it takes ter feed a hungry chil Ah got."

Scenes 315 et sec: We again suggest the greatest possible care in shooting scenes showing the dead or dying. The dead body of the Yankee should not be shown in a close-up. Such scenes are likely to become excessively gruesome or horrifying. Note also in this connection, <u>scenes 318</u> and <u>320</u>.

Scene 320: Please delete Scarlett's expression, "As God is my witness."

Scene 324: Please delete Mammy's line at the end of the scene, "...Ah's shore dey ain' no mo' louses on you," and in scene 325, Mammy's line, "Louses an' de dysentary. Dey ain' a soun' set of bowels in de whole Confed'rate Ahmy!"

Scene 353: We suggest that you substitute the word "Freedmen" for the expression, "Free niggers," in Scarlett's speech. Also in this same scene, we suggest the elimination of Scarlett's line, "And

Dr. Meade said she could never have any more children. But I could give you all the children you---"

Note in passing (scene 361): We feel that Scarlett's line with reference to Belle, "She's the town bad woman," is acceptable to indicate that Belle is a lady of loose conduct.

Scene 362: As suggested to you on Monday, we most earnestly urge that it be <u>not</u> indicated that Scarlett offers her body for sale to Rhett. We think that Scarlett's lines, beginning with the sentence, "You said you'd never wanted a woman as you wanted me," could be rewritten to suggest that she is offering herself in marriage. It might be that you could have her put forth the blunt suggestion to Rhett, "Will you marry me." This is <u>very important</u>.

Scene 362: We suggest that you eliminate the words, "made use of," in Rhett's speech, and substitute the words, "appealed to," making the line read, "Was there no other man you could have <u>appealed to</u>?"

Scene 380: Please be careful that the action wherein the white man attacks Scarlett, be <u>not</u> suggestive of <u>rape</u>.

Scenes 387 et sec: Be careful that Ashley, Rhett, et al, be not shown as <u>offensively drunk</u>.

Scene 387: We suggest the elimination of the word "establishment" from Rhett's speech, and the substitution, possibly, of "refreshment parlor," making the line read, "We've all been together at a refreshment parlor." In this same speech, we ask that you delete the expression, "there were ladies."

Scene 387: Please eliminate the following lines by Mrs. Meade, "Are there cut glass chandeliers and plush curtains and dozens of gilt mirrors? And are the girls...?" as well as the line, "...and this is my only chance to hear what a bad house looks like."

Page 200 (scene 387): In Rhett's speech at the top of the page, there should be no break in the line between the words "her" and "employees." We ask that the line be read <u>straight</u>.

Scene 390: Again we call your attention to the business of the sign of the cross.

Scene 392, page 203: Rhett's line, "That I still <u>want</u> you more than any woman on earth," should be amended, possibly to read, "That I still think more of you than any woman on earth." In this same scene we suggest that you eliminate the words spoken by Rhett, "intended having you." Possibly the line could read, "I have always thought that you were meant for me, Scarlett." In this same speech, we recommend that you delete, or rewrite, the line spoken by Rhett, "with more propositions for loans and collateral."

-6-

Scene 393: Please be careful with the Vorkapich shots, especially with the scenes of undressing. Also in this same scene, be careful with the business of Rhett fondling Scarlett and her "bare shoulders."

Scene 395: Please delete Rhett's line, "May your mean little soul burn in hell for eternity," as well as Scarlett's business of making the sign of the cross.

Scene 398: We suggest the elimination of Rhett's line, "You didn't want her," and Scarlett's reply, "I had her, didn't I."

Scene 409: We suggest the elimination of Scarlett's line at the bottom of the page, "I've decided I'm not going to have any more children," as well as Rhett's reply; Scarlett's line at the top of page 214, "You know what I mean, I think," and Rhett's reply, "Lock your door, by all means. I shan't break it down." Also his line, "I've never held fidelity to be a virtue;" Scarlett's line, "I shall lock my door every night," and Rhett's line, "Why trouble? If I wanted to come in, no lock would keep me out." All this dialogue is questionable from the standpoint of audience reaction. It is likewise enormously dangerous from the standpoint of political censorship. We suggest that a way be found to eliminate the suggestion or, if you deem this necessary, then to merely suggest that which is set out in the present script in detail.

In line with our discussion on Monday, we suggest that you eliminate entirely scene 411, which suggests the "unholy alliance" between Rhett and Belle.

Scene 421: Please be careful showing the scenes of Rhett "lacing Scarlett's corsets."

Scene 426: Please eliminate Rhett's line, "He can't be faithful to his wife with his mind, or unfaithful with his body."

Scene 427: Please eliminate Rhett's line, "You turned me out on the town while you chased him."

Scene 428: There should be no suggestion here that Rhett is about to rape Scarlett. It is our thought, in line with the suggestion made on Monday by Mr. Cukor, that you merely have him take her in his arms, kiss her, and then gently start with her toward the bedroom. It is our thought that you should not go so far as to throw her on the bed.

Scenes 433 to 437: It is our understanding that you are to shoot a scene showing exactly where Rhett went, and what he did, after he left his wife's bed--the purpose here being to get away from the present suggestion that he left his wife to consort with Belle. If such a scene is included in your story and it is thus affirmatively

-7-

shown that Rhett did not resort to Belle, the lines set forth in these scenes may be acceptable inasmuch as the audience will know that the charge made against Rhett is not true.

Scene 460: We suggest the elimination of Rhett's line, "You certainly have all the evidence you need to divorce me."

In conclusion, may I not say again that in our judgment you have done a magnificent job with this first draft script in translating to the screen play the magnificent story upon which Mr. Howard's yarn is based. Even the present draft suggests great possibilities for a superb picture which will add much to the prestige, the dignity and the artistry of the screen.

I congratulate you and Mr. Howard upon this splendid achievement, and it goes without saying that we shall be happy, indeed, to work along with you in the development of the steps leading to a final shooting script.

More power to you!

Cordially yours,

Joseph I. Breen

JIB/ch

JEZEBEL

Selznick jealously guarded his ownership of the rights to *Gone With The Wind* and objected to any film production that appeared to capitalize on the public's interest in the novel. Eddie Cantor wanted to present a spoof of the novel on his radio show, and Hal Roach registered the title "Gun With The Wind" for his Little Rascals. A short titled *Gone With The Wind Country* prompted legal action. But nothing got under Selznick's skin like Warner Brothers' film *Jezebel*, released in 1938. Not only did he feel the story about a headstrong young woman set against the backdrop of the Civil War was too close to that of *Gone With The Wind*, he also thought Warner Bros. was capitalizing on the title of his film in their promotion and advertising, and he complained to the Hays Office. Harry Warner denied any wrongdoing, and Hays decided the two films differed enough that the matter should be dropped. Still, Selznick ordered his head of publicity, Russell Birdwell, to monitor the situation. Although Selznick was extremely annoyed at Warner Brothers for their handling of *Jezebel*, he was not anxious to antagonize the studio. He was still considering their star, Errol Flynn, for the lead in *Gone With The Wind*.

(RIGHT) While Selznick confronted Harry Warner about Warner Brothers' production and promotion of *Jezebel*, Selznick did not want to antagonize him, "but rather should try to enlist his friendly cooperation in avoiding a steal both as to the content of the picture and the publicity, which could only reflect on the industry as a whole, and on Warner Brothers in particular."

(FACING) Selznick would later demand to know if any actor cast in *Gone With The Wind* had appeared in *Jezebel* or any other southern-themed film. He refused to consider Henry Fonda for the role of Ashley because he had starred in *Jezebel*.

December 1, 1937

Mr. Harry M. Warner, President
Warner Bros. Pictures, Inc.
Burbank, California

Dear Mr. Warner:

I do not mean to prolong unnecessarily any discussions on the "Jezebel" matter, especially since in your relations with me you have always been so friendly and so fair. However, I think it important, in order to preserve this relationship, that you should have a few points clarified.

The article which you enclosed with your letter gives complete confirmation to the warning I expressed to you some time back that your studio, if not cautioned by you, would stoop to publicizing its picture on the strength of "Gone With the Wind". Certainly there can no longer be any question on this fact since Jack is actually quoted, and since the publicity material from your studio goes so far as to say that around the studio Bette Davis is now known as "Scarlett".

May I remind you that the rights to "Jezebel" were repeatedly turned down by your studio, as by all other studios, until after the public's attention was directed to "Gone With the Wind"?

As to your inferences concerning the rumors on Bette Davis, and the source of these, if you are interested I will dig up and send to you the articles which started these rumors, including statements sent out by your Publicity Department quoting Bette Davis on a comparison of the two roles.

I do not know how far your organization intends to capitalize upon the work and investment of others, and since I think you will agree that the picture business has been happily free of such tactics for many years, I can only hope that your studio will not find itself in a position where it is "forced" to issue statements comparing your picture with that of another studio.

Cordially and sincerely yours,

DAVID O. SELZNICK

dos:bb
cc to: Mr. Will H. Hays

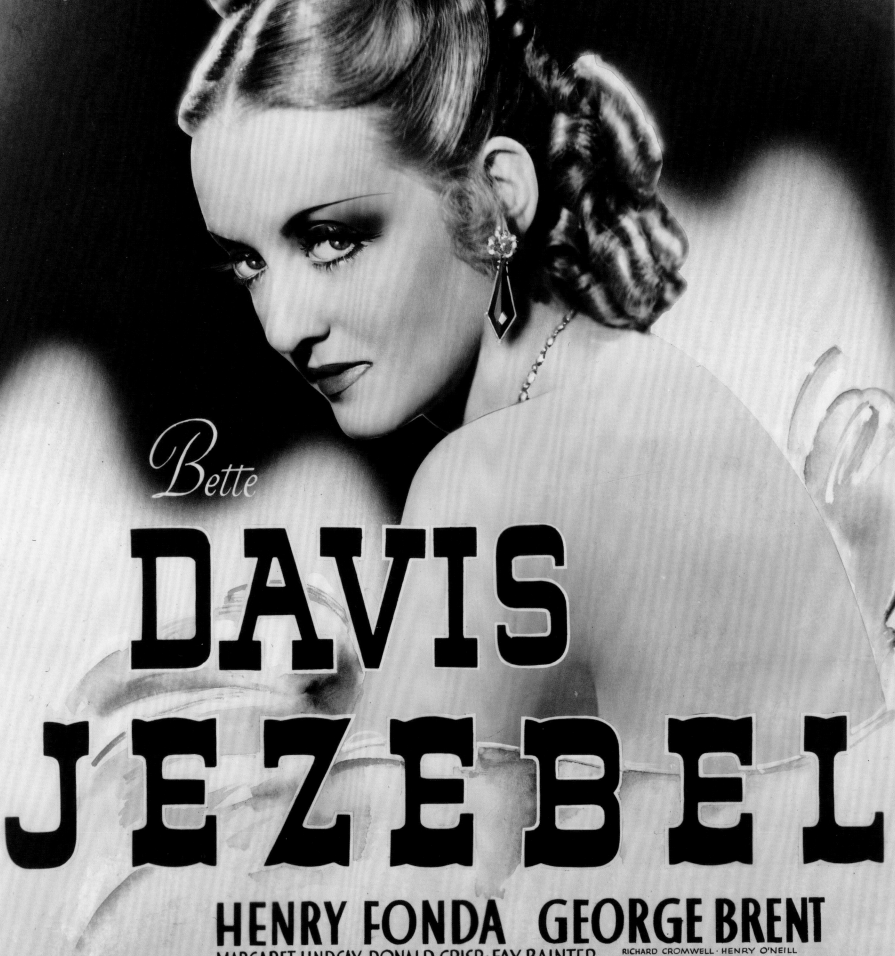

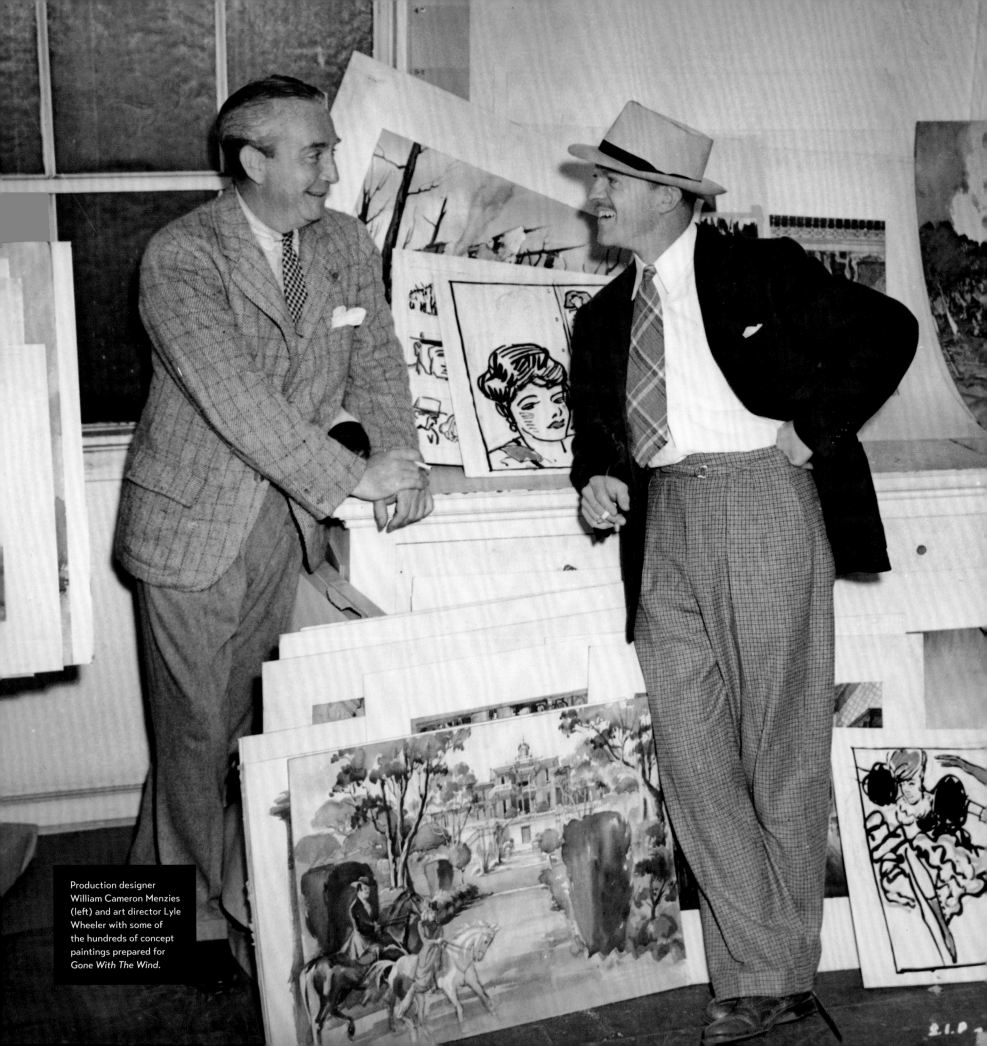

Production designer William Cameron Menzies (left) and art director Lyle Wheeler with some of the hundreds of concept paintings prepared for *Gone With The Wind*.

WILLIAM CAMERON MENZIES AND LYLE WHEELER

Throughout 1936, 1937, and 1938, Selznick thought the starting date for filming *Gone With The Wind* was imminent and planned and prepared accordingly. One of the most important personnel decisions Selznick made was to hire William Cameron Menzies, the renowned art director of such films as *The Thief of Bagdad* and *Sadie Thompson*. Selznick created the term "production designer" to describe the position he had in mind for Menzies. Specifically, he would be in charge of designing, coordinating, and supervising all the visual aspects of a film—sets, costumes, cinematography, and special effects. To test this concept, Selznick had Menzies design the climactic cave sequence in 1938's *The Adventures of Tom Sawyer*. Selznick was so pleased with the result that he hired Menzies as production designer on his next three films, *The Young in Heart* (1938), *Made for Each Other* (1939) and, most importantly, *Gone With The Wind*.

Lyle Wheeler had joined Selznick's company early on, working as set decorator on *The Garden of Allah* (1936) and then as art director for all subsequent Selznick International films, supervising the design, building, and dressing of all sets. Wheeler would become one of Hollywood's great art directors, with hundreds of films to his credit.

Menzies and Wheeler assembled their staff of designers and concept artists, which included J. McMillan "Mac" Johnson and Dorothea Holt. Most were architects or recent graduates from architecture school. After *Gone With The Wind*, Johnson went on to a successful career as art director for such films as *Rear Window* (1954), *Desire Under the Elms* (1958), and *Mutiny on the Bounty* (1962). Holt continued her career as a concept artist on *The Best Years of Our Lives* (1946), *Road to Bali* (1952), and *The Man Who Knew Too Much* (1956). In 1964, Holt joined Walt Disney's Imagineers and worked on Disneyland and Disney World.

Although the start date for filming *Gone With The Wind* would be pushed back again and again, the art department's lengthy preparations would pay off when filming eventually began.

(ABOVE) From late 1937 through all of 1938, the start date for filming was pushed back again and again. So when production finally began, in December 1938, the art department was prepared.

(BELOW) Art director Lyle Wheeler with an unidentified assistant and the set model for downtown Atlanta.

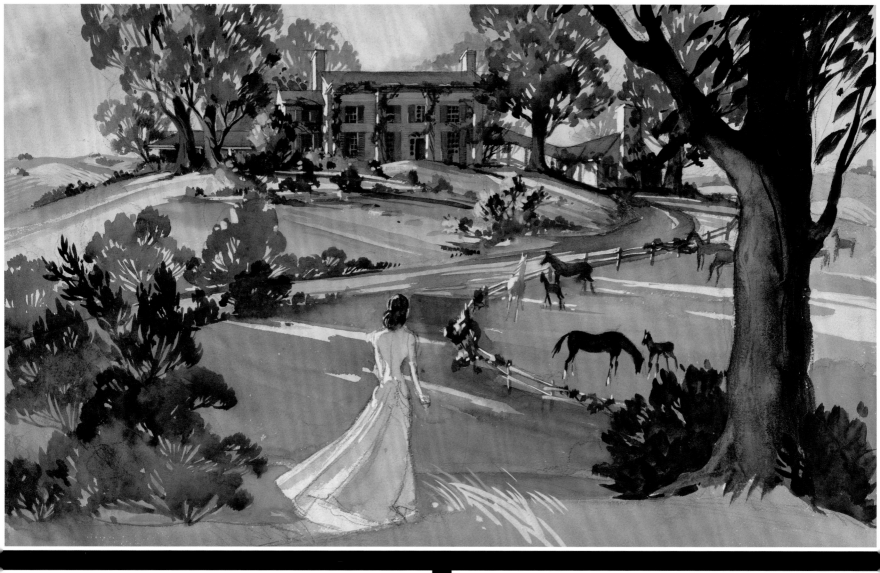

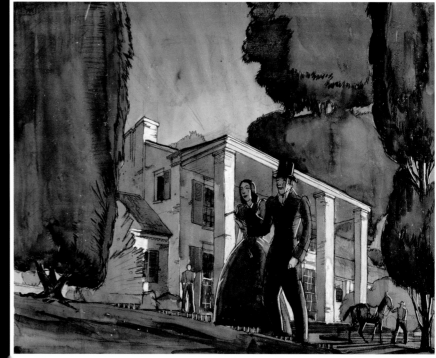

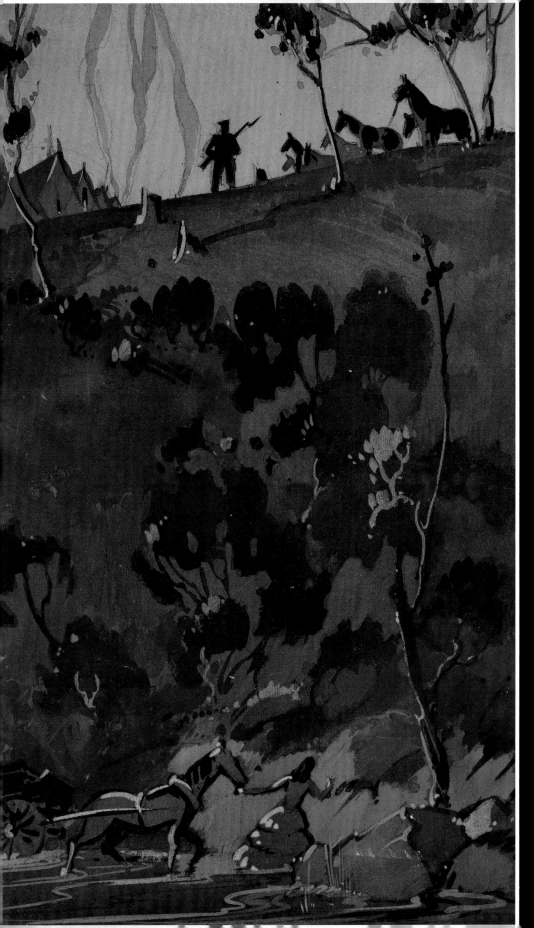

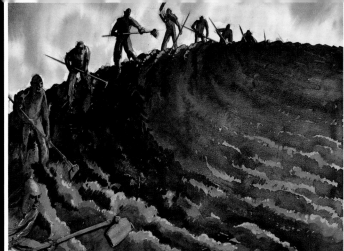

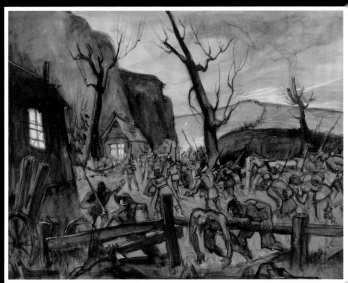

CONCEPT PAINTINGS BY
WILLIAM CAMERON MENZIES

(FACING, TOP) Scarlett at Tara.

(FACING, BOTTOM LEFT) William Cameron
Menzies with some of the hundreds of concept
paintings prepared for Gone With The Wind.

(FACING, BOTTOM RIGHT) Scarlett's walk
with Gerald.

(LEFT) From "Scarlett's Trek."

(ABOVE, TOP) For the opening montage.

(ABOVE) Soldiers fleeing Atlanta.

CONCEPT PAINTINGS BY DOROTHEA HOLT

(ABOVE, LEFT) Dorothea Holt studied architecture at the University of Southern California and was hired by William Cameron Menzies to work as a concept artist for SIP.

(ABOVE, RIGHT) Scarlett dressing for the barbeque.

(LEFT) The bonnet scene.

(FACING, TOP) An early painting of the Butler house interior. A straight staircase was ultimately used for the film.

(FACING, BOTTOM LEFT) The Butler house parlor.

(FACING, BOTTOM MIDDLE) A bedroom at Twelve Oaks.

(FACING, BOTTOM RIGHT) The Butler dining room.

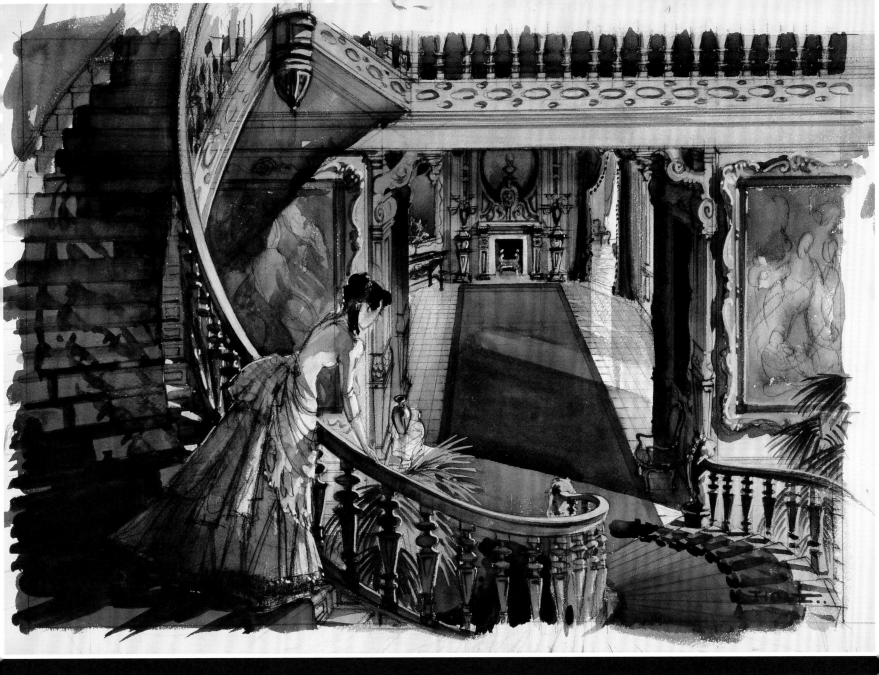

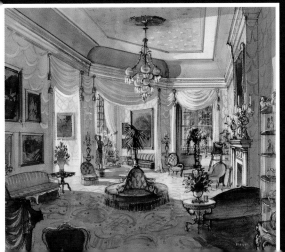

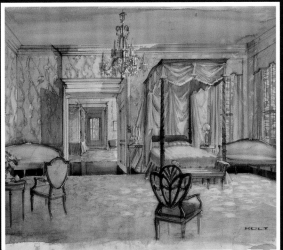

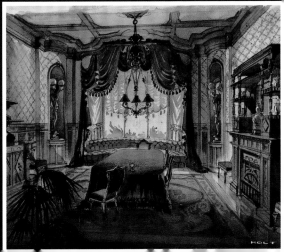

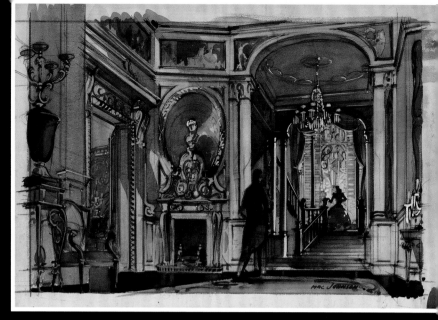

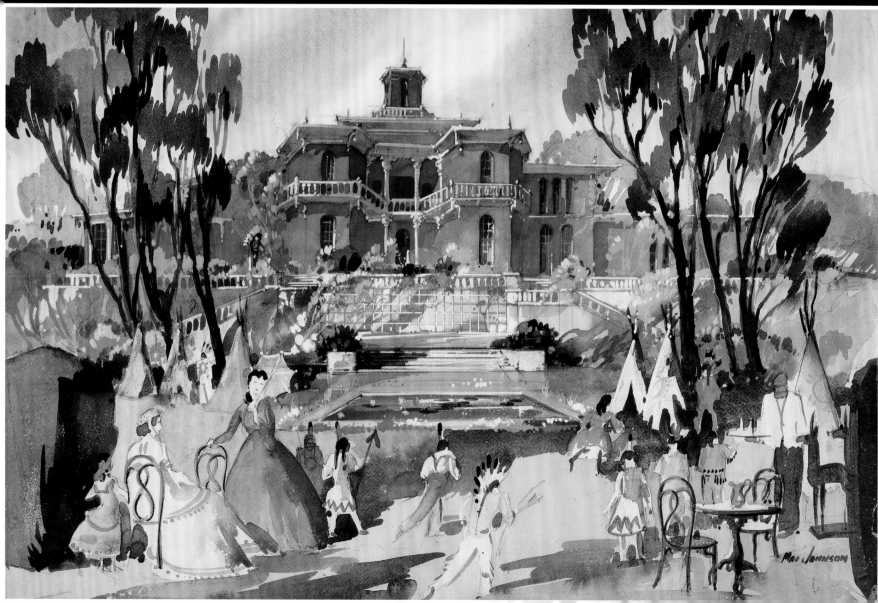

CONCEPT PAINTINGS BY JOSEPH McMILLAN "MAC" JOHNSON

FACING, TOP LEFT) Joseph McMillan "Mac" Johnson was an architect who went into film work. *Gone With The Wind* was his first film project.

FACING, TOP RIGHT) An early painting of the Butler house interior.

FACING, BOTTOM) The Butler house.

BELOW, TOP) Rhett's bedroom in the Butler house.

BELOW, BOTTOM) The library at Twelve Oaks.

RIGHT, TOP) The prayer scene at Tara.

RIGHT, BOTTOM) A battleground.

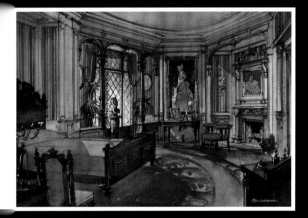

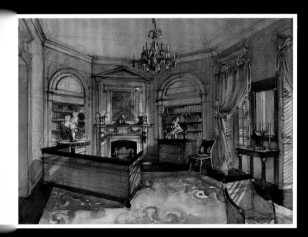

THE STORY DEPARTMENT

GONE WITH THE WIND
Script of Nov. 27/37 Macconnell

P. 13, Sc. 16 -- Mr. Wilkes welcomes Mrs. O'Hara to the barbecue,
whereas at the end of Sc. 30, Page 26, Scarlett
says she wants to go home to her mother. This
is probably an oversight. Mrs. O'Hara is not
at the barbecue in the book nor should she be,
in order to give Scarlett, who covets her mother's
good opinion, more latitude for her actions. It
is only because she is not carefully chaperoned
that she is able to behave in the way she does.

P. 29, Sc. 35 -- After Charles Hamilton has asked her to wait for
him Scarlett blurts out her real reason for
deciding to marry him. Charles isn't very quick
on the uptake but Scarlett, impulsive though she
often is, would be too shrewd to run any risk
of giving herself away, especially since she's
got to get him to marry her to save her face. I
think her speech, beginning "You'd take me to live
in Atlanta" and ending "And they'd never dare
laugh at me again" should be revised to come after
Charles has left her to speak to her father. She
is reflecting on the advantages of marrying this
young booby, as she considers him. Then would
come her lapse into misery on Ashley's account.

P. 32, Sc. 38 -- Scarlett says "I'm too young to be a widow!"
Couldn't we get over the fact that she is only
just turned seventeen? I think her youth should
be stressed as much as possible because, aside
from her artificial training, the fact that life
and some of its hardest problems crowded in upon
her when she was too young to face them is
responsible for the hardness that is later her
most unpleasant trait. Perhaps some reference
could be made to her age later on during that
gruelling period at Tara. She was barely twenty
then.

P. 31-2, Sc.38 -- Am glad this scene has been put in because of
Uncle Peter, who is a bit of the real old South.
To save footage Scene 39 on Pages 33 to 34 between
Rhett and Belle Watling might be dropped and
Belle might be introduced, passing by, in this
scene of Scarlett's arrival. Should like to
see Uncle Peter pouting and hear his indignant
mutter about "a passel of no-count folks..."
Later on P. 54, Scene 57 we have the episode of
Rhett's handkerchief in which Belle has brought
her contribution for the soldiers, and that seems
enough to establish Rhett's connection with Belle
so far as Scarlett is concerned. Rhett is a
scalawag but I doubt if he would discuss Scarlett
with Belle, even to the small extent that he does.

The first page of Franclien Macconnell's notes on the November 27, 1937, version of Sidney Howard's screenplay. Selznick relied heavily on Macconnell to maintain strong fidelity to the novel.

Sidney Howard turned in his first draft of the screenplay in February 1936. There was still an enormous amount of work to do, and Howard felt he needed Selznick's input on which parts of the novel to keep and which parts to drop. Selznick was preoccupied with other things, however, and rescheduled his story conferences with Howard over and over again. In April 1937, Howard traveled to Hollywood, but Selznick had him work on *The Prisoner of Zenda* instead of *Gone With The Wind*. Finally, in October, Selznick and Cukor traveled to New York and worked with Howard for a few weeks. Throughout 1937, Howard periodically sent rewrites of sections of the script, and in February 1938, he again met with Selznick in Hollywood for face-to-face story conferences.

But Selznick did not rely solely on Sidney Howard for the screenplay. He compared Howard's screenplay against the Production Code notes from the Hays Office and against the cutting notes from his editor Hal Kern. Most importantly, he relied on notes and analysis from Franclien Macconnell, one of the best "readers" from Val Lewton's story department. Macconnell had been drafted early on to write the synopsis of the novel. When she was finished with that, Lewton asked Selznick, "Don't you think that while she is still saturated with the story, contents and characters of this book, that it might be a good idea to have Mac keep right on and do a costume and character breakdown as well?" Selznick agreed, and over the next two years Macconnell became the resident expert on the novel, writing extensive reports on character relationships, costumes, and settings, a "Topical Dialogue Breakdown According to Characters," and reports comparing the script to the novel. Despite his own extraordinary familiarity with the novel, Selznick came to rely on Macconnell's evaluation of the script pages as they came in. "The ideal script, as far as I am concerned," Selznick wrote to Macconnell on December 5, 1938, "would be one that did not contain a single word of original dialogue, and that was 100% Margaret Mitchell, however much we juxtaposed it. With this objective, or something at least approaching it, in mind, call to my attention even individual lines that might be substituted for original lines that we have created."

Selznick hired John Darrow to continue the search for talent in the South. He found a number of promising young actors, like Dorothy Shapard, whom he described as a "young Garbo," Kate Galbreath, who had "vitality, charm, and a beautiful face," and Anne Smith, about whom he said, "From her picture I should say she looks very promising." Contract negotiations with these young actors, however, were often difficult. Some prospects, like Dorothy Shapard, were concerned about how the film production would interrupt their education. Many, like Kate Galbreath and Em Bowles Locker, wanted to be in *Gone With The Wind* but did not otherwise want to pursue a film career. This was quite frustrating for Selznick because the purpose of the search was to find and sign new talent for his company. But the biggest obstacle to signing these amateur actors was the seven-year contract that gave almost unlimited power to the studio and very little to the actor. Many of the Scarlett "hopefuls" balked at the terms of the contract and refused to sign.

DON'T GIVE UP THE "SCARLETT HUNT"

Hopeful that he would soon secure additional financing and cast his male lead, Selznick pressed on in his search for Scarlett. Kay Brown and Anton Bundsmann continued their search on the East Coast. In addition to stage actors, they were now interviewing fashion models and radio personalities. On the West Coast, Max Arnow and Will Price, young casting directors Selznick hired to help with Scarlett auditions, were interviewing ingénues and stock company players from all the studios. John Darrow, a former actor turned talent scout, traveled through the South, focusing on colleges and Little Theater groups. And letters from the general public continued to arrive in the Selznick offices. Since the fall of 1936, Selznick had placed ads and planted stories inviting ordinary people to apply for the role of Scarlett O'Hara. Now, as Selznick sensed that the script, financing, and casting of other roles were starting to come together, he renewed his efforts to finalize a choice for the role of Scarlett.

Inter-Office Communication

SELZNICK INTERNATIONAL PICTURES, INC.

9336 WASHINGTON BOULEVARD CULVER CITY, CALIFORNIA

OFFICE OF THE PRESIDENT

TO: Miss Katharine Brown - cc: Mr. Wharton

SUBJECT: *Weird - Casting Scarlett*

DATE December 18, 1937

 Excerpt (Original filed JUDD, Virginia)

...And incidentally, I hope you haven't given up on the Scarlett hunt. We don't seem to be any closer, and I am simply hoping that somebody will show up from one of our three sources: the Cukor search, the Casting Department, and the New York office. Please note that I consider the New York office source at least as important as either of the others, and I therefore hope you are still doing everything possible to find a Scarlett. I hope in particular that the new plays on the road and the acting schools are being watched. Are you keeping in close touch with the various acting coaches and so on?

 DOS

DICTATED BUT NOT READ BY
DAVID O. SELZNICK

Little did Selznick know that his search for Scarlett would go on for another year. But in late December 1937, he was certain he would be able to start filming *Gone With The Wind* within a few weeks.

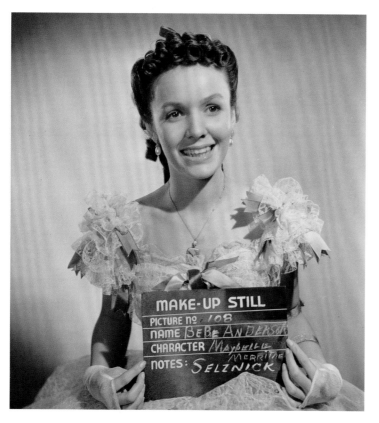

Makeup still of Bebe Anderson as Maybelle Merriwether.

Publicity photo of Margaret Tallichet for Selznick International Pictures, ca. 1937.

BEBE ANDERSON

Mr. Suggs from the Alabama Theater in Birmingham wrote to Kay Brown suggesting Bebe Anderson for a part in the film. Brown was impressed with the photos and arranged for an interview during her trip to Atlanta with George Cukor. Anderson signed an option agreement with the Selznick studio on May 20, 1937, and waited. Almost two years later, she was suddenly summoned to California, having been cast as Maybelle Merriwether.

MARGARET TALLICHET

Margaret Tallichet had moved from Dallas to Hollywood to pursue an acting career. She found work as a typist at Paramount Pictures, where she met Carole Lombard, who introduced her to Selznick. Kay Brown arranged for acting lessons for Tallichet in the spring of 1937 and got her jobs in summer stock companies. Tallichet was groomed for stardom for more than a year, and Brown was impressed with her intelligence, diligence, and pleasant personality. Selznick cast her in small parts in *A Star Is Born* (1937) and *The Prisoner of Zenda* (1937), and she was tested four times for *Gone With The Wind*. Selznick long planned to cast her in the part of Suellen but ultimately cast Evelyn Keyes in that role. Tallichet married the director William Wyler in October 1938 and decided to quit acting. This angered Selznick when he realized he would not be able to recoup his investment.

MERCEDES McCAMBRIDGE

SUSAN HAYWARD

Mercedes McCambridge was a twenty-year-old senior at Mundelein College in Chicago when she was auditioned for *Gone With The Wind* in September 1937. At the time, she was working her way through college as a radio actor on the NBC network, appearing in the programs *Dan Harding's Wife* and *Timothy Makepeace*. Although she was not cast in *Gone With The Wind*, McCambridge enjoyed a long career in film and television and continued her radio career through the 1950s.

Edythe Marriner was working as a fashion model in New York City when she auditioned for *Gone With The Wind*. Because she had just turned twenty, her mother cosigned her option agreement, which paid $200 a week and included a chaperoned trip to Hollywood for a screen test. Selznick liked her and used her in a number of tests with other actors but felt she was not right for *Gone With The Wind*. When her option ran out at the end of December, Selznick extended it on a week-to-week basis and, in early February 1938, found that Marriner had signed with Warner Brothers and would soon change her name to Susan Hayward.

Publicity photo of Mercedes McCambridge for NBC Radio, ca. 1937. McCambridge was working her way through college as a radio actor when she was recommended for the part of Scarlett by a Chicago agent. Photo by Maurice Seymour.

Modeling composite card for Edythe Marriner, who was working with the Walter Thornton Agency in 1937. Although Marriner made several screen tests for Selznick, he never cast her in a film. She eventually changed her name to Susan Hayward and signed with Warner Brothers.

BUTTERFLY McQUEEN

Thelma McQueen got the name "Butterfly" when she danced in the Butterfly Ballet in a 1935 stage production of *A Midsummer Night's Dream*. She was cast by George Abbott in his Broadway show *Brown Sugar* (1937), which led to a part in his long-running show *What a Life!* (1938). Kay Brown saw her in that show and invited her to audition for *Gone With The Wind*. Brown told Selznick that McQueen "has a most peculiar voice which is very high pitched and absolutely hilarious. Might be too comic for the part." Once Selznick saw McQueen's screen test, however, he never considered anyone else for the part of Prissy.

Portrait of Butterfly McQueen appearing in *Leo the Timekeeper* at the Lafayette Theater in Harlem, ca. 1936.

MARCELLA MARTIN

Max Arnow discovered Marcella Martin at the Little Theater in Shreveport, Louisiana. He noted, "This girl is quite good-looking, has a nice figure, and is a grand actress. Without doubt she is the best bet of the hundreds of people that I interviewed during my trip." Kay Brown liked her, too. After seeing Martin's screen test, Brown wrote to Arnow, "I think she is utterly charming and a definite Melanie possibility … in both Alicia Rhett's and Marcella Martin's tests, a woman viewing them gets a feeling of reality, authenticity and gentility." She added, "Incidentally, I got a great kick out of Tony's sexy modern close-up of her. We think she out-Hedys Hedy [Lamarr]." Martin was cast as Cathleen Calvert in *Gone With The Wind*.

Marcella Martin was discovered at the Shreveport Little Theater in 1938. She was cast as Cathleen Calvert, the woman who tells Scarlett about Rhett Butler as they walk up the stairway at Twelve Oaks.

"I AM SCARLETT"

By 1938, in response to advertisements and other publicity, Selznick had received thousands of letters from women asking to be considered for the role of Scarlett O'Hara. Many were encouraged by family members, teachers, agents, and Selznick's own talent scouts. Most of the women who wrote did so because they closely identified with the character of Scarlett in one way or another. Some felt they physically resembled the character as Margaret Mitchell described her, and some related to the character because of their southern heritage. But the majority of applicants felt they possessed an intimate understanding of Scarlett's resilience, resourcefulness, and sacrifice, as well as her failed romance.

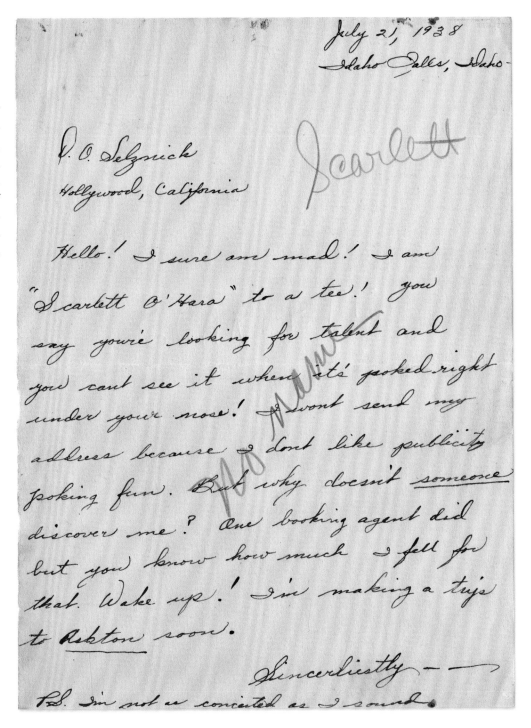

One of the thousands of letters Selznick received from women asking to be considered for the role of Scarlett O'Hara. Many wrote because they identified so closely with the character as written by Margaret Mitchell.

THE GABLE DEAL

After months of negotiations, Selznick finally secured Clark Gable as the male lead for *Gone With The Wind*. It was a handshake deal with Selznick's father-in-law, Louis B. Mayer, and Nick Schenck. In return for Gable, MGM would become the film's distributor. One major factor that still had to be determined was whether SIP would sell *Gone With The Wind* to MGM outright or attempt to make the film on its own with financing help from MGM. Either way, Selznick would produce.

Ultimately, Selznick and MGM agreed that SIP would produce the film. MGM would provide Clark Gable, half the budget up to $1,250,000, and access to resources such as its stock company, equipment, and costumes. In return, they would receive half the profits from the distribution of the film for seven years and 25 percent thereafter.

The first page of Selznick's confidential eight-page memo to Jock Whitney about his negotiations with MGM regarding the casting of Clark Gable in *Gone With The Wind*. MGM wanted to buy the production from SIP outright. Jock Whitney wanted to work with MGM but maintain ownership of the property. Regardless of the arrangement, Selznick would remain producer. See appendix for complete text.

THE CONFIDENTIAL PLAYER

In the initial stages of negotiations, MGM made it clear they wanted Norma Shearer to play Scarlett O'Hara. With the possible exception of Greta Garbo, Shearer was MGM's top female star. She had been cast with MGM's top male star, Clark Gable, in two films and was set for a third, *Idiot's Delight* (1939). *Gone With The Wind* would potentially be their fourth and greatest pairing.

Selznick, however, was sensitive to the overwhelmingly negative public reaction to Walter Winchell's announcement a year earlier that Shearer had been cast in the part. He still had not given up on finding a new "personality" to play Scarlett.

Still, for a brief period of time in the summer of 1938, it looked as though Shearer would play Scarlett. Because negotiations were in progress, Shearer discreetly communicated her thoughts about the character and the script to Selznick through Kate Corbaley, one of Louis B. Mayer's top advisors, who used no names in the interest of confidentiality.

INTER-OFFICE COMMUNICATION

FORM 73

METRO-GOLDWYN-MAYER CORPORATION
STUDIOS
CULVER CITY
CALIFORNIA

To David Selznick

Subject

From Kate Corbaley Date June 19, 1938

- N O T E S -

VERIFICATION OF TELEPHONE CONVERSATION WITH MR. SELZNICK

Up to the time the heroine leaves Rhett Butler's cell and meets Kennedy she is enthusiastic about both the story and the role. She has no criticism to make at all, or any suggestion to make other than the one already discussed in the change of her attitude to her little son, Wade.

From then on to the point of her marriage with Rhett, she feels a distinct loss of power and drive in the story, and has a very distinct objection to the characterization.

She feels the story begins to wander into so many paths that the initial drive is lost -- that at that part of the story the love duel between her and Rhett Butler should become of paramount interest and be the main story thread from then on, and that anything that distracts from this is a mistake.

She feels Rhett's love scenes are not culminative enough so that there is too much similarity. She feels you've pulled your punches in the big scene between them where she learns of his great need of her. She thinks perhaps this may be due to a fear of censorship, but that the scene, which is one of the most powerful ones in the book, is distinctly weakened.

Her great objection to the characterization after the scene in which Kennedy is, is this: She feels that there are many things excusable in a young, headstrong girl of seventeen, utterly inexperienced in life, that will never be forgiven a mature woman. She also feels, and rightly so, I think, that a woman who had gone through hell and come up out the other side would have lost all her pettiness, and she must emerge a big woman, with big wants and big virtues. She may still be headstrong and ungovernable, but she cannot do a mean, cruel thing.

Hence, she strongly objects to the marriage of Kennedy, particularly as it serves no vital purpose as I pointed out to you yesterday. If Kennedy marries Suellen, he would in that case pay the taxes, so the whole thing is a little pointless.

She mentioned a feeling against the showing of the degeneration of Ashley. She also mentioned the big scene at the party with Melanie, and it is quite true there is no greater situation in that part of the story for the heroine.

MG-22447

(ABOVE) Memo to Selznick from Kate Corbaley, one of Louis B. Mayer's top advisors, detailing Norma Shearer's thoughts on Scarlett O'Hara as written. See appendix for complete text.

(LEFT) Norma Shearer and Clark Gable in *Idiot's Delight* (1939). MGM's two top stars had been cast together in *A Free Soul* (1931), *Strange Interlude* (1932), and *Idiot's Delight*, all with great success. *Gone With The Wind* would have been their fourth film together.

WALTER WHITE AND THE NAACP

NATIONAL OFFICERS

PRESIDENT
J. E. SPINGARN

CHAIRMAN OF THE BOARD
DR. LOUIS T. WRIGHT

VICE-PRESIDENTS
NANNIE H. BURROUGHS
GODFREY LOWELL CABOT
HON. ARTHUR CAPPER
BISHOP JOHN A. GREGG
REV. JOHN HAYNES HOLMES
MANLEY O. HUDSON
JAMES WELDON JOHNSON
REV. A. CLAYTON POWELL
ARTHUR B. SPINGARN
OSWALD GARRISON VILLARD

TREASURER
MARY WHITE OVINGTON

BOARD OF DIRECTORS

Amenia, N.Y. J. E. Spingarn
Atlanta A. T. Walden
Baltimore Carl Murphy
Birmingham, Ala. Dr. E. W. Taggart
Charleston, W.Va. T. G. Nutter
Chicago Prof. Paul H. Douglas
Cleveland Hon. Harry E. Davis
L. Pearl Mitchell
Denver L. H. Lightner
Detroit Hon. Ira W. Jayne
Hon. Frank Murphy
Emporia, Kas. William Allen White
Nashville, Tenn. Dr. N. C. McPherson
Newark, N.J. Grace B. Fenderson
New York Lillian A. Alexander
Dr. Allan Knight Chalmers
Dr. Walter Gray Crump
Marion Cuthbert
Hubert T. Delany
Rachel Davis Du Bois
Douglas P. Falconer
Lewis S. Gannett
Rev. John Haynes Holmes
Dr. William Lloyd Imes
James Weldon Johnson
Dr. John B. Johnson
Hon. Herbert H. Lehman
Hon. Caroline O'Day
Mary White Ovington
James H. Robinson
Arthur B. Spingarn
Charles H. Studin
Hon. Charles E. Toney
Frances Harriet Williams
Dr. Louis T. Wright
Northampton, Mass. Dr. William Allan Neilson
Oklahoma City Roscoe Dunjee
Philadelphia Isadore Martin
St. Louis Sidney R. Redmond
Talladega, Ala. Rev. Joseph W. Nicholson
Topeka, Kas. Hon. Arthur Capper
Washington Hon. William H. Hastie
Charles Edward Russell
Dr. Charles H. Thompson
Dr. Elizabeth Yates Webb

NATIONAL LEGAL COMMITTEE

Arthur B. Spingarn, New York, Chairman
Berkeley, Calif. Walter A. Gordon
Boston Irwin T. Dorch
Cambridge, Mass. Felix Frankfurter
Charleston, W.Va. T. G. Nutter
Chicago Irvin C. Mollison
Edward H. Morris
Columbia, S.C. N. J. Frederick
Erie, Pa. William F. Illg
Los Angeles Thomas L. Griffiths, Jr.
Madison, Wis. Lloyd Garrison
Nashville, Tenn. Z. Alexander Looby
New York Hubert T. Delany
Morris L. Ernst
Arthur Garfield Hays
Charles H. Houston
Karl N. Llewellyn
James Marshall
Herbert K. Stockton
Charles H. Studin
Philadelphia Francis Biddle
Pittsburgh Homer S. Brown
Toledo, Ohio Jesse S. Heslip
William T. McKnight
Washington Leon A. Ransom
Wilmington, Del. Louis L. Redding

NATIONAL ASSOCIATION FOR THE ADVANCEMENT OF COLORED PEOPLE

69 FIFTH AVENUE, NEW YORK

TELEPHONE ALgonquin 4-3551

Official Organ: The Crisis

June
28th
1938 (Dictated June 25th)
(Mailed 7/13/38)

Dear Mr. Selznick:

Your very interesting and encouraging letter of June 20th comes just as I am leaving the city for our 29th Annual Conference at Columbus, Ohio, and for some lectures at Northwestern University. I shall write you on my return to the city around July 7th.

I am asking my secretary to gather and send you the reviews. I am also getting opinions from two or three persons who are exceedingly familiar with GONE WITH THE WIND and with the period of which it treats.

I know Mr. Sidney Howard and his work and thus know of how sincere his interest in and attitude towards the Negro are. His and your connection with the forthcoming picture are most heartening as guaranties of its attitude on the subject matter of the book and films. But you will understand that our apprehension in that the book fundamentally is so essentially superficial and false in its emphases that it will require almost incredible effort to make a film from the novel which would not be both hurtful and inaccurate picture of the Reconstruction era. In saying this I want to emphasize again that I do not by this mean to stress racial chauvinism or hypersensitiveness. Our interest is solely that of accuracy according to the most rigid standards of historical truth. But the writing of history of the Reconstruction period has been so completely confederatized during these last two or three generations that we naturally are somewhat anxious.

In saying this I do not mean to charge that all Americans are prejudiced. Most historical treatments of the pre-Civil War and Reconstruction days either completely ignore the considerable part played by the Negro in American history or give such distorted and essentially vicious treatment to the Negro that it is a wonder that white Americans are not more prejudiced than they are, though that in itself would be an achievement of no mean proportions. The motion picture, appealing as it

ENDORSED BY THE NATIONAL INFORMATION BUREAU, 215 FOURTH AVENUE, NEW YORK
29th ANNUAL CONFERENCE, COLUMBUS, OHIO, June 28th - July 3rd, 1938

EXECUTIVE OFFICERS

WALTER WHITE SECRETARY
ROY WILKINS
ASSISTANT SECRETARY
EDITOR, THE CRISIS
CHARLES H. HOUSTON
SPECIAL COUNSEL
THURGOOD MARSHALL
ASSISTANT SPECIAL COUNSEL
WILLIAM PICKENS
DIRECTOR OF BRANCHES
DAISY E. LAMPKIN
FIELD SECRETARY
JUANITA E. JACKSON
SPECIAL ASSISTANT TO THE SECRETARY
E. FREDERIC MORROW
BRANCH COORDINATOR

Selznick's assurances that he would treat African Americans fairly in *Gone With The Wind* did little to satisfy White, the head of the NAACP, who pressed Selznick to have an African American historical advisor on set to ensure the film's historical accuracy. The Harry Ransom Center wishes to thank the National Association for the Advancement of Colored People for authorizing the use of the correspondence of Walter White.

In the spring of 1938, Rabbi Robert Jacobs of Hoboken wrote to Rabbi Barnett Brickner, chairman of the Social Justice Commission of the Central Conference of American Rabbis, "Soon the David O. Selznick Studios of Hollywood will begin production of the play 'Gone With The Wind.' The book, a thrilling romance of the South, was shot through with an anti-Negro prejudice, and while it undoubtedly furnished almost half a million people in this country with many glowing hours of entertainment, it also in a measure aroused whatever anti-Negro antipathy was latent in them."

Rabbi Brickner in turn wrote to Selznick. "In view of the situation," he wrote, "I am taking the liberty of suggesting that you exercise the greatest care in the treatment of this theme in the production of the picture. Surely, at this time you would want to do nothing that might tend even in the slightest way to arouse anti-racial feeling. I feel confident that you will use extreme caution in the matter."

Brickner wrote a similar letter to Walter White, Secretary of the National Association for the Advancement of Colored People. White also wrote to Selznick, suggesting Selznick "employ in an advisory capacity a person, preferably a Negro, who is qualified to check on possible errors of fact or interpretation."

In his reply to White, Selznick wrote, "I hasten to assure you that as a member of a race that is suffering very keenly from persecution these days, I am most sensitive to the feelings of minority peoples." He added, "It is definitely our intention to engage a Negro of high standing to watch the entire treatment of the Negroes, the casting of the actors for these roles, the dialect that they use, etcetera, throughout the picture. One man whom we are considering, among others, is Hall Johnson." Hall Johnson was the founder of the Hall Johnson Negro Choir, which had gained fame for their choral arrangements of Negro

spirituals, and had appeared in the Broadway and film versions of *The Green Pastures* (1936). Selznick was considering using the Hall Johnson Choir for the soundtrack of *Gone With The Wind*.

Selznick sent Sidney Howard a blind copy of his letter to White. Howard wrote directly to White. "Mr. Selznick has sent me copies of your letter to him about GONE WITH THE WIND and his answer. I do not see how anything could be any clearer or finer than his answer, which must have satisfied you without any amplification on my part. I can tell you, however, that when I first undertook the job Mr. Selznick and I found that we were in complete agreement on the aspect of the picture over which you are concerned. We had both decided from the start, and independently of one another, that the picture should make no mention of the Ku Klux Klan and show no negro violence."

Walter White dictated his reply to Selznick on June 25. He was encouraged by Selznick's and Howard's letters but still felt apprehension "in that the book fundamentally is so essentially superficial and false in its emphases that it will require almost incredible effort to make a film from the novel which would not be both hurtful and inaccurate picture [*sic*] of the Reconstruction era." White ended his letter by saying, "I am interested in knowing of your intention to engage a Negro of high standing to watch the entire treatment of the Negro in the casting of actors, etc." He expressed "high regard" for Hall Johnson, but suggested Selznick consider hiring someone who had studied the Reconstruction period.

Selznick replied, "I would be most interested, and assure you that I will be importantly influenced, in the selection of Negro advisers, by any suggestions you might care to make." Roy Wilkins, assistant secretary of the NAACP, suggested Dr. Charles Wesley, dean of the graduate school at Howard University, as a possible advisor. While Selznick was eager to please White, he did not immediately move forward with plans to hire an advisor.

#2 - Mr. Selznick June 28, 1938

does to both the visual and auditory senses, reaches so many Americans, particularly of the middle classes, that infinite harm could be done in a critical period like this when racial hatreds and prejudices are so alive.

I am interested in knowing of your intention to engage a Negro of high standing to watch the entire treatment of the Negro in the casting of actors, etc. I have very high regard for Hall Johnson and believe he could be of great service to you. I would think, however, that since Mr. Johnson is sessentially an artist in the field of music, it might be well to have also, if you engage Mr. Johnson, the advice and assistance of one whose familiarity with the Reconstruction period would be somewhat more extended than one who has devoted his life largely to one field. In saying this I by no means wish to appear to criticise Mr. Johnson.

Ever sincerely,

Walter White

Secretary.

Mr. David O. Selznick
President,
Selznick International Pictures, Inc.,
9336 Washington Boulevard
Culver City,
California.

WW:CTF

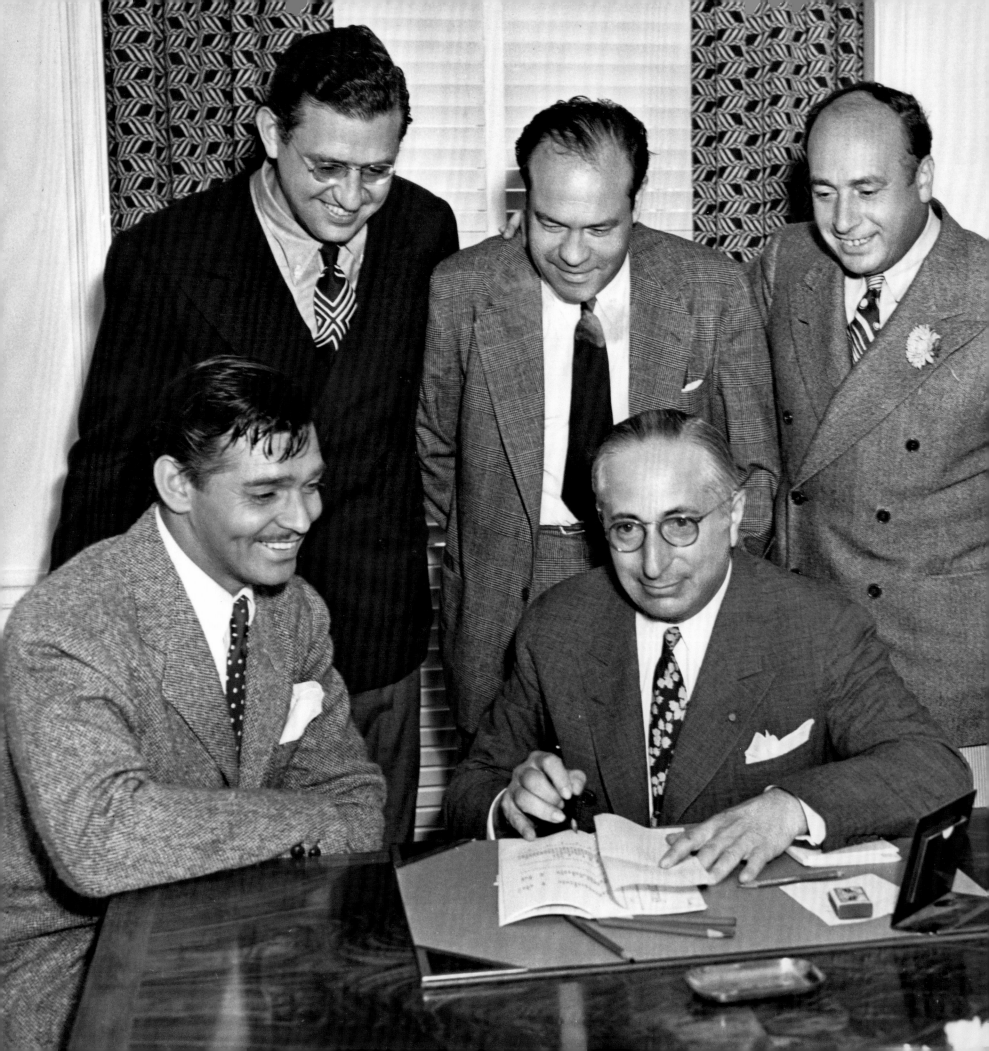

"TRY TO MAKE THIS GABLE'S NEXT PICTURE"

As the details of the deal with MGM were worked out, Selznick reminded his staff that the reason for the deal was to cast Clark Gable as Rhett Butler. Once the contracts were signed, Selznick was able to realize an equally important objective, a starting date. When *Idiot's Delight* finished filming, Gable would be available for a limited period of time. Selznick would have to wrap up all preparations for *Gone With The Wind*, including the search for Scarlett, by that date. With Clark Gable signing on to *Gone With The Wind*, all of Selznick International Pictures shifted into high gear.

(FACING) Publicity photo of David O. Selznick, MGM executives Eddie Mannix and Al Lichtman (standing, left to right), and Clark Gable looking on as Louis B. Mayer pretends to sign the contract. The contract had actually been signed on August 25 by Selznick and Lichtman. Gable would be available immediately after completing *Idiot's Delight* in January 1939.

(RIGHT) This page of Selznick's notes on the negotiations with MGM emphasizes Clark Gable's importance to the production. "They must definitely agree to deliver Gable on the specified date and it must be worded as the essence of the contract and the reason for making the deal . . . [is] that they deliver Gable without fail and without putting him in any other picture." See appendix for complete text.

7/29/38

Argument on the value of an earlier starting date. Try to make this Gable's next picture. Failing this, set it up definitely after "Idiot's Delight."

When picture was originally set up in March, this was done because it was the first time Gable and Shearer would jointly be available. Now that Shearer is out of it, there is no reason why it should not be set up as Gable's picture immediately following "Idiot's Delight" and his vacation. This would probably make it some time around November or December. This is the very latest we should agree to and we should try to set it up for much earlier since, obviously, our overhead will be enormously affected.

* * * * * * * * * * * * * * *

They must definitely agree to deliver Gable on the specified date and it must be worded as the essence of the contract and the reason for making the deal....a point on which we should be as adequately protected as is possible legally.....that they deliver Gable without fail and without putting him in any other picture.

It should further be specified that Gable will be charged to us at cost, this cost to be arrived at by dividing the number of pictures he does into his year's compensation, for which we get 12 or 13 weeks of his time, with weeks beyond this chargeable on a weekly basis.

It should be agreed that should they have any difficulty with Gable about bonuses or anything of the sort, they must pay them. Our understanding is we will receive Gable at the salary they presently pay him under the terms of his existing contract, this to protect us against Gable demanding extra money.

* * * * * * * * * * * * * * *

They must agree immediately the deal is made, to make it clear to Miss Shearer that the fact that she is not playing the role is by their preference. My relations with Miss Shearer are such that I would not think it fair that I should be asked to assume this burden, since it was Mr. Schenck's decision that she should not play the role.

* * * * * * * * * * * * * * *

It must be understood at/the outset, that the negative and story of the picture are our property and they are simply assisting in the financing and they do not have any ownership.

In this connection, and since they are assisting financing a picture for a very large share of the profits, they, of course, have no right to share in any remake rights, television rights, etc. -- except television rights, etc., on the one photoplay.

Ditto on commercial tieups, which are really no concern of theirs, but on which, if necessary, we could concede half.

Ditto on radio rights which they are not entitled to share in whatsoever and I doubt whether we should concede they are entitled to share in any part of these, even on the first picture.

But as far as future pictures, and rights that have nothing to do with this one photoplay, they obviously have no right to share.

With further reference to radio rights, they must surely concede that radio rights are valuable now. Our ownership of them is a fluke. Their investment is certainly not an element in making these radio rights valuable, as they can be sold today. Therefore, they have no right to share in them.

* * * * * * *

LANA TURNER AND OTHER STUDIO STOCK PLAYERS

Form 73—10M—2-38—K-I Co.

SELZNICK INTERNATIONAL PICTURES, INC.

9336 WASHINGTON BOULEVARD CULVER CITY, CALIFORNIA

Inter-Office Communication

TO Mr. Selznick DATE Sept. 12, 1938

FROM Mr. Arnow SUBJECT TALENT HUNT

Following you will find a further report on the talent hunt to date.

YOUNG STOCK PLAYERS - OTHER STUDIOS
M.G.M.
Went through the entire contract list with Datig, saw several tests and the only likely possibility is Jack Hubbard who, in a pinch might be suitable for Ashley. Among the girls, Mimi Lilligren and Lana Turner might fit into smaller parts but are not right, or experienced enough, for any of the bigger roles in the picture. You saw the test of Hubbard and Lilligren which was made at R.K.O.

WARNER BROTHERS

Had a very attractive blonde young woman by the name of Irene Rhodes come in and gave her a dialogue scene. If she reads this well will have her see Mr. Cukor. No others suitable for the picture.

PARAMOUNT
After having a talk with Bagnall and Bottsford they thought the only people we would be interested in were the following:
Evelyn Keyes - is a De Mille protege who is said to be a good young actress but who does not photograph as well as she should. She is in a picture now but they are going to send her to see me as soon as she has a day off as she seems to be on the order of "Scarlett".

Richard Denning - a young man of light complexion and hair, whom they feel might be a possibility for Ashley. They are sending us some tests which I will show you as soon as they arrive.

Louise Campbell - she is not a younger stock player but a contract player getting $1,000 a week. She is from the radio field in Chicago and has done only B pictures with the exception of the last, MEN WITH WINGS, in which she played opposite MacMurray and Milland. However she is more on the Melanie than the Scarlett type. The picture should be previewed in town this week and I will cover same.

20TH CENTURY FOX

Discussed the matter of stock players with Schreiber who says they have no one we would be interested in.

R. K. O.

Discussed matter with Rufus LeMaire who said they had no young players capable of doing these roles.

UNIVERSAL
Nothing on their list worthy of consideration.

While John Darrow continued his search through colleges and Little Theater groups in the South, and Kay Brown and Anton Bundsmann interviewed actors in the New York theater world, Max Arnow searched the stock companies of Hollywood film studios for someone to play Scarlett. Almost every available starlet in Hollywood who wanted a chance to try out for the part of Scarlett was at least interviewed. While most were passed over, a few, such as Lana Turner and Evelyn Keyes, were given serious consideration.

(ABOVE) Melvyn Douglas and Lana Turner in a screen test for *Gone With The Wind*. Selznick thought Turner "completely inadequate, too young to have a grasp of the part apparently, and generally surprisingly uninteresting in view of how fascinating she is as a modern young flapper." Douglas, Selznick thought, "gives the first intelligent reading of Ashley we've had, but I think he's entirely wrong in type, being much too beefy physically and even mentally—suggesting a lieutenant of Rhett Butler's rather than an aesthetic, poetic and defeated Ashley."

(LEFT) Once Clark Gable signed on to *Gone With The Wind* in late August, establishing a start date for filming just three months away, Selznick began focusing more and more on Hollywood actresses, especially young stock players in the studios, in his search for the right actress to play Scarlett. See appendix for complete text.

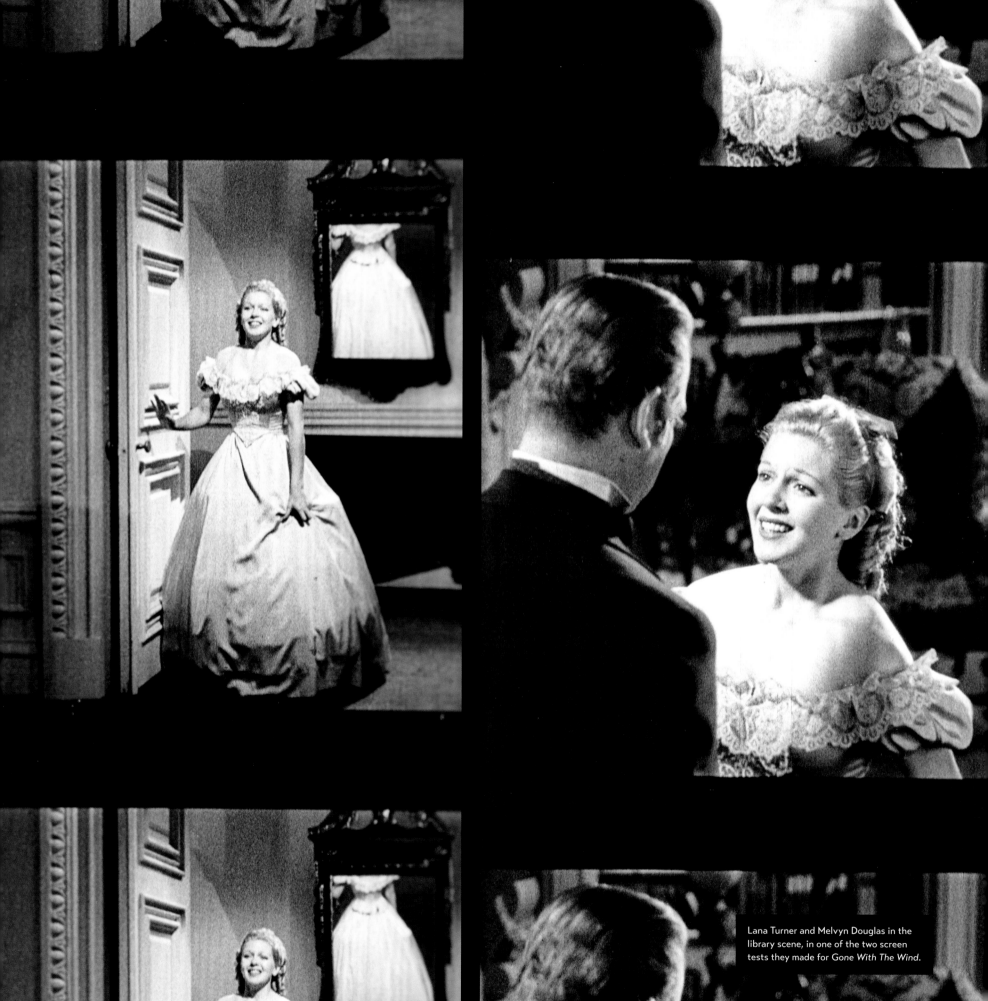

Lana Turner and Melvyn Douglas in the library scene, in one of the two screen tests they made for *Gone With The Wind*.

(ABOVE) Selznick's new star from Sweden, Ingrid Bergman, in her first American film, *Intermezzo: A Love Story* (1939).

(LEFT) One sheet poster for *The Young in Heart* (1938). Selznick seriously considered several of the film's stars for parts in *Gone With The Wind*.

OTHER FILM PROJECTS

Gone With The Wind had, at this point, been in development for longer than any other film Selznick had produced, and he had yet to shoot a single frame of film. To keep his company afloat, he concentrated on making black-and-white films employing simpler stories and smaller casts while maintaining high production values. *The Young in Heart* (1938) was based on a *Saturday Evening Post* serial by I. A. R. Wylie, titled "The Gay Banditti," about a family of con artists. In addition to Janet Gaynor, the film starred several people Selznick was seriously considering for *Gone With The Wind*. He wanted Douglas Fairbanks, Jr., for Ashley, but Fairbanks would only agree to test for the role of Rhett. Selznick also thought highly of Richard Carlson for Ashley. Billie Burke was his first choice for Aunt Pittypat, and Paulette Goddard was the front-runner for Scarlett for almost a year.

The script for *Made for Each Other* (1939), based on the book *Of Great Riches* by Rose Franken, went through so many changes throughout 1937 and the first half of 1938 that Selznick considered it an original story, and Franken had to pressure Selznick to at least grant the credit, "Suggested by a story by" The film starred James Stewart and Selznick's star Carole Lombard, and featured a small part with Louise Beavers, whom Selznick considered for the role of Mammy in *Gone With The Wind*.

Alerted by scouts to an exciting young actress in Sweden named Ingrid Bergman, Selznick also worked at this time to sign her to his studio. Selznick first brought her to the United States to star with Leslie Howard in a remake of the 1936 Swedish film *Intermezzo*, in which Bergman had first created the role of a young piano accompanist who becomes the love interest of a married virtuoso violinist. Selznick and Kay Brown worked to free her of her European contracts, including a contract with the German film company UFA, before she returned in 1939 on a seven-year contract with Selznick.

The writer, producer, and director Alfred Hitchcock had signed with Selznick in July 1938. Selznick wanted to exploit Hitchcock's talent for action and suspense by having Hitchcock's first American film be "The Titanic." But as *Gone With The Wind* occupied more and more of his time, Selznick abandoned "The Titanic" project, partly out of concern about lawsuits from people who had had similar motion picture ideas and from survivors of the tragedy. Instead, an adaptation of Daphne du Maurier's novel *Rebecca* would become Hitchcock's first American film.

James Stewart and Carole Lombard in *Made for Each Other* (1939).

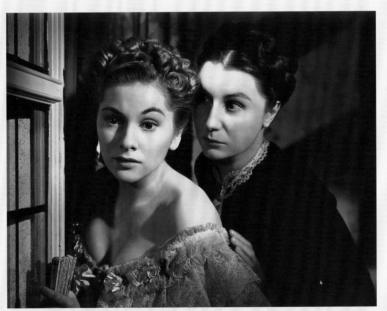

Joan Fontaine and Judith Anderson in Selznick's production of *Rebecca* (1940), Alfred Hitchcock's first American film. Anne Baxter, Loretta Young, Margaret Sullavan, and Vivien Leigh were all seriously considered for the lead role.

WILBUR KURTZ AND SUSAN MYRICK

Even before George Cukor's trip to Atlanta in spring 1937, two names came up again and again as possible historical advisors for the film. Wilbur Kurtz was well known in Atlanta as an authority on the Civil War in general and the Atlanta Campaign in particular. A professional draftsman and illustrator from Illinois, he had moved to Atlanta after the turn of the century to pursue his interest in history. W. E. Harrington of the Atlanta Chamber of Commerce was one of the first to recommend Kurtz, and when George Cukor and Hobe Erwin visited Atlanta, Margaret Mitchell and Kurtz showed them around the city.

Mitchell herself recommended Susan Myrick as an advisor in a letter to Kay Brown on February 14, 1937. "You said that you'd like to have me there to pass on the authenticity and rightness of this and that, the accents of the white actors, the dialect of the colored ones, the minor matters of dress and deportment, the small touches of local color, etc. Well I can't go and you know why. But I thought if you really wanted a Georgian for the job there wouldn't be anyone better than Sue."

Kay Brown thought Kurtz was "rare [for a historian] in being neither a bore nor impractical." Myrick she described as "a really swell woman, two-fisted, hard drinking, newspaper

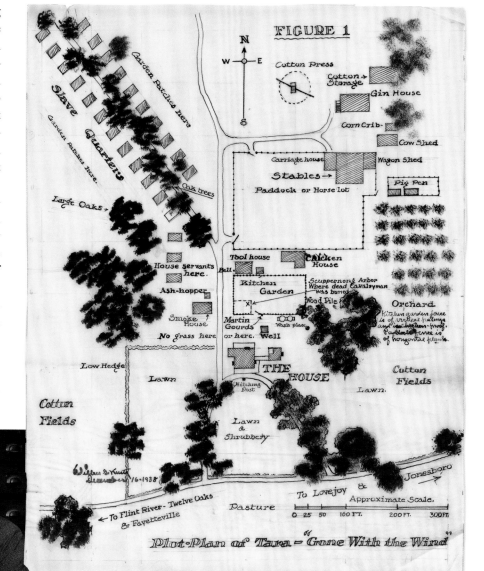

(ABOVE) Wilbur Kurtz's layout of the grounds of Tara. Kurtz provided historical background and advice on costumes, props, and sets. Among his most important contributions were his research and insight regarding the buildings and layout of downtown Atlanta and the citizens' appearance and behavior during the siege.

(LEFT) Art director Lyle Wheeler (left) and historical advisor Wilbur Kurtz discussing sketches.

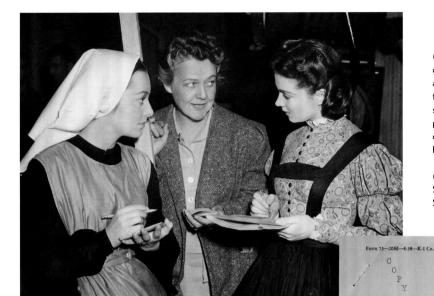

(LEFT) Susan Myrick with Olivia de Havilland and Vivien Leigh during the filming of the hospital scene. Myrick was hired to provide advice on southern etiquette and culture for the film. Soon after filming began, she was also asked to coach the actors on their southern accents. Myrick was close friends with Margaret Mitchell, providing both Mitchell and Selznick with a back channel for communication and a measure of confidence that the film would be historically accurate.

(BELOW) Susan Myrick's notes on the first pages of the screenplay. Selznick and the production staff quickly came to rely on her advice. See appendix for complete text.

type." But despite the strong recommendations, negotiations with the two were difficult. Both insisted on salaries far higher than Selznick was willing to pay an advisor. But neither could afford to move to California for an extended period at low pay while having financial obligations back in Georgia. In the fall and winter of 1938, as the start date for filming loomed, and as Kurtz and Myrick remained the best candidates by far, Selznick and the two came to terms. Myrick would be paid $125 per week, and Kurtz, with his wife as his assistant, would be paid $225 per week. Both would be allowed to write articles for their newspapers back home and keep the proceeds.

Cukor and Menzies were thrilled. In fact, virtually everyone on the production staff found the advisors' contributions "invaluable." And Selznick, always desirous of Margaret Mitchell's input and approval yet frustrated by her steadfast refusal to participate in the production, now had the next-best thing. As Kay Brown wrote in a 1937 telegram, "We do feel that Myrick will be of especial value because of her great personal relationship with authoress and because she can and will unofficially communicate with authoress on all points under discussion. We both feel this is one of the most important aspects in situation as it relieves authoress from actually committing herself and yet we will know things have been checked with her."

Form 73—20M—4-38—K-I Co.

COPY

SELZNICK INTERNATIONAL PICTURES, INC.

9336 WASHINGTON BOULEVARD CULVER CITY, CALIFORNIA

Inter-Office Communication

TO	Mr. David O. Selznick	DATE	January 18, 1939.
FROM	Miss Susan Myrick	SUBJECT	GONE WITH THE WIND Script Suggestions Pages 1 thru 44

Here are suggestions I have to offer on the GONE WITH THE WIND script through Page 44. I hope to get more of these to you during the day.

Copies of my report are going to various departments so that those concerned with production will be aware of these suggestions.

Page 5
Scene 7
"Gerald gallops into a pasture of blooded cattle."

These cattle should be Jerseys or Guernseys. No Holsteins or Black Angus known in the South in the sixties.

Page 5
Scene 8
"Follow Gerald as his horse jumps across a narrow stream to a glade."

Native Azalea would be in bloom at this time, and would add color about the stream. Also Red Bud is flowering at this time and might be near a stream.

Page 5
Scene 9
"--'snake fence' made of split logs."

The "snake fence" showing sign might have Wild Honeysuckle climbing on it, as Wild Honeysuckle is very prolific in Georgia. It is not in bloom at this time, however.

The fence should look aged, and an occasional small weed or China Berry bush might show alongside since the Georgia roadside fence would not be neatly kept.

Page 6
Scene 12
"About them are dogwood trees full of blossom."

Suggest Red Bud effective as shrub with Dogwood Trees. It would be blooming at the same time as Dogwood.

Page 10
Scene 19
Pork addressing Ellen: "He tuk on terrible at you runnin' out ter hulp dem w'ite trash..."

The word "hulp" should be "hope" or "holp"

Page 10
Scene 19
Jonas Wilkerson speaks of plowing the "back 40 acres."

The phrase "bottom land" is a typical southern phrase and could be substituted for "back 40 acres."

"DIXIE'S SACRED DRAWL"

Thousands of southerners sent letters to Selznick emphasizing the importance of getting the southern accents right in the making of *Gone With The Wind*. Other films set in the South, like King Vidor's *So Red the Rose* (1935), had used a generic "southern" accent that many letter writers pointed out was offensive to their sense of identity. By the time production on *Gone With The Wind* had begun, Selznick had developed a sensitivity to southerners' concerns, and he was alert to the accuracy of accents throughout the production.

Selznick met with Clark Gable on October 19, 1938, to discuss the film and his vision for the part of Rhett Butler. Gable then met with Cukor and Henry Ginsberg, head of production, to discuss his costume, makeup, and, in particular, his accent. Gable, anxious about perfecting his character's accent, requested a dialog coach to work with him while he was shooting *Idiot's Delight*. But just two days before the first scene of *Gone With The Wind* was to be shot, Selznick learned that Gable refused to use an accent at all. In response, Selznick instructed Will Price, from his casting department, and Susan Myrick, one of the technical advisors, to ensure that all the actors could at least employ an accent that would not offend.

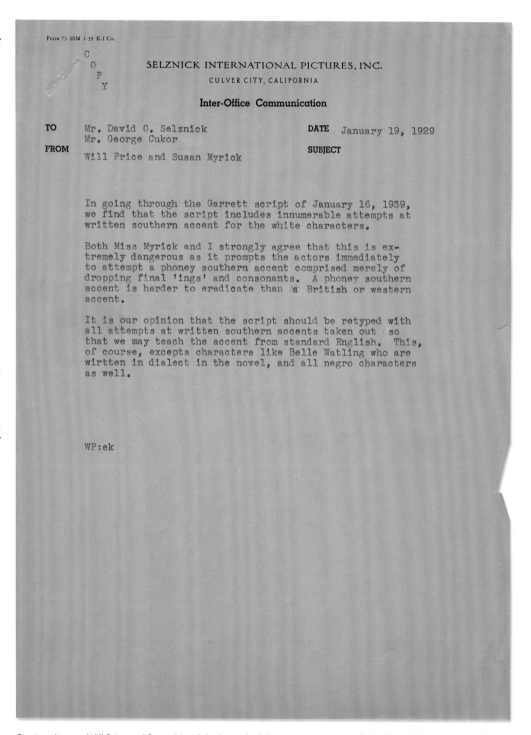

Casting director Will Price and Susan Myrick both coached the actors on accents. Selznick took their advice and had the screenplay retyped to eliminate the forced southern dialect.

Holman Hotel,
Athens, Ga.

Oct. 9, 1936

Mr. David B. Selznick:

You are no doubt receiving many letters regarding the subject I am interest-
ed in to the extent of writing to you. Miss Mitchell's story of the South
is <u>wonderful!</u> I am a Southern woman. Born of Southern parents. My father
born and raised in Columbus, Ga. My mother in Oxford, Ga., fifty miles from
Atlanta. My father was a Methodist minister in the North Georgia Conf.
until his death. My mother's father was also a "Carrie Harris Circuit Rider".
My grandfather owned slaves and gave four sons to the Southern Cause. The
Southern people are very proud of the Southern background. We love our
history and other parts of the U.S. are becoming more and more interested.
Allow me to say, Mr. Selznick, you have a big job on your hands when you
select the casting of this <u>big</u> picture. CLARK GABLE is perfect for RHETT
BUTLER. But -- please give SCARLETT's role to a woman who has the
<u>Southern dialect</u>. <u>Come South</u> and study our <u>dialect</u>. I don't know your
<u>people as you do</u>, but it cuts deep when we see our lovely old Southern
life "hashed up". You have <u>nothing</u> like it in the <u>world</u>. The old South!
How we love it. Go to Milledgeville, Ga. See and picture some of the
beautiful old Southern homes, standing since the war. The old Capital.
The Gov. Mansion. Perfectly intact. The <u>red</u>, <u>red</u> clay. Milledgeville
has <u>everything</u>. You would be thrilled with your find. Look for the old
Jarden farm. Jarden's Crossing. Six miles from Milledgeville. If you
will come to Athens, Ga., Holman Hotel, I will take you there myself, as
it is only a short ride by paved road, and I know every spa by heart!
MARIAM HOPKINS is not bad for SCARLETT. Could be better looking. The
Southern people will <u>never</u> forgive you if you don't cast this as it should
be. <u>Please</u> don't overdo the dialect and say "<u>you all</u>". You people just
don't know the South. It would pay you to come or send and study it.
Write to Mrs. Nellie Warmack Hines, Milledgeville, Ga. to give you some
fine points.

You may consider this as none of my business, <u>but believe me it is</u>. And
of every other true Southern woman or man.

My address and res. is the Holman Hotel, Athens, Ga. <u>Famous Old Georgia!</u>

Very truly,

Mrs. J. C. Stiles.

(RIGHT) Most of the letters to Selznick from the South urged him to take special care with what Margaret Mitchell once called "Dixie's sacred drawl."

(BELOW) Clark Gable initially agreed to work on a southern accent during breaks in filming *Idiot's Delight* (1939). While Selznick softened his position on Gable's accent, he remained vigilant over the accents of the other players, particularly Vivien Leigh.

Wind - Accents

<u>copy</u>

Mr. Cukor

CLARK GABLE

12/8/38

For your information, I am informed by MGM that Clark Gable refuses
under any circumstances to have any kind of a southern accent.

I am very anxious to talk to you generally about this entire accent
problem, and would appreciate it if you would make a note to take it
up with me when you see me tomorrow.

DOS

dos:bb

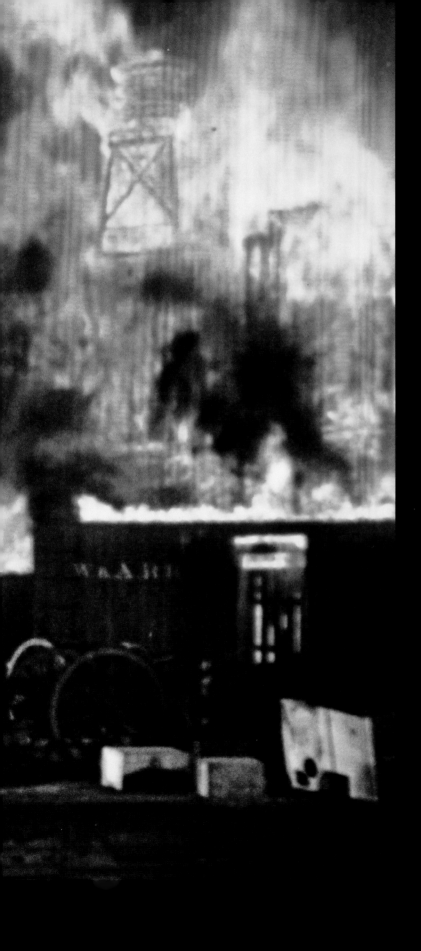

THE BURNING OF ATLANTA

On November 10, 1938, Henry Ginsberg, production manager Ray Klune, production designer William Cameron Menzies, and Lyle Wheeler met to discuss starting production of *Gone With The Wind*. The "40 Acres," Selznick's back lot, was full of sets from *The Garden of Allah*, *King Kong*, and other films by Selznick and the previous tenant, RKO. Their recommendation was to film the Burning of Atlanta scene first. They would dress the existing sets to look like antebellum downtown Atlanta, then set them on fire and film the long and wide shots as well as the "process plates" that would be used as backgrounds for the close-ups that would be filmed later. This approach would also serve to clear the lot and make room to build sets for Tara, Twelve Oaks, and downtown Atlanta. With Menzies in charge, they would use gas jets to control the size of the flames and a tractor to pull down a building on cue. Doubles would fill in for Gable, who was not yet available, and for the role of Scarlett, which had not yet been cast. Because Melanie and Prissy would be crouched down in the back of the wagon, dummies could be used instead of doubles. Selznick's MGM colleagues told him the plan would not work, and Selznick worried that the footage would be unusable if it looked less than convincing.

Production manager Ray Klune supervised the physical aspects of the production, from the building of sets to the coordination of the shooting schedule. His calm manner and even handling of Selznick served as a much-needed and much-appreciated buffer between the obsessive and demanding producer and the hardworking production team.

Production designer William Cameron Menzies directed the Burning of Atlanta scene, which he carefully planned in advance to ensure that close-ups of the principal actors filmed later would seamlessly intercut with the long shots and wide shots made on December 10. Those close shots would be set up and filmed periodically over the course of the production, and Selznick worried until the end of filming about whether all the shots needed would be completed in time.

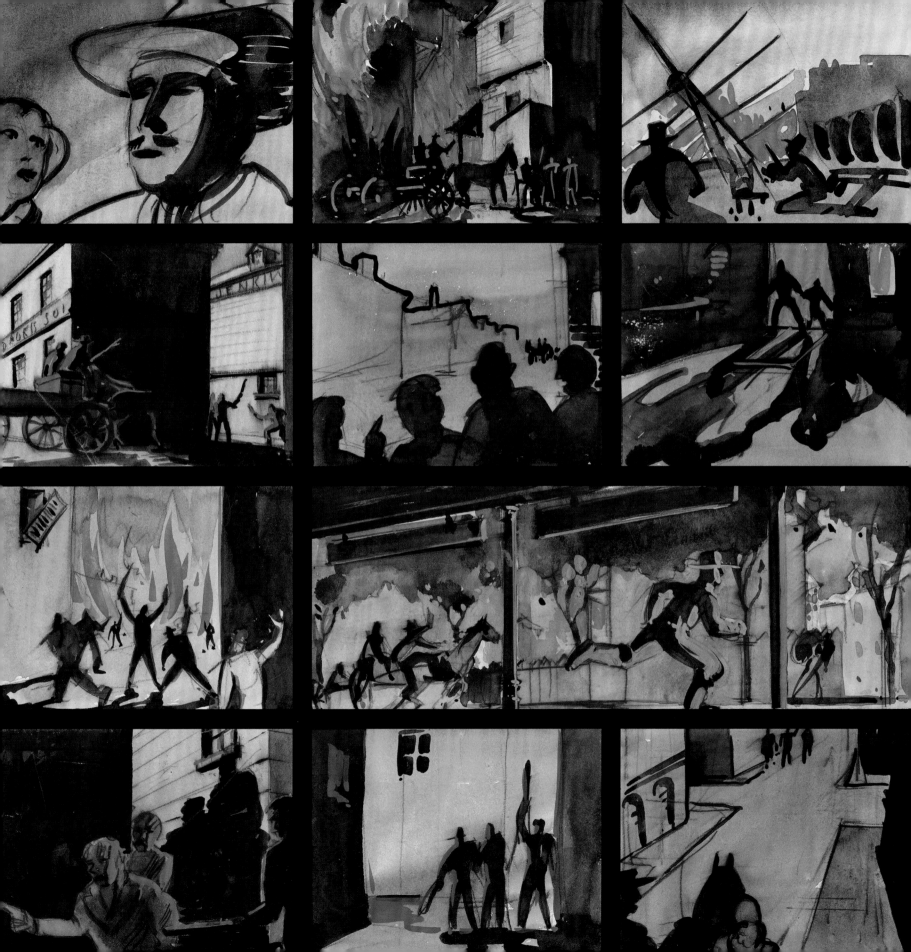

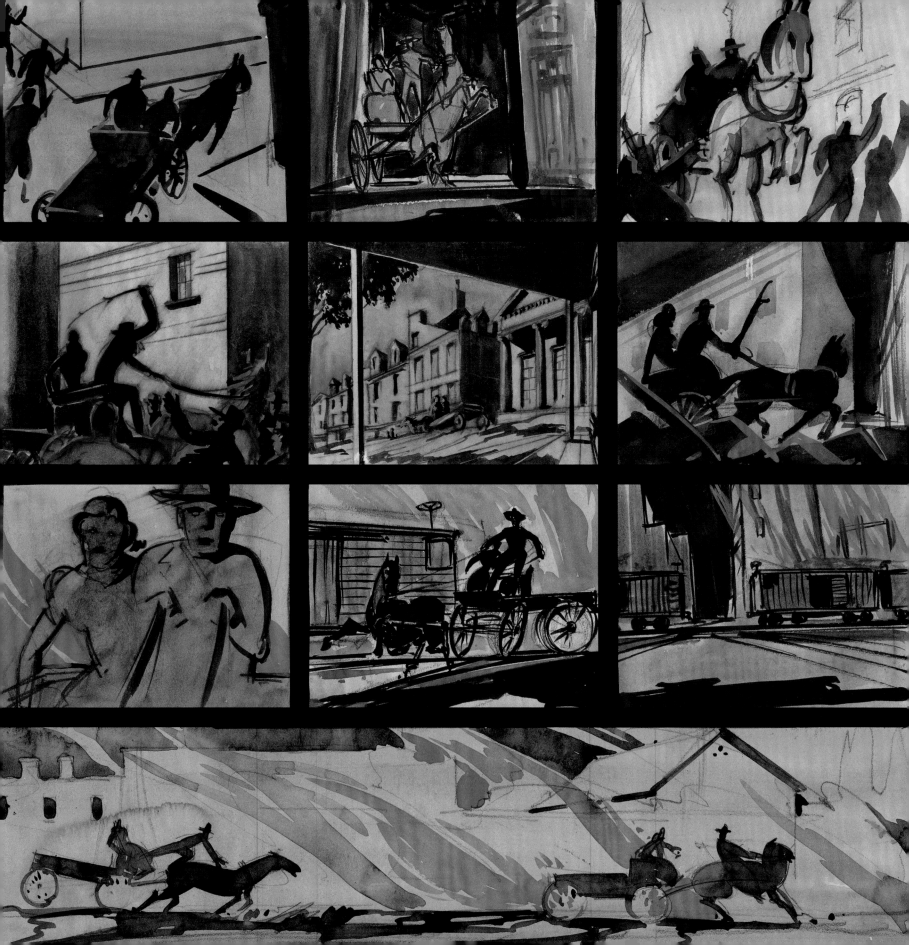

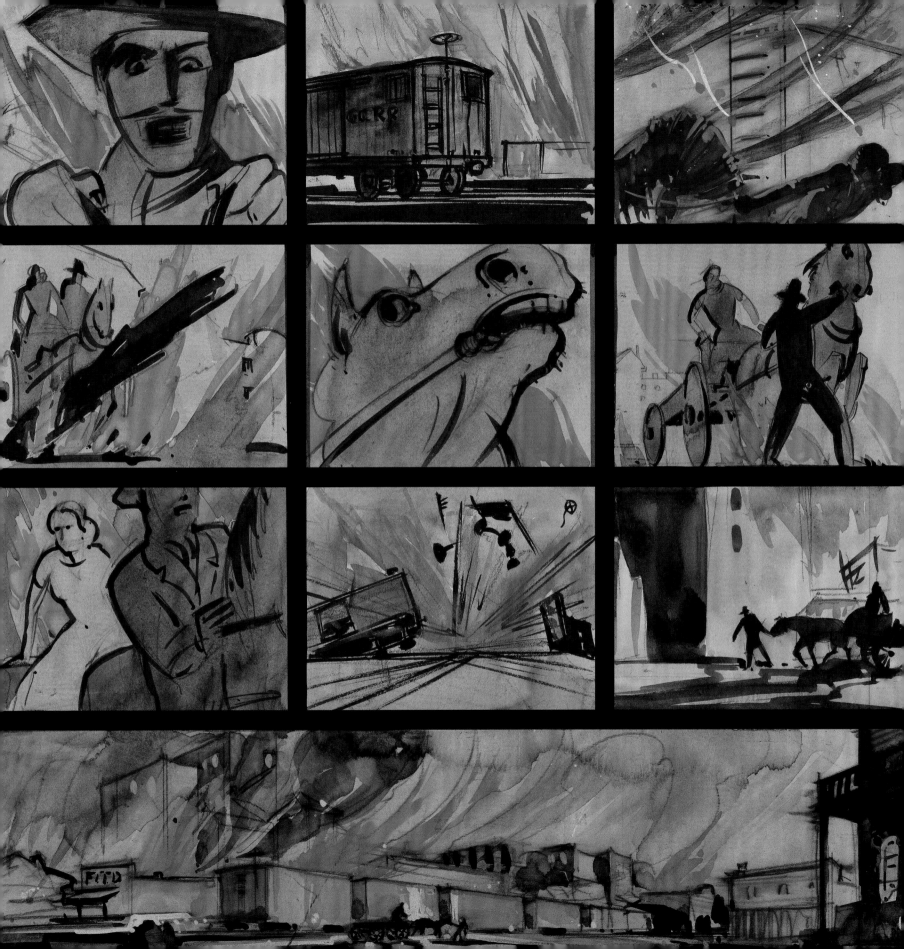

SELZNICK INTERNATIONAL PICTURES, INC.

9336 WASHINGTON BOULEVARD CULVER CITY, CALIFORNIA

Inter-Office Communication

TO Miss Barbara Keon DATE November 5, 1938

FROM R. A. Klune SUBJECT

Dear Bobby:

The space on the Forty Acres where we will construct Tara is presently occupied by a lot of old buildings. Instead of striking these buildings in the customary manner, we are burning them down and photographing such burning in technicolor. In order to simulate actual Atlanta scenes, we are going to build profiles and false fronts and generally dope the set up to make it look genuine. We are going to shoot all of the medium long shots and long shots that are in the script, using doubles for our people. We plan the actual shooting for Saturday night, November 26. The thought occurred to me that some of the work which you may be doing on the story may concern the fire stuff. If there are any changes which we should know about, will you please let us know prior to the 26th. Mr. Selznick is familiar with what we are doing in this respect and approved it prior to his departure. I have gone into the above detail purely because I do not know whether you are familiar with what we plan to do, ~~in respect to this fire stuff,~~ (redundant) N.? and so that you would know why it is important to let us know if any changes are made in it.

I hope you are enjoying -- shall I call it -- your vacation.

With kindest regards,

Ray

rak:cs

P.S. Cutlee is so enthusiastic about the above Bon-fire — that in order to get greater people he may burn down that part of Culver City where your home is located — is that alright? Love

CALL SHEET

DATE FRI., DEC. 10TH

PICTURE "GONE WITH THE WIND" DIRECTOR WM. MENZIES

SET EXT. R. R. YARDS

LOCATION 40 Acres CHARGE #46-695

NAME	TIME CALLED		CHARACTER, DESC., WARDROBE
	ON SET	MAKE-UP	
2 Doubles	1:00 PM		Rhett
2 Doubles	1:00 PM		Scarlett
2 Hidden Drivers	1:00 PM		

Doubles to report in own old clothes to rehearse and lineup. Will dress and makeup on set.

Horses & wagons on set at 1:00 PM	Truck at Technicolor
Standby Painter on set at 2:00 PM	at 8:00 AM to pickup
Provision for hot suppers at 5:00PM	four cameras.
P.A. SYSTEM on set at 1:00 PM	
	Truck at Technicolor
BLACK & WHITE camera on set	at 12:30 PM to pickup
at 5:00 PM	three cameras.
FIREMEN on set at 4:00 PM	Red O'Hara's small
	camera car at 2:00 PM
POLICE PROTECTION at 5:00 PM	
	Pickup Truck standby
FIRST AID MAN at 4:00 PM.	for Cosgrove.
	Standby cars at 1:00 PM
	at Auto Gate.
	1 Standby car at Auto
	Gate at 9:00 AM.

ASSISTANT DIRECTOR __ ERIC STACEY

(ABOVE) Production manager Ray Klune's memo to script supervisor Barbara "Bobby" Keon about the Burning of Atlanta scene. The date of the shoot was pushed back to December 10. Selznick was in Bermuda for a working vacation, so Keon and the rest of the staff had a brief respite from the intense work on the production.

(ABOVE, RIGHT) This call sheet was issued by assistant director Eric Stacey to notify all personnel where and when to report. This was an enormously difficult, expensive, and dangerous scene to film, so every precaution was taken. Backup doubles, hidden drivers, and all seven Technicolor cameras in existence, so large it took two trucks to carry them, were used to ensure they got the footage they needed.

(RIGHT) Jack Cosgrove was Selznick's head of special effects. His staff (pictured here) was present to capture special footage to use as backgrounds for the stars' close-ups that would be filmed later. Cosgrove was also charged with filming a triple-sized wide-screen version of the scene, a concept Selznick was eventually forced to abandon.

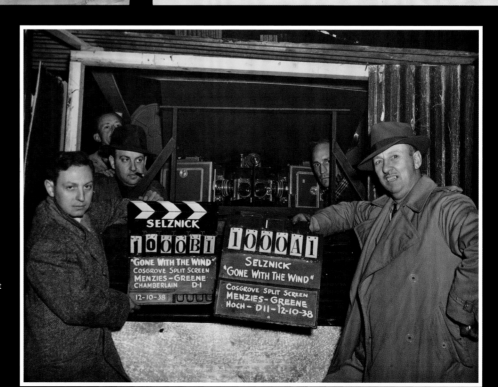

After a month of preparation, Menzies and his crew met the morning of December 10. Four cameras were picked up from Technicolor at 8 a.m. and three more at 12:30 p.m. Yakima Canutt, Gable's double, was one of the premiere stuntmen in Hollywood at that time. He and the other stuntmen selected their horses and inspected the wagons and props. Police, fire, and medical personnel arrived late in the afternoon. Filming began shortly after dark with Menzies directing. Selznick and Cukor were there to observe.

Selznick's brother, Myron, one of Hollywood's top agents, was there, too, accompanied by his newest client, Vivien Leigh. In an interview Selznick gave to the *Atlanta Constitution* in 1939, he said, "I shall never forget when Myron walked towards me with Miss Leigh. 'David,' he said, 'I want you to meet Scarlett O'Hara.'"

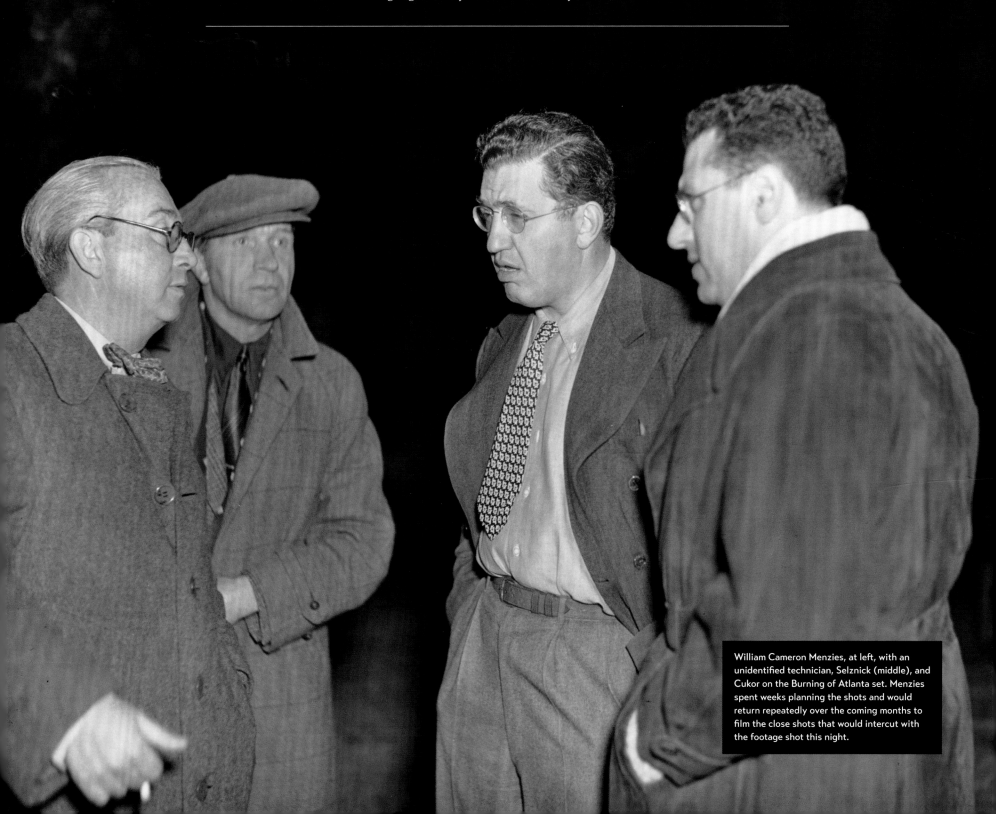

William Cameron Menzies, at left, with an unidentified technician, Selznick (middle), and Cukor on the Burning of Atlanta set. Menzies spent weeks planning the shots and would return repeatedly over the coming months to film the close shots that would intercut with the footage shot this night.

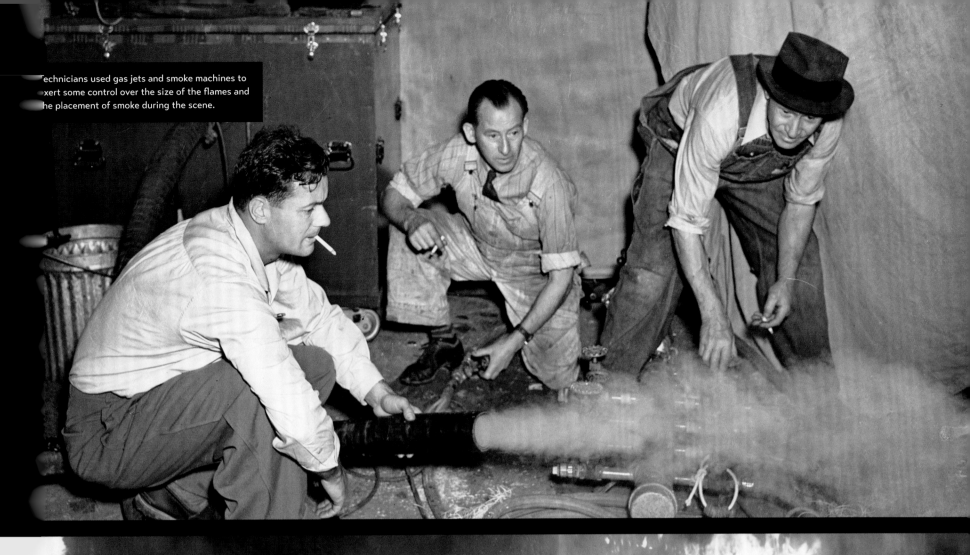

Technicians used gas jets and smoke machines to exert some control over the size of the flames and the placement of smoke during the scene.

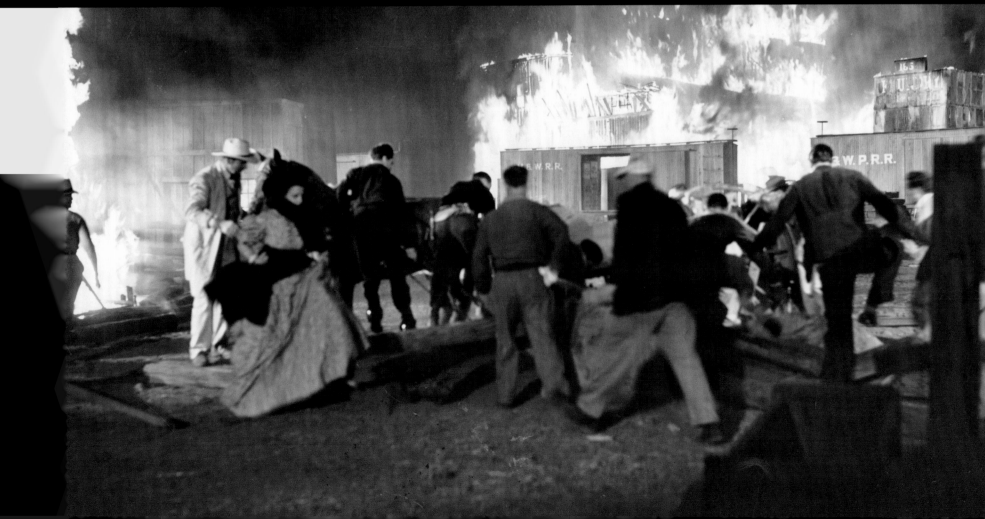

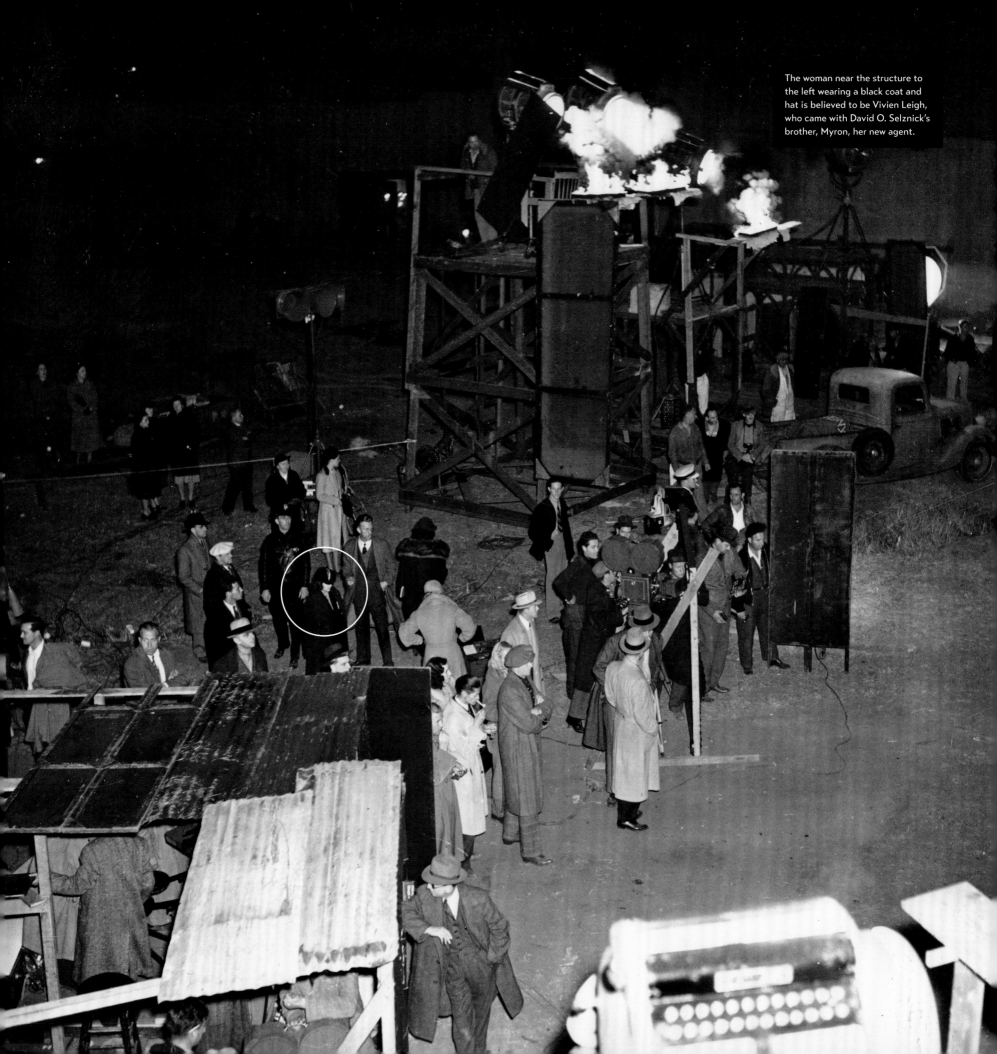

The woman near the structure to the left wearing a black coat and hat is believed to be Vivien Leigh, who came with David O. Selznick's brother, Myron, her new agent.

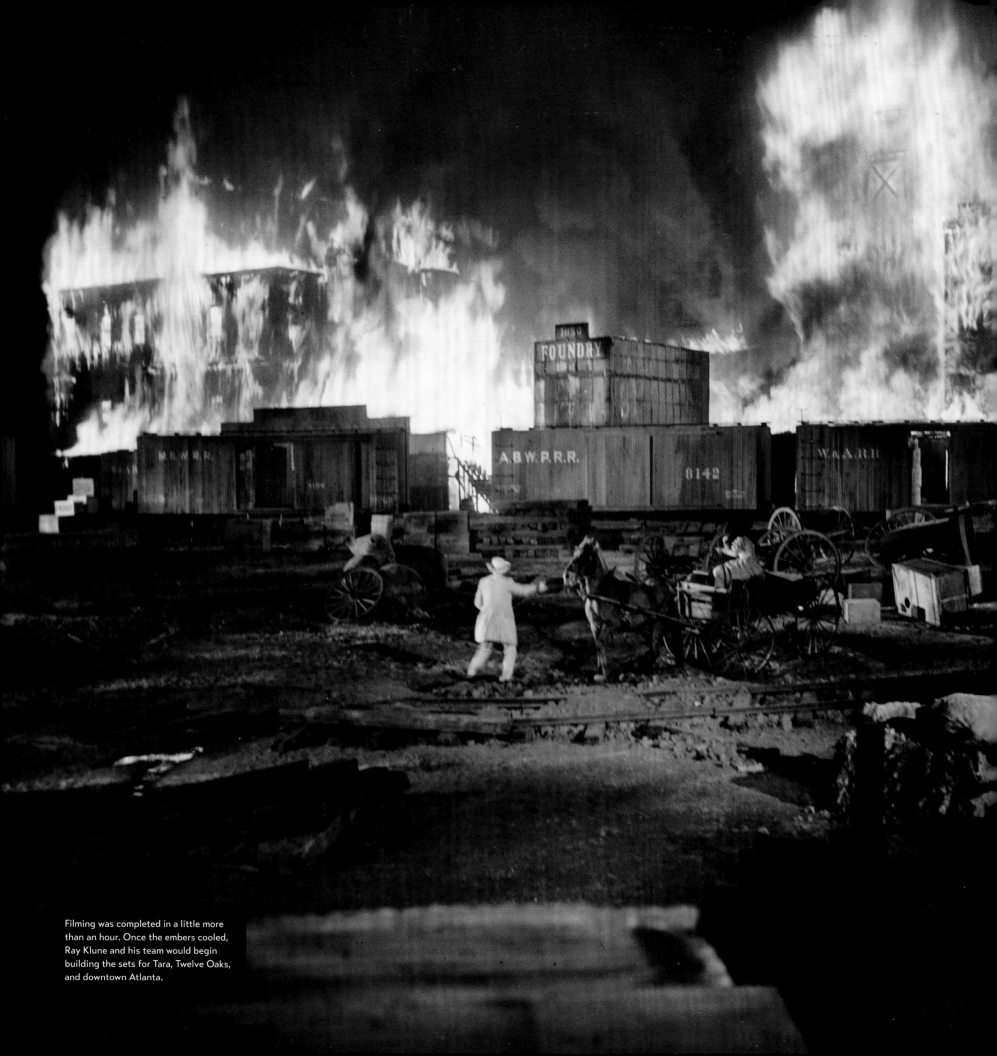

Filming was completed in a little more than an hour. Once the embers cooled, Ray Klune and his team would begin building the sets for Tara, Twelve Oaks, and downtown Atlanta.

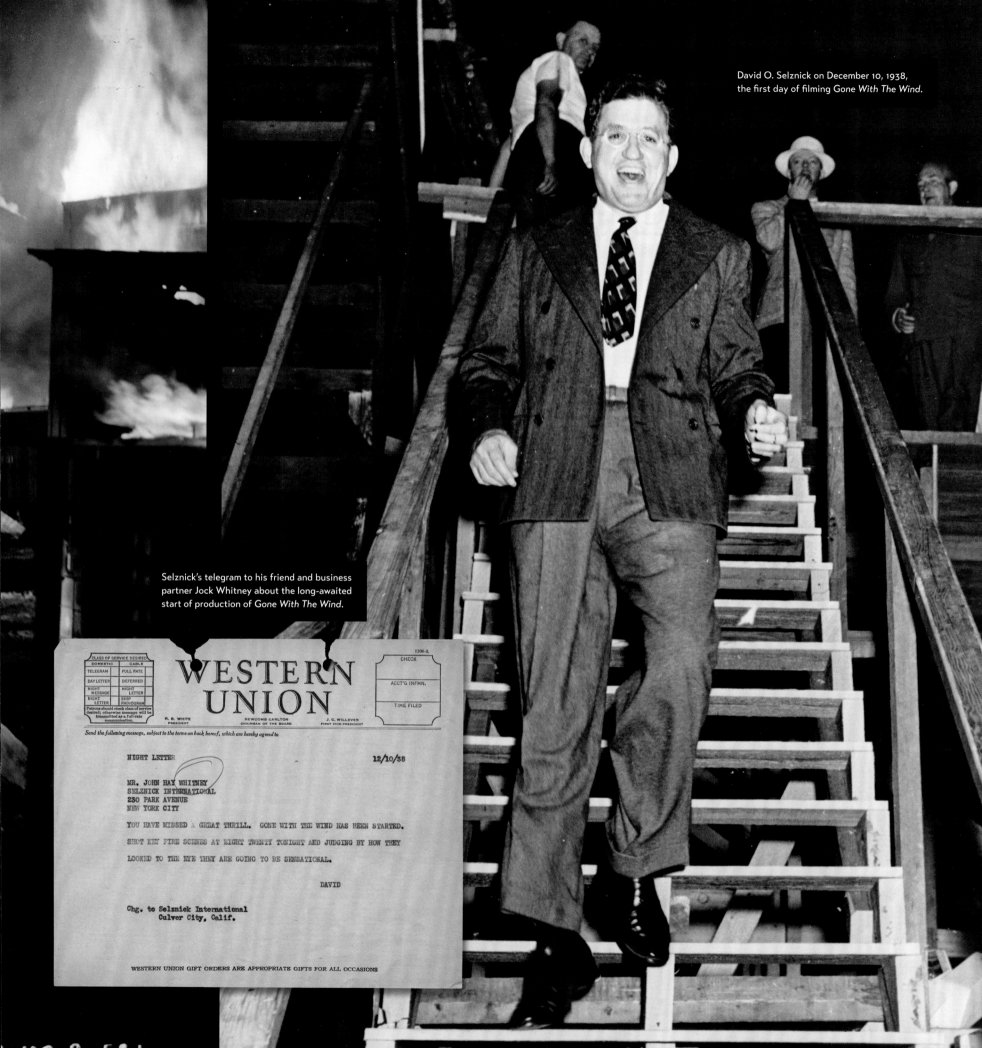

David O. Selznick on December 10, 1938, the first day of filming *Gone With The Wind*.

Selznick's telegram to his friend and business partner Jock Whitney about the long-awaited start of production of *Gone With The Wind*.

THE FINALISTS

On the Monday morning following the filming of the Burning of Atlanta sequence, the clearing of debris and set construction on the 40 Acres lot commenced. In a little more than a month, Clark Gable would arrive. The time had come to make a decision about Scarlett. In the next ten days the four finalists, Paulette Goddard, Jean Arthur, Joan Bennett, and now Vivien Leigh, would all make screen tests.

Until Vivien Leigh's arrival, Paulette Goddard was Selznick's first choice for Scarlett. But she was not a favorite with Selznick's staff. Both Russell Birdwell and Daniel O'Shea told Selznick she was difficult and demanding and that they disliked working with her. But Selznick and Cukor agreed that she was the only candidate at that point who had the Scarlett O'Hara quality they were seeking. Goddard had made half a dozen tests over the course of the year and would make two more, on December 20 and 21. Jean Arthur made her screen tests on December 17, and Joan Bennett on December 20. Vivien Leigh made three tests in two days, on December 21 and 22.

Mr. Ginsberg

"GONE WITH THE WIND" TESTS

12/12/38

I wish you would meet with Danny, Richards and George Cukor, and also Eric Stacey, and lay out the schedule of the remaining tests of our principals for "WIND", which are much the most important that we have made. Scarlett will definitely be decided upon as the result of this next group of tests, which I hope we will be able to see by Monday or Tuesday of next week. The boys should be cautioned to keep things as confidential as possible.

I have had discussions with George this morning and he understands my desire that we test four candidates in three key scenes. These scenes should be the same, so that we have a basis of comparison. The scenes are:

(1) The scene in which Mammy is dressing Scarlett for the barbecue;
(2) The paddock scene in which Scarlett tries to get Ashley to run away with her;
(3) The drunk scene in which Rhett proposes to Scarlett.

The girls to be tested in these scenes are Miss Goddard, Joan Bennett, Jean Arthur and Vivian Leigh. Miss Goddard needs to make only the two scenes, since we have the paddock scene with her.

Rhett appears only in the drunk scene of these three, and I wish that you could make an attempt with Clark personally - or, if you think desirable, through Benny Thau - to have Gable work with at least one of the girls. It would be much more desirable if it could be arranged for him to make this scene with all of the girls, since we are down to our final selections and since we should have the benefit of seeing Gable with our final possibilities for Scarlett. I think it is worth a special trip on your part to see either Gable personally, or Thau, or both. I think it would be very helpful if you could so time it as to see Clark when Carole was with him, as I think Carole would be helpful in pointing out to him the importance of his doing this....You may, however, decide to handle it through Thau, since we are, after all, entitled to have Gable report for he is actually on our payroll commencing this week.

The Mammy scenes should be made with our two principal candidates for this role, Hattie McDaniels and Hattie Noel. However, since the scene will be shot four times, it would be highly desirable to bear down at once on other possible Mammy candidates and take advantage of this opportunity to see two others, one of whom I should like to be Louise Beavers - unless two other possibilities should emerge who seem better, in which case I should like to hear them read before we hear them in the tests. Even if there is only one other Mammy possibility that I have not seen, I should like to hear her read before being included in the test. We can save ourselves considerable money on testing for these roles if we include the best possibilities in the Scarlett tests instead of testing them separately later. I have already heard the best of the group they have been working with to date, and have selected and approved Miss McDaniels and Miss Noel as strong possibilities.

Selznick wrote this memo on Monday, December 12, less than 48 hours after meeting Vivien Leigh for the first time. All four principal candidates for the part of Scarlett—Paulette Goddard, Joan Bennett, Jean Arthur, and Vivien Leigh—were experienced actors, but the front-runners, Goddard and Leigh, were not as well known to the public. Selznick also discusses the problems with casting two other important roles, Mammy and Ashley. See appendix for complete text.

Selznick was having difficulty casting several other key roles as well. Many women had asked for the part of Mammy. Georgette Harvey, who had created the role of Maria in the 1935 Broadway production of *Porgy and Bess*, made a screen test for the part. Selznick's top choice for the role of Mammy, however, was Louise Beavers, an established film actress who had played maids and servants in dozens of films since the early 1920s. But it was Beavers's turn as Delilah in the 1934 film *Imitation of Life* that caught Selznick's attention. Her performance made an impact disproportionate to the importance of the role, something Selznick wanted for *Gone With The Wind*. He cast her as a maid in his 1939 film *Made for Each Other*, but it is unclear why she did not make a screen test for *Gone With The Wind*. In the end, the two front-runners for the role of Mammy were Hattie Noel, a relative newcomer to films, and Hattie McDaniel, an established film actress.

Laurence Olivier, who would be cast in *Rebecca* and who was romantically involved with Vivien Leigh, was considered for the part of Ashley. Joel McCrea and Ray Milland were considered as well, but neither wanted the part. Leslie Howard, the public's favorite for the part of Ashley, was also lukewarm about the role. He had wanted to play Lawrence of Arabia for Alexander Korda, but when that project fell through, he let Selznick know he was open to taking the part. As the start date approached, feeling he had no better options, Selznick selected Howard for the part.

Louise Beavers and Carole Lombard in *Made For Each Other* (1939). Beavers, who had made such a huge impact as Delilah in *Imitation of Life* (1934), was Selznick's first choice for the part of Mammy. It is unclear from the record why she never made a screen test for the role.

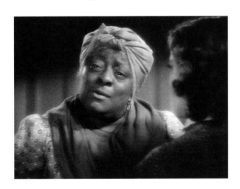

Georgette Harvey originated the role of Maria in *Porgy and Bess* on Broadway. Though she impressed Brown and Bundsmann enough to warrant a screen test, Selznick quickly eliminated her as a possibility for Mammy.

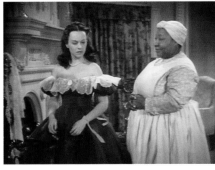

Paulette Goddard with Hattie Noel, one of the top contenders for the role of Mammy. Hattie Noel sang with the Count Basie Orchestra and had appeared on Eddie Cantor's radio show. In the end, she was Hattie McDaniel's primary competition for the role of Mammy.

The daughter of former slaves, Hattie McDaniel grew up in Colorado and as a teenager performed in her brother's minstrel show, which toured the western United States. After the stock market crash of 1929, McDaniel followed her siblings to Hollywood, where she found occasional work in film and on radio. Her break came in 1934, when she appeared in John Ford's *Judge Priest* with humorist Will Rogers, soon followed by a role in *The Little Colonel* (1935) with Shirley Temple. That year she joined the Screen Actors Guild and found regular work in films, though often uncredited and usually in the roles of cooks or maids. In late 1938 she appeared in screen tests opposite Jean Arthur and Vivien Leigh. Hattie McDaniel signed a contract with Selznick on January 27, 1939, the day after principal photography began.

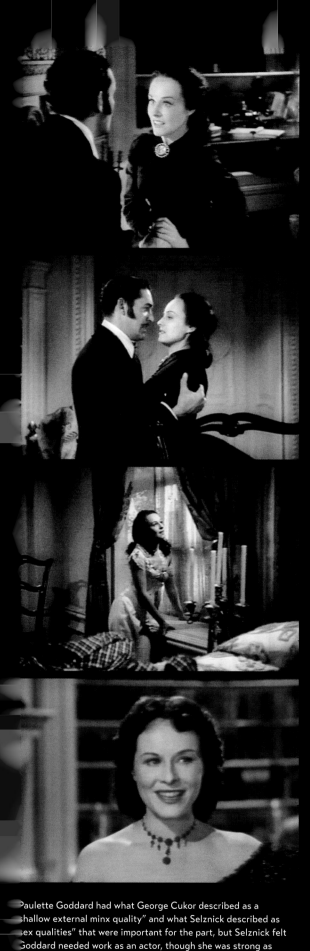

Jean Arthur was a well-known actress who started in film during the silent era. But her husky voice, versatility, and adeptness at comedy made her a top star after the advent of sound. She wanted the part of Scarlett badly, and Selznick thought enough of her to make three screen tests. Nevertheless, he thought her fame worked against her and found other actresses less "stale." Months later, Arthur managed to borrow three of her screen tests and, presumably after viewing one of them, destroyed it.

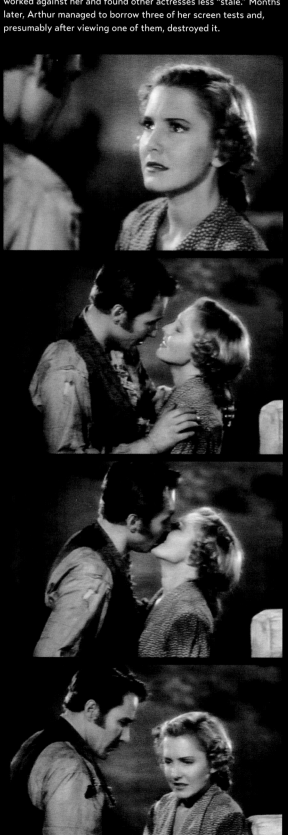

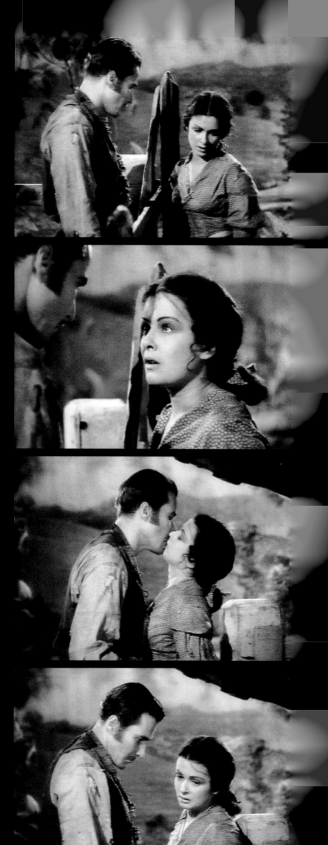

Paulette Goddard had what George Cukor described as a "shallow external minx quality" and what Selznick described as "sex qualities" that were important for the part, but Selznick felt Goddard needed work as an actor, though she was strong as a "personality." She was the only one of the candidates besides

Joan Bennett came from a show business family; her sisters Barbara and Constance were also actors. By 1939, Bennett was well known and well respected. She had also changed her hair color from blonde to black the previous year for the film *Trade Winds* (1938), a change that proved popular with audiences.

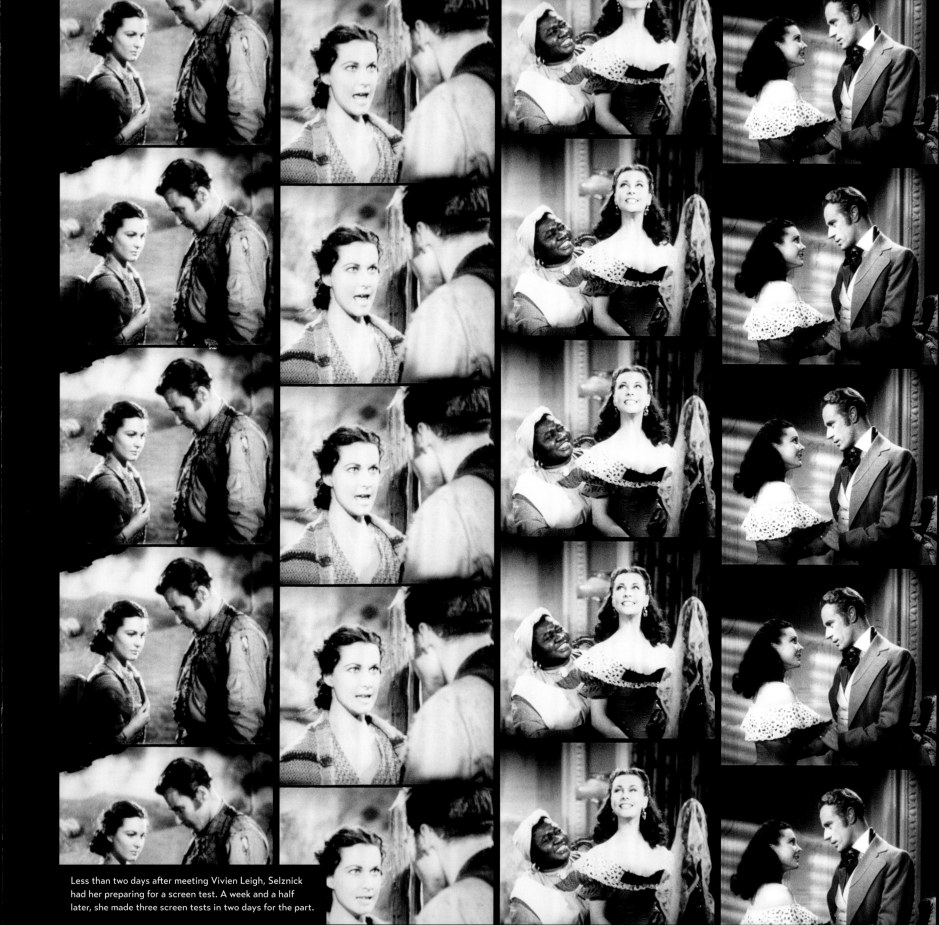

Less than two days after meeting Vivien Leigh, Selznick had her preparing for a screen test. A week and a half later, she made three screen tests in two days for the part.

(ABOVE, LEFT) George Cukor suggested Laura Hope Crews for the role of Aunt Pittypat after Billie Burke refused the role. Still, Cukor wanted Crews to play the role "in a Billie Burke–ish manner" with "the same zany feeling."

(ABOVE, RIGHT) Oscar Polk had appeared in several Broadway plays, including *You Can't Take It With You* (1936) and both the stage and screen versions of *The Green Pastures* (1935, film 1936).

(LEFT) The role of Prissy was intended to be played for comedy. Oscar Polk's wife, Ivy, auditioned and was thought to be quite good. An actress from George Abbott's Broadway shows, Inge Hardison, auditioned, too, but her face, according to Max Arnow, "somehow does not look comic." Kay Brown saw Butterfly McQueen in George Abbott's *What a Life!* She told Selznick, "I auditioned Butterfly McQueen this morning who, if she isn't a caricature [*sic*] of Prissy, is the funniest thing I have ever heard." Once Selznick saw McQueen's screen test, no one else was considered for the role.

CASTING SUPPORTING ROLES

As the start date for filming approached, casting the supporting roles became a priority. Selznick had spent so much time and energy searching for a new actress to play Scarlett and negotiating with studios for a suitable star to play Rhett that he had to scramble to cast the supporting roles in time to meet the shooting schedule. Charles Richards, Max Arnow, and the rest of the casting department scoured the stock companies of all the studios but concentrated on MGM, SIP's partner in the production. They cast dozens of speaking parts and even more "bits" and extras in the coming weeks, often just days before their scenes were to be filmed. Virtually all of them had to be personally approved in advance by Selznick and Cukor.

Selznick had a specific look and characterization in mind for each role, no matter how small, and everything from contracts to costumes had to be arranged for each individual. In some cases, like that of Thomas Mitchell, who played Gerald O'Hara, schedules had to be coordinated with another studio's shooting schedule.

Billie Burke, best known today for her role as Glinda, the Good Witch, in 1939's *The Wizard of Oz*, was Selznick's first choice for the role of Aunt Pittypat. Her distinctive voice and flair for comic scatterbrain roles made her ideal for the part. But she was a slender woman, not the Pittypat described in the novel. Edward Lambert, head of the wardrobe department at SIP, added padding to her costume to make her fat enough for the screen test, but the experiment was "unsuccessful, Miss Burke complaining that she simply could not work under such a handicap." George Cukor recommended Laura Hope Crews for the part, and she was instructed to play the part "in a Billie Burke-ish manner."

Oscar Polk was an established stage actor in New York, best known for *The Green Pastures*, a 1936 film depicting biblical stories as visualized by the play's African American characters. Polk

Form 73—20M—4-38—K-I Co.

SELZNICK INTERNATIONAL PICTURES, INC.

9336 WASHINGTON BOULEVARD CULVER CITY, CALIFORNIA

Inter-Office Communication

TO	Mrs. Rabwin	DATE	1-9-39
FROM	David O. Selznick	SUBJECT	GONE WITH THE WIND -

Please immediately get hold of Arnow and tell him we are going to be in serious trouble unless we cast Ellen, Jonas Wilkerson, Suellen, Carreen, Gerald and the Tarleton Twins within the next forty-eight hours in order to have their costumes ready for the possible starting date next Monday. Nothing should take priority with either him or me in getting these parts cast today and tomorrow.

Let me know definitely whether there is any truth in the report I hear that Mitchell may not be available for the role of Gerald, in which case, of course, we should not waste any money or time on testing him.

I want to check on my approval of the man we set for Big Sam so please have him come in.

What was the last letter to (or from) Walter White in reference to the technical advice on the negroes?

DOS

bk:gw

This memo from Selznick hints at the complicated nature of a big production like *Gone With The Wind*. Specific roles had to be cast quickly so their costumes could be ready to fit the shooting schedule, which was set to accommodate the schedules of leading actors.

was cast as Pork, and his wife was seriously considered for the part of Prissy.

Eddie Anderson was the son of minstrel and circus performers and was an established performer in vaudeville and films. He had also appeared in *The Green Pastures*, as well as *Show Boat* (1936), *You Can't Cheat an Honest Man* (1939), and many others. By the time he was cast in *Gone With The Wind*, he was already working with Jack Benny on the radio, a partnership that would last many years. Anderson was cast as Uncle Peter.

Ann Rutherford and Rand Brooks were borrowed on the same day from MGM for the respective roles of Carreen O'Hara and Charles Hamilton.

Selznick found it tremendously difficult to cast the parts of Belle Watling and Frank Kennedy. Early on he had wanted Mae West or Gypsy Rose Lee for the part of Belle. Although a number of women tested for the role, it was not until late April that Selznick met the stage and screen actress Ona Munson and cast her in the part.

For the character of Frank Kennedy, Selznick felt they needed to strike a balance: "We must bear in mind that Scarlett is married to this man," Selznick wrote, "and we cannot risk a relationship which, however mean, is physically distasteful . . . he is not an old man in the first part of the picture, and he is a man with whom Suellen, presumably a pretty girl, and a girl in her middle teens, is in love when the picture opens. The war wearies him and turns him prematurely into a man who is old by comparison—but we must have an actor who is able in the first part to portray a figure of at least sufficient appeal to warrant Suellen's love and jealousy and her bitterness over losing him. The description of him as an 'old maid in trousers' does not warrant our casting too unattractive an actor." The part went to Carroll Nye.

Barbara O'Neil was from St. Louis, Missouri, and attended the Yale School of Drama. She was twenty-eight when she was cast as Scarlett O'Hara's mother, Ellen.

Evelyn Keyes of Port Arthur, Texas, was under contract to Cecil B. DeMille when she was cast as Scarlett's younger sister, Suellen.

Ann Rutherford was well known for her role as Polly opposite Mickey Rooney in MGM's enormously popular Andy Hardy series when she was cast as Scarlett's younger sister Carreen.

MAKE-UP STILL
PICTURE Nº
NAME GLECKLER
CHARACTER WILKINSON
NOTES:

MAKE-UP STILL
PICTURE Nº
NAME
CHARACTER TARELTON
NOTES: TWINS
G. BESSOLO F. CRANE

MAKE-UP STILL
PICTURE Nº WIND
NAME CARROLL NYE
CHARACTER FRANK KENNEDY
NOTES:

MAKE-UP STILL
PICTURE Nº
NAME EDDIE ANDERSON
CHARACTER UNCLE PETER
NOTES:

(FAR LEFT) Robert Gleckler was an experienced character actor in films and on Broadway. He was cast as Jonas Wilkerson but died before he finished filming his part. He was replaced by Victor Jory.

(LEFT) George Bessolo, left, who later changed his name to George Reeves, and Fred Crane were cast as the Tarleton Twins shortly before their first scene. Both signed waivers to allow their hair to be dyed red, and it took a couple of attempts before Selznick was satisfied with their look. Reeves became known much later for his role in *Adventures of Superman* on television in the 1950s.

Carroll Nye had started in film during the silent era playing young leading men. He landed the role of Frank Kennedy in part because he could be made to look older through makeup. His younger brother, Ben Nye, was a makeup technician on the film.

One of the greatest character actors in film, Thomas Mitchell was much in demand, appearing in *Mr. Smith Goes to Washington*, *Only Angels Have Wings*, *The Hunchback of Notre Dame*, and *Stagecoach* in the same year he appeared in *Gone With The Wind*. Selznick had to work hard to accommodate Mitchell's busy schedule.

Eddie Anderson, best known today for his role as Rochester on Jack Benny's radio and television programs, was an established performer in vaudeville and films when he was cast as Uncle Peter.

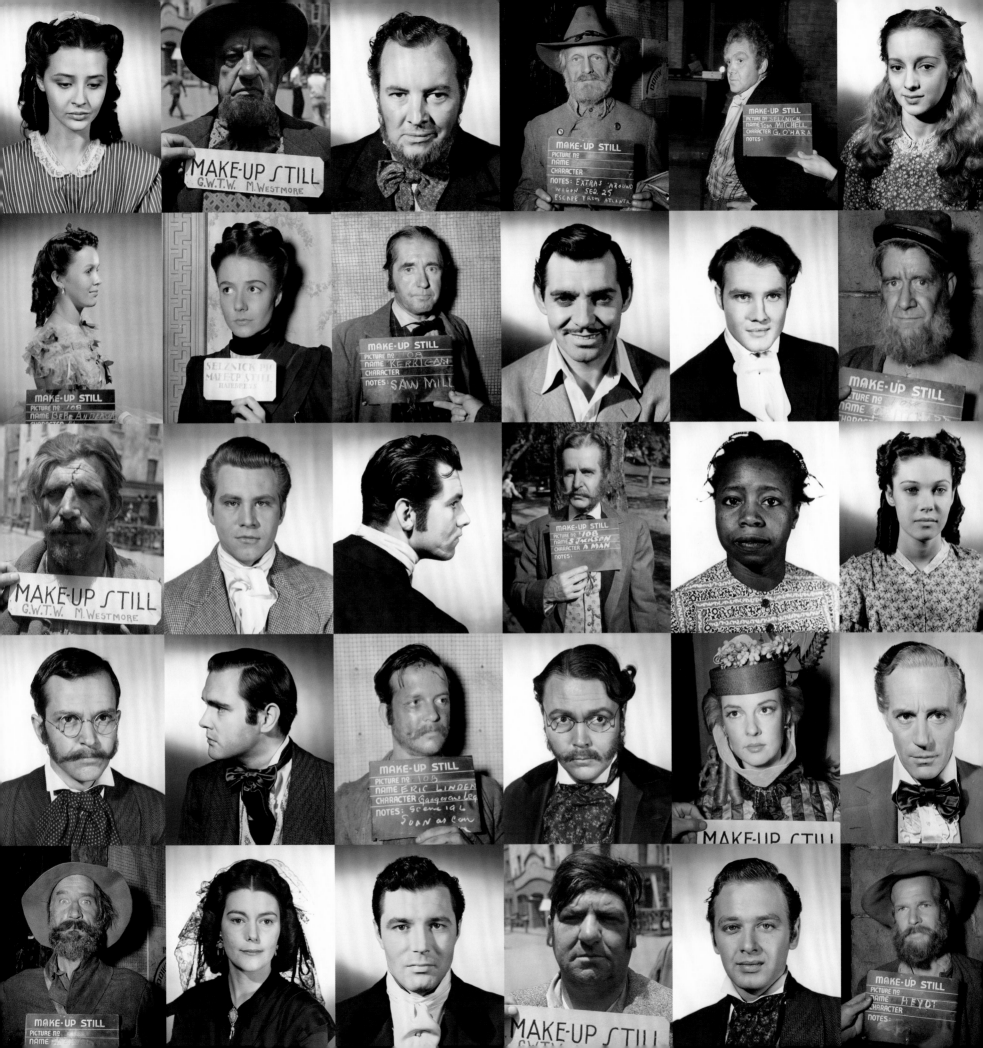

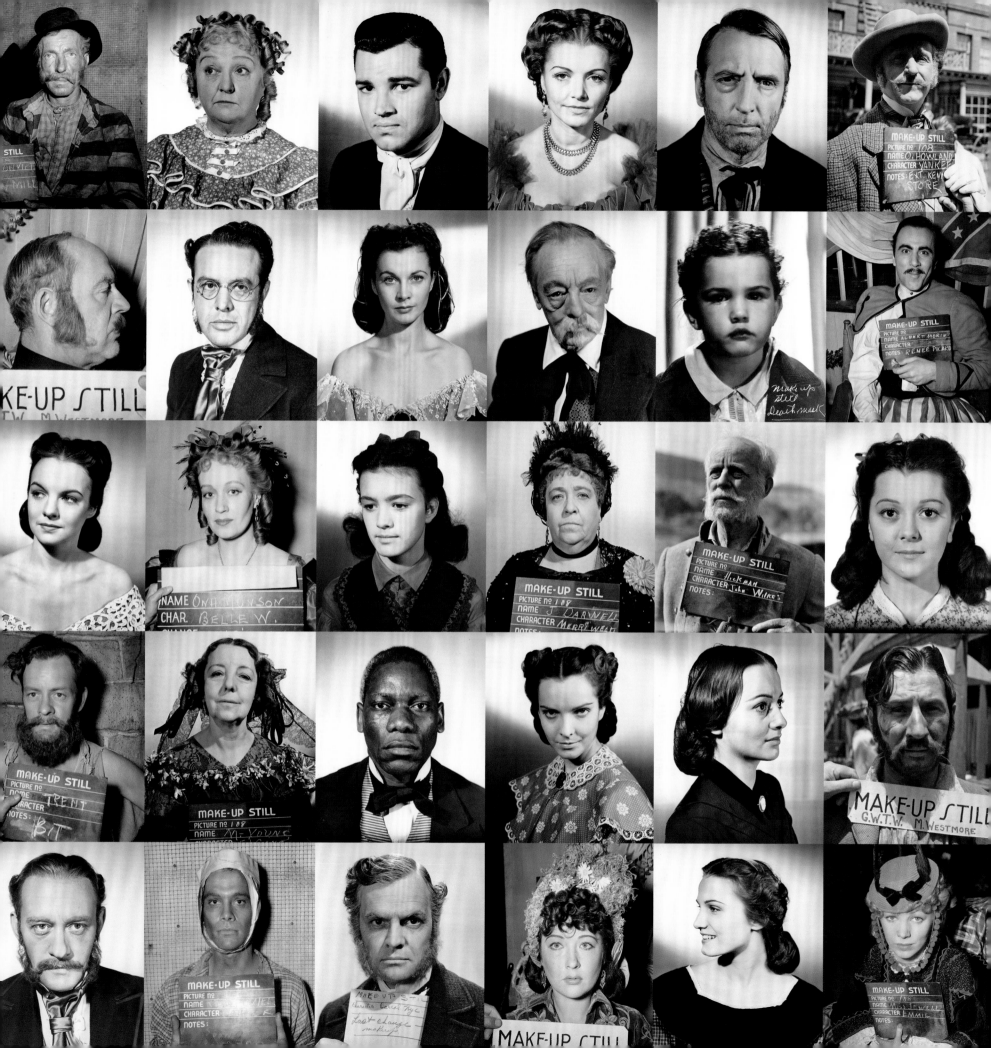

VIVIEN LEIGH

It is impossible to know exactly when Selznick made the decision to cast Vivien Leigh as Scarlett O'Hara. Kay Brown suspected Selznick had made his choice as early as December 12, two days after he was introduced to Vivien Leigh by his brother, Myron. That day Selznick talked with Jock Whitney about asking Margaret Mitchell to make a statement when he announced whom he was casting as Scarlett, but he told Brown he had not yet made a decision. On December 14, however, he told George Cukor and Ray Klune that he wanted to see Evelyn Keyes and Margaret Tallichet, the front-runners for the role of Suellen, standing next to Leigh in their next tests, a full week before Leigh made her first test.

Vivien Leigh undertook intensive preparation for her screen tests. She worked with several people on her southern accent, including Marcella Martin, the actress discovered in Shreveport earlier that year. There were experiments with hair, makeup, and costumes, and she rehearsed extensively with George Cukor.

Leigh filmed her screen tests on December 21 and 22. On December 22, after Leigh's final test, Selznick told Jock Whitney that he was not sure any of the candidates were right, and he was worried about Margaret Mitchell's reaction. They had to make the announcement soon, but the final screen tests would not be ready to view until Saturday, Christmas Eve.

On December 27, Selznick told Whitney and Brown he was sending the tests to New York for them to see. Brown said she was in "a dither of excitement" and cautioned Whitney to remain discreet. On December 29, Brown told Selznick she had spoken to Margaret Mitchell, who had expressed the desire to see some of the tests of the minor characters. But, Brown said, she only wanted to see "the one Scarlett test." She did not want to see "the discarded Scarletts."

On January 4, 1939, Joe Shay with the *Hollywood Reporter* wrote to Selznick that his paper would be reporting that Vivien Leigh had been

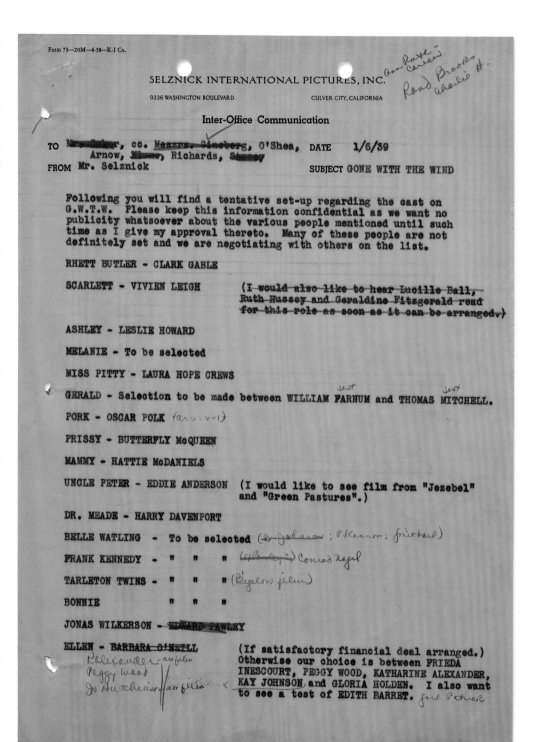

Selznick was angered when he realized this cast list had been widely circulated within SIP.

cast as Scarlett. He thought it was "an unfortunate selection" to cast anyone other than a southerner. Two days later, Selznick cautioned his staff to be more discreet. A cast list with Vivien Leigh listed as Scarlett was sent out to the various production departments at SIP.

The entertainment columnist (and, later, television host) Ed Sullivan knew about Vivien Leigh and wanted the scoop for his column. Anticipating criticism for casting a foreigner after a lengthy nationwide search, Selznick and Birdwell crafted a letter to Sullivan on January 7, telling him that Vivien Leigh had not been cast as Scarlett and that there were three other candidates in the running. He concluded the letter, however, with a five-point list of reasons why Vivien Leigh was the right choice for the role should she get it. On January 13, the day Vivien Leigh, Olivia de Havilland, and Leslie Howard signed their contracts, United Press was the first out with the news. Sullivan, who had expected an exclusive from Selznick, was furious. "Next time you ask me to play ball I'll bring a bat," he said.

January 7, 1939

Gate proofs

Mr. Ed Sullivan
621 North Alta Drive
Beverly Hills, California

Dear Ed:

Vivien Leigh is by no means cast as Scarlett. There are three other possibilities. But should we decide on Miss Leigh for the role, I think the following answers your question:

1. Scarlett O'Hara's parents were French and Irish. Identically, Miss Leigh's parents are French and Irish.

2. A large part of the South prides itself on its English ancestry, and an English girl might presumably, therefore, be much more as acceptable welcome in the role than a Northern girl. as

3. Experts insist that the real Southern accent, as opposed to the Hollywood conception of a Southern accent, is basically English. There is a much closer relationship between the English accent and the Southern accent than there is between the Southern accent and the Northern accent, as students will tell you, and as we have found through experience.

4. I think it would be outrageously ungrateful on the part of Americans, particularly Americans in the film and theatrical worlds, to feel bad about such a selection in view of the English public's warm reception of American actors' portrayals of the most important and best-beloved characters in English history and fiction, ranging all the way from Wallace Beery in "Treasure Island", to Fredric March as Browning in "The Barretts", to Gary Cooper in "Bengal Lancer".

5. And, finally, let me call your attention to the most successful performances in the American theatre in many, many years -- those, respectively, of the American Helen Hayes as "Queen Victoria" and the British Raymond Massey as "Abraham Lincoln".

I feel that these are days when we should all do everything within our power to help cement British-American relationships and mutual sympathies, rather than to indulge in thoughtless, half-baked and silly criticisms. As I have said, Miss Leigh is not set for the role, but if she gets it

(ABOVE) Ed Sullivan, then a gossip columnist, had learned that Vivien Leigh was Selznick's choice for the role of Scarlett. Selznick denied it but, anticipating resistance to his decision, had already developed a five-point justification, which he began to circulate to entertainment reporters like Sullivan, Louella Parsons, and Hedda Hopper. See appendix for complete text.

(RIGHT) As Dorothy Carter's report on fan mail for the week of January 23, 1939, shows, the campaign to convince the public that Vivien Leigh was the right choice for Scarlett would be long and difficult. Eventually the shock that a foreigner had landed the part would wear off and be replaced by curiosity about how she would perform.

Form 73—20M—4-38—K-1 Co.

SELZNICK INTERNATIONAL PICTURES, INC.
9336 WASHINGTON BOULEVARD CULVER CITY, CALIFORNIA

Inter-Office Communication

TO Mr. Selznick DATE Jan. 23, 1939
FROM Dorothy Carter SUBJECT GONE WITH THE WIND
 FAN MAIL

Dear Mr. Selznick:

Following you will find a report on the GONE WITH THE WIND fan mail situation from Jan. 13th to Jan. 21st.

Total number of letters received - 189
CALIFORNIA and vicinity - 65
NEW YORK and vicinity - 34
MIDWEST and vicinity - 46
THE SOUTH - 43
NEW ZEALAND - 1
 189

VIVIEN LEIGH Votes for 11 Votes against 193
OLIVIA DE HAVILLAND 1 24
LESLIE HOWARD 17
MISS LEIGH personally received 45 votes from her fans in favor of her playing role.
There were 64 threats of boycott.
1 Chain letter to be organized.
Racial letters received 12 (included in the above total)

113 of the writers will not attend the theatre when the picture is shown.

The general tenor of the mail was in the nature of complaints against the non-American casting of an historical American picture. In voting against Miss Leigh the fans expressed a preference for the stars listed below.

SCARLETT		MELANIE		ASHLEY	
Miriam Hopkins	17	Janet Gaynor	3	Phillip Holmes	3
Bette Davis	16	Jean Parker	5	Doug. Fairbanks Jr	2
Katharine Hepburn	12	Helen Hayes	1	Fredric March	1
Jean Arthur	12			Franchot Tone	1
Margaret Sullavan	9			Joel McCrae	1
Paulette Goddard	9			Robert Taylor	1
Tallulah Bankhead	4			Alexander Kirkland	1
Carole Lombard	4				
Myrna Loy	4				
Rosalind Russell	3				
Barbara Stanwyck	3				
Norma Shearer	2				
Claudette Colbert	2				
Gloria Swanson	2				
Una Merkel	2				
Frances Dee	2				

Many others received 1 vote each.

dc

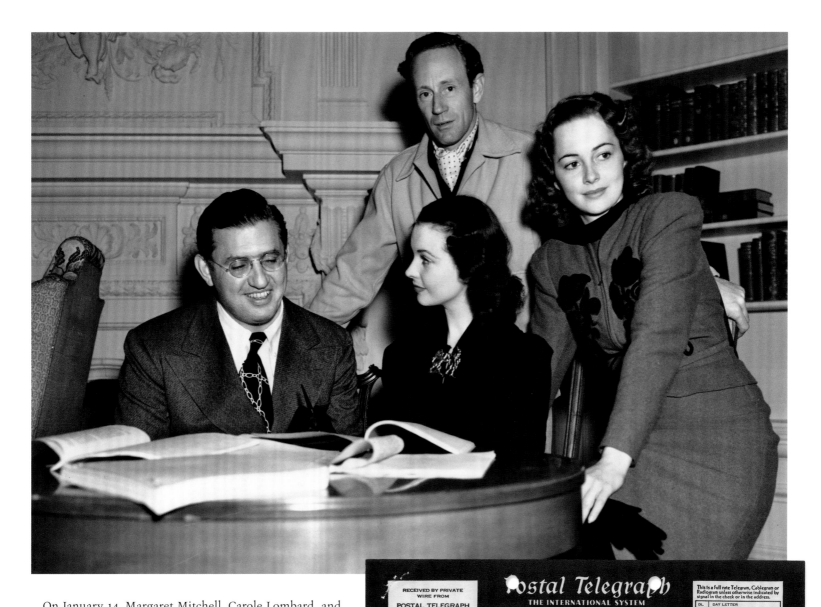

On January 14, Margaret Mitchell, Carole Lombard, and others sent congratulations to Selznick. While these initial responses were positive, others to come were not. Selznick and Birdwell immediately pushed forward their campaign to sell Vivien Leigh as the right choice for Scarlett O'Hara.

(ABOVE) Publicity photo of Selznick with Vivien Leigh, Leslie Howard, and Olivia de Havilland.

(RIGHT) Telegram from the Dickinson chapter of the United Daughters of the Confederacy. When the choice of Vivien Leigh as Scarlett O'Hara was announced, the reaction was swift and, in the South, mostly negative. Susan Myrick was instrumental in convincing Mrs. W. D. Lamar, president of the UDC, that the choice was a good one. Lamar "expressed her personal pleasure at the choice of Miss Leigh," Myrick told Daniel O'Shea on January 18, "saying that she greatly preferred an English-woman for the part of Scarlett O'Hara, rather than a woman from the East or Middle West, as she had always felt there was a close kinship between the Southerner and the English people." Used with permission from the United Daughters of the Confederacy.

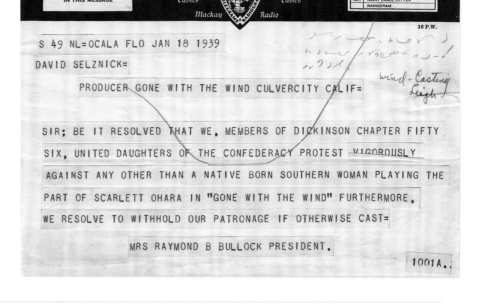

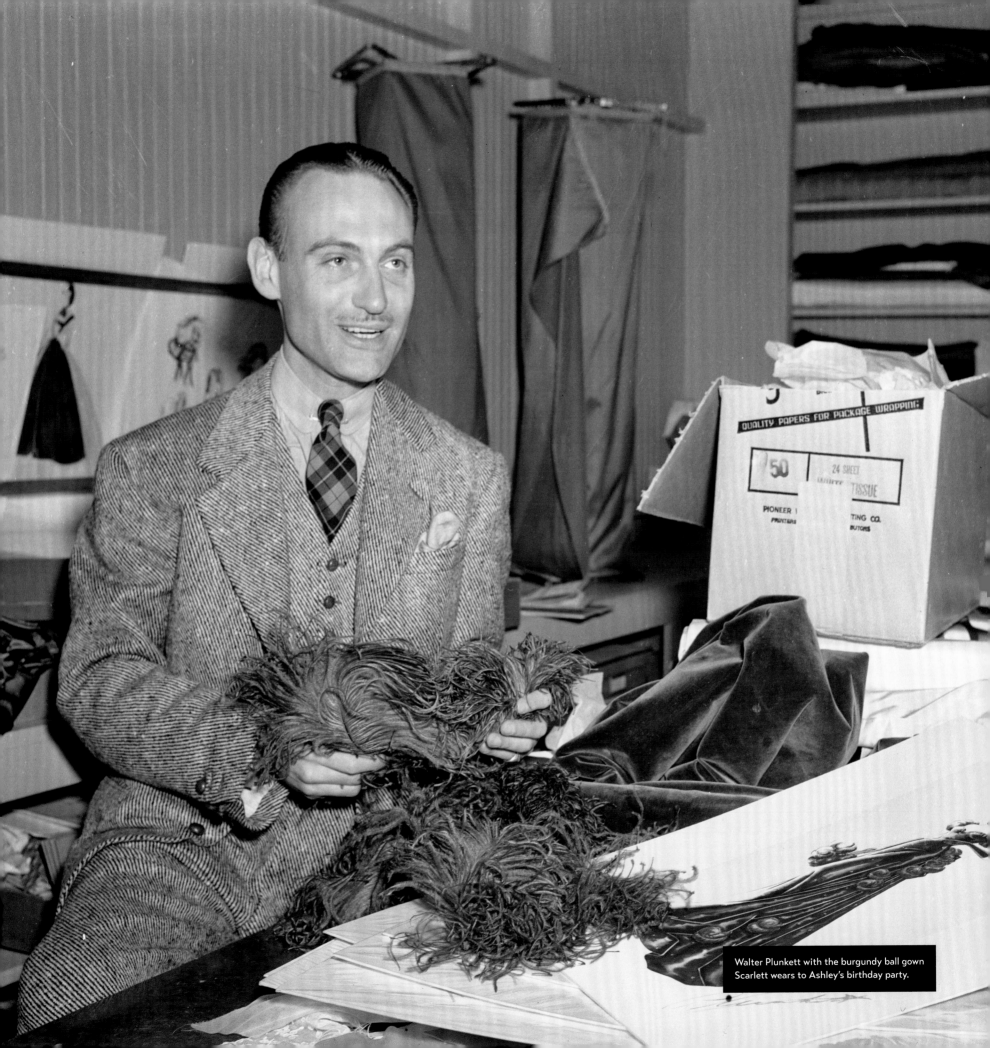

Walter Plunkett with the burgundy ball gown Scarlett wears to Ashley's birthday party.

"PLUNKETT HAS COME TO LIFE"

alter Plunkett was already an accomplished Hollywood costume designer when, in 1936, his agent recommended him for *Gone With The Wind*. Both Selznick and Cukor had worked with him previously and sent him to Georgia on a research trip. Equipped with letters of introduction, he met with Margaret Mitchell, who took him on a day trip to Jonesboro, the closest town geographically to the fictional setting of Tara. Plunkett developed a terrible cold, and Mitchell urged him to stay in bed at his hotel before traveling to Savannah and Charleston. "He attempted to do this," she recalled, "but was forced to leave town due to the scores of people who called on him bringing costumes of the [18]60s. Half of them believed he wished to buy them. What finally drove him from his bed of pain was a woman who produced the actual dress Scarlett had worn at the barbeque. This made Mr. Plunkett wonder if he had become delirious."

On a trip to Atlanta in 1937, Hobe Erwin, an early hire as art director for *Gone With The Wind*, gave Margaret Mitchell a costume design by Muriel King, a fashion designer who had designed gowns for such films as *Sylvia Scarlett* (1935) and *Stage Door* (1937). Mitchell was enchanted by it and asked to buy it. Instead, Muriel King presented it to her as a gift. Mitchell, in her thank-you note to King wrote, "The soft, dim blue background of the night appealed to me as much as the weary frown on Scarlett's face and the lovely dress."

Learning of Mitchell's fondness for the design, Selznick contacted King about serving as the film's costume designer. King wanted too much money, however, and although Selznick considered hiring her solely to design Scarlett's gowns, after months of negotiation the two were unable to come to terms. In the meantime, other top costume designers—Irene, Travis Banton, Ladislaw Czettel, Lucinda Ballard, and Adrian—expressed interest in the job. But when Walter Plunkett delivered a set of sketches, Selznick wrote Kay Brown, "Plunkett has come to life, and turned in magnificent Scarlett costumes so we won't need anyone else."

John P. John, whose company was known as John-Frederics, was one of the best-known milliners of the day. Not interested in a commercial "tie-up" or merchandising arrangement, he had approached Selznick about creating Scarlett's hats for the film at cost and simply for the publicity. Inexperienced in dealing with film companies, Mr. John neglected to stipulate in his contract that he be given screen credit. Daniel O'Shea, SIP's lawyer, declined to renegotiate. Despite this, Mr. John felt he received enough favorable publicity to make his efforts worthwhile.

copy

TDS CULVERCITY CALIF JAN. 6, 1939

TO KB FROM DOS

PLUNKETT HAS COME TO LIFE AND TURNED IN MAGNIFICENT SCARLETT COSTUMES SO WE WON'T NEED ANYONE ELSE. WITH FURTHER REFERENCE TO FREDERICKS COMMENCING TO WORRY ABOUT THE PRACTICABILITY OF THE IDEA. WOULD HE SEND SKETCHES OR MUSLIN PATTERNS AND JUST HOW WOULD THIS WORK? WOULD HE BE WILLING TO COME OUT FOR A COUPLE OF DAYS? THE WHOLE PRODUCTION IS SO COMPLICATED THAT I AM TRYING TO SIMPLIFY THE STAFF AND THE WORK SO AM ANXIOUS TO GET COMPLETE PICTURE OF THE FREDERICKS SITUATION IN ORDER TO DECIDE WHETHER THE WHOLE IDEA IS WORTHWHILE. IF WE SHOULD GO AHEAD WITH HIM IS THERE ANY OBLIGATION AS TO CREDIT AND IS THERE ANY OBLIGATION AS TO USING ANY OR ALL OF HIS HATS?

SORRY TO SEEM SO CONFUSED BUT EVERYTHING IS PILING UP IN THESE LAST WEEKS.

(ABOVE) Walter Plunkett and John P. John were to make Scarlett O'Hara the primary focus of any scene in which she appeared. Despite having been the first choice for his job and having traveled to Atlanta to meet Margaret Mitchell, Plunkett had to work to get the assignment. Mr. John agreed to create Scarlett's hats in return for the publicity.

(LEFT) Mr. John with two of the hats he created for *Gone With The Wind*.

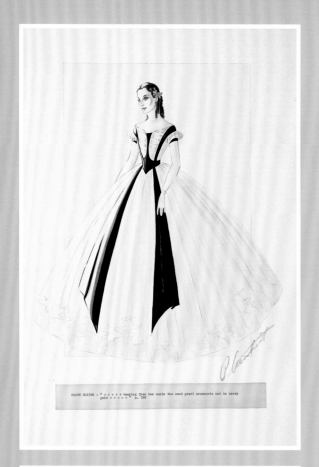

PANSY ELSING - " hanging from her curls the seed pearl ornaments set in heavy
gold " p. 198

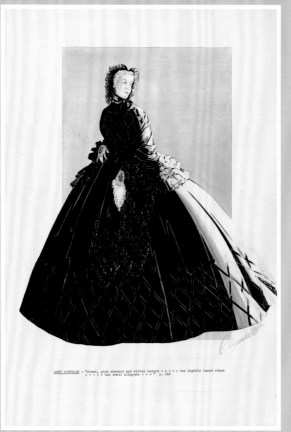

AUNT PITTYPAT - "stout, pink cheeked and silver haired too tightly laced stays
. too small slippers . . . " p. 156

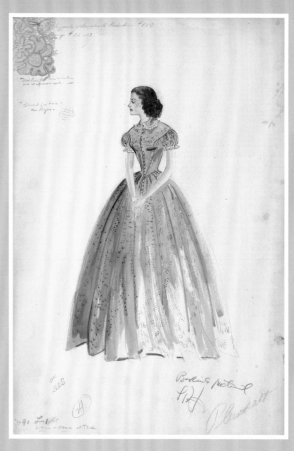

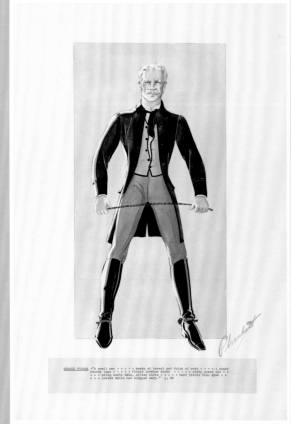

GERALD O'HARA - "A small man heavy of barrel and thick of neck stout
sturdy legs finest leather boots sixty years old . . .
. . . crisp curly hair, silver white hard little blue eyes . .
. . . creased which had slipped awry." p. 52

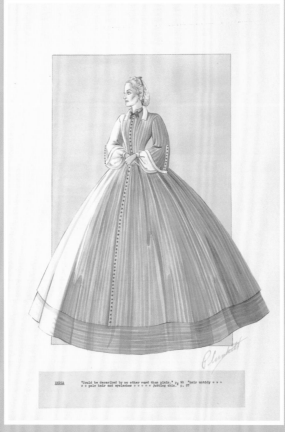

INDIA "Could be described by no other word than plain." p. 95 "hair untidy . . .
. . pale hair and eyelashes jutting chin." p. 97

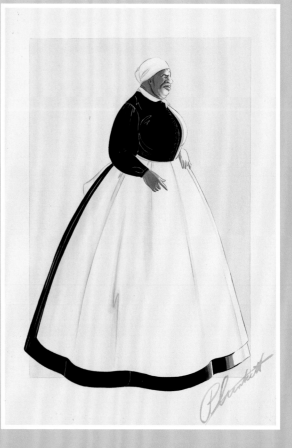

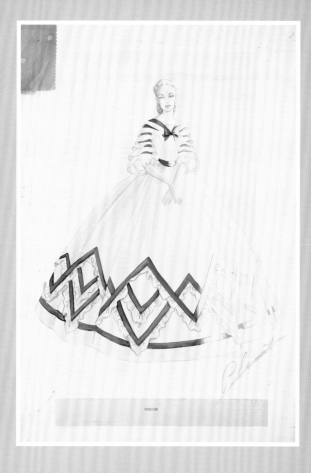

(FACING, TOP LEFT) Fanny Elsing: ". . . tearing from her curls the seed pearl ornaments set in heavy gold . . ." (p. 185).

(FACING, TOP MIDDLE) Aunt Pittypat's mourning dress: "Stout, pink cheeked and silver haired . . . too tightly laced stays . . . too small slippers" . . . (p. 156).

(FACING, TOP RIGHT) Design for an unidentified character.

(FACING, BOTTOM LEFT) Gerald O'Hara: "A small man . . . heavy of barrel and thick of neck . . . short sturdy legs . . . finest leather boots . . . sixty years old . . . crisp curly hair, silver white . . . hard little blue eyes . . . cravat which had slipped awry" (p. 29).

(FACING, BOTTOM MIDDLE) India Wilkes: "Could be described by no other word than plain" (p. 96). "Hair untidy . . . pale hair and eye lashes . . . jutting chin" (p. 97).

(FACING, BOTTOM RIGHT) One of several designs for Mammy.

(ABOVE) Suellen's dress for the prayer scene.

(RIGHT) The burgundy ball gown Scarlett O'Hara wore to Ashley's birthday party.

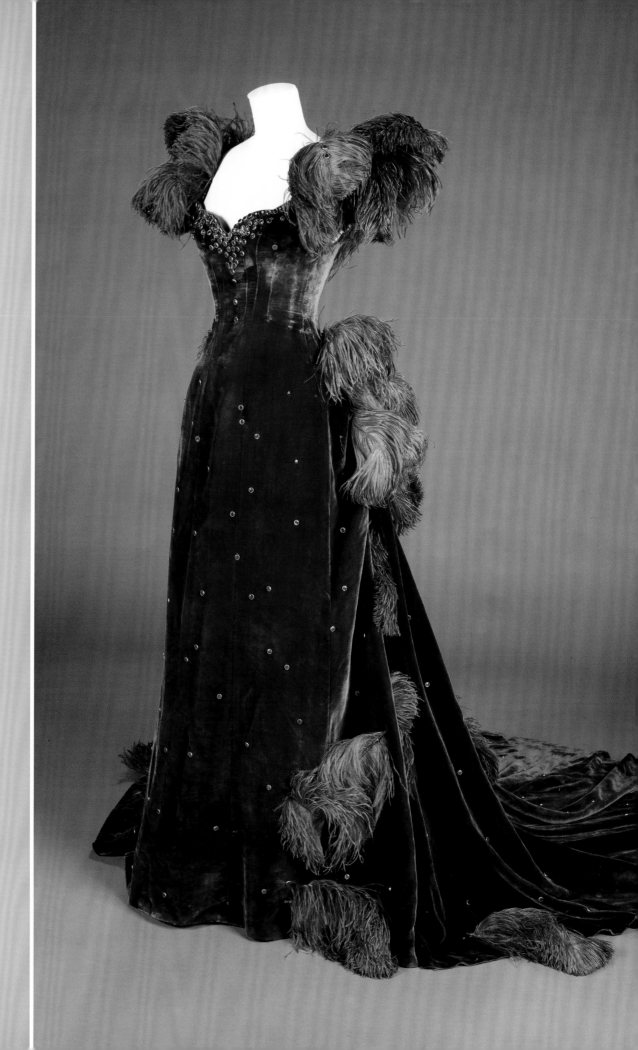

INTERIORS

After two years of waiting, turning down lucrative job offers, and learning that he would be working under the supervision of William Cameron Menzies, art director Hobe Erwin resigned. Erwin was flattered that for more than a month Selznick, Brown, and O'Shea pressed him to return, but he would not change his mind.

Ray Klune wrote to Kay Brown on December 14, 1938, "While there are a number of set dressers out here, Mr. Selznick and Mr. Cukor feel that it is just possible there may be someone in New York in the interior decorating line of outstanding ability, whom we might be able to secure advantageously. It is not absolutely essential for him to have any motion picture experience. It is essential, however, that he be particularly adept at Early Victorian interiors, with a very fine sense of color values, which he would have to have in order to be an interior decorator in the first place, I suppose."

Even as Brown continued her work casting parts and negotiating with possible costume designers, she set to work looking for a suitable set dresser. Her first thought was to talk to her friends at *Harper's Bazaar* and *Vogue*. Selznick suggested she consult with the noted Broadway scenic designer Jo Mielziner and Dorothy Paley, the wife of his friend William. Mielziner recommended John Hambledon, who was designing costumes for Broadway shows. Dorothy Paley suggested William Pahlmann, a Texan who was working as head of the interior decorating department at Lord & Taylor. Brown suggested Stuart Chaney, who designed interiors for *Jezebel*, and talked to Ruby Ross Wood, a well-known New York interior designer. Money was, as always, an issue, as was time. Selznick needed someone "immediately" and was hoping to find someone who would be willing to do the work in return for the publicity.

Brown continued to try to talk Hobe Erwin into returning to the production, but he was firm in his decision to leave. Brown was having the same luck with the other designers she was talking to. Some, like Bruce Buttfield, wanted too much money. Others, like Schuyler Parsons, had no photographs of their work because their clients didn't like publicity.

In the last days of 1938, as Selznick despaired of finding a suitable set dresser, Kay Brown contacted him. "Have just had long talk with Jo [sic] Platt," she wrote, "Mr. Platt is the consultant for all Condé Nast publications on decorations. He is considered among the first ten designers of America, in addition he is at present time consultant for 'House and Garden,' the March issue, which is featuring all the low-land Georgia plantations and he has done all the research for them." Platt was available immediately but could only come for ten days then fly home to take care of his clients. Brown advised that Platt's fee for the job would be completely out of the question and suggested he do it for no salary but expenses and publicity. Platt accepted, and a week later he was in Hollywood. Selznick wrote to Brown, "Sets coming along nicely and very pleased with Platt who is exactly what we wanted."

But almost a year later, as *Gone With The Wind* neared completion, Selznick wrote to Jock Whitney and Kay Brown about a story that appeared in *House & Garden* about the film. "I am a little

After two years of waiting for *Gone With The Wind* to start production, Hobe Erwin had grown increasingly frustrated. When Selznick announced that the start date had been moved to January 1939, Erwin, already annoyed at the news that he would work under William Cameron Menzies, balked at yet another delay and resigned. Nevertheless, he was later flattered that Selznick tried to keep him and was gracious when he learned he was replaced by Joseph Platt.

surprised that Joe Platt should give so little consideration to the contributions of Menzies and Wheeler . . . I don't know whether or not you both know that Platt's contributions, while excellent, were only to a small number of sets, and even on these the Art Department contributed at least as much as he did. Several of the sets he worked on were designed before we ever heard his name. His contributions were most important in connection with Rhett's home, but even here do not discount Menzies . . . and whether or not Platt sees fit to be gracious, I shouldn't like either of you to be fooled."

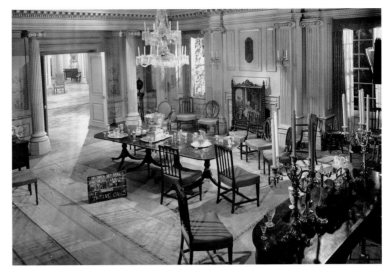

(TOP) Set still for the dining room at Twelve Oaks.

(MIDDLE ROW) Concept painting and set still for Scarlett's bedroom in the Butler house.

(BOTTOM ROW) Concept painting and set still for Aunt Pittypat's parlor.

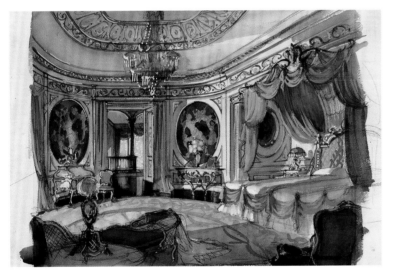 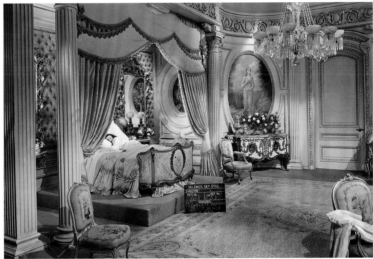

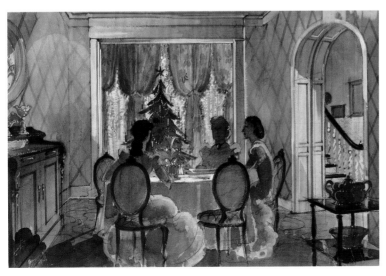 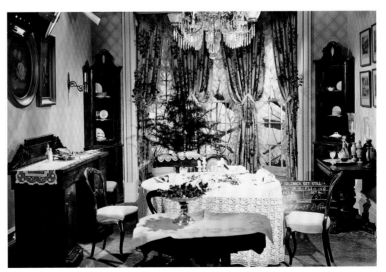

SCRIPT DOCTORS

Although Sidney Howard had been working on the *Gone With The Wind* screenplay intermittently for two years, the script was still too long. Although the pay was good, the project was encroaching on Howard's writing for the theater, and he was becoming increasingly frustrated. Selznick began soliciting other writers, at one point going so far as to authorize a contest among writing students at Columbia University, in the hope that they would have some new ideas. Howard ridiculed the idea: "Cutting *Gone With The Wind*," he said, "will be hard enough without confusion from the undergraduate point of view."

Selznick was obsessed with the length of the film. If *Gone With The Wind* were too long, exhibitors would object. He would then be in the position of having to cut the film down to size in the editing room, which would be both more expensive and more destructive than shortening the script before committing to film.

Indeed, as Selznick had outlined many months before, the task of converting the novel to a screenplay was "an enormous editing job," requiring shortening the script while simultaneously inserting more of the story from the novel. According to Selznick's theory of adaptation, this meant either combining, rewriting, or cutting out entire sequences.

After a casual conversation with Eddie Mannix, one of the top executives at MGM, in October 1938, Selznick sent copies of the Sidney Howard script to Laurence Stallings and Bradbury Foote, two of MGM's best screenwriters, with a deadline of eight days and a request of confidentiality. But Selznick was unimpressed by their suggestions. Stallings recommended a "ruthless wielding of the hatchet" in cutting the script down to size. He suggested, for example, cutting most of the barbeque scene, leaving little more than the scene in the library between Scarlett and Ashley followed by her exchange with Rhett. Selznick was equally

Selznick delivered "the so-called Howard-Garrett script" the day before filming was to begin. George Cukor was not happy with it and thought the previous version, the Sidney Howard script, was superior. Cukor's attitude toward the script eventually led to his leaving the production altogether. See appendix for remaining text.

249 CONTINUED (2)

 Rhett (continued)

I liked to pretend that Bonnie was you - a little girl again - before the war had done things to you. I gave her the love you didn't want. When she went, she took everything.

 Scarlett bursts into a paroxysm of sobs. Rhett looks at her for a moment, then offers her his handkerchief.

 Rhett

Here, take my handkerchief. Never at any crisis, Scarlett, have I known you to have a handkerchief.

 Scarlett (wipes her eyes; desperately)
But, Rhett - you loved me once. There must be something left for me now!
 (then, however, looking up, she sees that he has left her. She totters to the front door, screaming wildly --)
Rhett! Rhett!
 (she reaches the door, supporting herself against the jam)

250 EXTERIOR - STREET IN FRONT OF THE NEW HOUSE - DAY

From Scarlett's angle (over her shoulder if possible) Rhett can be seen as he gets into the carriage and drives off. A final cry from her.

 Scarlett
Rhett!

 Mammy appears beside her. She falls back against her for support. CAMERA GOES CLOSE as Scarlett turns to Mammy.

 Scarlett
I'll go crazy if I think about this now! I'll think about it tomorrow!

 Mammy
Never you mind tomorrow, honey. This here is today! There goes your man!

 DISSOLVE TO:

251 EXTERIOR - DAY - RAILROAD STATION

A rattletrap of a train stands ready to pull out. Various people about, waving goodbye, etc. Rhett, debonair as ever, his eyes on the future, enters, crosses to train and climbs aboard. He is followed by a darky carrying his grips.

252 INTERIOR - COACH - DAY

Rhett enters, finds a seat and settles down as the darky disposes of Rhett's luggage. The darky leaves. The train starts. As it does, Scarlett comes down the aisle, sits in the seat beside Rhett. Rhett doesn't look up, or express surprise.

 Rhett (quietly)
It's no use, Scarlett.

 Scarlett (bravely)
I've never been to London -- or Paris --
 (she takes his hand in both of hers --)
Oh, Rhett! Life is just beginning for us! Can't you see it is? We've both been blind, stupid fools! But we're still young! -- We can make up for those wasted years!
 (he tries to withdraw his hand --)
Oh, Rhett -- let me make them up to you! Please! Please!

 He looks at her for a long moment, then down at the hands that hold his. Slowly, he lifts them to his lips, turns the palms upward and kisses them, as we --

 FADE OUT.

 THE END.

(LEFT) Bradbury Foote's happy ending to *Gone With The Wind*. Selznick thought it was "awful."

(BELOW) One of Val Lewton's lists of possible screenwriters for *Gone With The Wind*. The last person on this list, Oliver H. P. Garrett was hired to do a major last-minute rewrite.

Form 73—20M—4-38—K-I Co.

SELZNICK INTERNATIONAL PICTURES, INC.

9336 WASHINGTON BOULEVARD CULVER CITY, CALIFORNIA

Inter-Office Communication

TO Mr. David O. Selznick DATE October 12, 1938

FROM Val Lewton SUBJECT SUGGESTED WRITERS FOR "GONE WITH THE WIND"

 Naturally you understand that the field of good writers is limited, especially for an assignment of this sort. This is not so much an apology for the shortness of my list as for some of the choices, which at first blush, might strike you as rather odd.

CLEMENCE DANE No one can quarrel with the worth of her dialogue and it is my feeling that she can give the character of Scarlett an intangible quality of life and fire. She's always been good with rebellious women characters. If you are going to Bermuda she could go straight there from England. The fact that she is an English woman should not deter you. "Abraham Lincoln," the best play ever written on an American historical character, was written by John Drinkwater. I think the English know and love our Civil War period even better than we do.

BEN HECHT This seems the wrong assignment for him, but I think he can do anything he sets his mind to.

THORNTON WILDER I don't know how much screen experience he has had, but he has a good quality of mind and it seems to me enough real intelligence, rare enough in writers, to be able to pick it up quickly from you. From all accounts he is a very pleasant person and I have a hunch that you might get on very well with him. His dialogue and its range over periods, peoples and countries, is exceptionally good.

LOUIS BROMFIELD Here again I am not certain as to whether or not he has had enough screen experience. I know that he has had some, but how much I've been unable to find out in this brief time. He has nice structure sense and is such a good story teller that his limited experience as a screen writer might not count against him.

LAURENCE STALLINGS His dialogue, to judge from his last picture, is pretty bad, but that may have been the fault of a collaborator or producer. He has a lot of feeling for this period and might work out, although I would not strongly recommend him to your attention; just a slight possibility.

LYNN RIGGS He's good on dialogue, a little vague and poetical in his plays, but you might be able to keep this tendency in leash as you did in "Garden of Allah."

O.H.P.GARRETT. If only structural changes are needed, cuts of scenes and general rearrangement, he might be a good man. As to dialogue, much as I love the man, I, personally, wouldn't let him write dialogue for a "Mickey Mouse." I think visualization of scenes and general plot carpentry are his field, and he excels in it.

 Val. (more suggestions to come.)

Sweerling?
Lillian Hellman?

unenthusiastic about Foote's ideas. He thought Foote's happy ending "awful."

At Selznick's request, his story editor, Val Lewton, provided lists of possible screenwriters with comments on each. Among others, Lewton offered his opinions on Sinclair Lewis ("He can write dialogue, is now very much interested in the theater, but might be either a little too political-minded or a little too gin-minded for this job"), William Faulkner ("Now in Oxford, Miss, but can fly anywhere in his own plane. Not very reliable in his plane nor his habits but his last collection of Civil War stories, 'The Unvanquished' show [sic] what he can do with this sort of background"), Rachel Field ("Handles her women characters beautifully, as shown in her novels 'All This and Heaven Too' and 'Time Out of Mind.' Has a nice grasp of period talk and is a very easy person to work with"), and Thornton Wilder ("I don't know how much screen expertise he has had, but he has a good quality of mind and it seems to me enough real intelligence, rare enough in writers, to be able to pick it up quickly from you. From all accounts he is a very pleasant person and I have a hunch that you might get on very well with him").

Selznick hired Oliver H. P. Garrett, an established screenwriter of whom Val Lewton said, "If only structural changes are needed, cuts of scenes and general rearrangement, he might be a good man. As to dialogue, much as I love the man, I, personally, wouldn't let him write dialogue for a 'Mickey Mouse.'" Garrett started working on the script with Selznick in early December 1938 and completed a draft by late January 1939.

But Selznick was still not satisfied and hired one writer after another to work on specific scenes or come up with ideas to combine and shorten sequences. F. Scott Fitzgerald, Ben Hecht, John Van Druten, John Balderston, Roland Brown, and Edwin Justus Mayer each worked on the script for three weeks or less, while Michael Foster was on the payroll for almost two months.

Of the more than a dozen writers known to have worked on the screenplay of *Gone With The Wind*, almost all began their work after filming had commenced.

A page from F. Scott Fitzgerald's work on the Atlanta Bazaar scene. Fitzgerald worked on several scenes, but little of his work made it into the final film.

"ONE MORE WILL ONLY CONFUSE US"

In early January 1939, as the sets of Tara and Twelve Oaks were being built, as Selznick, Cukor, and Arnow were auditioning and casting actors for the minor roles, and as the first in a long line of screenwriters was trying to improve and shorten the script, Susan Myrick arrived on set. Selznick had already brought to Hollywood the illustrator and historian Wilbur Kurtz as an advisor about Atlanta's early history and was paying both Kurtz and Myrick more than he had originally budgeted. When Selznick remembered his promise to Walter White to employ yet another advisor to "protect the race," he had his executive assistant, Marcella Rabwin, write to Kay Brown asking her to smooth things over with White.

Brown wrote about her conversation with White, "He was tremendously concerned about the probable effect of the picture but seemed to be completely reassured when I recited my piece taken from your very excellent notes." Brown, anticipating Selznick would say no, concluded, "Now comes the sad news: he would consider it a great privilege if he could read the manuscript."

For more than a year Selznick had been seriously protective of the screenplay, not allowing anyone outside the organization to see it and admonishing everyone to be careful with their copies. Rabwin replied, "Surprise—DOS has no objections to your letting Mr. White see the script of GWTW. It will not be available for him for 2 or 3 weeks, however, for they are re-doing the dialogue right now."

Six months earlier, Selznick had promised Walter White of the NAACP that he would "engage a Negro of high standing" to act as an advisor on the film. As the start date approached, however, and the organized chaos of production began, Selznick had second thoughts and instructed his secretary, Marcella Rabwin, to have Kay Brown break the news to White.

Form 73—20M—4-38—K-I Co.

SELZNICK INTERNATIONAL PICTURES, INC.

9336 WASHINGTON BOULEVARD CULVER CITY, CALIFORNIA

Inter-Office Communication

TO Miss Katharine Brown DATE 1/9/39

FROM Marcella Rabwin SUBJECT GWTW - Negro Adviser

Dear Kay:

Mr. Selznick asked me to tell you about the situation which came about through his correspondence with Walter White who is Secretary of the National Association for the Advancement of Colored People.

Mr. White (who, as you probably know, is a white man sincerely interested in the Negro cause) wrote us about the desirability of having on the picture a Negro adviser who would be qualified to check on facts and errors concerning the race -- since they felt the book had not presented the Reconstruction period in exactly the true and proper light. DOS assured White that we would protect the race and would use an adviser during the filming of the picture.

However, we now find ourselves surrounded on all sides by advisers, and one more will only confuse us.

So ----

DOS asks if you will talk to Mr. White, so we will not be in the position of having broken a promise. He would like you to say to White that we have brought out Miss Susan Myrick -- explaining who she is -- so that we would be sure everything was right; and in view of this, he can be sure we will not turn out a Hollywood or NY conception of the Negro. Tell him, too, that we have made changes in the script so that even the famous Tax Scene involves a white man now and he is the real culprit while it is a Negro who saves Scarlett. We have eliminated the K.K.K. DOS would like you to try to make White happy with this arrangement.

We're so concerned about White because he is a very important man and his ill-will could rouse a swarm of bad editorials in negro journals throughout the country. It is even important enough for DOS to think Mr. Whitney might say "hello" to him.

Explain how sympathetic we are and tell him that the only negro characters in the picture now are: Mammy, who is treated very loveably and with great dignity; Uncle Peter, who is also treated in the same way; Big Sam, who saves Scarlett; Prissy, who is an amusing comedy character; and Pork, who is an angel. Assure him that the only liberties we have taken with the book have been liberties to improve the Negro position in the picture and that we have the greatest friendship toward them and their cause.

DOS is very anxious to avoid having a Negro technical adviser because we now have the two advisers, Myrick and Kurtz, and because such a man would probably want to remove what comedy we have built around them, however loveable the characters may be.

You can assure White that we have not characterized any of the Negroes as mean or bad and that they have nothing to worry about as far as a pro-slave angle or anything else is concerned, for the picture will be absolutely free of any anti-Negro propaganda.

Then, will you let the boss know what's what with White?

mlr

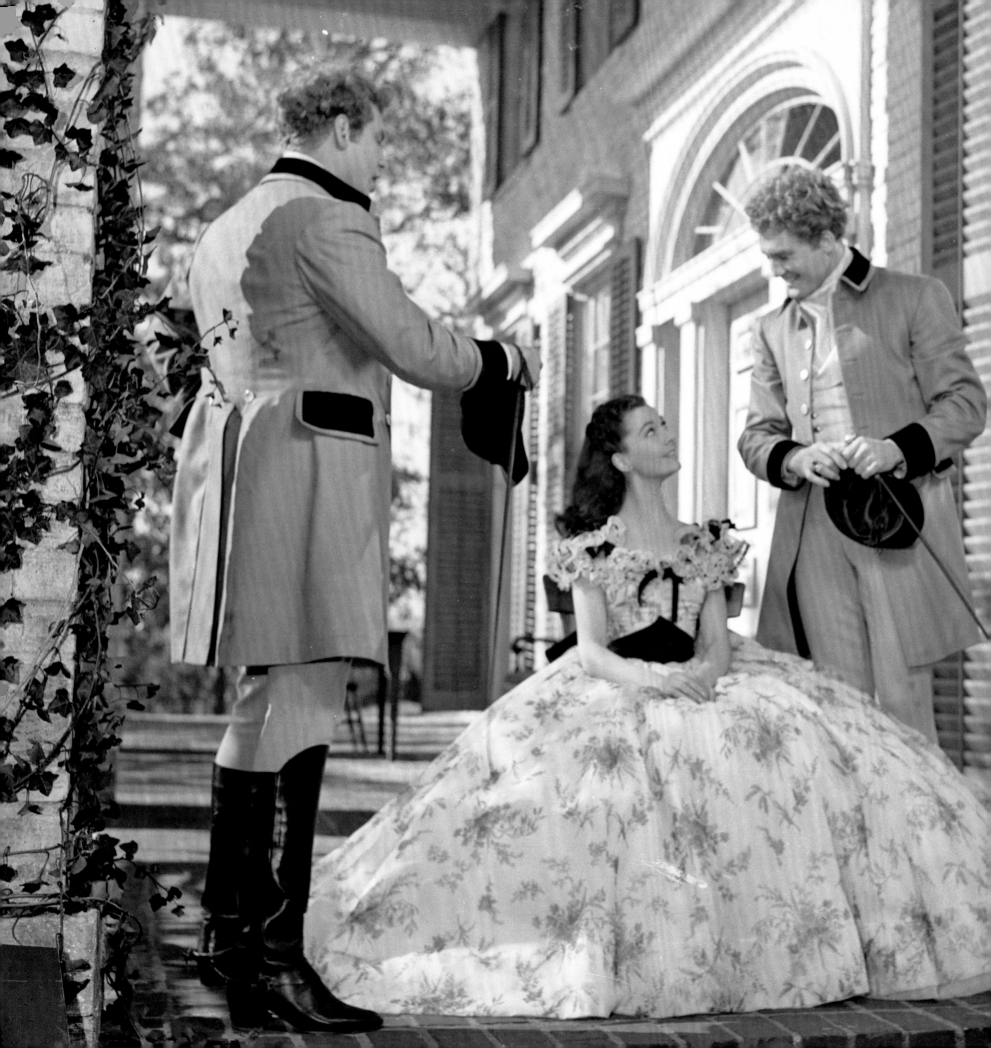

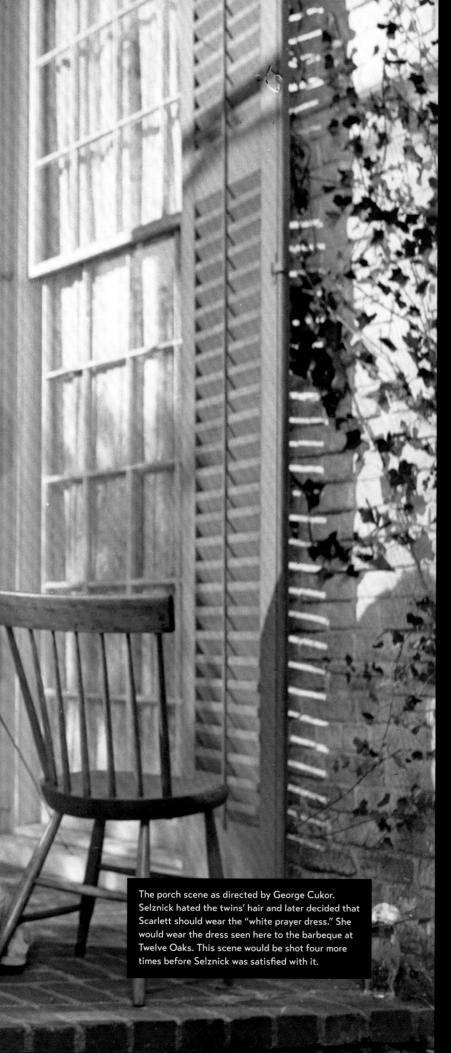

The porch scene as directed by George Cukor. Selznick hated the twins' hair and later decided that Scarlett should wear the "white prayer dress." She would wear the dress seen here to the barbeque at Twelve Oaks. This scene would be shot four more times before Selznick was satisfied with it.

FILMING BEGINS

On January 26, the first day of filming, as the first take of the opening scene of *Gone With The Wind* was being shot, the huge Technicolor camera broke down and had to be replaced. Selznick hated the results of the day's filming. The Tarleton Twins, George Bessolo and Fred Crane, had been paid a week's salary to dye their hair red, and Selznick thought they looked "grotesquely like a pair of Harpo Marx comics."

Once the replacement camera arrived at 10 a.m., Cukor, Vivien Leigh, and the camera crew began with Scene 2, Scarlett running across the grounds of Tara. The first take had "unsatisfactory action." In the second, Leigh stepped on her hoop skirt. The third take was good.

They then filmed the scenes with the Tarleton Twins and her walk through the grounds of Tara with her father, Gerald, in which Scarlett wears the green-sprigged "barbeque dress." Out of three takes, two were rejected for "badly read lines."

By lunchtime, the light conditions were unfavorable for an outdoor shoot, so the crew moved to the bedroom set to film Scarlett's scene with Mammy in which she is dressing for the barbeque. At 6:55 p.m., the company was dismissed.

For months, Selznick had considered dropping the porch scene, the film's opening with Scarlett and the Tarleton Twins, and would continue to contemplate a change. Over the coming months, this scene would be reshot several more times.

Cukor had been with the production since the beginning, consulting on the script, auditioning thousands, and supervising the construction of sets and costumes. He was Selznick's friend and star director, a veteran of the New York stage who had moved to Hollywood during the rise of the talkies and directed such classics as *Dinner at Eight*, *Little Women*, and *David Copperfield*. Yet despite Cukor's skill and experience, almost every scene he directed would later be reshot.

wind - Tarleton Twins

Mr. George Cukor cc: Messrs. Plunkett, Westmore, Stacey

1/30/39

I feel very strongly that the hairdress we used on the twins makes them look grotesquely like a pair of Harpo Marx comics, even more so than was the case with Tommy Mitchell, because of the color of their hair. All feeling of a pair of young aristocrats of the period, which I worried about in the casting of the roles, is lost and they look like a pair of bohunks. This is almost entirely due, I think, to the hairdress but is also due in part to the size of one of the boys and to the way they wear their clothes. I think the boys should be encouraged to take off some weight before we use them again; and that corsets or whatever is necessary should be used to give them sleeker appearances when they are next used; and that an attempt should be made to get them smarter looking in their next costumes.

Also, I think that their hair should be dressed attractively. I would like Mr. Westmore to re-dress their hair and I would like him to arrange with Mr. Plunkett for me to see them again in their next costumes and with their hair re-dressed before they work.

dos

dos*f

wind - Wardrobe

Mr. George Cukor

1/30/39

Since it is my strong feeling at the moment that we will be forced to drop the twin scene, for length if for no other reason, and since further it is my feeling that even if we should eventually decide to keep it, we will re-take the one shot that we had with Miss Leigh, I feel that we should plan on using the white dress in the opening scene - which means that she should wear this dress in the scene with Gerald.

Plunkett feels very strongly that this would be the best plan.

If you have any different feelings, please call me.

dos

dos*f

(FACING, TOP) Storyboards by William Cameron Menzies.

(FACING, BOTTOM) Storyboard by William Cameron Menzies for an earlier version of the porch scene.

(LEFT, TOP) Selznick's memo about the Tarleton Twins' hair color. It would take some time before Selznick could get his visual conception of the film across to his production staff.

(LEFT, BOTTOM) Scarlett's scene on the porch with the Tarleton Twins would be reshot several times before Selznick was satisfied and Scarlett's white "prayer dress" would eventually be used.

(BELOW) Walter Plunkett's costume design for the Tarleton Twins.

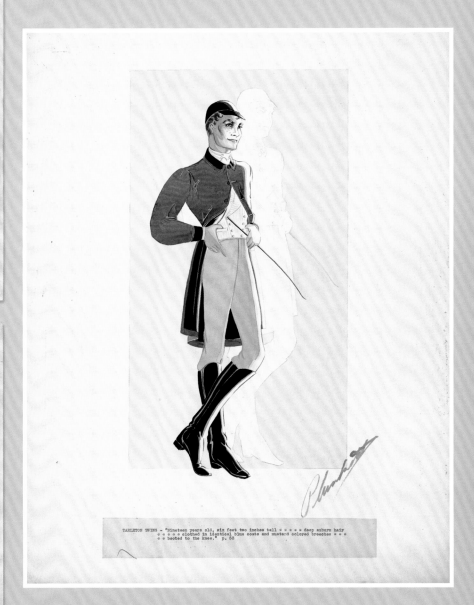

TARLETON TWINS - "Nineteen years old, six feet two inches tall deep auburn hair . . . clothed in identical blue coats and mustard colored breeches . . . booted to the knee." p. 53

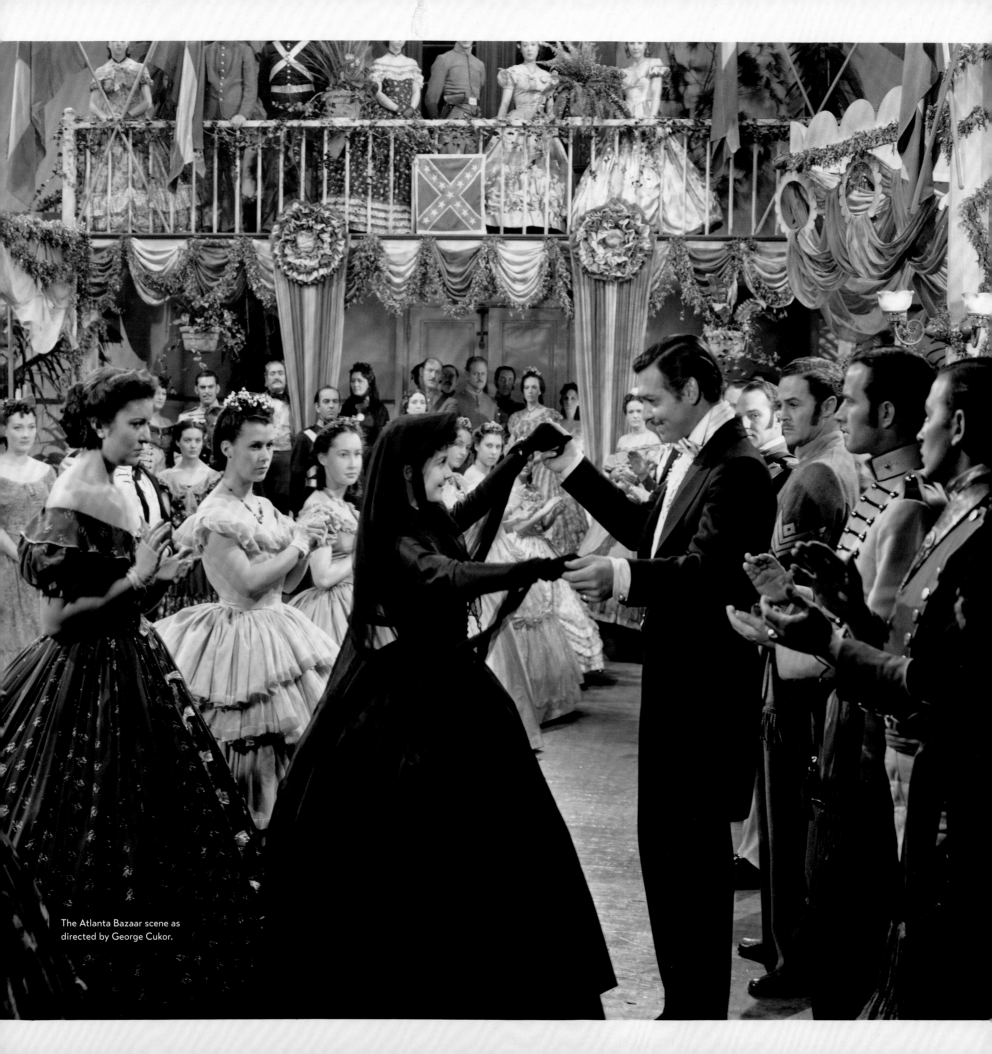

The Atlanta Bazaar scene as directed by George Cukor.

THE ATLANTA BAZAAR
(CUKOR'S VERSION)

Cukor began filming the Atlanta Bazaar scene on Wednesday, February 1, with shots of people dancing. The camera was then moved to Scarlett's booth and tilted down to show Scarlett's dancing feet. After lunch, a long scene with Rhett and Scarlett dancing was shot. Seventeen takes were necessary due to "blowup in dialog."

Thursday's filming included the scene in Scarlett's booth with Melanie, Pittypat, Mrs. Merriwether, and Mrs. Elsing, as well as Rhett's introduction by Dr. Meade. Friday's schedule was filled with Rhett, Scarlett, and the extras dancing. Saturday's shoot with Rhett and Scarlett waltzing went smoothly. One take of Rhett bidding for Scarlett was ruined when an extra wandered into the shot.

With this scene in particular, Selznick had to come to terms with the tension between maintaining authenticity and achieving beauty in filming *Gone With The Wind*. Disappointed with "the very ordinary costumes" and overall lack of spectacle in the scene, Selznick was assured by the advisors that the costumes were historically accurate. "Where authenticity means loss of beauty," Selznick asserted, "we should take liberties, and considerable ones, with the authenticity," adding, "The first people to complain about the lack of beauty will be the Southerners that we are trying to satisfy with authenticity."

The first clash between beauty and authenticity came early. Selznick thought the costumes worn by extras were "ordinary" and "cheap looking" and blamed a lack of effort and overzealous economization on the part of the production staff.

Mr. R. A. Klune cc: Mr. Lambert

Costumes

2/3/39

I was very disappointed by the costumes in the bazaar sequence during the dance. Much of the loveliness that this sequence could have had has been lost through the very ordinary costumes worn by the dancers. I am aware that we do not want to spend money building costumes for extras, but I think that we might have done much better if we had used a little more effort to get costumes worn by stars in other pictures, notably at M.G.M. Certainly costumes worn by Miss Shearer and Miss Rainer and Miss Crawford and all the other woman stars in various costume pictures could have given us a much more beautiful effect in this scene than the cheap looking extra costumes that we have utilized.

I am particularly concerned lest this be repeated in the interior of Twelve Oaks, in the barbecue scene, etc. I wish you would give your personal attention to the attempt to round up stars' former costumes from other studios, especially M.G.M. You must bear in mind that M.G.M. is our partner in this enterprise and if you ever have any trouble in securing their cooperation on such matters, you have only to ask help from Mr. Ginsberg - or in the final analysis from myself.

Plunkett feels that if we built ten or twelve costumes for the extras we could use them to advantage through the picture and estimates that these could be made at about an average cost of $80 or $90. In the first place, I dislike going into this expense unless it is necessary and in the second place, such costumes certainly could not be the equal of star costumes on which a great deal of money has been spent. But in any event, I think something should be done so that we do not repeat the lack of beauty that is in the bazaar.

Incidentally, I think the men look awfully sloppy and I cannot understand why we cannot do a better job on uniform fitting throughout. Late in the picture we want the contrast of the seedy looking men against the brilliantly uniformed officers when the war begins. But with the men looking as they do in the bazaar sequence, there is no contrast possible. Also it seems to me that there should be a greater variety in the uniforms of the men.

In short, I think that the whole flavor and color of the bazaar sequence, which should have been filled with brilliantly and smartly dressed officers and charmingly and beautifully gowned women, has been largely if not entirely lost because of a very cheap, ordinary and thoughtless costuming job on our supernumeraries.

dos

dos*f

Form 73—20M—4-38—K-I Co. *Wind—Wardrobe*

SELZNICK INTERNATIONAL PICTURES, INC.

9336 WASHINGTON BOULEVARD CULVER CITY, CALIFORNIA

Inter-Office Communication

TO Mr. Selznick DATE February 6, 1939

FROM R. A. Klune SUBJECT COSTUMES

Your memorandum concerning costumes in the Bazaar Sequence brings up
a number of important points that should be given consideration
immediately, the principal one concerning authenticity, and another,
to what extent Mr. Cukor's approvals may be considered final by Mr.
Lambert and Mr. Plunkett. 105 of the dresses on women in the Bazaar
were manufactured by Western Costume Company from scratch in accordance
with sketches and specifications as to color and material as submitted
by us. Samples of the dresses were in each case shown to Mr. Cukor
for his approval. In all cases Miss Myrick felt that we were dressing
the women much too nicely for Atlanta of that day. However, both
Lambert and Plunkett went very much further than she said was
permissible in attempting to make the gowns lovely. It would have been
just as easy and not much more expensive to have gone to more pictures-
que dresses because of having completely manufactured so large a
number. While on a production rental basis we are paying much less,
some of these manufactured dresses have cost as much as $75.00 to make.
It seems a shame now that they are not what you wanted. Lambert and
Plunkett both took your instructions literally when you suggested
that they accept Mr. Cukor's approval on the wardrobe for bits and
extras, and of course feel very badly now that they have missed giving
you what you wanted in the sequence.

The uniforms worn by the men in most cases were made to measure. The
sloppiness of which you complain does not result from ill-fitting
as much as from the fact that in all but a very few cases they were
worn by men not accustomed to carrying themselves as army officers.
Van Opel's men would have carried themselves like officers and gentlemen
for $16.50 a day, as against the $8.25 a day we paid most of the men
extras on that set. Here again, we were advised by our technical
people that after two years of war the officers of the South would not
have possessed the immaculateness and trimness that West Point men
might display.

I believe that you should immediately clarify to Mr. Cukor and Mr.
Plunkett and Mr. Lambert to what extent authenticity is to be disregarded,
and license with respect to the general beauty of the picture is to be
taken.

 rak

 Wind—Misc

Messrs. Cukor, Menzies, Wheeler, Lambert, Plunkett cc: Mr. Klune

 * Authenticity

2/8/39

There is no question in my mind but that to date we have seriously hurt the beauty
of our production by letting authenticity dominate theatrical effects. There is
such a thing as carrying authenticity to ridiculous extremes and I feel that in our
sets and in our costumes in the future, where authenticity means a loss of beauty,
we should take liberties, and considerable ones, with the authenticity. The first
people to complain about the lack of beauty will be the Southerners that we are
trying to satisfy with authenticity.

 dos

dos*f

(ABOVE, TOP) Extras preparing for the Atlanta Bazaar scene.

(ABOVE) Walter Plunkett and assistants preparing extras for the Atlanta Bazaar scene.

(LEFT, TOP) In Ray Klune's measured response to Selznick's memo of February 3, Klune explains that the women's costumes in the Atlanta Bazaar scene had been approved by both Susan Myrick, the expert on such matters, and George Cukor, the film's director, before they were manufactured at significant expense. He further explains that the problem with the men's costumes has more to do with the person wearing the costume than the costume itself. Klune recognizes that the real problems are the balance between historical accuracy and spectacle and who makes the decision regarding that balance.

(LEFT) Selznick's response to Klune's memo of February 6, in which he opts for beauty over authenticity.

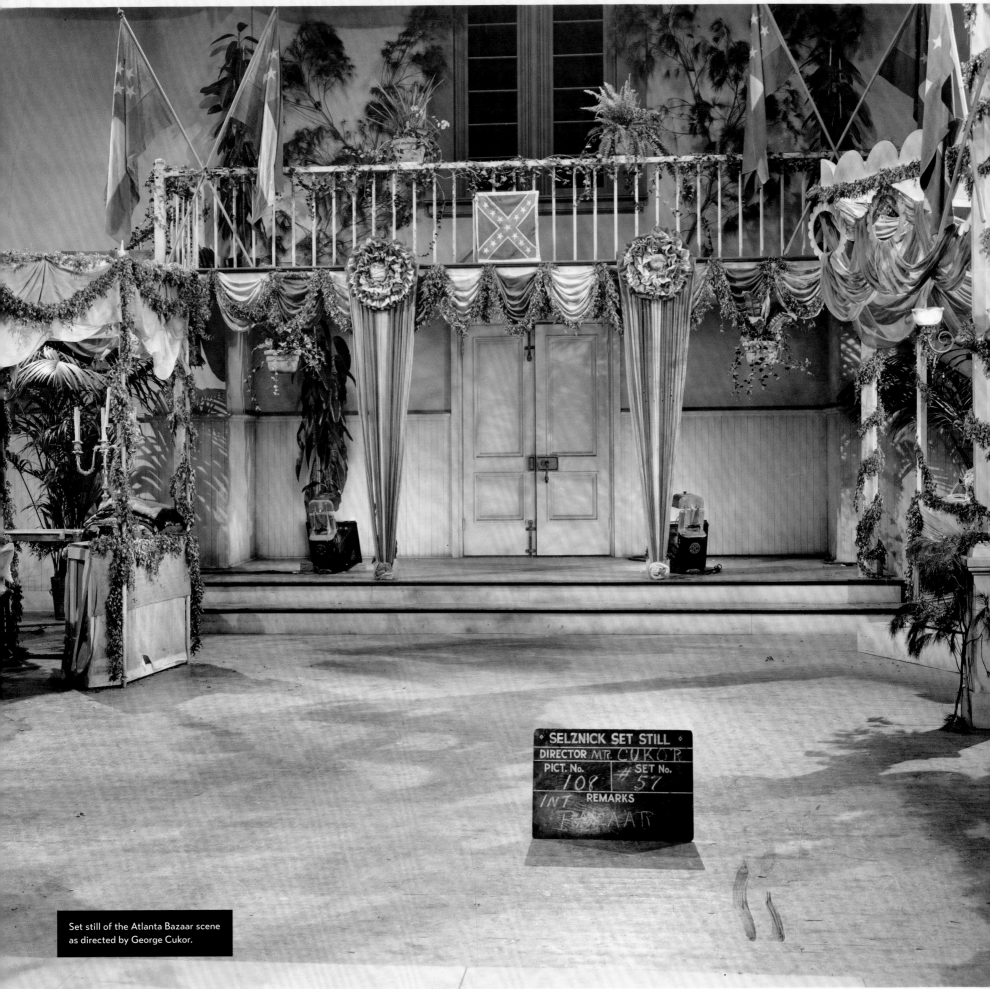

SELZNICK SET STILL
DIRECTOR MR. CUKOR
PICT. No. 108 # SET No. 57
REMARKS
INT BAZAAR

Set still of the Atlanta Bazaar scene
as directed by George Cukor.

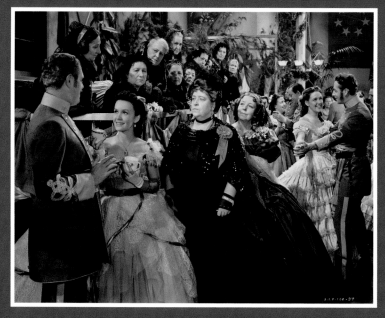

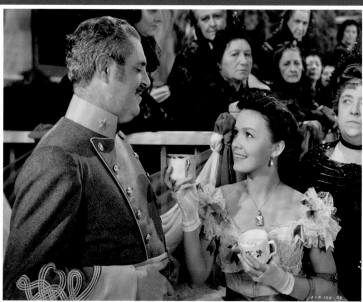

(LEFT) Two scenes filmed by Cukor that did not appear in the final film: Maybelle Merriwether with her mother and Mrs. Elsing offering a cup to a soldier collecting valuables (top and middle) and the Chaperone's Corner (bottom).

(RIGHT) Concept painting of the Atlanta Bazaar sequence.

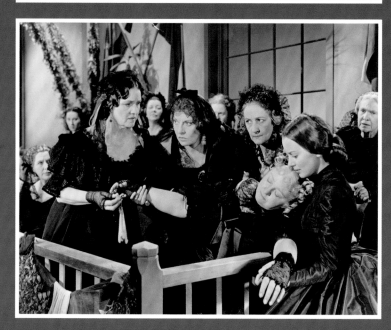

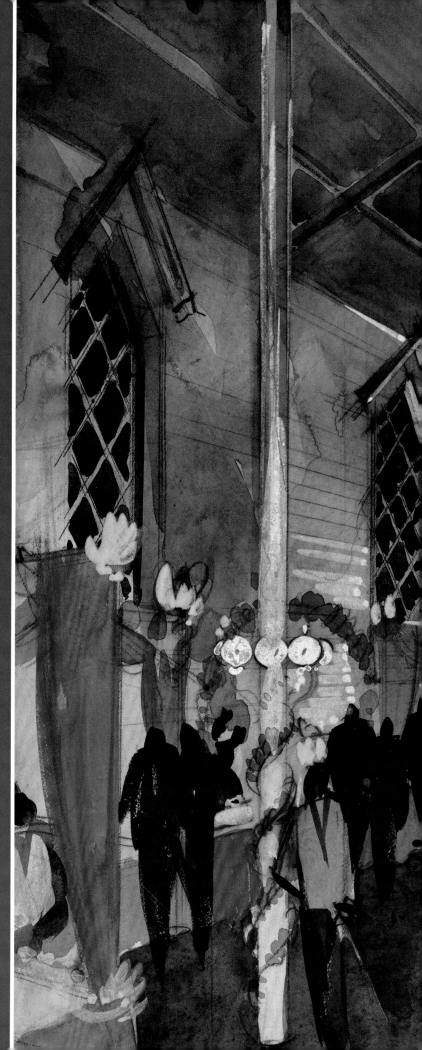

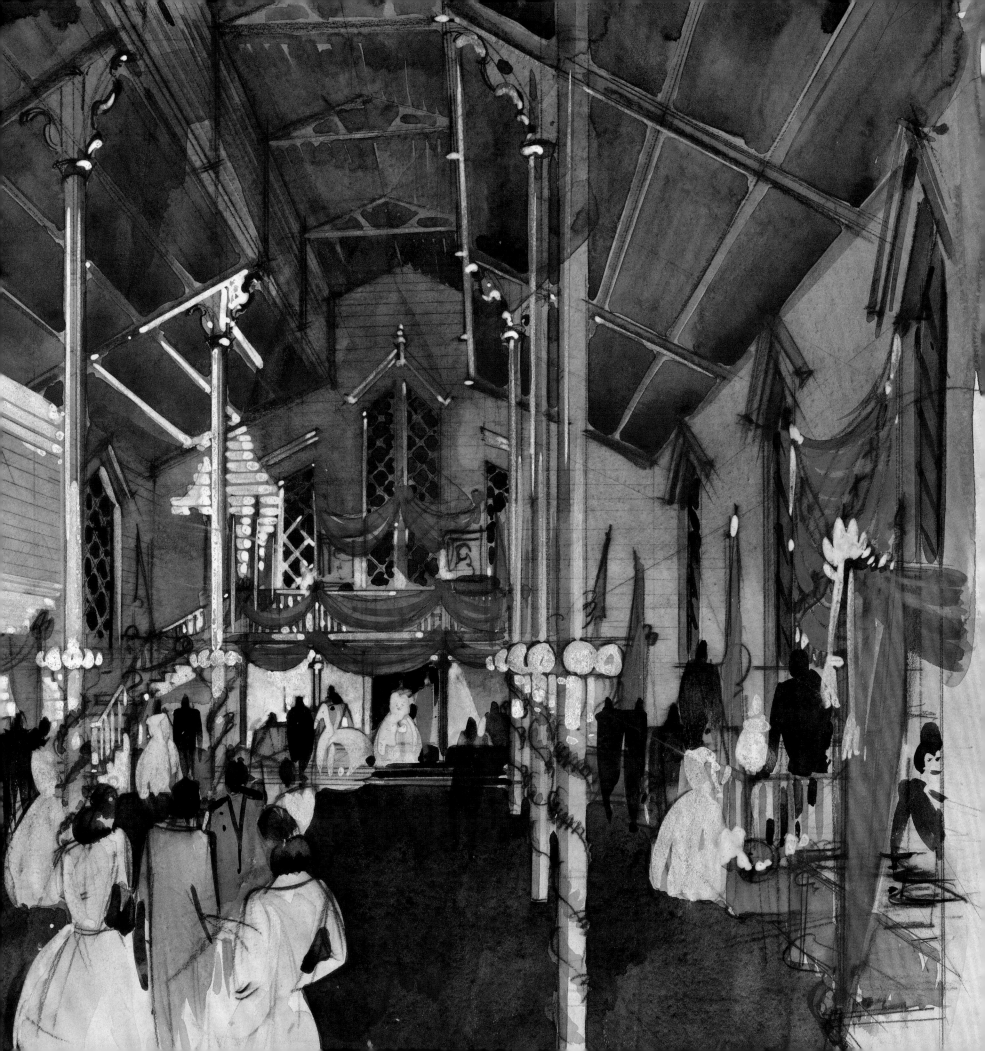

"THE NEGRO PROBLEM"

In early February 1939, about the time that Kay Brown was scheduled to send a copy of the screenplay of *Gone With The Wind* to Walter White at the NAACP, Victor Shapiro, the studio's new head of publicity, forwarded to Selznick two articles from the African American press. "'Gone With The Wind' Put On The Spot by Earl Morris: Predicts Picture Will Be Worse Than 'Birth of a Nation'" was written by Earl J. Morris, motion picture editor for the *Pittsburgh Courier*, on February 4. "Hollywood Goes Hitler One Better" had appeared in the February 9 issue of the *Los Angeles Sentinel*, a weekly African American–owned newspaper. Both editorials were apprehensive about the treatment of African Americans in the upcoming film based on the contents of the novel.

These editorials were soon followed by a five-page article by Morris, titled "Sailing With The Breeze," mailed directly to Selznick's office with a note saying, "For Your Information: This Copy is being forwarded to one hundred and thirty-three Negro newspapers located in all parts of these United States." The article began, "HOLLYWOOD, FEB. _____. Seventy-five years of racial self-respect has flown with the breeze in the much ballyhooed Hollywood epic film 'Gone With The Wind.' Picture yourselves standing before Producer David O. Selznick, Director George Cukor, and 26 members of the production staff, all white, and reading script [*sic*] which contains the word 'Nigger' several times. Well, approximately one hundred Negro actors did just that in competing for coveted roles in the picture while all their years of racial pride was being wafted away on the wings of a gust of 'Wind.'"

This was followed by news from Shapiro that Col. Leon H. Washington, founder of the *Los Angeles Sentinel*, was organizing a boycott of the film by maids in the Los Angeles area.

Selznick was unnerved. Filming was in full swing, he was not satisfied with the footage his director, George Cukor, was producing, and protests against his having cast a British woman in the main role were pouring in. He turned to his friend Jock Whitney for help: "Herewith the syndicated article and editorial on GONE WITH THE WIND in which we are attacked by the Negroes," he wrote. "I think this could become wide-spread and dangerous, and I feel it particularly keenly because I think it might have repercussions not simply on the picture, and not simply upon the company

When Earl Morris's editorials objecting to the treatment of African Americans in the film version of *Gone With The Wind* began appearing in the *Pittsburgh Courier*, Selznick was completely engrossed in the production of the film and was taken by surprise. He took the criticism personally. He felt he was being quite progressive in his treatment of African Americans in the film. He pointed to his elimination of the Ku Klux Klan from the story and his elimination of white characters' use of the word "nigger," among other changes to the story. Selznick appealed to Jock Whitney for help. See appendix for complete text.

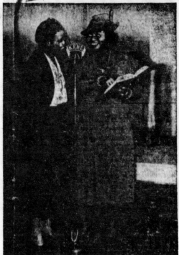

Two newspaper clippings from a folder in the Selznick archive labeled "The Negro Problem." As a direct result of Earl Morris's editorials in the *Pittsburgh Courier*, David O. Selznick decided to remove the word "nigger" from the film version of *Gone With The Wind*.

wind Negro Prob.

Dear -- :

Your letter about "Gone With the Wind" has been referred to my attention by Mr. Selznick, who has asked me to let you know that your fears concerning our treatment of the Negro characters in our forthcoming production of "Gone With the Wind" are entirely unnecessary.

We have been in frequent communication with Mr. Walter White, of the Society for the Advancement of Colored People, and have accepted his suggestions concerning the elimination of the word "nigger" from our picture. We have, moreover, gone further than this and have portrayed important Negro characters as lovable, faithful, high-typed people -- so picturized that they can leave no impression but a very nice one.

That section of the book which deals with the Ku Klux Klan has been deleted in deference to the ideals of all advanced people.

You will find confirmation of these efforts on our part to live up to the expectations of Negroes in America in the February eighteenth edition of the Pittsburgh Courier, in which Mr. Earl Morris says:

> "In an exclusive interview with this writer, Monday, the Publicity Department of the Selznick Studios informed me that the objectionable word "n----r" has been deleted from the film script of Margaret Mitchell's "Gone With the Wind." Also deleted will be the Ku Klux Klan sequence. The department has assured me that nothing offensive to the Negro race will be used in the picture."

Again on February 25th, Mr. Morris wrote:

> "Thanks to Selznick Studios for their invitation to visit and see the photographing of the film to assure those fair-minded Americans and "Black America" that nothing objectionable will be in the film."

We sincerely believe that your apprehensions concerning our treatment of the Negro characters in Miss Mitchell's book are unwarranted; and we are sure that you will heartily approve of our film when it is completed.

Sincerely yours,

m

(ABOVE, TOP) Earl Morris's telegram to Selznick's head of publicity, Victor Shapiro, asking for confirmation that racial epithets had been removed from the screenplay of *Gone With The Wind.*

(ABOVE, BOTTOM) Victor Shapiro's confirmation to Earl Morris.

(LEFT) Selznick and Victor Shapiro crafted this form letter to use in response to letters objecting to the treatment of African Americans in the film. The form letter was individually tailored to each recipient.

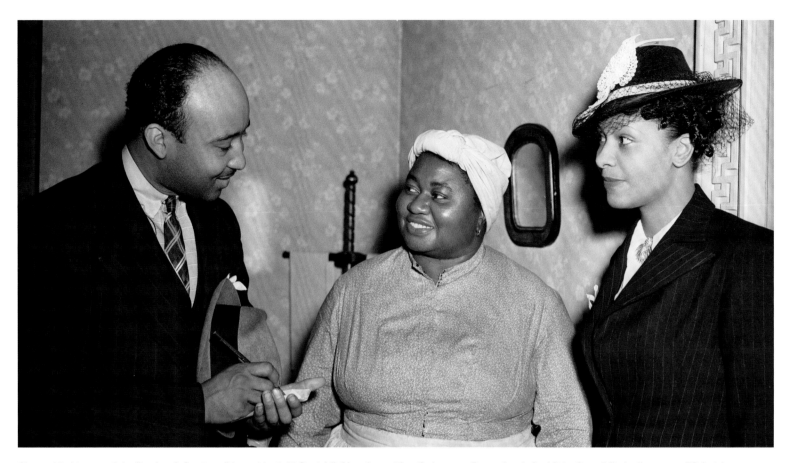

Chester Washington of the *Pittsburgh Courier* talking to Hattie McDaniel (left) and an unidentified woman. Former head of publicity Russell Birdwell suggested Selznick try to make the African American actors more available to the press in order to counter negative publicity.

and upon me personally, but on the Jews of America as a whole among the Negro race."

On February 14, Whitney responded with a plan: "I think there are several things we can do which will be of advantage," he wrote, "not only in counteracting present indications of disapproval, but in creating a positive enthusiasm for the picture. I do not believe that there is any cause for alarm at the present time, however, since, as you may have heard, the chief instigator of the articles which worried you, Earl Morris, has learned that his information was false. I think he will retract quite handsomely."

Indeed, Morris had wired Shapiro the day before: "Is it true that objectionable epithets referring to Negroes used in Gone With The Wind have been removed from the script of the motion picture production. Please wire answer collect."

Shapiro replied, "It is true that objectionable epithets are not in script Gone With The Wind, also no Ku Klux Klan sequence appears and nothing in film will be objectionable to Negro people. Regards."

The February 18 edition of the *Pittsburgh Courier* included an article by Morris, "Offensive Word and KKK Sequence Deleted From Film Version of 'Gone With The Wind'—Publicity Department of Selznick Studios Gives Courier Reporter Information in Exclusive Interview."

Shapiro also invited Morris to visit the set to interview African American cast members. On March 20, Shapiro reported to Selznick that Morris and a colleague had visited the studio:

We had a fine chat and they were highly pleased with the assurances we gave them

again, first that the word n—r does not appear in the script, that the Ku Klux Klan sequence is out, and that there is nothing offensive to the Negro people in the picture. They were most voluble in their praise of the studio's attitude, and Morris took special pains to show me the front page denial herewith of February 18th, which I don't believe you saw.

To further cement this relationship, at Mr. Morris' request we had a photograph taken at my desk with Mr. Menzies, Mr. Morris and Mr. Christmas looking over the script. This they wanted as concrete evidence they had been out to the studio and had been received. This will be published in the negro papers."

Shapiro closed with, "For the time being, at least, it seems to me that the situation is well in hand."

THE CHILDBIRTH SCENE

In the first two weeks of filming, as George Cukor struggled to set the tone for the production and deliver footage that would satisfy his producer, one writer after another was tinkering with the script, changing dialog and adding, deleting, and combining scenes. Despite promising not to do so, Cukor, too, was making changes as he directed scenes.

Selznick had been concerned about Cukor's work for months. Long before principal photography began, he had noticed that the screen tests Cukor directed were significantly longer, often as much as thirty to forty percent longer, than the estimates provided by his film editor, Hal Kern, and estimators at MGM. Selznick was increasingly concerned that Cukor would make a six-hour film from a four-hour screenplay. Cukor blamed the ever-changing script. Their differences came to a head as Cukor filmed the childbirth scene.

They began the scene on Tuesday, February 7, shortly before lunch, having just finished the bonnet scene between Rhett and Scarlett. The shots of Scarlett sending Prissy to fetch Dr. Meade then tending to Melanie in bed were first. They continued the work the next day and at 4:35 p.m. began setting up the "shadow effect scene" with Scarlett, Melanie, and Prissy. The Production Code prohibited the depiction of childbirth as painful. Consequently, changes had been made to the dialog, and they filmed the scene in silhouette to avoid showing Melanie's or Scarlett's face.

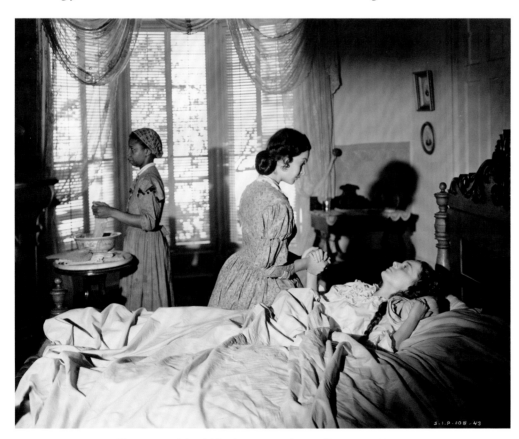

This portion of the childbirth scene was shot in silhouette to mitigate some of the issues the Hays Office had with the subject matter.

Concept painting for the childbirth scene.

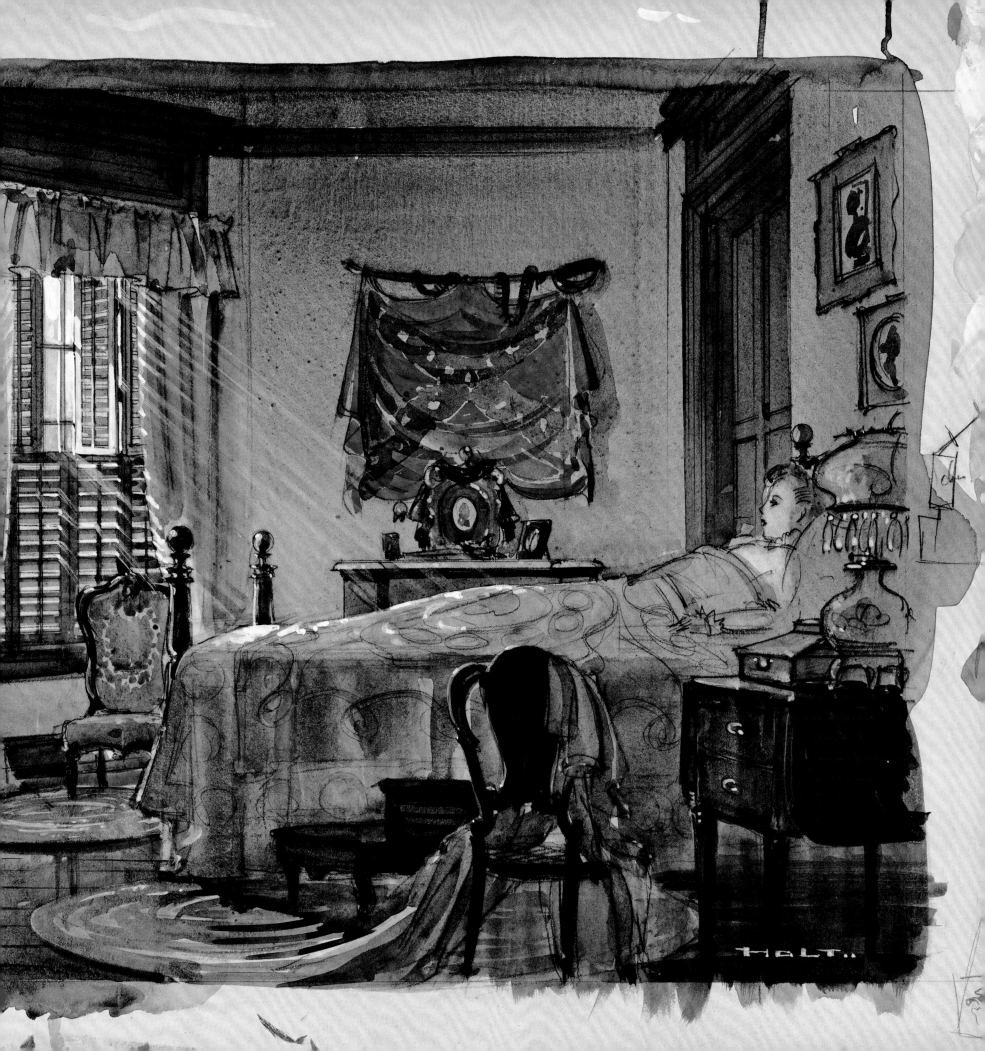

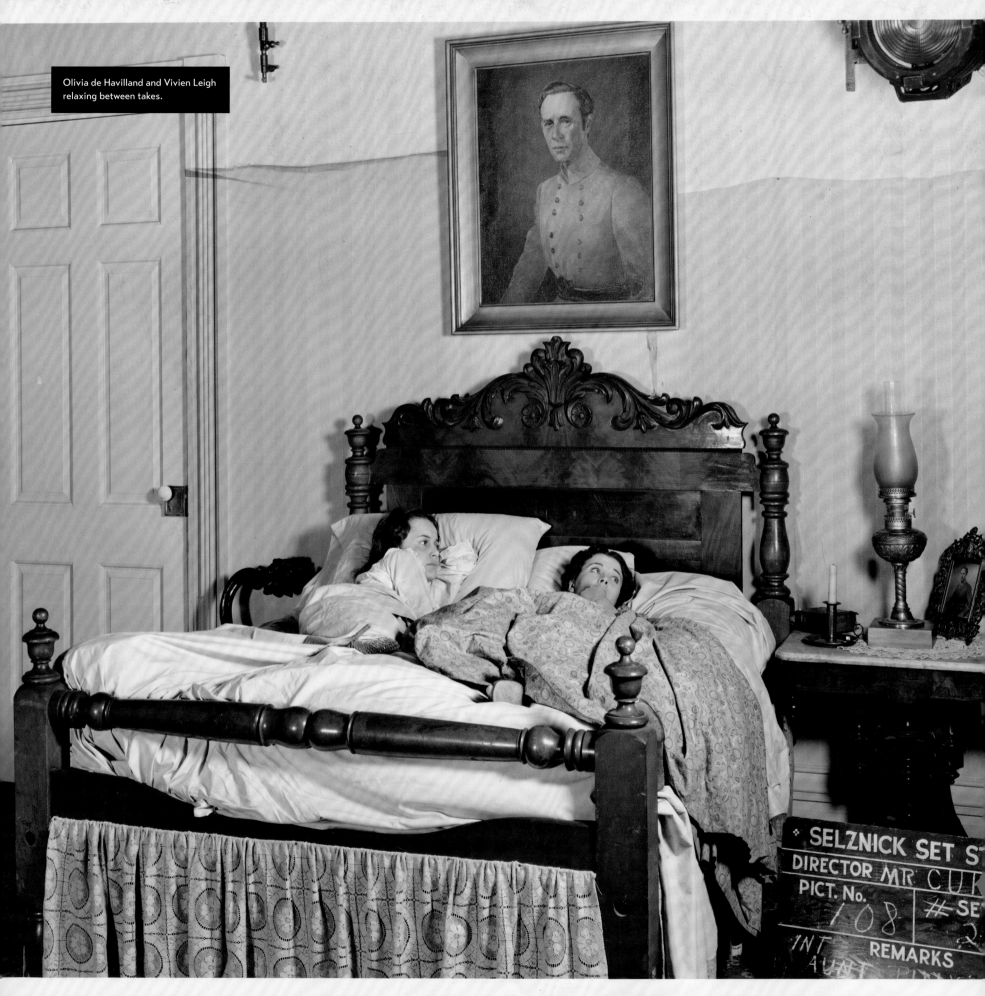

Olivia de Havilland and Vivien Leigh relaxing between takes.

SELZNICK SET ST
DIRECTOR MR CUK
PICT. No.
108 # SE
 Q
INT REMARKS
AUNT PIT

On February 8, Selznick told Cukor he wanted to see and approve rehearsals and blocking of scenes before they were shot. Again, Selznick found himself at odds with Cukor over tempo. Cukor wanted the childbirth scene to be tense and somewhat panicked. Selznick wanted a deliberate pace and an oppressive feeling.

Over the next several days, through the morning of Tuesday, February 14, the company completed the childbirth scenes, including Rhett carrying Melanie to the wagon. That afternoon, they worked on the scene in which Scarlett gives a sash to Ashley as he leaves for the war. They continued the next morning, but shooting did not go well. Leslie Howard was late and had problems remembering lines and action. They tried the scene with Howard sitting. One shot was ruined by the sound of an airplane overhead. The company was dismissed early, shortly after 4 p.m., because Vivien Leigh said she felt ill. Leigh knew Cukor had resigned from the production. She had grown fond of him, and this was the last scene he directed on *Gone With The Wind.*

Mr. George Cukor

February 8, 1939

Dear George:

You will recall that before we started the picture we had a long discussion concerning my anxiety to discuss with you in advance the points that I personally saw in each scene. We had both hoped that we would have a period of rehearsals and that we would have a chance to see the whole script rehearsed. This, for many reasons, was impossible. Then we discussed seeing each scene rehearsed, and this idea was in turn lost sight of in the pressure of many things.

Now the idea becomes more important than ever, because we have little or no opportunity in most cases even to discuss each rewritten scene before you go into it. I therefore would like to go back to what we discussed, and to try to work out a system whereby I see each block scene rehearsed in full before you start shooting on it. I am worried as to the practicability of this and as to whether it would lose too much time, but I should appreciate it if you would give some thought to it, as it might even save time in the long run. Also, it would avoid the necessity of my coming down on the set at any other time; any feeling on my part that I ought to go down to make sure a point we had intended has been made clear to you; would avoid projection room surprises to me; and, conceivably, would be of considerable service to you. Therefore, unless you see something in the way of the plan, I'd like, commencing immediately, to be notified when you are rehearsing each block scene. If this means I have to get in at the same time as the rest of you, so much the better --- I'll get home earlier and Irene will appreciate it!

D.O.S.

dos:bb

VICTOR FLEMING IS HIRED—HIATUS

Selznick had considered replacing George Cukor with Victor Fleming as early as September 1938. Fleming was a seasoned, veteran director, a former cinematographer, and, as the director of *The Wizard of Oz*, experienced with Technicolor. Once Cukor left the production, Fleming was Selznick's first choice as a replacement, and MGM, owning a fifty percent stake in the production, willingly agreed to the change.

But, like Cukor, Fleming did not like the Howard-Garrett script and preferred to start over with the Sidney Howard version. It still needed work, however, and Selznick agreed to a two-week hiatus while they got the screenplay in shape.

John Lee Mahin, friend and frequent collaborator of Victor Fleming, went to Palm Springs with Fleming and Selznick to work on the script. Although they made some fundamental decisions about the plot, they did not finish the script. So Selznick called on his old friend Ben Hecht. In his 1954 autobiography, *A Child of the Century*, Ben Hecht said he rewrote the screenplay in a week, with Fleming and Selznick telling him the story and acting out the roles as he typed.

Though he now had a workable script, Fleming's time as director was not without problems. Selznick was already looking for a replacement for cinematographer Lee Garmes who, feeling he was being blamed for mistakes made by the Technicolor advisors and operators, was only too happy to bow out. And Robert Gleckler, who had already filmed his first scene as Jonas Wilkerson, died unexpectedly just as Fleming was about to start.

Fleming was a no-nonsense leader, and many in the cast and crew, especially Vivien Leigh, chafed under his direction. But he worked quickly and efficiently, and took Selznick's continued criticism and interference in stride.

This undated interview with Patsy Ruth Miller was likely conducted by Russell Birdwell, Selznick's head of publicity. Miller's husband, John Lee Mahin, was a friend and frequent collaborator with Victor Fleming, the new director of *Gone With The Wind*. See appendix for complete text.

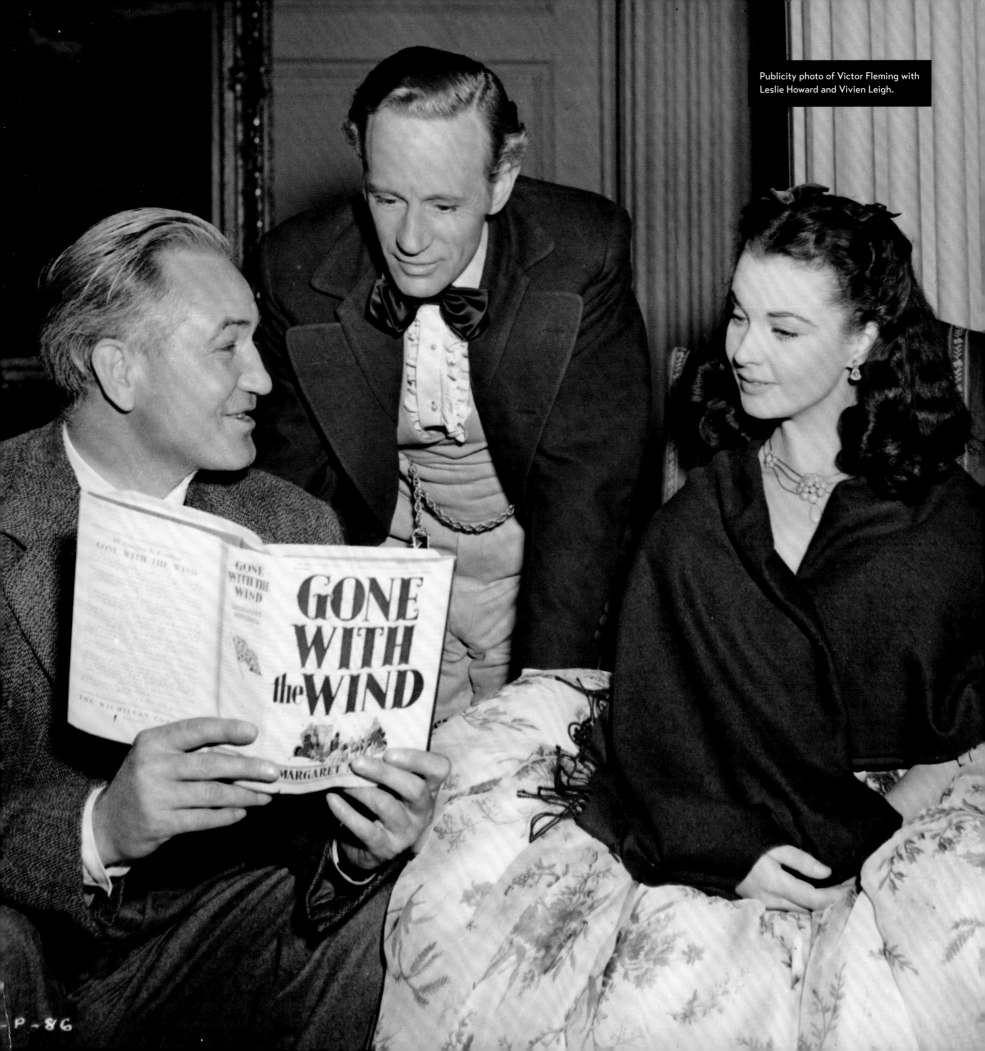

P-86

(ABOVE) Victor Fleming with
Vivien Leigh.

(RIGHT, TOP) Fleming with
Susan Myrick and Clark Gable.

(RIGHT, BOTTOM) Fleming with
Ona Munson.

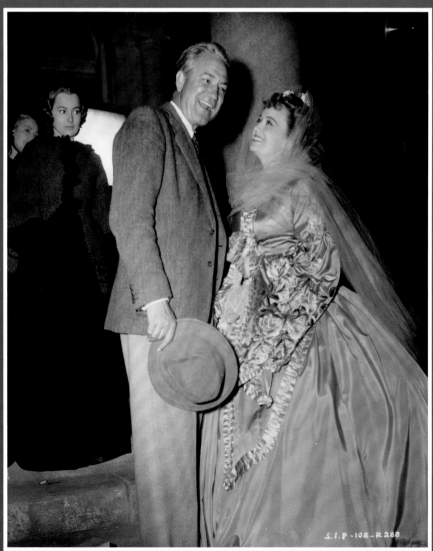

"GONE WITH THE WIND"

SCRIPT NOTES

Mr. Selznick
Mr. Fleming
Mr. Mahin

1. Give Scarlett more right to believe in her own heart, the
 minute she does the unconventional thing of telling Ashley
 she loves him, he will immediately accept her in spite of
 his rumored engagement to Melanie.

2. Possibly draw parallel between Ashley's scene in the Dining
 Room in his talk to the men (showing his fear of losing what
 is through war) and his talk to Scarlett in the Library. In
 other words he might feel he doesn't want to marry Scarlett
 because he will also lose there.

3. Dining Room scene should contain polite clash between Ashley
 and Rhett. That is, both disagree with the other men but
 have different reasons.

4. Establish reason for Rhett to be at the Barbecue where he
 seems so obviously unwelcome and out of key.

5. In connection with the above, dramatize Rhett as a terrific
 duelist and mention his calling out and killing the brother
 of the girl he took buggy riding.

6. Instead of showing marriage of Hamilton and Scarlett, show
 scene after the marriage when Hamilton and Ashley are leaving
 with their troop in uniform. Marriage of both couples can be
 easily planted in the dialogue and such a scene of goodbye
 lends to more poignancy and size.

7. Go to Montage of the South beating hell out of the North and
 end with the first battle of Bull Run, shooting over the
 parasols of the Northern ladies who have come out to watch
 the battle in their carriages.

8. Belle must have some reason to give Melanie the money at the
 bazaar. Melanie should be established as head of the bazaar
 committee.

9. Whole Bazaar Scene needs work. Rhett should be physically
 connected with the end in some manner.

10. Bazaar Scene to be re-written so that Scarlett takes Rhett as
 a means to lift her out of her doldrums and give her a good
 time again. She even excuses his relationship with Belle, she
 is that selfish. The subsequent Bonnet Scene is Rhett's
 misinterpretation of her attitude.

m:gw

Miss Barbara Keon

3/3/39

Please remind me at our next script conference about placing the "think about
that tomorrow" line several times in the course of the script and keep remind-
ing me of it as we progress with the script changes.

DOS

dos*f

Mr. Henry Ginsberg

 Immediate

2/28/39 (Dictated 2/27/39)

Nobody seems to be paying any attention to the accent problem
during this all-important interim period. We know that Leslie
Howard has made little or no attempts in the direction of accent
and since he is on our payroll there is little excuse for this.

I mentioned to Gable today the necessity of his doing a little
work on it and I think this should be followed up.

I am particularly worried about Vivien Leigh since she has been
associating with English people and more likely than not has
completely got away from what was gained up to the time we stopped.

I wish you would have somebody keep an eye on this whole question,
especially since I have occasional worries as to whether we are
safe in turning this over to Myrick instead of continuing with
Price.

In any event, somebody ought to take the responsibility of watch-
ing this since Mr. Fleming is less likely to be interested in it
than was Mr. Cukor.

May I have some word from you on this?

 DOS

dos*f

(ABOVE) Because he had received so many letters
urging him to be careful with the southern accent,
Selznick never let up on the actors and advisors.
Susan Myrick was so vigilant that Selznick eventually
turned over the responsibility for accents to her.

(ABOVE, LEFT) Notes for the work session between
Selznick, Victor Fleming, and John Lee Mahin.

(LEFT) Even after the hiatus, changes to the
screenplay continued to be made.

THE WEDDING

Now under Fleming's direction, at about 10:30 a.m. on Friday, March 3, after filming Ellen's return to Tara, the crew moved to Tara's parlor set on Stage 3 to film the wedding sequence. Tracks were laid down for a dolly shot that would start on the wedding bouquet then move to Scarlett and the group. During lunch a chandelier was hung, and shooting began after lunch. Over the course of the afternoon, the lighting was changed, the lens was changed, and the cast was rehearsed. Shooting was completed at 6 p.m.

Scarlett rushes into marriage with Charles Hamilton, wearing her mother's wedding dress rather than having one custom-made. To create a dress that was a little too long and a little too wide for Scarlett, Walter Plunkett fitted the costume on the dress form of Barbara O'Neil, who played Ellen O'Hara.

Scarlett's wedding dress by Walter Plunkett features more than 150 silk leaves.

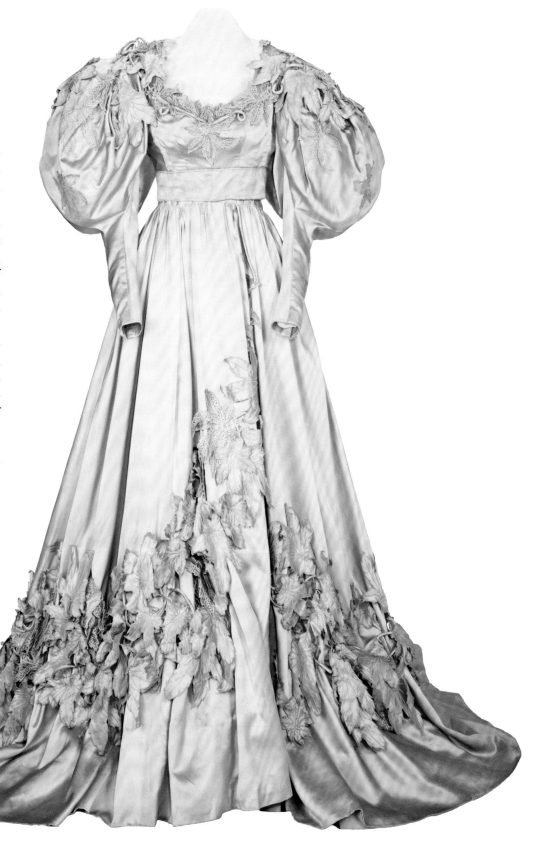

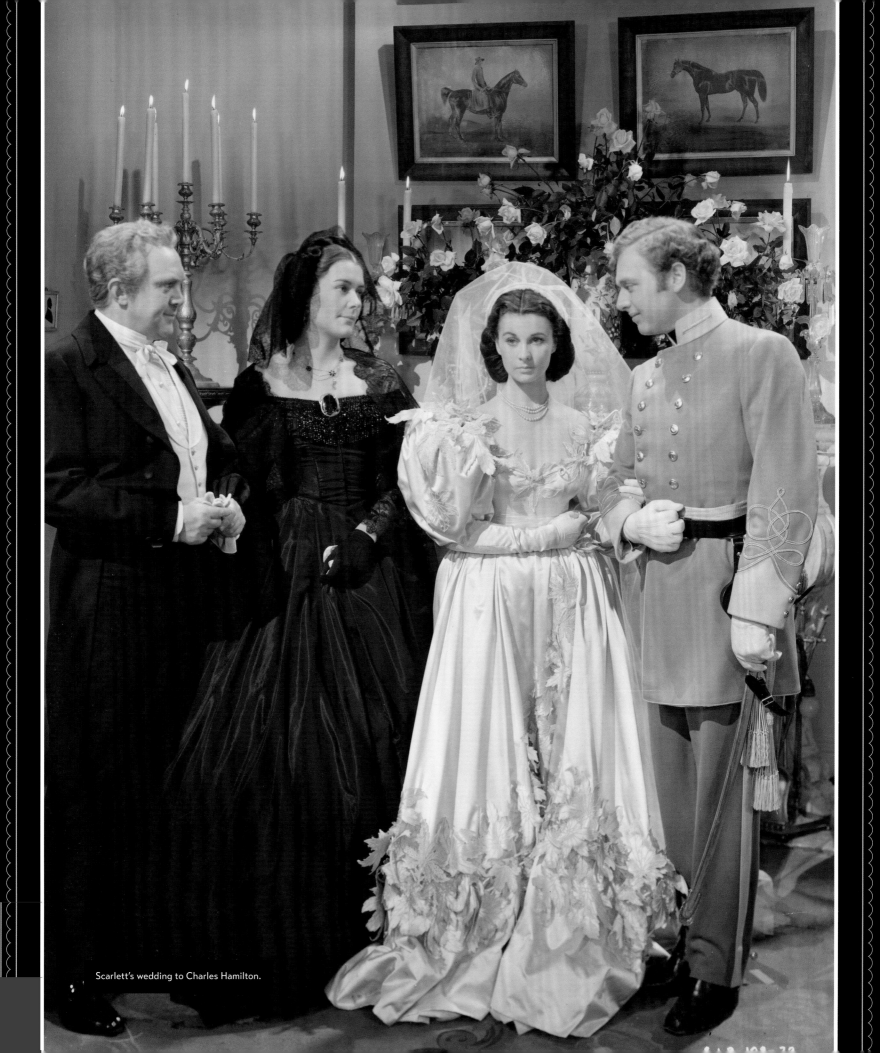

Scarlett's wedding to Charles Hamilton.

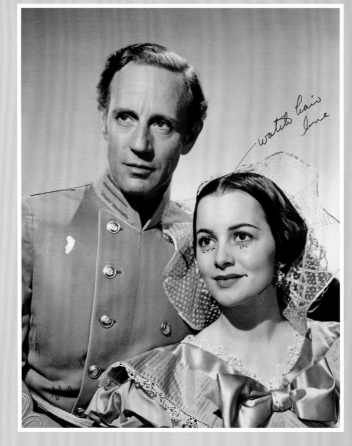

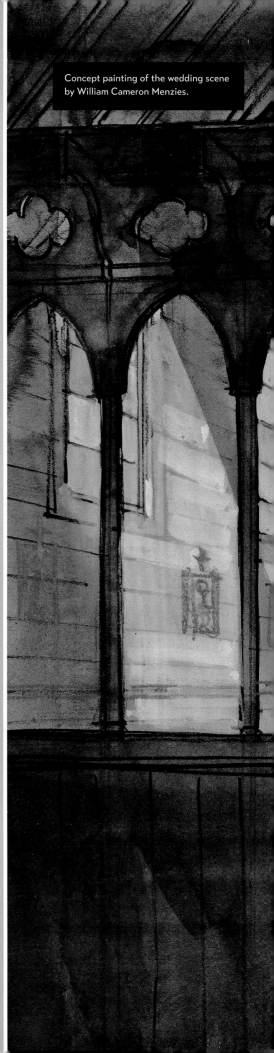

(ABOVE, LEFT) Walter Plunkett adjusts Leslie Howard's costume.

(ABOVE, RIGHT) Publicity portraits, like this one of Leslie Howard and Olivia de Havilland, were carefully retouched to achieve an appearance of larger-than-life perfection.

(RIGHT) Monte Westmore and Hazel Rogers prepare Olivia de Havilland for the wedding scene.

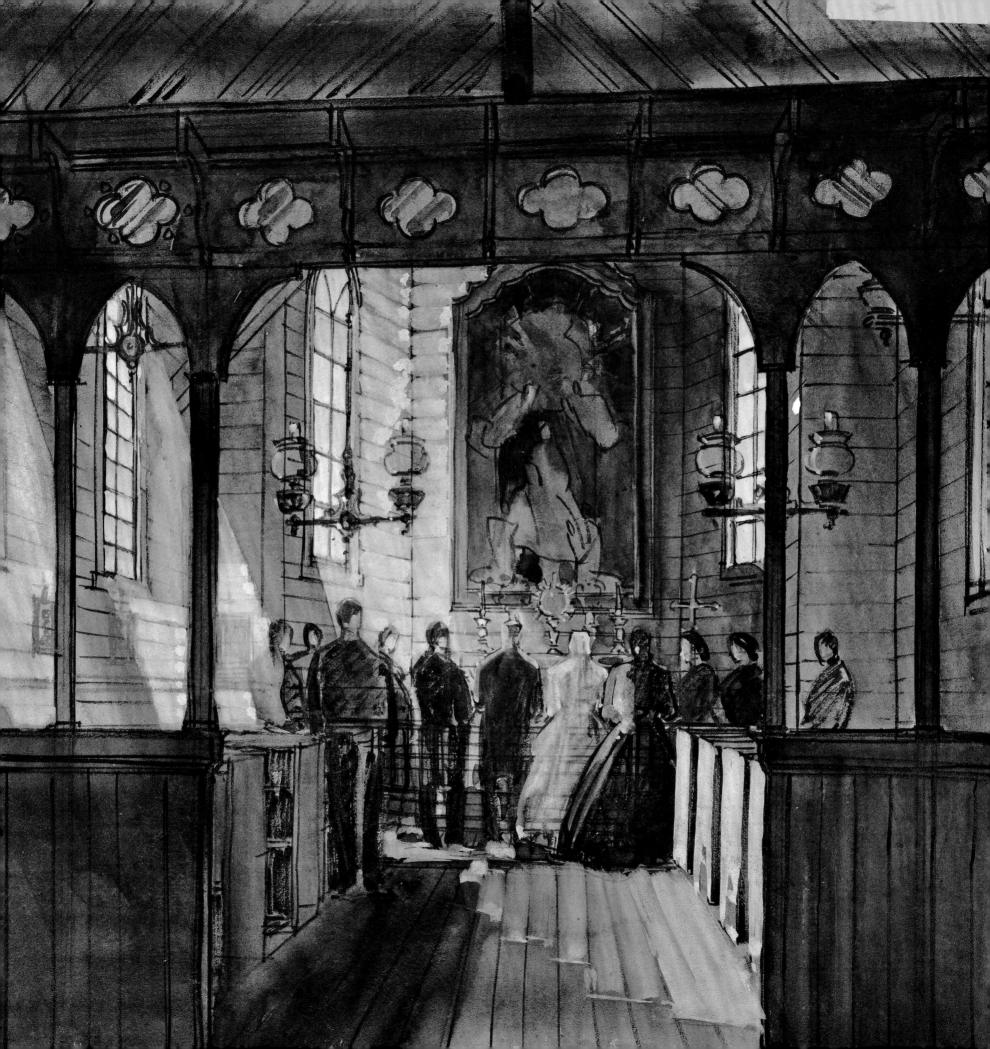

SCARLETT'S WALK WITH GERALD

On the morning of Saturday, March 4, Fleming had the company set up at the creek location on the 40 Acres lot. A stunt double for Gerald began riding a white horse and jumping over a fence. The double fell off the horse twice, so a "cowboy" was made up and costumed and realized two good takes. Close shots of Thomas Mitchell, as Gerald, dismounting and shots of Vivien Leigh, as Scarlett, were shot before lunch was called.

Fleming then changed the camera setup to a roadway for the long dolly shot of Gerald's walk with Scarlett. Four takes were made with the camera raised to avoid the sky, because Selznick felt the natural sky did not reproduce dramatically enough in Technicolor. Shortly before 3 p.m. the crew stopped for almost an hour to "fix" dogwood trees in the background and to paint the roadway red. The company was dismissed at 5:15 p.m.

Scarlett's walk with Gerald, like the porch scene, was shot with Scarlett wearing the green-sprigged "barbeque dress." Since it was decided that the porch scene would be reshot, Scarlett would wear the white "prayer dress" in this scene as well.

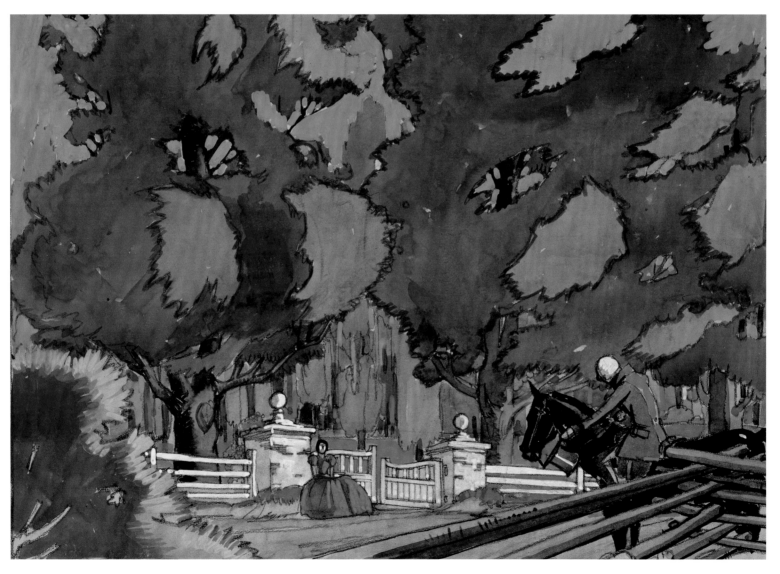

Concept painting by William Cameron Menzies of Scarlett's walk with her father, Gerald.

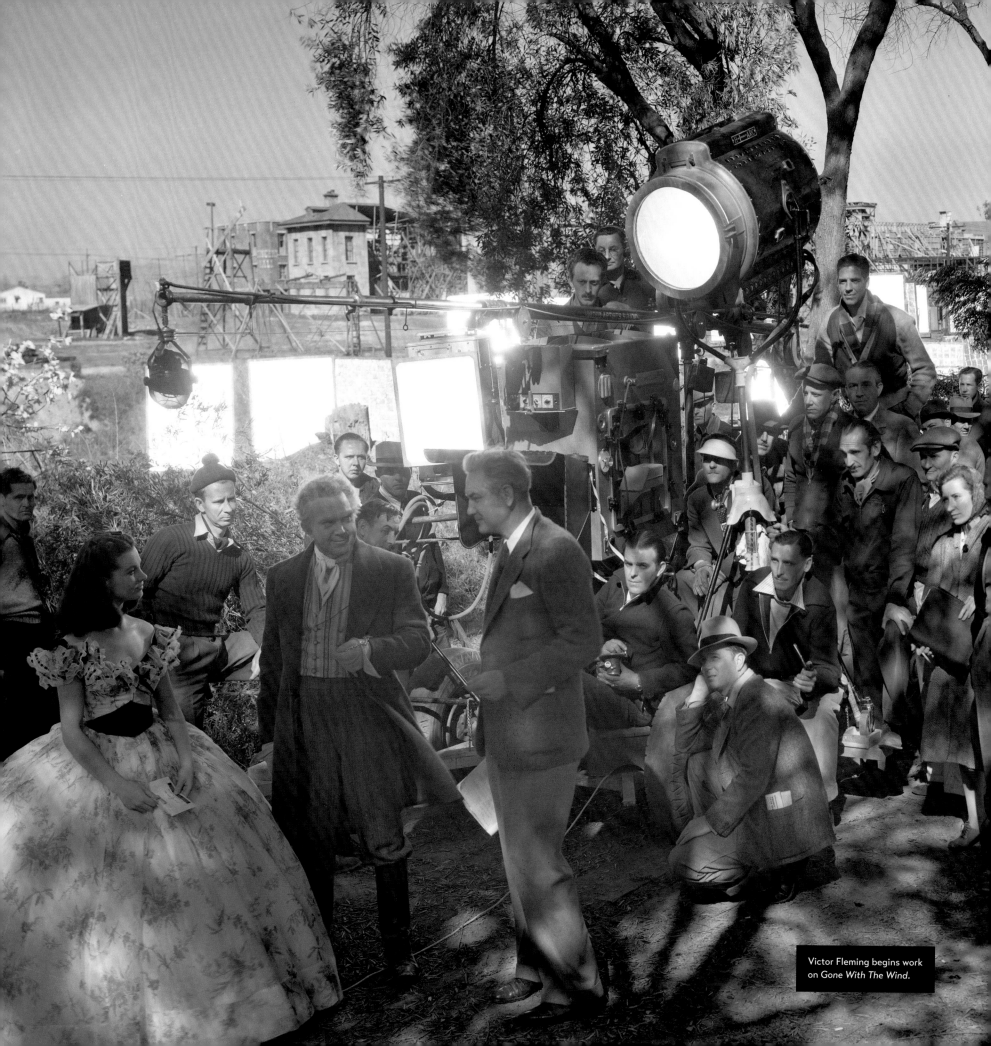

Victor Fleming begins work on *Gone With The Wind*.

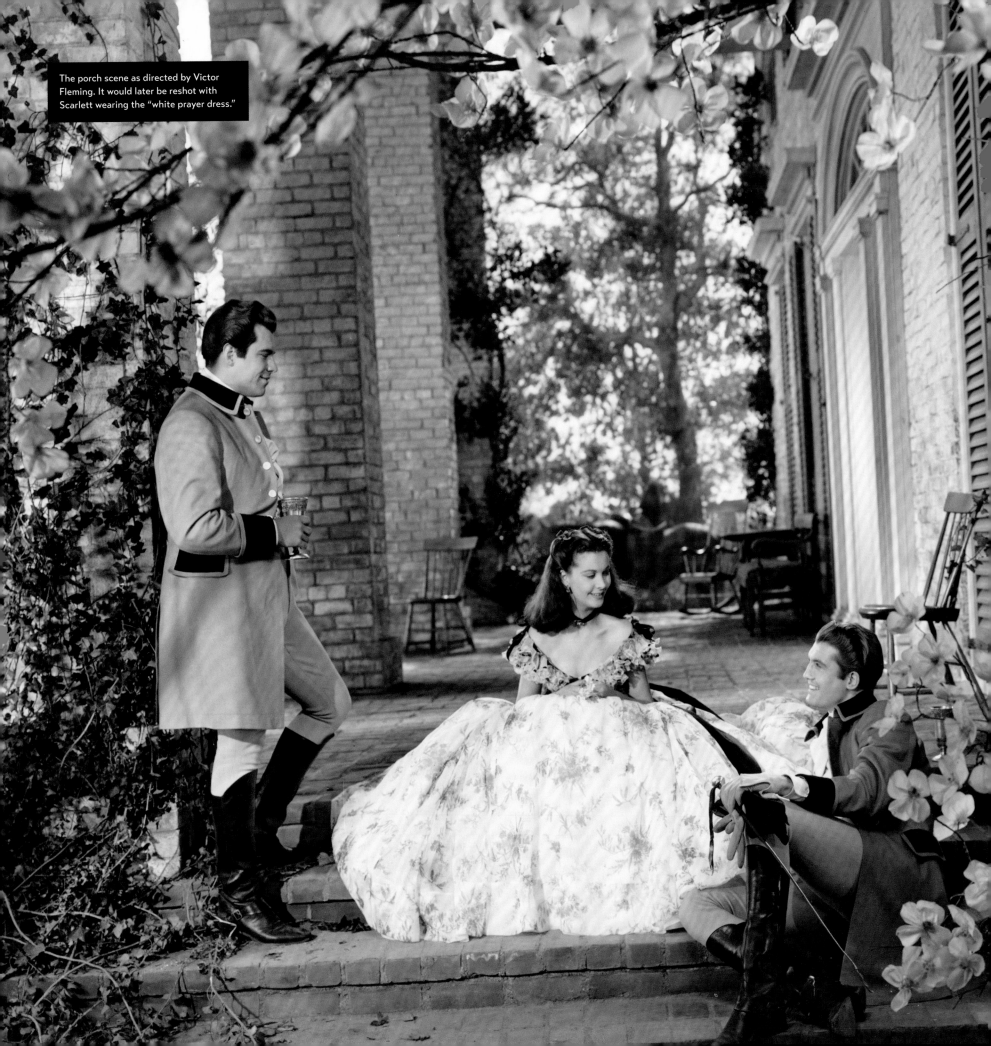

The porch scene as directed by Victor Fleming. It would later be reshot with Scarlett wearing the "white prayer dress."

108	"GONE WITH THE WIND"	Mar. 4, 1939
Prod. No.	Picture	Date

SET EXT. CREEK LOCATION (Tara) ~~STAGE NO.~~ 40 Acres.

TIME	LEGEND
8:00 AM	Company call.
	Lining up and rehearsing scene with Double for Gerald riding
	to foreground and jumping over fence.
9:04	SHOOTING SCENE 9 B. take 1. Incomplete
9:10	" " 2 Complete. NG action
9:12	" " 3 " "
9:14	" " 4 In." (rider falls in f.g.)
9:28	" " 5 Complete. NG. action
9:40	" " 6 Incomplete. (rider falls in f.g.)
	Cowboy being made up and costumed to try scene, as above.
10:15	SHOOTING SCENE 9 B. take 7. OK Print.
10:20	" " 8. OK Print.
	Changing set-up - Close shot Gerald, dismounting.
11:00	SHOOTING SCENE 10 take 1. Complete. NG.
11:02	" " 2. Incomplete.
11:04	" " 3. Complete. HOLD
11:10	" " 4. OK Print.
	Changing set-up - to Long shot Scarlett, running foreground.
11:54	SHOOTING SCENE R. 10.A. take 1. NG action
11:58	" " 2. NG action
12:00	" Sc.R.10.B. take 1. OK Print. (exits Left)
12:05 PM	Sc.R.10.A. " 3. OK Print. (exits right)
	Changing set-up to Close shot Scarlett.
12:28	SHOOTING SCENE R.10.C. take 1. Complete NG. action
12:30	" " 2 OK Print.
12:32	" " 3 OK Print.
12:38	". R.10.D. " 1. OK Print. (Different dialog.)
12:40	LUNCH -on location (Crew ½ hr.)
	Changing set-up over to Roadway - and preparing Long Dolly
	shot along road - Rehearsing Dialogue and dolly action
	with Gerald and Scarlett.
2:36	SHOOTING SCENE R. 13 take 1. Complete. NG action
2:38	" " 2 HOLD
2:42	" " 3 OK Print.
2:50	" " 4 OK Print. (Camera raised to avoid
	Lining up next set-up. sky)
	Fixing dogwood trees in b.g. and painting the roadway red.
3:40	Rehearsing action and dialogue,(Dolly shot)
3:46	SHOOTING SCENE R. 13.A take 1. Complete. NG.action
3:50	" " 2. OK Print. (Reloading)
4:00	" " 3. OK Print.
	Lining up Close shot toward Scarlett -Gerald at R.f.g.
4:55	SHOOTING SCENE R. 13.B. take 1. Incomplete. Plane noise.
5:00	" " 2. " Waiting for plane to exit.
5:06	" " 3. Complete. NG. action.
5:10	" " 4. Incomplete. Tears fall
	black, on account of mascara on eyes.
5:15	COMPANY DISMISSED.

Daily production log for Scarlett's walk with Gerald.

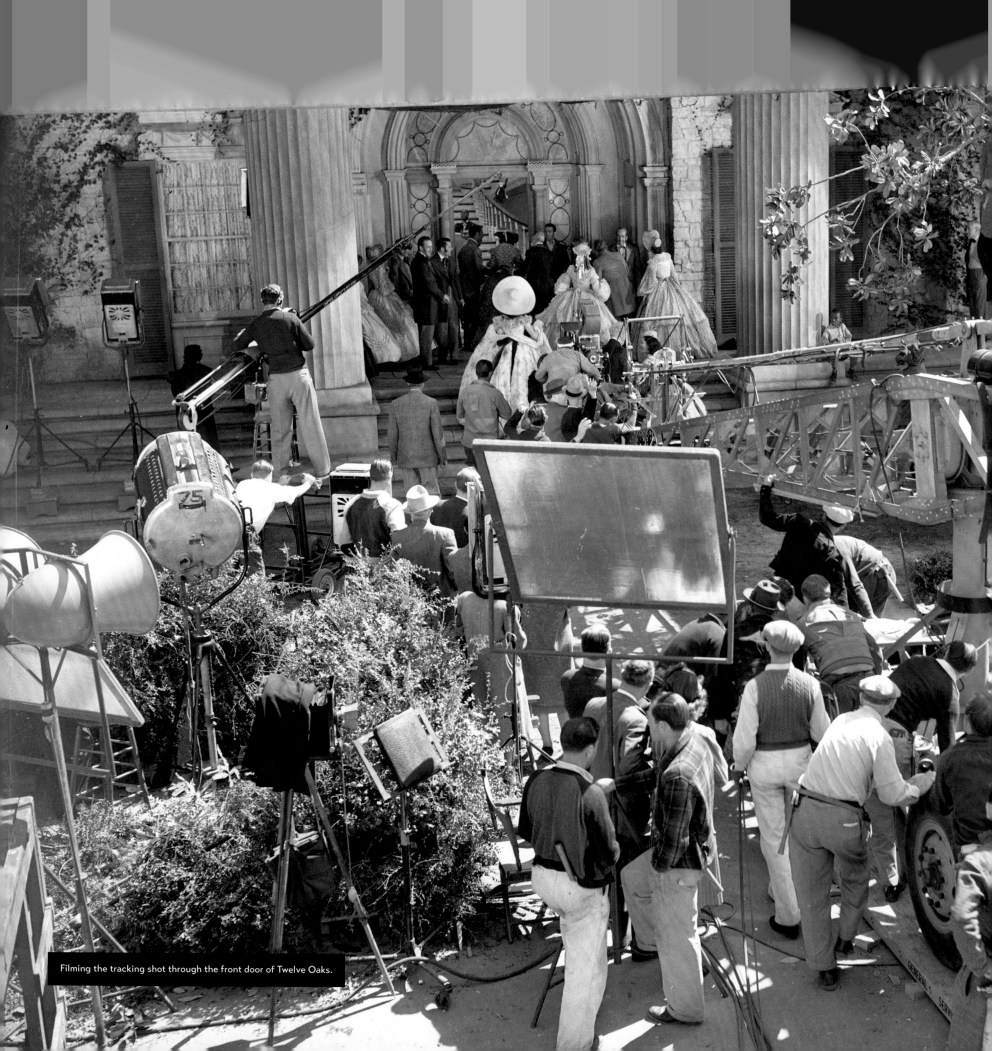

Filming the tracking shot through the front door of Twelve Oaks.

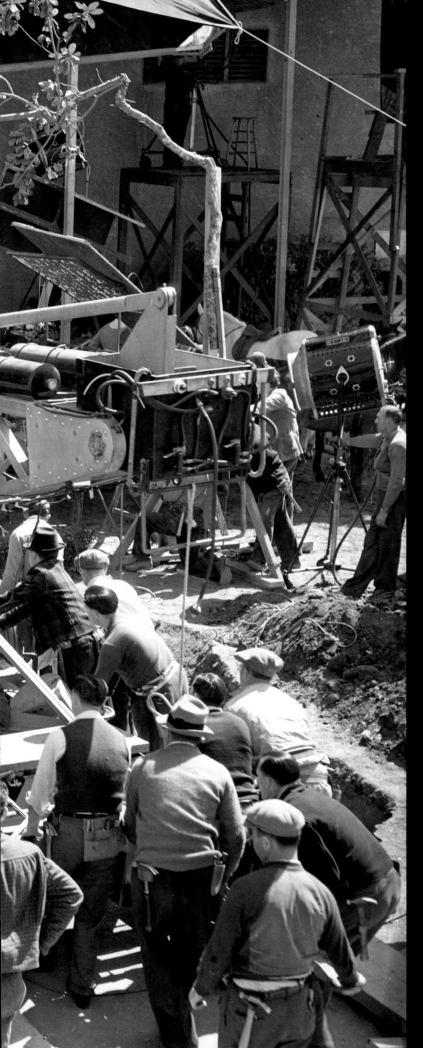

TWELVE OAKS

Filming at Twelve Oaks, on Stage 11, began in the library on Tuesday, March 7. The crew worked with stand-ins until Selznick arrived at 11:25 a.m. to discuss with Fleming how he wanted the scene played. Shooting began at noon, broke for lunch, and then continued for the rest of the day.

The next morning work began on the complicated shot of the O'Haras arriving at Twelve Oaks and walking through the front door. Rehearsal and camera boom setup began at 8:45 a.m., and shooting began on the first part of the scene at 11:55 a.m. After several false starts involving horses in wrong positions and bumps to the camera boom, takes seven and eight were good, and the company broke for lunch.

An overhead scaffolding was removed, and the camera was set up to film a medium-long shot toward the entrance to Twelve Oaks, which would follow Scarlett through the door and into the mansion.

The next morning, Fleming began shooting Scarlett's introduction to Melanie in the reception hall of Twelve Oaks. Nineteen takes were made of the scene with Scarlett, Ashley, Melanie, and Charles Hamilton before the company stopped for lunch. The afternoon was spent shooting close-ups.

The scenes on the stairway with Scarlett flirting with various men and gossiping with Cathleen Calvert were shot on Friday, March 10. Filming for the shot of Rhett Butler at the foot of the stairs started filming at 5:15 p.m.

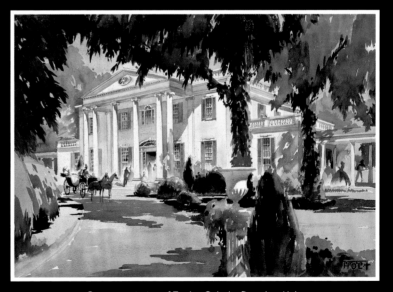

Concept painting of Twelve Oaks by Dorothea Holt.

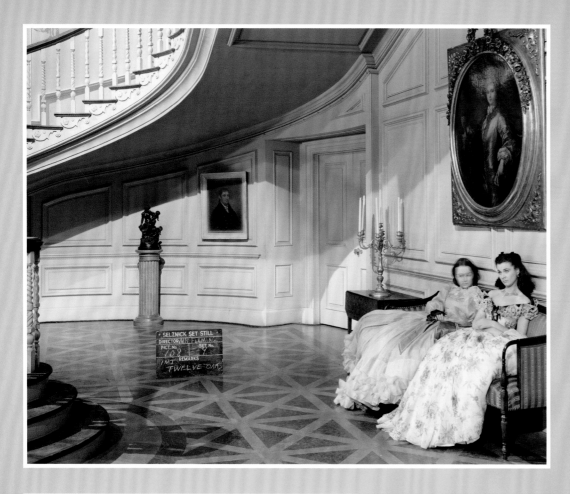

(ABOVE) Olivia de Havilland (left) and Vivien Leigh between takes.

(LEFT) Costume design by Walter Plunkett of Melanie Hamilton's barbeque dress. The caption reads: "She was a tiny, frailly built girl . . . She had a cloud of curly dark hair which was so sternly repressed beneath its net that no vagrant tendrils escaped, and this dark mass, with its long widow's peak, accentuated the heart shape of her face . . . Her grey organdie dress, with its cherry-colored satin sash . . . and the yellow hat with long cherry streamers . . . her heavy earbobs . . . down from loops of tidily netted hair . . . black lace mitts."

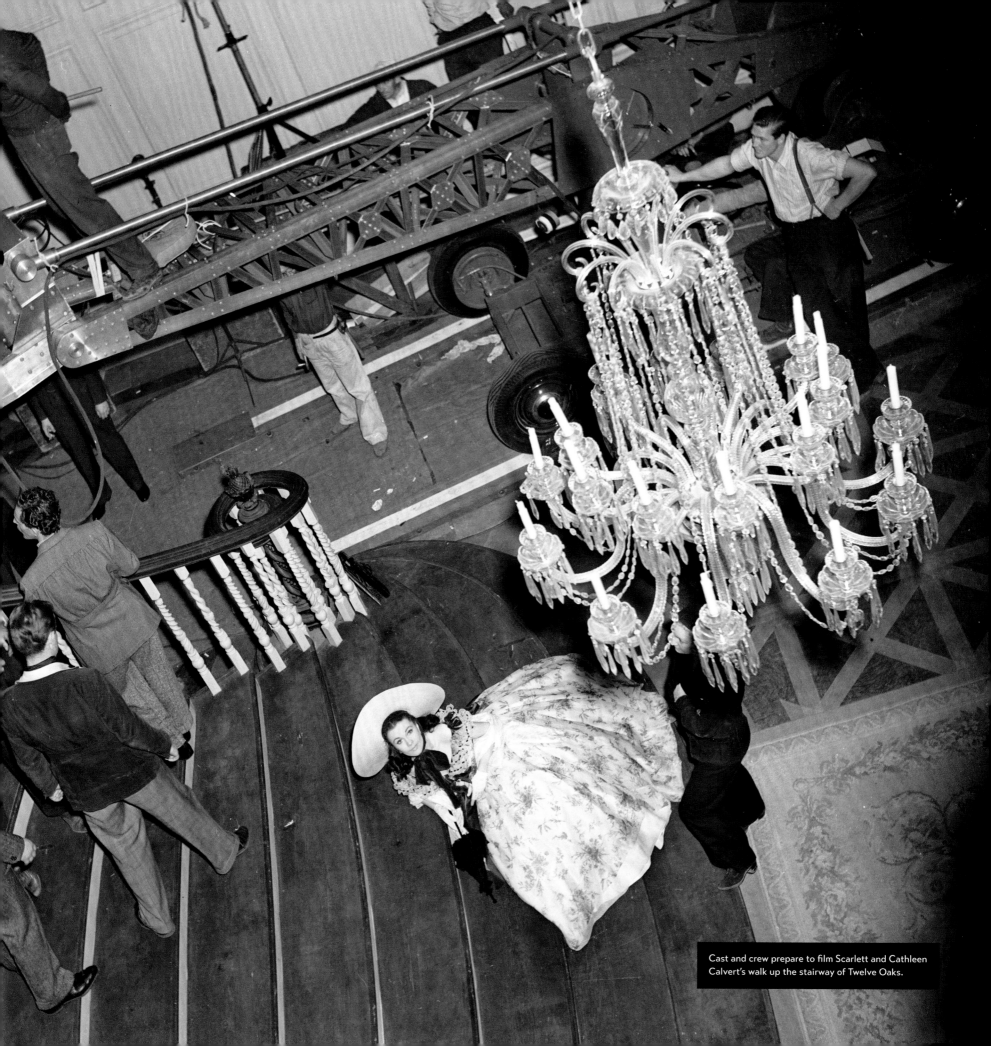

Cast and crew prepare to film Scarlett and Cathleen Calvert's walk up the stairway of Twelve Oaks.

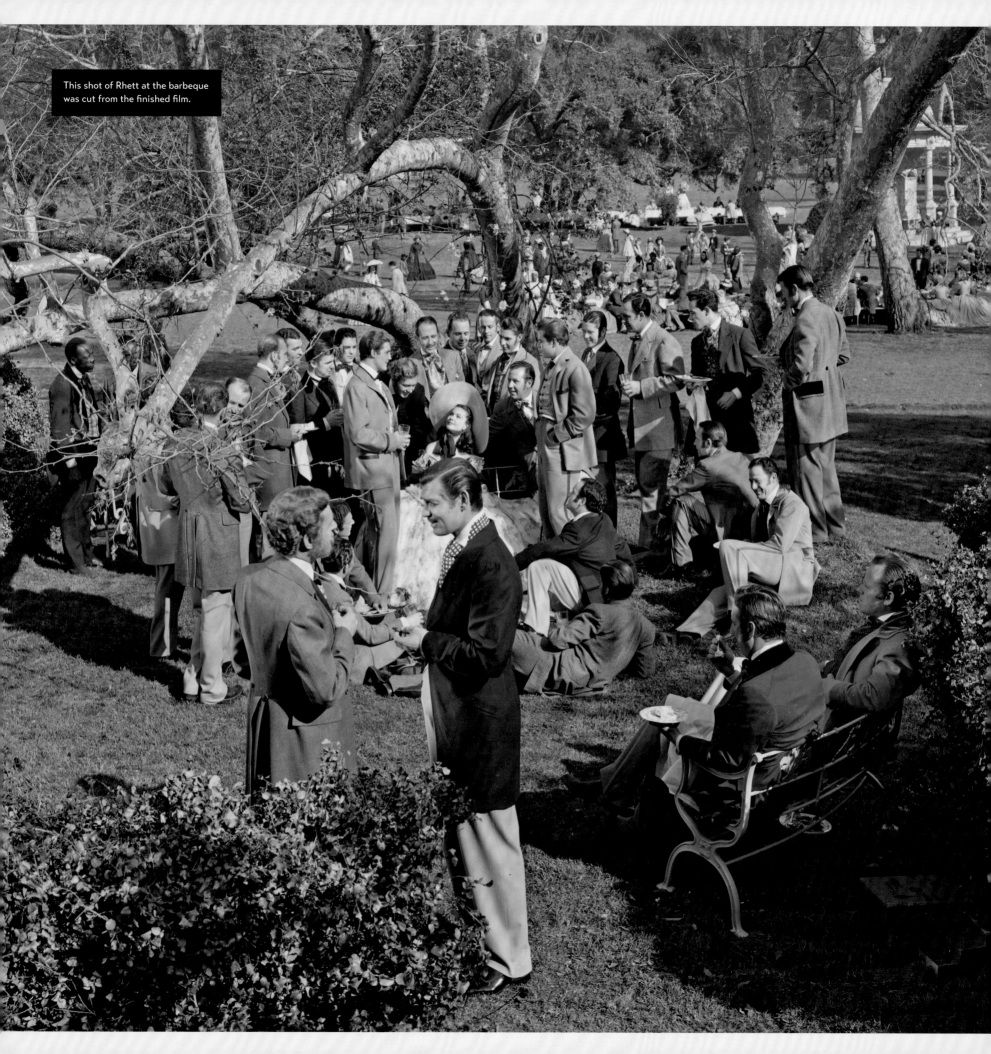

This shot of Rhett at the barbeque was cut from the finished film.

The outdoor scenes of the barbeque began shooting off the lot at Busch Gardens on Saturday, March 11. The morning was spent shooting the scene of Ashley and Melanie as seen through a window and a long shot of the scene through a doorway. After lunch, the long shot of Scarlett "surrounded by boys" was filmed, and "wild tracks" (audio without image) of birds and other outdoor sounds were recorded.

On Monday morning the crew completed the stairway scenes and in the afternoon shot the scenes of Scarlett leaving the library and avoiding India and Melanie. Tuesday morning the crew was back at Busch Gardens. They waited until 10 a.m. for Leslie Howard to arrive. After the lunch break, they filmed the close shots of Scarlett surrounded by young men.

Wind - Wardrobe

Mr. R. A. Klune cc: Mr. Fleming

3/15/39

A brief visit to the set this afternoon disappointed me in the costumes of the four girls walking down the great staircase. The costumes have no real beauty, especially as to color. I discussed this with Plunkett and Lambert and found that the technicolor experts have been up to their old tricks of putting all sorts of obstacles in the way of real beauty.

The costumes of the picture, and the sets also, should have dramatized much more than we have done to date, and much less than I hope they will do in future, the changing fortunes of the people with whom we are dealing. The first part of the picture - especially the sequences at Twelve Oaks - have been so neutralized that there will be no dramatic point made by the drabness of the costumes through the whole second half of the picture. We should have seen beautiful reds and blues and yellows and greens in costumes so designed that the audience would have gasped at their beauty and would have felt a really tragic loss when it saw the same people in the made-over and tacky clothes of the war period. The third part of the picture should, by its colors alone, dramatize the difference between Scarlett and the rest of the people - Scarlett extravagantly and colorfully costumed against the drabness of the other principals and of the extras.

I am hopeful that this will be corrected in such things as the bazaar re-take. I am aware that the former scene at the bazaar looked like a cheap picture post-card in its color values - but this was because we were foolish enough to over-dress the set so that it looked cheap and garish, instead of neutralising the set as to its color values, so that it was obviously an armory and playing against this the beauty of the costumes which gave us a marvelous opportunity for beautiful colors against the set which obviously gave us no opportunities. The shots that Mr. Fleming has in mind on the waltz will fulfill their complete promise of beauty only if the costumes are lovely and colorful - so that Scarlett's black is a complete contrast and so that the colors of the costumes of the others are a complete contrast with the neutral colors that we should see as the war goes on, and in fact throughout the entire picture Twelve Oaks and the bazaar were, and to a degree still are, our only opportunities for beautiful color for the entire race of people we are portraying in the entire film. In the last part we have only the opportunity of Scarlett.

We should have learned by now to take with a pound of salt much of what is said to us by the technicolor experts. I cannot conceive how we could have been talked into throwing away opportunities for magnificent color values in the face of our own rather full experience in technicolor, and in the face particularly of such experiences as the beautiful color values we got out of Dietrich's costumes in "The Garden of Allah," thanks to the insistence of Dietrich and Dryden, and despite the squawks and prophecies of doom from the technicolor experts. The color values of the costumes that she wore in the picture itself, and in some

(ABOVE) Selznick wanted an abundance of beauty and spectacle in the early parts of the film so there would be a contrast with the later parts, when the war had taken its toll on the characters. See appendix for complete text.

(ABOVE, LEFT) Concept painting by William Cameron Menzies.

(LEFT) Selznick dictated these notes about the Twelve Oaks scene less than a week before Victor Fleming began filming the scene.

"GONE WITH THE WIND"
3/2/38

NOTES for discussion: Barbeque Sequence:

Discuss Jonas Wilkerson thing in place where it is in book - while girls saying goodbye to Ellen.

Characterizations of Suellen and Carreen.
Very anxious, if possible, to characterize Carreen's unusual sweetness the one or two times we see her.

Who drives the O'Hara carriage?
Possibility of Gerald riding alongside on horseback.

Long cardboard boxes in carriage - see them also in 12 Oaks bedroom.

L.S. 12 Oaks: possibility of kids playing on lawn (book p. 94)

Describe barbeque as on pg. 93, book.

Costume notes: Parasols for girls; fawn and grey trousers for men.

Possibility of combining Honey and India, so that Chas. Hamilton is India's beau.

Be sure India's relationship is very clear.

Do we have Melanie complimenting Scarlett? (as on pg. 102, book)

Have we retained line re Kennedy: "If I couldn't get a better beau than that old maid in britches!"

Scarlett, when gathering together her men, might use stock phrase repeatedly: (pgs. 97 and 98) "Now you wait right here" -- etc.

Describe (pg. 100, book) the high rosewood ottoman on which Scarlett sits.

Use "Fiddledeedee" from Scarlett at least once in barbeque sequence.

I think we should have some action during dialogue of boys trying to get closer to Scarlett as on pg 102, with Chas. Hamilton close to her and the twins trying to dislodge him - this manoeuvering for position going on thru dialogue.

Possibility, when Scarlett looks over and sees Ashley and Melanie, even if it means forgetting angle I described today, of seeing Melanie either picking at her food or turning down food, as an even better cue to Scarlett's "I guess I'm not as hungry as I thought."

I think probably the goggle-eyed Carreen, sitting at one end of the table, is the only one of the girls who is not furious with Scarlett: she lets out big sigh as indicated on pg. 103, book.

Rhett smiles as Scarlett looks at him.

When Scarlett looks over at Rhett and says "Who's that?", cut back to Rhett laughing and staring at her (pg. 103, book)

Possibility of one line re Rhett, instead of the background about Charleston, telescoping right down to following from one of the boys with all the rage of a Southern gentleman: "Why, I understand he took a girl out one afternoon

Selznick's attention to detail often went beyond sets and costumes. Here he instructs Ray Klune to hire more attractive extras for the crowd scenes.

A wardrobe technician works on the hem of Scarlett's dress between takes.

Mr. Richards, Mr. Klune

3/9/39

I mentioned to Charlie Richards this morning the obvious desirability of having pretty girls and attractive young men on our sets, particularly in such sequences as the exterior of Twelve Oaks, the exterior of the barbecue, the bazaar, etc. Richards told me that he was doing this — but when I mentioned it to Mr. Fleming, I found that he was also unhappy about the unattractive people he had on the set, stating in particular that he had a complete shortage of pretty girls. I don't see any excuse in the world for this and wish Mr. Klune would get together with Mr. Richards on this and correct it immediately, even if we have to spend a few dollars extra to correct it.

DOS

dos*f

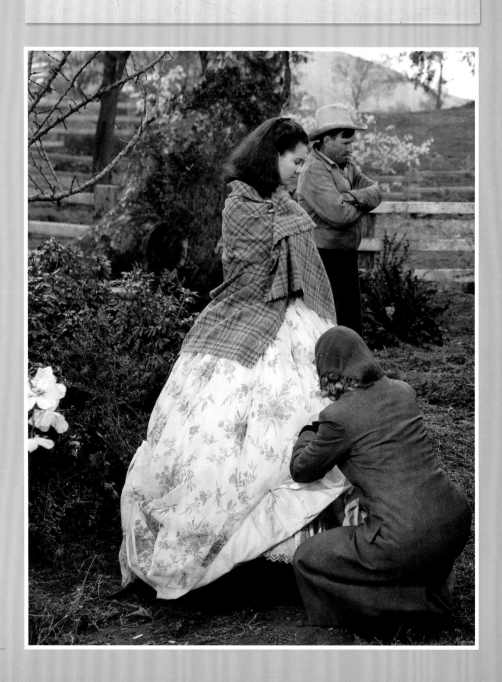

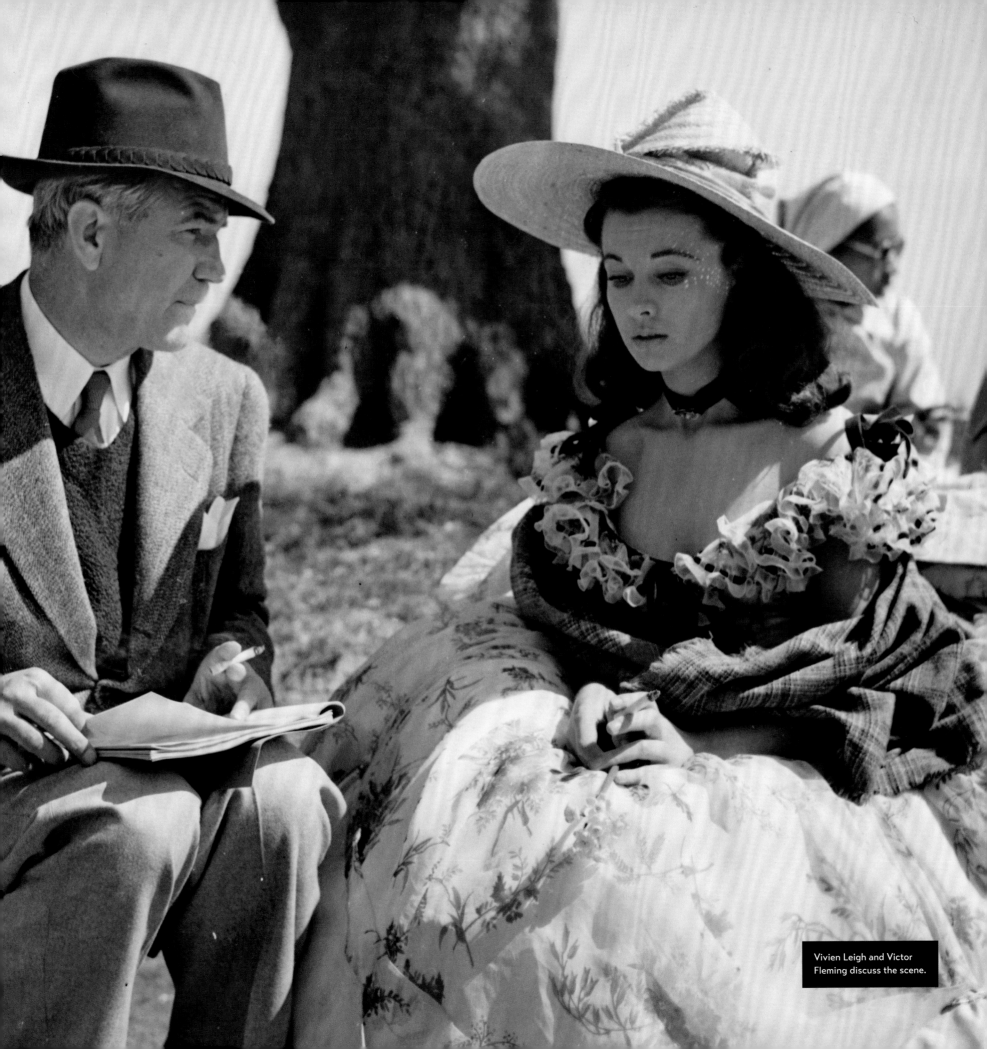

Vivien Leigh and Victor
Fleming discuss the scene.

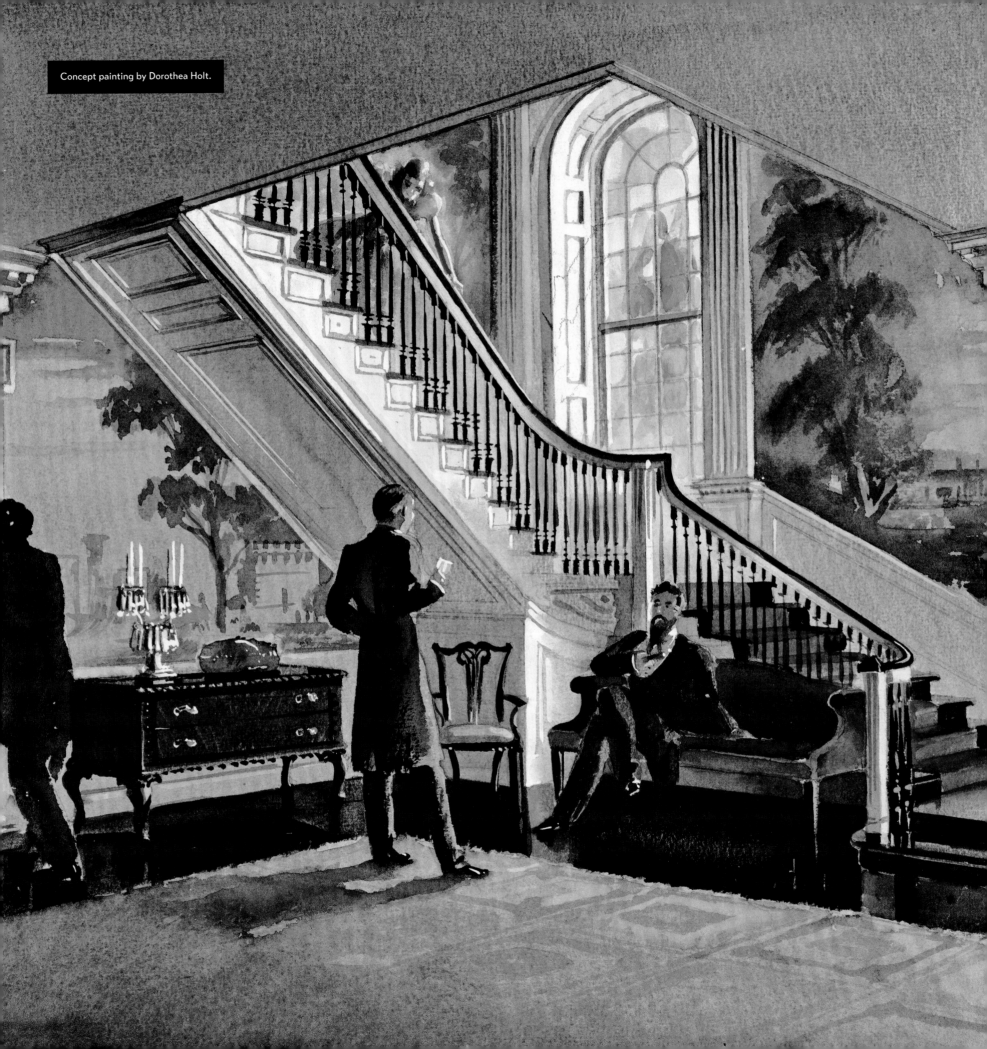

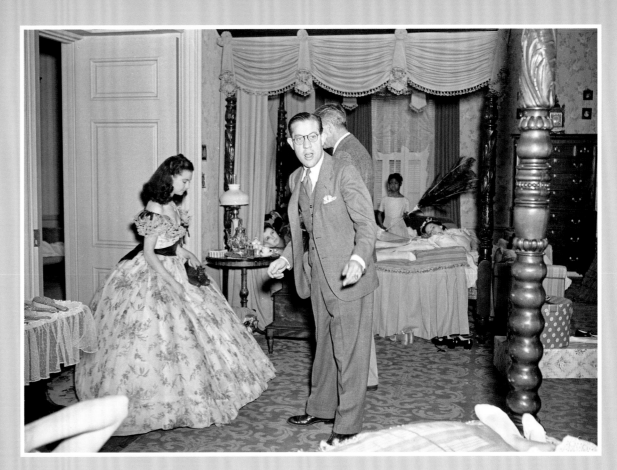

Cinematographer Ernest Haller and Victor Fleming line up the shot of Scarlett quietly leaving the bedroom at Twelve Oaks.

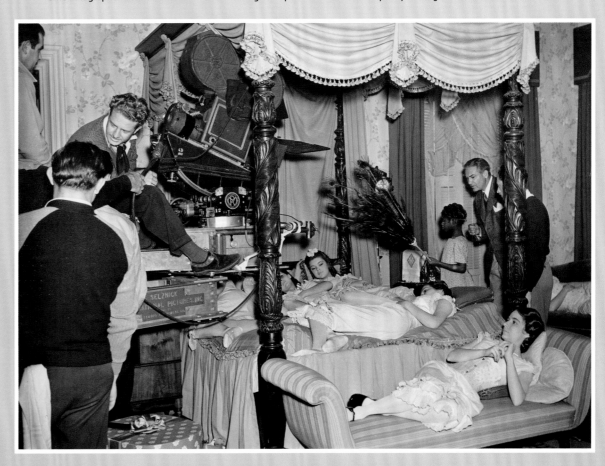

Victor Fleming (right) directs the sleepy time scene. Alicia Rhett is on the couch in the foreground. Arthur Arling is behind the camera.

On Wednesday, the crew was back in the reception hall of Twelve Oaks. New dialog had been written, which involved bit players who had to be called in at extra expense. Shooting of these scenes continued through the next day, and on Friday, March 17, they filmed the scene of the men in the dining room arguing about war.

The sleepy time scene was shot on Saturday morning. Then the crew moved back to the stairway to shoot the scenes with Frank Kennedy and Charles Hamilton. Monday morning the crew moved to the library. They worked on Scarlett's scene with Ashley and Rhett most of the day. Selznick showed up on the set shortly before 4 p.m. and ordered filming to stop until he saw the dailies.

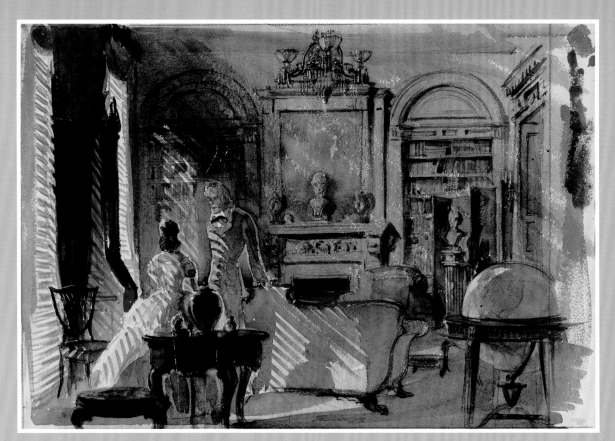

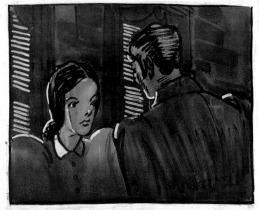

(ABOVE) Storyboard by William Cameron Menzies for the library scene.

(ABOVE, RIGHT) Concept painting by Dorothea Holt.

(RIGHT) Set still of the library at Twelve Oaks.

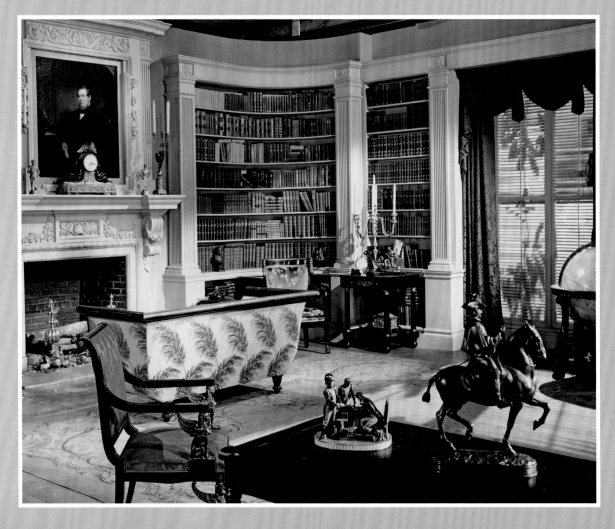

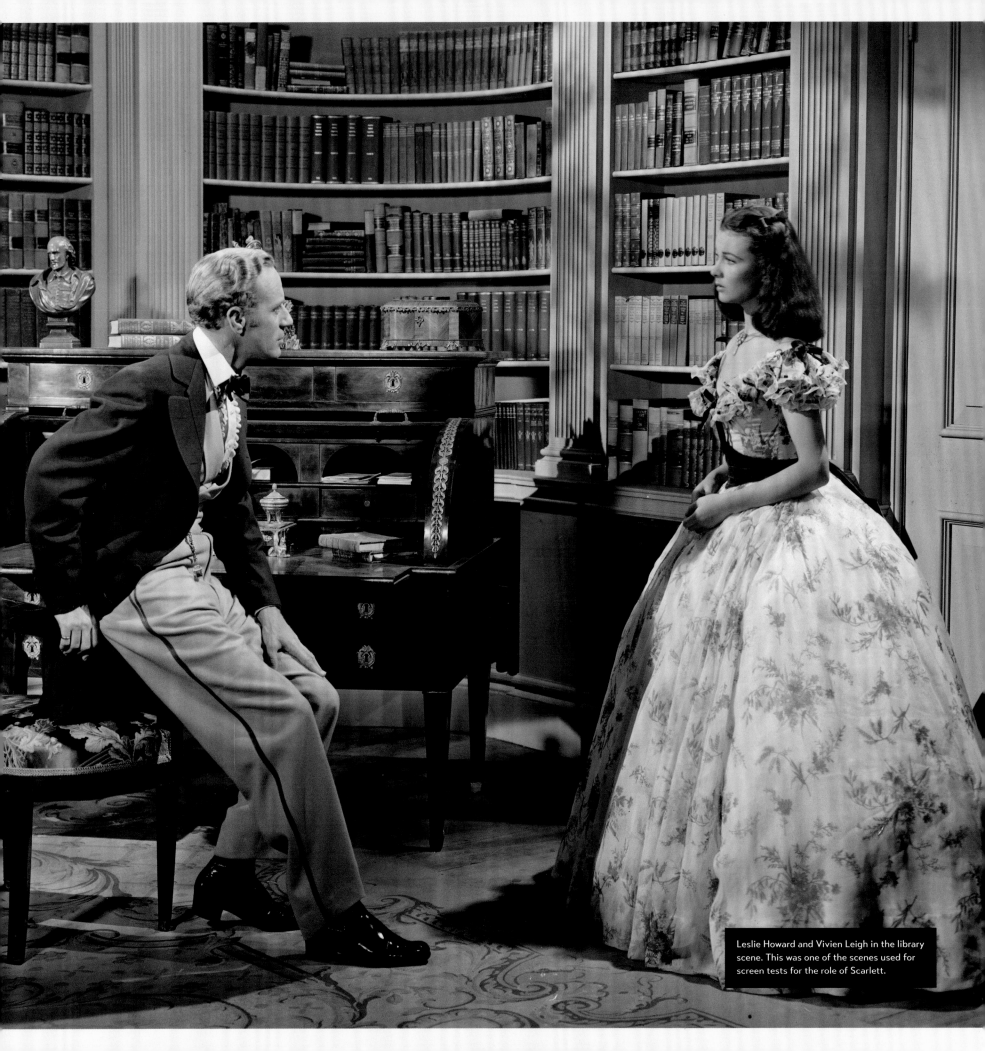

Leslie Howard and Vivien Leigh in the library scene. This was one of the scenes used for screen tests for the role of Scarlett.

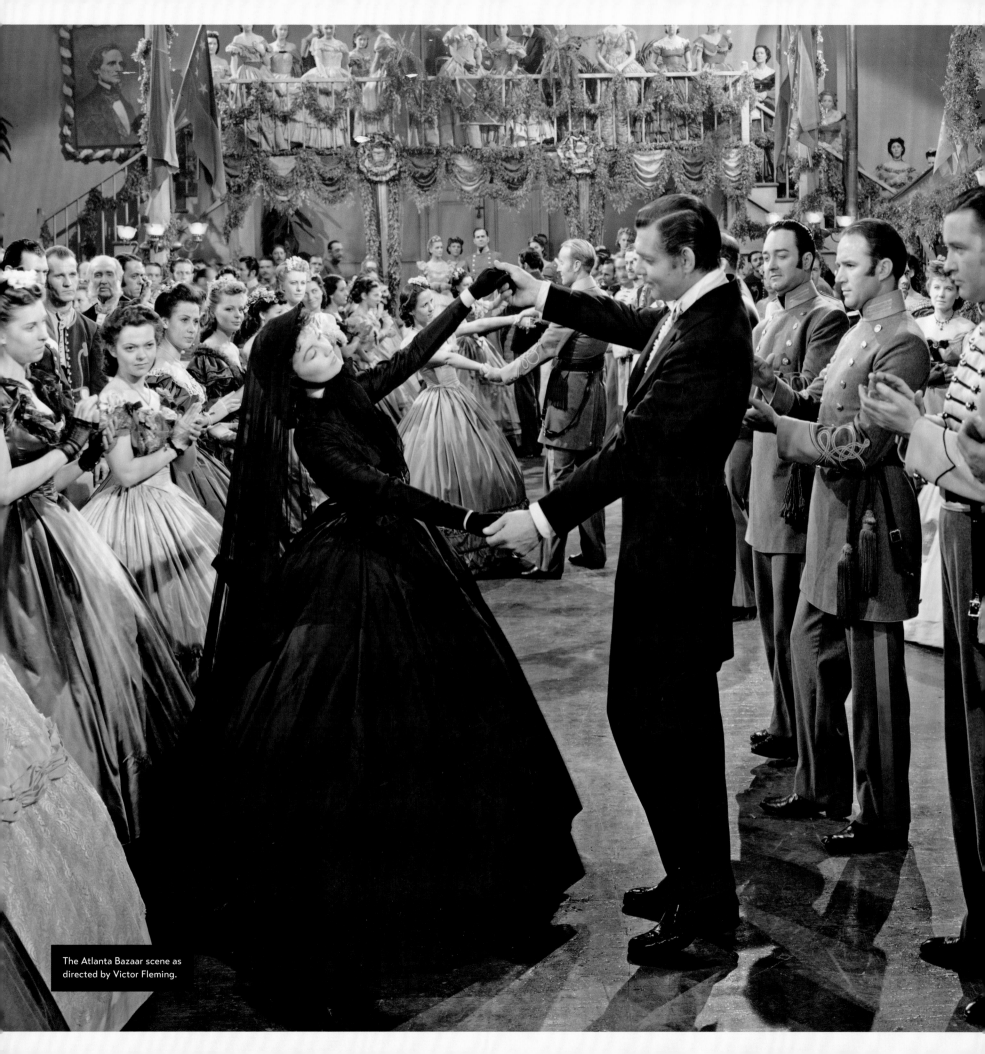

The Atlanta Bazaar scene as directed by Victor Fleming.

THE ATLANTA BAZAAR (FLEMING'S VERSION)

Victor Fleming began shooting his version of the Atlanta Bazaar scene the morning of Tuesday, March 21. Work began at Scarlett's booth with Scarlett, Melanie, and Aunt Pittypat. The scene took most of the morning, as Laura Hope Crews had trouble with her lines. After lunch they filmed Rhett's entrance and were finished shooting by 5 p.m., though Scarlett, Melanie, and Rhett rehearsed for another hour.

The crew continued with the same scene the next morning and moved on to the auction in the afternoon. Filming continued through the afternoon and into the evening with Dr. Meade's shots introducing Rhett.

The dancing scenes were shot on March 23. The reel was filmed in the morning, and stills were shot after every few takes. Footage for one of Jack Cosgrove's effects shots was filmed after lunch, followed by the waltz scenes. Filming of the waltz continued until about 5 p.m., when the camera boom was brought in. Filming of the moving camera shots with the boom continued until 8 p.m., when the set was dressed completely and photographed from every angle for use as a background in special effects shots of Rhett and Scarlett waltzing. The company was dismissed shortly before 11 p.m.

```
                                          "GONE WITH THE WIND"
                                               Notes
                                               2/21/39

Following Barbecue and Scarlett's marriage or alternate:

MONTAGE covering two years of War.

SCARLETT IN WIDOW'S WEEDS: New scene getting over Scarlett is going
to Aunt Pitty's in Atlanta.
                                               DISSOLVE TO:

EXT. BAZAAR
                                               DISSOLVE TO:

INT. BAZAAR:
Starting on closeup basket in man's hands into which are being
dropped pieces of ladies' jewelry....follow basket as it is passed
around until a gold cigar case is dropped into it.  Man's voice
says "Thank you, Captain Butler" and camera pans up to show that it
is Rhett who has just donated his case for the 'Cause'.

Rhett is standing on a balcony over the main floor of the Armory where
the Benefit bazaar is in progress.  A full shot of the room is seen
in back of him.

Rhett looks down at one of the booths:
                                counter of
Scarlett - rear to camera, is leaning on/her booth, her feet tapping
in time to the music.

Back to Rhett - smiling.

Cut to Scarlett-Melanie-Pitty Pat in booth, Pitty scolding Scarlett
for putting in an appearance in public, and Melanie defending Scarlett.
   Pitty: xxxxxxxxxxxxxxxx (gesturing off)
              "The eyes of Atlanta are on you.  I can't stand it....I think
              I shall faint..."
Cuts of scandalized dowagers.
Scarlett promises to behave.
Pitty exits.
Melanie puts her arm around Scarlett, comforting.
Scarlett looks up, dismayed, as:

Rhett comes to Scarlett and Melanie. "I hardly hoped you'd remember--"
Greetings. (Shortening present version; Rhett already knows status of
              Melanie and Scarlett - ab't their marriages and bereavement,
              etc.)
Basket passed to Melanie and Scarlett.
Melanie drops in her wedding ring.  "You're a courageous little lady,
   Mrs. Wilkes."
Scarlett donates her wedding ring.
Melanie, with tears in her eyes, exits from Rhett and Scarlett.

Rhett-Scarlett: short scene, talk about blockade running.  Rhett
confesses he is not the hero he is thought to be -- he is actually
making a great deal of money from the blockade.  Tells Scarlett he
half expected to find her here when he came back to town.  Work up
to quarrel between them, and to Scarlett saying in effect: "Get
out of here. You're hateful!"
                                                         CUT TO:
```

(ABOVE) Selznick's notes on the Atlanta Bazaar were made after George Cukor's version of the scene had been filmed.

(LEFT) Between takes of the waltz.

Wind – Camerawork (Photog)

Mr. Fleming - cc: Messrs. Menzies, Klune, Haller, Kern, Lambert
 Plunkett and Forbes

3/20/39

I am still worried about the waltz and am still hopeful that you will be able to get something comparable in quality with some of the shots you got in THE GREAT WALTZ -- even though we don't go in for anywhere near the variety of shots. I realize you haven't got the possibilities in the set that you had in THE GREAT WALTZ, but we have things that you did not have in that picture -- two infinitely more interesting personalities; color; Scarlett's black dress against the color of the others; etc.

I feel that the last time we shot this we leaned so strongly toward the side of authenticity, as we did in other things, that we robbed the waltz of a large part of its charm through holding to what would have been the actual tempo of a waltz danced in the South at this time. But Rhett is, after all, a widely travelled man and we might get something very exciting if he actually went into a Viennese waltz against the less interesting waltz of the other dancers -- or, if the tempo of the music makes it impossible for his waltz to be basically different from the waltz of the other dancers, and if the Viennese tempo and style of dancing make for something more attractive than the actual waltzes danced in the South, I'd certainly take the license in order to get the most stunning and romantic effect. Without a little theatricalism we are never going to get what we want here.

I realize that we have some dialogue during the dancing, which hampers you some-what, but I should appreciate it if you would think about how to get a few silent shots with perhaps something of the accelerated tempo that you got in THE GREAT WALTZ so that the dance mounts to a really romantic climax. I think we could have some silent dancing shots both before the dialogue starts and after Scarlett's last line - before the roll of the drums and Dr. Meade's speech.

It may be that we have the wrong dance director. Certainly we have judging by the effect we got last time. Maybe it's too late to change, but I wish Ray Klune would, immediately upon receipt of his copy of this note, check with you as to whether there is somebody who worked with you on THE GREAT WALTZ that you'd like to get over, either as a substitute and/or in addition to the man we have.

The costumes of the other dancers should also be selected for the most effective contrast with the black costumes of Scarlett and Rhett. The uniforms of the men should be brilliant and varicolored, including Zouaves and officers of other regiments that would give us a variety in the officers' uniforms, and the costumes of the women should be as colorfully contrasting as possible with Scarlett's black.

And, finally, photographically I hope we will be able to get lighting that will give us a sense of shadows and the mood that is obtainable if we can capture the feeling of the illumination of the period. Do you think we might get anything out of an angle that would give us both the dancers and their shadows on the wall?

 DOS

dos:bb

Wind – Cosgrove

Mr. Victor Fleming

4/12/39

Dear Vic:

If and when you get a moment when you are not awreck and haven't got nine million other things to do, I should appreciate it if you would take a look at the plate of the dance and have a talk with Bill Menzies about what we can do to get more effective shots, and perhaps two or three of them, of the waltz, than are promised by this plate -- which I frankly think is terrible. I have already had a discussion of it with Menzies and Cosgrove.

As we have previously discussed many times, I think it is terribly important to our love story that we romanticize this waltz. Maybe the plate is satisfactory for that section of the waltz which has the dialogue in it -- but in any event, we certainly need at least two or three extremely effective silent shots of the waltz, and I am prepared to go to the extreme of getting back extras and other dancers to stage this properly in order that the dance may be worthy of the picture, and in order that it may be at least as good as what they have had in other pictures in the way of waltz shots.

I should be grateful if you could find the time to have a little chat about this, perhaps over lunch one day, and if you would discuss it with me.

 DOS

dos:bb

Form 73A—20M—4-38—K-I Co.

SELZNICK INTERNATIONAL PICTURES, INC.

9336 WASHINGTON BOULEVARD CULVER CITY, CALIFORNIA

Inter-Office Communication

TO Mr. Chas. Richards cc: Mr. Klune DATE March 10, 1939

FROM Eric Stacey SUBJECT BAZAAR

In the new bazaar sequence, there is a character known as "Basket Carrier." Mr. Fleming wishes, if possible, to get an actor who has only one arm. I suggest you work on this immediately, and if there are no one-armed actors, we will, of course, have to resort to trickery. Please start working on this right away. We will possibly get to the bazaar sequence around Wednesday or Thursday of next week.

Also, notice in the new script coming out today that the character of Uncle Peter is back in with quite a lot of dialogue, possibly necessitating recasting. Would you please advise whether we are to plan on continuing to use Jessie Clark, who was not particularly good, although no complaints have reached me.

 Eric Stacey

es:ls

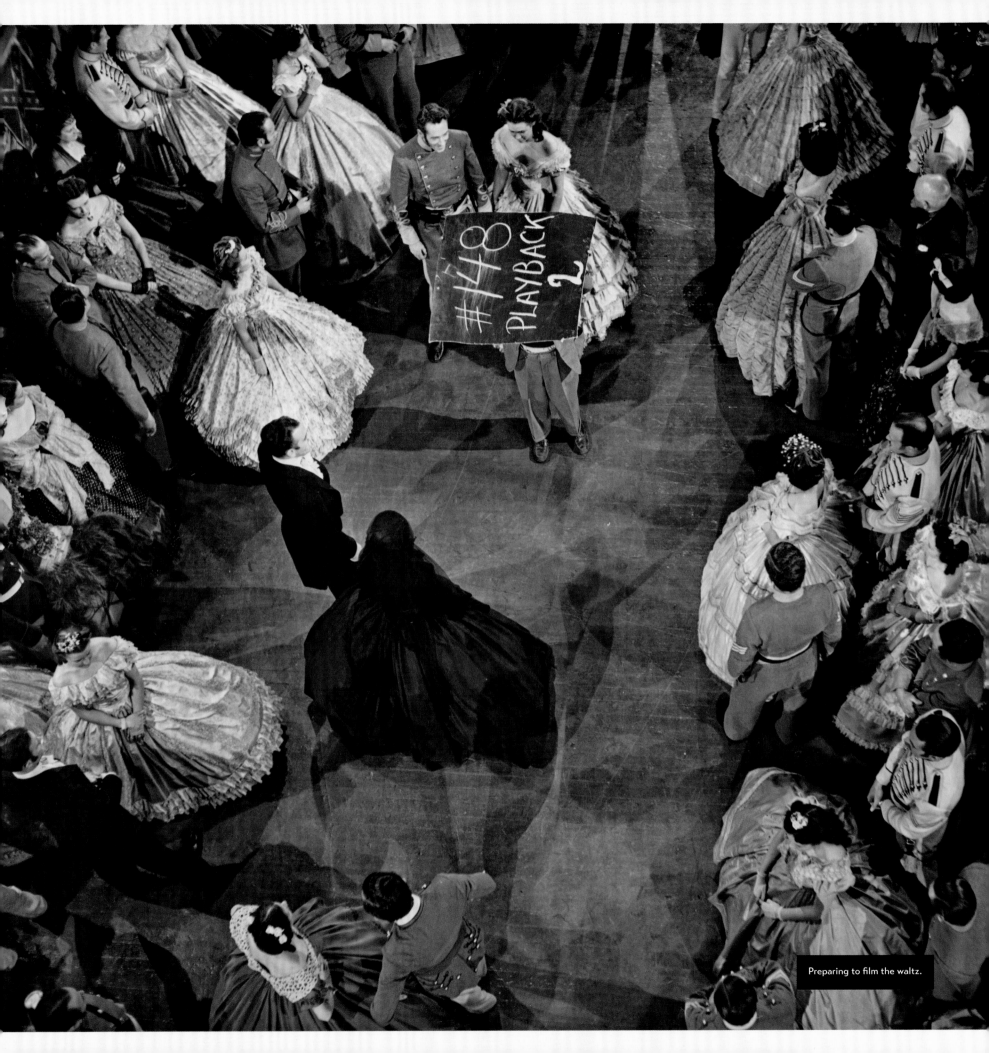

Preparing to film the waltz.

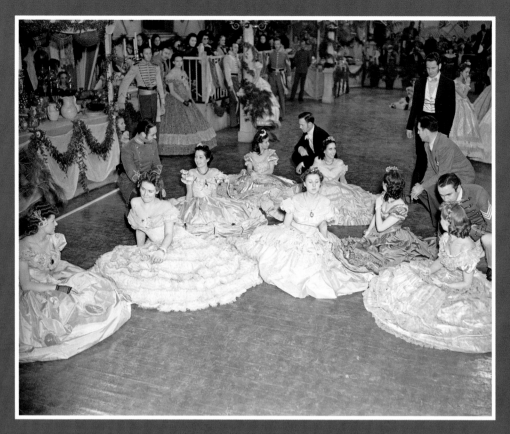

Extras relaxing between takes.

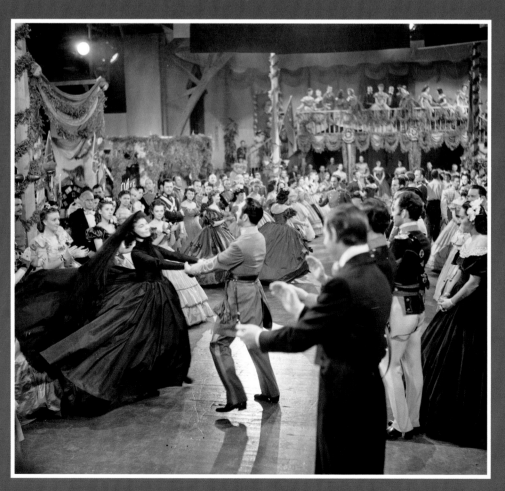

The Atlanta Bazaar scene as directed by Victor Fleming.

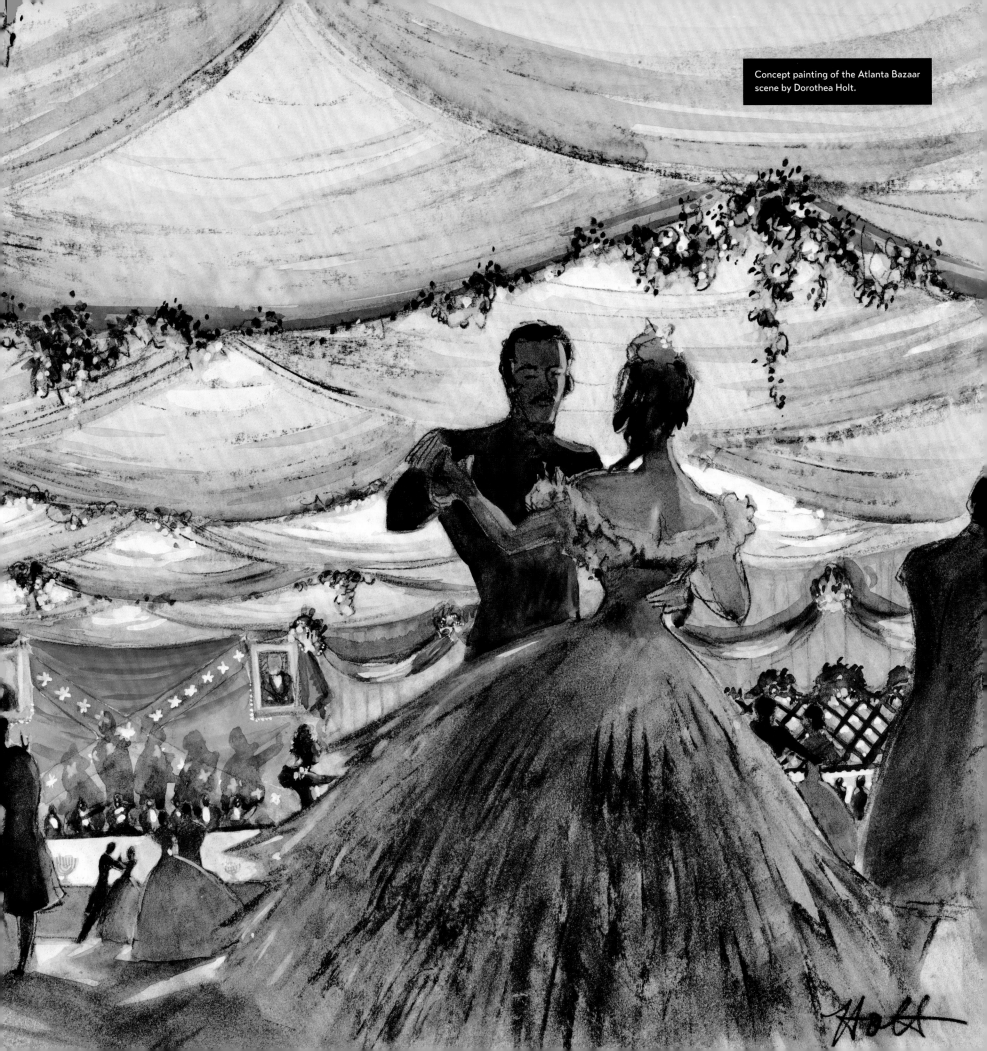

THE *EXAMINER*

On the morning of Friday, March 31, the scenes of the printing and distribution of the casualty list from the Battle of Gettysburg were filmed. The crew began with the scene of Melanie and Scarlett in the carriage and continued with Rhett's arrival on horseback after lunch.

Fleming continued work Saturday morning with the vignettes of townspeople reacting to the news. A scene showing a group of African American men reading the list began at 8 a.m., followed at 9:30 a.m. with a scene of a widow with her dog, an Irish setter at first, finishing with a better-behaved Llewellin setter that enabled the crew to

complete the scene in two takes. A brief scene of Grandmother Tarleton learning of the deaths of the twins came next, followed by a scene with a priest and a clergyman. A scene with Dr. and Mrs. Meade and Melanie had to wait for the end of a "downpour of rain" before it could be filmed. The company was dismissed at 5:55 p.m.

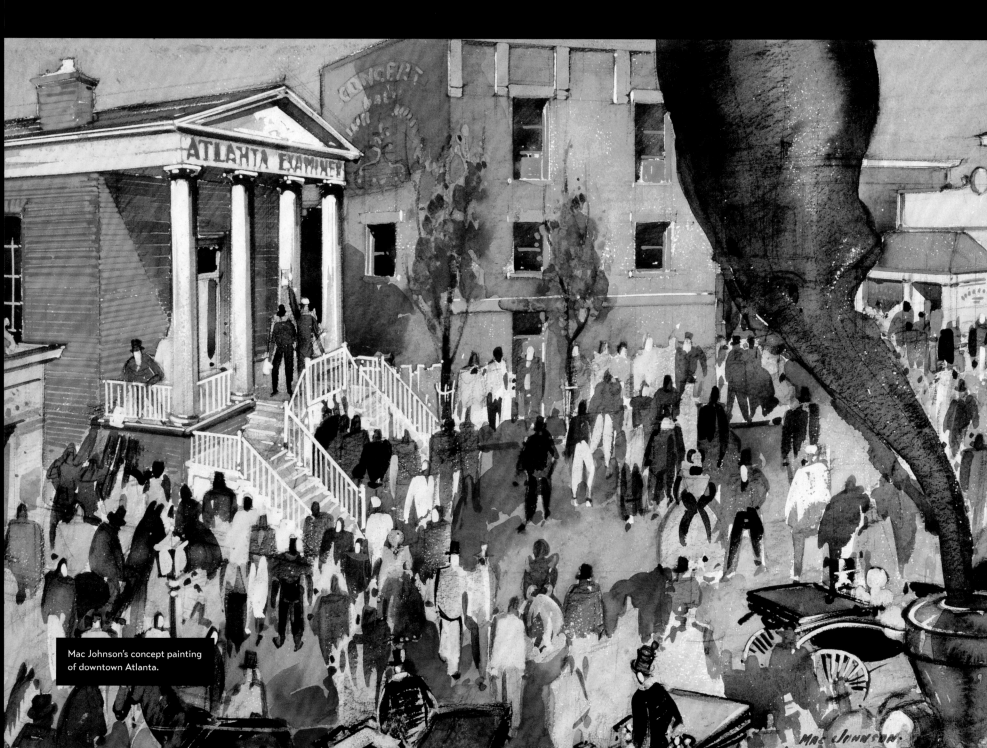

Mac Johnson's concept painting of downtown Atlanta.

Inter-Office Communication

SELZNICK INTERNATIONAL PICTURES, INC.

9336 WASHINGTON BOULEVARD CULVER CITY, CALIFORNIA

OFFICE OF THE
PRESIDENT

To: Messrs. Lambert, Plunkett, Richards
 cc: Messrs. Fleming, Klune, Stacey, Kurtz
Subject: GONE WITH THE WIND

Date 3/13/39

copy

In deciding the proportion of men to women in ordering our extras for the
sequences in Atlanta, care should be taken that we clearly have many more
women than men and a decreasing number of men as the picture progresses
and as we get deeper and deeper into the war in our Atlanta sequences.

Thus, for instance, the scene of the news of Gettysburg being received should
have infinitely more women than men. Also, such males as there are, should
for the most part be old men and adolescents. There should, of course, also
be the usual proportion of children.

Probably, too, such men as there are, particularly any men of fighting age,
would be in uniform as being either soldiers on leave or Home Guard. Probably,
also, there would be wounded or convalescent soldiers.

Similarly, there should be an increasing percentage of mourning costumes as
the picture progresses, with a great deal more black being worn by the women
and such mourning as would be worn by the men.

I think that Mr. Kurtz should supply to the casting and costume departments,
details on the above matters on each sequence of the script that calls for
mobs or even for a comparatively small number of extras.

DOS

(ABOVE) Extras between takes.

(LEFT) Selznick insisted that Fleming, Klune,
and the rest of the production team pay
close attention to the proportion of men to
women in various parts of the film.

Mr. Klune - cc: Mr. Ginsberg

BIT PLAYERS, ETC. — G.W.T.W.

4/7/39

Dear Ray:

While, believe me, I am not unappreciative of attempts at economy, I think we must be awfully careful not to spoil scenes that cost many, many thousands of dollars by an economy of a few dollars, or even of a few hundred dollars on actors. Scenes such as the individual bits at the Examiner Office are totally unusable because of the amateurish performances by the bit players, and we will have to either retake them or do without these pieces entirely. The scene at the Railroad Depot is a disappointment insofar as the bit action, and the long shot which caused so much trouble and took so much time is comparatively worthless and may never be used because the bit action gives us nothing, again due to bad and amateurish playing. I am informed that at the Railroad Station there was a limit of $25.00 for each of these bits. Had we used $100.00 actors for five or six of these small bits we would have had a scene that we could use and that would mean something to the picture.

I have always felt that it is the falsest kind of economy to save on bit actors. The time that cheap and inexperienced actors cost through the director's inability to get performances out of them, alone more than makes up the difference between their salaries and the salaries of good actors; film shot with cheap actors for a picture requiring the perfection of GONE WITH THE WIND obviously cannot be used, where the cheap actors fail to deliver what is demanded of them; and even if the cheap actors should work quickly and should give adequate performances, it is still bad economy because nothing is as important on the screen as the actor. To save money on actors and spend it on sets is silly -- the audiences are looking at the actors, not at the sets, if our action means anything. And while a bit actor is on the screen, if it is for only two seconds, he is as important as the star. I should appreciate it if you would always bear this in mind, so that we don't come in for any more shocks such as we had on the exterior of the Examiner Office, the exterior of the Railroad Station, and such as I have just had with the officer in charge of the black troops.

DOS

dos:bb

(ABOVE) Selznick had the vignettes of townspeople reading the casualty list reshot because he was not satisfied with the acting.

(RIGHT) Three of the vignettes of townspeople reading the casualty list.

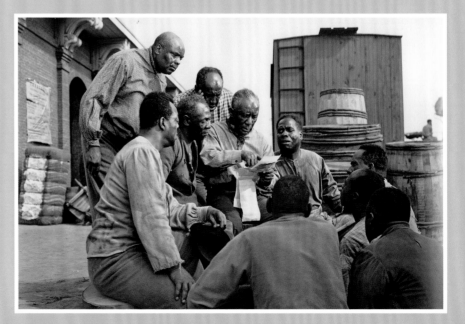

March 16, 1939

EXAMINER OFFICES – Extra Peo[ple]
(as discussed with Mr. Kurtz)

Based on a total of 350 people:
 26 negro men and boys
 72 white men (civilians)
 30 men in uniform
 128 Total

 14 colored women and girls
 14 well-dressed women
 154 medium dressed women
 40 poor char. women
 222 Total

MEN

 7 negro coachmen for private carriages.
 1 negro driver of mule-cart filled with cotton bales.
 1 negro driver for cab.
 1 negro driver for long seated hack.
 1 negro driver for covered army wagon.
 12 negro porters and laborers carrying parcels
 3 negro boys
 26 Total

 16 civilian men - well-dressed.
 34 middle class men - merchants, clerks, etc.
 7 men - riff-raff
 3 men - train crew - engineer, fireman - wood passer
 4 men - printers from Examiner offices
 2 men - bakery men with bread baskets
 4 men - mechanics from roller mill
 1 man - Catholic clergyman
 1 man - Episcopal clergyman
 72 Total

 8 soldiers (Provost guard) from Atlanta garrison, with rifles
 5 divisional headquarters officers
 17 convalescent officers and men
 30 Total

WOMEN

 3 colored mammies - riding in carriages with white children
 8 " women - carrying parcels
 3 " girls, children with mother
 14 Total

 14 well dressed women in carriages
 154 medium dress women
 40 poor class women, all ages, character (suggested a toothless old hag with cob pipe)
 208 Total

NOTE: Mr. Kurtz suggested that about one third of the women would be
in mourning of various stages, and according to their stations.

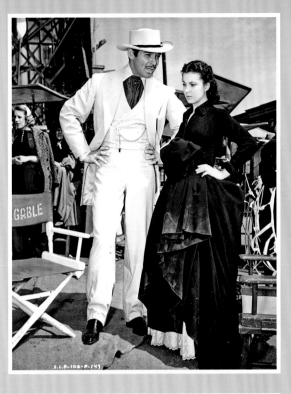

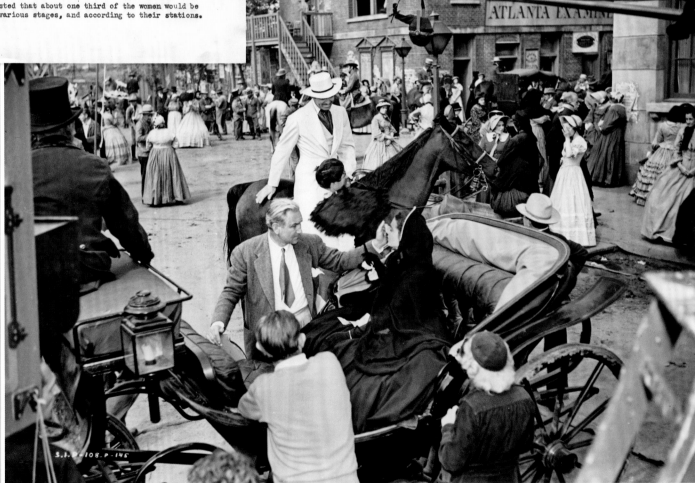

(TOP, LEFT) List of extras needed for the *Examiner* scene.

(TOP, MIDDLE) Walter Plunkett's design for a costume for Rhett Butler. Some of Plunkett's designs include the description of the character from the novel that he used for inspiration: "RHETT shining boots, handsome white linen suit . . ." (p. 257).

(TOP, RIGHT) Clark Gable and Vivien Leigh between takes.

(RIGHT) Victor Fleming with Vivien Leigh preparing to film the *Examiner* scene.

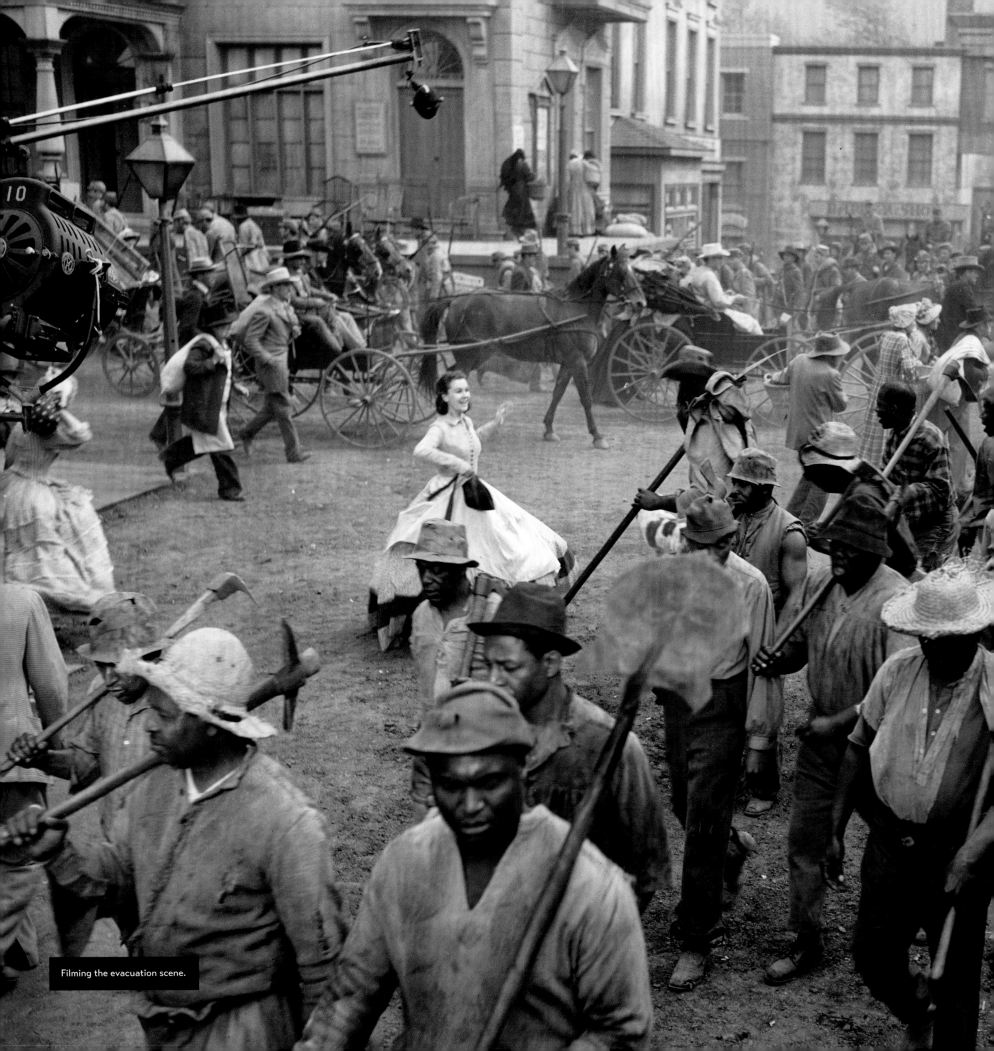

Filming the evacuation scene.

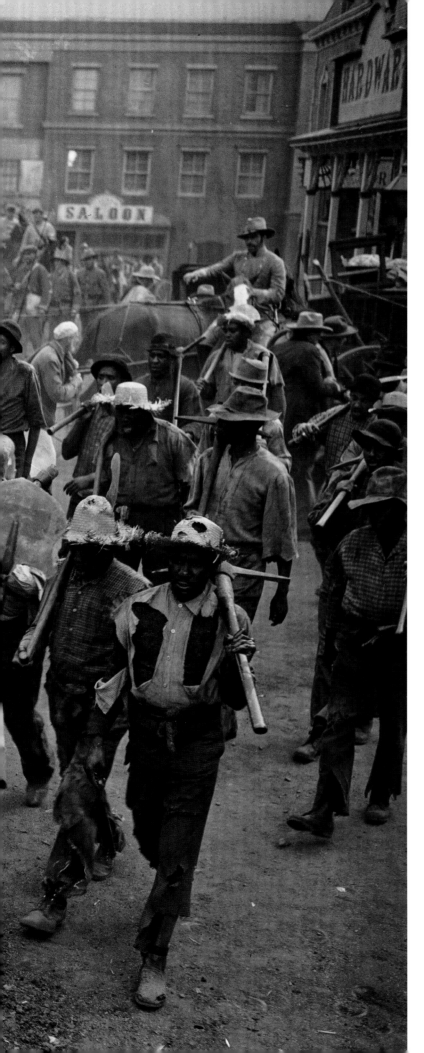

THE EVACUATION

Work on the evacuation scene began the morning of Tuesday, April 4. Two cameras were prepared, one on a boom, and then the company waited for the sun to come out. Vivien Leigh was called to the set at 10:20 a.m. and rehearsed with the cameras and extras until 11:30 a.m. The scenes of frightened people running through the streets were filmed from various angles until 5 p.m., when a camera was placed in a pit in order to film, from a low angle, Scarlett exiting the church hospital.

Filming continued the next day with the scenes of Scarlett meeting Big Sam. Again the film crew had to wait for the sun to come out, but aside from a brief period in the mid-afternoon when a dogfight broke out, filming proceeded smoothly until 5:40 p.m.

Some shots were made on Friday, mostly of people and horses passing by. On Saturday, scenes of Rhett and Scarlett in the wagon riding through Atlanta's streets to Aunt Pittypat's house were filmed.

Almost a month later, on May 3, a short portion of the evacuation scene was filmed with Rhett and Scarlett in the buggy headed for Aunt Pittypat's house. It was a "process" shot that used film footage shot in April as a backing. Camera action was rehearsed to match the "plate," or previously shot footage. Wind and dust were blown in as the shot was filmed, and shortly before lunch, a runway was added in front of the buggy so extras could run by during a side-angle shot of Scarlett.

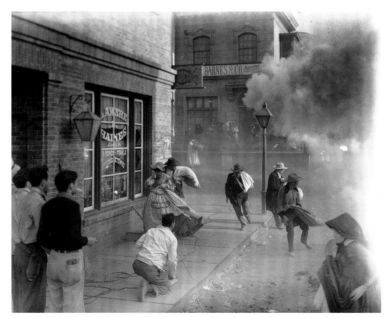

A special-effects technician sets off explosions during the evacuation scene.

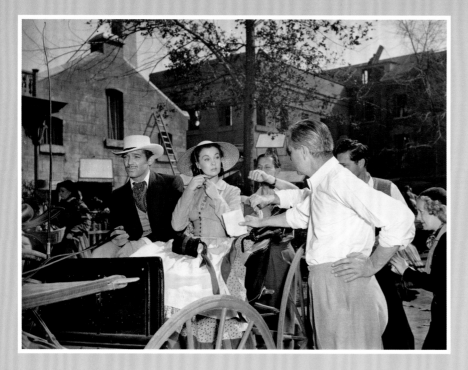

CALL SHEET

DATE **Tues., April 4, 1939**

PICTURE **"GONE WITH THE WIND" - Prod. #108** DIRECTOR **VICTOR FLEMING**

SET **EXT. CHURCH AND STREET**

LOCATION **40 Acres** Set **#17** Scenes No. **204-205-206-207-208**

NAME	TIME CALLED		CHARACTER, DESC., WARDROBE
	ON SET	MAKE-UP	
Vivien Leigh	8:30 AM	7:30 AM	Scarlett #8
Stand-in	7:30 AM	7:00 AM	-
Extras as requisitioned	8:00 AM	6:30 AM	As fitted
			PROPERTY DEPT:
CAMERAS	7:00 AM		10 Heavy Farm wagons
SOUND (Ready)	8:15 AM		10 Carriages, coachman driven
COSGROVE	WILL NOTIFY		5 " " owner
P.A.SYSTEM (Ready)	7:30 AM		5 Buggies " "
Play-back for singing of			5 " " " (women)
Negro troops	8:00 AM		10 Horses (for elderly civilians)
			1 Exploding wagon
			1 4-horse Fire Engine
			1 Hearse
			2 Gun units complete (24 horses)
			6 Horses with Artillery Unit
			1 Rhett's carriage
			3 Horses for Officers of Labor
			Battalion
			(Ready on set - 7:30 AM)

COVER SETS

EXT. McDONOUGH ROAD - STAGE #14 - SET #24 (CONTINUATION)

Vivien Leigh	9:00 AM	8:00 AM	Scarlett #8
Clark Gable	9:00 AM	8:00 AM	Rhett #4
Olivia de Havilland	9:00 AM	7:00 AM	Melanie #4
Butterfly McQueen	9:00 AM	8:00 AM	Prissy #2
Stand-ins	8:15 AM	8:00 AM	

INT. JAIL - STAGE #7 - SET #39 (Scenes to be supplied)

Clark Gable		
Vivien Leigh		
Bits and extras as requisitioned	WILL NOTIFY	

ASSISTANT DIRECTOR **ERIC STACEY**

(ABOVE) Call sheet for the evacuation scene.

(LEFT, TOP) Victor Fleming discusses the scene with Clark Gable and Vivien Leigh.

(LEFT) Selznick's notes on the evacuation scene.

"GONE WITH THE WIND"
Notes
2/22/39

After Ashley's departure back to War:

Pick up Int. Hospital (Book 302) -- full shot of wounded men crowding cots, doctors, nurses, etc.

Scarlett is nursing one of the wounded. Some violent bit of atmosphere- such as man crying out in pain because he is being operated without anaesthetic, or etc. Perhaps he lets out a fearful xxixxx cry and falls back dead.

Above or alternate - leads into Scarlett running out on her duties. She is sick at her stomach, disgusted, fed up -- goes to closet, grabs her hat and coat just as shells are heard bursting in street. Tells someone she is going home.

STREET
As Scarlett runs out -- wartime activity in street -- citizens refugeeing -- wagons crowded with wounded pouring through city -- retreating Confederate soldiers straggling through a-foot, thirsty and weary.

Scarlett runs for home -- meet BIG SAM (Book 306) in a detachment of negroes on their way to dig trenches for the white folks.....He tells her the news of Tara -- her father sick, the girls down with typhoid, etc. (No mention of Ellen ill.)

At the end of Scarlett's scene with Big Sam she hears Rhett call to her --- looks over. He is driving by in his carriage - offers her a lift. (BOOK 303,336,

CARRIAGE SCENE starts with Scarlett telling Rhett she is going home to her mother at Tara, working in news that Melanie is to have baby in few weeks.

This leads into proposition from Rhett: Why doesn't Scarlett let him take care of her -- they will get away from all this blood and this idiotic Cause and go to Paris and have the time of our lives.

He explains to Scarlett that city is under seige and explains what a seige is..... Yankees will soon be in the city. The Cause is ended.

Scarlett furious when she realizes Rhett hasn't been proposing marriage to her -- but wants her for his mistress says she will have no part of him. "You varmint! I want to get home to Tara!"

Rhett: "What about Mrs. Wilkes? You can't take her on that journey, can you? Perhaps this is not necessary in view of following scene with Meade.

They have arrived in front of Aunt Pitty's house. Scarlett jumps out of Rhett's carriage in a huff -- and he goes off.

EXT. AUNT PITTY'S: Pitty and Aunt Peter about to refugee -- getting into carriage. Dr. Meade is there, having just been to visit Melanie, and saying goodbye to Pitty. Scarlett runs to them --distraught -- she is going with them!

Meade, however, tells her Melanie cannot be moved -- the journey might lead to a miscarriage. Scarlett, furious, reminded of her promise to

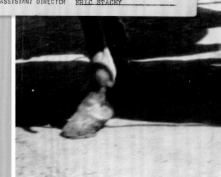

Reflectors in the background redirect sunlight for the Technicolor cameras.

THE JAIL SCENE

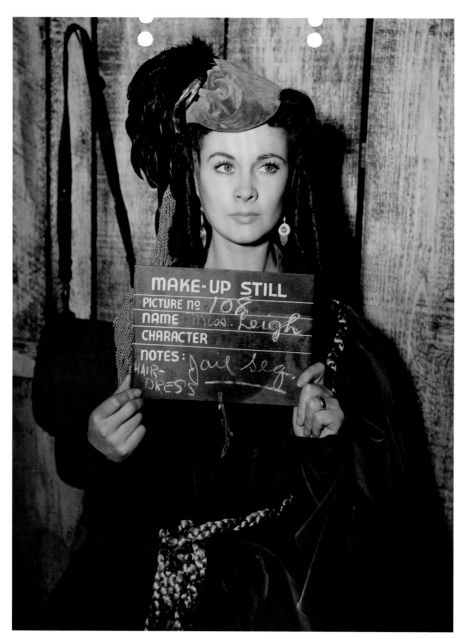

Scarlett's visit to Rhett in the Yankee jail was shot on April 11. Although the crew had begun working at 9 a.m., filming did not begin until 11:30. Selznick came to the set in the morning and provided feedback on the rehearsal.

William Cameron Menzies was directing minor scenes that did not involve the principal actors. On this day he directed the scene of Uncle Peter stalking a rooster in the rain to cook for dinner. Work began at 6 a.m. with a white rooster that kept running for shelter as soon as it was released. At 9 a.m. they switched to a Plymouth Rock rooster that kept jumping under the wagon to get out of the rain. A black rooster was called in at 10:30 a.m., and the scene, complete with close-ups of Uncle Peter and the rooster, was completed by 1 p.m.

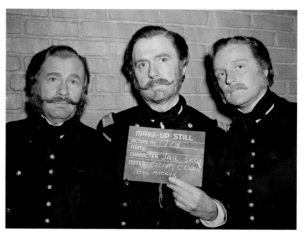

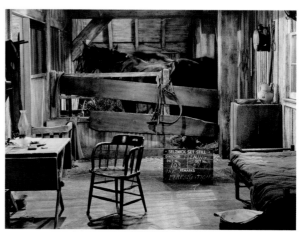

(ABOVE) Makeup still of Vivien Leigh for the jail scene.

(RIGHT, TOP) Makeup still of (left to right) Robert Elliot, Wallis Clark, and George Meeker.

(RIGHT, BOTTOM) Set still of Rhett Butler's jail cell in the Atlanta firehouse.

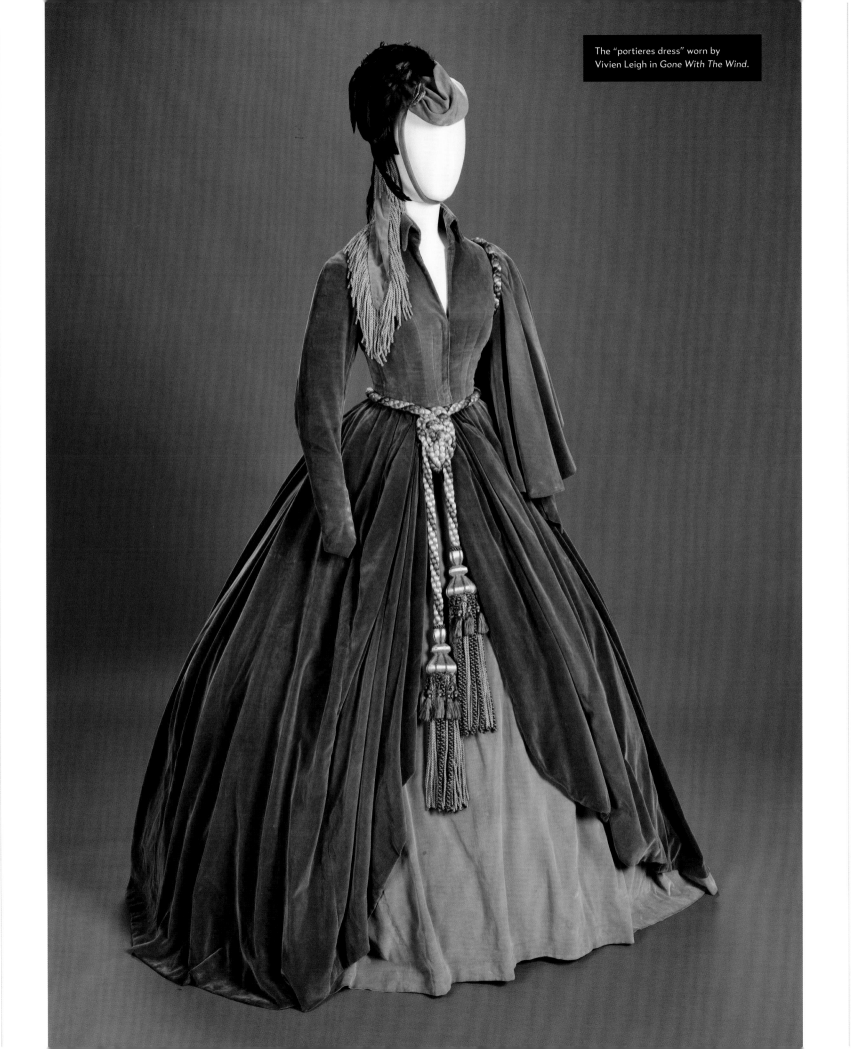

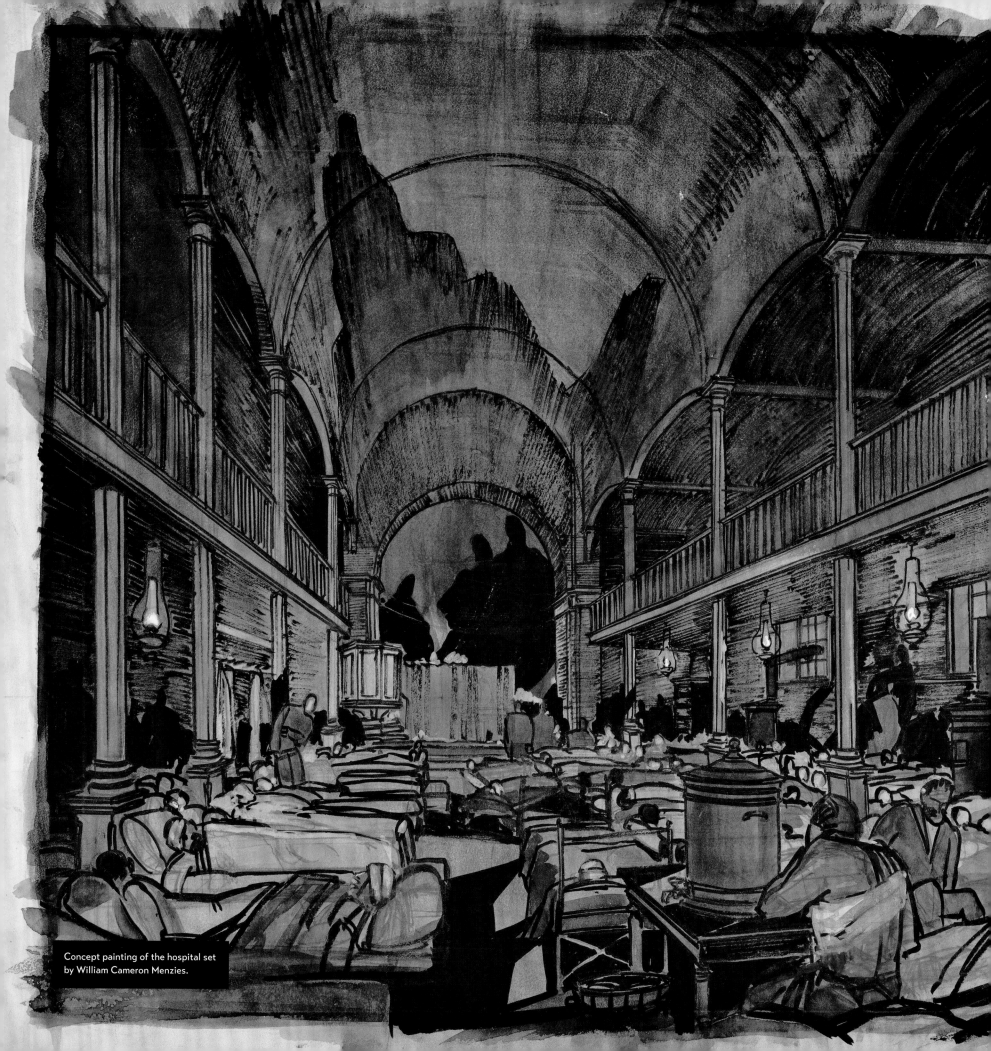

Concept painting of the hospital set by William Cameron Menzies.

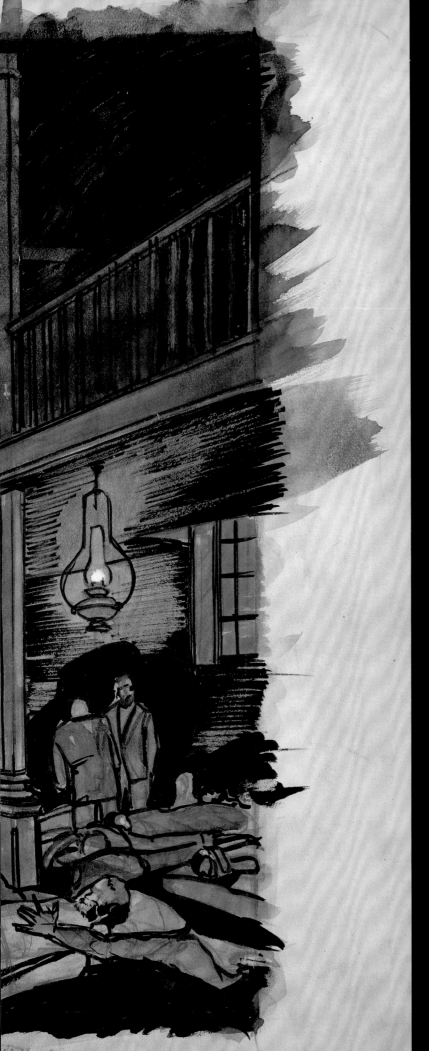

THE HOSPITAL

Scenes in the church hospital began shooting on Wednesday, April 12. In addition to Vivien Leigh and Harry Davenport, seventy-six male and ten female extras were called for 9 a.m. filming. Scenes shot included the stained glass window exploding, Dr. Meade finding a dead man on a cot and ordering a nurse to clear it, Scarlett witnessing a man having his leg amputated, and a dolly shot through the hospital.

Filming in the hospital continued the next day with a soldier reacting to the order that his leg be amputated and Scarlett tending to patients and talking to Frank Kennedy. The hospital scene was completed on Saturday, April 15, with the scene of Scarlett and Melanie's shadows on the wall and the scene of Scarlett approaching the operating room where a leg is being amputated.

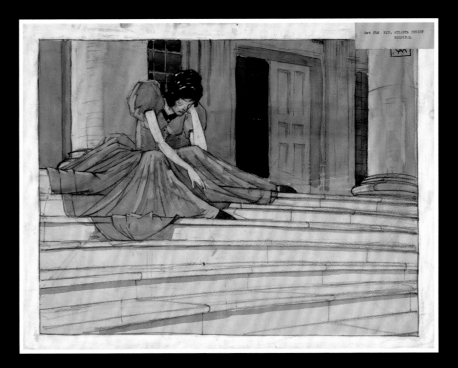

Concept painting by William Cameron Menzies.

(TOP) Melanie's and Scarlett's doubles appear in this set still of the hospital.

(MIDDLE) Olivia de Havilland and Victor Fleming (left) and assistant director Eric Stacey (right), look on as Walter Plunkett shows Fleming his costume designs.

(BOTTOM) This shot from the hospital scene was cut from the final film.

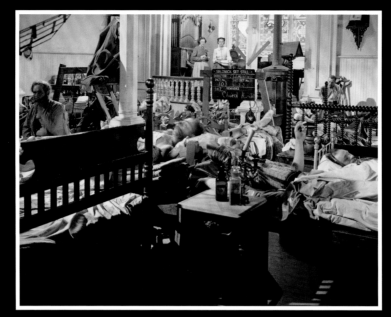

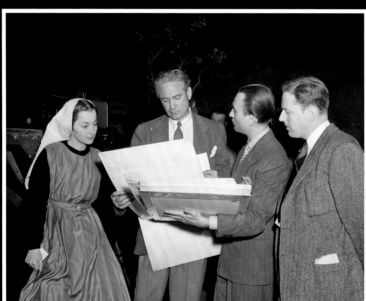

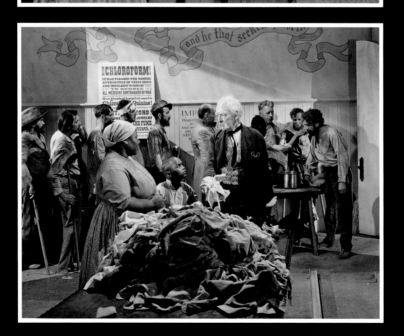

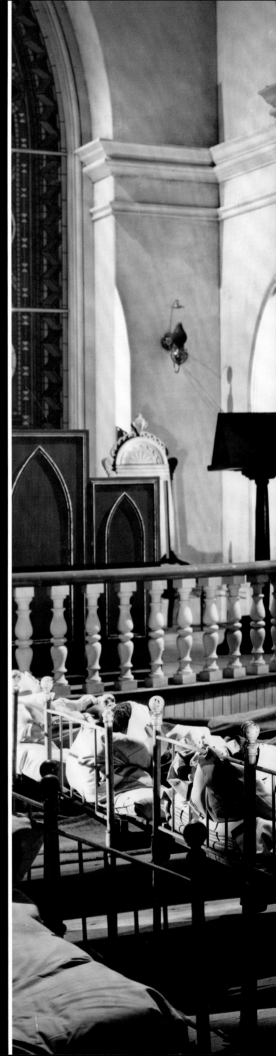

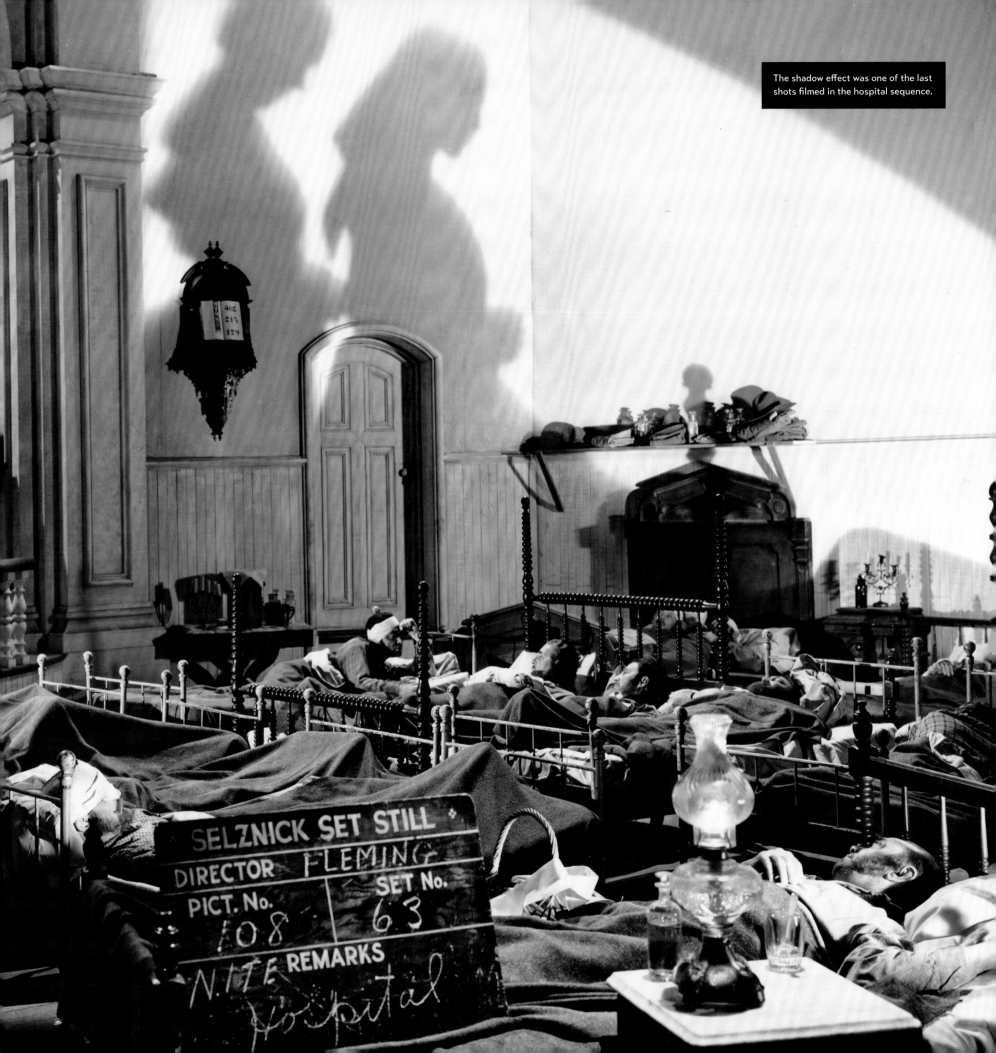

The shadow effect was one of the last shots filmed in the hospital sequence.

SELZNICK SET STILL
DIRECTOR FLEMING
PICT. No. | SET No.
108 | 63
NITE REMARKS
Hospital

THE "KLAN SEQUENCE"

Selznick arrived at 9 a.m. on the morning of Monday, April 17, to help Fleming rehearse the scene at Melanie's house where Melanie, Scarlett, India, and Mrs. Meade await word of Ashley and Frank, who have left to take revenge on the men who attacked Scarlett. Despite Selznick's 1936 decision to eliminate the Ku Klux Klan from the film, the production crew continued to refer to this scene as the "Klan sequence." Filming did not begin until 3:40 p.m. but went rapidly.

Work on this scene continued the next day with the shots of Rhett asking about Ashley and Melanie and admitting the Yankee captain, and again, the day after, with close-ups of India, Melanie, and Rhett. Most of the crew were dismissed at 6:40 p.m., but some stayed to film screen tests with candidates for the role of Belle Watling.

On April 19 filming continued with the entrance of Ashley, Rhett, and Dr. Meade, pretending to be drunk. And on April 20 the shots of the group tending to Ashley after the Yankees leave were filmed. The shots of Melanie reading calmly, and the other women waiting and terrified, were shot on April 21.

Meanwhile, at the Baldwin Hills pit, William Cameron Menzies and crew began working on shots to cut in with the Burning of Atlanta scene. They began at 7 p.m. and worked throughout the night.

Ray Klune forwarded this letter to SIP's lawyer and vice president, Daniel O'Shea, who returned it, saying that correspondence regarding "controversial matters" should be answered by the addressee. Klune responded to the letter, saying that the film "is being produced in all respects with fidelity to the story written by Margaret Mitchell." Klune added, "Since the shooting of the picture has been completed, there is naturally no need for any further technical advice on it." This letter underscores the range of people and organizations that recognized the film's potential to shape America's thinking about a highly contested period in the country's history.

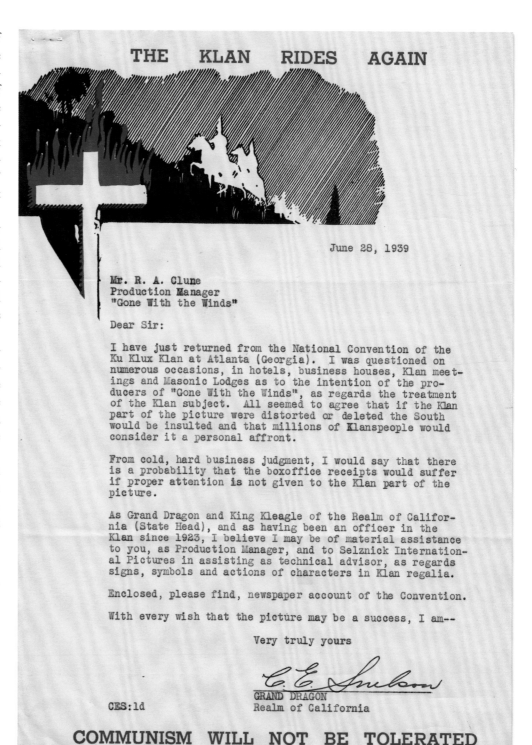

THE KLAN RIDES AGAIN

June 28, 1939

Mr. R. A. Clune
Production Manager
"Gone With the Winds"

Dear Sir:

I have just returned from the National Convention of the Ku Klux Klan at Atlanta (Georgia). I was questioned on numerous occasions, in hotels, business houses, Klan meetings and Masonic Lodges as to the intention of the producers of "Gone With the Winds", as regards the treatment of the Klan subject. All seemed to agree that if the Klan part of the picture were distorted or deleted the South would be insulted and that millions of Klanspeople would consider it a personal affront.

From cold, hard business judgment, I would say that there is a probability that the boxoffice receipts would suffer if proper attention is not given to the Klan part of the picture.

As Grand Dragon and King Kleagle of the Realm of California (State Head), and as having been an officer in the Klan since 1923, I believe I may be of material assistance to you, as Production Manager, and to Selznick International Pictures in assisting as technical advisor, as regards signs, symbols and actions of characters in Klan regalia.

Enclosed, please find, newspaper account of the Convention.

With every wish that the picture may be a success, I am--

Very truly yours

GRAND DRAGON
CES:ld Realm of California

COMMUNISM WILL NOT BE TOLERATED

Form 73A 20M 1-39 K-I Co.

SELZNICK INTERNATIONAL PICTURES, INC.
CULVER CITY, CALIFORNIA

Inter-Office Communication

TO Messrs. Klune, Kern DATE April 27, 1939

FROM Barbara Keon SUBJECT GONE WITH THE WIND

At the same time we make the Close Up of Ward Bond in the
Klan Sequence in Melanie's Parlor with his new speech about
the Provost Marshal, Mr. Selznick wants to make an additional
Close Up of him reacting and looking around incredulously at
the drunken act of the men.

 BK

BK:ps

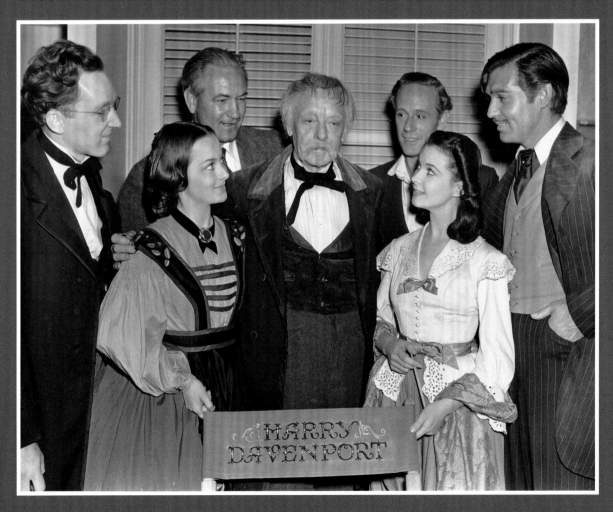

(ABOVE) Makeup still of Vivien Leigh in the
"Klan sequence."

(LEFT, TOP) Although Selznick had long since
eliminated mention of the Ku Klux Klan from the
screenplay, the production crew continued to call
the scene by this name.

(LEFT, BOTTOM) Harry Davenport, who played
Dr. Meade, enjoyed the respect and admiration of
his fellow actors. In 1913 he cofounded the Actors'
Equity Association, the actors' labor union.

SELZNICK SET STILL

DIRECTOR FLEMING

PICT. No. SET No.
108 46

REMARKS
Melanie's Bedroom
Death Seq.

Set still of Melanie's death scene.

MELANIE'S DEATH

Work on Melanie's death scene began Thursday, April 27, with Scarlett, India, Rhett, Ashley, and the children waiting in the parlor. When Selznick arrived at 2 p.m., the scene was rehearsed for him. Selznick requested lighting changes, and Menzies recommended they use smoke to create an early morning fog effect outside. Shooting began at 6:30 p.m. and continued for a half hour.

The crew resumed work the next morning after Leslie Howard arrived at 9:30 a.m. Filming went smoothly all morning. The baby "cried very well." After lunch they moved into Melanie's bedroom, where the cast and crew rehearsed and adjusted lighting for three hours. Selznick arrived for a rehearsal at 5 p.m. Filming resumed with close-ups of Scarlett and Melanie. The crew was dismissed at 7:30 p.m.

The next morning Scarlett and Ashley rehearsed their scene in the parlor as Melanie is dying. Fleming was not satisfied and called for Selznick. Because Selznick was not available, Sidney Howard, who happened to be in town, came to discuss the scene. At 11:18 a.m. they made a brief shot ahead of Selznick's arrival. After lunch, the cast rehearsed while Sidney Howard and Selznick rewrote dialog. Shooting resumed at 3:45 p.m. Alternate dialog and alternate takes were made. The scene was completed at 7 p.m., and the crew began moving the equipment to the 40 Acres lot.

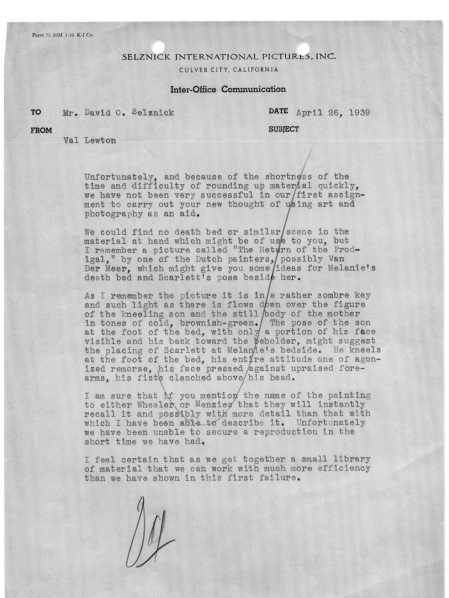

SELZNICK INTERNATIONAL PICTURES, INC.

CULVER CITY, CALIFORNIA

Inter-Office Communication

TO Mr. David O. Selznick DATE April 26, 1939

FROM SUBJECT

Val Lewton

Unfortunately, and because of the shortness of the time and difficulty of rounding up material quickly, we have not been very successful in our first assignment to carry out your new thought of using art and photography as an aid.

We could find no death bed or similar scene in the material at hand which might be of use to you, but I remember a picture called "The Return of the Prodigal," by one of the Dutch painters, possibly Van Der Meer, which might give you some ideas for Melanie's death bed and Scarlett's pose beside her.

As I remember the picture it is in a rather sombre key and such light as there is flows down over the figure of the kneeling son and the still body of the mother in tones of cold, brownish-green. The pose of the son at the foot of the bed, with only a portion of his face visible and his back toward the beholder, might suggest the placing of Scarlett at Melanie's bedside. He kneels at the foot of the bed, his entire attitude one of agonized remorse, his face pressed against upraised forearms, his fists clenched above his head.

I am sure that if you mention the name of the painting to either Wheeler or Menzies that they will instantly recall it and possibly with more detail than that with which I have been able to describe it. Unfortunately we have been unable to secure a reproduction in the short time we have had.

I feel certain that as we get together a small library of material that we can work with much more efficiency than we have shown in this first failure.

(ABOVE) In this memo, Val Lewton turns to art in an attempt to help Selznick in his struggle to add a sense of grief and sorrow to Melanie's death scene.

(LEFT) Walter Plunkett's costume design for Melanie.

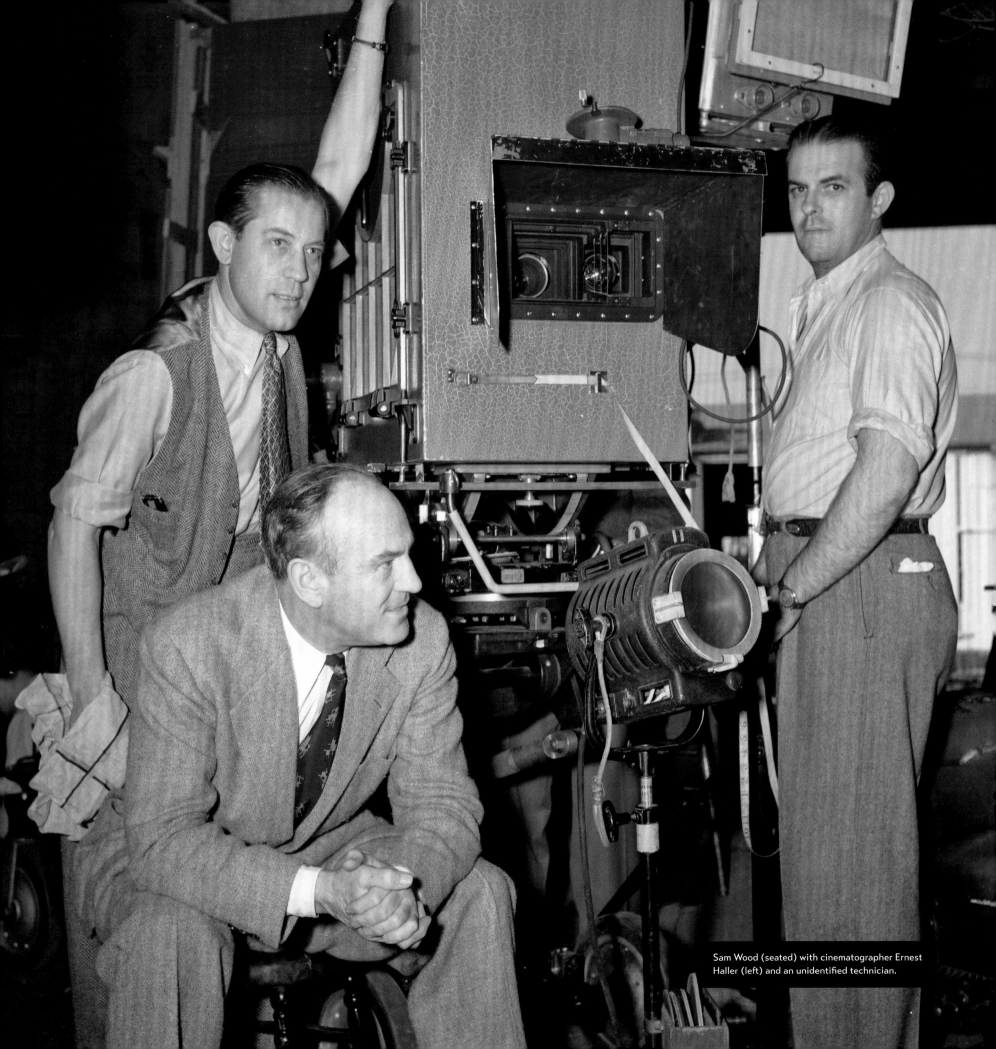

FLEMING COLLAPSES; SAM WOOD STEPS IN

Selznick complained that the Technicolor consultants were "putting all sorts of obstacles in the way of real beauty" by resisting Menzies's color choices and arguing with cinematographer Lee Garmes, who eventually quit the production, feeling he was being blamed for the consultants' errors. Garmes was replaced by Ernest Haller, who usually worked for Warner Brothers and had served as the cinematographer on *Jezebel*. Haller's first experience with Technicolor had been on one of Vivien Leigh's screen tests, and his work was good enough that Selznick turned to him when Garmes left.

For almost two months Fleming and his crew endured a grueling schedule of filming six days a week, usually from 9 a.m. to 7 p.m. and often later. Once Ernest Haller came on board, they shot the complex scene at Twelve Oaks, then the Atlanta Bazaar scene, followed by the *Examiner* and evacuation of Atlanta scenes, which involved hundreds of extras. In late March Selznick suggested adding a second camera unit to speed up the production, and in April he complained that bad actors in bit parts had ruined the *Examiner* office scene and demanded the scene be reshot.

"I have for some time been worried that Fleming would not be able to finish the picture because of his physical condition," Selznick said. "He told me frankly yesterday that he thought he was going to have to ask to be relieved immediately, but after talking with his doctor was told that it would be all right for him to continue. However, he is so near the breaking point both physically and mentally from sheer exhaustion that it would be a miracle, in my opinion, if he is able to shoot for another seven or eight weeks." Sometime around April 29, Fleming "collapsed," leaving Selznick unsure if Fleming would be able to return.

Veteran director Sam Wood took over. Wood had started in the silent era as an assistant to Cecil B. DeMille and rose through the ranks at MGM, gaining a reputation as a solid, reliable director.

Victor Fleming had no sooner completed his work on *The Wizard of Oz* (1939) than he started on *Gone With The Wind*. By mid-April, Fleming was exhausted, and even before his collapse, Selznick was considering asking Sam Wood, a seasoned director, to come in and take over some of the directing work.

BELLE ON THE STEPS
OF THE HOSPITAL

Wood directed his first scene, in which Belle Watling approaches Melanie and Scarlett on the steps of the hospital, on the night of April 29, immediately after Victor Fleming filmed Melanie's death scene. Filming began when Vivien Leigh arrived on the set at 9:25 p.m. but was slowed by camera and light problems. Vivien Leigh delayed things further when, at 11:45 p.m., she had to leave the set to make a telephone call to New York. A meal break was called, and filming resumed at 1 a.m., not concluding until 4 a.m.

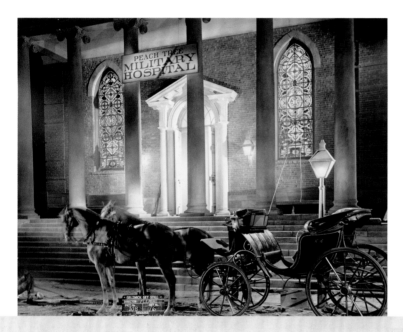

Mr. Schuessler

4/21/39

I will let you know about Lola Lane after seeing the Ona Munson test. I was enormously impressed with Miss Munson's reading for me yesterday and at the moment I feel that she is going to be our Belle. However, keep up your search until you hear from me and check with me again tomorrow or Monday, or whenever the test comes in. You might ask Hal Kern to keep you informed so that you could see it with me.

DOS

dos*f

(ABOVE) Makeup still of Ona Munson.

(LEFT, TOP) Set still of the steps of the hospital.

(LEFT) Ona Munson was not cast until shortly before her first scene.

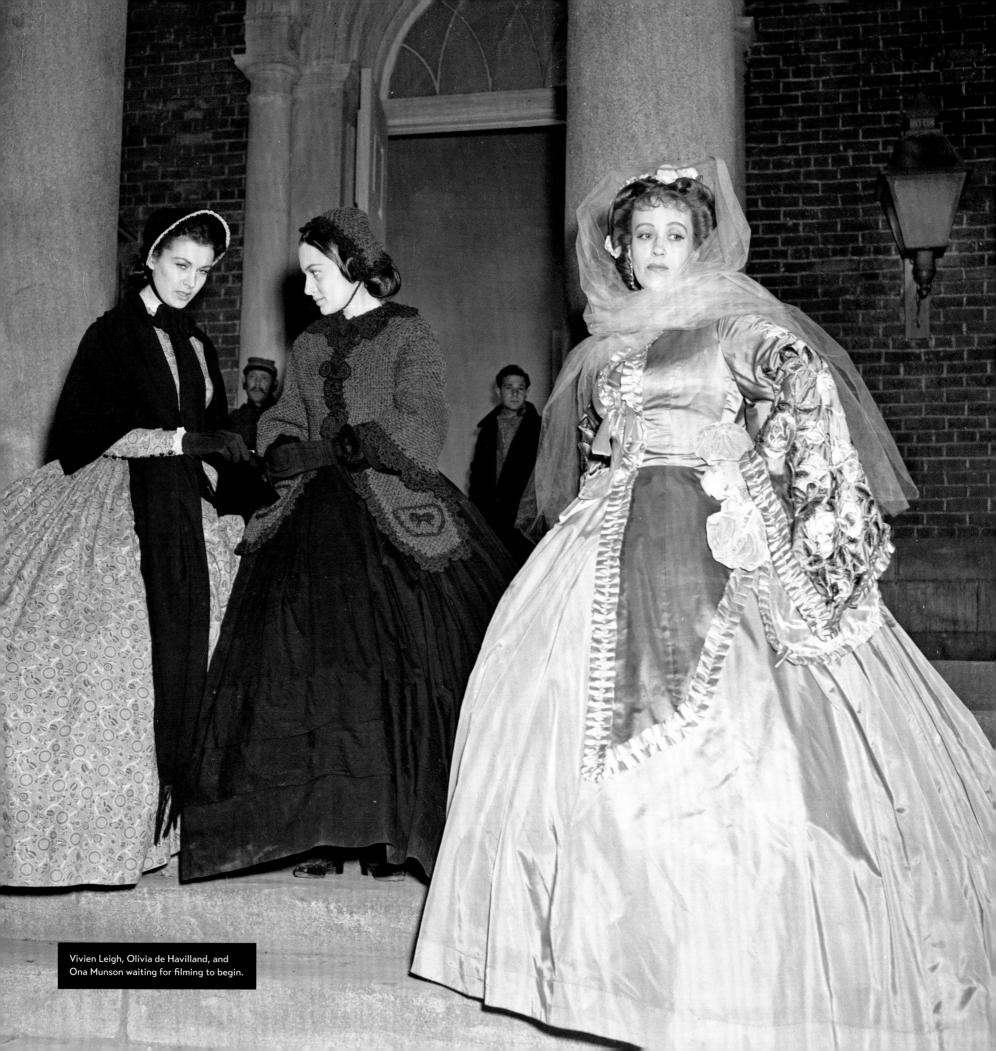

Vivien Leigh, Olivia de Havilland, and Ona Munson waiting for filming to begin.

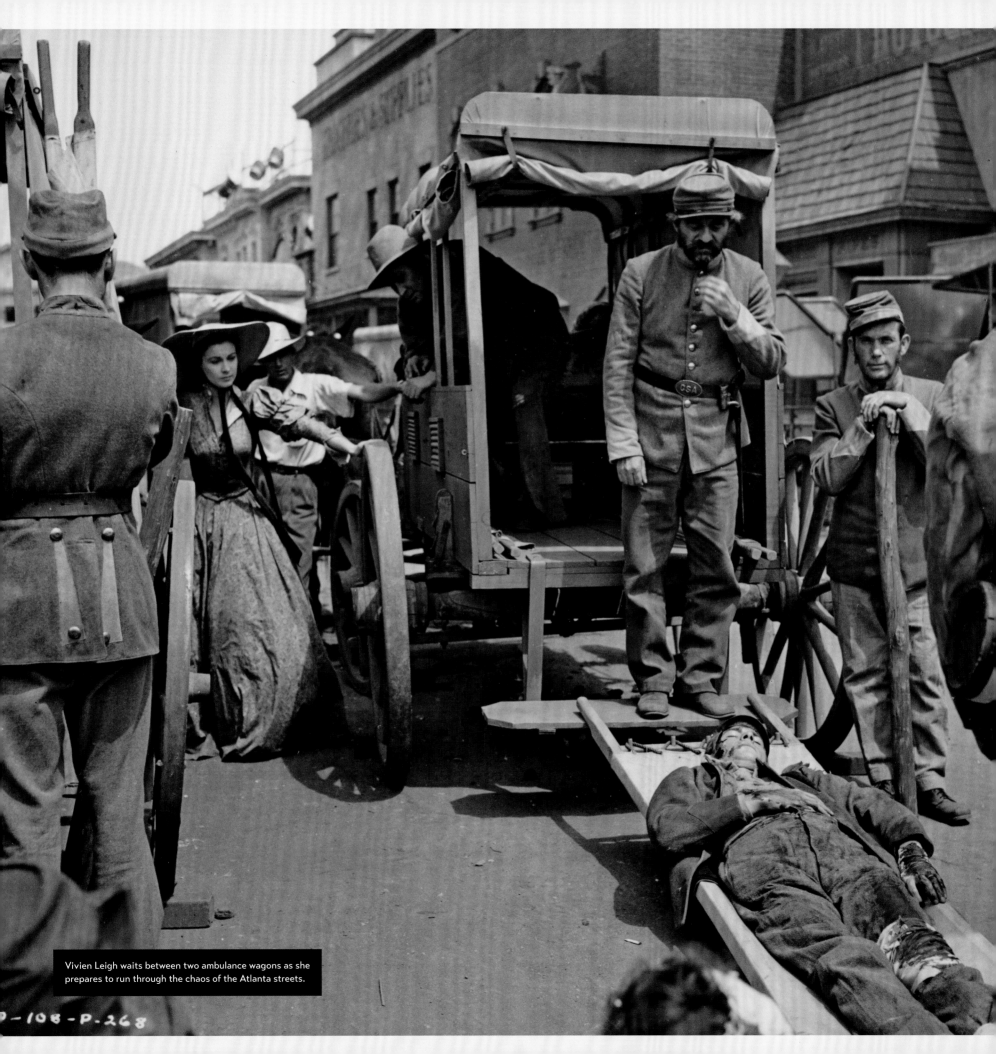

Vivien Leigh waits between two ambulance wagons as she prepares to run through the chaos of the Atlanta streets.

THE SEARCH FOR DR. MEADE

The search for Dr. Meade was one of the most complicated and difficult scenes to film. Sam Wood began work on it on Thursday, May 4. Eighty-four extras, eighty-one soldiers, and three women had already been fitted for costumes and were asked to arrive for makeup at 7:00 a.m. Another thirty men, eight women, and nine boys were asked to arrive at the same time to be fitted for costumes. The filming of Scarlett's walk through the chaos of Peachtree Street, dodging soldiers carrying the wounded, began at 10:15 a.m. Out of four takes, only one was acceptable. The cast and crew stopped and rehearsed for forty-five minutes before proceeding, then filmed until 4:30 p.m. They then moved to the Tara set on Stage 3 to film the scene between Scarlett and Ashley after she has married Frank Kennedy.

Sam Wood directed the first part of Scarlett's search for Dr. Meade. Victor Fleming was on sick leave, having collapsed from exhaustion. Fleming returned two weeks later to film the "pull-back shot."

RETURN TO TARA

On Friday, May 5, Wood began work on the scenes of Scarlett's return to Tara after the evacuation. He began with Gerald opening the door to Scarlett's frantic knocks. The next day they worked on the rest of the scene. Filming proceeded quickly with ten setups, including three showing Ellen's body on the bier and three of Scarlett's reaction to seeing her mother's body.

After filming the scene of Melanie and Belle Watling in Belle's carriage, Wood returned to Tara, filming the scenes between Scarlett, Gerald, and Mammy. On the afternoon of May 8, Menzies filmed establishing shots of Shanty Town, where Scarlett is attacked. That evening, Menzies prepared shots of Rhett's proposal to Scarlett and the wreath on the door after Kennedy's death.

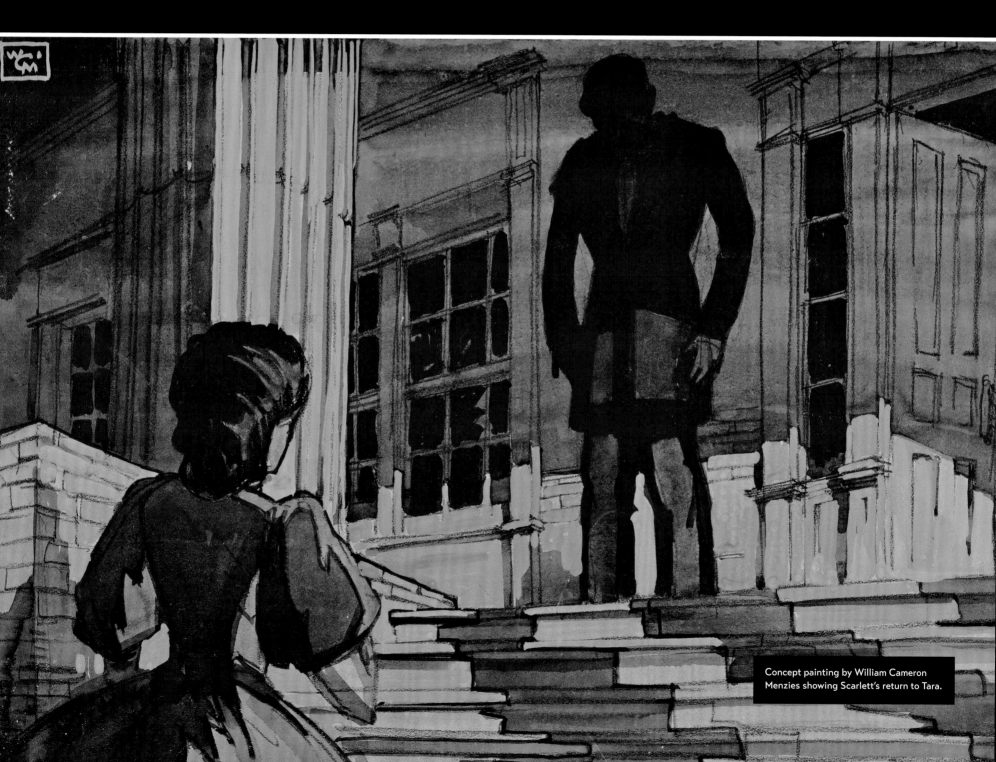

Concept painting by William Cameron Menzies showing Scarlett's return to Tara.

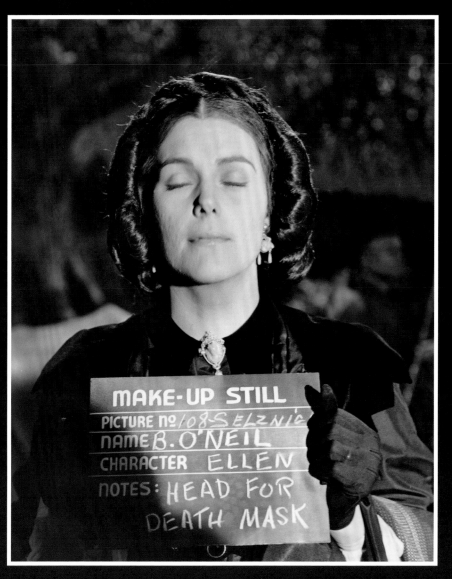

(LEFT, TOP) Set still of the road leading to Tara.

(LEFT, MIDDLE AND BOTTOM) Set stills of Tara.

(RIGHT, TOP) Set still showing Ellen O'Hara's body on the bier.

(RIGHT, BOTTOM) Makeup still of Barbara O'Neil, who played Scarlett's mother, Ellen.

THE YANKEE DESERTER

On Wednesday, May 10, Sam Wood began filming the scene in which Scarlett shoots the Yankee deserter. He began with the scene of Scarlett ordering Melanie back to her room. The crew then filmed Scarlett running up the stairs to retrieve the gun. After lunch, Leigh and the deserter's stunt double rehearsed, and filming began of the Yankee's fall down the stairs. This was followed by close shots of Scarlett firing the gun. Back at the top of the stairs they filmed Scarlett taking off her shoes, then Melanie's close-up as she comes running out of her room holding her brother's sword.

The crew continued work the next morning, filming Scarlett and Melanie disposing of the Yankee's body. They filmed Scarlett and Melanie's discussion of the situation in the morning, then filmed the searching and dragging of the body that afternoon.

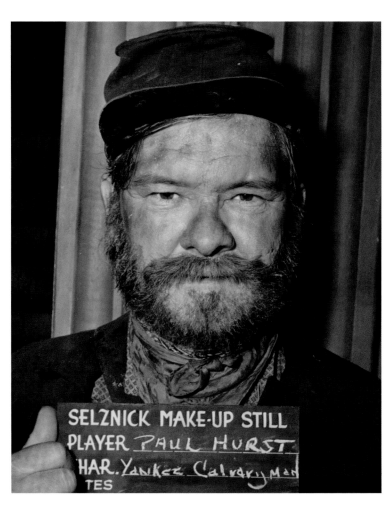

Makeup still of Paul Hurst as the Yankee cavalryman.

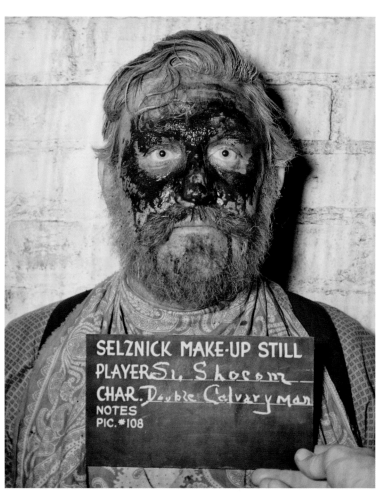

Makeup still of S. Shokum, the stunt double for Hurst. Shokum had to fall down the stairs after being shot in the face.

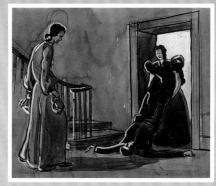

Storyboard paintings by William Cameron Menzies.

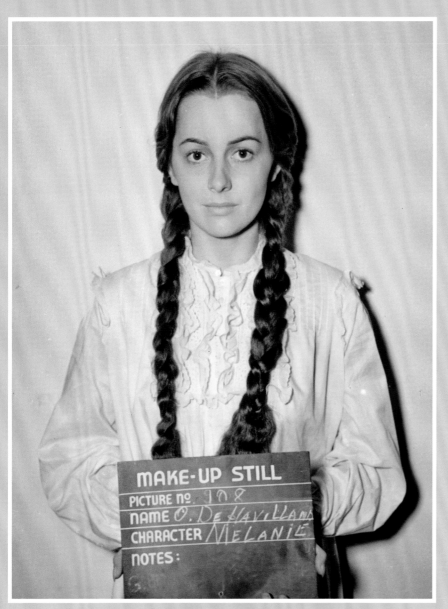

Makeup still of Olivia de Havilland. Melanie's hair was changed to a single braid for the film.

Three months later, after the Auxiliary to Sons of Union Veterans of the Civil War protested the depiction of a Union soldier attacking a female civilian, Selznick made a point of referring to the soldier as a "deserter" rather than a "soldier." This did little to placate the organization, which, like other organizations at the time, and many southerners for that matter, had firm beliefs about what happened during the Civil War.

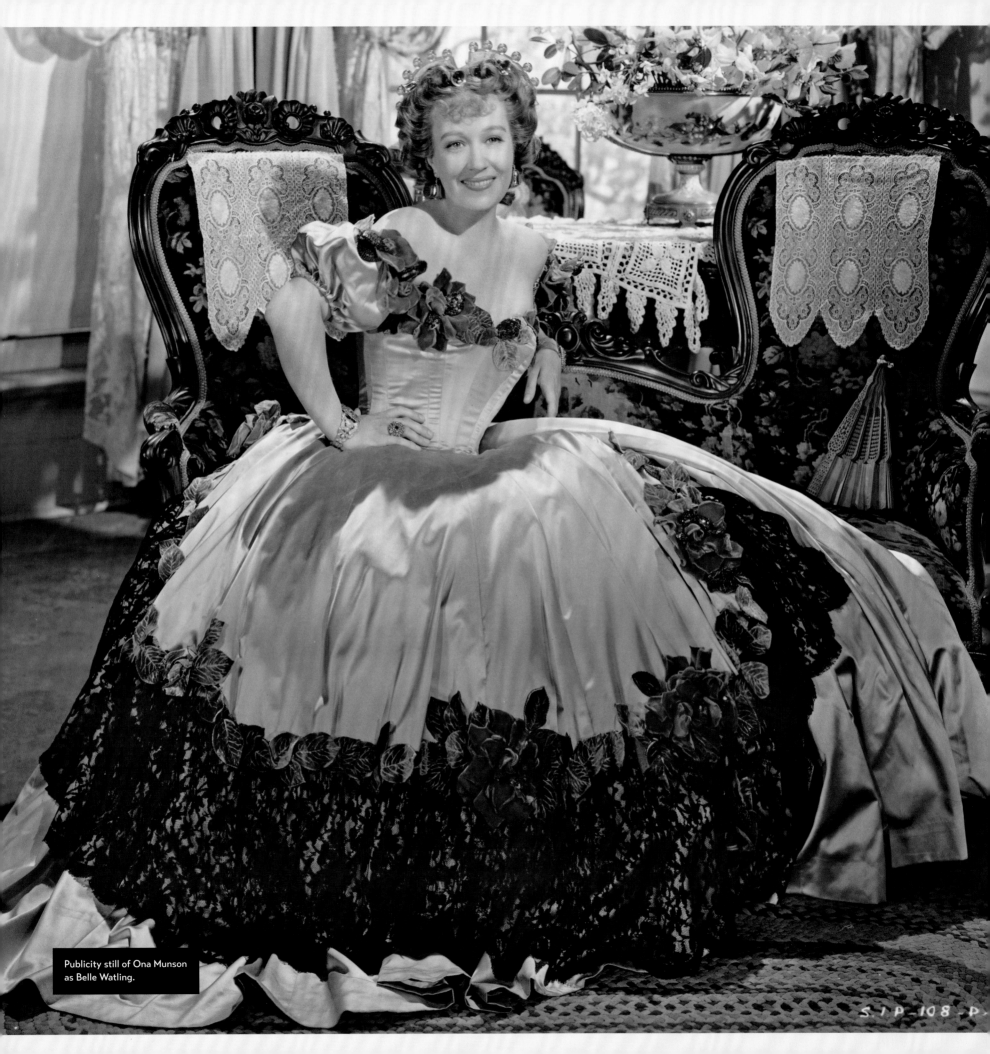

Publicity still of Ona Munson as Belle Watling.

SIP-108-P

RHETT AND BELLE

Selznick International Pictures

DAILY PRODUCTION LOG

108	"GONE WITH THE WIND"	May 13, 1939
Prod. No.	Picture	Date (63rd Day)

SET INT. BELLE WATLING'S HOUSE & INT. TARA HALLWAY STAGE NO. 4 & 3

TIME	LEGEND
9:00 AM	Company Call
	Going over the two new scenes and the novel - discussing it with Rhett and Belle.
	Consult D.O.S. on phone on how scene will be played.
11:05	Rehearsing action on set - Lining up, with principals.
11:35	Lining up with Stand-ins.
	LUNCH (1 hr.)
	Lining up and rehearsing.
2:14 PM	SHOOTING SCENE 592 take 1. OK Print.
2:16	" " 2 Inco.
2:18	" " 3 NG.
2:22	" " 4 OK Print.
	Changing lens.
2:58	SHOOTING SCENE 592 A take 1. Fair.
3:00	" " 2 OK Print.
3:06	" " 3 OK Print.
	Changing set-up
3:26	SHOOTING SCENE 592 B take 1. NG action
3:34	" " 2 OK Print.
	Changing set-up to Med. shot
4:08	SHOOTING SCENE 592 C take 1. OK Print.
	Changing set-up to Dolly to CU Belle at end of scene.
4:30	SHOOTING SCENE 592 D take 1. Comp. NG
4:34	" " 2. NG action
4:36	" " 3. OK Print.
4:38	" " 4. OK Print.
	Rehearsing scene with Nurse in bedroom - Rhett, Bonnie.
5:00	Moving to Stage 4 - and crew also having DINNER
	Lining up on Scene of Yankee riding into scene on window by Scarlett) DOLLY to CU.
7:50	SHOOTING SCENE 410 take 1. OK Print.
	Changing set-up to CS Door -Legs of Yankee enter
8:26	SHOOTING SCENE 412 take 1. NG
8:30	" " 2 OK Print. (Moving to
8:50	SHOOTING SCENE 416 take 1. OK Print.
	Lining up and rehearsing Yankee soldier (at newe
9:38--:52	SHOOTING SCENE 426 8 takes - Print take 4 & 4.
	Setting up scene (shot through glass) of Yankee'
10:25-:35	SHOOTING SCENE 426 B - 2 takes -Print both.
10:52	" SCENE 426 C take 1. OK Print.
11:10	" SCENE 426 D take 1. OK Print.
11:12-:14	Recording wild tracks - Vase breaking and basket
11:15	Company dismissed.

(ABOVE) Daily production log for May 13, 1939. Selznick insisted on being consulted any time there was a question of interpretation. In this case, the consultation resulted in a two-hour delay.

(RIGHT) Set still of Belle Watling's house.

Clark Gable, Ona Munson, and Sam Wood met with the production crew at 9 a.m. on May 13 to film the scene in which Belle tells Rhett, who is angry with Scarlett, "the child is worth ten of the mother." After consulting with Selznick on the telephone, they began filming after lunch and were finished with the scene by 4:30 p.m.

After dinner, the crew moved to the Tara set on Stage 4 to film shots of the Yankee deserter riding up to Tara and the shot of his legs as he enters the house. The last shots of the day, filmed through glass, were of the face of the Yankee deserter as he is shot by Scarlett.

Later that evening, Vivien Leigh filmed a screen test with Alfred Hitchcock for *Rebecca*, then arrived at the set at Lasky Mesa, a woodland location northwest of Los Angeles, at 3 a.m. for a first, failed attempt to shoot Scarlett's "I'll never go hungry again" speech, known within the studio as the "Scarlett's Oath" scene. Victor Fleming had returned, briefly, to direct the scene, and, though scheduled to direct the cotton patch scene the coming week, did not return to work until May 20.

"NO MORE BABIES"

Although Victor Fleming had first insisted on shooting in continuity, that is, shooting scenes in the order in which they appear in the final film, there was no attempt to do that now. By the time Fleming returned in late May, Selznick had three, sometimes four, directors working on *Gone With The Wind*, a chaotic arrangement that created scheduling conflicts on days when all the directors were working simultaneously. Charts, wardrobe and makeup reference photographs, and a Moviola film editing machine were used in combination to help match new shots to those filmed previously.

After directing the scene in which Rhett names his daughter Bonnie Blue Butler, Victor Fleming moved the crew to Scarlett's bedroom, where film stills were shot and Fleming worked out camera angles using stand-ins. A half hour of rehearsals began at 12:45 p.m. on May 19, but filming did not begin until 4:15 p.m. Fleming shot six takes, then stopped to rehearse and correct the camera movements. One close-up of Scarlett with Rhett seen in the mirror took almost an hour to line up. Aside from that, almost all the shots needed for that scene were completed by 6:45 p.m.

Filming did not go quite as smoothly five days later when Fleming returned to shoot the last part of the scene. The company arrived on set at 9 a.m. Fleming immediately decided to change the camera angle, then the camera lens. After four takes, he decided to change to a complicated camera movement that proved to be unsatisfactory. So the crew changed the camera angle again then broke for lunch. Filming began again at 2:20 p.m., and for the rest of the afternoon Fleming continued to change lens and camera angles until he settled on a close-up of Rhett that panned down to the daguerreotype of Ashley on the floor. After an exhausting nine takes, the company was dismissed shortly before 6 p.m.

The scene was completed the next afternoon. Most of the day was spent filming Rhett and Scarlett's argument and Scarlett dressing for Ashley's party. They began filming at 4:45 p.m. and finished all the shots in about two hours, including an insert close-up of the daguerreotype on the floor and Rhett kicking down the door.

While Victor Fleming filmed this scene, production designer William Cameron Menzies and special effects supervisor Jack Cosgrove worked on shots to be cut into the Burning of Atlanta scene. After dark on May 20 and again on the evening of May 24 they filmed the scene in which hooligans attempt to steal the horse from Rhett and Scarlett as they drive the wagon with Prissy, Melanie, and the baby through the burning streets. Yakima Canutt and Aline Goodwin doubled for Gable and Leigh. Eighteen "Tough Men" and seven "Tough Women" also appeared. On the evening of May 25, they filmed complicated process plates to combine with previously shot footage. They were far from finished, however, and would return five times in late June and early July to complete the scenes.

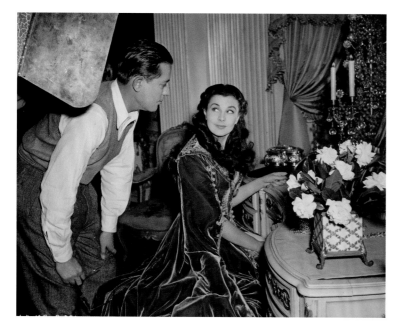

(LEFT) Cinematographer Ernest Haller talks to Vivien Leigh before shooting the "No More Babies" scene. (RIGHT) Set still of the "No More Babies" scene.

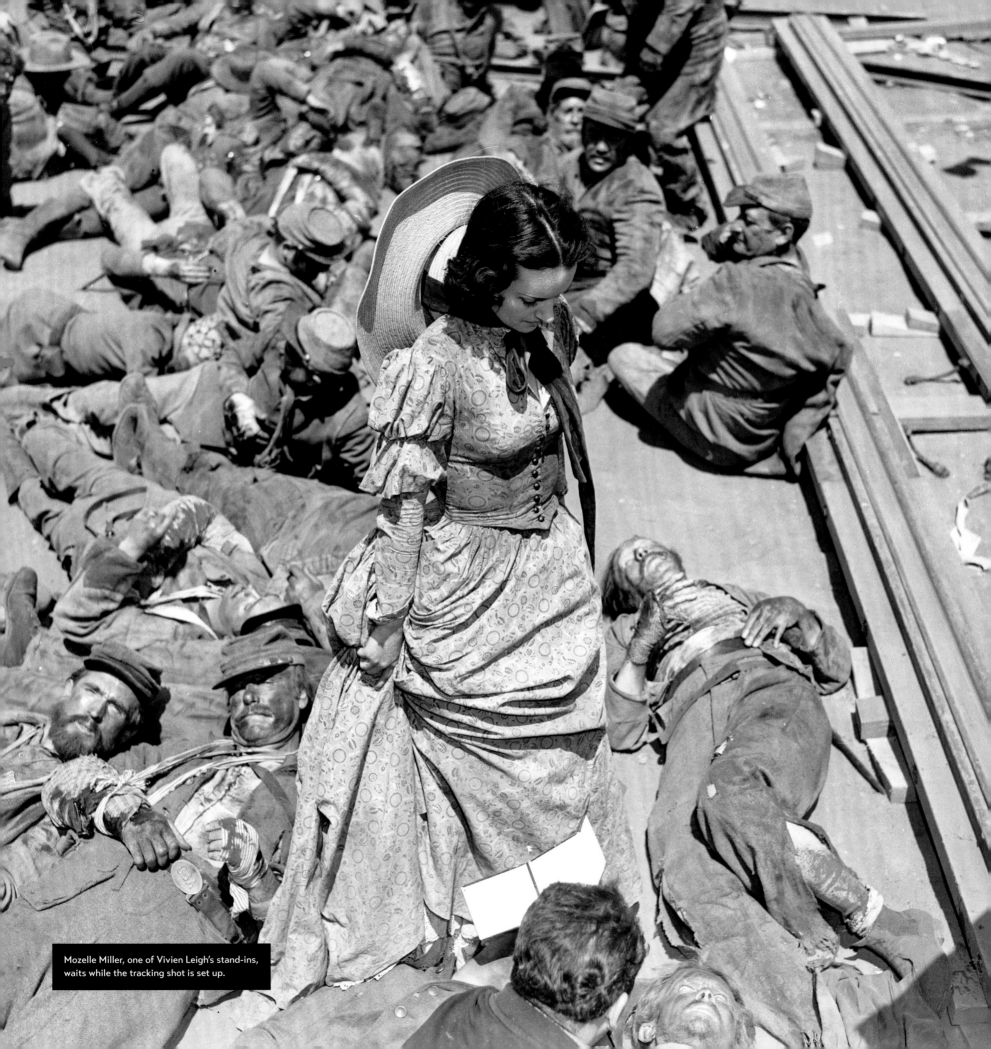

Mozelle Miller, one of Vivien Leigh's stand-ins, waits while the tracking shot is set up.

THE "PULL-BACK SHOT"

By Saturday, May 20, Victor Fleming had recovered and resumed work on the set. Vivien Leigh, Harry Davenport (Dr. Meade), Howard Hickman (John Wilkes), and Ona Munson (Belle Watling) arrived for makeup at 7 a.m. along with hundreds of extras. The call had been for 997 extras—300 requiring complete costumes and full makeup, 310 partial costumes and makeup, 300 partial costumes but no makeup, 6 previously costumed, and 83 to be fitted with costumes on arrival.

But there was a problem. There were not enough extras available in Hollywood that day. As early as March 24, Selznick had contacted the Screen Actors Guild to negotiate a reduced pay scale of $5.50 for the day since the extras would be used "merely for atmospheric background" and would not be required to supply their own wardrobes. The guild had requested $8.25 per person, since they would be "acting the part of soldiers." While the guild stood firm at $8.25 per person, it also became clear that it could not supply the full number of extras needed. Over the guild's protests, Selznick proceeded with his plan to augment the 997 extras with 680 dummies, which the "animate" extras would manipulate to simulate movement.

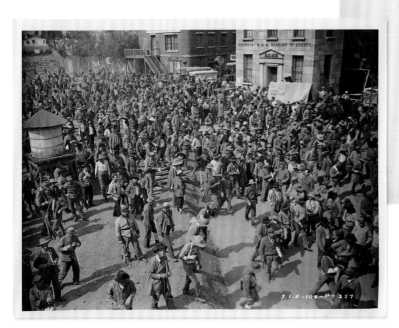

```
                    SCARLETT'S SEARCH FOR DR. MEADE

                        WOUNDED IN THE SQUARE

                           EXTRA TALENT

                 (BASED ON 8:00 A.M. SHOOTING CALL)

                  DRESSING TENT ACCOMODATIONS

          Men's Dressing Tent - - - - - - 250
          Women's    "      "  - - - - - - 250
          Combination Tent- - - - - - - - 200
          Colored Men's Tent- - - - - - - 100
          Colored Women's Tent- - - - - - 100
          Hoop Tent - - - - - - - - - - -  49
                                          949

                            C A L L S

6:00 AM. - 300 Men    These are for fore-ground action.  To be completely
                      wardrobed.  Will be assigned to Men's and Women's
                      Dressing Tents.  After dressing will report to Makeup
                      Tent.  After makeup, will be placed in position on set.

7:00 AM - 300 Men     Will be issued partial wardrobe and after dressing,
                      will proceed direct to set.  No makeup.

            49 Men    As fitted prior to call:
                         20 Stretcher bearers
                         10 Orderlies
                          5 Doctors
                          3 Confederate Officers
                          3 Mounted Officers
                          8 Ambulance Drivers
                         49 Total
                      Wardrobe for these 49 men will be issued from Ladies'
                      Wardrobe Tent.  After dressing in Hoop Tent, will be
                      made-up and placed in position on set.

7:30 AM - 300 Men     Will be issued partial wardrobe and after dressing,
                      will proceed direct to set.  No makeup.

            949 TOTAL

7:00 AM -    4 Women-Nurses.  Will be madeup in Make-up Dept. and transported
                      to the set.

7:30 AM -    6 Boys -Colored water boys.

                    NOTE TO CASTING DEPARTMENT

    When call is issued by F.K. to 900 men, as many bearded men to be used as
    is available.  The 600 men on the 7:00 AM and 7:30 AM call must be ordered
    to report in their oldest clothes with no sport shoes permitted.  These
    600 men must be notified that they may be required to lie down on the
    ground in their own clothes and calls must only be given under this condi-
    tion.
```

(ABOVE) Six huge tents were used as dressing rooms for extras on *Gone With The Wind* and all six were pressed into service for this one scene. More than 900 extras needed at least partial wardrobe; 300 of those needed complete wardrobe and makeup. Ten "first aid men" were assigned to bandage "the wounded," and eight assistant directors were brought on to help arrange and coach the extras during the scene.

(LEFT) Extras portraying wounded soldiers break for lunch. Part of the Atlanta set is in the background.

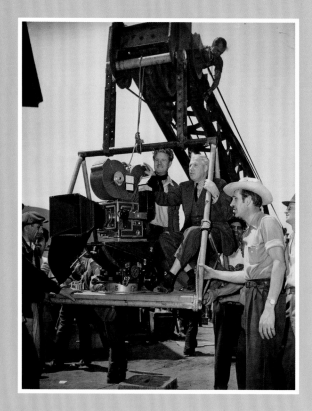

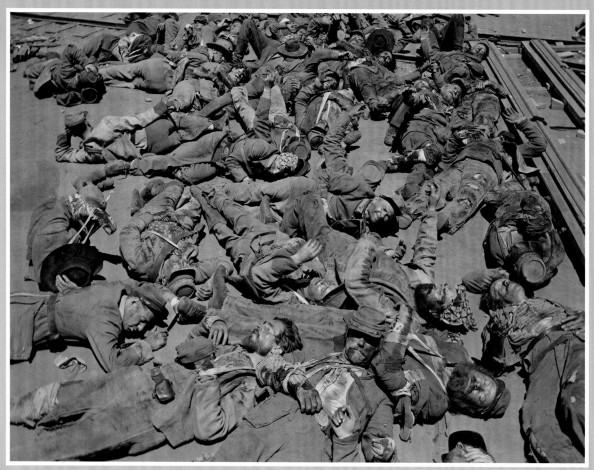

(TOP, LEFT) Arthur Arling (left) and Ray Rennahan wait to be lifted by a construction crane to film the "pull-back shot."

(TOP, RIGHT) Extras portraying wounded soldiers wait for filming to begin.

(BOTTOM, LEFT) Call sheet for the "pull-back shot." By May 20, Victor Fleming had recovered and returned to work.

(BOTTOM, RIGHT) Selznick worried they would get bad publicity if word got out they had used dummies in the "pull-back shot."

SELZNICK INTERNATIONAL PICTURES, INC.

CALL SHEET

DATE SAT., MAY 20, 1939

PICTURE "GONE WITH THE WIND" PROD. NO. 109 DIRECTOR VICTOR FLEMING

SET INT. & EXT ATLANTA R. R. STATION SUMMER 1864

LOCATION 40 ACRES SET NO. 12 SCENES SCS. 2500-H to 262

NAME	TIME CALLED		CHARACTER, DESC, WARDROBE
	ON SET	MAKE-UP	
Vivien Leigh	8:00 AM	7:00 AM	Scarlett #11
Harry Davenport	10:30 AM	9:30 AM	Dr. Meade #4
Howard Hickman	8:00 AM	7:00 AM	John Wilkes #2
Ona Munson	Will call		Belle Watling #5
Bits as requisitioned	Will call		Wounded men, as fitted
			TO REPORT TO 40 ACRES
EXTRAS - - -			
300 Men	6:00 AM	6:00 AM	Complete wardrobe and makeup
310 "	8:00 AM	7:00 AM	Partial wardrobe - no makeup
77 "	8:00 AM	7:00 AM	As fitted - to be made up
300 "	8:00 AM	7:30 AM	Partial wardrobe - no makeup
987 Total			
4 Women	8:00 AM	7:00 AM	Nurses, as fitted) To report
6 Colored boys	8:00 AM	7:30 AM	To be fitted) to studio
10 Total			
			PROPERTY DEPT.
CAMERAS - - - - - - -	7:00 AM		18 Ambulances and teams - 7:30AM
(2 Straight and 2			3 Officers riding horses-7:30AM
Cosgrove)			
SOUND (Ready) - - - - -	8:00 AM		
P.A. SYSTEM - - - - -	7:00 AM		
COSGROVE (Ready) - - -	8:00 AM		
10 FIRST AID MEN TO			
BANDAGE WOUNDED - -	6:00 AM		
6 EXTRA ASST. DIRECTORS	5:00 AM		
LUNCHES (Ready) - - - -	11:30 AM		

IN CASE OF BAD WEATHER

INT. SCARLETT'S BEDROOM-RHETT'S HOUSE - STAGE #11 - SET #53 - (CONTINUATION)
"No More Babies" Seq. Spring 1867

Vivien Leigh	9:00 AM	8:00 AM	Scarlett #26
Clark Gable	9:00 AM	8:30 AM	Rhett #20
Hattie McDaniel	9:00 AM	8:30 AM	Mammy #9
Stand-ins	8:15 AM	8:00 AM	

LATER

SCENES 600-601 (Dressing for Party Seq.) SUMMER 1872 - NIGHT

Vivien Leigh	-	-	Scarlett #28
Clark Gable	-	-	Rhett #22

ADVANCE SHOOTING SCHEDULE
ON REVERSE SIDE OF CALL SHEET

ASSISTANT DIRECTOR ERIC STACEY

SELZNICK INTERNATIONAL PICTURES, INC.
CULVER CITY, CALIFORNIA

INTER-OFFICE COMMUNICATION

TO Mr. O'Shea

SUBJECT:

OFFICE OF
DAVID O. SELZNICK
PRESIDENT

DATE 6/10/39

Do anything you please about running the Evacuation scene for the Guild or anybody else that is necessary in the dispute about the extras.

The only thing that distresses me is the possibility that we will get still further publicity about the use of the dummies in this scene. Actually, I regret now that we used the dummies (except that as I recall it there was a shortage of extras and we would have had to use them regardless, which point, however, unfortunately has not been publicized: you might speak to Hebert about this).

It is a crime that with all the money we have spent on this picture, our biggest shot should be publicized as having been made with dummies and I would rather pay twice the saving than have it given further publicity. As it is, we have probably spoiled this shot for the critics and will spoil it for the public too if the controversy goes further.

DOS

dos*f

Extras and dummies were in place by 8 a.m., and rehearsals began involving two cameras. Filming began at 8:30 a.m. with a shot of Scarlett walking among the wounded and happening upon Ashley's father, John Wilkes, a scene that would later be cut. The scene where Dr. Meade is tending to the wounded was modeled after a photograph in one of the production's many reference works, *The Photographic History of the Civil War*.

The spectacular "pull-back shot" began filming after lunch at 1:35 p.m. The first two takes were not acceptable. Five more takes were made, with take seven being printed and used in the final film. Once the shot was complete, the crew recorded "wild tracks," the sounds of "Noise—Groans—Wounded in the street." Then at 3 p.m. the cast and crew rehearsed Scarlett's scene with Dr. Meade. Filming was completed for the day at 6:30 p.m.

On Monday, May 22, filming of the search for Dr. Meade resumed with Scarlett's scene with John Wilkes, Belle Watling's scene with wounded soldiers, and a tracking shot through the wounded with Scarlett. The crew was dismissed at 4 p.m. to go to the set of Tara to film a sunrise shot. Much of what they filmed this day would not be used in the finished film.

(BELOW) Set still for the search for Dr. Meade.

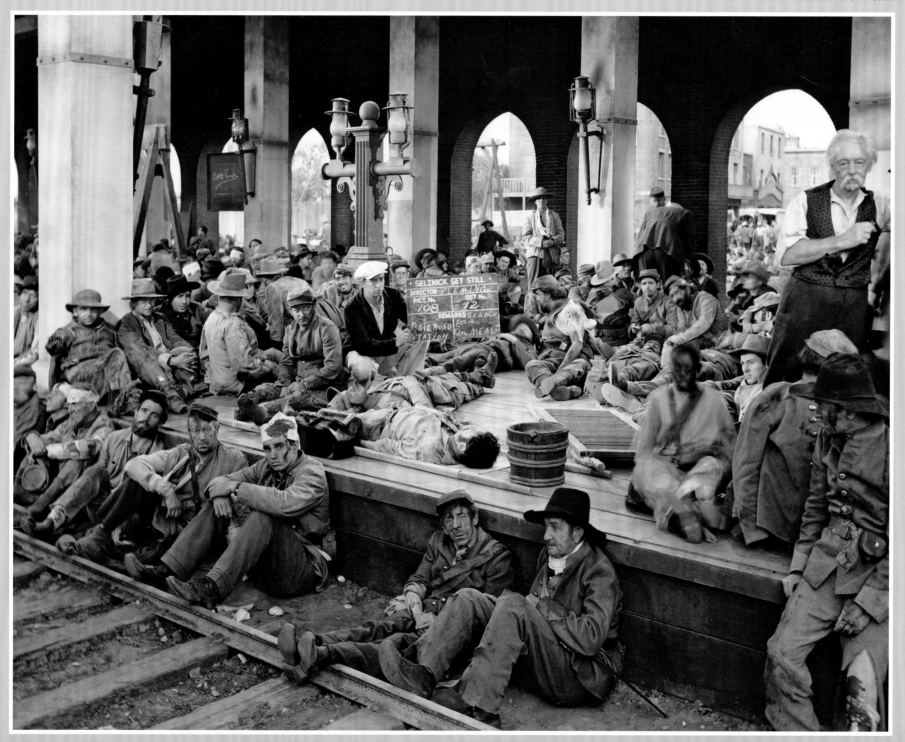

SCARLETT'S OATH AND TARA COTTON FIELD

Victor Fleming's first attempt to film the Scarlett's Oath scene in the wee hours of May 13 at the Lasky Mesa location was derailed by rain and heavy fog.

Ten days later, beginning at 4:45 a.m. on May 23, Fleming successfully filmed three takes of Scarlett's "I'll never go hungry again" soliloquy, all of which were printed for editing. Long shots of Leigh's double with her fist raised would be filmed later.

The crew then stopped for breakfast before filming the scenes in the cotton patch with Suellen, Carreen, Mammy, Prissy, Pork, and Scarlett. Two cameras were used, and at first the light was not adequate. Eleven takes were made of a shot in which Scarlett scolds Pork and Mammy, but the shot was cut from the final film. Shooting proceeded rapidly after that. By 4:45 p.m. they had completed all of the scenes set in Tara's cotton patch, including that of Melanie trying to explain the unexpected sound of a gunshot to Suellen and Carreen. It was actually Scarlett shooting the Yankee deserter.

Scarlett's Oath was one of the most important scenes in the film, and Selznick took his characteristic care with the interpretation and execution of the sequence. Shots of Leigh's double would be made later and intercut with her footage.

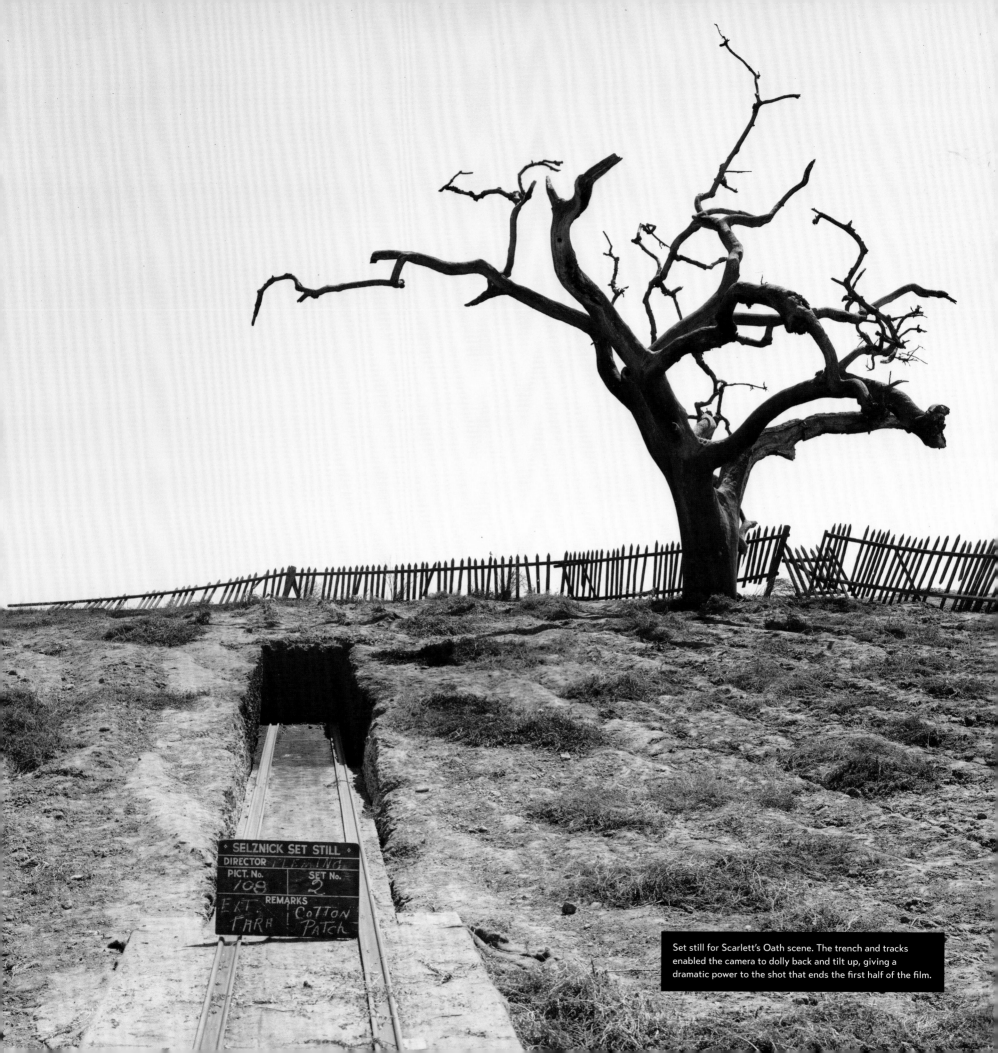

SELZNICK SET STILL
DIRECTOR FLEMING
PICT. No. 108 SET No. 2
REMARKS
EXT. FARM COTTON PATCH

Set still for Scarlett's Oath scene. The trench and tracks enabled the camera to dolly back and tilt up, giving a dramatic power to the shot that ends the first half of the film.

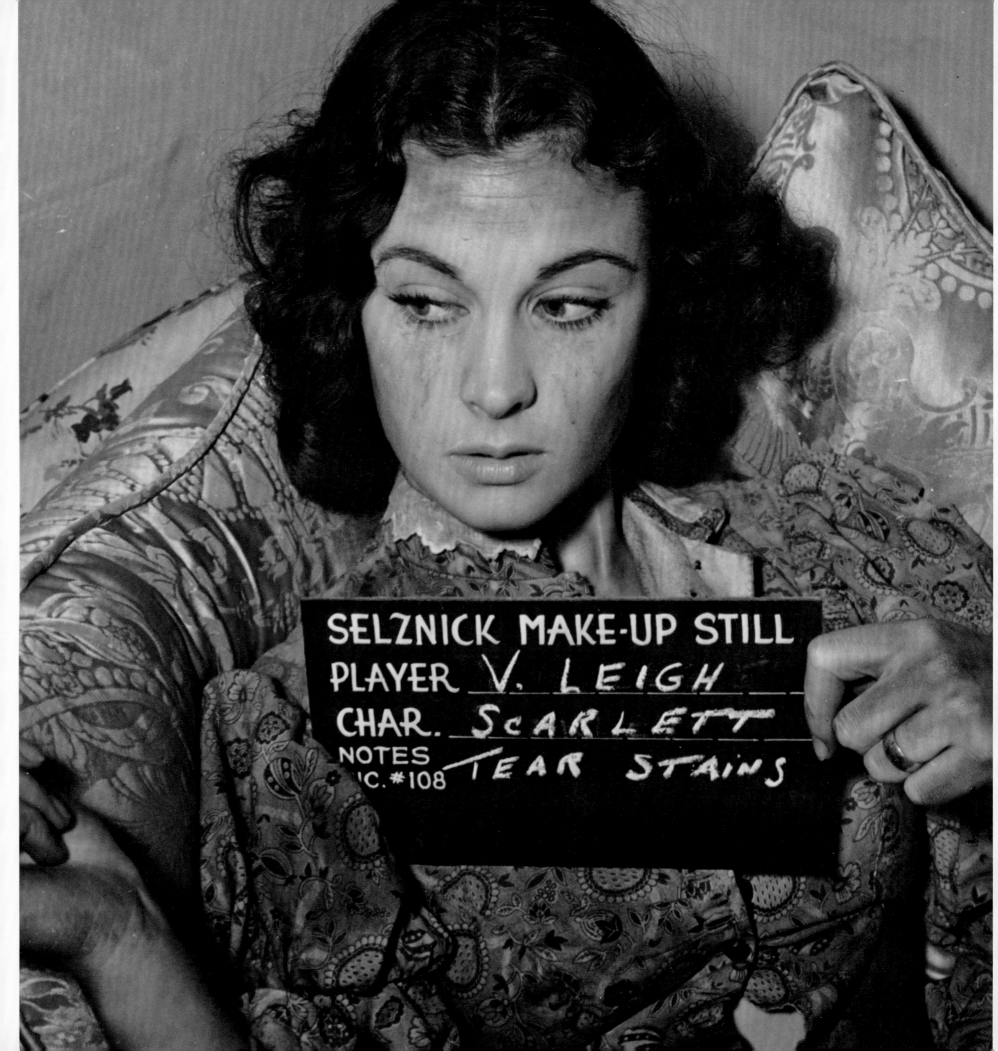

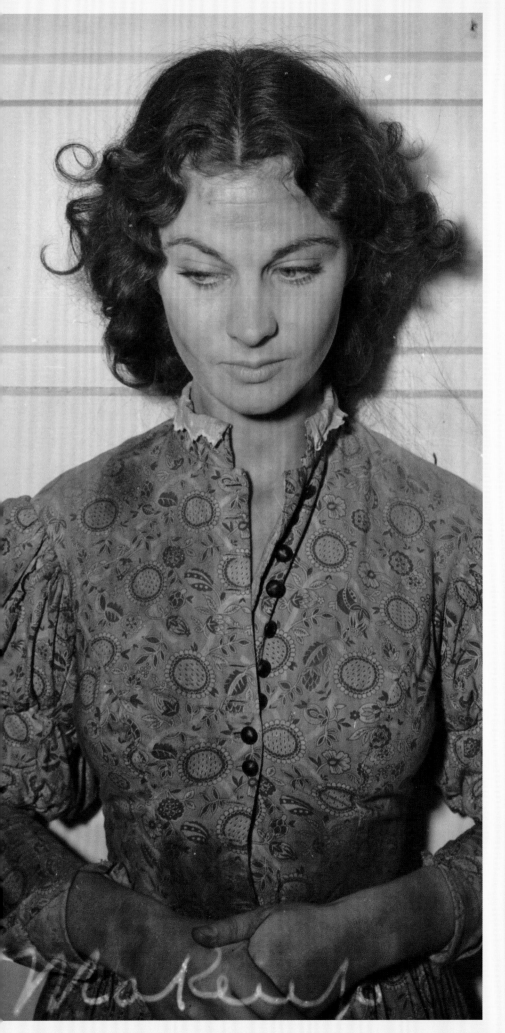
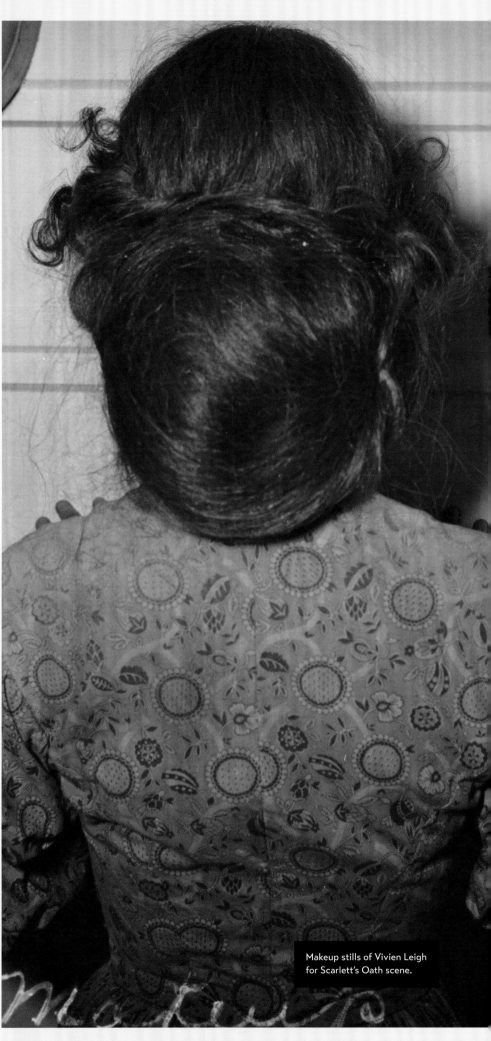

Makeup stills of Vivien Leigh for Scarlett's Oath scene.

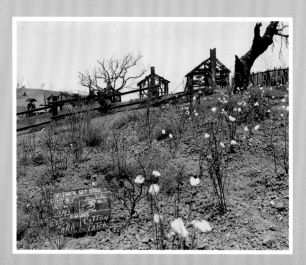

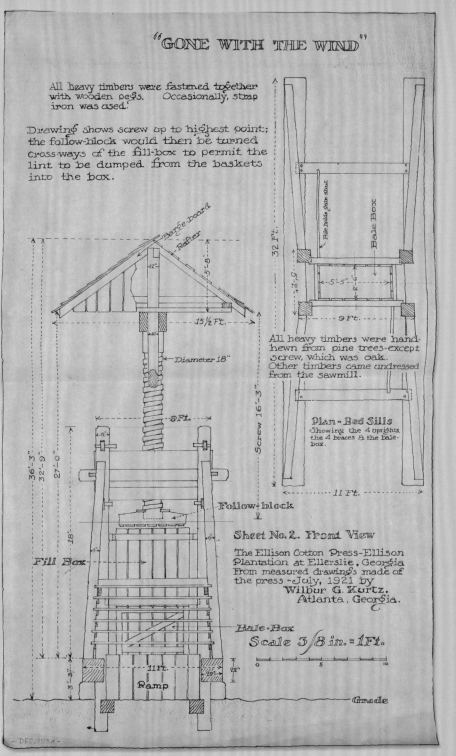

(ABOVE) Details of the cotton press were provided by
Wilbur Kurtz, who had made detailed drawings of such
structures many years earlier.

(LEFT, TOP) Concept painting by William Cameron
Menzies of Tara's cotton press and devastated grounds.

(LEFT, MIDDLE) Set still of Tara's cotton press.

(LEFT, BOTTOM) Set still of Tara's cotton patch and
burned out buildings.

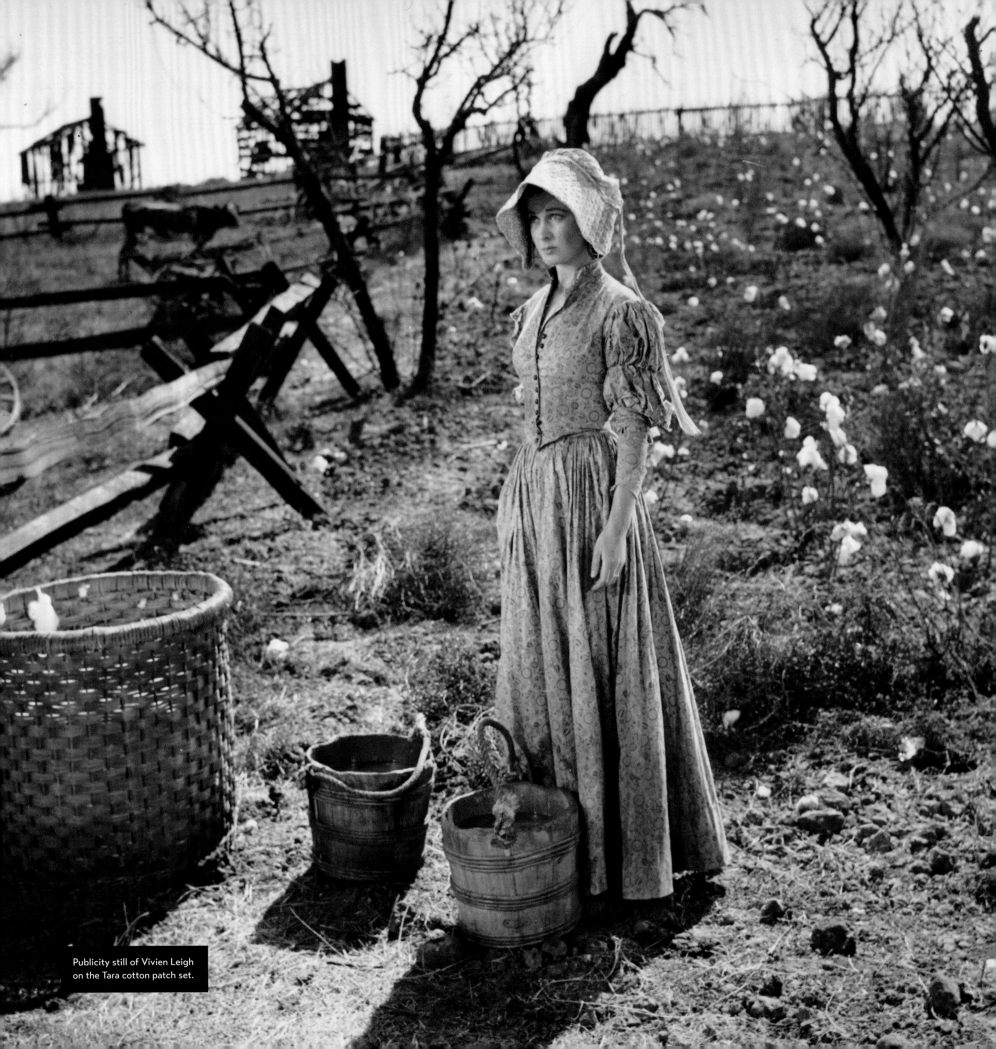

Publicity still of Vivien Leigh on the Tara cotton patch set.

(TOP, LEFT) Publicity still of Evelyn Keyes (left) and Ann Rutherford in the cotton patch at Tara.

(TOP, RIGHT) Butterfly McQueen in the cotton patch at Tara.

(BELOW) Costume designs by Walter Plunkett for Suellen. Plunkett intended Suellen to wear this dress earlier in the film. Later, without the hoop, the same dress serves as her work clothes and emphasizes how the family's fortunes have changed.

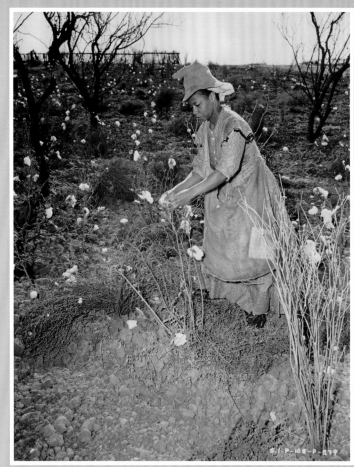

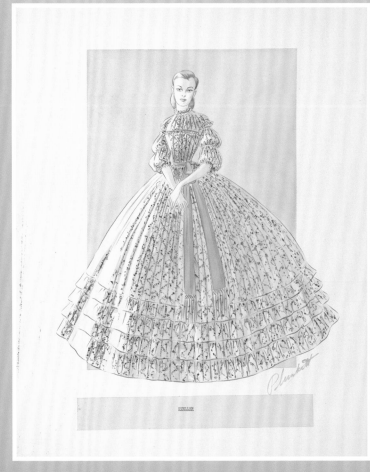

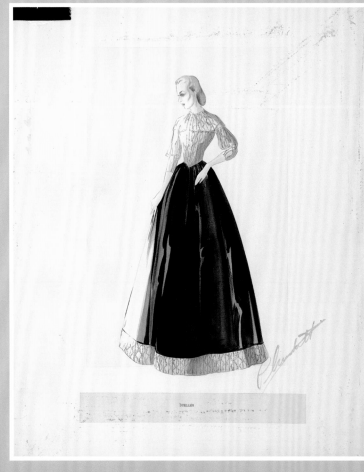

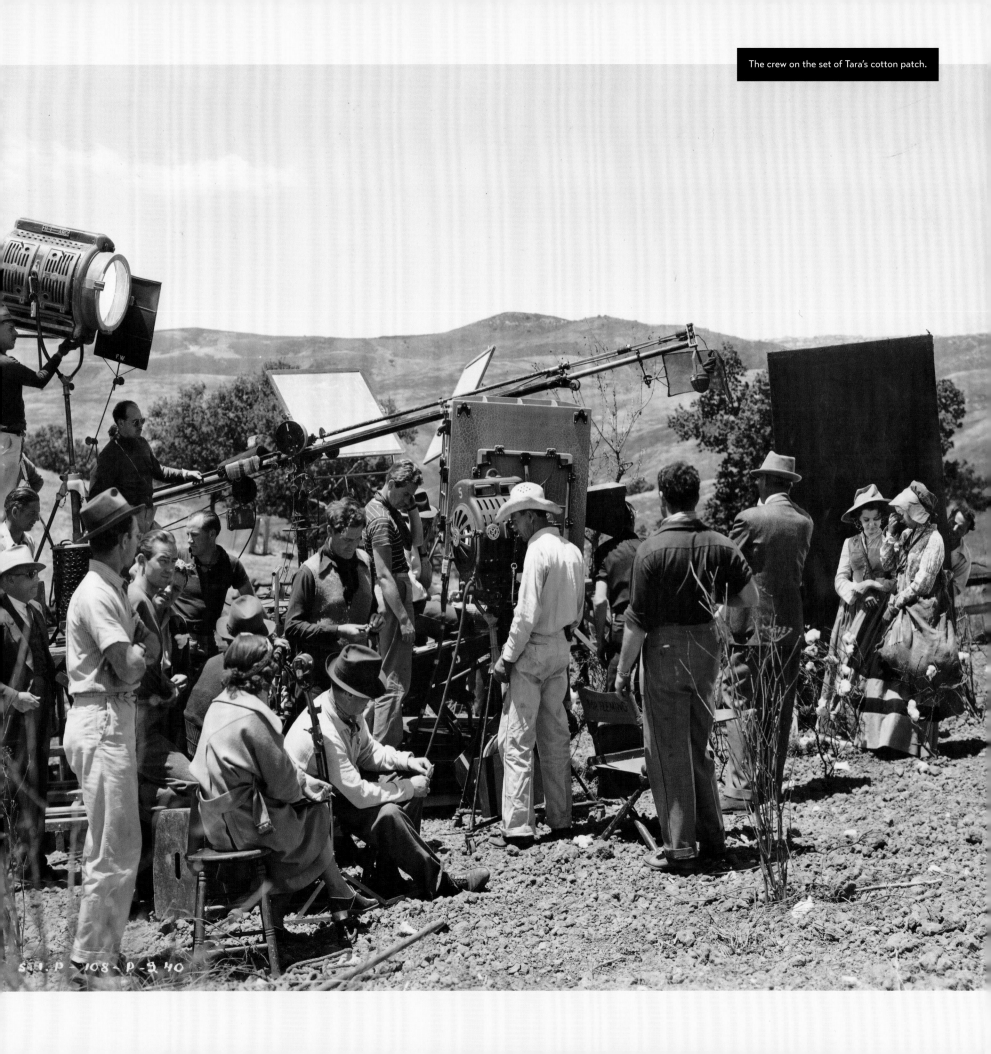

The crew on the set of Tara's cotton patch.

SH.P - 108 - P - 40

SELZNICK SET STILL
DIRECTOR VICTOR FLEMING
PICT. No. 108 | SET No. #1
REMARKS
TARA BACK PORCH
FEEDING SOLDIERS
SET

PICTURE Nº 108
WARDROBE STILL
NAME
CHAR. PARRY
CHANGE R. TRENT
LOU KELLY
SC-452-C

FEEDING SOLDIERS

Victor Fleming directed part of the scene in which Melanie gives food to soldiers on the steps of Tara and learns that Ashley has been captured. Filming took place on Monday, May 29. Louis Jean Heydt was cast as the Cobb's Legion soldier. Several extras were requested, including two "emaciated soldiers," one one-armed soldier, and one one-legged soldier. Beau Wilkes was a "to be selected" 11-month-old baby. The part was eventually played by Ricky Holt, whose brother appeared in *The Adventures of Tom Sawyer*.

The filming began shortly after 10 a.m. following rehearsals. The first seven takes were scrapped because the baby began crying during the scene. The twelfth take was considered good enough to print for editing. The rest of the morning was spent filming close-ups of Heydt and of Melanie and baby Beau, followed by the shot of Scarlett scolding Melanie for feeding the soldiers.

On Saturday, June 3, Sam Wood's film unit began rehearsing the delousing scene. Although inadequate natural light delayed the morning shoot, the crew completed this scene and Mammy's rebuke of Suellen before lunch.

(ABOVE) Hattie McDaniel resting between takes.

(LEFT) Carroll Nye in the delousing scene.

199

(RIGHT) Set still of Tara's "covered way," where the delousing takes place.

(BELOW, LEFT) Set still of Tara for the delousing scene.

(BELOW, RIGHT) Set still of Tara's back porch.

(FACING PAGE) Victor Fleming (left) watches as Olivia de Havilland holds Beau Wilkes, played by Rickey Holt, while Louis Jean Heydt offers a black-eyed pea to get Rickey in the mood for the scene.

(RIGHT) Set still of Tara's "covered way," where the delousing takes place.

(BELOW, LEFT) Set still of Tara for the delousing scene.

(BELOW, RIGHT) Set still of Tara's back porch.

(FACING PAGE) Victor Fleming (left) watches as Olivia de Havilland holds Beau Wilkes, played by Rickey Holt, while Louis Jean Heydt offers a black-eyed pea to get Rickey in the mood for the scene.

FEEDING SOLDIERS

Victor Fleming directed part of the scene in which Melanie gives food to soldiers on the steps of Tara and learns that Ashley has been captured. Filming took place on Monday, May 29. Louis Jean Heydt was cast as the Cobb's Legion soldier. Several extras were requested, including two "emaciated soldiers," one one-armed soldier, and one one-legged soldier. Beau Wilkes was a "to be selected" 11-month-old baby. The part was eventually played by Ricky Holt, whose brother appeared in *The Adventures of Tom Sawyer*.

The filming began shortly after 10 a.m. following rehearsals. The first seven takes were scrapped because the baby began crying during the scene. The twelfth take was considered good enough to print for editing. The rest of the morning was spent filming close-ups of Heydt and of Melanie and baby Beau, followed by the shot of Scarlett scolding Melanie for feeding the soldiers.

On Saturday, June 3, Sam Wood's film unit began rehearsing the delousing scene. Although inadequate natural light delayed the morning shoot, the crew completed this scene and Mammy's rebuke of Suellen before lunch.

(ABOVE) Hattie McDaniel resting between takes.

(LEFT) Carroll Nye in the delousing scene.

199

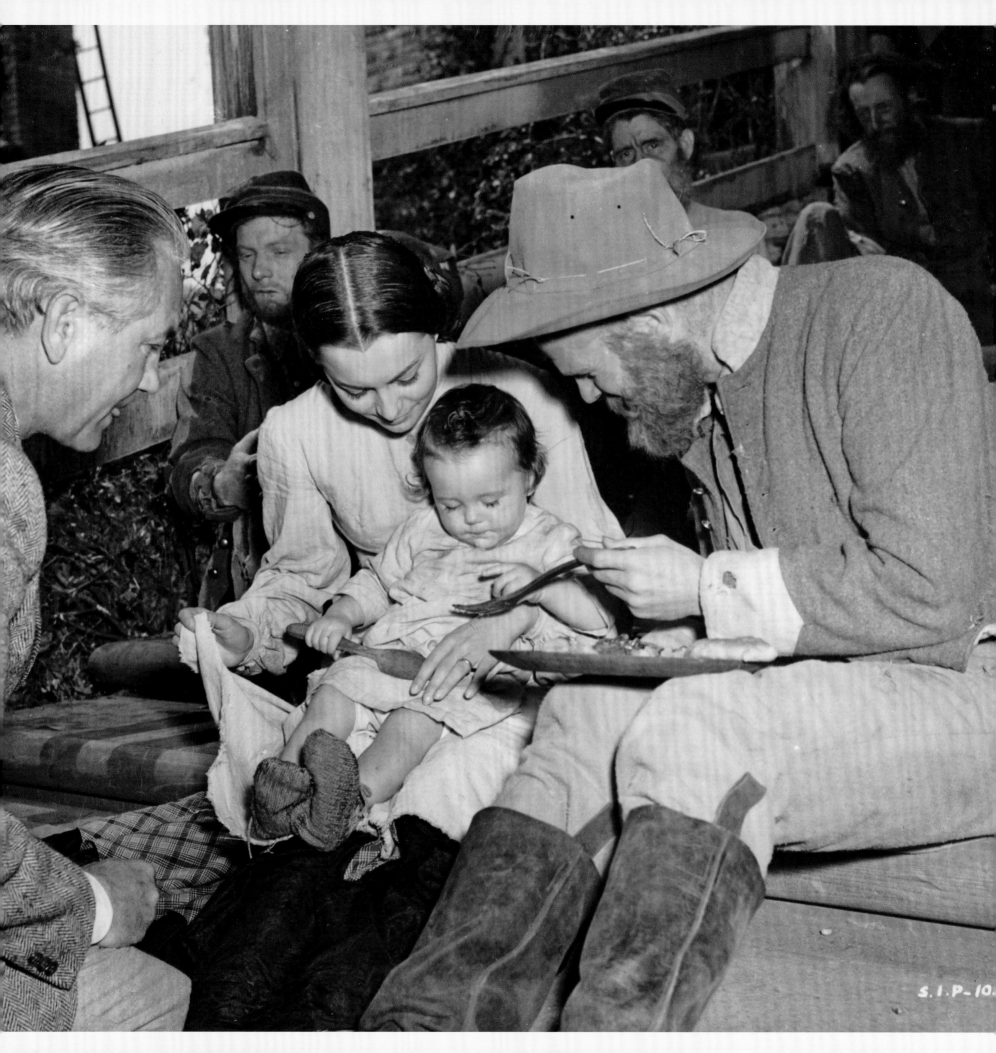

S.I.P-10

MELANIE AND MAMMY ON THE STAIRS

In the afternoon of May 29, the crew moved to Stage 14, the interior of the Butler home, to work out the logistics of Melanie and Mammy's walk up the stairs. This was Hattie McDaniel's most emotional scene, so she rehearsed offstage all afternoon and evening while the crew set up the crane and lighting.

The scene was filmed the next day, May 30. The crew was plagued by mechanical difficulties with the camera crane, and filming did not begin until 11 a.m. Meanwhile Hattie McDaniel continued to rehearse alone offstage and then, with Olivia de Havilland, on the stairs.

Fourteen takes were made of the master shot, each one involving Melanie and Mammy walking up, then down, the stairs. Misspoken lines ruined three takes. Most of the others were incomplete or unusable due to mechanical problems. After the camera lens was changed to achieve a closer composition, six more takes were made.

After lunch, at the bottom of the stairs, the crew filmed Mammy opening the front door to admit Melanie. Then at the top of the stairs they filmed Melanie and Mammy's approach to Bonnie's nursery door. This part of the scene went smoothly; only the first of the five takes was marked "NG" (No Good). The day ended with the shot of Mammy kneeling to pray. Three takes were made, and the crew was dismissed for the day.

They returned on June 1 to complete the scene beginning with Melanie entering Bonnie's nursery. Hours were spent working out which way the door should open, positioning the bed so Bonnie's body could be clearly seen, and silencing a squeaky floor. After a dozen takes, some of which were scrapped due to problems with the door, the crew changed the angle and filmed three more takes and finished at 4:30 p.m.

After Clark Gable shaved and changed costumes, and after the crew moved the bed and toys, they began filming the scene in which Rhett tells Bonnie they are going on a trip to London. The scene required only three takes for the first camera angle and four takes for a second and took just over an hour to complete.

Makeup still of Olivia de Havilland.

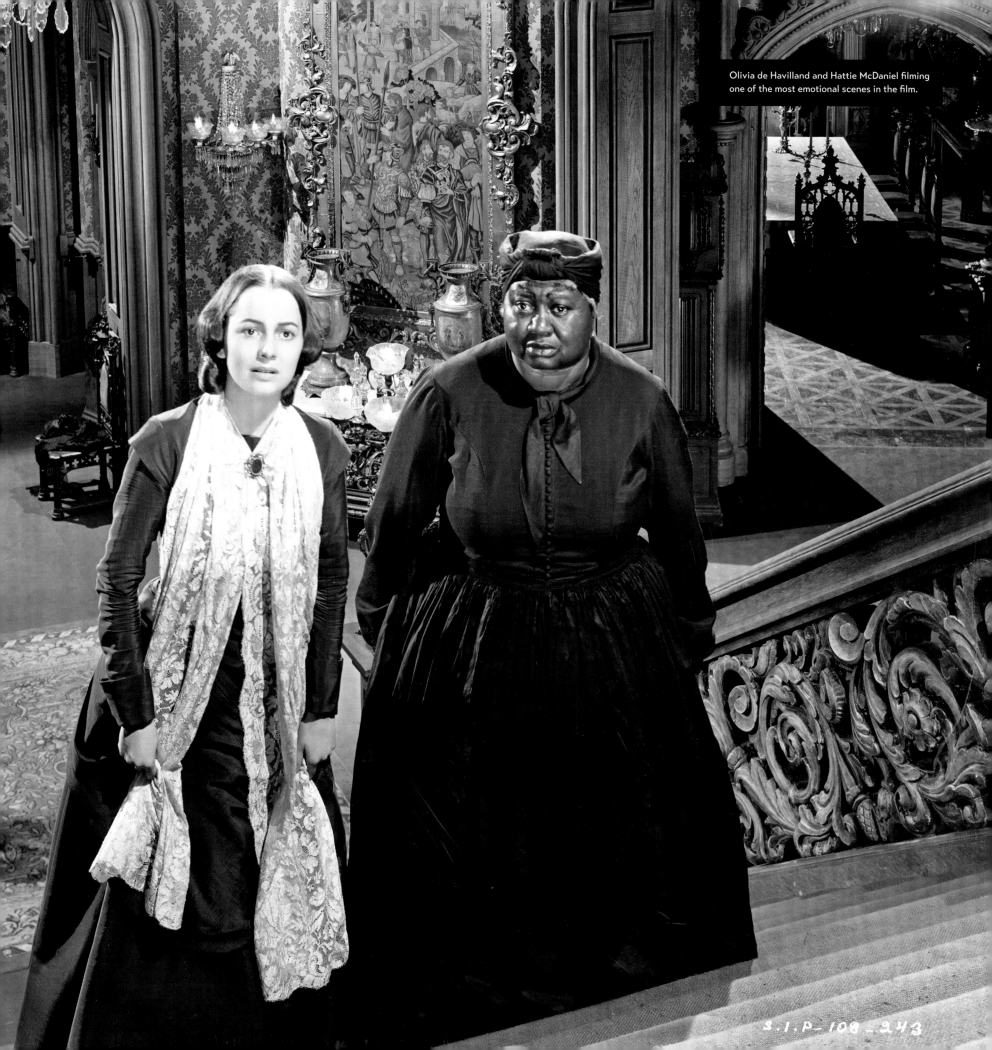

S.I.P. 108 243

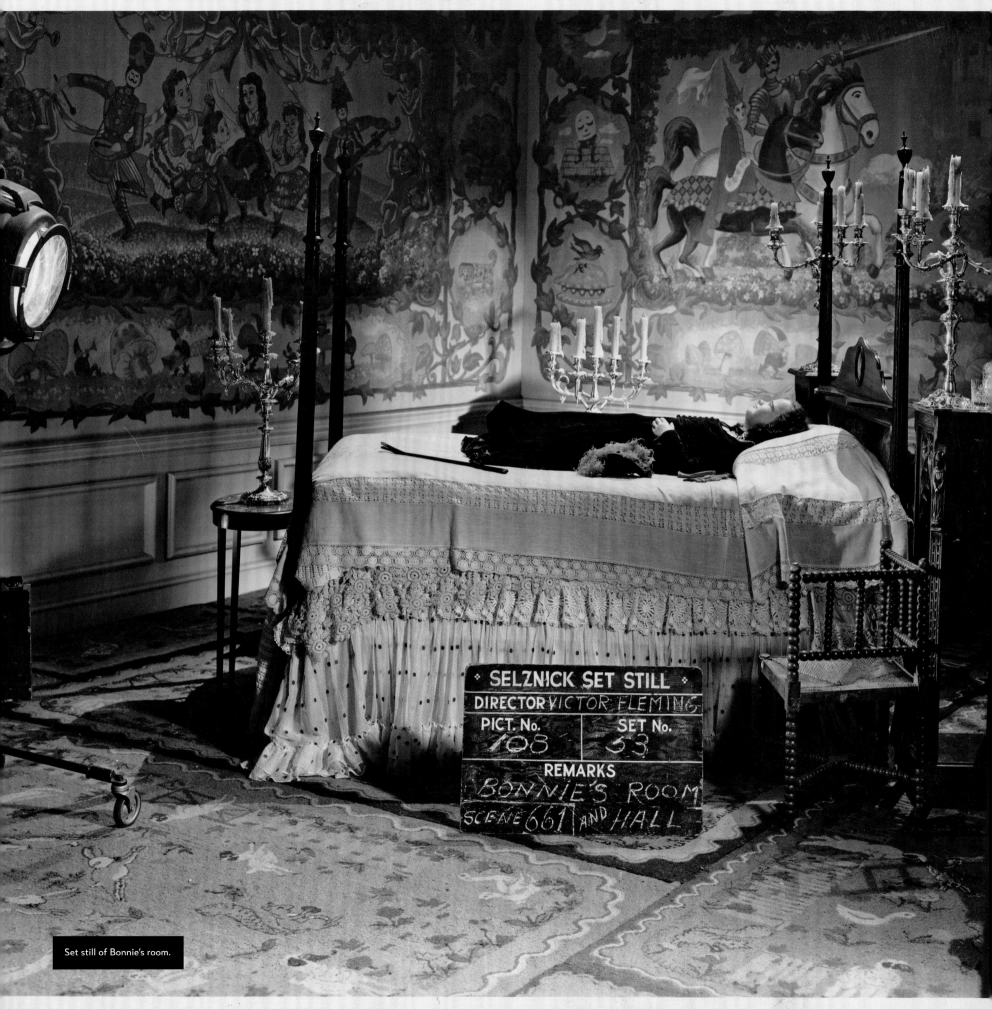

Set still of Bonnie's room.

(ABOVE, LEFT) Makeup still of Cammie King as Bonnie.

(ABOVE, RIGHT) Set still of the Butler house front door.

(RIGHT) Concept drawing of Bonnie's room.

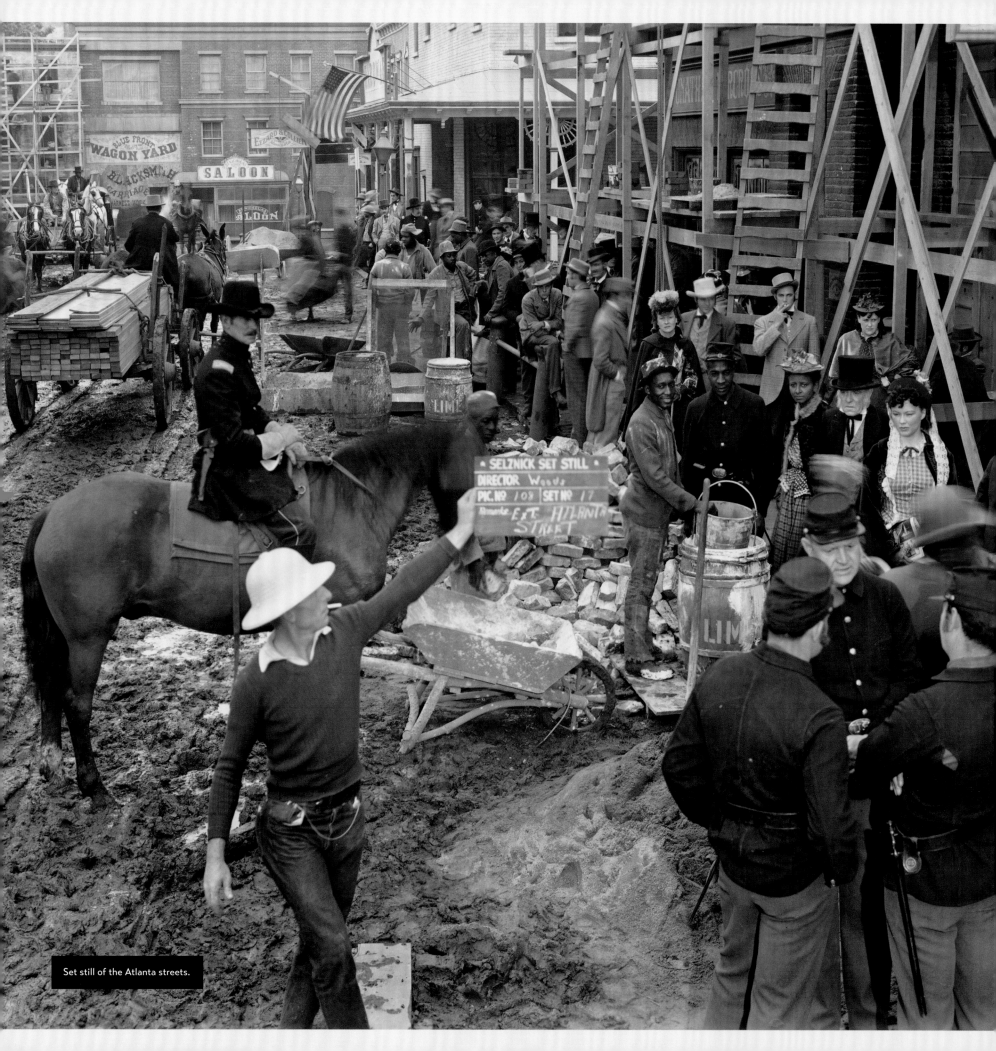

Set still of the Atlanta streets.

OUTSIDE JAIL; ATLANTA STREETS

As Victor Fleming was filming Mammy's scene with Mela-nie on the stairs of the Butler house, Sam Wood was preparing the scenes outside the jail on the bustling streets of Atlanta. On Wednesday, May 31, Vivien Leigh, Hattie McDaniel, Ona Munson, and Carroll Nye were scheduled to arrive on set at 8 a.m. after makeup. Irving Bacon was cast as the Yankee corporal who talks to Belle, and Murray Harris, Al Hill, and Buddy Dangi were cast as "Street Urchins." In addition, 113 men, forty women, and five children were scheduled. The property department supplied Belle Watling's carriage, two Union army wagons, a beer truck, four lumber wagons, a brick wagon, two carriages, two buggies, and four horses.

The camera was mounted on a boom, and the filming of Belle, Scarlett, and Mammy on the street outside the jail began shortly after 10 a.m. It took sixteen takes to complete this shot. After lunch, the camera was mounted on a dolly for a subsequent tracking shot. After six takes, the angle was changed twice. Filming of the scene was completed at 5:45 p.m.

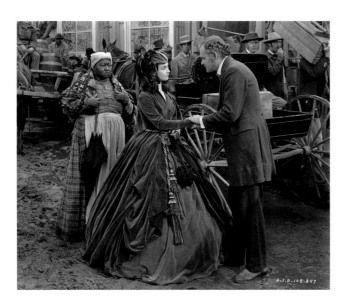

(ABOVE) Publicity still of Frank Kennedy greeting Scarlett outside his store.

(RIGHT, TOP) Call sheet for the Atlanta streets scene. This scene, directed by Sam Wood, was as complicated and required as much planning as any in the film.

(RIGHT) Memo from Selznick to Sam Wood regarding the bit players in the streets of Atlanta.

SELZNICK INTERNATIONAL PICTURES, INC.
CALL SHEET

DATE... WED., MAY 31, 1939

PICTURE..."GONE WITH THE WIND" PROD. NO. 108 DIRECTOR... SAM WOOD

SET......EXT. ATLANTA STREETS WINTER 1865-1866

LOCATION...40 ACRES SET NO... 17 SCENES... 505-513

NAME	TIME CALLED		CHARACTER, DESC., WARDROBE
	ON SET	MAKE-UP	
Vivien Leigh	8:00 AM	7:00 AM	Scarlett
Hattie McDaniel	8:00 AM	7:30 AM	Mammy
Ona Munson	8:00 AM	6:00 AM	Belle Watling
Irving Bacon	8:00 AM	6:30 AM	Yankee Corporal
Murray Harris)			
Al Hill, Jr.)	8:00 AM	7:30 AM	Street Urchins
Buddy Dangi)			
Carroll Nye	10:30 AM	9:00 AM	Frank Kennedy
Stand-ins	7:30 AM	7:00 AM	--
Extras:			
97 Men - - - - - 49	8:00 AM	7:00 AM	As fitted
48	9:00 AM	8:00 AM	" "
30 Women - - - - 12	8:00 AM	7:00 AM	" "
18	9:00 AM	8:00 AM	" "
36 Col. men- - - 13	8:00 AM	7:00 AM	" "
23	9:00 AM	8:00 AM	" "
10 " women- - 3	8:00 AM	7:00 AM	" "
7	9:00 AM	8:00 AM	" "
5 " children	8:30 AM	8:00 AM	" "

PROPERTY DEPT.

Belle Watling's carriage)
Frank Kennedy's ")
2 Union army wagons)
1 Beer truck) Ready
4 lumber wagons) 8 AM
1 brick ")
2 carriages)
2 buggies)
4 Union officers' horses)

CAMERAS - - - - - -	7:00 AM
SOUND (Ready) - - - -	8:15 AM
SELZNICK BOOM (Ready)	7:30 AM
P.A.SYSTEM - - - - -	7:30 AM

ASSISTANT DIRECTOR...REGGIE CALLOW

Wind - Casting Bits

Mr. Sam Wood

5/31/39

Dear Sam:

I have just sent Schuessler down to see you because I think there is a much better job to be done in the differentiation along the lines that you just spoke of -- that is, that the fine sensitive types, the Southern aristocrats, are those that are in faded and somewhat patched clothes -- and the horrible types are the well-dressed Yankees. Also, I suggest that you talk with Kurtz and Schuessler about any bits that you may want of the Yankees trying to pick up Scarlett, making cracks at her, etc., and if you need any better type or higher priced bit people for these characters, please don't hesitate to order them.

DOS

dos*f

THE SHOOTING SCHEDULE BECOMES MORE CHAOTIC

The *Gone With The Wind* shooting schedule for June 7, 1939, was typical of the choreography worked out among the three directors working simultaneously on the same film. The Victor Fleming–directed scene in which Rhett attempts to reconcile with Scarlett on the terrace of the Butler house as the couple witness their daughter's fatal accident was filmed that day on Stage 14. Vivien Leigh and Clark Gable arrived on set at 9 a.m., and their shots were completed by lunchtime.

Cammie King and the "welfare worker" hired to care for her were on call all morning but did not begin work until after lunch, when the crew moved to Stage 8 and set the camera angle to show the Butler garden. Cammie King and the pony supplied by the property department were called to the set for rehearsal. Filming began again shortly after 3 p.m., and the shots of Bonnie riding through the garden were completed before 6 p.m. Bonnie's fatal fall would not be filmed, however, until almost two weeks later.

Meanwhile, Vivien Leigh had moved to Stage 9 and changed costumes and makeup to work with Sam Wood on the scene in which Scarlett is stirring soap in a kettle and Oscar Polk, as Pork, tells her about the taxes she owes on Tara. Despite a small problem with the horse at the beginning of the scene, filming went smoothly and Vivien Leigh was dismissed at 8:45 p.m. Wood completed the scene with Polk and left at 9:25 p.m. William Cameron Menzies then took over and directed the shot of Gerald O'Hara mounting his horse for his "death ride." The crew waited an hour and a half for the actor Thomas Mitchell to arrive. Filming began at midnight, and despite trouble with the horse, the shots were completed relatively quickly, and the crew was dismissed shortly after 1 a.m.

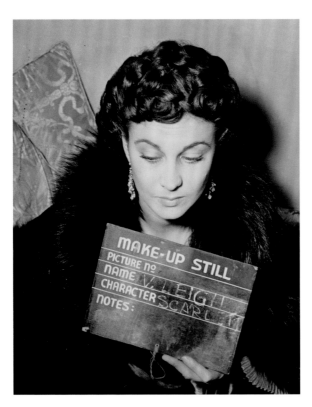

Makeup still of Vivien Leigh.

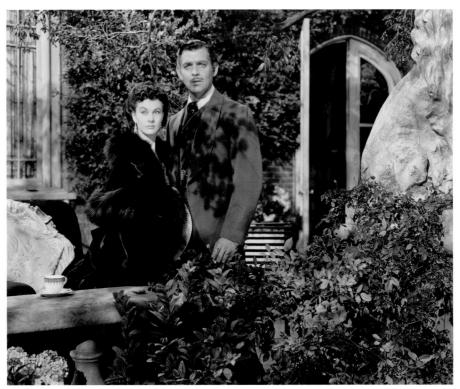

Publicity still of Vivien Leigh and Clark Gable.

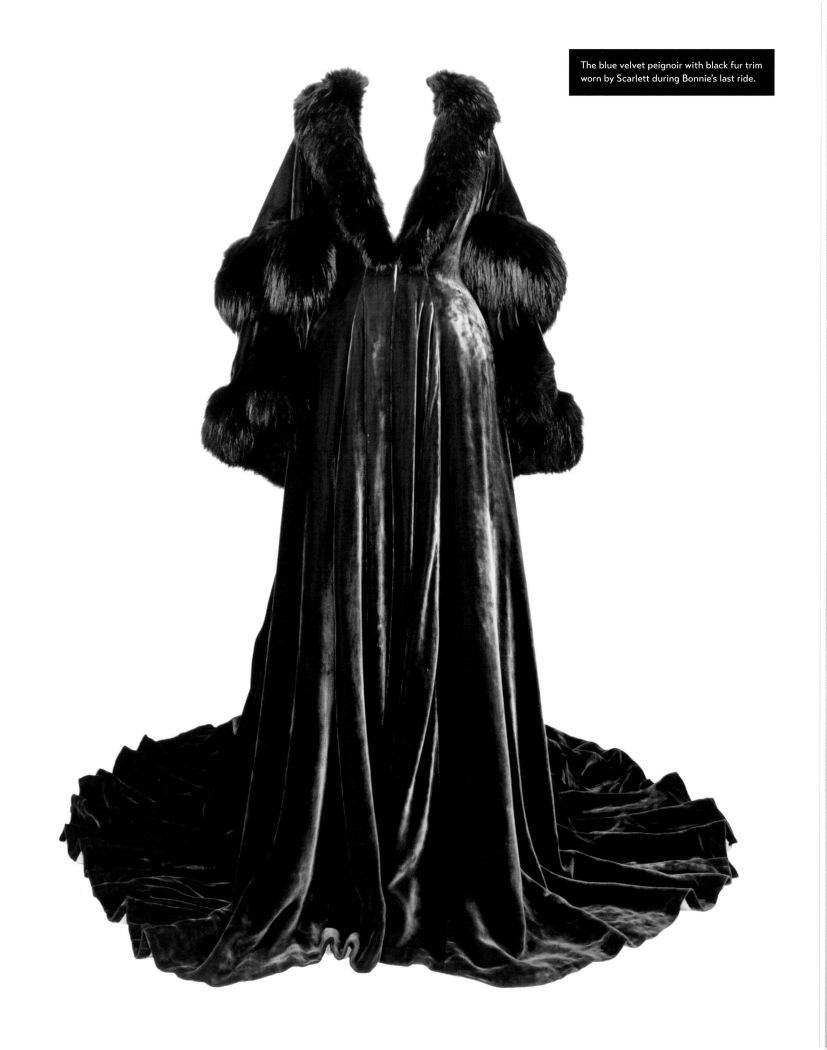

The blue velvet peignoir with black fur trim worn by Scarlett during Bonnie's last ride.

DATE _____

TITLE **GONE WITH THE WIND**

NO. _____

DIRECTOR _____

ASSISTANT _____

UNIT MGR. _____

ART _____

CAMERA _____

PROP MAN _____

MIXER _____

— IN CONTINUITY —

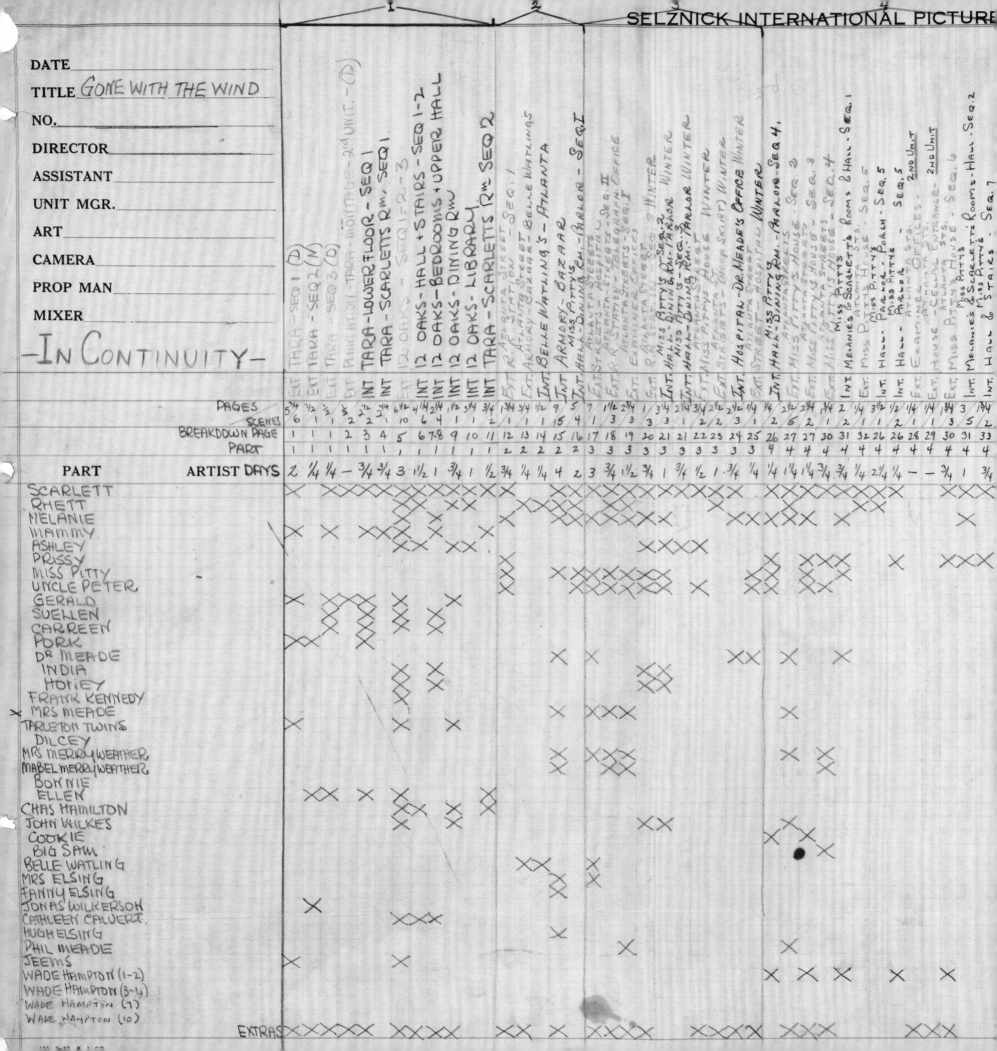

Column (set / sequence) headings, left to right:

1. EXT. TARA – SEQ 1 (D)
2. EXT. TARA – SEQ 2 (N)
3. EXT. TARA – SEQ 3 (D)
4. EXT. PLANTATION – TARA – MONTAGE – 2ND UNIT – (D)
5. INT. TARA – LOWER FLOOR – SEQ 1
6. INT. TARA – SCARLETTS RM. SEQ 1.
7. EXT. 12 OAKS – SEQ 1-2-3
8. INT. 12 OAKS – HALL + STAIRS – SEQ 1
9. INT. 12 OAKS – BEDROOMS + UPPER HALL
10. INT. 12 OAKS – DINING RM
11. INT. 12 OAKS – LIBRARY
12. INT. TARA – SCARLETTS RM. SEQ 2
13. EXT. ATLANTA STREET – SEQ 1
14. EXT. ARMORY – BAZAAR – BELLE WATLINGS
15. INT. BELLE WATLINGS – ATLANTA
16. INT. ARMORY – BAZAAR
17. INT. MISS PITTY'S RM. – PARLOR – SEQ I
18. INT. ATLANTA STREETS
19. EXT. STREETS – HOSPITAL – SEQ. II
20. EXT. R. STATION – TELEGRAPH OFFICE
21. EXT. ATLANTA STREETS – SEQ. I
22. EXT. EXAMINER OFFICES
23. EXT. ATLANTA STREET – SEQ. 3 WINTER
24. INT. MISS PITTY'S RM. – PARLOR – WINTER
25. INT. HALL – DINING RM. – PARLOR WINTER
26. INT. ATLANTA STREET – WINTER
27. EXT. MISS PITTYS HOUSE – WINTER
28. EXT. STREETS (DROP SKIRT) WINTER
29. INT. HOSPITAL – DR. MEADE'S OFFICE WINTER
30. EXT. ATLANTA STREET – HOSPITAL WINTER
31. INT. HALL – MISS PITTY – DINING RM. – PARLOR – SEQ 4.
32. EXT. MISS PITTY'S HOUSE – SEQ. 2
33. EXT. ATLANTA STREETS
34. EXT. MISS PITTY'S HOUSE – SEQ. 3
35. INT. MISS PITTY'S HOUSE – SEQ. 4
36. INT. MELANIE & SCARLETT'S ROOMS & HALL – SEQ. 1
37. EXT. MISS PITTY'S HOUSE – SEQ. 5
38. INT. HALL – PARLOR – PORCH – SEQ. 5
39. INT. HALL – MISS PITTYS – SEQ. 5
40. EXT. ATLANTA STS. – 2ND UNIT
41. EXT. EXAMINER OFFICES – ATLANTA – 2ND UNIT
42. EXT. MISS PITTY HOUSE – SEQ. 6
43. INT. MELANIE & SCARLETTS ROOMS – HALL – SEQ. 7
44. INT. HALL & STAIRS – SEQ. 7

PAGES: 5/4 1/2 2/3 1/3 2 1/2 2 1/4 6 1/2 4 1/4 2 1/4 1/2 3 1/4 3/4 1 3/4 3/4 1/2 9 5 7 1 1/2 2 3/4 1 3/4 2 3/4 3/4 2 1/2 2 1/2 2 1/2 1/4 1/4 2 1/2 2 3/4 3/4 2 1/4 3 1/2 1/2 1/4 1/4 3/4 3 1 3/4

SCENES: 6 1 1 2 2 1 10 6 4 1 1 1 1 3/4 3/4 1/2 15 4 1 3 3 3 1 2 2 3 1 2 5 2 1 2 1 1 2 1 3 5 2

BREAKDOWN PAGE: 1 1 1 2 3 4 5 6 7-8 9 10 11 12 13 14 15 16 17 18 19 20 21 21 22 23 24 25 26 27 27 30 31 32 26 26 28 29 30 31 33

PART: 1 1 1 1 1 1 1 1 1 1 1 1 2 2 2 2 2 3 3 3 3 3 3 3 3 3 3 4 4 4 4 4 4 4 4 4 4 4 4 4 4 4

ARTIST DAYS: 2 1/4 1/4 – 3/4 3/4 3 1 1/2 1 3/4 1 1/2 3/4 1/4 1/4 4 2 3 3/4 1/2 3/4 1 3/4 1/2 1 3/4 1/4 1/4 1 1/4 1 1/4 3/4 3/4 1/4 1/4 2 1/4 1/4 – – 3/4 1 3/4

PART (artists):

- SCARLETT
- RHETT
- MELANIE
- MAMMY
- ASHLEY
- PRISSY
- MISS PITTY
- UNCLE PETER
- GERALD
- SUELLEN
- CARREEN
- PORK
- DR MEADE
- INDIA
- HONEY
- FRANK KENNEDY
- MRS MEADE
- TARLETON TWINS
- DILCEY
- MRS MERRYWEATHER
- MABEL MERRYWEATHER
- BONNIE
- ELLEN
- CHAS HAMILTON
- JOHN WILKES
- COOKIE
- BIG SAM
- BELLE WATLING
- MRS ELSING
- FANNY ELSING
- JONAS WILKERSON
- CATHLEEN CALVERT
- HUGH ELSING
- PHIL MEADE
- JEEMS
- WADE HAMPTON (1-2)
- WADE HAMPTON (3-4)
- WADE HAMPTON (7)
- WADE HAMPTON (10)

EXTRAS

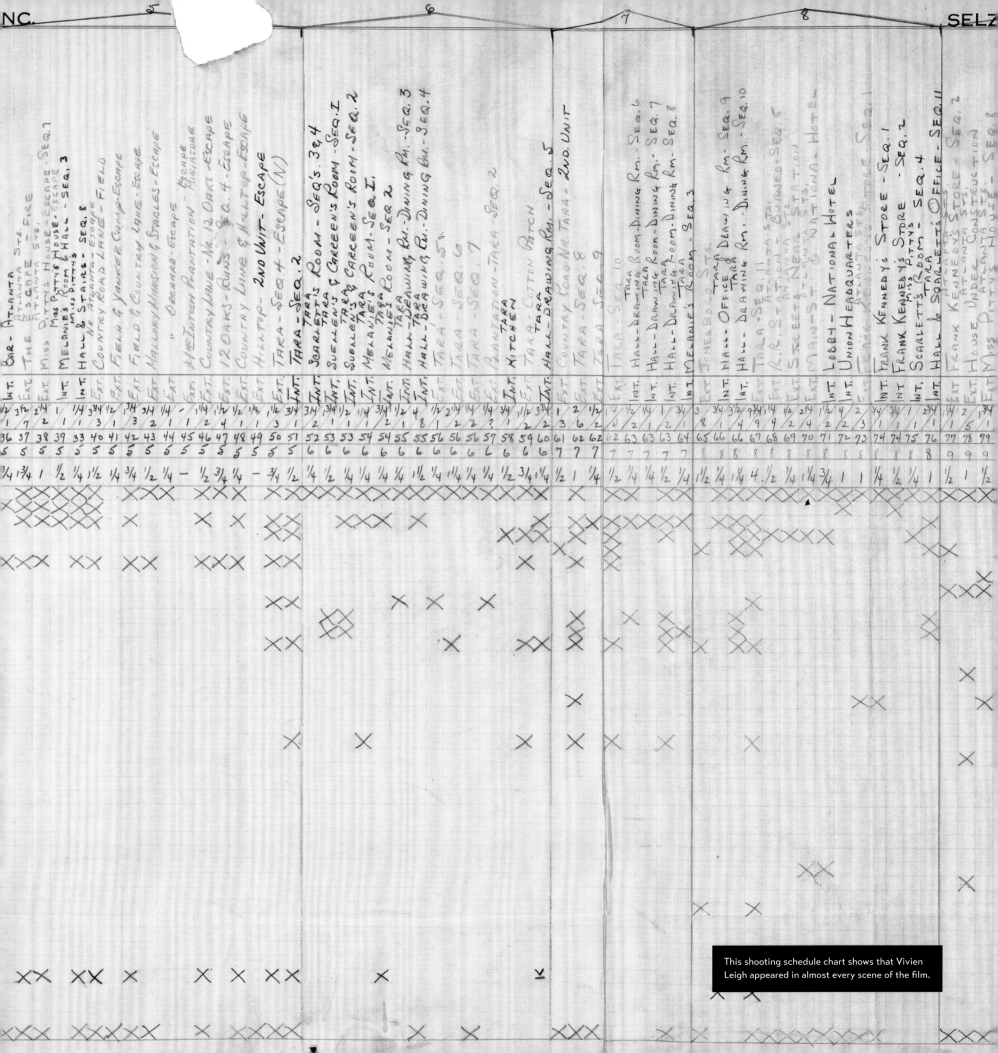

This shooting schedule chart shows that Vivien Leigh appeared in almost every scene of the film.

THE "HATE WORD"

Despite Selznick's promises to Earl Morris at the *Pittsburgh Courier* and others who objected to the use of the word "nigger" in *Gone With The Wind*, the word crept back in, most likely when Selznick reverted to the earlier Sidney Howard script. When Val Lewton and Joseph Breen pointed this out, Selznick found himself backed into a corner.

If Selznick adhered to his "theory of adaptation" and remained faithful to the source material, including its "seeming faults," he risked alienating large segments of the film's potential audience. Lewton made his case against the use of the word in his June 9, 1939, memo to Selznick, reminding Selznick of his previous promises and public statements. Selznick responded later that same day, "Okay, we'll forget it."

Form 73 20M 1-39 K-I Co. *for file* *Wind - Negro Prob.*

SELZNICK INTERNATIONAL PICTURES, INC.
CULVER CITY, CALIFORNIA

Inter-Office Communication

TO Val Lewton DATE June 7, 1939.

FROM Mr. Selznick SUBJECT

Increasingly I regret the loss of the better negroes being able to refer to themselves as niggers, and other uses of the word nigger by one negro talking about another. All the uses that I would have liked to have retained do nothing but glorify the negroes, and I can't believe that we were sound in having a blanket rule of this kind, nor can I believe that we would have offended any negroes if we had used the word 'nigger' with care; such as in references by Mammy, Pork, Big Sam, etc. It may still not be too late to salvage two or three of these uses, and I'd like to have a very thorough and clear picture of what we can and cannot do, without delay.

Incidentally, it can't be a code violation, judging by uses of the word 'wop' in the Claudette Colbert-Jimmy Stewart picture "It's a Wonderful World" in a manner which probably won't offend any Italian any place, but which certainly at best is much more offensive than the way in which we would use the word 'nigger'.

Please try to let me know about this today if you can.

I suggest that you secure Mrs. Rabwin's help in looking up correspondence that Vic Shapiro and I myself had with various negro groups, and perhaps also secure the advice of some local negro leaders on the subject. Maybe even talk to some of the negro leaders yourself.

I suggest, for instance, that you look up the wonderful use of the term by Uncle Peter on page 673, which is the most sympathetic and friendly-to-the-negroes piece possible, and which deals with Peter's reaction to the whites calling him a nigger; and also Big Sam's reference to trashy niggers on page 779; and Mammy's reference to niggers on her arrival in Atlanta when she sees the invasion of the black and white scum alike (page 553). I think you can feel free to discuss these specific pieces with important negroes and with Breen's office.

 DOS

Selznick's memo to Val Lewton demonstrates indecisiveness and his single-minded attempt to stay faithful to the novel.

Form 73 20M 1-39 K-I Co.

SELZNICK INTERNATIONAL PICTURES, INC.

CULVER CITY, CALIFORNIA

Inter-Office Communication

TO	Mr. Selznick	**DATE**	June 9, 1939
FROM	Val Lewton	**SUBJECT**	"NIGGERS"

Dear David:

After having spent some time with Joe Breen, having seen his files, and having spoken with several very intelligent negroes, including Mr. Williams, the famous architect, I can only come to one conclusion: that it would be extremely dangerous for you to use the word "nigger" on the screen. I know that you will lose a certain amount of dramatic value and that it is certainly a great loss of comic material, but I feel sure that if you had seen what I have seen and spoken to those whom I have spoken to, you would come to exactly the same conclusion.

The word "nigger" is like a red flag in front of a bull, so far as the colored people of the United States are concerned. Mr. Breen pointed out to me, when I used the argument that we only had negroes calling other negroes "niggers", that the intelligent negro might understand this subtlety and that he is certain that by dint of persuasion we could get one or another of the negro societies to endorse this view of the matter, but that no one could answer for the rank and file who threw bricks at the screen in Chicago, Washington, Baltimore, New York and Los Angeles when "The House of Connelly" was shown and inadvertently Lionel Barrymore was allowed the use of the word "nigger".

Mr. Williams subscribes to this same view and says that despite the humorous use of the epithet by negroes, that they abhor it and resent it as they resent no other word.

Also, insofar as I could gather from glancing over our own correspondence with negro societies, we have repeatedly promised them, under the names of various persons here, that the word "nigger" would not be used in the picture.

vl:lb VAL LEWTON

OK. 2

In Lewton's reply to Selznick's memo of two days before, he explains, as he has before, why he thinks the word should be eliminated from the script and reminds Selznick of the promises he made to Earl Morris of the *Pittsburgh Courier* and Walter White of the NAACP. Selznick's reply that "we'll forget it" was final. The word was eliminated from the film.

"FRANKLY, MY DEAR . . ."

On June 1, 1939, Selznick asked his story editor, Val Lewton, to compile a list of uses of the word "damn" in magazines and, if possible, films. The now much-quoted final scene of *Gone With The Wind* was coming up on the shooting schedule, and Selznick knew he was going to need ammunition in the face of anticipated objections by the Hays Office. Lewton reported that the *Saturday Evening Post* allowed the word when it is used "properly in character," as did *Cosmopolitan* and *Collier's*. Lillian Deighton, Selznick's researcher and a former schoolteacher, noted that Edward Everett Hale's classic short story, "The Man Without a Country," contains the line "Damn the United States!" yet was read and studied in the classes she taught in the Philadelphia school system without protests from students or parents.

On June 8, Victor Fleming began rehearsing the final scene with Gable and Leigh while Selznick observed and rewrote the dialog. At 2 p.m., filming began. After eight hours, only the first two sections of the scene—Rhett and Scarlett's dialog about Melanie's death and Rhett packing his bag as he tells Scarlett he is leaving—were completed.

The next day, Lewton and Selznick discussed the situation. Lewton had pressed Joseph Breen, the head of the office that enforced the Production Code, on the use of the word "damn" during a discussion about the protests coming from the African American newspaper, the *Pittsburgh Courier*. Lewton argued that the word was vital to the telling of the story and had been used in *Arrowsmith* and "The Man Without a Country" and in numerous household magazines, but Breen would not budge. The word was specifically prohibited by the Code, and he was not going to make an exception.

Lewton warned Selznick that the situation was delicate and to oppose the Code might have repercussions. For example, there was concern that the shooting of the Yankee deserter "looks

Selznick's letter to Will Hays in which he makes his case for the use of the line, "Frankly my dear, I don't give a damn." See appendix for complete text.

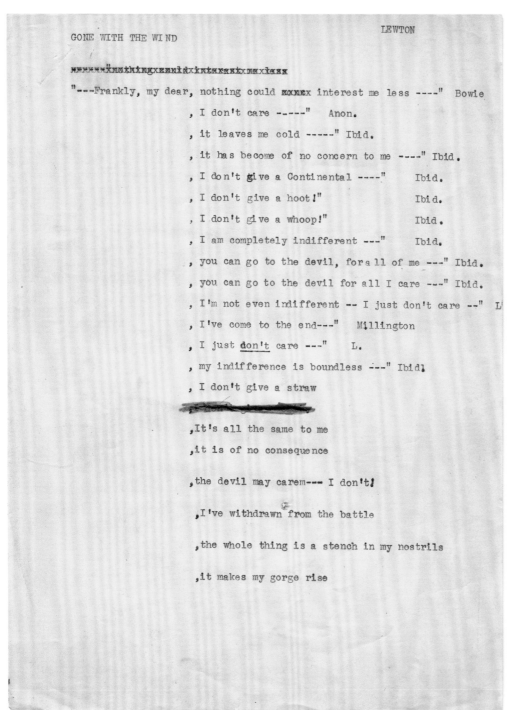

GONE WITH THE WIND LEWTON

~~nothing could interest me less~~

"---Frankly, my dear, nothing could ~~xxxxx~~ interest me less ----" Bowie

 , I don't care -----" Anon.

 , it leaves me cold -----" Ibid.

 , it has become of no concern to me ----" Ibid.

 , I don't give a Continental ----" Ibid.

 , I don't give a hoot!" Ibid.

 , I don't give a whoop!" Ibid.

 , I am completely indifferent ---" Ibid.

 , you can go to the devil, for all of me ---" Ibid.

 , you can go to the devil for all I care ---" Ibid.

 , I'm not even indifferent -- I just don't care --" L

 , I've come to the end---" Millington

 , I just don't care ---" L.

 , my indifference is boundless ---" Ibid!

 , I don't give a straw

 ~~————————————~~

 ,It's all the same to me

 ,it is of no consequence

 ,the devil may carem--- I don't!

 ,I've withdrawn from the battle

 ,the whole thing is a stench in my nostrils

 ,it makes my gorge rise

List of alternatives to the famous line.

worse on screen than it does on paper." Lewton also anticipated problems with their upcoming production of *Rebecca*, to be directed by Selznick's new employee, Alfred Hitchcock, which involved a central character accused of murder and undertones of homosexuality. Lewton cautioned against antagonizing the Hays Office and that they should film the scenes both with and without the word "damn" as a precaution. Selznick agreed. In communicating the decision to Victor Fleming and Clark Gable, Selznick instructed Lewton to stress the fact that he intended to "put up a strong fight for the line" with the Hays Office.

Following a two-hour morning rehearsal, Fleming began shooting the controversial scene on Saturday, June 10, at 11 a.m. After lunch, Rhett and Scarlett's exchange at the door was filmed both with the line as written and with the alternate, clearly less dramatic line, "Frankly my dear, I don't care." Fleming finished filming at 8 p.m., after which Vivien Leigh took a break before arriving at the 40 Acres lot at 10:15 p.m. to shoot the scene of her running through the mist toward the Butler house under the direction of William Cameron Menzies. After five takes from two different camera angles, Leigh had had enough and left the set at 12:30 a.m., despite Menzies needing to film a close-up. For that, he worked with an unidentified double and did not finish until 3:15 a.m.

When Selznick finally did confront the Hays Office over the "Frankly my dear, I don't give a damn" line, he did not mention he had already filmed an alternate version. Selznick wrote a letter directly to Will Hays laying out his case for retaining "the punchline of Gone With the Wind." Selznick knew that if he were allowed to keep the line, the Code would have to be changed, and to do that Hays would need to call a meeting of the board of directors. That meeting was set for October 27. In the week leading up to the board meeting, Selznick and Jock Whitney lobbied board members to change the Code, and although the deliberations were described as "very stormy," Selznick prevailed, and the Code was amended to make future use of the word "damn" discretionary.

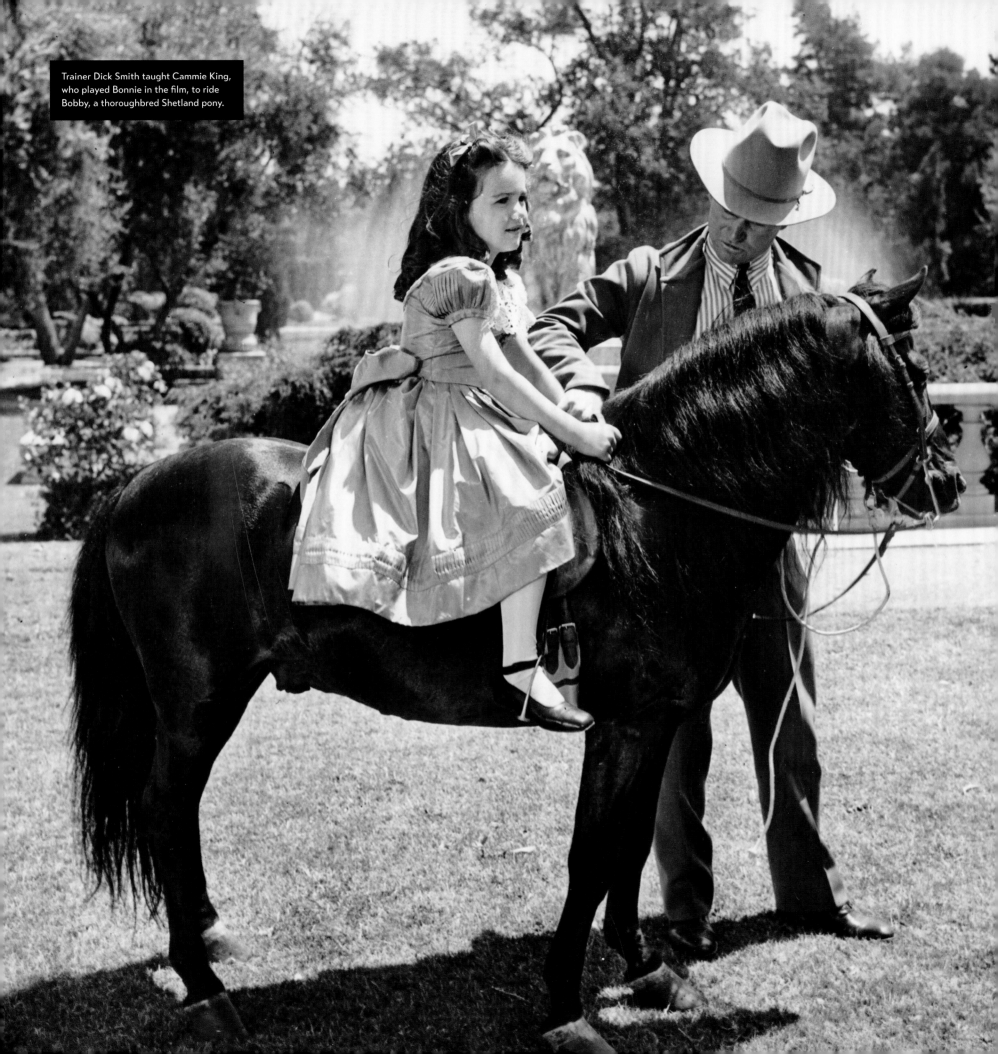

Trainer Dick Smith taught Cammie King, who played Bonnie in the film, to ride Bobby, a thoroughbred Shetland pony.

BONNIE LEARNS TO RIDE

Victor Fleming directed the scene in which Bonnie learns to ride her pony on Tuesday, June 13, at the MGM back lot known as Cohn's Park. Jack Cosgrove used one of two cameras to line up the establishing shot of the scene so he could add the top of the Butler house in postproduction.

Filming went well in the morning, but in the afternoon Cammie King fell off the horse on her first take. The second take also did not go well, and she forgot her lines on the third. The fourth take was good, however, and Bonnie's shots were complete by 4 p.m.

Rhett and Mammy's scene together was finished an hour later. Mammy then shot her close-up, the crew recorded a "wild track" of the sound of the fountain, and filming wrapped up for the day at 5:25 p.m.

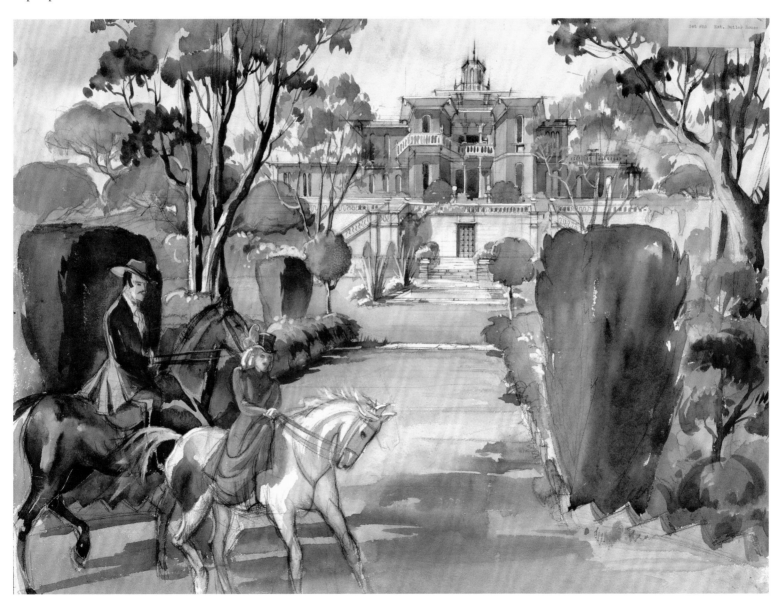

Concept painting of Rhett teaching his daughter, Bonnie, to ride.

SHANTY TOWN

On the same day Fleming was shooting Bonnie's riding scene, B. Reeves "Breezy" Eason, one of Hollywood's most dependable second-unit directors, began filming the Shanty Town scene at Big Bear Lake in Southern California.

Work had begun before dawn, when five large trucks carrying construction equipment, set dressings, props, wardrobe, lights, and generators left the studio for the Big Bear Lake location. The crew included carpenters, set dressers, painters, landscapers, and a first aid technician. A large amount of red brick dust was hauled there to simulate the red dirt of Georgia. The film's historical advisor, Wilbur Kurtz, traveled by car to observe the construction of the camp, and production designer William Cameron Menzies arrived later to supervise. A third car arrived at noon with Aline Goodwin, Scarlett's double, Lydia Schiller, the script supervisor, and other support staff.

The next morning, one of the generators broke down due to the altitude, and Eason was forced to film that day without sound. The generator was repaired overnight so they were able to shoot with sound the next day.

After lunch, they began filming the scene in which Scarlett is attacked. The scene had undergone considerable revision in an effort to avoid trouble with the Hays Office, which had cautioned Selznick to avoid any suggestion of rape in this scene, and to fulfill Selznick's promise not to make an "anti-Negro film." Though the novel featured an African American man attacking Scarlett, Selznick cast the attacker as a white man. Upon acquiring the rights to *Gone With The Wind*, this was one of the first changes Selznick made to the story, mindful of concerns about the depiction of African American characters in the film.

Big Sam's fight scene with Scarlett's attacker was shot on Thursday, June 15. Fay Helm took over as Scarlett's double. Aside from the occasional car horn or spectator wandering into the frame, filming proceeded quickly and efficiently for the next two days, with only two or three takes made for each camera angle. The scene was substantially finished on June 16, though some of the crew stayed the next day to film "moving process plates" at various speeds (easy trot, gallop, runaway) that would be used as backgrounds for Vivien Leigh's close-ups. These close-ups, as well as the close-ups of Yakima Canutt as the "Degenerate White," Blue Washington as the "Degenerate Black," and Everett Brown as Big Sam, were filmed by Victor Fleming two weeks later on July 1.

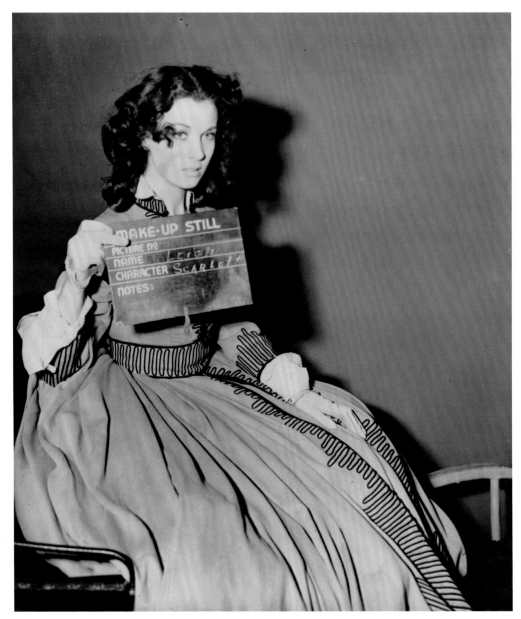

Vivien Leigh in the Shanty Town scene.

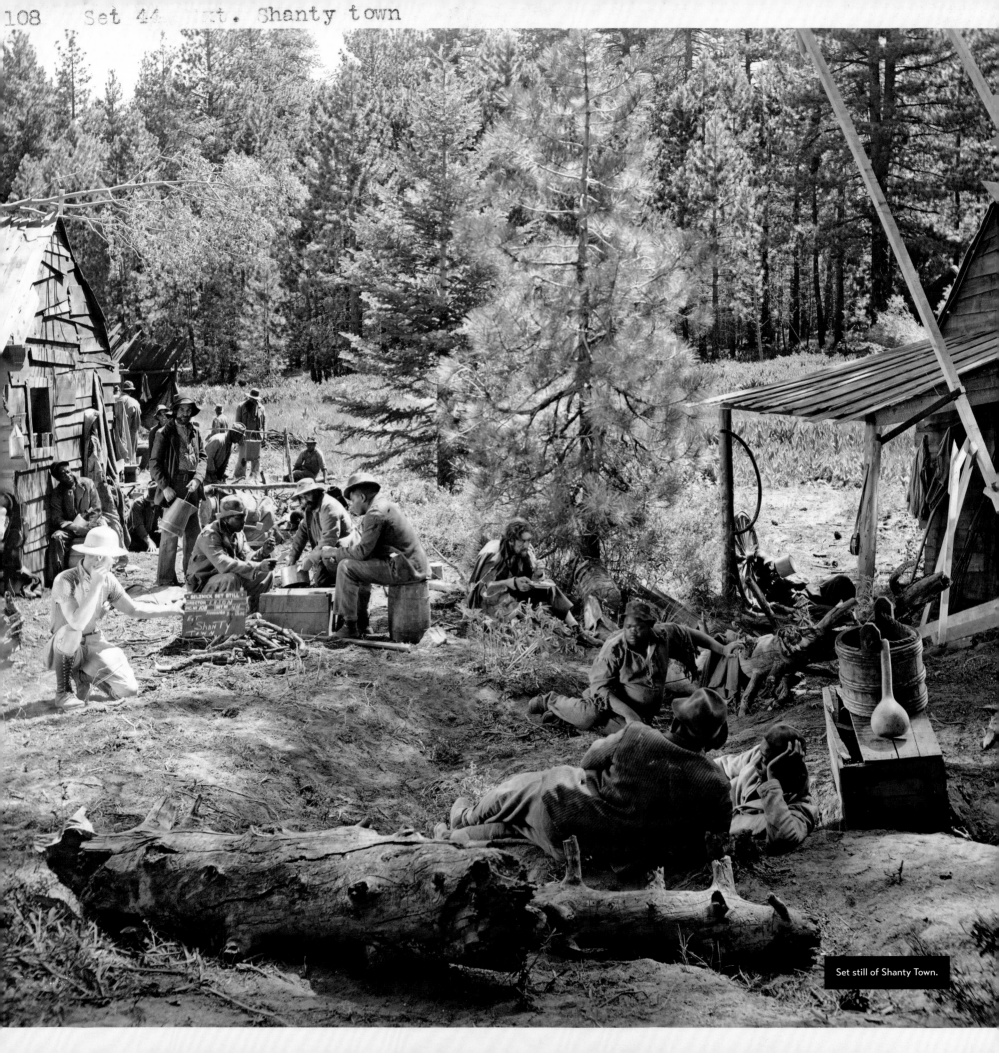

Set still of Shanty Town.

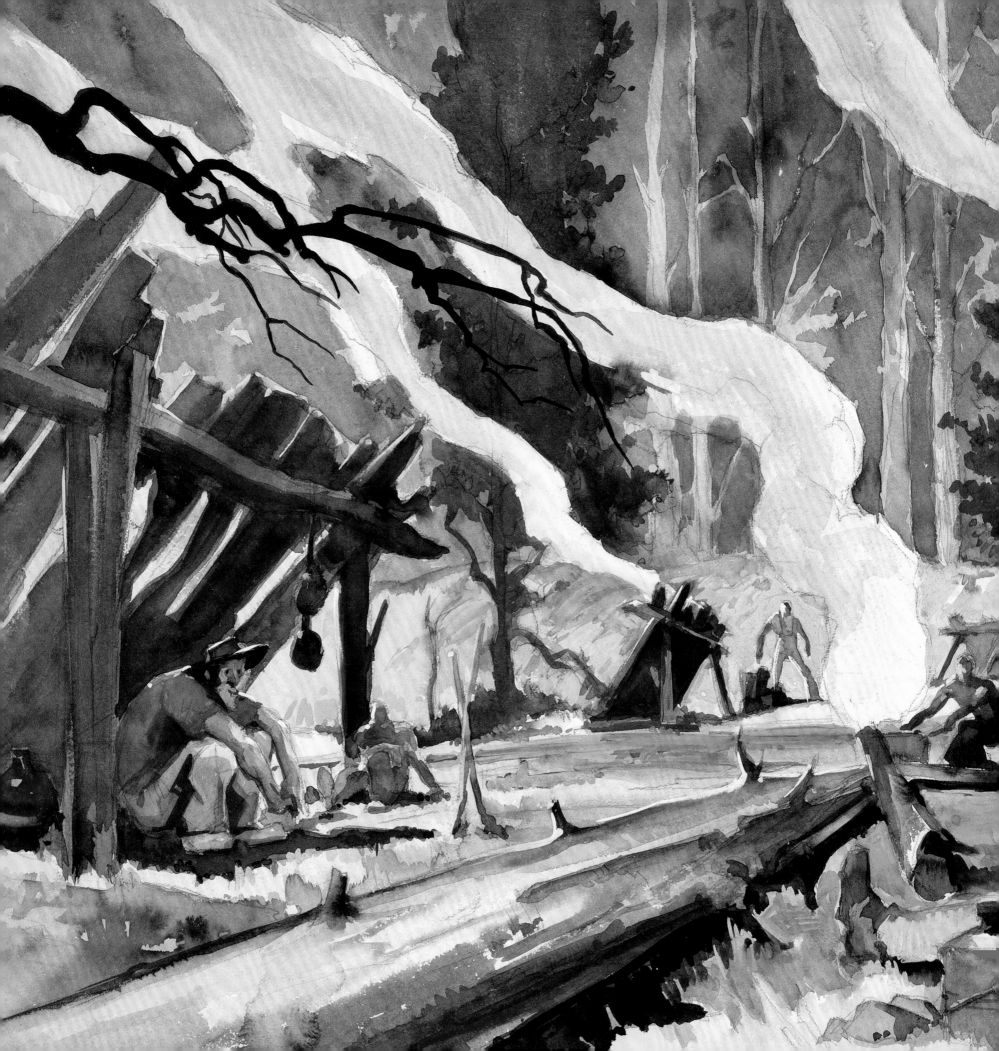

Set #44 Ext. Shanty Town.

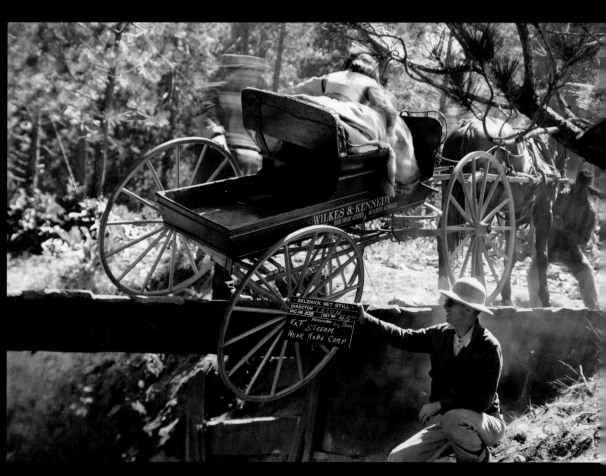

(ABOVE) Concept painting by William Cameron Menzies.

(LEFT) Concept painting by William Cameron Menzies.

(BELOW) Set still showing Vivien Leigh's stunt double in the wagon during filming of the Shanty Town scene.

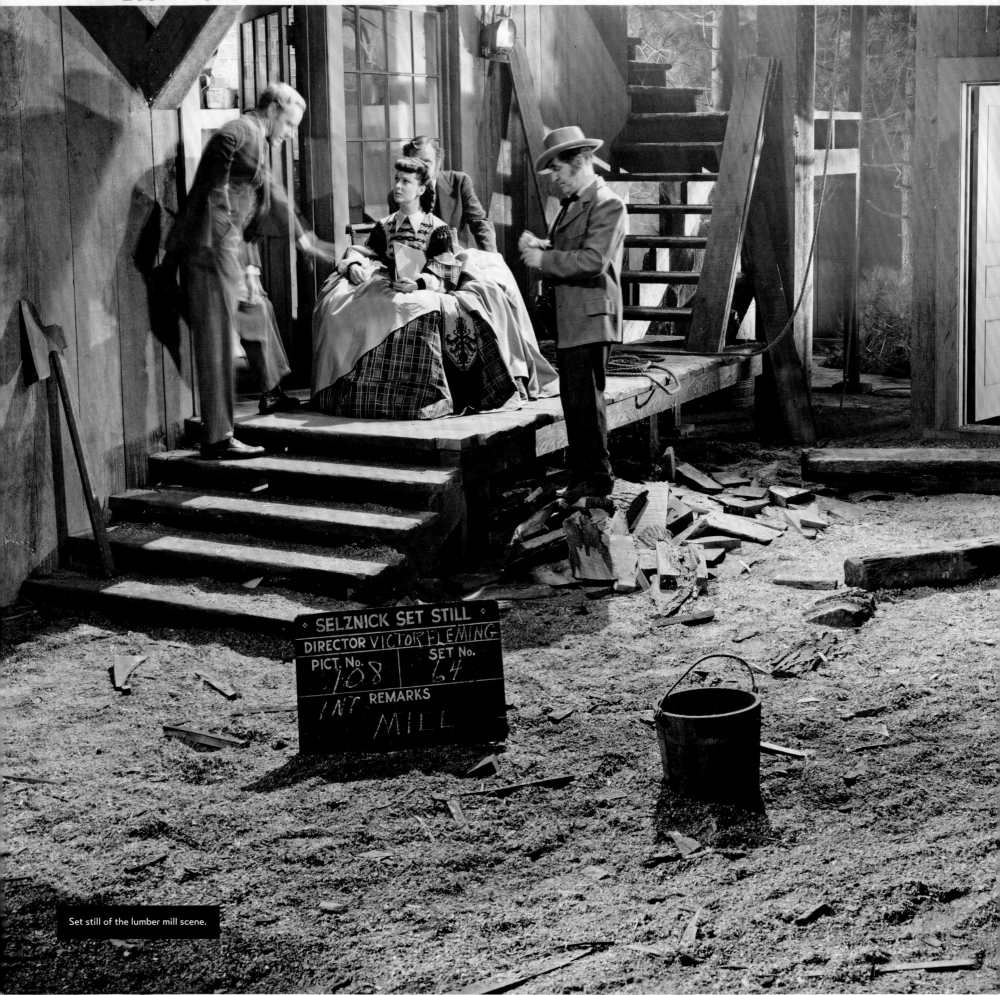

SELZNICK SET STILL
DIRECTOR VICTOR FLEMING
PICT. No. SET No.
108 64
INT REMARKS
 MILL

Set still of the lumber mill scene.

THE LUMBER MILL

Victor Fleming directed the lumber mill scene on Sunday, June 18. It was unusual to shoot on a Sunday, but the end of the shooting schedule was nearing, with much still to do. Vivien Leigh, Leslie Howard, Caroll Nye, and J. M. Kerrigan, who was to play Johnny Gallagher, the lumber mill foreman, arrived on set at 9 a.m. along with the guards and convict labor extras "as requisitioned."

The camera was mounted on a boom and set up for a close-up of the buzz saw, to be followed by a pullout for a long shot of Scarlett, Ashley, and Frank Kennedy. Three takes were made before the saw broke. While the saw was being repaired, the sound effect of chains rattling as the convicts walked was recorded.

Close shots of Johnny Gallagher, Scarlett, Ashley, and Frank were filmed before the camera was moved inside the office. A camera angle was lined up so the shadows of the convicts could be seen through the door, and the scene was completed by 6 p.m.

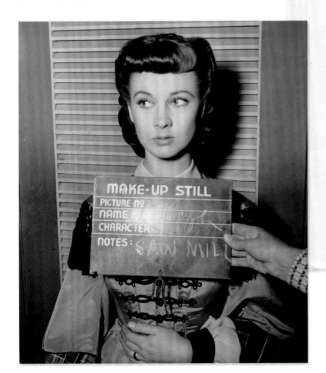

GONE WITH THE WIND
May 12, 1939
Colleen Traxler

OUTLINE SHOWING THE ATTITUDE OF THE SOUTH
TOWARD SCARLETT AS A BUSINESS
WOMAN AND ASSOCIATE OF
YANKEES (from novel)

Scarlett's becoming a business woman is the signal for a great deal of more or less silent disapproval to become exceedingly vocal, and the last straw is her marriage to Rhett. From then on she is no longer a member of the Southern society into which she had been born. The members of that society consider her worse than a Yankee or Scallawag because they consider that she has deliberately defied their traditions and her own; she is not only unwomanly but unworthy, and hasn't the cultural sense to "shake the tramps off" when she gets what she wants, and foolishly allows them to drag her down to their level.

When Scarlett buys the mill with the money Rhett loaned her, Frank and all the rest of Atlanta think she has "unsexed" herself by going into business. 636-643

None of the men she knows wants to work for her, they would rather work for themselves and besides, she has "a hard way of looking at things." 664-6

Atlanta is scandalized at Scarlett's business dealings with the Yankees. Even Uncle Peter tells her that it won't do her any good to stand high with the Yankees and white trash if her own folks don't approve of her. 668-671 674-675

The penalty for getting the money she wants so badly is loneliness. 678-680

Rhett tells Scarlett that one reason the ladies of Atlanta don't approve of her is because her conduct may cause the neck-stretching of their sons and husbands. 683-4

Grandma Fontaine tells Scarlett they have heard of her didoes in Atlanta with the Yankees. 719

Ashley tells Scarlett she has shouldered a man's burdens. 726

Frank forbids Scarlett to lease the convicts when she first mentions this idea. 742

When she does lease the convicts the town expresses disapproval for her hardness and inhumanity. 759-760 763-764

Rhett tells not only what he thinks of her way of doing business but, by inference, what everyone else would think: she is a woman quite without honor and he shouldn't have expected fair dealing from her, knowing her as he does. 768-775

Scarlett is accused of putting the Klansmen's lives in danger by riding around town by herself 794-5 798

(ABOVE) Selznick struggled to find a way to portray the southerners' attitudes toward Scarlett's business dealings. He ultimately settled on a montage sequence and used this list of scenes from the novel as a guide. See appendix for remaining text.

(LEFT) Makeup still of Vivien Leigh in the lumber mill scene.

Walter Plunkett's costume design for Scarlett's lumber mill dress.

SCARLETT

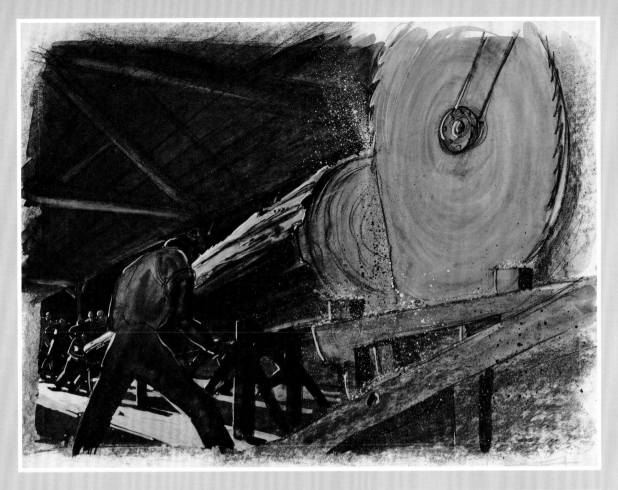

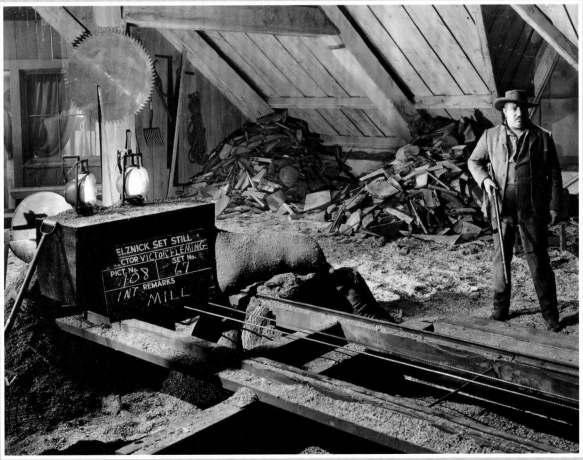

(ABOVE) Publicity still of Leslie Howard, Carroll Nye, and Vivien Leigh in the lumber mill scene.

(LEFT, TOP) Concept painting by William Cameron Menzies of the lumber mill. Selznick wanted shadows, especially a shadow of the spinning saw blade, to be prominent in this scene.

(LEFT) Set still of the lumber mill scene.

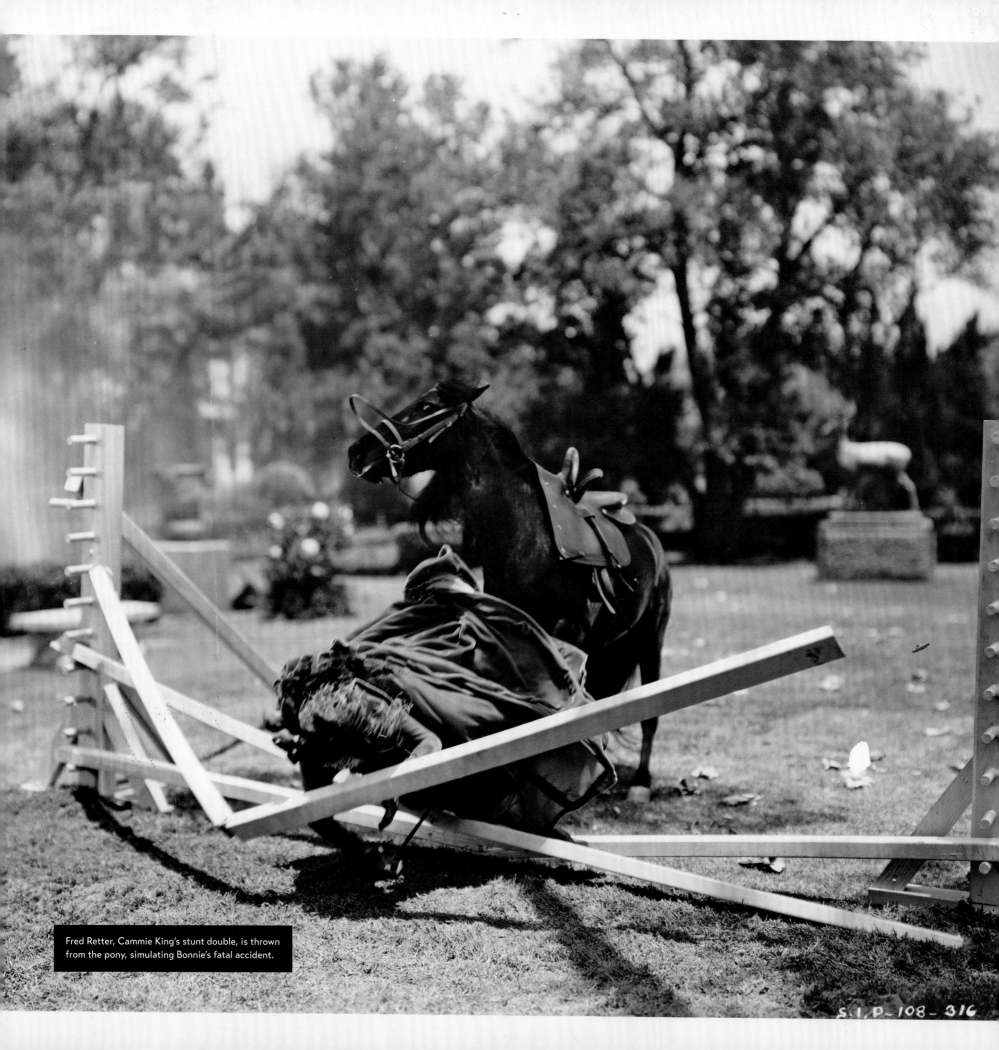

Fred Retter, Cammie King's stunt double, is thrown from the pony, simulating Bonnie's fatal accident.

"BONNIE'S DEATH RIDE"

Bonnie's death scene, characterized in production documents as "Bonnie's Death Ride," was directed by B. Reeves "Breezy" Eason. The scene was filmed at Cohn's Park on the MGM lot on Tuesday, June 20. Cammie King was present with the welfare worker who accompanied her when she was working. Also working that day were Richard Smith, Bonnie's double for riding, and Fred Retter, Bonnie's stunt double. Clark Gable and his stand-in, Lou Smith, were filming Rhett's proposal scene and would come to the MGM lot once they were finished.

Eason initially had the huge Technicolor camera mounted on a car to film Bonnie's riding scene but abandoned the setup after changing the lens twice. He then had two cameras set up on the hurdle and filmed twelve takes, printing only two for editing. He used the same setup to do an alternate take of the horse's jump and filmed sixteen takes before he quit trying to get a better shot of it. After lunch he lined up a new angle with the two cameras and quickly shot three takes. He changed the camera setup twice before he resorted to the use of a "Running W," a risky arrangement of wires looped through the sides of the saddle and attached to the horse's front feet to cause the animal to stop suddenly. Use of the "Running W" stunt would soon be banned from Hollywood productions.

A week later, on June 28, Victor Fleming reshot Rhett picking up Bonnie's body. The script supervisor pointed out that Bonnie's position on the ground did not match the long shot made the previous week, but Fleming disregarded the advice on continuity and finished the shot in four takes.

(ABOVE) Publicity photo of Cammie King as Bonnie.

(LEFT) Walter Plunkett's costume design for Bonnie's riding costume.

RHETT AND SCARLETT'S HONEYMOON

Rhett and Scarlett's honeymoon was filmed on Wednesday and Thursday, June 21 and 22. Both the New Orleans hotel room set and the riverboat set had been constructed on Stage 14. Although Fleming began with the hotel room scene, he spent the first hour Sunday morning "discussing and criticizing the boat set" with the cameramen. Selznick's research department had failed to locate any descriptions or photographs of riverboat cabins, so Menzies and Wheeler created one from scratch. Filming went smoothly and efficiently, so both scenes were completed by 3:45 p.m.

Selznick arrived on Stage 11 as the crew was setting up for Scarlett's nightmare scene. Again, filming the scene went well, and the crew was dismissed an hour and a half later.

Thursday morning found Victor Fleming on the 40 Acres lot waiting for the fog to lift. He was preparing to film Scarlett's close-ups under the bridge as the Union army passes overhead and her close-ups as she arrives at Tara after her long trek. Fleming left for Stage 14 and the New Orleans café set at 10 a.m. then returned to the 40 Acres lot an hour later only to find that the fog was still heavy. Selznick arrived at the café set at noon and began discussing the camera angle and the food used in the scene. Fleming also disapproved of how the

Butler table was set, so the extras were dismissed for lunch while the art department acquired and arranged a new table setting. Filming began at 4 p.m., and despite a few minor problems (the boom bumped into the wall, the waiter cut off Scarlett's light, and a scratch was discovered on the film), the scene was completed by 6 p.m., and Fleming returned to the 40 Acres lot.

Filming of Scarlett's close-ups under the bridge went quickly, but the shots on the Tara set took longer. The cast and crew finished the scene shortly after midnight. Although Leigh was scheduled for makeup at the usual time of 8 a.m. the next morning, she arrived almost two hours late.

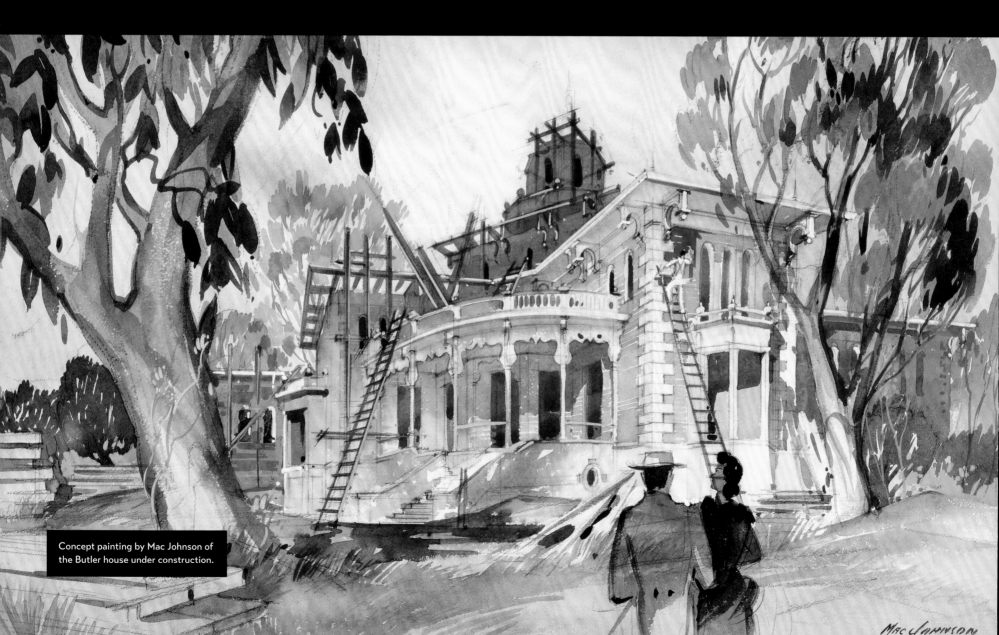

Concept painting by Mac Johnson of the Butler house under construction.

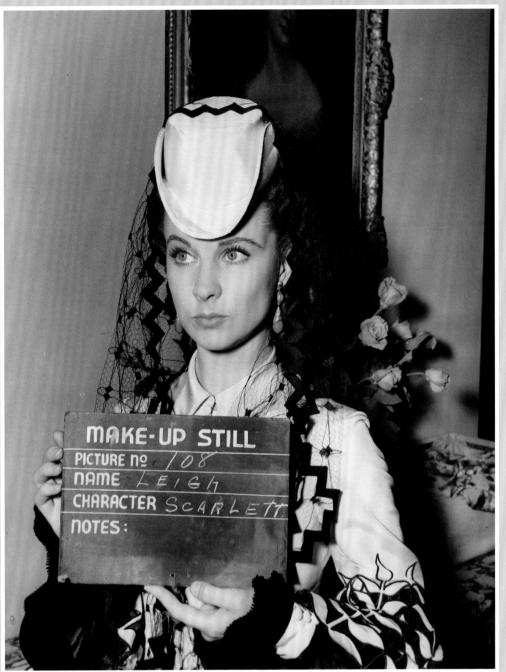

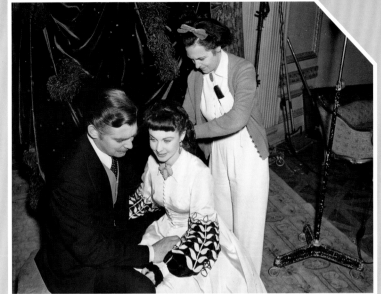

(ABOVE) Makeup still of Vivien Leigh.

(RIGHT, TOP) Hazel Rogers, *Gone With The Wind*'s hair designer, adjusts Vivien Leigh's hair as Clark Gable waits.

(RIGHT, MIDDLE) Arthur Arling (left) and Paul Hill sit behind the Technicolor camera as the cancan dancers rehearse. Left to right: Jolane Reynolds, Barbara Lynn, Peaches Jackson, and Geraldine Fizette.

(RIGHT, BOTTOM) Set still of Rhett and Scarlett's honeymoon cabin on the riverboat. Menzies and Wheeler were unable to find any authentic plans or descriptions of riverboat cabins so they had to improvise.

THE PADDOCK AND SCARLETT UNDER THE BRIDGE

SELZNICK INTERNATIONAL PICTURES, INC.
CULVER CITY, CALIFORNIA

INTER-OFFICE COMMUNICATION

TO Mr. Raymond A. Klune

SUBJECT: GONE WITH THE WIND OFFICE OF
 DAVID O. SELZNICK
DATE June 22, 1939 PRESIDENT

One of the reasons we had so much difficulty with Leslie Howard on the extremely hard and trying paddock scene was because of the number of people that were on the set. Please give strict orders that on the retake of this scene the set is to be closed to every person who is not absolutely vitally necessary to the shooting of the scene, including our own employees who are not on the picture, and including members of the press.

Please tell Hebert that he can have visitors on any day but this one.

Also, please station an extra policeman to make sure that we have a tighter rope around the stage on this day than we customarily have and make clear to the assistant director and the police that this rule goes even for our own employees.

 DOS

dos:ro

Sam Wood had first tried to film the paddock scene between Scarlett and Ashley on May 30. The entire morning was spent rehearsing and lining up the shot. Filming began shortly after noon, and fifteen takes were made before the crew stopped for lunch. Three takes were unacceptable due to technical difficulties, such as scratched film. Two takes were printed for editing, one was put on "hold," and nine takes were discarded due to Leslie Howard making dialog mistakes.

After a late lunch, five new camera setups were attempted, but Howard continued to have problems with his lines. Even after he stopped at 8 p.m. to study them, subsequent takes were unsuccessful, and the crew was dismissed shortly after 9 p.m.

Victor Fleming returned to the scene again a month later on Saturday, June 24. The morning was spent rehearsing and recording "wild tracks," sound with no accompanying image. Filming of the Paddock scene began shortly before 3 p.m. after a complete rehearsal. Again, as on May 30, the rather long scene was broken into parts that were filmed separately. Over five camera angles and twenty-seven takes, the scene was wrapped at 8:47 p.m.

(ABOVE) After months of filming, far longer than usual, all the actors were exhausted. Leslie Howard had a particularly difficult time with the paddock scene, and Selznick and Klune did their best to give him the space he needed to concentrate.

(RIGHT) Set still of the paddock set.

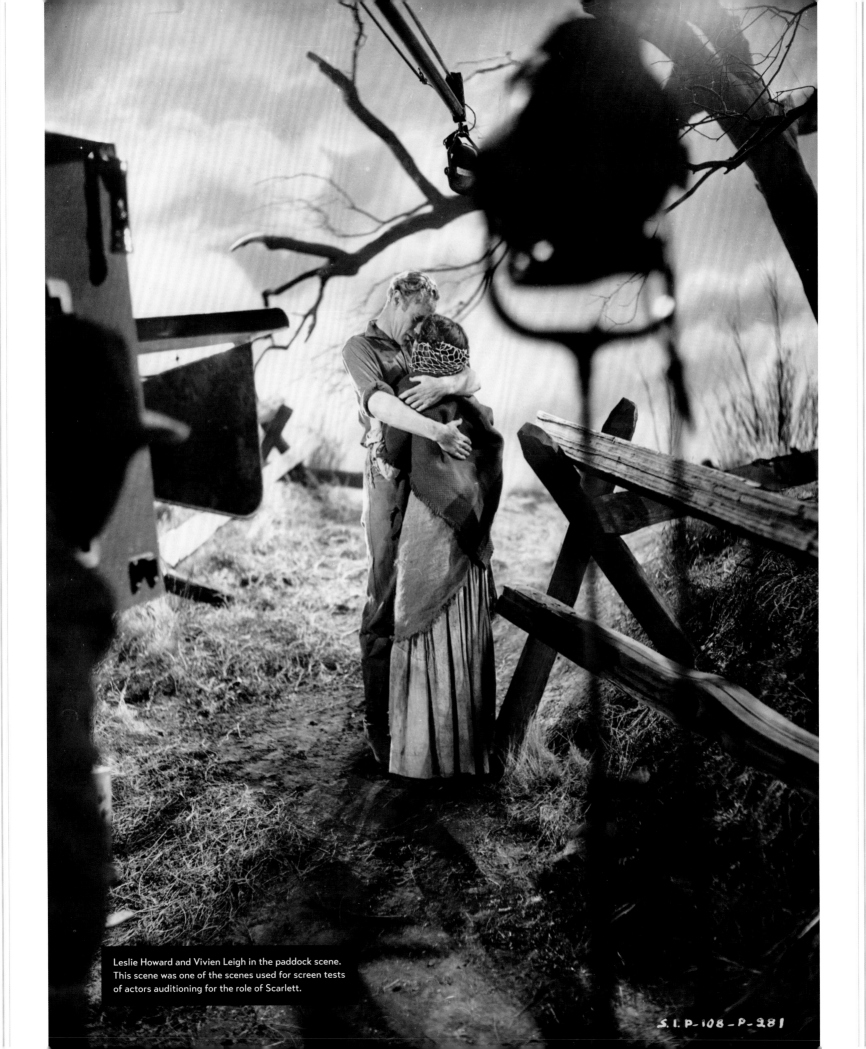

Leslie Howard and Vivien Leigh in the paddock scene. This scene was one of the scenes used for screen tests of actors auditioning for the role of Scarlett.

S.I.P-108-P-281

On that day, as Vivien Leigh and Leslie Howard were filming the paddock scene, William Cameron Menzies was directing the scene with Scarlett hiding the wagon under the bridge as Union soldiers pass overhead. Butterfly McQueen and Joan Rogers, Vivien Leigh's acting double, were scheduled to arrive on set on the Forty Acres lot at 4 p.m. They waited until almost 5:45 for the sun to move into the right position then filmed four takes in fifteen minutes. The crew left at 6 p.m. to return to the studio. Close-ups of Vivien Leigh holding the horse's reins were filmed on October 5 after Leigh returned from vacation for retakes.

(RIGHT) Set still of the bridge where Scarlett, Prissy, and Melanie hide from the Union troops.

(BELOW) Storyboard by William Cameron Menzies of the proposed sequence, beginning with Scarlett under the bridge. The scene underwent numerous changes.

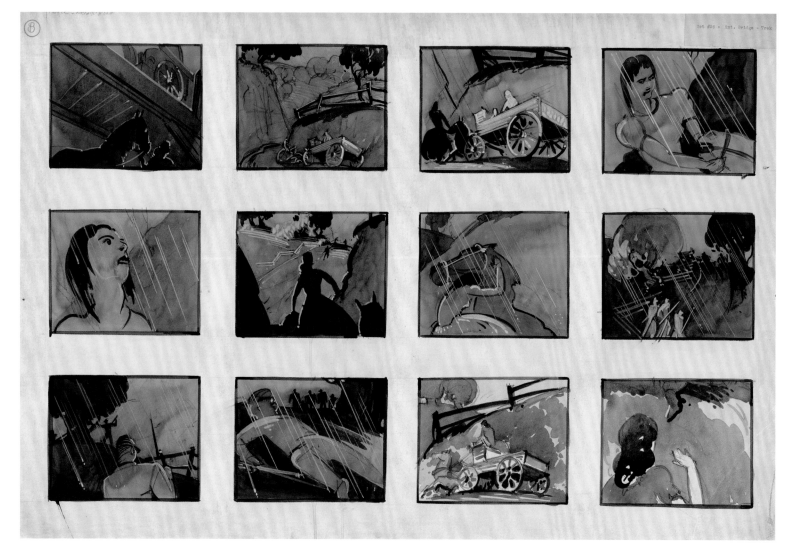

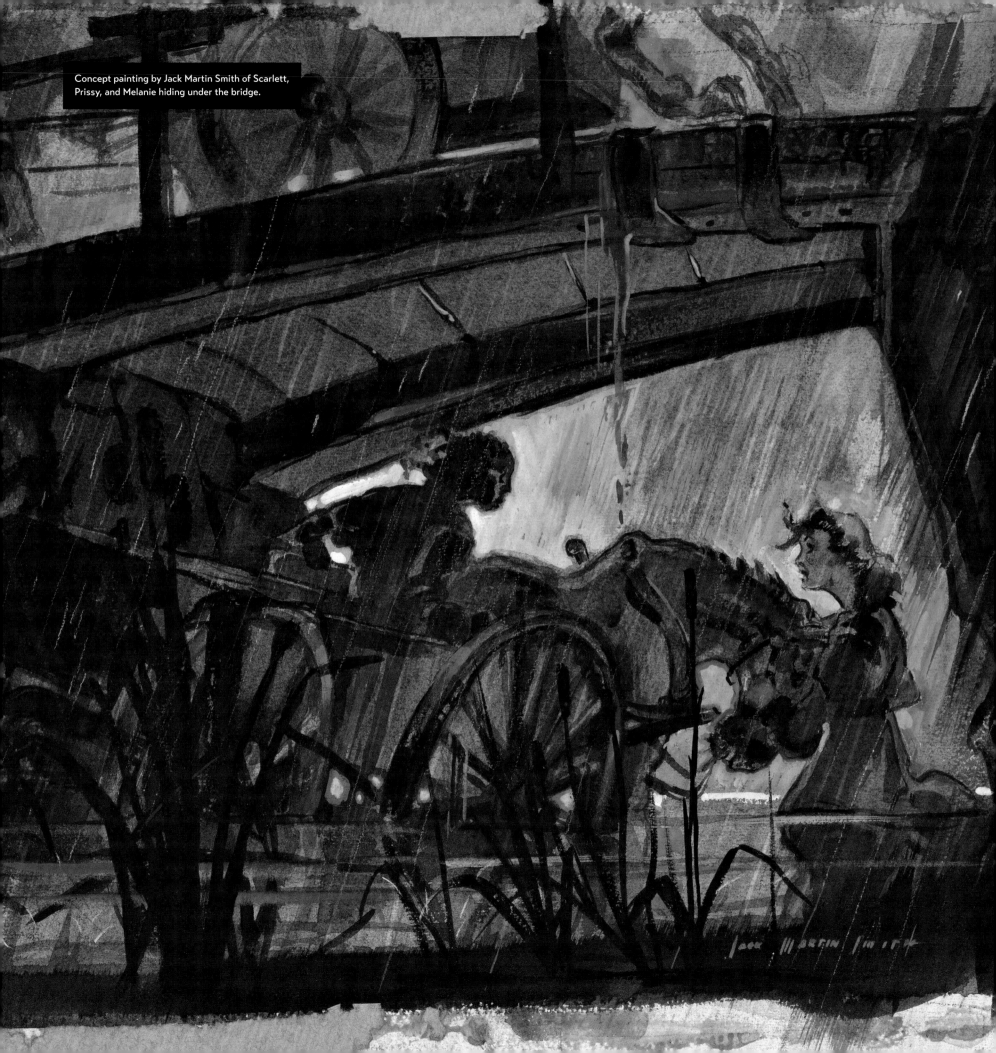

Concept painting by Jack Martin Smith of Scarlett, Prissy, and Melanie hiding under the bridge.

BITS AND RETAKES

Principal photography on *Gone With The Wind* officially ended on Tuesday, June 27, though there was still much to do. All the principal actors, however, were contractually obligated to return for retakes and added scenes.

The next morning, Fleming reshot Mrs. Meade's and India Wilkes's reactions to seeing Scarlett and Ashley embrace in the lumber mill. At noon he began working on finishing all of Gable's close-ups, moving to Stage 8 to film Rhett picking up Bonnie's body after her horse-riding accident, then to Stage 7 to film Rhett's close-ups at Ashley's birthday party, then to Stage 11 for close-ups at Melanie's house as the women waited for Ashley and Frank Kennedy. The next morning he filmed Ward Bond's close-ups for the same scene before leaving for the Slauson Blvd. set to supervise shots of slaves working in the fields for the opening montage.

In gratitude for your unfailing efforts and courtesy during the long Siege of Atlanta, and in celebration of the conclusion of the damned thing, we request the pleasure of your company at a little party to be given on Stage 5 immediately after Tuesday's shooting, June 27th.

Vivien Leigh
SCARLETT

Olivia de Havilland
MELANIE

Clark Gable
RHETT

Leslie Howard
ASHLEY

Victor Fleming
BIG SAM

David O. Selznick
JONAS WILKERSON

(ABOVE) Invitation to the wrap party. While June 27 was the official last day of principal photography, filming retakes, inserts, and bits would go on for more than three months.

(LEFT) Production still of Rhett picking up Bonnie's body.

William Cameron Menzies was busy as well. As Fleming filmed close-ups of Olivia de Havilland in the back of the wagon and at Ashley's party, Menzies directed Joan Rogers and Aline Goodwin, doubles for Scarlett, working in Tara's cotton patch and driving the wagon through a corpse-littered battlefield. He filmed Cammie King's close-ups in the London hotel room, Gerald's and Ellen's graves at Tara, Victor Jory as Jonas Wilkerson being hit in the face with dirt, and Mozelle Miller, another double for Scarlett, pulling a radish from the ground. He also filmed "insert" shots of the Yankee deserter's hat on the floor, the letter regarding Charles Hamilton's death, the bank draft for $300 for Tara's taxes, and the letter from Rhett returning the wedding rings.

July saw Hal Kern and Jack Cosgrove filming "trick shots" such as Butterfly McQueen and Joan Rogers, doubling for Scarlett, walking onto the set while a miniature of the ruins of Twelve Oaks was positioned in front of the camera.

These bits and retakes continued off and on for weeks. Finally, in early October, Vivien Leigh returned from vacation. The production had been hard on her. She had appeared in almost every scene, and the work had taken its toll. Fleming had tried to reshoot her opening scene on the porch with the Tarleton Twins much earlier, but Leigh had looked worn and tired so Selznick insisted she rest. Leigh returned on October 3. That day she filmed retakes of shots in the sleepy time scene at Twelve Oaks, and the next day she filmed her close-ups in the ruins of Twelve Oaks. On October 5, she filmed her close-ups holding the horse and wagon under the bridge as soldiers passed overhead. On October 12, Vivien Leigh appeared with Fred Crane and George Bessolo, now George Reeves, to film the opening porch scene once again, this time wearing the white prayer dress. David O. Selznick visited the set that morning and gave her the flowers she is holding in the scene.

The filming of *Gone With The Wind* was now complete.

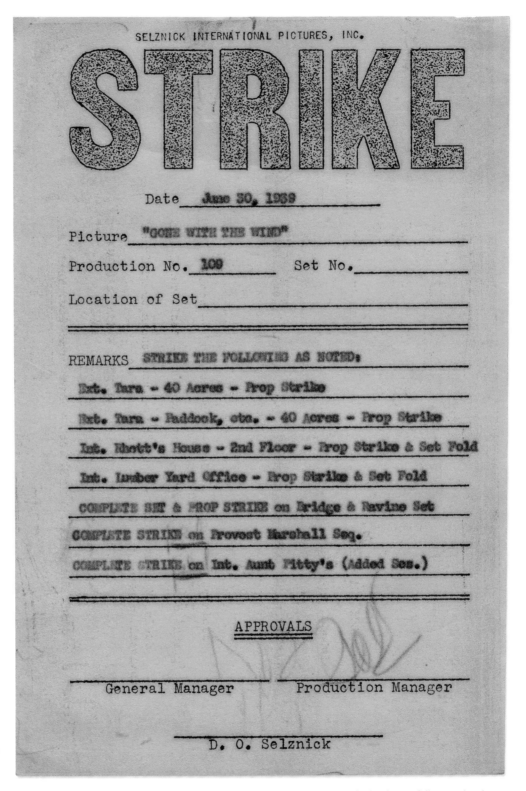

Strike order for Tara, the Butler house, and other sets. Orders to take down a set had to be carefully considered and approved by Henry Ginsberg, the general manager, Ray Klune, the production manager, and finally by David O. Selznick himself.

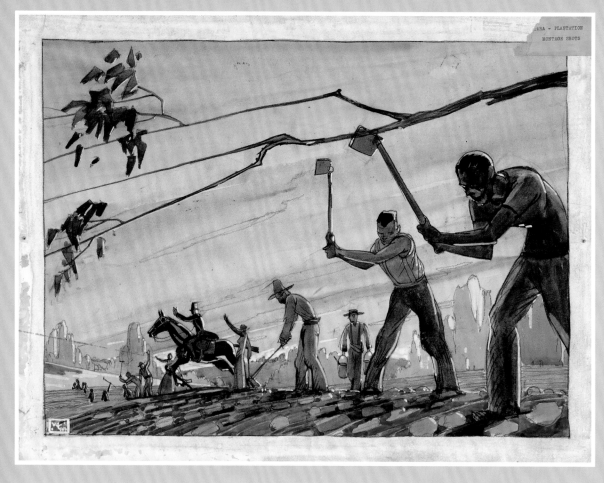

(ABOVE) Concept painting by William Cameron Menzies of field hands for the opening montage.

(LEFT, TOP) Concept painting by William Cameron Menzies of field hands for the opening montage. Gerald O'Hara rides through the scene on his horse.

(LEFT) Actors preparing to film shots for the opening montage.

(ABOVE, LEFT) Concept painting of a battlefield scene.

(ABOVE, RIGHT) Concept painting of a battlefield scene during the siege of Atlanta.

(RIGHT) Concept painting for the Sherman's March montage.

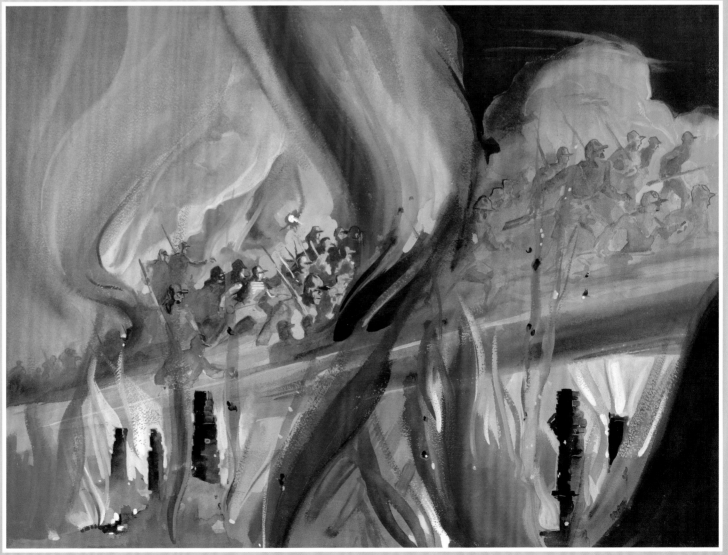

(RIGHT) Concept painting by William Cameron Menzies of Scarlett's arrival at the ruins of Twelve Oaks.

(BELOW, LEFT) Set still of the ruins of Twelve Oaks.

(BELOW, RIGHT) Concept painting by Frank Powers of the approach to Twelve Oaks.

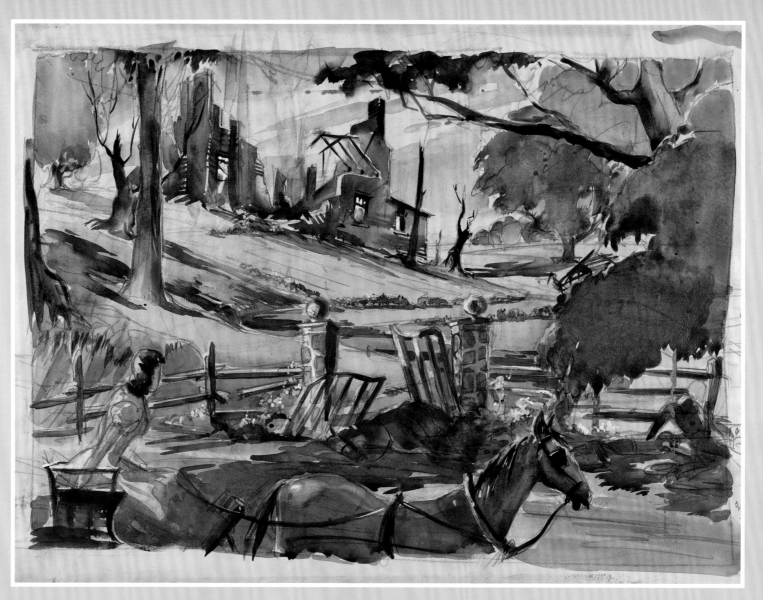

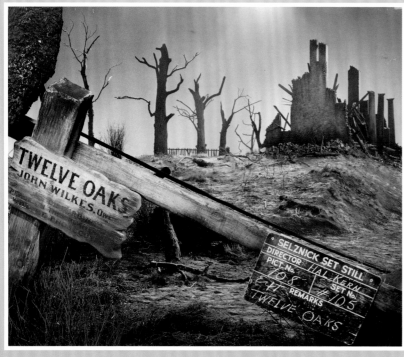

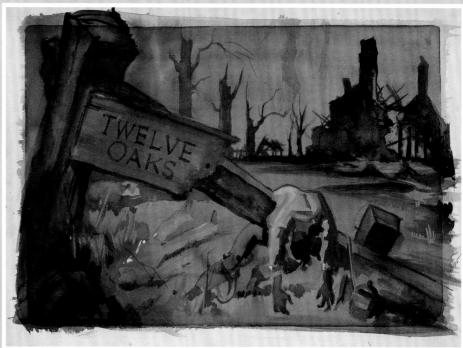

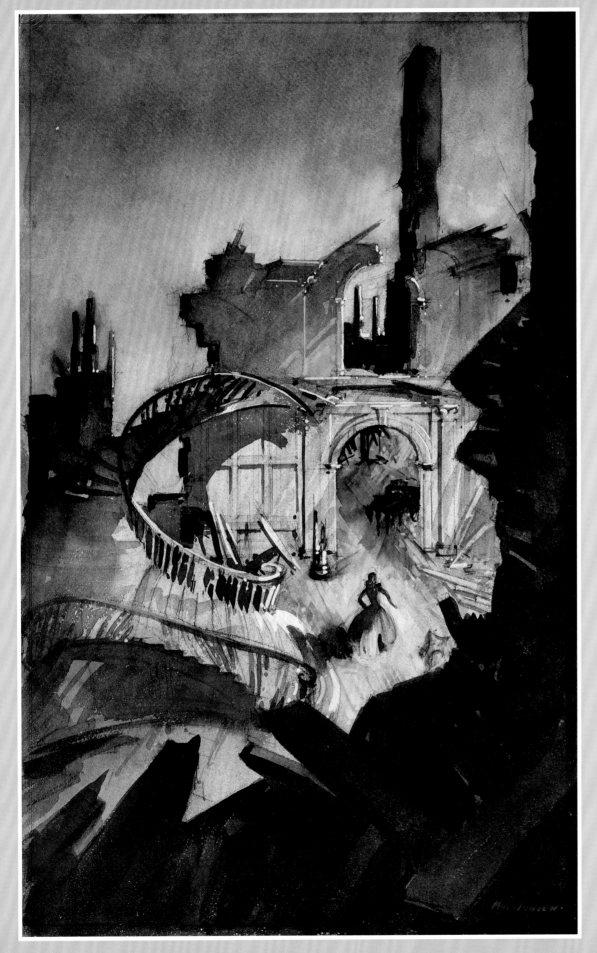

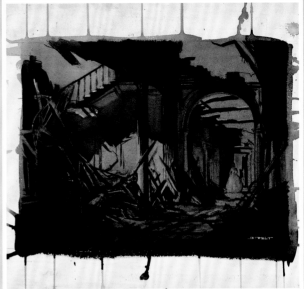

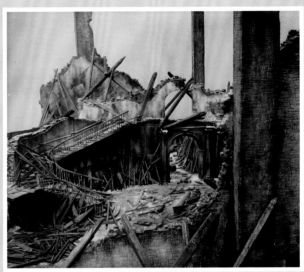

(ABOVE, TOP) Dorothea Holt's concept painting of the ruins of Twelve Oaks.

(ABOVE, BOTTOM) A set model of the ruins of Twelve Oaks.

(LEFT) Concept painting by Mac Johnson of the ruins of Twelve Oaks.

Wind - Mandrake

Messrs. Klune, Stacey, Lambert, Westmore

6/5/39

If and when we re-take the scene on the porch, I will want Scarlett in a white dress and made up exactly the same way she was in the scene in the hall on the introduction of Ellen -- and I want her looking as youthful as possible.

If we have time, the last day we are shooting, we should plan the re-take of Scarlett in the prayer scene and since she will be in the same make-up and costume as the porch scene, it should be made the same day as the porch scene and probably immediately following it.

DOS

dos*f

SELZNICK INTERNATIONAL PICTURES, INC.
CALL SHEET

DATE...Thurs., Oct., 12, 1939........

PICTURE....GONE WITH THE WIND - 46-826.... PROD. NO........... DIRECTOR....Victor Fleming.......

SET...EXT. TARA.............

LOCATION.......FORTY ACRES..SCENES..(weather permitting)...........

NAME	TIME CALLED		CHARACTER, DESC., WARDROBE
	ON SET	MAKE-UP	
Vivien Leigh	8:00a	6:45a	Scarlett #1
George Reeves	7:30a	5:30a	Stuart Tarleton #1
Fred Crane	7:30a	5:30a	Brent Tarleton #1
1 Colored Boy	7:30a	7:00a	as before
Welfare Worker	7:00a		
Standin	7:30a	6:30a	For Miss Leigh

LATER

INT. EXAMINER OFFICE (PROCESS) STAGE #3

Boy Printer's Devil will call			as before
1 Man Printer	" "		to be fitted

LATER

EXT. SUN DIAL ----------STAGE #4

LATER

INT. LONDON HOTEL ROOM (PROCESS) STAGE #4

PROPERTY DEPARTMENT

Twins' Horses
Turkey
Hound Dogs
Mother Cat & kitten

CAMERA	7:30a	
SOUND (READY)	8:00a	
COSGROVE	7:30a	
SELZNICK BOOM	7:30a	
DON MUSGRAVE	will notify	
LUNCHES READY	11:30a	

TRANSPORTATION DEPARTMENT

2 Cars at 6:00 am for Staff & Crew.

3 Uniformed police officers to stop traffic on Higuera Street.

ASSISTANT DIRECTOR.....ERIC STACEY...............

(ABOVE) By the end of June, Vivien Leigh was so exhausted from the grueling production schedule that Selznick sent her on vacation to rest and rejuvenate. Once she returned, though, there were several more scenes to film.

(LEFT) Call sheet for the final attempt at filming the porch scene. The scene was both one of the first and one of the last to be filmed.

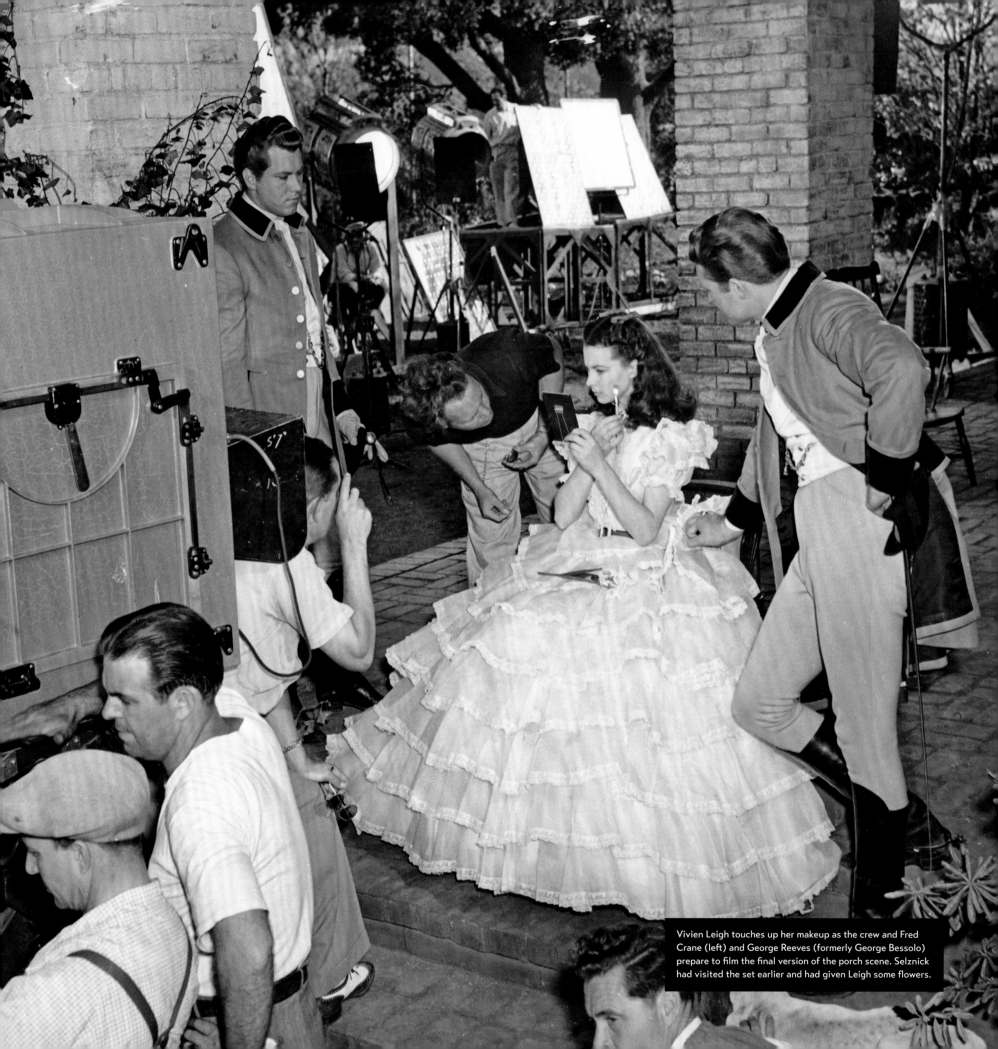

Vivien Leigh touches up her makeup as the crew and Fred Crane (left) and George Reeves (formerly George Bessolo) prepare to film the final version of the porch scene. Selznick had visited the set earlier and had given Leigh some flowers.

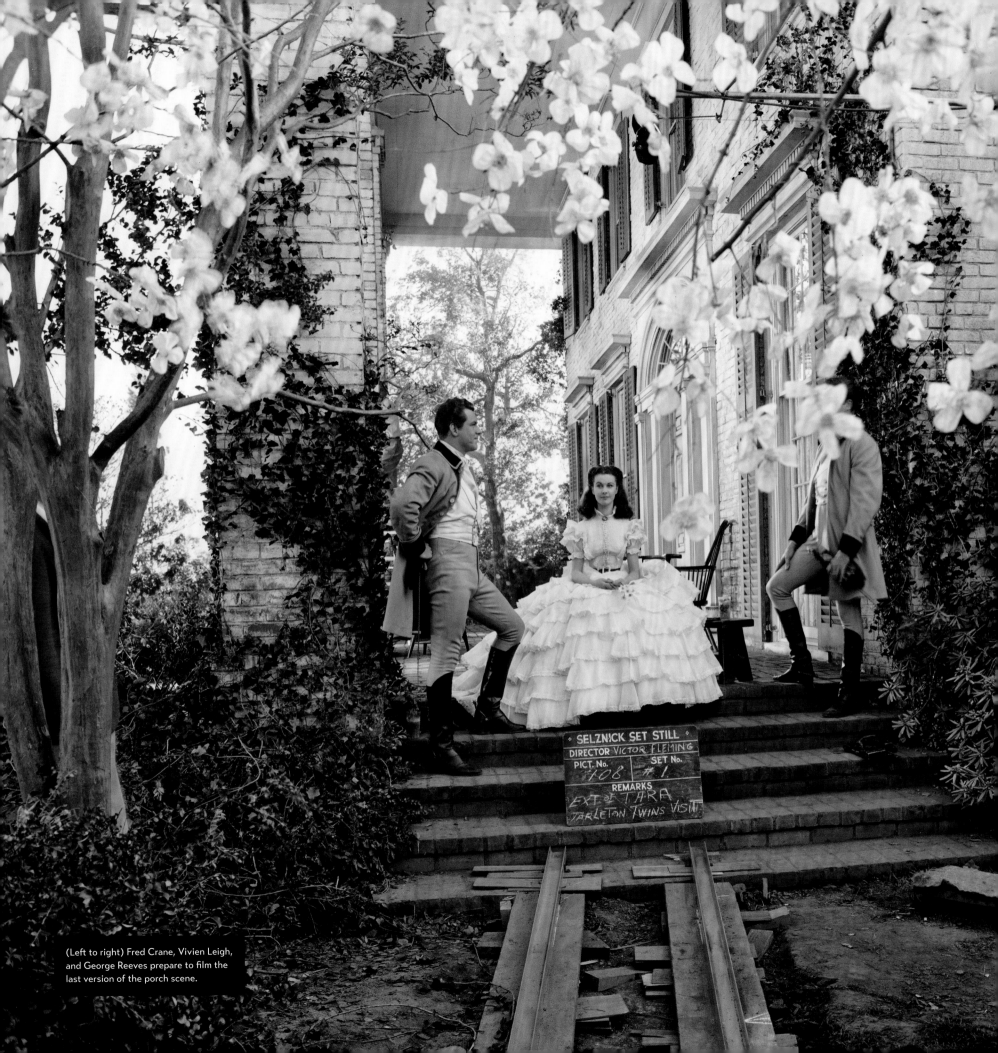

SELZNICK SET STILL
DIRECTOR Victor FLEMING
PICT. No. 108 SET No. #1
REMARKS
EXT of TARA
TARLETON TWINS VISIT

(Left to right) Fred Crane, Vivien Leigh, and George Reeves prepare to film the last version of the porch scene.

June 27, 1939

MR. JOHN HAY WHITNEY PERSONAL DELIVERY
630 FIFTH AVENUE
NEW YORK, N.Y.

SOUND THE SIREN. SCARLETT O'HARA COMPLETED HER PERFORMANCE AT NOON

TODAY. GABLE FINISHES TONIGHT OR IN THE MORNING AND WE WILL BE SHOOTING

UNTIL FRIDAY WITH BIT PEOPLE. I AM GOING ON THE BOAT FRIDAY NIGHT AND

YOU CAN ALL GO TO THE DEVIL. WE ARE TRYING TO KEEP VIVIEN'S ARRIVAL IN

NEWYORK THURSDAY A SECRET. HEBERT 12 WILL ACCOMPANY HER AND WILL LOOK

YOU UP. VIVIEN IS EXPECTING A CALL FROM YOU SO IF YOU CAN ARRANGE ONE

EVENING OR SUNDAY FOR HER AND LARRY I THINK IT WOULD BE A NICE THING TO

DO. PLEASE TELL MARGARET MITCHELL WHAT SHE CAN DO TO HERSELF.

DAVID

THE QUICKEST, SUREST AND SAFEST WAY TO SEND MONEY IS BY TELEGRAPH OR CABLE

Selznick's telegram to Jock Whitney about the completion of
principal photography of *Gone With The Wind*.

MUSIC

Gone With The Wind elicited from many involved in the production the finest work of their careers. Selznick often exploited this realization, when negotiating salaries, for example, but also used it as a motivational tool.

When Selznick hired Max Steiner to compose the score for *Gone With The Wind*, he knew "Maxey" could be slow and prone to pessimism and self-doubt. Consequently, Selznick had several other composers, including Franz Waxman, working on the score as a "precautionary measure." When in mid-November 1939, Steiner had not finished his composition, Selznick began talks with Herbert Stothart, a highly regarded composer at MGM who had recently completed the score to *The Wizard of Oz*. Whether or not the move was a serious attempt to change composers or just a ploy to prod Steiner to work faster, it worked, and Steiner delivered one of film's best-known scores on time, despite the fact that he was simultaneously scoring two other films for Warner Bros.

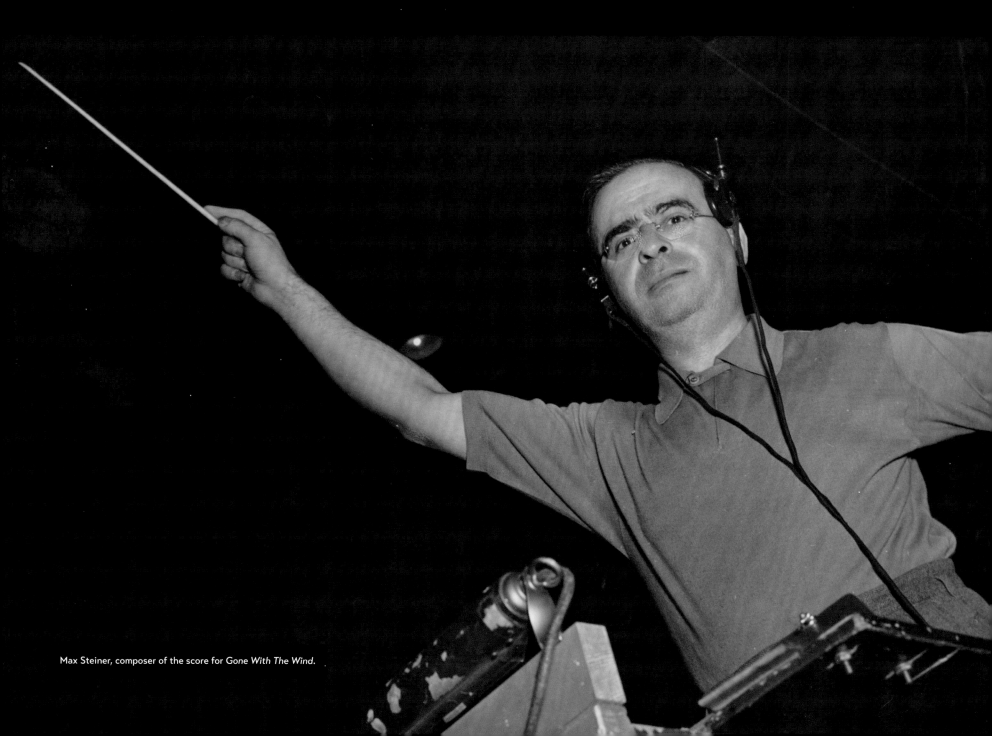

Max Steiner, composer of the score for *Gone With The Wind*.

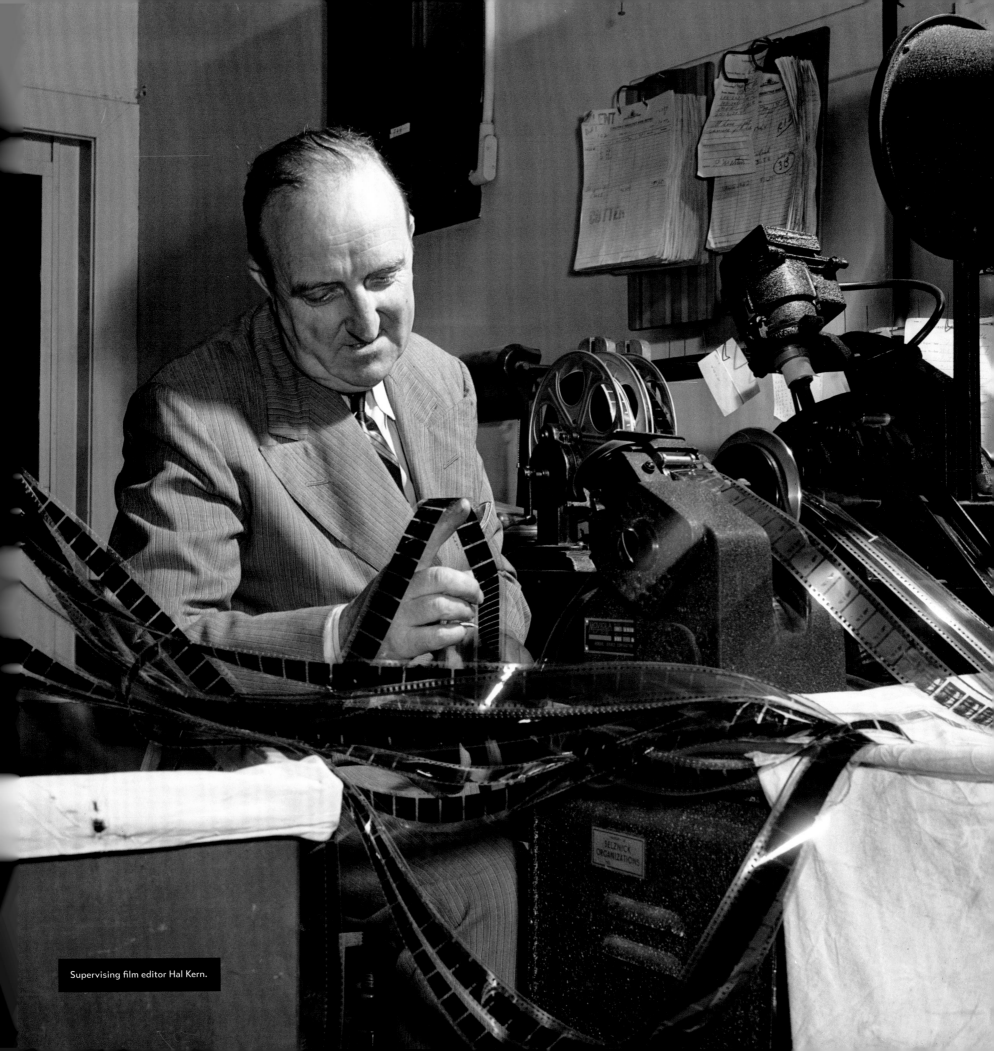

Supervising film editor Hal Kern.

POSTPRODUCTION

The film editors Hal Kern and James Newcom edited *Gone With The Wind* as it was being filmed to accommodate Selznick's demand to see entire sequences on an almost daily basis. It was an enormous task for which the two received Academy Awards. *Gone With The Wind* was twice as long as other films being made at the time, and the fact that it was made in Technicolor complicated the process because there were three strips of negatives to deal with and because they had to ensure color matching between shots that were often filmed days or weeks apart. Almost a million and a half feet of film was exposed. More than half of that was printed for editing. SIP's records indicate that editing consumed some 16,000 hours.

Selznick's head of special effects, Jack Cosgrove, worked closely with William Cameron Menzies during production and with Hal Kern during postproduction. Scores of shots in *Gone With The Wind* are process shots in which foreground performances are combined with pre-filmed backgrounds. Selznick relied heavily on Cosgrove's skills and, especially in the final weeks of filming and throughout the postproduction period, worried that Cosgrove would not finish on time without help.

(TOP) Hal Kern (holding film) and some of his editing staff, who worked feverishly throughout the production to supply edited versions of scenes for Selznick to see as the production progressed.

(BOTTOM) Jack Cosgrove, Selznick's head of special effects. Cosgrove worked closely with William Cameron Menzies, and some of the film's most dramatic images were the results of their collaboration.

THE FOX RIVERSIDE PREVIEW

"Gone With The Wind"
Preview Questionnaire

MEMBERS OF THE PREVIEW AUDIENCE:

"GONE WITH THE WIND" is still in unfinished rough form and your opinions about it will be of great benefit to us in the final editing. Will you please be good enough to give us your answers to the following questions?

1. How did you like the picture? Very very much. Whoever has the final editing of "Gone with the Wind" will certainly have a gigantic task. It is perfect, it seems to me, as we saw it, and will be a sacrifice to cut any of it. It is the finest adaption from a book I have ever seen, and the cast is perfect, especially the principles. Noteworthy too, are the grand performances of Mammy and Prissie. The filming in technicolor has greatly enhanced the charm of the picture, the fire scenes in particular standing out with breathtaking naturalness.

2. Was the action of the picture entirely clear? If not, where was it confusing? I had no difficulty following the sequence at any time.

3. Was the sound entirely clear and could you understand the dialogue? If not, do you recall which parts were not audible? The only place I recall that wasn't entirely clear was where Scarlett and the twins were talking in the very beginning of the picture. This may have been due to the fact that we had not heard Scarlett talk and had to become accustomed to her way of speaking--- or to the excitement of at last seeing this much discussed picture. This was the only place and the fault was probably ours.

4. Did any parts seem too long? If so, what parts? The only part that seemed to drag in the least was shortly after the intermission, where their-a-day toil is shown is such detail. I thoroughly enjoyed every minute of the three hours and forty minutes and this is not a criticism, but if it does have to be cut I believe that would be the logical place.

5. Do you think that any battle scenes should be added to the picture, or any fuller portrayal of the Civil War, its causes and development? No. I think you have shown cause and effect very well, and at this particular time of unrest, the hospital scenes should prove an object lesson to our youth who can only see the glamour of War.

6. Have you any other suggestions to make? I can't think of a single thing that would improve what you have already done, but I do know that I shall never forget " Gone with the Wind" and want to thank you for allowing we folk in Riverside the priviledge of seeing it first. May we have more of your good pictures? Thank you.

(One intermission made it very enjoyable and enabled us to stretch a bit. It came at a high point of interest that made us eager for more.)

7. Please check one: Do you think the picture should be played?
☐ With no intermission? ☐ With Two intermissions? ☒ With one intermission?

Name Dora Neuber Wahle

Address 4277-6th Street City Riverside

Your replies will
be appreciated
THANK
YOU!

On the afternoon of August 17, 1939, the Arlington Theatre in Santa Barbara advertised a sneak preview of the newest film by David O. Selznick. No title was provided, but it was billed as "the most important picture of the year." Rumor spread that the preview screening was of *Gone With The Wind*, and there was a near riot outside the theater at showtime. The people who managed to get in to the screening reportedly groaned loudly when they learned the film being shown was *Intermezzo*, starring Leslie Howard and Selznick's new star from Sweden, Ingrid Bergman.

Selznick was considerably more careful on the night of September 9 when he arrived at the Fox Theater in Riverside, California, with his wife, Irene, Jock Whitney, Hal Kern, his editor, and script supervisor Bobby Keon. The audience was there ostensibly to see the new Gary Cooper film, *Beau Geste*, but was told that, instead, a three-hour-and-forty-three minute film with a brief intermission would be shown. They could not use the telephone. They would be allowed to leave, but if they did so, they would not be readmitted. There was "an unprecedented outburst of cheering and applause" as the title, *Gone With The Wind*, began moving across the screen, and the audience reportedly cheered "for four solid minutes when they saw Gable on screen."

There were no walkouts during the entire screening. When it was over, just before midnight, the audience filled out questionnaires. Their responses were remarkably considered and articulate and were studied by Selznick and Kern as they fine-tuned the film for the premiere in Atlanta.

Preview questionnaires from the first preview screening of *Gone With The Wind* at the Riverside Fox Theater on September 9, 1939. Used with permission.

"Gone With The Wind"
Preview Questionnaire

MEMBERS OF THE PREVIEW AUDIENCE:

"GONE WITH THE WIND" is still in unfinished rough form and your opinions about it will be of great benefit to us in the final editing. Will you please be good enough to give us your answers to the following questions?

1. How did you like the picture?
Best picture I've seen this year so far, and believe that this picture be admired by the millions in near future to come.

2. Was the action of the picture entirely clear? If not, where was it confusing?
Yes. I do believe the action of the picture was very clear.

3. Was the sound entirely clear and could you understand the dialogue? If not, do you recall which parts were not audible?
Conversation between Scarlet and dying Mrs. Wilkes should be made little louder.

4. Did any parts seem too long? If so, what parts?
No.

5. Do you think that any battle scenes should be added to the picture, or any fuller portrayal of the Civil War, its causes and development?
I should think adding of more clear battle scenes would make "Gone with The Wind" stand out better, such as "Battle of Gettysburge"

6. Have you any other suggestions to make?
I would like very much to hear more of the songs by the darkies.

7. Please check one: Do you think the picture should be played?
☐ With no intermission? ☐ With Two intermissions? ☒ With one intermission?

Name Kayne Muramoto
Address 2145 John St. City Arlington, Calif.

Your replies will be appreciated THANK YOU!

"Gone With The Wind"
Preview Questionnaire

MEMBERS OF THE PREVIEW AUDIENCE:

"GONE WITH THE WIND" is still in unfinished rough form and your opinions about it will be of great benefit to us in the final editing. Will you please be good enough to give us your answers to the following questions?

1. How did you like the picture?
I consider it the finest picture I have ever seen outside of the Ziegfeld picture. I consider I had the pleasure of a very rare treat. Had debated whether we would go to the theatre or not and when we found what the preview was we were thrilled.

2. Was the action of the picture entirely clear? If not, where was it confusing?
I think it was very clear

3. Was the sound entirely clear and could you understand the dialogue? If not, do you recall which parts were not audible?
Good, and we sat in the first balcony

4. Did any parts seem too long? If so, what parts?
The only part I would consider too long was the scene where Mammy was telling about the death of the child, it played on the emotions too much. May be would not affect anyone who had not had children. I have had five.

5. Do you think that any battle scenes should be added to the picture, or any fuller portrayal of the Civil War, its causes and development?
No, I think there were just enough.

6. Have you any other suggestions to make?
I would not want it changed a bit. The characters were all wonderful. I have never cared very much for Clark Gable but he won me completely over in his portrayal of the part Sat. night. Miss Leigh was excellent, so was Leslie Howard (one of my favorites anyway), Olivia de Haviland wonderful and Mammy I think just about played the best I have ever seen her.

7. Please check one: Do you think the picture should be played?
☐ With no intermission? ☐ With Two intermissions? ☒ With one intermission?

Name Eleanor J. McClaskey
Address 3364 Walnut Street City Riverside
Member of the Riverside Motion Picture Council

Your replies will be appreciated THANK YOU!

"Gone With The Wind"
Preview Questionnaire

MEMBERS OF THE PREVIEW AUDIENCE:

"GONE WITH THE WIND" is still in unfinished rough form and your opinions about it will be of great benefit to us in the final editing. Will you please be good enough to give us your answers to the following questions?

1. How did you like the picture?
Very much. It was as though I were seeing the same scenery, characters and actions I had imagined as I read the book two years ago.

2. Was the action of the picture entirely clear? If not, where was it confusing?
The action was wonderful. I sincerely believe it could not possibly be better. I also enjoyed the unusual number of close ups.

3. Was the sound entirely clear and could you understand the dialogue? If not, do you recall which parts were not audible?
The sound was very clear and I don't remember even once not being able to hear very distinctly.

4. Did any parts seem too long? If so, what parts?
For adults this picture is so complete and balanced so perfectly that no part is too long. I wish the public in general might have the chance to see it in this form.

5. Do you think that any battle scenes should be added to the picture, or any fuller portrayal of the Civil War, its causes and development?
Please don't add any more battle scenes. What you have is entirely sufficient, not to be monotonous and yet giving one a thorough understanding of the horrors of war at any period.

6. Have you any other suggestions to make?
No suggestions - just Congratulations. In my estimation it is definately the greatest picture ever made and is worth sitting through any length of time. The story deserves your effort.

7. Please check one: Do you think the picture should be played?
☐ With no intermission? ☐ With Two intermissions? ☒ With one intermission?

Name Nancy Anne Carter
Address 202 Langstaff City Elsinore, Calif.

Your replies will be appreciated THANK YOU!

"Gone With The Wind"
Preview Questionnaire

MEMBERS OF THE PREVIEW AUDIENCE:

"GONE WITH THE WIND" is still in unfinished rough form and your opinions about it will be of great benefit to us in the final editing. Will you please be good enough to give us your answers to the following questions?

1. How did you like the picture?
The picture in every way more than truthfully told Margaret Mitchell's story. It is a grand picture.

2. Was the action of the picture entirely clear? If not, where was it confusing?
The whole action was perfectly clear and if it isn't an academy picture I will be very much surprised

3. Was the sound entirely clear and could you understand the dialogue? If not, do you recall which parts were not audible?
Yes.

4. Did any parts seem too long? If so, what parts?
No

5. Do you think that any battle scenes should be added to the picture, or any fuller portrayal of the Civil War, its causes and development?
The story is complete with the battle portrayed. No more is needed

6. Have you any other suggestions to make?
I think the slavery question was pushed too far in the background. That after all was the cause of the war.

7. Please check one: Do you think the picture should be played?
☐ With no intermission? ☐ With Two intermissions? ☒ With one intermission?

Name Margaret Livingston
Address 4231 Westmoreland City Riverside

Your replies will be appreciated THANK YOU!

"Gone With The Wind"
Preview Questionnaire

MEMBERS OF THE PREVIEW AUDIENCE:

"GONE WITH THE WIND" is still in unfinished rough form and your opinions about it will be of great benefit to us in the final editing. Will you please be good enough to give us your answers to the following questions?

1. How did you like the picture?
Swell but to many unnecessary parts. Now is a good time to play up the hospital scenes and results of the war as hopeless

2. Was the action of the picture entirely clear? If not, where was it confusing?
More explanation about Carpet baggers.

3. Was the sound entirely clear and could you understand the dialogue? If not, do you recall which parts were not audible?
I thought the sound was good.

4. Did any parts seem too long? If so, what parts?
The whole picture had too much detail.

5. Do you think that any battle scenes should be added to the picture, or any fuller portrayal of the Civil War, its causes and development?
More battle scenes and more about causes of the war and its result

6. Have you any other suggestions to make?
In some scenes you would see a distant shot, a close up, then distant shot & this last distant shot would be a lot brighter.

7. Please check one: Do you think the picture should be played?
☐ With no intermission? ☐ With Two intermissions? ☒ With one intermission?

Name LYNDON HARP Jr.
Address 4436 LEMON ST City RIVERSIDE

Your replies will be appreciated THANK YOU!

"Gone With The Wind"
Preview Questionnaire

MEMBERS OF THE PREVIEW AUDIENCE:

"GONE WITH THE WIND" is still in unfinished rough form and your opinions about it will be of great benefit to us in the final editing. Will you please be good enough to give us your answers to the following questions?

1. How did you like the picture?
Gone With The Wind fulfilled every expectation. I fully enjoyed each minute of it. Having read the book, I appreciated the fact that the picture followed so closely the original story.

2. Was the action of the picture entirely clear? If not, where was it confusing?
The action was exceptionally clear for a story envolving a large number of rolls and characters.

3. Was the sound entirely clear and could you understand the dialogue? If not, do you recall which parts were not audible?
The sound was entirely clear but seemed very loud, especially at the front of the theater. I had no trouble in understanding the dialogue.

4. Did any parts seem too long? If so, what parts?
The length of all parts seemed very well gauged and if cut down would endanger the clarity of the story.

5. Do you think that any battle scenes should be added to the picture, or any fuller portrayal of the Civil War, its causes and development?
The course of the Civil War as portrayed in the picture seemed entirely clear. Those scenes showing the wounded of the war carried with them a full realization of its horror without showing actual battle scenes.

6. Have you any other suggestions to make?
My only suggestion would be that the picture be left just as it is. Despite the fact that it is considered still in length for it would seem that cutting it or condensing it any more would detract from the picture.

7. Please check one: Do you think the picture should be played?
☐ With no intermission? ☐ With Two intermissions? ☒ With one intermission?

Name Jean Shall
Address 3616 Bandini Ave. City Riverside, Calif.

Your replies will be appreciated THANK YOU!

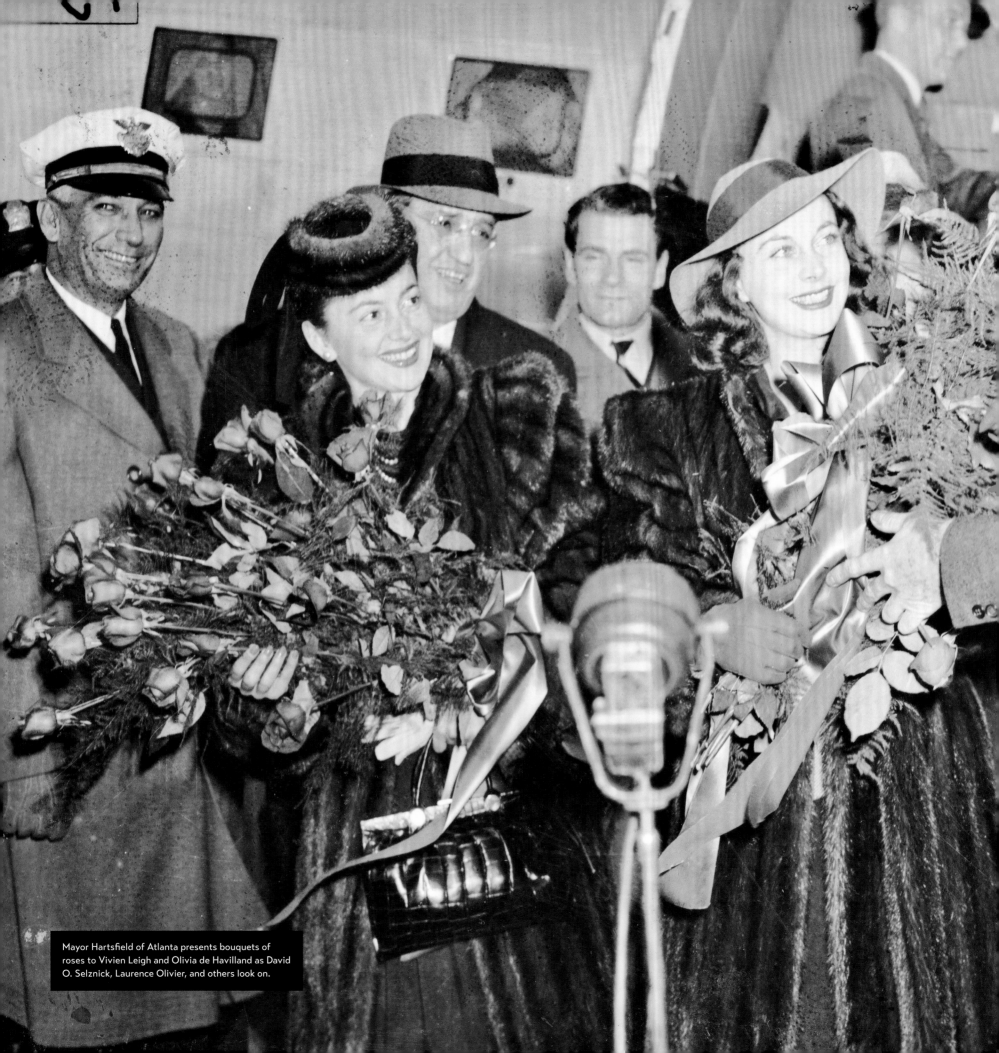

Mayor Hartsfield of Atlanta presents bouquets of roses to Vivien Leigh and Olivia de Havilland as David O. Selznick, Laurence Olivier, and others look on.

THE ATLANTA PREMIERE

When Mayor William B. Hartsfield of Atlanta wrote to Selznick in early 1937 suggesting the premiere of *Gone With The Wind* be held in his city, Selznick's reply was positive but noncommittal. Privately he said he thought it was a good idea. Later, as Selznick was deep into filming, the mayor wrote again. This time Selznick confirmed that "the official world premiere of the finally edited picture will, according to our present plan, be in Atlanta, which is a prospect that you may be sure is as appealing to me as it could possibly be to any Atlantan."

Soon thereafter, requests and invitations began to pour into the Selznick offices. Kay Brown was put in charge of those arrangements that required a personal touch. Selznick happily turned over the general planning of the premiere to Howard Dietz, head of publicity for MGM, though he worried that someone from MGM might make a false step and damage any goodwill the Selznick organization had built up.

As the months passed and the filming of *Gone With The Wind* ground on, the plans for the premiere took shape. The governor of Georgia declared the opening of *Gone With The Wind* a state holiday, and Mayor Hartsfield declared a three-day holiday for the city. The city scrambled to erect historical markers that identified significant locations from history and the novel. Every business and organization in the city, it seemed, got involved in one way or another. Margaret Mitchell herself worked behind the scenes with friends in the Atlanta press to wage a campaign to treat the visiting celebrities "like human beings."

Indeed, some of the stars of the film were reluctant to attend. Gable, in particular, did not want to go. Two weeks before the premiere, speaking about the planned Junior League Ball, Selznick said that Gable "is still squawking about the ball, claiming that going to the opening is bad enough, but that selling thousands of tickets because of a personal appearance by him at a ball is a little thick." Vivien Leigh was hesitant at first but

Nationally syndicated cartoonist Zack Mosley paid tribute to the Atlanta premiere of *Gone With The Wind* with this installment of his comic strip *The Adventures of Smilin' Jack*, which appeared in the *Atlanta Constitution* on December 14, 1939.

changed her mind as the date approached, especially when she learned that her fiancé, Laurence Olivier, would attend as well. Warner Brothers resisted letting Olivia de Havilland attend and insisted she return immediately after the premiere to work on a film. Ann Rutherford was eager to attend, and Selznick invited other cast members, including Laura Hope Crews and Ona Munson, as well.

Selznick also wanted Hattie McDaniel, Butterfly McQueen, Oscar Polk, and Eddie Anderson to attend. He was proud of their performances in the film and thought they could help get publicity in the African American newspapers in Atlanta. He suggested they also make a brief appearance onstage at the premiere. But Atlanta was a racially segregated city in 1939. Legare Davis, the advertising manager for Atlanta Gas Light, whom John Marsh recommended as a consultant for the premiere, advised against honoring the black cast members. Kay Brown explained, "Davis felt that it was possible to include the negroes but better to leave them out. The inclusion might cause comment and might be a handle that someone could seize and use as a club." Howard Dietz said he wanted to maintain the spotlight on the main cast members and felt that as guests of Atlanta, they should follow the prevailing customs.

Selznick went along but was frustrated. He had been acutely moved by an invitation from a young African American student named Robert Willis from the University Players of Atlanta University. Willis wrote, "After having seen some of the plans for your stay in Atlanta, we found that the Negro is excluded from participation in the celebration of the Premiere of Gone With The Wind. Not only are we excluded from the Preview, but there is wholesale talk of forcing us to the back during the parade so that we may not hinder other people who want to see their favorite Movie People, just as we." Selznick responded that the festivities surrounding the premiere were "out of our hands entirely" but added, "I hope you understand that the feelings of myself and our company toward the Negro race are the friendliest possible." He offered scripts of his past productions to the University Players and separately instructed Brown and Dietz that, regarding the promotion of the film in the South, "anything we can do to demonstrate our friendliness, and any courtesies we can extend to Negroes, should be most carefully handled."

(TOP) Kay Brown's memo about plans for the premiere and Junior League Ball also mentions Margaret Mitchell (Peggy) and her husband's campaign to remind Atlanta's citizens to "treat these celebrities like human beings."

(BOTTOM) Selznick's memo to Kay Brown with his thoughts about the Atlanta premiere festivities and his impression of Clark Gable's and Vivien Leigh's attitudes about attending.

In a final effort to acknowledge his African American cast members, Selznick pushed to include Hattie McDaniel's image on the back of the souvenir program, along with those of the white cast members, but yielded to counterpressure, concluding "it may be best to play safe" to avoid offending an enormous potential audience.

(RIGHT, TOP) Selznick's memo to MGM's head of publicity, Howard Dietz, regarding Hattie McDaniel's portrait on the back of the souvenir program. Selznick was justifiably proud of McDaniel's work and felt it should be acknowledged. His suggestion that the African American cast members attend the premiere festivities was rejected by Howard Dietz and the organizers in Atlanta. Selznick's suggestion that Hattie McDaniel's portrait be included on the back of the souvenir program was rejected as well.

(RIGHT, BOTTOM) By the time Hattie McDaniel wrote this gracious letter to Selznick on the eve of the Atlanta premiere, she knew she had not been invited to attend.

(BELOW) Ultimately, three versions of the souvenir program were produced, one with the white cast members on the back cover, one with Hattie McDaniel and the white cast members, and one with a blank back cover.

AAF13 TWS PAID (DEL FRI A M)

 TDS CULVERCITY CALIF NOV 30 1939

MR. HOWARD DIETZ

METRO GOLDWYN MAYER

1540 BROADWAY

NEWYORK NY

SOUTHERNERS HERE THINK LEGARE DAVIS IS NUTS CONCERNING USE OF NEGROES IN PROGRAM. HOWEVER, IF THERE IS ANY QUESTION IT MAY BE BEST TO PLAY SAFE. BUT IN ANY EVENT I THINK THAT NEWYORK AND PARTICULARLY HOLLYWOOD EDITIONS SHOULD INCLUDE MAMMY. MAYBE SAFEST THING TO DO IS TO FORGET ALL PORTRAITS ON THE BACK AND SIMPLY USE ORIGINALY SKETCH OF TARA YOU HAD FOR THIS PURPOSE OR SOMETHING COMPARABLE. CERTAINLY FOR HOLLYWOOD WOULD INFINITELY PREFER HAVING NO PORTRAITS TO OMITTING MAMMY AS I THINK THERE WILL BE BITTER RESENTMENT OF THIS AND WOULD NOT BE SURPRISED IF SAME WERE TRUE IN NEWYORK. THEREFORE IF YOU SHOULD DECIDE TO OMIT MAMMY FROM THE WHOLE THING OR FROM SOUTHERN EDITION PLEASE GIVE US FOR HOLLYWOOD AND NEWYORK EITHER A SEPARATE EDITION WITHOUT ANY PORTRAITS, OR SEPARATE EDITION WITH HER IF YOU POSSIBLY CAN. SORRY TO BE SUCH A NUISANCE ON THIS POINT BUT IN THESE INCREASINGLY LIBERAL DAYS (THANK GOODNESS) I HATE TO BE PERSONALLY ON THE SPOT OF SEEMING UNGRATEFUL FOR WHAT I HONESTLY FEEL IS ONE OF THE GREAT SUPPORTING PERFORMANCES OF ALL TIMES, WHICH IS THAT OF MAMMY. EVERYONE WHO HAS EVER SEEN PICTURE IS IN UNANIMOUS AGREEMENT THAT ONE OF HER SCENES WHICH IS VERY CLOSE TO END OF PICTURE IS EASILY THE HIGH EMOTIONAL POINT OFTHE FILM AND I THINK SHE IS GOING TO BE HAILED AS THE GREAT NEGRO PERFORMER OF THIS DECADE.

 DAVID.

McDaniel Hattie

 2177 West 31st Street,
 Los Angeles, Calif.
 Dec. 11, 1939.

Mr. David O. Selznick,
9336 Washington Boulevard,
Culver City, California.

Dear Mr. Selznick:

 On the eve of your departure for Atlanta, Ga., to attend the world premiere of "Gone With The Wind", I am writing to thank you for your very kind letter and for the opportunity given me to play the part of Mammy in the epochal drama of the old South.

 I have nothing but the highest praise for the cooperation extended by my fellow-players and the entire studio staff. I am sure that the picture will live up to every expectation of the producer and pre-view critics and I hope that Mammy, when viewed by the masses will be the exact replica of what Miss Mitchell intended her to be.

 Thanking you for the privilege of having a part in the screen's greatest undertaking, I am,

 Gratefully yours,

 Hattie McDaniel.

HMD/g

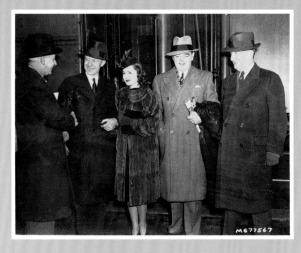

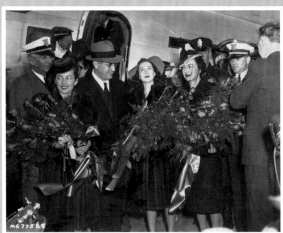

(TOP) Ann Rutherford arrives in Atlanta.

(MIDDLE) Olivia de Havilland, David O. Selznick, Vivien Leigh, and Selznick's wife, Irene, are greeted by Mayor Hartsfield at Candler Field in Atlanta.

(BOTTOM) This poster was used to promote the *Gone With The Wind* premiere festivities in Atlanta.

The Atlanta premiere and related activities went more smoothly than any of the Selznick team and cast anticipated. Ann Rutherford arrived first, with her mother, the morning of Wednesday, December 13. They were met at the train station by Mayor Hartsfield and a retinue of city and MGM officials. Rutherford toured the *Atlanta Journal* and sat at Margaret Mitchell's desk.

That afternoon, Vivien Leigh, Olivia de Havilland, Laurence Olivier, and David O. Selznick and his wife, Irene, arrived at Atlanta's Candler Field via Eastern Airlines. Mayor Hartsfield was there to greet them and presented the women with large bouquets of roses. Evelyn Keyes and Ona Munson arrived on a separate plane shortly thereafter and were met by the chief of police. The guests were taken to the Georgian Terrace Hotel.

Laura Hope Crews arrived the next morning on the Dixie Limited from Chicago and was met by the mayor carrying flowers. Claudette Colbert, Jock Whitney, and a number of New York journalists and MGM officials arrived by train from New York at Terminal Station shortly after that.

That afternoon, officials from the Junior Chamber of Commerce, the Blue Rainbow Drill Team, and the Russell High Military Band arrived with Mayor Hartsfield at Candler Field to greet Clark Gable and Carole Lombard's plane. From there, the parade through downtown Atlanta began. Vivien Leigh rode in a car with Selznick, Jock Whitney, and Governor Ed Rivers. Gable and Lombard rode with Mayor Hartsfield. Ann Rutherford, Evelyn Keyes, Laura Hope Crews, Ona Munson, Alicia Rhett, and the various officials and dignitaries followed at ten miles per hour through a crowd estimated at 300,000.

At the Georgian Terrace hotel, the 100-piece Georgia State Girls Military Band played, the Confederate flag was raised, and Mayor Hartsfield, David O. Selznick, and Clark Gable spoke briefly to the huge crowd before going to the press reception in the grand ballroom of the hotel. There, members of the press had the chance to meet and interview the producer and his stars.

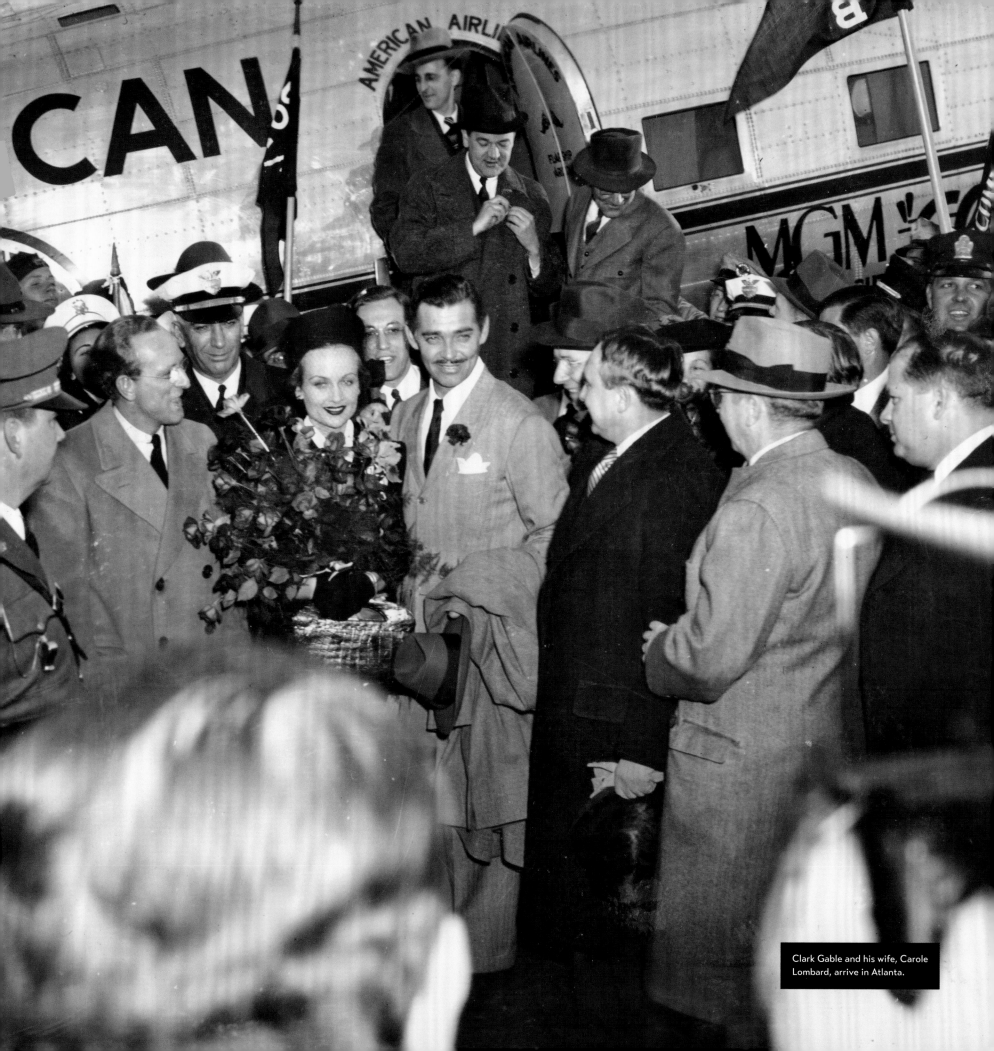

Clark Gable and his wife, Carole Lombard, arrive in Atlanta.

Virtually every business in Atlanta found a way to tie in to the *Gone With The Wind* premiere festivities.

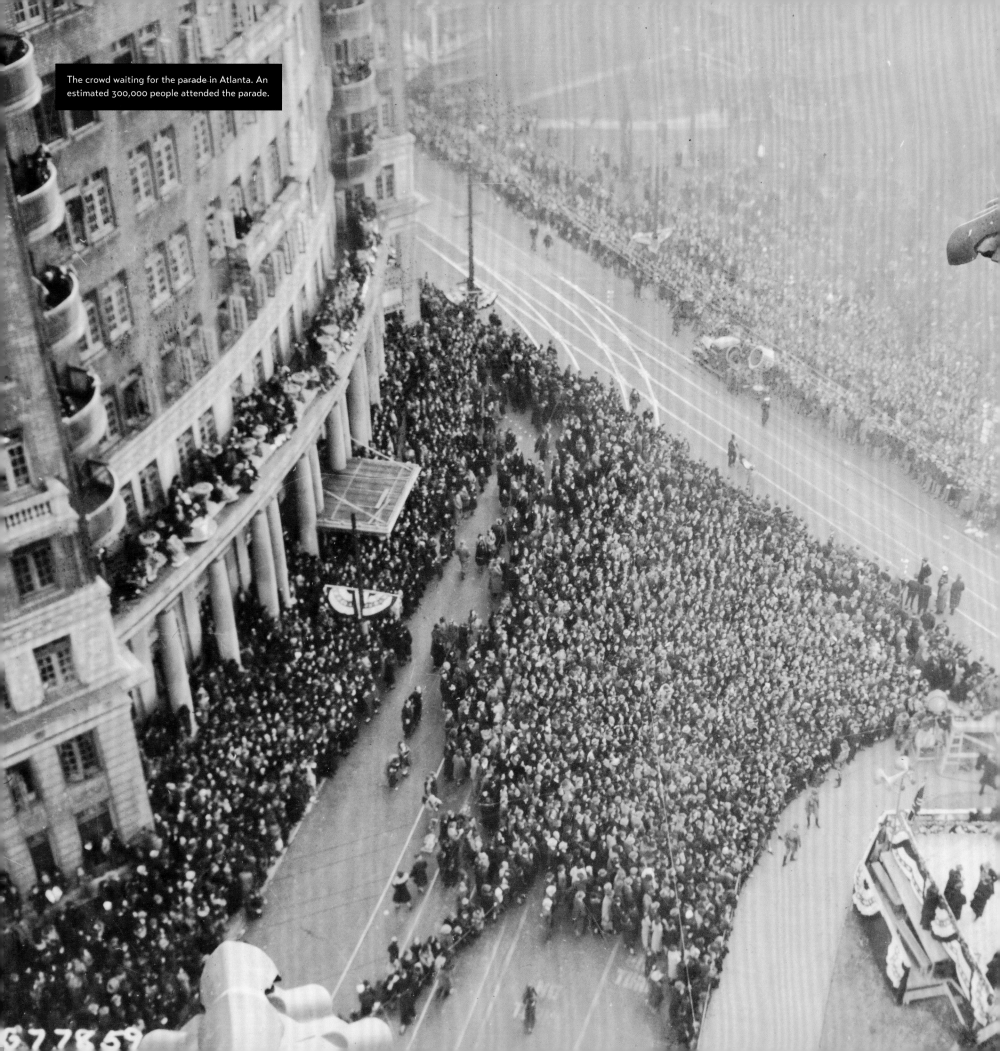

The crowd waiting for the parade in Atlanta. An estimated 300,000 people attended the parade.

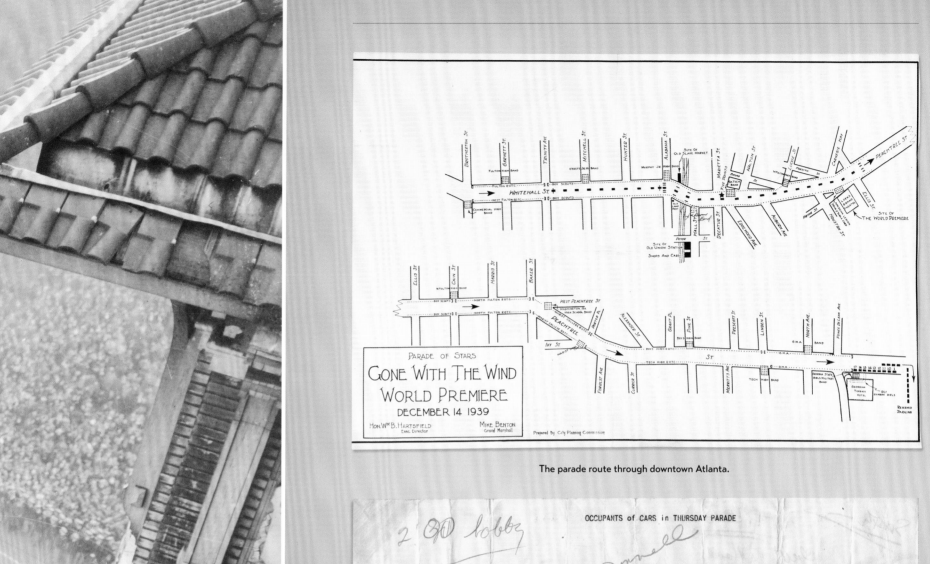

The parade route through downtown Atlanta.

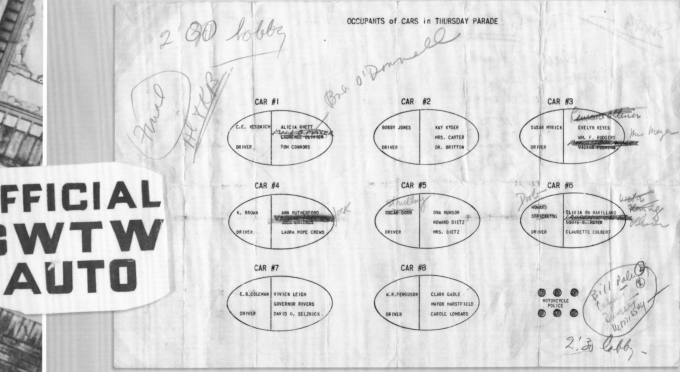

Arm band worn by drivers of cars and chart of the order of the vehicles for the parade through downtown Atlanta.

(TOP) Governor Ed Rivers with David O. Selznick and Vivien Leigh in the parade through Atlanta.

(MIDDLE) The Georgia State Girls Military Band at the Georgian Terrace hotel.

(BOTTOM) Clark Gable speaks after the parade.

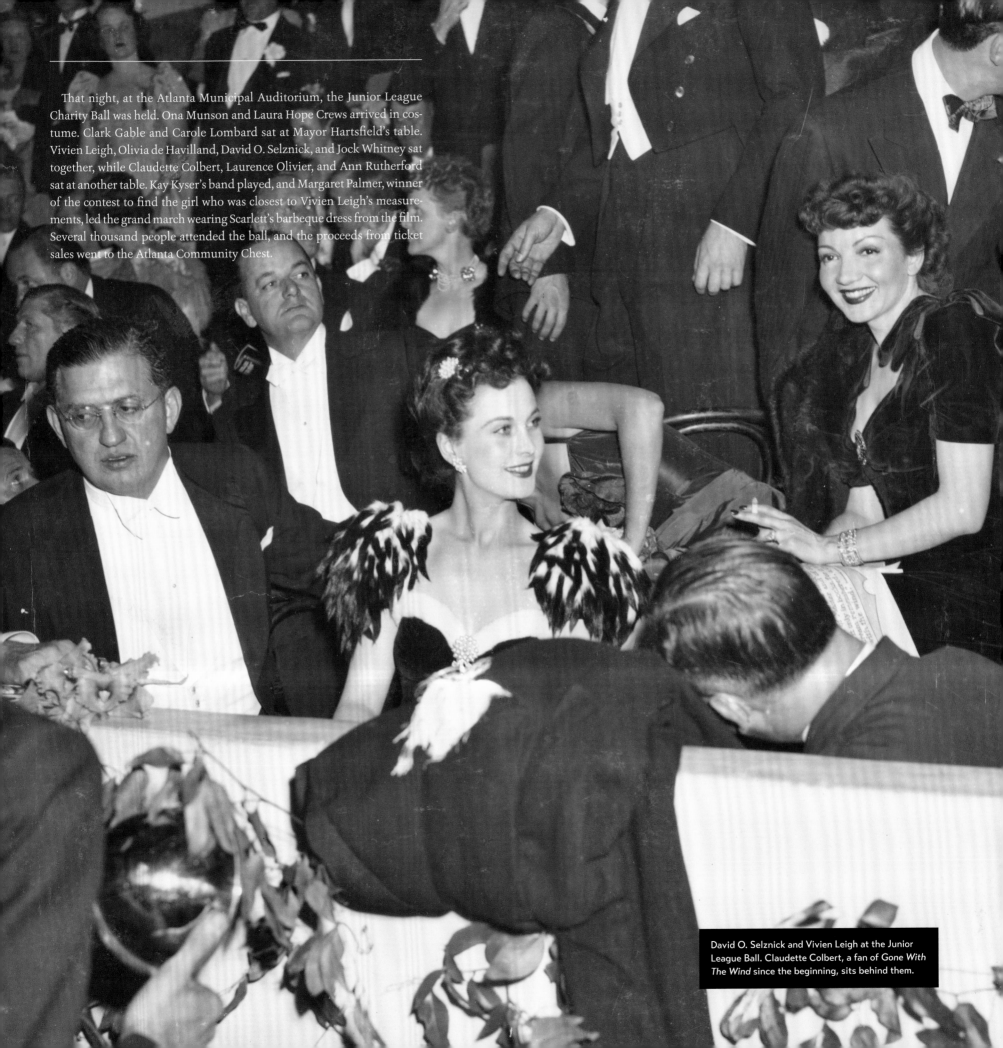

That night, at the Atlanta Municipal Auditorium, the Junior League Charity Ball was held. Ona Munson and Laura Hope Crews arrived in costume. Clark Gable and Carole Lombard sat at Mayor Hartsfield's table. Vivien Leigh, Olivia de Havilland, David O. Selznick, and Jock Whitney sat together, while Claudette Colbert, Laurence Olivier, and Ann Rutherford sat at another table. Kay Kyser's band played, and Margaret Palmer, winner of the contest to find the girl who was closest to Vivien Leigh's measurements, led the grand march wearing Scarlett's barbeque dress from the film. Several thousand people attended the ball, and the proceeds from ticket sales went to the Atlanta Community Chest.

David O. Selznick and Vivien Leigh at the Junior League Ball. Claudette Colbert, a fan of *Gone With The Wind* since the beginning, sits behind them.

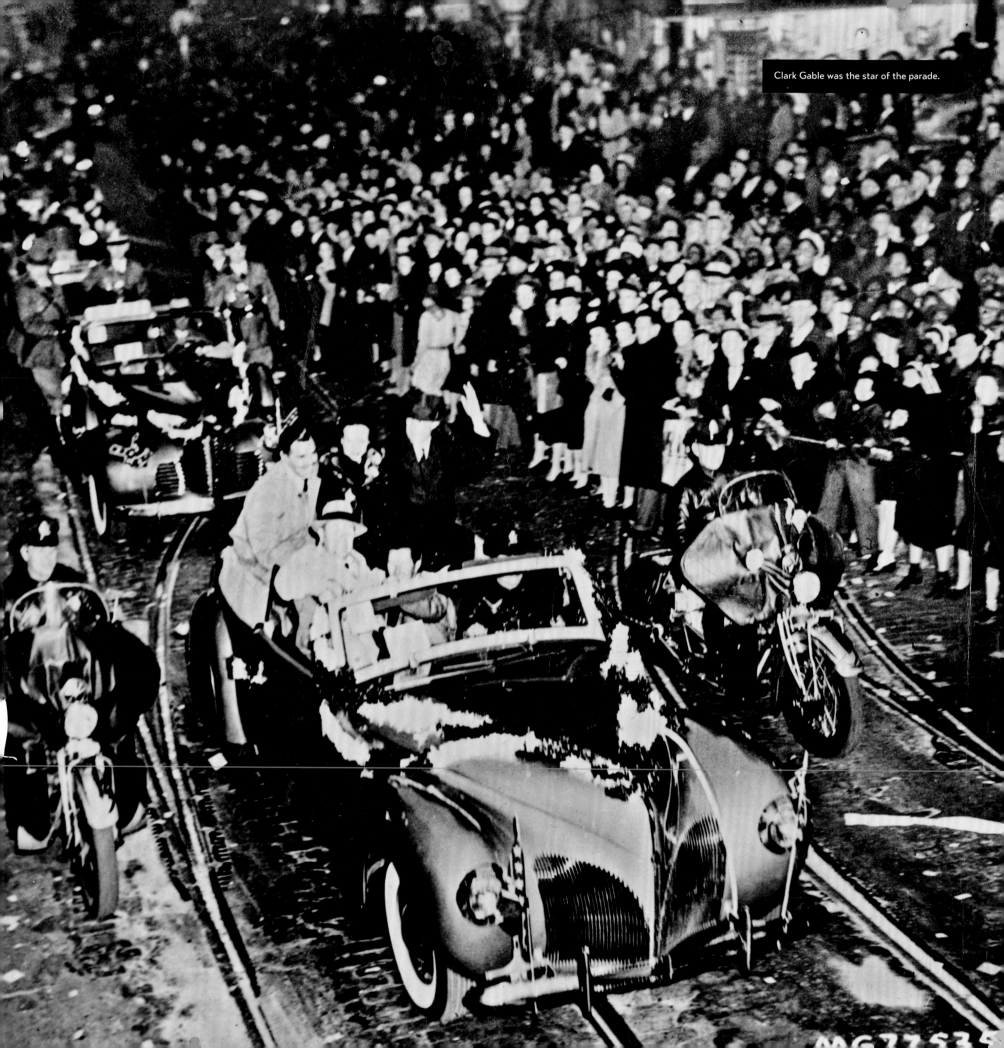

Clark Gable was the star of the parade.

Postal Telegraph

Mackay Radio All America Cables
Commercial Cables Canadian Pacific Telegraphs

THIS IS A FULL RATE TELEGRAM, CABLE-GRAM OR RADIOGRAM UNLESS OTHERWISE INDICATED BY SYMBOL IN THE PREAMBLE OR IN THE ADDRESS OF THE MESSAGE. SYMBOLS DESIGNATING SERVICE SELECTED ARE OUTLINED IN THE COMPANY'S TARIFFS ON HAND AT EACH OFFICE AND ON FILE WITH REGULATORY AUTHORITIES.

NA104 119 DL =F ATLANTA GA 20 1239P 1939 NOV 20 PM 2 44

MISS KATHERINE BROWN =

SELZNICK INTERNATIONAL PICTURES 630 FIFTH AVE NYC=

HAVE SCHEDULED CONTEST WITH CONSTITUTION AND JUNIOR LEAGUE FOR
DEBUTANTE WHO MOST NEARLY APPROXIMATES VIVIEN LEIGHS
MEASUREMENTS TO WEAR THE BEST OF THE SCARLETT OHARAS GOWNS
YOU WILL MAKE AVAILABLE TO US. NEED TO KNOW AT ONCE, THEREFORE
WHICH GOWN IT SHALL BE SO THAT WE CAN START PLANNING ART OF
THIS GOWN. KINDLY ADVISE AS SOON AS POSSIBLE WHICH OF THE GOWNS

WILL BE AVAILABLE FOR THIS PURPOSE. I THINK IF YOU MERELY DESCRIBE
THE GOWN TO ME I CAN PULL THE NECESSARY ART OUT OF THE FILES
WOULD ALSO LIKE TO OBTAIN THIS GOWN AT LEAST A WEEK IN ADVANCE
TO PUT ON DISPLAY IN ONE OF THE LOCAL WINDOWS. PLEASE ADVISE
ON THIS ALSO BEST REGARDS

=BILL HEBERT.

Leigh
Bust 32
Waist 23
Hip 34½
Neck 14
Glove 6½
Hose 9
Shoe 5½ C
Head 21½
Ht 5' 3½"
Wt 105

(ABOVE, LEFT) Telegram to Kay Brown regarding a contest to find the girl who most closely matched Vivien Leigh's measurements. The winner would wear one of Scarlett's gowns to the ball. The contest was repeated in other cities to promote the film.

(ABOVE, RIGHT) Vivien Leigh's measurements.

(RIGHT) One of the highlights of the Junior League Ball was Margaret Palmer, winner of the contest to find the girl whose measurements were closest to those of Vivien Leigh. Palmer led the grand march wearing Scarlett's barbeque dress from the film.

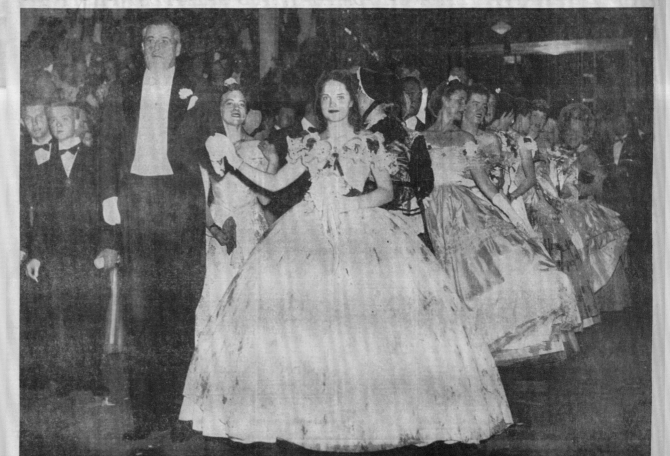

PAGE SIXTEEN THE CONSTITUTION, ATLANTA, GA., FRIDAY, DECEMBER 15, 1939. THE SOUTH'S STANDARD NEWSPAPER

CITY'S OWN 'SCARLETT' LEADS GRAND MARCH AT BALL

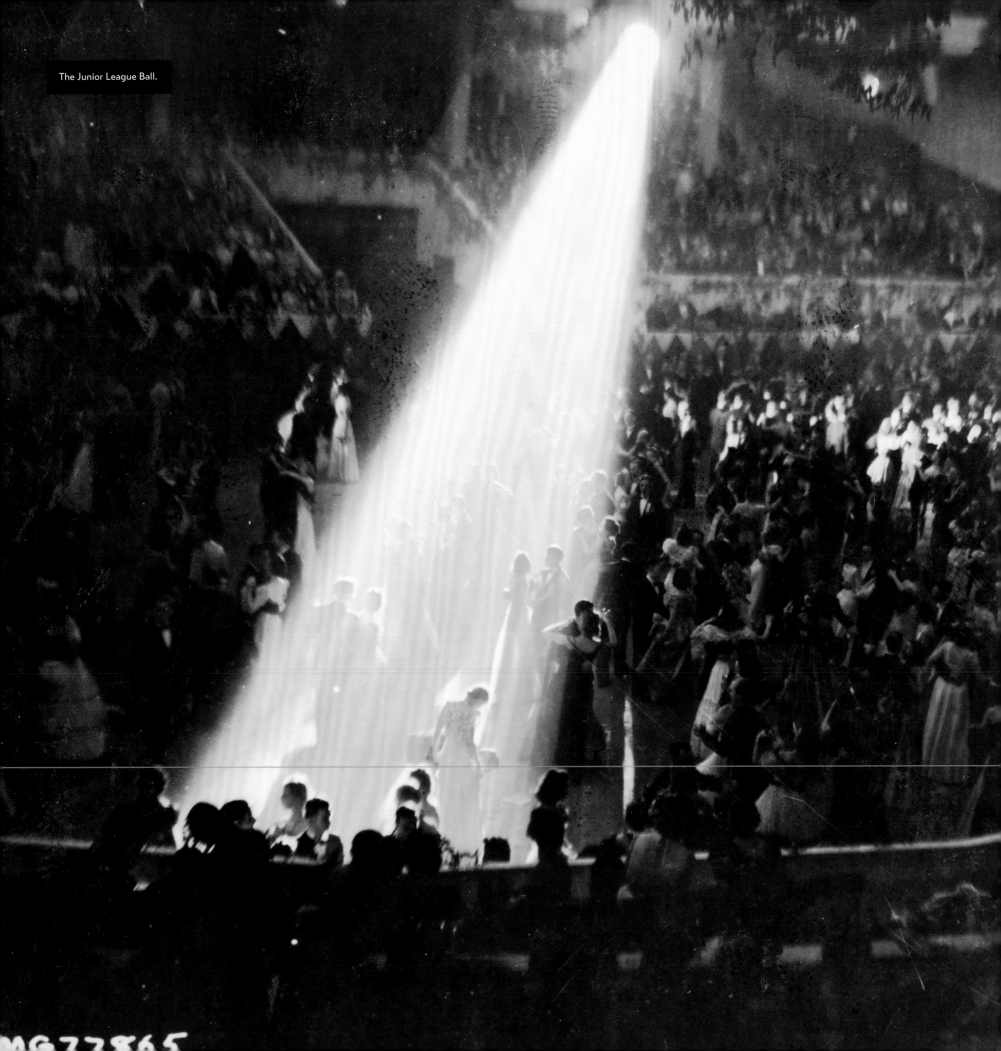

The Junior League Ball.

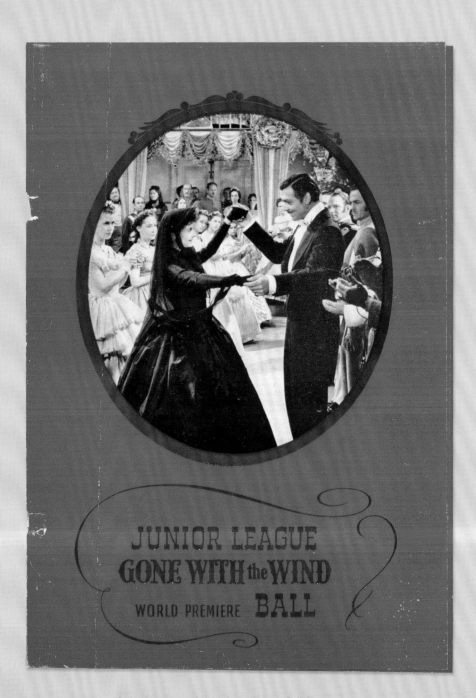

Souvenir program for the Junior League Ball. The program
was sponsored by the Nunnally Candy Company.

Guest of The City of Atlanta
Cyclorama
Friday afternoon, December fifteenth
nineteen hundred and thirty-nine
at half after twelve o'clock

(ABOVE) Clark Gable and Margaret Mitchell meet at the press party before the premiere.

(LEFT, TOP) Invitation to the Cyclorama in Atlanta.

(LEFT) Vivien Leigh, Clark Gable, and Olivia de Havilland (left to right) are shown the cyclorama in Atlanta by city official George Simons.

(FACING) Vivien Leigh, Clark Gable, Margaret Mitchell, and David O. Selznick at the press party arranged by Mitchell.

At noon the next day, Friday, December 15, the Atlanta Better Films Council hosted a luncheon at the Atlanta Athletic Club. Ann Rutherford, Evelyn Keyes (a native Atlantan), Laura Hope Crews, and Ona Munson were the honorees. At the same time, Clark Gable, Carole Lombard, Vivien Leigh, Olivia de Havilland, and David Selznick were given a special tour of the Battle of Atlanta cyclorama in Grant Park. After a reception at the Governor's Mansion at which Gable, Selznick, and Wilbur Kurtz were commissioned lieutenant colonels in the Georgia National Guard, the stars of *Gone With The Wind* attended the press party arranged by Margaret Mitchell.

Then finally the premiere was that night at the Loew's Grand Theatre on Peachtree Street. The façade had been dressed to look like Tara, and a giant portrait of Rhett and Scarlett hung above. Searchlights waved back and forth as the stars arrived. The local radio stations had microphones set up, and the stars, Selznick, and Margaret Mitchell were invited to speak on their way into the theater. Mitchell and her husband, John Marsh, sat with Olivia de Havilland and Jock Whitney on one side and Clark Gable and Carole Lombard on the other. Vivien Leigh sat next to Governor Rivers. Her fiancé, Laurence Olivier, was seated three rows back.

As the film played to the exhilarated audience, the *Atlanta Journal* had arranged for a benefit dance called The Jamboree to be held for people who were not able to get tickets to the movie premiere. The dance was held at the Atlanta City Auditorium, where the Junior League Ball had been the night before, and cost $1.50 per ticket. The plantation settings and special lights were held over for the event, and Kay Kyser and his band played. Some six thousand people attended.

The next day, tickets to *Gone With The Wind* went on sale to the general public.

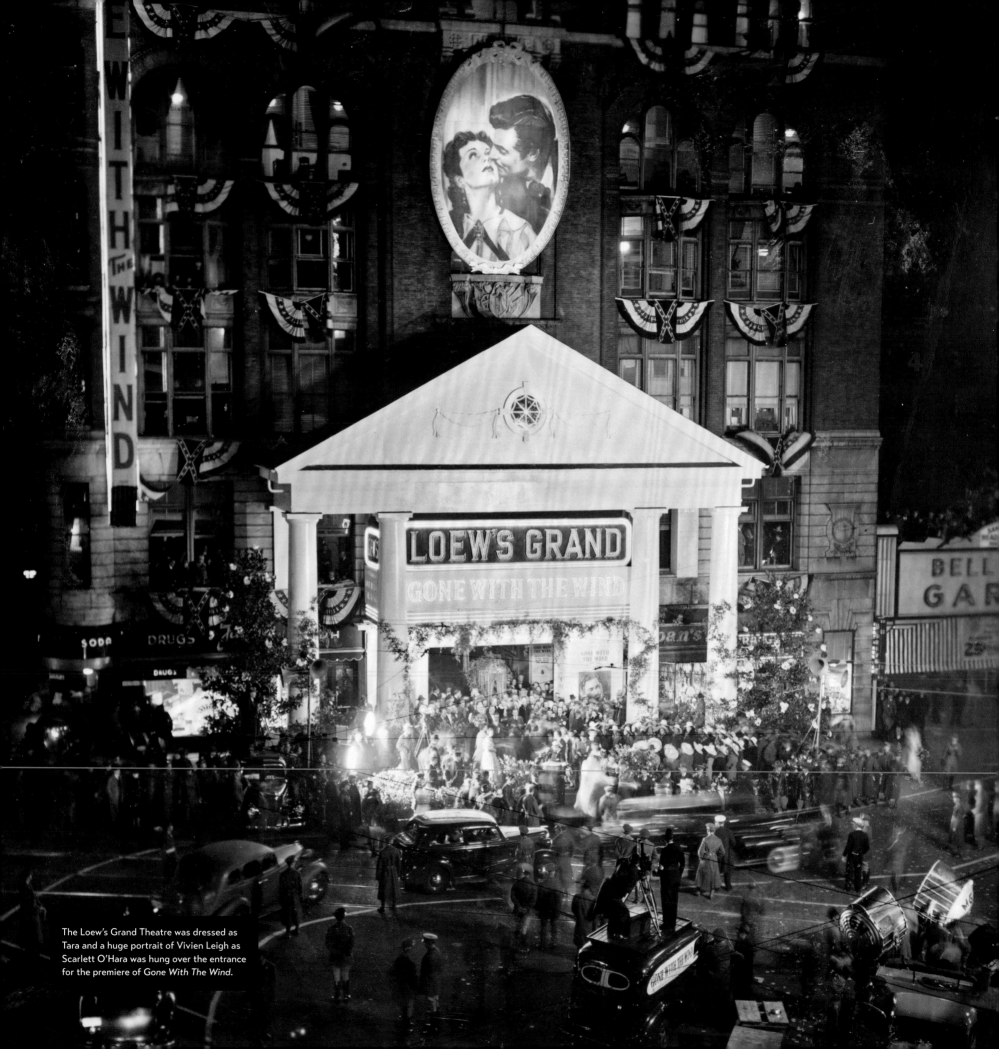

The Loew's Grand Theatre was dressed as Tara and a huge portrait of Vivien Leigh as Scarlett O'Hara was hung over the entrance for the premiere of *Gone With The Wind*.

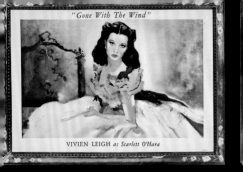

VIVIEN LEIGH *as Scarlett O'Hara*

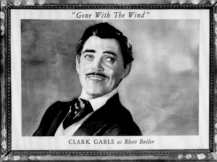

CLARK GABLE *as Rhett Butler*

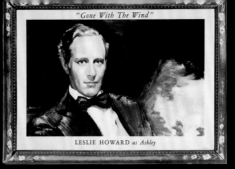

LESLIE HOWARD *as Ashley*

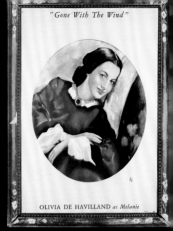

OLIVIA DE HAVILLAND *as Melanie*

ABOVE) Dan Sayre Groesbeck painted portraits of the four principal actors who were featured in the souvenir program.

BELOW) The entrance of the Loew's Grand Theatre the night of the premiere.

GONE WITH THE WIND

NEVER IN A LIFETIME HAVE EYES BEHELD ITS EQUAL

MG 77851

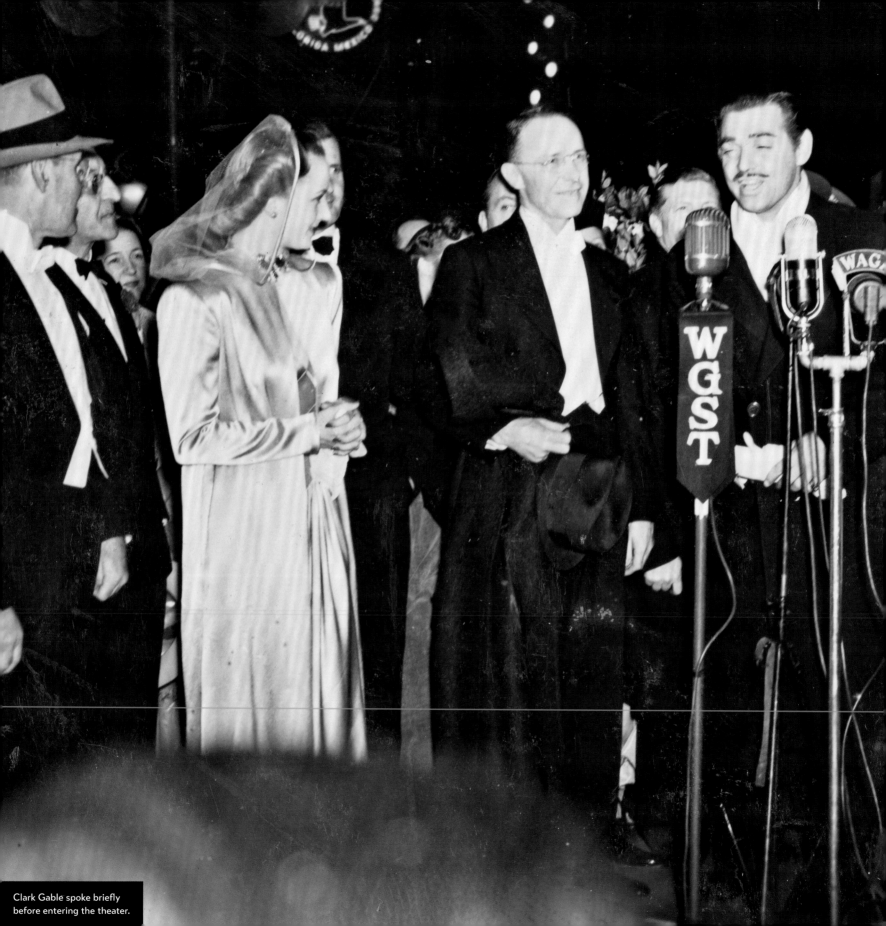

Clark Gable spoke briefly before entering the theater.

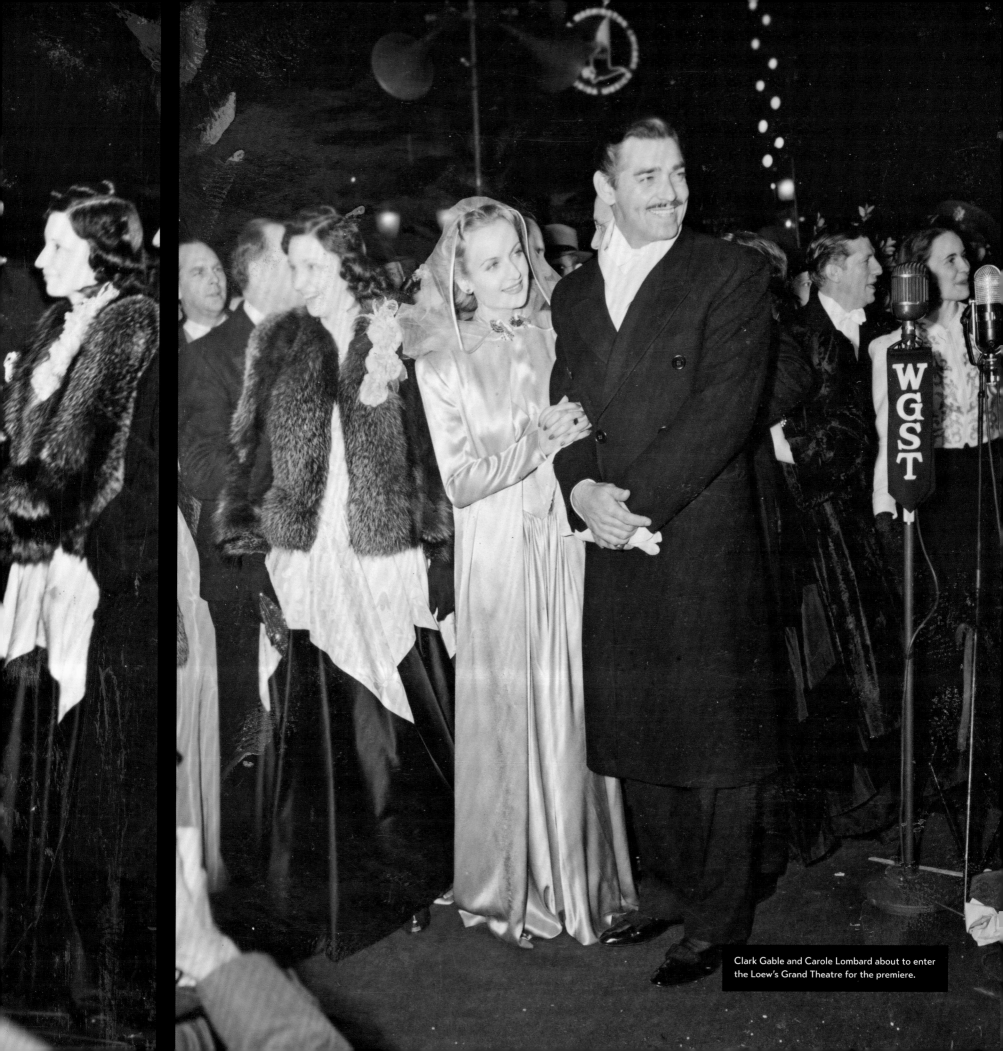

Clark Gable and Carole Lombard about to enter the Loew's Grand Theatre for the premiere.

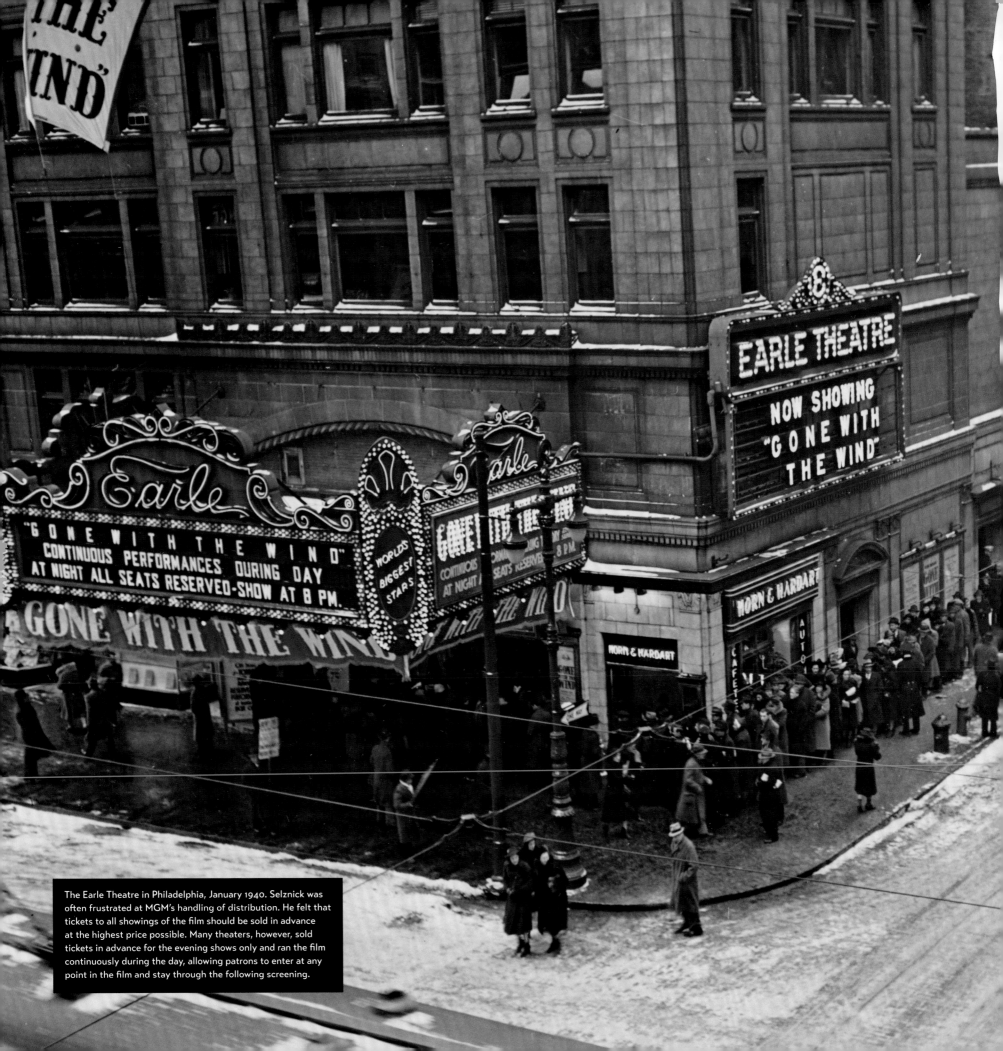

The Earle Theatre in Philadelphia, January 1940. Selznick was often frustrated at MGM's handling of distribution. He felt that tickets to all showings of the film should be sold in advance at the highest price possible. Many theaters, however, sold tickets in advance for the evening shows only and ran the film continuously during the day, allowing patrons to enter at any point in the film and stay through the following screening.

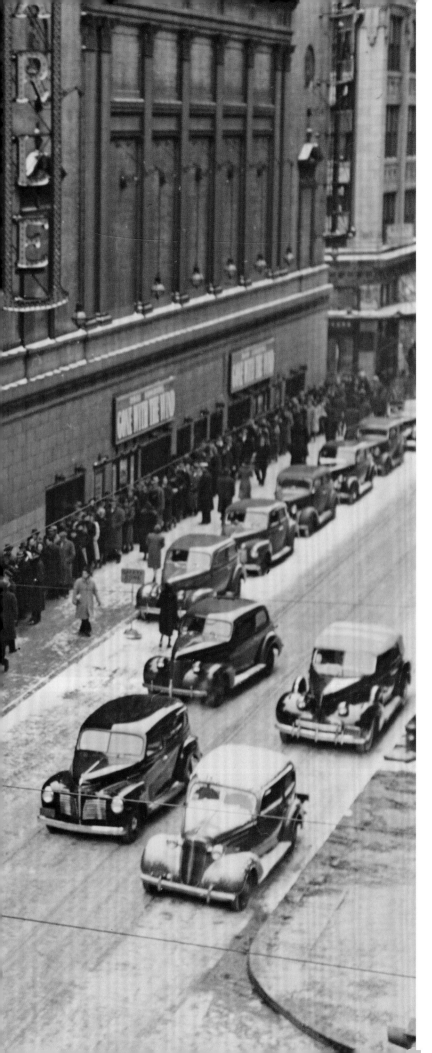

WIDE RELEASE

The days after the Atlanta premiere were busy. Kay Brown's former assistant, Harriett Flagg, was now in Los Angeles working in Selznick's office. "All I can think about these days is getting back to NY where I can relax!" Flagg wrote. "It is still pretty hectic here, mostly because so many things piled up during the worst period and nobody has any energy left with which to cope with them."

Selznick was concerned that the valet, the bartender, the maids in his suite, and especially the telephone switchboard operators at the Georgian Terrace hotel be properly tipped. He was also worried about his gift to Wilbur Kurtz. In the excitement of the premiere, he had not had the chance to talk to Kurtz, so the next day he left the gift, a leather-bound copy of the script, with an MGM publicity agent, who in turn left it with someone else. The script was eventually found and forwarded to Kurtz.

Todd Ferguson, MGM's publicity agent, who did much of the work organizing the festivities, stayed in Atlanta to wrap up the details and to make sure the costumes and paintings on display around town were packed and sent on to New York. Only a few minor items were lost. Ona Munson wore her red wig and bell earrings back to the hotel after the ball and took them with her when she left Atlanta. Laura Hope Crews had "too much bubbly water" and forgot to leave her velvet and lace headpiece with her costume. Aside from that, all that was missing was a black-and-white shoe, a handkerchief, two pairs of pantalets, and a bustle.

Many of the costumes were shipped to New York to be displayed in promotion of the film. Two Maybelle Merriwether costumes were held for Birmingham, Alabama, for the same purpose. In addition, 145 Walter Plunkett costume designs, 108 large paintings, and 128 small paintings by Menzies were shipped to New York. For almost a month, a collection of costumes and paintings traveled to cities playing *Gone With The Wind*. The "costume caravan," as it was called, was discontinued for fear that the costumes would wear out.

At Susan Myrick's suggestion, Selznick agreed to donate one of Scarlett's dresses to the United Daughters of the Confederacy, though he worried that he would be flooded with similar requests. There was talk of Selznick donating the curtain dress and two Confederate uniforms for the cyclorama. The Atlanta Historical Society requested the miniature models of Tara, the train depot, and Peachtree Street. And Selznick agreed to donate the large painting of Scarlett from the Butler house to the High Museum of Art. The director there was "perturbed" that the painting had no frame, but the frame was being used for retakes of *Rebecca*.

In preparing for the Atlanta premiere, Selznick had not paid as much attention to the New York premiere. As the Atlanta premiere approached, he was distressed to find there was not a similar celebration planned in New

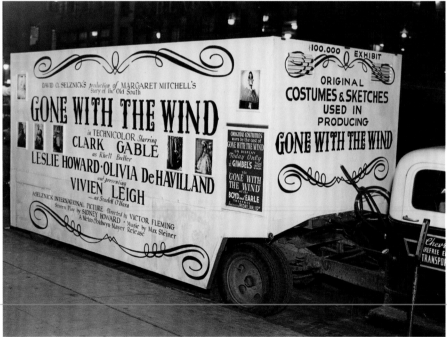

(TOP) This display at Gimbel Brothers in Philadelphia was part of the traveling caravan of costumes and sketches. Other cities on the tour included Baltimore; Washington, DC; Pittsburgh; Buffalo; Cleveland; Detroit; Chicago; Milwaukee; Des Moines; Omaha; Minneapolis; St. Paul; Canton; Columbus; and Dayton. The costumes and sketches were shown for a single day in each city.

(BOTTOM) The "costume caravan" was intended to be a nationwide tour of original costumes and sketches, many of which appear in this catalog. The tour was stopped after less than a month because the organizers became alarmed at the wear and tear on the costumes.

York; rather, the plan was to hold blocks of tickets for VIPs at the two theaters premiering the film and sell the rest of the tickets to the general public. He worried about which theater, the Astor or the Capitol, would be best to attend. Jock Whitney's guest list would be seeing the film at the Capitol, but he was assured that there would be plenty of important people at the Astor. He also worried that he did not have enough seats held to accommodate all the friends and colleagues he needed to bring, so he asked Jock Whitney to buy as many tickets as he could from the "speculators."

It had been unclear until very late if Olivia de Havilland could attend the Atlanta premiere. Warner Brothers said they needed her the afternoon following the screening. So de Havilland immediately returned to Hollywood by airplane, worked for one day, then flew to New York for the premiere there. Jimmy Stewart accompanied her to the screening and Jock Whitney's party afterward. She insisted that she pay her own expenses, but Selznick would not hear of it. Neither Clark Gable nor Vivien Leigh attended the New York premiere, so de Havilland's appearance was all the more valuable to Selznick.

President and Mrs. Roosevelt were invited to attend either the Atlanta or New York premiere. They declined but happily accepted the offer to screen the film at the White House the day after Christmas. Lowell Calvert, Selznick's head of distribution, sent in a report: "About thirty in attendance including the President, Mrs. Roosevelt, the mother, daughter, several sons and members of the family in general. At the beginning of reel four the President was summoned by Secretary Hull and was forced to leave and did not return . . . the picture received a 'really terrific and enthusiastic reception—the picture was enjoyed tremendously.'"

On December 28, in time to qualify for the Academy Awards, *Gone With The Wind* played to a packed house at the Carthay Circle Theatre for the premiere in Selznick's hometown of Los Angeles. After the screening, Jock Whitney threw a party at the Cafe Trocadero. Tickets to the premiere were in high demand, so Selznick sent invitations first to his "A-List," requesting an RSVP.

The day after the Los Angeles premiere, congratulatory telegrams began to arrive at Selznick's office. Many were from industry executives. Jack Warner, Harry Cohn, and Will Hays sent telegrams. Mervyn LeRoy, who had competed with Selznick for the rights to *Gone With The Wind* three and a half years before, wrote, "All I can say is—the right man made it!" Tallulah Bankhead saw the film in New York and wrote, "No one knows but yourself how many headaches

(ABOVE) David O. Selznick and Jock Whitney at the Los Angeles premiere of *Gone With The Wind*.

(RIGHT) The interest in *Gone With The Wind* among industry people in Hollywood was so great that Selznick developed an "A List," "B List," and so on. Those invited to the party at the Cafe Trocadero after the Los Angeles premiere were asked to RSVP at their earliest convenience.

you had during its birth, but I have a small inkling of your trials and tribulations during the embryonic stage." Another Scarlett contender, Norma Shearer, sent a telegram: "Just to tell you from the bottom of my heart how proud and happy I am for you in your great success."

The morning after the Atlanta premiere, reserved-seat tickets went on sale to the general public in that city and broke all records. For six consecutive days, every single seat sold for each screening. Such heavy sales would continue for months as the film opened in city after city. Val Lewton reported that fan mail since the Atlanta opening had "increased roughly an hundred fold"

from cities where the film was playing. He added that for the previous four years he had answered letters personally but now asked to be allowed to answer with mimeographed form letters. Selznick said no but authorized him to assign a part-time secretary to help with the backlog.

Distribution of the film was being handled by MGM, but Selznick nevertheless made his opinions known. He wanted gala openings modeled on the Atlanta premiere in major cities. He pressed for a top price of $1.65 for advance sale "road show" tickets, but MGM wanted a set price of 75 cents. They finally settled on $1.10 for the highest-priced ticket. "It will yet be proven," he

wrote to Jock Whitney, "that I have not been insane and that we have undersold the greatest attraction of the century by millions of dollars. MGM has been operating under the assumption that boosting the price to 75 cents was a big jump, but this is [the] equivalent of patting yourself on the back because you are getting 75 cents for a diamond when rhinestones have been sold for a quarter."

Requests for bookings came in faster than MGM and SIP could manage. Technicolor simply could not produce projection prints fast enough, and each theater required separate negotiations, contracts, and advertising. Theaters sold tickets

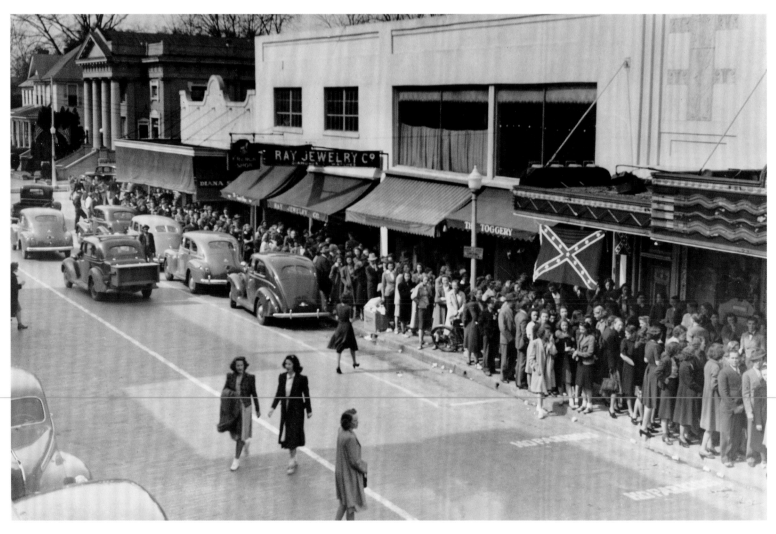

The line at the 2:30 p.m. matinee at the State Theater in Tallahassee, Florida, ran four deep for a block and a half. Large crowds for *Gone With The Wind* were the norm across the country for weeks.

The original release one-sheet poster for *Gone With The Wind*.

in advance for their afternoon and evening showings, and many theaters had to install additional telephone lines to keep up with the calls. Some theaters were adding a 75-cent morning screening in addition to the advance-sale afternoon and evening screenings and cutting the intermission to as short as one minute. Some theaters played the film on a "continuous" basis, meaning that as soon a showing finished, the film was started again. Consequently, many in the audience saw the film "backward," catching the second half of the film first, then staying to see the first half. One theater in Los Angeles planned to show the film five times in one day on New Year's Eve.

Selznick was flabbergasted at these reports. He had Hal Kern and Val Lewton produce a brochure to send with the projection prints advising the theater managers and projectionists on how best to present the film. He pressed Howard Dietz and the MGM staff on ticket prices, showtimes, intermission times, souvenir programs, advertising, and promotion. He wanted to know how far in advance tickets were being sold, if Selznick International Pictures was being credited in advertising over MGM, and why the booming business was not touted more in the industry publications like *Variety*.

If *Gone With The Wind* was not receiving the attention in the trade press that Selznick thought it should, it was certainly receiving attention in the mainstream press. The reviews of the film there were almost universally positive. The film was applauded for its technical achievement and fidelity to the novel. Praise for the cast, Vivien Leigh in particular, was unanimous.

Soon after the New Year, as the film opened in more and more cities, talk turned to the Academy Awards. Selznick noted that Hedda Hopper had voiced her preference of Bette Davis over Vivien Leigh and pointed to an article about Olivia de Havilland's chances for the award that stated she had a starring role. He felt she had a better chance for an award in the supporting category and worried that she would not even be nominated if the votes were split. He was also anxious that William Cameron Menzies, working under the newly created title of "production

designer," and Sidney Howard, who had died tragically a few months earlier in a farming accident, be recognized for their important contributions. Selznick suggested that Russell Birdwell plant stories in the gossip columns. "I don't want to do any electioneering or indulge in Warner tactics," he said, "but I do think that in justice to the people who have worked so hard for us, we should protect them with publicity at least calling their eligibility to the attention of the voters."

The 12th Academy Awards was held on February 29, 1940, at the Ambassador Hotel. *Gone With The Wind* had been nominated for thirteen awards and won for Outstanding Production, Directing (Victor Fleming), Actress (Vivien Leigh), Art Direction (Lyle Wheeler), Cinematography (Color) (Ernest Haller and Ray Rennahan), and Film Editing (Hal Kern and James Newcom). Sidney Howard posthumously received the Writing (Screenplay) award, and William Cameron Menzies received a special award for "outstanding achievement in the use of color for the enhancement of dramatic mood in the production of *Gone With The Wind*." And in the Actress in a Supporting Role category, Hattie McDaniel became the first African American to receive the award. David O. Selznick was presented the Irving G. Thalberg Memorial Award.

It was about this time that the film began to play in African American theaters, which were often smaller third- or fourth-tier theaters and therefore further down the distribution chain. Because of what they had found in the novel, many reviewers for African American newspapers were apprehensive about the film, and their reviews were mixed. Many complained that the depiction of African Americans as happy in their subservient roles was offensive. Others commended the film for eliminating offensive scenes and dialog that were present in the novel. After the Academy Awards, praise in the African

American press for the performances of Butterfly McQueen, Oscar Polk, Eddie Anderson and, in particular, Hattie McDaniel, was passionate, even in those papers that criticized the film as a whole.

Despite her Academy Award, better film roles did not materialize for Hattie McDaniel. She was, however, deluged with requests for personal appearances. Since she was still under contract, Selznick supported the tour with hopes that her appearances would boost ticket sales for *Gone With The Wind*.

Shortly after the premieres, Olivia de Havilland found herself under suspension by Warner Brothers for refusing a role they had assigned her. For the next several years she struggled with the studio over the roles she was offered and how her contract was enforced. In 1943, she sued Warner Brothers for adding the time she was under suspension to the end of her contract. The Supreme Court of California ruled in her favor, and that ruling is still known today as the De Havilland Law.

Clark Gable was already the biggest star in Hollywood when the public insisted he play Rhett Butler. Neither Gable nor Leslie Howard was enthusiastic about appearing in the film, both thinking they could not live up to the public's expectations. Gable continued a long career in film, though he would always be known for *Gone With The Wind*. Leslie Howard returned to England, where he made several films before he was killed in 1943 when the plane in which he was traveling was shot down by the German Luftwaffe.

Selznick loaned his new star, Vivien Leigh, to MGM to star in *Waterloo Bridge* (1940) and to Alexander Korda for *That Hamilton Woman* (1941). Leigh married Laurence Olivier in August of 1940 and, over Selznick's objections, soon returned to England. She appeared in *The Doctor's Dilemma* on stage and steadfastly refused to leave her country or her husband until the war was over.

In the days before television, home video, and streaming digital files, a film was thought to have exhausted its profit-making potential when it finished its initial release. And even with Hollywood's "creative accounting," *Gone With The Wind* had turned a tremendous profit. Believing his film would eventually "play out," and told by his advisors that he faced a personal income tax

Hattie McDaniel surprised everyone at the Academy Awards when she won the Best Supporting Actress award. This was the first time motion picture cameras recorded the event. The reference to Selznick and her agent William Meiklejohn occurred at the banquet but not when she reenacted her speech for the camera.

M Daniel, Hattie

3/5/40

Hattie McDaniel's speech in the short was as follows:

"Academy of Motion Picture Arts and Science, fellow members of the motion picture industry and guests: this is one of the happiest moments of my life and I want to thank each of you who had a part in selecting me for one of the Awards, for your kindness. It makes me ffel very humble, and I shall always hold it 'as a beacon for anything I may be able to do in the future. I sincerely hope that I shall always be a credit to my race and to the motion picture industry. My heart is too full to express just how I feel, so may I say thank you and God bless you." (business with a handkerchief)

(This is exactly what she said at the Dinner except for the reference to you and Mr. Mickeljohn.)

rate of ninety percent, Selznick decided in 1940 to liquidate Selznick International Pictures and sell his share in the film in order to pay a capital gains rate of twenty-five percent. He lamented the decision for the rest of his life.

As Selznick's plan to liquidate SIP progressed, the United States' involvement in World War II grew. The effects of the war on Selznick's film production were harsh. Fuel and building materials were in short supply, and some of his staff left to help with the war effort. Still, Selznick had to economize, and in the summer of 1942, he fired Kay Brown. It was not an easy separation, and there were hurt feelings on both sides. But Brown persevered. She shifted from talent scout to theatrical agent and represented a number of high-profile clients, including Ingrid Bergman, Alec Guinness, Montgomery Clift, Lillian Hellman, and Arthur Miller.

Brown's last contact with Selznick was in March 1961. MGM planned a gala showing of *Gone With The Wind* to mark the centenary of the Civil War. Selznick was reluctant to attend but felt he should. Vivien Leigh and Olivia de Havilland went, too, and Selznick wrote to Brown, "Somehow it will not seem right to me if you are not there also." Brown could not attend but told him, "The most fun would be just to be with you for old times [*sic*] sake."

David O. Selznick spent the rest of his career trying to regain the artistic and commercial success of *Gone With The Wind*. Although his later efforts, from the epic western *Duel in the Sun* to his last film, *A Farewell to Arms*, never reached the heights of his most famous production, the name David O. Selznick is still synonymous with guts, ambition, extravagant production values, incredible attention to detail, and the highest standard of quality in film production.

In the seventy-five years since *Gone With The Wind* premiered, Selznick's masterpiece has continued to elicit emotional responses from viewers. It is both adored and reviled. The controversies that attended the production of *Gone With The Wind* remain, and the film continues to be a powerful touchstone for questions of race, gender, violence, and regionalism in America.

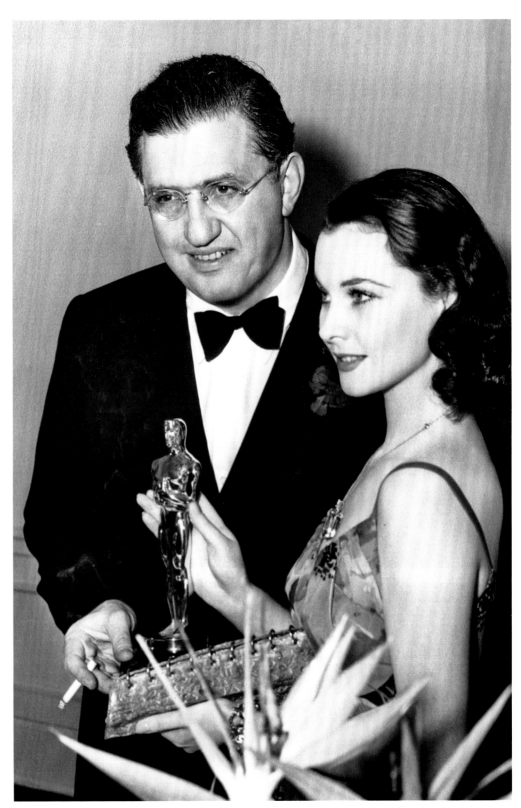

David O. Selznick and Vivien Leigh at the 12th Academy Awards.

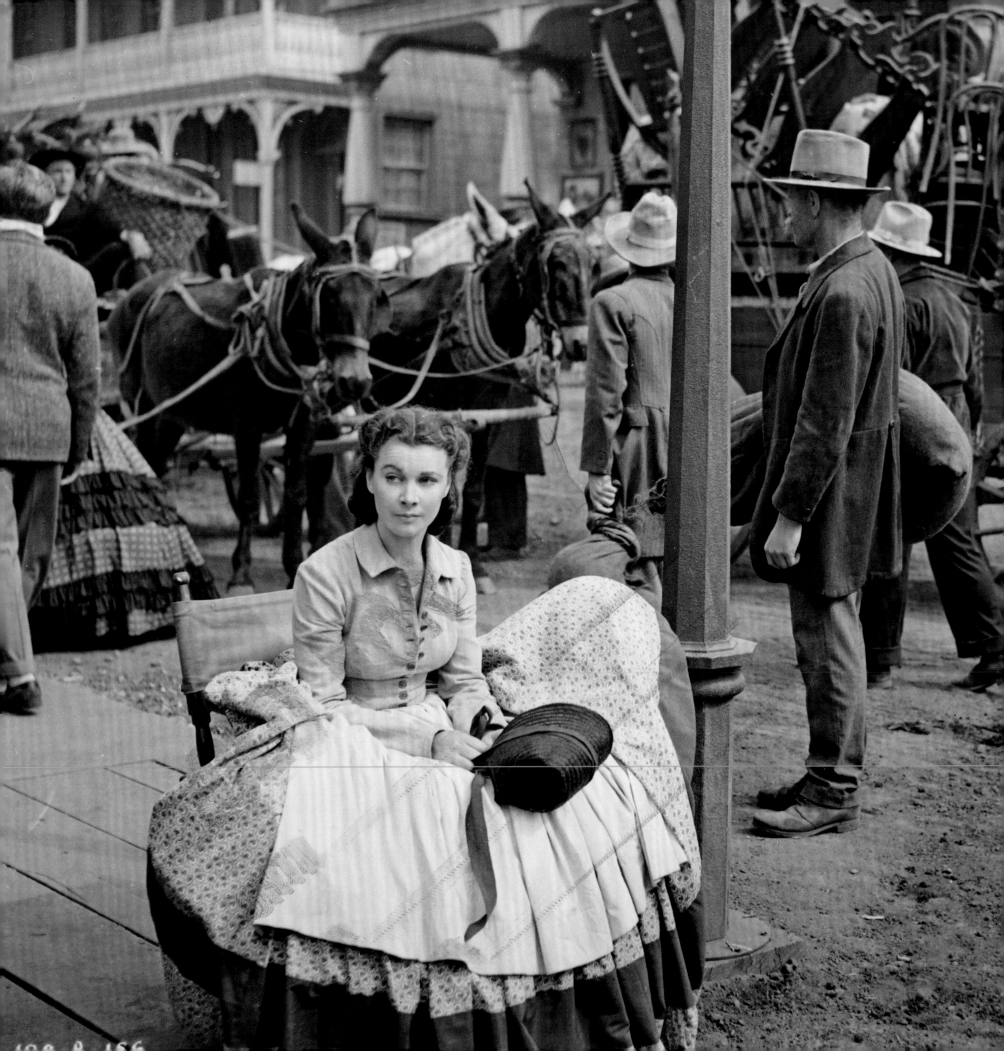

APPENDIX

(DOCUMENT TRANSCRIPTIONS)

Most of the letters, memoranda, and other textual documents reproduced in the book are transcribed in their entirety below, including multi-page documents for which only the first page or pages appear in the main text. Some documents, such as call sheets, have not been transcribed.

PAGES 3-4

TO DOS FROM KB 5/20/36

We have airmailed detailed synopsis of "Gone With The Wind" by Margaret Mitchell and also copy of book to Val STOP This is Civil War story and magnificent possibility for Miriam Hopkins or Margaret Sullavan STOP It will be the July Book of the Month Club and is over a thousand pages long and I guess that is why everybody thinks it is going to be another Anthony Adverse STOP All picture companies have definitely registered their interest one going so far as to make a 25,000 offer on hearing the story told to them by a person who was going to do its review STOP We have told McMillan the publishers that you have been looking for a civil war story told from a different angle and asked them to do nothing on it before Monday of next week therefore would appreciate it greatly if you would give this your prompt attention.

END

—

Pioneer Selznick

TO KB FROM SS

July 7, 1936

DOS on set Following his reply

If you can close "Gone With The Wind" for 50,000 do so STOP Alternate proposition 5500 against 55,000 for 90 [or] 60 day option STOP I realize there is not much chance of your being able get this on optional basis but you might make a stab at it as I would prefer this in order to have opportunity determine how could cast it etc STOP On outright purchase regret inability to pay more than 50,000 but I frankly think this, which is much higher price than has been [paid] for Anthony Adverse and other

important books, is as high [as]we should go in view of the fact that even if [book] justifies the highest hopes that are held for it it could not bring much more money and 50,000 would be excellent price [even] in such circumstances therefore in [advance] of publication I cannot see my way clear to paying any more than 50,000 STOP Know how hard you have worked on this and hope this will not mean our loss of property but if it does it just can't be helped STOP You may ask what difference an extra five or ten thousand dollars would [make] on a property like this but the point is that I feel we are extending ourselves considerably even to pay such a price for it in view of fact that there is no certainty we can cast it properly

END DOS SS

Min

OK Will call you back in about fifteen mins

EKB

—

SIP LA

July 7, 1936

Is Sylvia there

Hold your seat I've closed for fifty thousand.

Marvelous. Thrilled to death. Wait till DOS hears it. Who is check payable to and will you take care of all this afrom [sic] your office.

Will take care of everything. Please tell Mr. Selznick how important it is that we do not tell this price. Doris Warners wire which I have just read clearly indicates she would have paid fifty and so that no one can say that wexxxxx [sic] agent played favorites let it be known it was about fifty two thousand. Am o so pleased.

Do you want to tell DOS before ringing off

END KB

Can't. He is on set watching rehearsal of last scene of picture and cannot disturb him but if he wants [to] wire you further am sure morning will be time enough or we can always put thru call to your home STOP May I please have number again.

End You are sure there is no mistake in my authorization to close as I ha[v]e worked my G D head off on this. There is no reason for you to baby me and say hoop la and no reason to telephone me if you are sure everything is all right. I'm in such a dither I was afraid I didn't read English. Flagg and I out to get drunk. Will not be home until eleven o'clock as there is no train till nine twenty-one from New York.

END KB

Absolutely certain your [authorization] close for 50,000 STOP I still say hoop la and have a drink for me.

END

PAGE 6

CROSS REFERENCE SHEET

Name or Subject: "Gone With The Wind"

Regarding: Telegram to DOS from SS:

File No.: Scarlett

Date: 8-7-36

"Hepburn crazy about 'Gone with Wind'—Hayward suggest waiting your return before doing anything about this."

Honolulu * DOS general files

—

INTER-OFFICE COMMUNICATION

Selznick International Pictures, Inc.

Culver City, Calif.

To: Mr. David O. Selznick (copy: Mr. George Cukor)
Subject: "Gone With The Wind"–#2
From: L. Schiller
Date: Nov. 14, 1936

Total compilation to date:
Role

SCARLETT O'HARA

Artist	For	Against	2nd Choice
Miriam Hopkins	24	4	4
Margaret Sullavan	6	4	2
Katharine Hepburn	4	7	1
Tallulah Bankhead	0	5	–
Bette Davis	5	2	–
Joan Crawford	11	–	3
Norma Shearer	1	–	–
Luise Rainer	2	–	–
Claudette Colbert	1	–	–
Constance Bennett	0	2	–
Olivia de Havilland	–	–	1
Myrna Loy	1	–	1
Barbara Stanwyck	–	–	1

RHETT BUTLER

Artist	For	Against	2nd Choice
Ronald Colman	6	9	–
Clark Gable	22	9	2
Warner Baxter	8	1	–
Fredric March	2	3	3
William Powell	3	–	–
Franchot Tone	1	–	–
Randolph Scott	1	–	–
Cary Grant	2	–	1
Henry Hull	1	–	–
Ian Hunter	1	–	–
John Boles	2	1	1
Henry Fonda	–	1	–
Basil Rathbone	1	1	–
Melvyn Douglas	1	–	–
Noel Coward	1	–	–
Sidney Blackmor	2	–	–
Leslie Banks	1	–	–
Alan Mowbray	1	–	–
Alan Marshal	–	–	1
Errol Flynn	1	–	1
Spencer Tracy	–	–	1
C. Henry Gordon	1	–	–
John Mack Brown	1	–	–
Preston Foster	–	–	1
Richard Dix	1	–	–
Laurence Olivier	1	–	–

Sunday morning, September 20, 1936
Who Should Play Scarlett?
And What Film Actor Is Best Suited to the Role of Rhett Butler? Atlanta Is Particularly Interested in How the Movies Will Answer These Questions in Filming "Gone With the Wind"
By Frank Daniel

Atlanta takes a proprietary pride in "Gone With the Wind," its immense success and its fidelity to the section and the sentiments of the Civil War Era it reflects, and one manifestation of this interest is the general speculation about the forthcoming film version of the novel.

There might be more trepidation about the outcome if Hollywood had not learned a great deal about making historical novels, and novels about the south, since talking pictures arrived. In early films—Mary Pickford's "Coquette" remains unforgettable—players attempted to talk the synthetic southern accent which passed unchallenged on Broadway. The chief difficulty with this dialect was that southerners couldn't understand it at all, so gradually Hollywood learned to abandon southern accent almost entirely.

When Paramount undertook to film "So Red the Rose," the producers assembled a cast of players from various parts of the south. But it was the quality of their voices, rather than the accents, that lent conviction to the dialogue in this film. Even when people as colloquial as those in "The Trail of the Lonesome Pine" were presented on the screen, the diction of the players was not indigenous to the Kentucky mountains. Colloquialisms conveyed the atmosphere effectively.

* * *

There are several reasons why southern is a dangerous dialect to attempt on the screen. One is that magnolia talk and the machine age are inharmonious—as is immediately apparent when a radio speaker palatizes his vowels too noticeably. Mechanisms seem to exaggerate these qualities disproportionately.

Another reason is that no actor seems able to talk southern without immediately going into caricature. Jack Oakie can talk a highly amusing southern, because he is a fine comedian, and Una Merkel can talk another sort, because she is southern-born and

knows its intonations at first hand. But Gary Cooper and Marion Davies and other serious actors have achieved some extraordinary vocal effects in the interest of sectional authenticity. And, of course, the strangest southern, to southern ears, ever to emerge from the sound horns is that spoken by John Mack Brown, of Alabama and Georgia.

Perhaps another important reason against the use of southern dialect indiscriminately is that the southern people who say "impawdunt" for "important" and "twinny" for "twenty" and "say-ing" for "sing," are not aware of it. To their own ears their speech sounds Oxonian, and when they hear similar sounds under stress of screen dramatics, they are offended. Even the type of southerner who says "Sarrowday" and "Lilly Whi-ut wuz a ri-ut ni-us gu-ul" isn't conscious of his variations from the norm.

In "Gone With the Wind," Margaret Mitchell managed to convey the quality of her characters' speech with uncanny accuracy. Readers are usually aware that Scarlett O'Hara's voice is more high-pitched, and her speech more careless, than the voice of Melanie Wilkes, which is cool, accurate, and well-placed. How Miss Mitchell manages to achieve this effect, not for only two characters, bur for many, is one of the mysteries which make her novel so impressive.

With some of these ideas in mind, at dinner parties, or where two or more "Gone With the Wind" readers are gathered together, the conversation is likely to turn to the projected filmization, and then someone will inquire, "Who do you think should play Scarlett?" And almost equally important, "What actor would you like to see play Rhett Butler?"

* * *

The romantic renegade Rhett Butler apparently captures feminine interest as effectively in 1936 as he did in the sixties, and nine ladies out of ten will assure you that Rhett isn't really as bad as he is painted. Some are even inclined to blame Miss Mitchell for some of the less decorative qualities she attributed to Rhett. After all, there's no reason to go around spreading scandal about an obviously well meaning, unfortunate and VERY handsome young man.

Almost everybody has his or her chosen Scarlett and his chosen Rhett. Meanwhile Miss Mitchell herself is uncommunicative.

"When I sold the screen rights to 'Gone With the Wind' I sold them outright, and I have no part in the

film adaptation," she declares. "I don't want to go to Hollywood, and if I went I don't think I'd be able to help anybody make a moving picture.

"I did tell the representative of Selznick International that I hoped a southern actress would play Scarlett. I haven't any other preference about who should play it. I haven't followed the movies very closely of late. For one thing, I've been busy with the book, and for another, my eyes have been troubling me.

"I've said I thought the girl who played David Copperfield's mother (Elizabeth Allan) would represent my conception of Melanie Wilkes, but probably there are others who will do so as accurately."

* * *

Hollywood has at least three scenarists from Georgia—Lawrence Stallings, Lamar Trotti and Nunnally Johnson—who might be available if their services are required in the adaptation.

Actresses most mentioned for the film role of Scarlett are Miriam Hopkins (from Bainbridge and Savannah), Margaret Sullavan (from Virginia) and Katharine Hepburn and Bette Davis (both from New England).

Nominations for the screen Rhett Butler have ranged from Basil Rathbone to Edward Arnold, with Clark Gable and Ronald Coleman most often mentioned. Everybody seems to concur that Leslie Howard is the man to represent Ashley Wilkes, unfortunately secondary to Rhett Butler.

Miss Davis' work in "Dangerous" and in several other roles makes her a promising Scarlett. She is expert at characterization, as expert perhaps as any actress in Hollywood, and would combine the apparent charms and the shallowness and selfishness of the character in her impersonation.

After seeing and hearing Katharine Hepburn in "Spitfire," in which she represented a southern mountain girl, most southerners will probably prefer to see her as Scottish Queens and Louisa M. Alcott heroines.

Margaret Sullavan conveyed the celebrated "southern charm" of the heroine of "So Red the Rose" effectively, but Miss Sullavan is a lighter actress than will be required for Scarlett. She plays most often in comedies, and would probably not undertake the "Gone With the Wind" role.

Miriam Hopkins knows Georgia, having been born here, and she is an actress who doesn't demand entirely "sympathetic roles." Her performance as Becky Sharp was conspicuously fine, even in a film chiefly concerned with exploiting the marvels of colored movies, and reviewers have often compared Scarlett to Becky (though Miss Mitchell says she didn't read "Vanity Fair" until after her book was written).

* * *

Scarlett will be a demanding role, one for a dramatic actress of unusual abilities, of qualities which can range from the sinister to the alluring. She must be young enough to play the early scenes, in which Scarlett is an adolescent coquette, and mature enough as an actress to lend dignity and conviction to Scarlett's later experiences.

Where this actress will be found remains to be seen.

The film version of "Gone With the Wind" will probably deal in more detail with the episodes during and after the Civil War. The antebellum scenes will no doubt be used, dramatically, for contrast, to present the prosperity and graciousness of a doomed civilization, as against ensuing deprivations. Scarlett will be introduced as the flirtatious girl who seeks to attract most men, but who is herself most attracted by the gentlemanly Ashley Wilkes, affianced to Melanie. Her principal scene, in the early part of the film, will surely be that in which she avows her feeling to Ashley, while Rhett Butler unintentionally overhears. That's a scene for an intensely dramatic actress, as are most of the scenes thereafter—when Scarlett watches Atlanta and the Confederacy waste away to defeat and starvation, when she begins her fight for financial security, when she eventually marries Rhett Butler, when she learns that the man she loved so long is no longer lovable, and when at last she is financially and socially secure—and alone and unloved.

—

OK Ready with NY 1-1366
Sept 25 1936

MESSRS WHITNEY WHARTON AND MISS BROWN FROM DOS

I am anxious to know probability for sale of Gone With The Wind abroad and especially in England and to continue to be kept advised on this because I feel that our decision as to whether to cast the picture with new people or with stars should be largely dependent on the success of the book abroad STOP Obviously the picture is going to be enormously expensive and equally obviously we will have to get a large return from Europe. If the book is not important abroad we will consequently have to protect our investment with one or two stars in the picture. If, on the other hand, it is an equal or comparable success abroad, we can attempt to find new people for development into stardom for certainly as far as this country is concerned, the picture requires no stars to make it an outstandingly important attraction.

PAGE 8

Selznick International Pictures, Inc.
New York City
INTER-OFFICE COMMUNICATION

To: Mr. David O. Selznick
From: Miss Katharine Brown
Subject: Tallulah Bankhead
Date: September 23, 1936

Dear Mr. Selznick:
I went to see REFLECTED GLORY last night and laid out the red plush carpet for Miss Bankhead who is so, so happy to be in my most capable hands!

It doesn't seem necessary to me to shoot more than one talking sequence with Miss Bankhead and therefore I am selecting the scene with Ashley. It is my opinion that she could play the last part of the book magnificently and our biggest worry is how she will look and play the earlier scenes.

I told her I would go over the Eaves with her and get her a perfectly divine costume for the party sequence and also a velvet costume with hat for silent close-ups.

There is no mistaking the fact that Miss Bankhead wants this part and what will happen to me the day she hears other people are making tests for it in New York is something else again.

Cordially yours,
Katharine Brown

kb*f

PAGE 12

TO KB FROM DOS
On Sidney Howard my suggestion is that you advise him that I would [like] very much to have him come out and do a script whenever he is available and if

he does not like the one I have for him right now perhaps I will have something else to offer him. At any rate I think best procedure is to determine when he will be clear of present play troubles. Please follow this up in a week or ten days, or whenever you think Howard will be clear and at regular intervals if he does not seem to be free then. Although he need not know this I feel that he and Hecht are probably the two best writers for pictures who are not tied up with studios and they are both rare in that you don't have to cook up every situation for them and write half their dialogue for them. Therefore I don't want there to be any slip about getting them whenever Howard is available STOP Hecht I don't feel like going after in view of his behavior toward the chairman although Jock has been good enough to indicate that he would not stand in the way if we really needed Hecht.

TO KB FROM DOS

I think we could do a lot better than Helen Chandler as Melanie and don't think you ought to test her in the role unless you need someone to play with Platt. Incidentally Colonel Merian Caldwell Cooper now en route to New York will bitterly resent the suggestion of anyone but a girl he knows by the name of Dorothy Jordan for the role of Melanie so I put you on your guard and I must say I think Dorothy is a very good possibility for it.

Have received yours and Jock's wires about "Seen But Not Heard" and will wire you about the play tomorrow. We have heard about the boy named Raymond Rowe and if either he or the other kids are possibilities for Tom, Huck, or Joe, or any other roles in Sawyer, urge you to test them immediately, particularly if the play looks as if it is going to close thereby making them available.

PAGE 13

INTER-OFFICE COMMUNICATION
Selznick International Pictures, Inc.
Culver City, Calif.

To: Mr. Russell Birdwell
Subject: "Gone With The Wind"
From: Silvia Schulman
Date: 10/9/36

Dear Russell:

Mr. Selznick asks as a very special favor—would you please stop printing stories about how he is breaking his neck to get Katie Hepburn for "Gone With The Wind". T'aint true and he would so appreciate your forgetting this idea.

He says he seldom does anything these days but deny the story.

ss

PAGE 15

TO SS FROM DM 12/2/36
KB called from Atlanta to say that all her messages would have to be sent out on the teletype as everything pertaining to Gone with the Wind is nobody's business but the South's and everything she does is immediately broadcast to the winds and published post haste hence the relay of her reports.

TO DOS FROM KB IN ATLANTA
We are barricaded in our room having arrived this morning from Charleston. Was offered several eleven months old babies and if you need a cook say the word as all the mammies want to come north. We have been photographed from every possible angle including rear view. Charleston was marvelous. One particular youngster, Alicia Rhett, has definite qualities for Melanie. Don't worry about test situation. No commitments have been made whatsoever. The rich junior leagues from Baltimore offered to pay their own fare to California. Regarding people in which we are definitely interested have full knowledge of financial situation and man in a position to make specific recommendations to George on this point. By the way, where the hell is George and when does he arrive. Margaret Mitchell got up early this morning and is absolutely marvelous. Wants to put on a disguise and come to the Friday auditions which are open to the public. Five other days of auditions have been scheduled including various college groups, Junior Leagues, little theatre groups within a radius of 120 miles. Sorry this is such an incoherent wire. It shouldn't be as we are in a dry state but the Marshs are exposing us to a little corn tonight.

—

Gone With The Wind . . .
Scarlett O'Hara . . .
Daughter of Gerald O'Hara and Ellen Robillard O'Hara. Sister of Suellen and Careen O'Hara. 1861 . . . at sixteen . . . married to Charles Hamilton of Atlanta. 1865 . . . at twenty . . . married to Frank Kennedy. 1868 . . . at twenty-three . . . married to Rhett Butler. Mother of Wade Hampton Hamilton, of Lorena Ella Kennedy and of Bonnie Blue Butler. At sixteen Scarlett is the belle of North Georgia. She has had proposals from practically every man in the countryside. Outwardly demure with all the graces of a southern-gentlewoman, she is, under the surface veneer, a woman vain, obstinate, self willed, passionate. Her face, arresting if not beautiful, is a blend of the delicate features of her mother, a coast aristocrat of French descent, and the heavy ones of her florid, Irish father. Her eyes are a clear, pale green above which black brows slant upward. Her lashes are a bristly black, against skin of magnolia petal white. Curly black hair is neatly parted, smoothed and netted into a lady-like chignon. Above a seventeen inch waist, firm but mature breasts are emphasized by tightly pulled stays. Her hands are tiny, slender, and very white. Her feet are small and graceful. Her dimpled face is schooled to a modest sweetness that belies the turbulent, willful eyes, lusty with life. Her airs are for men . . . women are her natural enemies.

At twenty Scarlett has been matured by hard work and suffering. She has been hardened; her temper sharpened, her hands roughened. Greed and ruthlessness show through the veneer more often. Only two weak spots in her armor . . . her love for Ashley Wilkes and her passionate love for Tara, her home plantation . . . for the land.

As wife to Frank Kennedy she is alternately sweet and teasing, and a raging wildcat, with the temper of a tartar. When she is angry, black brows meet in a sharp angle above blazing eyes. As a business woman she is alternately a brave but timid lady, helpless and dependent, and a cold, greedy, businesslike and unscrupulous harridan.

-2-

As wife to Rhett Butler, between the ages of twenty-three and twenty-eight, she is softened somewhat by financial security and a kind of happiness; a little less certain of herself. Criticism brings out defiance, a flaunting of the common and earthy streak in her. She runs more to expensive gaudiness in taste and adornment. In contrast with Rhett her lack of imagination and sense of humor is emphasized. As a reaction from hunger and want of war years, luxury

and rich food make her eyes glitter with greed, and satiation brings animal content.

PAGE 17
FEBRUARY 15, 1937
TO KB FROM HF
Following wire received from Szold. . . . "Terribly sorry Billies parents unwilling to allow her go New York for test stop do hope you find possible consider one of our other girls as they most anxious to come stop Billie heartbroken sends many thanks and regrets." Alicia Rhetts signed contracts arrived today. No word from others as of yet.

—

TO DOS FROM KB APRIL 14, 1937
Have just had long talk with George and this is his opinion on Billie Longmire, the Creole girl, and he bases this on having worked with her for an hour. He feels that she has a great intensity and a real acting talent. She would be useable in the young emotional roles like Silvia Sidney plays. She is not a possibility for Scarlett in Gone With The Wind. We have discussed the problems of this young lady and we both feel that there is a good chance Bernard Szold will doublecross us and sell her to Metro for higher money than we are offering and if upon reading George's opinion as to her ability you want her I believe that it will necessitate my going to New Orleans and seeing the family and getting her signed up right there.

PAGE 18
Dear Sir,
Even as one who has lived in the South all my life—I found "Gone With The Wind," a distortion of history plus a lot of malicious lying and bad writing—I can think of no intelligent reason for making it into a movie.

Sincerely,
Julia Esther

—

Dear Sir:
The filming of "Gone With The Wind"—its glorification of Southern lynch society—is distasteful. If filmed, I promise to join any organization to boycott it.

Sincerely,
Leon Sharlip (White)

PAGE 19
Excerpt (Original filed GONE WITH THE WIND—
 Casting—Southern Talent Search)
Mr David Selznick
Culver City, Calif.

Dear David: Dec. 11, 1936
Memo III—Macon
. . . Your suggestion of Hobe Irwin is, I think, absolutely perfect. The problem, as I see it, is to get Peggy's permission to take license with the settings in the book. The book, she says, is projected through Scarlett's eyes and as Scarlett saw 'Tara' it was beautiful but in reality it was an ugly place, in keeping with the architecture of the period and from what I saw of these houses they were an absolute horror. I pictured 'Twelve Oaks' as a beautiful plantation, such as the Louisiana plantations. This is inaccurate. It was beautiful to Scarlett because it was Ashley's home. The mistake I made is a common one. In every city we visited they wanted us to go to a beautiful plantation "just like Twelve Oaks and Tara." In Louisiana they picture their own lovely places as the ones described in the book and the majority of people are going to be very disappointed if we portray these places as ugly buildings. I'm sure there is a compromise with complete authenticity which will be beneficial to all concerned but it will have to be handled intelligently and with diplomacy. Mitchell worked ten years not seven on the background to make it completely authentic so it is somewhat of a problem to discuss changes. Both she and her husband know intimately what you stand for in pictures and are counting on you to film the book so the South will have its first real Southern picture. All the South will have its different ideas and it will be no cinch to lick this problem in a commercial as well as artistic manner.

Kay Brown

PAGE 20
Sidney Howard
157 East 82nd Street
New York City
January 11, 1937

Dear David:
Thank you for mailing me your reactions to the treatment. It was a good idea for you to do so because, believe it or not, Cukor has lost his copy. I don't think that there is much of any value in any treatment, beyond that of forcing a writer to do some initial planning and discover for himself where the most obvious snags are going to come.

George and I are spending every afternoon together. He has already had script on the first two sequences and I can come pretty close to giving him the most, if not all, of the first draft before he sails on Saturday. I was very pleased indeed that you felt as I do about the Klan and if what George and I worked out on Saturday holds water for us today, we have licked that problem and all its present day unpleasant implications by a great big, clean omission, which would almost certainly have been necessary in any event.

You don't have to worry about actual changes. There is ample material in this book without adding anything new of our own. The tough nut is the arrangement of the material. The book is written in a series of islands: good enough novel technique, but you have to produce a picture, not an archipelago. Where the islands are big enough, as, for example, the whole passage beginning with Melanie's baby and ending with the flight from Atlanta, we encounter no trouble. Where they are small, as, for example, Belle Watling's attempt to give money to the hospital, they can be fairly fussy. My object in this first draft is to give the story on paper structurally for picture purposes and largely in master scenes, and I am going through to the end even though I am already conscious of some rather brutal transitions. Almost all of those, I think, will be taken care of in the revision one expects to do with the director. I have learnt from experience that a writer can waste a lot of time by getting his wires crossed and writing his first draft as though he were himself directing the picture. My plan is to push this first draft right through and get it in the mail to you as soon as possible.

—S
David Selznick, Esqre.

PAGE 21
INTER-OFFICE COMMUNICATION
Selznick International Pictures, Inc.
9336 Washington Boulevard Culver City, California
Office of the President

To: Mr Ring Lardner, Mr. Russell Birdwell
Subject: "Gone With the Wind"—Woollcott Broadcast
Date: January 7, 1937

I can't think of any new angles for Woollcott's "Gone with the Wind" broadcast—much as I would like to. However, perhaps he can do something with the following:

Cukor is about to make a trip through the South, accompanied by Sidney Howard and Hobe Erwin, the famous interior decorator. Cukor will not merely look for talent, but together with Erwin will make a detailed study of Southern interiors and furniture, to make sure that the picture is accurate in these respects.

With further reference to the accuracy of atmosphere and casting, you need only refer to Cukor's work on "David Copperfield," "Little Women" and "Romeo and Juliet" and my own work on "Copperfield," "Fauntleroy," "Tale of Two Cities," etc.

It may be of interest to Woollcott to know I have a theory of adapting successful novels, which I do not apply to unsuccessful novels or to originals, and which theory I do not think is followed by other producers.

It is that I make no attempt to correct seeming faults in a successful novel but to include these seeming faults of the novel with its seeming successes. I feel no one ever knows what chemicals have gone to make up success and that successful adaptation is obtained by the most conscientious effort to recapture these chemicals.

In the picturization of a long novel, cuts are obviously necessary because of length. However, in making these cuts, I try my best to make block cuts so that the scenes we retain can be done as fully as possible and as closely as possible to the original scenes in the book. I do not share the general motion picture theory that the screen is a different medium and because of that necessitates a different approach. I feel that the screen is much closer to the novel in form than it is to the play and that its latitude is at least that of the novel.

I see no reason at all for the wide departures in adaptations of successful novels. I have followed the approach, of which I speak above, in the picturization of "David Copperfield," "Anna Karenina," "Tale of Two Cities," "Little Lord Fauntleroy" and "The Garden of Allah" and am now following it in the production of "The Prisoner of Zenda."

As to the casting of "Gone With The Wind," I feel that new personalities are preferable—first, selfishly because of my belief [that] the roles of Scarlett and Rhett will make stars for us; and second, from the standpoint of illusion created by the picture itself: wellknown [sic] personalities will be accepted, provided they are sufficiently talented and properly cast as Scarlett and Rhett.

PAGE 23
TO DOS FROM KB March 16, 1937
George arrived and is telephoning you later this morning. He was so nice on the phone and completely cooperative about Southern girls. He is meeting them this afternoon at three, seeing their silent tests and auditioning them and they will get away either tonight or tomorrow, unless George decides he thinks one or two of them have real ability and keeps them over for further tests. Four newspaper cameramen were on the set during entire day. The publicity breaks look as though they will be tremendous outside of New York. George is being photographed with the girls this afternoon and this should hit the New York papers big. Will airmail silent tests tomorrow.

Briefly discussed with George his Southern trip and he [is] most anxious to make it. He will advise you all details.

—

Selznick International Pictures, Inc.
New York City
INTER-OFFICE COMMUNICATION

To: Mr. David O. Selznick
From: Mr. George Cukor—In Atlanta
Date: March 29, 1937
Subject: Gone With The Wind Second Talent Search

Dear David:
Will you have somebody in your office look this girl up. She seems definitely interesting. (Betty Barney)

We arrived yesterday with a great fanfare. Margaret Mitchell was absolutely divine with us, helpful, cooperative, very intelligent about the whole thing. Yesterday, she took Hobe and me up and down the city, showing us where she imagined various houses to be; then we followed the road that Scarlett took to Jonesboro and 'Tara,' looking at houses, etc. I found it enormously helpful.

In the afternoon, we went to a meeting of the Atlanta Historical Society where I was my usual gracious self and made a very good impression for Selznick International—which was not difficult for me. We have made all arrangements with the Historical Society to Photostat their records and pictures; have had long lists of reference books, some of which we will buy locally, so we will be as completely equipped as we were for COPPERFIELD.

Kay and Darrow and Miss Flagg arrived today and we are organizing the talent bureau and giving a big tea for the press tomorrow. Kay and Miss Mitchell and I have been looking for suitable technical advisors. One is a Wilbur Kurtz who is regarded as the great authority on architecture, military movements, Civil War, etc. in Atlanta. For the social customs, women's costumes, general behavior, there is a very intelligent friend of Miss Mitchell's who is very well born—Miss Myrick—who has lived both in Atlanta and in the country outside Atlanta who would be ideal. Kay is talking to them both about money. I should imagine you would get them very inexpensively. With them I feel we can make no glaring mistakes and they will be of enormous help to us.

After all my gracious promises, I forgot that I did not have Garbo's telephone number. I am getting it and will call her one evening, either today or tomorrow.

Can you do something about Time Magazine—current issue? I suppose you read the item in which it said that I said I will select Scarlett, I want her to be this and I won't have this—all of which you know with my usual tact and modesty I did not say—and then after making fun of me they make me still further a fool by saying that the part had been filled three days before.

After we finish here we are going to Savannah, Charleston and New Orleans, combing the country quite thoroughly for talent, etc. I think I want to go back to California and then go East with you, if you want me to.

Affectionate regards,
George

PAGE 25
March 30, 1937
To L. V. Calvert, Monroe W. Greenthal, Samuel Cohen—from Birdwell please release following statements from David O. Selznick and Norma Shearer, without any additional comment, for use in Thursday, April first, a. m. editions—

David O. Selznick today issued the following statement—

"Miss Norma Shearer and we of Selznick International have jointly come to a conclusion against further consideration of the idea of Miss Shearer playing the role of Scarlett O'Hara in 'Gone With The Wind.'

"Miss Shearer has made other arrangement[s], and we are continuing the search begun several months ago, and never interrupted, for an unknown, or comparatively unknown, actress for the part. To this end the staff assisting George Cukor in his survey of potential talent in theatrical and other groups in the east and south has been augmented.

"Our regret that Miss Shearer's decision and our own have made impossible our association at this time is tempered by the hope she may one day find it possible to do a picture for us."

Norma Shearer today issued the following
 statement—
"I regret very much that due consideration by Mr. Selznick and myself has caused us to abandon the exciting part of 'Scarlett O'Hara' as a possibility for me. I have other plans, which I cannot divulge at this time, which preclude my giving the idea any further consideration.

"I shall be watching with great interest to see who Mr. Selznick selects and whether she will be a well known star or a newcomer. I know she will be wonderful, and I will be wishing her luck."

PAGE 26

TO OSHEA FROM DOS May 10, 1937
Paulette Goddard has for a long time been campaigning for the role of Scarlett. Recently she has telephoned George a couple of times. I have explained to George that while I agree she is an excellent possibility that would be well worth testing, there is no point in even making a test until and unless we can determine that we can secure her at reasonable terms and with the usual long term options. Certainly I have no intention of making a star for Chaplin although I would be agreeable to let Chaplin have her for any pictures he personally wants to make with her, not to exceed one yearly and to make sure he doesn't spend a whole year on the picture as he is wont. I suggest you contact Chaplin through Arthur Kelly if he is still on the coast because I explained our position to Kelly and he under took to secure her on this basis. If Kelly has left suggest you contact Chaplin through Dr.

Gianninni although you may consider it preferable to contact Miss Goddard direct in view of what I confidentially learned is an imminent split between Chaplin and Goddard. You can reach her through Chaplin's home, the telephone number of which you can get over at my home or from the United Artists Studio. Please keep me advised.

PAGE 30

THE COTTON CLUB
Special Rental Rates to Clubs and Private Parties
Monroe Kennedy, Manager
322 North 17th Street · Phone 7-8996
Birmingham, Alabama

June 21, 1937
Exploitation Department,
Selznick-International,
New York City

Dear Sirs:
We had planned a contest for the right to go to New York and take a screen test for possible selection of the winner for a part in "Gone With The Wind."

There will be many Negro characters in the play and we thought that we might give the screen play a great deal of publicity and at the same time conduct a stunt of mutual benefit.

Our proposal is to conduct the contest for the best Negro performer and actor, pay all expenses to and from New York, if Selznick-International will agree to give the winner a screen test, with no obligation on their part unless screen test merits your further attention.

Negroes of Birmingham are very talented and there is no doubt but what we could build real interest in the film with the contest.

We wait your further ideas and wishes,
Martel Brett
president,
Cotton Club.

PAGE 31

Selznick International Pictures, Inc.
New York City
INTER-OFFICE COMMUNICATION

To: Mr. George Cukor
From: Tony Bundsmann
Date: April 27, 1937

Subject: Tuesday Appointments

These are the colored people we lined up in Harlem:
3:00 J. Louis Johnson ~~Uncle Peter~~ Pork
3:00 Wilhelmina Williams Dilcey
3:05 Ollie Burgoyne Dilcey
3:10 James H. Dunmore Jeeves
3:15 Alex Lovejoy Pork
3:20 Edgar Martin Pork
3:25 Marie Young Dilcey
3:30 Leona Hemingway Dilcey
3:35 Abner Dorsey ~~Pork~~ Jeeves
3:40 Richard Huey Big Sam
3:45 Fred Muller Uncle Peter
3:50 Floretta Earle Dilcey
4:00 Rex Ingram Big Sam
4:15 Georgette Harvey Mammy
4:20 ~~Greenleaf—5 people~~
4:25 [Illegible]
 [Illegible]
 Gerald Gooding— Dilcy—
 Tony Dad Lucas(?)—
 Sally Ellis—2432 7th Ave Apt 5—
Light Chairs—Tables—Sofa—Ashtrays—
Lists—
Tomorrow's appts

—

Twentieth Century Fox
Director Selznick

Dear Sir,
I understand that you are in the throes of the casting of "Gone With the Wind."

I have read the book and am interested in the portrayal of "Prissy." If you recall Prissy was the frightened, vain, hardly efficient little negro maid given by her mother to Scarlett and she follows the heroine throughout the book.

Now, I feel that I understand Prissy and am more capable of making her live on the screen than anyone else.

[Enclosed] are a couple of rough, unfinished pictures. I am twenty-two, five-three and weight 107 pounds.

I would have been a actress if the field for negroes were wide enough. As it is I have spoken lines for many of the studios.

Mr. Selznick I am counting on your considerate nature and your desire to cast truly.

Sincerely,
Elizabeth Coleman
1330½ E. Adams
Ce. 24434

PAGE 32

A(
GA 8/23/37
HYX3 TWS PAID AUG 23
Selznick Intl. Pictures
 WUX Culver City California
TO DOS FROM KB
Alfred Hitchcock is in this country for ten days. It is my understanding he has no picture commitment. I have been asked to meet him but think this unnecessary unless you are interested in him as a director. Please advise.

TO VL FROM KB
Have airmailed Benson script with note to Kate Corbaley. Selznick Intl. Pictures.

PAGE 33

INTER-OFFICE COMMUNICATION
Selznick International Pictures, Inc.
9336 Washington Boulevard Culver City, California
Office of the President

To: Mr. Ginsberg
Subject: Notes on Mr. Ginsberg's letter to
 Mr. Wharton
Date: August 26, 1937

Wind—[illegible]
Dear Henry:
Please advise me if my notes are in any degree liable to misinterpretation.

Incidentally, I have another thought which is the possibility, which I think SIP and Pioneer might secure if a deal were refused on any other basis to make "Gone With The Wind" in color, of "Gone With The Wind" being considered two pictures under the Pioneer-Technicolor contract. This would mean that the whole Pioneer deal would be completed with the production of "Gone With The Wind" in color, and that we might secure 30,000 options. Certainly it would be worthwhile for Technicolor to have "Gone With The Wind" in color instead of two other pictures. From Pioneer's angle it would relieve them of the financing of a second picture, and from SIP's angle it would justify the extra cost. Again, from Technicolor's angle, the actual dollars and cents business on negative and on prints would undoubtedly be equal on "Gone With The Wind" to what it would be on two other pictures. And certainly from the standpoint of its value to color, it would be equal to four other pictures.

If you like this idea I suggest you take it up at once with Kalmus and Wharton.

DOS

dos:bb

PAGE 34

Mr. John F. Wharton
September 20, 1937
CONFIDENTIAL

Dear John:
Replying to your memo of September 16, I shall number my answers to your questions in accordance with the numbers your have given to the questions:

1. I think we have no alternat[iv]e but to assume that we definitely cannot get Gable unless M.G.M. releases the picture.

2. I am in hopes that fatherhood has softened Gary Cooper's heart and bolstered his judgment—and that he might persuade to play the part. More importantly, I think that if Goldwyn agreed to give him to us, he could deliver. I now feel that he would in many ways give an interest to the role that would compensate for other superior qualities that Gable has, and I would be equally happy with either Gable or Cooper.

3. I think Colman is an extremely bad third and that it would be difficult to get out of him the virility and bite that are essential to a satisfactory Rhett. (Incidentally, all of these opinions are of course subject to complete right about faces if and when we find that we can't get who we want—so please do not quote me on any of these opinions to anybody.)

4. The only other man that we have thought of as a possibility is Errol Flynn.

The worries about Scarlett are different than those about Rhett. We feel definitely that we must find a new Scarlett, and it may be that this week's tests will reveal her; but we feel equally definitely that it is hopeless to expect to find a new Rhett, hence our anxiety to get either Gable or Cooper.

We are probably testing Margaret Sullavan for Melanie. Hepburn is anxious to test for Scarlett but I think she's all wrong for it.

I hope this gives you the information you want. For the love of Pete don't permit this letter to be seen by anyone.

DOS

dos/cl

PAGES 36 TO 40

MOTION PICTURE PRODUCERS &
DISTRIBUTORS OF AMERICA, INC.
28 West 44th Street
New York City
Will H. Hays President
Carl E. Milliken Secretary

October 14, 1937

Mr. David Selznick
Hotel Sherry-Netherland
Fifth Avenue and 59th Street
New York, New York

Dear Mr. Selznick,
This goes to you in the nature of a follow-up of our discussion on Monday afternoon with Messrs. Cukor, Howard and yourself concerning the first draft script for your proposed production titled GONE WITH THE WIND.

There are four, or five, major difficulties suggested by the present script, all of which, however, may, we feel, easily be changed in order to bring the basic story into conformity with the Production Code, and, likewise, to make it generally acceptable from the standpoint of political censorship.

There ought to be at no time any suggestion of rape—or the struggles suggestive of rape; Rhett should not be so definitely characterized as an immoral, or adulterous, man; the long scenes of childbirth should be toned down considerably; Scarlett should not offer her body to Rhett in the scene in the prison; and the character of Belle should not definitely suggest a prostitute.

In the hope that a page-by-page discussion of details may be helpful in the rewriting of this present script, we respectfully direct your attention to the following:

Page 2: We suggest a check with your Research Department concerning the suggestion that there was a college in the city of Atlanta in 1861.

Scene 9: Because there is considerable discussion throughout this story regarding childbirth, babies, pregnancy, etc. we recommend that you consider

deleting Ellen's line in scene 9, and Gerald's line in scene 11, suggesting that Wilkerson is the father of the illegitimate Slattery child.

Scene 11: In the recitation of the prayers known as the "Rosary," it is our thought that the opening prayer should be the "Credo"—"I believe in God, the Father Almighty," etc.—and not the "Confiteor."

Scene 12: Please be careful in this, and all other scenes of

-2-

undressing, that there be no undue exposure of the person of Scarlett.

Scene 20: We question Scarlett's use of the line, "Did the girl have a baby?" in this place because of the frequency with which such references are repeated throughout the story. It is also our judgment that Cathleen's line, "She was ruined, though," will be deleted by political censor boards.

Scene 25: We recommend, again, that you exercise the greatest care in this scene in order that there be no undue exposure of the persons of the girls.

Scene 26: Gerald's expression, "God's nightgown, man," is likely to be deleted by political censor boards.

Scene 30: The same thing needs to be said with regard to Scarlett's expression, "damned to you."

Scene 36: There should be no suggestion of rape in shooting these Menzies scenes. This is important.

Scenes 39 et sec: Belle Watling's "establishment" should not be characterized as a bawdy house or house of assignation. This, too, is important. Can it not be suggested that it is a drinking, or possibly, a gambling establishment?

In this same connection, Belle should not be characterized as a prostitute. It might be well if she were suggested as, possibly, a loose character operating a drinking saloon or gambling joint. We direct your particular attention to the suggestion at the bottom of page 35 regarding the "gilt mirrors and bar room art."

Scene 39: We suggest that you delete Rhett's line, "If I feel inclined," and substitute, possibly, the word "maybe."

Scene 115: The observations set forth above regarding scene 20 apply to the lines of Scarlett and Miss Pitty in this scene.

Scenes 163 et sec: We urge and recommend that you change the expression, "Fo' de Lawd," to possibly the expression, "Lawsy," or "Law-see."

Scenes 168 et sec: Please be careful that these scenes showing the dead or wounded, be not too realistically gruesome. There is danger here of such scenes being eliminated in toto by political censor boards.

Scenes 187 et sec: For your British print, we recommend that you shoot a protection shot of scenes showing the characters making the sign of the cross. The action is acceptable pretty generally throughout the world except with the British Board in London.

-3-

Scene 190: With a view to cutting down much of the broad detail of the dialogue and action suggesting the birth of Melanie's child, we recommend that you endeavor to delete, wherever you can, such action and dialogue which throws emphasis upon the pain and suffering of childbirth. This, likewise, is of very great importance. To this end we recommend that, in scene 190, you rephrase Melanie's line, "It began at daybreak" to "I have known since daybreak," and that you also delete from Melanie's line, at the end of the scene, the phrase, "she'd know when to send for him."

Scene 191: We suggest that you eliminate Scarlett's speech at the top of the page, "Miss Melly's baby's coming," and Prissy's reply, "Oh, Lawd!" This, of course, will make it necessary for you to rewrite Scarlett's next speech in this scene.

Scene 193: We suggest that you eliminate the word "bad" from Scarlett's speech at the beginning of the scene, making the line read, "How do you feel?" We further recommend that you eliminate Melanie's speech, "How long did it take" etc.; Scarlett's reply; Melanie's line, "I hope I'll be like one of the darkies," and Scarlett's line, "We've still got plenty of time."

Scene 202: The girls who "reel drunkenly" out of the door of the saloon should not be suggestive of prostitutes.

Scene 203: Again we ask that you be careful that these scenes of the dead and dying be not shot as too realistically gruesome.

Scene 204: Please delete the expression, "Oh, God," from Dr. Meade's line.

Scene 209 (page 102): We ask that you amend Scarlett's line, ". . . You've got to bring the baby," making it read, "You've got to superintend things." In this same scene we recommend that you amend Prissy's expression, "Fo' de Lawd," used twice.

Scene 209 (page 103); Please do not over-emphasize the anguish in Melanie's voice. There should be no moaning or loud crying and you will, of course, eliminate the line of Scarlett, "And a ball of twine and a scissors."

Note: Beginning with scene 210 down to the end of scene 227: We urge and recommend that these scenes of childbirth be cut to an absolute minimum, in order merely to suggest Melanie's suffering. We think, for instance, that you might well delete showing her teeth "biting her lower lip till it bleeds;" her holding on to Scarlett's hands in desperation; all of the business of tying the towel to the foot of the bed, and the dialogue accompanying such scenes.

Scarlett's line in scene 218, "She can't stand many more hours of this;" Melanie's line, "I can't stand it when you're not here;"

-4-

Prissy's line, in scene 219, "Miss Meade's Cookie say effen de pain git too bad, jes' you put a knife unner Miss Melly's bed an' it cut de pain in two," and Scarlett's line at the bottom of the page, "I think it's coming now,"—these scenes, together with all the business set forth on page 107, are enormously dangerous from the standpoints of both the Production Code and of political censorship.

It seems to us that you may carefully suggest these scenes of childbirth without over-emphasizing the distress and pain attended thereto. It may be possible to do this effectively by playing the camera on Scarlett's face, or, possibly, on the faces of some of the other characters. As now written, however, the scenes are hardly acceptable and should be materially toned down.

Scene 252: Political censor boards everywhere will delete the business of Rhett kissing Scarlett's body as set forth in the script. The words "I want" and "wanted" are dangerous, too. It would be well to substitute some other words for these.

Scene 260: We question the suggestion on page 122 showing Melanie's "blood-stained lips."

Scene 268: We recommend that you merely suggest the body of the dead Confederate soldier and not actually photograph it.

Scenes 277 et sec: Here, and elsewhere throughout your script, we urge and recommend that you have none of the white characters refer to the darkies as "niggers." It seems to us to be acceptable if

the negro characters use the expression; the word should not be put in the mouth of white people. In this connection you might want to give some consideration to the use of the word "darkies."

Scene 291: Please delete the line by Dilcey, "An' whut it takes ter feed a hungry chil Ah got."

Scenes 315 et sec: We again suggest the greatest possible care in shooting scenes showing the dead or dying. The dead body of the Yankee should not be shown in a close-up. Such scenes are likely to become excessively gruesome or horrifying. Note also in this connection, scenes 318 and 320.

Scene 320: Please delete Scarlett's expression, "As God is my witness."

Scene 324: Please delete Mammy's line at the end of the scene, "... Ah's shore dey ain' no mo' louses on you," and in scene 325, Mammy's line, "Louses an' de dysentary. Dey ain' a soun' set of bowels in de whole Confed'rate Ahmy!"

Scene 353: We suggest that you substitute the word "Freedmen" for the expression, "Free niggers," in Scarlett's speech. Also in this same scene, we suggest the elimination of Scarlett's line, "And

-5-

Dr. Meade said she could never have any more children. But I could give you all the children you—"

Note in passing (scene 361): We feel that Scarlett's line with reference to Belle, "She's the town bad woman," is acceptable to indicate that Belle is a lady of loose conduct.

Scene 362: As suggested to you on Monday, we most earnestly urge that it be not indicated that Scarlett offers her body for sale to Rhett. We think that Scarlett's lines, beginning with the sentence, "You said you'd never wanted a woman as you wanted me," could be rewritten to suggest that she is offering herself in marriage. It might be that you could have her put forth the blunt suggestion to Rhett, "Will you marry me." This is very important.

Scene 362: We suggest that you eliminate the words, "made use of," in Rhett's speech, and substitute the words, "appealed to," making the line read, "Was there no other man you could have appealed to?"

Scene 380: Please be careful that the action wherein the white man attacks Scarlett, be not suggestive of rape.

Scenes 387 et sec: Be careful that Ashley, Rhett, et al., be not shown as offensively drunk.

Scene 387: We suggest the elimination of the word "establishment" from Rhett's speech, and the substitution, possibly, of "refreshment parlor," making the line read, "We've all been together at a refreshment parlor." In this same speech, we ask that you delete the expression, "there were ladies."

Scene 387: Please eliminate the following lines by Mrs. Meade, "Are there cut glass chandeliers and plush curtains and dozens of gilt mirrors? And are the girls ... ?" as well as the line, "... and this is my only chance to hear what a bad house looks like."

Page 200 (scene 387): In Rhett's speech at the top of the page, there should be no break in the line between the words "her" and "employees." We ask that the line be read straight.

Scene 390: Again we call your attention to the business of the sign of the cross.

Scene 392, page 203: Rhett's line, "That I still want you more than any woman on earth," should be amended, possibly to read, "That I still think more of you than any woman on earth." In this same scene we suggest that you eliminate the words spoken by Rhett, "intended having you." Possibly the line could read, "I have always thought that you were meant for me, Scarlett." In this same speech, we recommend that you delete, or rewrite, the line spoken by Rhett, "with more propositions for loans and collateral."

-6-

Scene 393: Please be careful with the Vorkapich shots, especially with the scenes of undressing. Also in this same scene, be careful with the business of Rhett fondling Scarlett and her "bare shoulders."

Scene 395: Please delete Rhett's line, "May your mean little soul burn in hell for eternity," as well as Scarlett's business of making the sign of the cross.

Scene 398: We suggest the elimination of Rhett's line, "You didn't want her," and Scarlett's reply, "I had her, didn't I."

Scene 409: We suggest the elimination of Scarlett's line at the bottom of the page, "I've decided I'm not going to have any more children," as well as Rhett's reply; Scarlett's line at the top of page 214, "You know what I mean, I think," and Rhett's reply, "Lock your door, by all means. I shan't break it down." Also his line, "I've never held fidelity to be a virtue;" Scarlett's line, "I shall lock my door every night," and Rhett's line, "Why trouble? If I wanted to come in, no lock would keep me out." All this

dialogue is questionable from the standpoint of audience reaction. It is likewise enormously dangerous from the standpoint of political censorship. We suggest that a way be found to eliminate the suggestion or, if you deem this necessary, then to merely suggest that which is set out in the present script in detail.

In line with our discussion on Monday, we suggest that you eliminate entirely scene 411, which suggests the "unholy alliance" between Rhett and Belle.

Scene 421: Please be careful showing the scenes of Rhett "lacing Scarlett's corsets."

Scene 426: Please eliminate Rhett's line, "He can't be faithful to his wife with his mind, or unfaithful with his body."

Scene 427: Please eliminate Rhett's line, "You turned me out on the town while you chased him."

Scene 428: There should be no suggestion here that Rhett is about to rape Scarlett. It is our thought, in line with the suggestion made on Monday by Mr. Cukor, that you merely have him take her in his arms, kiss her, and then gently start with her toward the bedroom. It is our thought that you should not go so far as to throw her on the bed.

Scenes 433 to 437: It is our understanding that you are to shoot a scene showing exactly where Rhett went, and what he did, after he left his wife's bed—the purpose here being to get away from the present suggestion that he left his wife to consort with Belle. If such a scene is included in your story and it is thus affirmatively

-7-

shown that Rhett did not resort to Belle, the lines set forth in these scenes may be acceptable inasmuch as the audience will know that the charge made against Rhett is not true.

Scene 460: We suggest the elimination of Rhett's line, "You certainly have all the evidence you need to divorce me."

In conclusion, may I not say again that in our judgment you have done a magnificent job with this first draft script in translating to the screen play the magnificent story upon which Mr. Howard's yarn is based. Even the present draft suggests great possibilities for a superb picture which will add much to the prestige, the dignity and the artistry of the screen.

I congratulate you and Mr. Howard upon this

splendid achievement, and it goes without saying that we shall be happy, indeed, to work along with you in the development of the steps leading to a final shooting script.

More power to you!

Cordially yours,
Joseph I. Breen

JIB/ch

December 1, 1937
Mr. Harry M. Marner, President
Warner Bros. Pictures, Inc.
Burbank, California

Dear Mr. Warner:

I do not mean to prolong unnecessarily any discussions on the "Jezebel" matter, especially since in your relations with me you have always been so friendly and so fair. However, I think it important, in order to preserve this relationship, that you should have a few points clarified.

The article which you enclosed with your letter gives complete confirmation to the warning I expressed to you some time back that your studio, if not cautioned by you, would stoop to publicizing its picture on the strength of "Gone With the Wind." Certainly there can no longer be any question on this fact since Jack is actually quoted, and since the publicity material from your studio goes so far as to say that around the studio Bette Davis is now known as "Scarlett."

May I remind you that the rights to "Jezebel" were repeatedly turned down by your studio, as by all other studios, until after the public's attention was directed to "Gone With the Wind"?

As to your inferences concerning the rumors on Bette Davis, and the source of these, if you are interested I will dig up and send to you the articles which started these rumors, including statements sent out by your Publicity Department quoting Bette Davis on a comparison of the two roles.

I do not know how far your organization intends to capitalize upon the work and investment of others, and since I think you will agree that the picture business has been happily free of such tactics for many years, I can only hope that your studio will not find itself in a position where it is "forced" to issue statements comparing your picture with that of another studio.

Cordially and sincerely yours,
DAVID O. SELZNICK

dos:bb
cc to: Mr. Will H. Hays

Mr. Ginsberg
GONE WITH THE WIND—Menzies
12/6/37

Dear Mr. Ginsberg

Confirming our conversation, Mr. Selznick believes he will be able to start "Gone With the Wind" much sooner than was expected—possibly even as early as February 1st or 15th. He wants, therefore, for you to speak to Menzies at once about the possibility of his handling the supervision of the art dept. as well as the cutting script (or whatever script that is). You can find out, too, what sort of assistance Menzies wants in the way of a unit art man. And you might talk to Menzies about how soon we should send for Erwin.

mbr

GONE WITH THE WIND

Script of Nov. 27/37 (Macconnell)

P. 13, Sc. 16—Mr. Wilkes welcomes Mrs. O'Hara to the barbecue, whereas at the end of Sc. 30, Page 26, Scarlett says she wants to go home to her mother. This is probably an oversight. Mrs. O'Hara is not at the barbecue in the book nor should she be, in order to give Scarlett, who covets her mother's good opinion, more latitude for her actions. It is only because she is not carefully chaperoned that she is able to behave in the way she does.

P. 29, Sc. 35—After Charles Hamilton has asked her to wait for him Scarlett blurts out her real reason for deciding to marry him. Charles isn't very quick on the uptake but Scarlett, impulsive though she often is, would be too shrewd to run any risk of giving herself away, especially since she's got to get him to marry her to save her face. I think her speech, beginning "You'd take me to live in Atlanta" and ending "And they'd never dare laugh at me again" should be revised to come after Charles has left her to speak to her father. She is reflecting on the advantages of marrying this young booby, as she considers him. Then would come her lapse into misery on Ashley's account.

P. 32, Sc. 38—Scarlett says "I'm too young to be

a widow!" Couldn't we get over the fact that she is only just turned seventeen? I think her youth should be stressed as much as possible because, aside from her artificial training, the fact that life and some of its hardest problems crowded in upon her when she was too young to face them is responsible for the hardness that is later her most unpleasant trait. Perhaps some reference could be made to her age later on during that grueling period at Tara. She was barely twenty then.

P. 31-2, Sc. 38—Am glad this scene has been put in because of Uncle Peter, who is a bit of the real Old South. To save footage Scene 39 on Pages 33 to 34 between Rhett and Belle Watling might be dropped and Belle might be introduced, passing by, in this scene of Scarlett's arrival. Should like to see Uncle Peter pouting and hear his indignant mutter about "a passel of no-count folks..." Later on P. 54, Scene 57 we have the episode of Rhett's handkerchief in which Belle has brought her contribution for the soldiers, and that seems enough to establish Rhett's connection with Belle so far as Scarlett is concerned. Rhett is a scalawag but I doubt if he would discuss Scarlett with Belle, even to the small extent that he does.

INTER-OFFICE COMMUNICATION
Selznick International Pictures, Inc.
9336 Washington Boulevard Culver City, California
Office of the President

To: Miss Katharine Brown—cc: Mr. Wharton
Date: December 18, 1937
Excerpt (Original filed JUDD, Virginia)

... And incidentally, I hope you haven't given up on the Scarlett hunt. We don't seem to be any closer, and I am simply hoping that somebody will show up from one of our three sources: the Cukor search, the Casting Department, and the New York office. Please note that I consider the New York office source at least as important as either of the others, and I therefore hope you are still doing everything possible to find a Scarlett. I hope in particular that the new plays on the road and the acting schools are being watched. Are you keeping in close touch with the various acting coaches and so on?

DOS

Dictated but not read by David O. Selznick

PAGE 55
July 21, 1938
Idaho Falls, Idaho

D.O. Selznick
Hollywood, California

Hello! I sure am mad! I am "Scarlett O'Hara" to a tee! You say you're looking for talent and you can't see it when it's poked right under your nose! I won't send my address because I don't like publicity poking fun. But why doesn't <u>someone</u> discover me? One booking agent did but you know how much I fell for that. Wake up! I'm making a trip to <u>Ashton</u> soon.

Sincerliestly—

P.S. I'm not as conceited as I sound.

PAGE 56

Selznick International Pictures, Inc.
9336 Washington Boulevard Culver City, California
INTER-OFFICE COMMUNICATION

To: Mr. John Hay Whitney
From: David O. Selznick
Date: 6/10/38
Subject: Gone With The Wind

<u>CONFIDENTIAL</u>
Dear Jock:

Mr. Mayer informs me that the deal on "Gone With the Wind" is likely to go through and he has advised me to operate on the assumption that it will go through. However, before considering it definite, I am most anxious—for your protection and my own, and to avoid any possibility of future criticism—that you discuss the deal thoroughly with all our stockholders who are in the East, including Sonny, Jean and Bobby Lehman. Also, I would be obliged if you should discuss it with any or all of your own advisers.

I want to say right now that I consider it entirely possible that the picture will turn out to be the greatest money-maker of all time and that its profits may mount into the millions. This is even more possible with MGM than it would be with us, because of the casting advantages there. Gable alone, of course, would make an enormous difference due to his domestic drawing power and due to the additional quality his performance would give the picture. Also, his name, plus the possibility of other important MGM names, would give the picture an insurance abroad which we would probably lack.

However, I am perfectly aware that all of this will be forgotten if and when the picture comes out and makes theatrical history—for it is still my strong opinion that as an attraction it has had no parallels in theatrical history for the last few generations, with the exceptions only of "Ben Hur" and "The Birth of a Nation." It is needless to say that this opinion is, of course, predicated upon the picture being, in itself, more than merely a great one; but I have every confidence that it will emerge as a magnificent film. It is also predicated upon the assumption that it will be properly cast, exploited and distributed, and also that it is made reasonably soon—for there is no doubt in my mind that the picture should have been made by now and that it was a mistake in policy not to have dropped everything else and made it; and while it is difficult to estimate how much damage would be done by a further delay, certainly damage there would be.

You are familiar with the factors that have caused us to consider the deal for its sale: to begin with, there is the difficulty of our casting the picture. It is my feeling that there is no Rhett comparable with Gable, but we must bear in mind that we could undoubtedly get Gary Cooper, and there is a good chance we could get Errol Flynn; and it is my belief that either of these two could play the role very well. I think that, at the moment, Flynn would be my second choice to Gable. However, there is ample evidence that the book's enormous number of passionately interested fans demand Gable.

Scarlett is going to present as much of a difficulty to MGM as it is to us. For your very confidential information, it is MGM's present plan to cast Shearer. If we made it, I question whether we could find a new girl since our widespread search has failed to uncover even a slight possibility. If we made it, it would

-2-

be my feeling that we should cast one of the girls now in pictures who is not yet a star or a big star, but [whom] the picture would undoubtedly make into a big star, provided we could get all or part of the girl's future services. In this connection, I feel that the best possibilities are Loretta Young, whom I could sign exclusively and whom I think could surprise the work under Cukor's direction; Anita Louise; and Frances Dee. We could probably get half of Louise's future contract with Warner Bros. and extend it. We could probably share in the remainder of Dee's contract with Paramount and get her exclusively, or almost exclusively, beyond.

I think there are a number of girls who could play Melanie and my choice, at the moment, regardless of whether the picture would be made by us or by MGM, would be Olivia de Havilland, whom I believe we could borrow.

The best Ashley we could get, if we made the picture ourselves, would be Leslie Howard, and there is no certainty we could get him. There is, also, the additional factor that we would certainly have a rather aged and decrepid [sic] Ashley if we used Howard. The only other possibility that I see on the horizon for us is Ray Milland, whom [sic] could, I think, get away with the role; and he might, conceivably, be a better choice than Howard. I will grant you, without the slightest argument, that both of these men are far from ideal.... MGM has an enormous advantage on us in that they have obligated themselves to me, if we sell the property to them, to bond every effort to secure Tyrone Power who is, I think, the ideal Ashley. They are in a position to secure Power through a trade; and should they fail to get him, which I don't think they would, I think they would be prepared to cast Robert Taylor as Ashley—and while he is not my idea of Ashley, I think the public would accept him a lot more readily and forgive him his shortcomings more than they would Howard or Milland.

So if we made the picture, our cast would probably be: Errol Flynn (or Gary Cooper); Loretta Young (or Anita Louise); Leslie Howard (or Ray Milland); and Olivia de Havilland.

If MGM made the picture, the cast would probably be: Clark Gable, Norma Shearer, Tyrone Power and Olivia de Havilland.

Whether we make it or not, the above cast is, of course, subject to material change. If we sell the property to MGM and new players should be uncovered for any of the roles, or we should decide to use some new players whom we already know about but whose possibilities are not yet apparent to us, I don't want it to be said that we could have used the same players had we retained the property; and I call this possibility to your attention now so that it can be weighed.

INCIDENTALLY, I BEG YOU MOST FERVENTLY TO KEEP ALL OF THESE CASTING CONCLUSIONS

STRICTLY CONFIDENTIAL. . . . AND IF YOU SHOULD SHOW THIS LETTER TO ANYONE ELSE, TO

-3-

BEG THAT PERSON TO KEEP THESE IDEAS STRICTLY CONFIDENTIAL—SO AS NOT TO SPOIL THE BIGGEST MOTION PICTURE NEWS BREAKS OF ALL TIME. . . . AND, MORE IMPORTANTLY, SO AS NOT TO JEOPARDIZE DEALINGS WITH THE ALTERNATE SELECTIONS FOR THE ROLES.

We presently have $394,000. invested in the property. It has for many months been our plan to deduct from Cukor's charges against the picture the profits we have made on him through loanouts. We have held Cukor on tap for "Gone With the Wind," he has not worked on other pictures, and there are a dozen reasons, which it is not necessary to go into in this letter, why it would be proper to deduct the profits we have made on him through loanouts from his charges on "Gone With the Wind." In any event, this is simply a matter of bookkeeping; and we can figure that Cukor plus "Gone With the Wind" stand us, to date, $394,000.—less our profits on the outside, which will bring the figure down to between $330,000. and $340,000. Let us say, to figure conservatively, that the amount is $340,000.

The MGM deal will call for our paying Cukor's services to complete the picture. Under the terms of Cukor's contract, he receives $4250. weekly while working for us, and at least $5250. weekly when working on the outside. (Under our loanouts, his salary has been between $7500. and $10,000. per week—with a net to Cukor of between almost $6000. and $7000. per week.) I do not believe George will insist upon the $5250. figure, for several reasons; first, because of the amount of money he has already drawn from us; second, because I will ask him not to demand the $5250. but to be content with the $4250. figure; third, he is anxious to do the picture; fourth, it will really be a production of mine, and I have an argument in that the $4250. was supposed to have been established when he was working with me, rather than for the company, as against an extra $1000. weekly when working for someone else; and, finally, MGM really does not want him on the picture, preferring to have van Dyke, and if he does it, it will be because I have insisted with MGM that he do it. . . . However, again to be conservative, let us figure that he will demand the $5250. and that we will accede to this demand; also, and still again to be conservative, let us figure that twenty weeks of his time will be required. This means that we would have to pay Cukor an additional $105,000., bringing our cost up to $445,000. before we compute our profits on the MGM deal.

Under the MGM deal, we will also have to pay for the complete script. I estimate that approximately four more weeks of Sidney Howard's time is required. I believe I can make a deal with Sidney to secure him for less than his regular salary of $3000. weekly. However, again to play on the safe side, let us say I cannot make any reduction, and let us say further that I need six weeks of his time—this means that we would have to pay an additional $18,000., bringing our total cost up to $463,000., plus O.A.B. and Unemployment Insurance tax of $5000. on Cukor's and Howard's salaries, making a grand total of $468,000.

Under the MGM deal, the company will receive $900,000. in cash on an outright purchase. This should leave us with a net profit of at least $432,000. . . . with the total leeway in the various items of profits on Cukor on loanouts,

-4- and -5-

cost of direction to complete, and the script, the profit above $432,000. can be anything from zero to an additional $36,000. There is, of course, the question as to whether you want to compute the profits on Cukor's loanouts separately, in which case our bookkeeping profits might be brought down accordingly. . . . There are a few other items, such as our commitment with Hobe Erwin which MGM might not be willing to take over (we have not yet discussed it); and therefore, even though I think the profits will be higher than this, we had better consider that they would be somewhere between $375,000. and $400,000.

Under the terms of the deal, I would receive $100,000. personally as a supervisory fee for making the picture. Under the terms of my contract with S.I.P., I would have received $80,000. Neither I nor our company would have any interest whatsoever in the picture's profits, nor any responsibility whatsoever for its losses, if any.

MGM would obligate itself to make the picture in Technicolor . . . but we could retain all of the Technicolor options. Under our deal with Technicolor, we receive from 14,500 to 32,000 options, depending upon the length and cost of the picture. Assuming, as I do, that the picture will be at the very least 14,000 feet long and will of course cost "at least $2,000,000," we will receive 30,700 options. The present market value of these options is $675,400,00 [sic]. You may care to figure that these options are worth less, if you want to argue that they could not be sold at this price without depreciating the market price; or you may care to figure that they are worth more because of the length of time we will have them and the possibility that Technicolor will be selling for a little, or a lot, higher price some time during the 46 days that we would have these options. (We have not exceed[ed] 45 days from delivery of our negative to the laboratory to exercise the options.) However, taking them at their market value as of today, we would have an additional profit on the deal of $337,000., bringing the total profit up to between $712,000. and $737,000.—the first figure being arrived at by adding $375,000. to the option profits, and the second figure by adding $400,000. to the option profits.

I am assuming that there will be no difficulty with the Technicolor Company about our retaining these options despite the production of the picture by MGM. It is clearly even more to the advantage of Technicolor that MGM make the picture than that we make it; first, because of getting MGM into greater Technicolor production; second, because of the slight possibility that we could not make it in Technicolor, however much we wanted to; and, third, because the picture should be a bigger success with the MGM cast than if we made it. However, I should think it a matter of great urgency for you immediately to determine, through Fran Alstock or John Wharton or whomever you wish, whether we have the right to retain these options if MGM makes the picture; and if we do not have this right, whether there would be any difficulty. I should think it would be absurd of Technicolor to raise any difficulty, but it is, of course, vital that we know before we close this deal—and since we are right at the point of closing, subject only to the contents of this letter in regard to approval by our stockholders and yourself, after checking with your advisers, it is important that this point be cleared up at once. I would prefer that whoever discusses it with the Technicolor Company, if discussion be necessary, should not reveal what cast is contemplated by MGM . . . and should be pledged to secrecy about the deal.

MGM prefers that it should not be known that we have sold the property outright, although I question that this can be kept secret. It is the feeling of MGM that I will have an easier time in controlling costs if it is felt that I am still interested in it on a percentage basis, or that our company is still interested in it on a percentage basis. This is a matter of no importance really, but if it is possible to abide by their wishes, it is probably to the benefit of our company's prestige that the terms of our deal not be known. Certainly the reason advanced for making the deal, in our public announcements, should be our difficulty in casting the picture properly, by comparison with the excellent cast available at MGM, with particular stress upon our deal being the only road to securing Gable, the public's choice for the part of Rhett Butler.

The picture would be produced at MGM's studios and I would, presumably, share my time between the two studios if it is possible for us to produce other pictures simultaneously. It is fortunate, if this is possible, that the two studios are only a few minutes apart.

MGM has agreed that our company will receive billing, and I believe I can work this out so that on the screen and in advertising the picture will be offered as follows:

METRO-GOLDWYN-MAYER
in association with
SELZNICK INTERNATIONAL PICTURES, INC.
PRESENTS
"GONE WITH THE WIND."

I would, of course, receive credit as the producer.

It breaks my heart to have the company sell the property, because of my pride in having the company make one of the great theatrical attractions of all time; and, more important than pride, because I think there are great benefits to the company's reputation to be derived from such a picture, which greater reputation is translatable into profits that are not immediately apparent on a balance sheet. Further, I think it is our most important asset, and that it would be an enormous factor in any deal that we might make in the future. However, this asset is of great value only if there is a deal—such as a merger—that is likely to be open to us in the very near future; because holding the story much longer

might conceivably so materially affect its value as to negate its unique values to a program—especially when the high cost of producing it is considered. It is obvious that its grossing potentialities are reduced in some relation to the delay in its production. How much longer a delay is tolerable is questionable; it would be my guess that it would be folly to wait more than a few months longer. . . . But it would be a great pity indeed if a few

weeks or even a few months after we made the deal, and before production was started by MGM, or even while the picture was being made by MGM, we made a deal such as an RKO merger—for it is obvious that having "Gone With the Wind" as the first attraction of a new Selznick-RKO company would mean millions of dollars in the sales of the entire program of that company.

I believe that if we retain the property we can handle its financing. United Artists has already agreed that it will advance us $750,000. as secondary money to be recouped after a Bank loan of, perhaps, $1,000,000. or $1,250,000., with our present investment of $340,000. to $394,000. (exact figure dependent upon how the Cukor profits are computed) being third money to be recouped last. . . . (The picture would undoubtedly cost us somewhere between $2,000,000. and $2,500,000. It will cost MGM, because of its deal with us, considerably more.)

Accordingly we would have only a small part of the cost of the picture tied up—assuming that the Bank loan can be secured on the collateral of the picture itself, apart from the rest of our product, which I believe can be handled. (The U.A. loan would have no relation to the rest of our negatives and other collateral.)

If we made the deal, we would have available for production of other pictures, monies that would not otherwise be available to us, to the extent of the $900,000. we would receive from MGM, less the $128,000. we would have to pay to Cukor and Howard to complete the job . . . or a balance of $772,000. There would be no other complication that I can, at the moment, see in our financial or Banking setup, due to "Gone With the Wind" being financed (if we make it ourselves) separately from the rest of our program. We would, of course, if we made the picture, take on a company obligation of $1,000,000. or $1,250,000. to the Bank and $750,000. to U.A. . . .

the only point I am making in this paragraph being that we would still be able to finance the rest of our product without regard for the fact that we were making "Gone With the Wind." However, our financial picture, if we make the deal, will of course be materially improved in that instead of having an additional obligation of $1,750,000. or $2,000,000., we will have additional working capital of $772,000.

If the picture is a financial success, we might make $500,000. or $2,500,000.—who knows? It is dependent upon the quality of the picture, conditions at the time of its release, whether the public interest in it is still hot or has cooled off, whether a war starts in Europe, and any other number of factors. Even if it should fail, it would still do an enormous gross—and despite its high cost, it is my feeling that the chance is very slight indeed that we would not be able to pay back U.A. and the Bank. All the experts would have to be wrong for the picture to lose more than our present investment in it, which would be third money. The point I am making here is that the obligation we would take on, through the Bank and U.A., is not one that we need face with any great trepidation, in my opinion. Even if the picture were a failure, I don't think we could lose more than the amount of money we presently have invested in it. … However, you may feel differently. It is anybody's guess. This is a business of hazards; and any picture that today costs

$1,000,000. or $1,500,000. is a great risk indeed; a picture that will cost between $2,000,000. and $2,500,000., plus another $500,000. or more in Technicolor prints and advertising, is more than a mere risk—it is a venture to be undertaken with only the greatest deliberation. If we make the picture, my hair will turn white worrying about not merely its production but also its exhibition and exploitation and sales all over the world, for a period of two or even three years. If we sell the picture, my hair will merely turn gray producing it.

If there were any chance of our making a merger deal with Paramount or with RKO, I would scream till the cows came home against selling the picture, because of its enormous value to the whole program, to the distributing company, and to the company's theatres; because the distribution cost would be much less than it would be under our present setup; and because it would lift the whole program,

standing and profits of the company, regardless of whether the picture itself lost money or broke even. If there is any chance of our making such a deal, I think it is folly for us to sell the property.... If there is no chance of our making such a deal in the near future, it is a conservative step to sell it; it is a magnificent gamble to keep it and make it.

So there you have both sides of the picture. I don't want the decision to be mine alone. I don't want to take the slightest chance that at some later date—before the picture is made, or while it is being made, or even after it is made—someone inside or outside the company will start torturing you or one of our other stockholders with statements, or even insinuations, that we have foolishly disposed of the greatest asset any picture company ever had. I cannot, of course, stop these statements for everybody; nor can I even stop them from people close to you or our other stockholders; but I can, at least, put on notice your advisers and our stockholders that there may be such statements or such feelings, and let them face the facts now and see how they feel about it. Most of all, I want to avoid even the slightest suspicion that I have sold out to my father-in-law. Let them face the fact now that he is my father-in-law, and forever hold their peace.... I might call to your and their attention that if we make this deal it will have been made despite—and _after_—your expressed willingness a few days ago to make the deal if we could secure a profit of $250,000.

I, personally, feel only the following: I insist upon personally producing the picture—I have spent back-breaking months on the script, perhaps more time than I have ever spent on any other script. (Incidentally, I should like to point out, that, in considering whether we are selling at the right price, it should be borne in mind that during the time I spent on "Gone With the Wind," we would have made probably two more pictures.) ... My career as a producer, and the value of my name to myself and to the company, is wrapped up in whether this picture lives up to expectations and I am, therefore, naturally more than simply eager that it be made. ... As the head of the company, I think the picture should be made or sold

-9-

without serious further delays; but I think we should sell it only if there is no chance of a merger deal in the next few months, and if we are not prepared

to make it without delay (for it is by no means certain that MGM or anybody else would be willing to make this kind of deal with us even a few months from now). I am content that we should make it ... and I am content that we should sell it, despite my personal emotions about selling it. But let us make up our minds one way or the other—and fast! As to which decision we make, here I pass the buck to our stockholders, East and West, and to your friends uptown and downtown.

Incidentally, as to our Western stockholders, apart from myself: Myron feels we should sell it; if Norma does it for MGM, she will presumably be content that we have sold it.

I know MGM, and I know that however much they may want to stall on their decisions, they will be insistent on 4 quick decisions from us once they have finally made up their minds, which will probably be by the time you have received this letter; and since it is my belief that Mr. Mayer will receive Mr. Schenck's approval to the deal, I should appreciate it if you would let me hear from you with the very least possible delay.

I should have pointed out above that in considering our total profit, inclusive of profits on Technicolor options, the fact that if we make the picture ourselves in color, we would, of course, still have these options and the profits on them.

I have not yet discussed with MGM the radio rights, or the commercial tie-up rights. I thought it preferable from a trading standpoint not to burden the deal with these points until we arrived at a figure that was mutually acceptable, and until we determined finally that we wanted to go through with the sale. I hope to have our company horn in on some of these radio and commercial tie-up monies—but the chances are that I will not be able to do so because we really would have no right to any of them. However, I'll make the attempt.

As a suggestion that might simplify and expedite the securing of options and advice by you, perhaps you might call a meeting, to be attended by Sonny, Jean, Bobby Lehman, and whomever else you wish to have in, at which you could read and/or discuss this letter. Or perhaps you would care to wait until you have telegraphic word from me that MGM is prepared to close.

This entire letter has been read by the Messrs. Scanlon and Altstock, and I have asked them to write you separately, with copies to me, if they have

any comments about the deal. I know that they have, in particular, some worries about absorption of overhead if production by me of the picture for MGM should mean that we would make fewer pictures here.

Of course, after some of our other dealings with MGM, I will not be terribly surprised if they should finally decide not the make the deal—but it is my honest opinion that they will be prepared to close if we are.

D.O.S.

m

PAGE 57

Metro-Goldwyn-Mayer Corporation
Studios Culver City, California
INTER-OFFICE COMMUNICATION

To: David Selznick
From: Kate Corbaley
Date: June 19, 1938

- NOTES -
Verification of Telephone Conversation
with Mr. Selznick

Up to the time the heroine leaves Rhett Butler's cell and meets Kennedy she is enthusiastic about both the story and the role. She has no criticism to make at all, or any suggestion to make other than the one already discussed in the change of her attitude to her little son, Wade.

From then on to the point of her marriage with Rhett, she feels a distinct loss of power and drive in the story, and has a very distinct objection to the characterization.

She feels the story begins to wander into so many paths that the initial drive is lost—that at that part of the story the love duel between her and Rhett Butler should become of paramount interest and be the main story thread from then on, and that anything that distracts from this is a mistake.

She feels Rhett's love scenes are not culminative enough so that there is too much similarity. She feels you've pulled your punches in the big scene between them where she learns of his great need of her. She thinks perhaps this may be due to a fear of censorship, but that the scene, which is one of the most powerful ones in the book, is distinctly weakened.

Her great objection to the characterization after the scene in which Kennedy is, is this: She feels that there are many things excusable in a young, headstrong girl of seventeen, utterly inexperienced in life, that will never be forgiven a mature woman. She also feels, and rightly so, I think, that a woman who had gone through hell and come up out the other side would have lost all her pettiness, and she must emerge a big woman, with big wants and big virtues. She may still be headstrong and ungovernable, but she cannot do a mean, cruel thing.

Hence, she strongly objects to the marriage of Kennedy, particularly as it serves no vital purpose as I pointed out to you yesterday. If Kennedy marries Suellen, he would in that case pay the taxes, so the whole thing is a little pointless.

She mentioned a feeling against the showing of the degeneration of Ashley. She also mentioned the big scene at the party with Melanie, and it is quite true there is no greater situation in that part of the story for the heroine.

-2-

As a minor objection which can easily be remedied, she also felt a certain heartlessness in her attitude towards Bonnie.

She was very big about the whole thing as I told you, and I think is tremendously interested in the role.... In the final analysis the thing that is worrying her is that in the last part of the play she may emerge on the screen as understandable, to be sure, but completely unsympathetic. She also wonders whether it will be convincing in this last part of the story when the heroine has fallen under the charm of Rhett Butler, that she could still be fascinated by Ashley. If Clark Gable plays the role and is as fascinating in it as he will probably be, and your audience sees those two men together on the screen, I am aware it IS going to be a very weak point in your story.

A young girl obsessed by something she couldn't have, and attracted by a man of her own people we can understand, but a woman who has gone through all she has and become what she must have become, and thrown again and again under the influence of Rhett Butler, is going to be exceedingly difficult to make your audience believe in in that last love scene with Ashley.

To prove to you that she's pretty right in what she feels, David, is that you yourself said this morning

that though the story went to pieces and had a distinct drop in interest after the scene in Rhett Butler's cell, it picked up amazingly in the last four—this is exactly your feeling that as soon as Rhett Butler and the heroine are in continued close contact your story becomes tremendously interesting, and this she distinctly feels. As I said before, the last set of this story is the love story, and the love duel between her and Rhett Butler, and it's got to be built like a million dollars to have the dramatic value that you have in the middle of that story.

It is going to be tough to top the Atlanta sequences, and the sequences at Tiara [*sic*].

I think this pretty well covers what she feels and a lot that I feel about it, and I do hope sincerely that I've been of some service in the matter.

Kate Corbaley

KC/dow

PAGES 58–59

NATIONAL ASSOCIATION FOR THE
ADVANCEMENT OF COLORED PEOPLE
69 Fifth Avenue, New York
Telephone Algonquin 4-3551
Official Organ: The Crisis

June 28th, 1938
(Dictated June 25th)
(Mailed 7/13/38)

Dear Mr. Selznick:

Your very interesting and encouraging letter of June 20th comes just as I am leaving the city for our 29th Annual Conference at Columbus, Ohio, and for some lectures at Northwestern University. I shall write you on my return to the city around July 7th.

I am asking my secretary to gather and send you the reviews. I am also getting opinions from two or three persons who are exceedingly familiar with GONE WITH THE WIND and with the period of which it treats.

I know Mr. Sidney Howard and his work and thus know of how sincere his interest in and attitude towards the Negro are. His and your connection with the forthcoming picture are most heartening as guarantees of its attitude on the subject matter of the book and films. But you will understand that our apprehension in that the book fundamentally is so essentially superficial and false in its emphases that it will require almost incredible effort to make a

film from the novel which would not be both hurtful and inaccurate picture of the Reconstruction era. In saying this I want to emphasize again that I do not by this mean to stress racial chauvinism or hypersensitiveness. Our interest is solely that of accuracy according to the most rigid standards of historical truth. But the writing of history of the Reconstruction period has been so completely confederatized during these last two or three generations that we naturally are somewhat anxious.

In saying this I do not mean to charge that all Americans are prejudiced. Most historical treatments of the pre-Civil War and Reconstruction days either completely ignore the considerable part played by the Negro in American history or give such distorted and essentially vicious treatment to the Negro that it is a wonder that white Americans are not more prejudiced than they are, though that in itself would be an achievement of no mean proportions. The motion picture, appealing as it

#2—Mr. Selznick June 28, 1938
does to both the visual and auditory sense, reaches so many Americans, particularly of the middle classes, that infinite harm could be done in a critical period like this when racial hatreds and prejudices are so alive.

I am interested in knowing of your intention to engage a Negro of high standing to watch the entire treatment of the Negro in the casting of actors, etc. I have very high regard for Hall Johnson and believe he could be of great service to you. I would think, however, that since Mr. Johnson is essentially an artist in the field of music, it might be well to have also, if you engage Mr. Johnson, the advice and assistance of one whose familiarity with the Reconstruction period would be somewhat more extended than the one who has devoted his life largely to one field. In saying this I by no means wish to appear to criticize Mr. Johnson.

Ever sincerely,
Walter White,
Secretary.

PAGE 61
7/29/38

Argument on the value of an earlier starting date. Try to make this Gable's next picture. Failing this, set it up definitely after "Idiot's Delight."

When [the] picture was originally set up in March, this was done because it was the first time Gable and Shearer would jointly be available. Now that Shearer is out of it, there is no reason why it should not be set up as Gable's picture immediately following "Idiot's Delight" and his vacation. This would probably make it some time around November or December. This is the very latest we should agree to and we should try to set it up for much earlier since, obviously, our overhead will be enormously affected.

* * *

They must definitely agree to deliver Gable on the specified date and it must be worded as the essence of the contract and the reason for making the deal . . . a point on which we should be as adequately protected as is possible legally . . . that they deliver Gable without fail and without putting him in any other picture.

It should further be specified that Gable will be charged to us at cost, this cost to be arrived at by dividing the number of pictures he does in his year's compensation, for which we get 12 or 13 weeks of his time, with weeks beyond this chargeable on a weekly basis.

It should be agreed that should they have any difficulty with Gable about bonuses or anything of the sort, they must pay them. Our understanding is we will receive Gable at the salary they presently pay him under the terms of his existing contract, this to protect us against Gable demanding extra money.

* * *

They must agree immediately the deal is made, to make it clear to Miss Shearer that the fact that she is not playing the role is by their preference. My relations with Miss Shearer are such that I would not think it fair that I should be asked to assume this burden, since it was Mr. Schenck's decision that she should not play the role.

* * *

It must be understood at the outset, that the negative and story of the picture are our property and they are simply assisting in the financing and they do not have any ownership.

In this connection, and since they are assisting financing a picture for a very large share of the profits, they, of course, have no right to share in any remake rights, television rights, etc.—except television rights, etc., on the one photoplay.

Ditto on commercial tieups, which are really no concern of theirs, but on which, if necessary, we could concede half.

Ditto on the radio rights which they are not entitled to share in whatsoever and I doubt whether we should concede they are entitled to share in any part of these, even on the first picture.

But as far as future pictures, and rights that have nothing to do with this one photoplay, they obviously have no right to share.

With further reference to radio rights, they must surely concede that radio rights are valuable now. Our ownership of them is a fluke. Their investment is certainly not an element in making these radio rights valuable, as they can be sold today. Therefore, they have no right to share in them.

* * *

-2-

Any new talent that is discovered and presented in the picture will, of course, be our property, since we are the producers of the picture.

* * *

We should have use of their stock company, other than stars, as we need it for the picture and at cost, cost being actual weeks used.

In the case of all players, we should try to avoid any retaining time, simply paying for players at cost. If necessary, as a concession, we might agree to three weeks retaining.

However, under no circumstances should there be any retaining time on players who do other pictures simultaneously with ours, and on these players we should pay only for the time actually used.

* * *

They agree to lend us equipment at actual cost, as determined elsewhere.

* * *

We should be in charge of all publicity during production—which is part of our overhead.

* * *

Advertising should be subject to our approval.

* * *

Billing to be specified and designated by us, but we agree that this billing will include prominent credit to MGM as distributors.

* * *

The picture will be an SIP picture, carrying our trademark, and simply carrying the legend: "Distributed by Metro Goldwyn Mayer."

* * *

Discussion as to how they feed in the money to us.

* * *

Overhead charge on a basis similar to other deal.

* * *

Overhead will include a fund for my personal fee of $100,000., [sic] possibly to be set up in Trust by both companies, payable over a period of years, after Alstock discussed this phase of the matter with attorneys in N.Y.

-3-

It has already been agreed that the Technicolor options remain our property.

* * *

We to have [sic] complete charge of production and without limitations of any kind as to length or anything whatsoever about final form of the script or finished picture, except that I am willing to agree that script and finished picture shall conform to Breen regulations.

* * *

I am to have complete charge of all other phases of production, including casting and including, also, selection of director, it being understood that my choice is Cukor.

* * *

IMPORTANT: In connection with the following paragraph, first read note on Page 5:
It is open to debate as to who shall have charge of the number of prints to be made, according to who pays the cost. If it comes out of both our shares, as I presume it will, and if cost of prints and advertising are to be recouped out of 80% of the gross of the first monies coming in, I have no real objections to their having control over this, except we should set

up some kind of limitation on the number of prints, and, also, some kind of limitation on monies they shall expend—it being also understood that the media selected for such advertising shall be subject to our approval and that they should agree there will be no charge to us for general MGM advertising.

It should, also, be understood there will be no advertising of the picture in group with other MGM pictures without clearly and importantly specifying it is our picture.

* * *

Distribution clauses to be in accordance with the protective formula as worked out by Lichtman, to which we did not previously agree. In other words, these clauses give us protection against being sold down the river; against having the picture sold at anything but top terms; against having the picture given away to Loew's Circuit, etc; and provide for arbitration—but we waive approval of contracts.

* * *

The picture will, of course, be presented by Selznick International.

* * *

[manuscript bracket] Road Shows shall be set up on basis agreed to in our original deal with them…that is, they should agree to no distribution charge other than actual cost of road showing.

* * *

We might bring up the cost of Distribution in those countries where they sell outright. For this, the original Distribution contract for our entire product—the contract with MGM which was never signed—should be consulted.

* * *

-4-

The entire MGM distribution contract which was never signed should be gone over very carefully by all of you for anything else we may have thought of at that time but which escapes us at the moment.

* * *

We have the right to check and audit their books, and they have the right to check and audit ours.

* * *

It is to be debated what should be done about reissue, because we might very well not see fit to reissue it some years from now and they might see fit to reissue it. For instance, they might think it would harm Gable at that time . . . whereas, on the other hand, *we* might not want to reissue it, preferring to remake it, and they might want to reissue it.

There should, therefore, be a protective clause on the length of time they have the picture for Distribution and on our right to take it elsewhere as the picture is ours for reissue if they see fit not to reissue it.

* * *

They can have the right, if they wish, to have a representative, at their expense, at the studio. Or it is debatable whether we should not bring this point up but instead suggest they have a representative to be charged to the picture for auditing and expense purposes (without, of course, right to beto [sic] any expenditures) if they agree to share jointly with us the cost of our representatives to observe and check (without right of approval) their activities.

* * *

The contract should be so drawn that even though we do not have approval, we have legal recourse should they sell us down the river with cost to us and/or to their own benefit.

* * *

It should be borne in mind throughout the dealings that they must get out of their heads any psychology that is a carry-over from the purchase deal. This becomes strictly a releasing deal—a releasing deal which has the unusual additional factors of their assisting in the financing and their securing, in exchange, a substantial share of the profits. Otherwise, it is a releasing deal and should be handled as such, and they are entitled to no rights that they would not have under any other releasing deal.

* * *

I would also suggest that on any snags that may be reached, we should try to settle these among ourselves and they should not report back to NY and get Mr. Schenck all worked up into again feeling thing [sic] is being kicked over. Might point out that one of the reasons for difficulties in the past has been too many bickerings through too many

people. If they know their business up the street, and if we know our business, we should be able to settle these without recourse to NY on either side.

* * *

dos:m

-5-

They are to agree, should we fail to find a Scarlett, that they will trade one of their major stars if it is necessary to secure a major star from another studio for the role

* * *

*****CHANGE IN NOTE WITH REFERENCE TO PRINTS AND ADVERTISING

MGM previously, in its Distribution agreement, agreed to pay 20% of the advertising. Therefore, advertising should be recouped out of 100% of the gross.

With reference to prints, MGM should share in the cost of the prints in some measure such as U.A. does. It is arguable as to whether we should not share in the print cost from the onset, but even conceding this, they certainly should share in the cost of the prints beyond a certain number because their distribution profit will be fabulous if the picture gets up to a point where extra prints will be required.

They have already agreed to finance prints. I am not certain whether they have already agreed to finance advertising, but this should, of course, be specified.

* * *

The picture probably should be sold on a separate contract.

* * *

They should agree that under no circumstances will terms for the picture be less than those obtained for any picture they have released in the last couple of years, and also that they should not be less than any picture which they shall distribute during the first two years or so of the release of this picture. It might be wise to specify certain pictures in particular, such as "Great Ziegfeld," "Marie Antoinette," "Northwest Passage," etc., without limiting it to these specific pictures.

* * *

The remake rights to this picture might conceivably be worth a fortune. Certainly today you could not buy remake rights to "Ben Hur" from MGM for half a million dollars. These rights may be worth as much. I would vote today against an offer of, let us say, $250,000. for the remake rights. Accordingly, we should insist upon retaining all remake rights without sharing by them. They are no more entitled to share in these rights than they would be in the remake rights of a picture distributed through them and produced by anybody else—and certainly "Gone With the Wind" is entitled to more concessions rather than less concessions.

* * *

Alstock has raised the point about the Music Hall. They previously agreed on the Music Hall and I don't think you will have any trouble on this point. In other words, it should be agreed that the second run in N.Y., after road show, will play the Music Hall if possible to work out a good deal with them, as, of course, it will be. (Incidentally, the Music Hall has played many pictures after they have completed road show engagements.)

* * *

-6-

Alstock has raised the point about the Trailer, and this has led me to believe that a complete one-reel trailer on the picture may gross a fortune and it is debatable as to what they are entitled to in connection with this. Under the U.A. contract, we take the gamble and get the revenue.

* * *

I understand that MGM has abandoned the sales formula worked out by Lichtman and that was provided in our incompleted [sic] distribution agreement with MGM. Accordingly, there will have to be a discussion as to how to protect us under any formula Lichtman is now using or may subsequently use.

* * *

The old contract should be consulted as well as my notes on the old contract in reference to foreign currency abroad. Also, time of payment by them to us, etc.

With reference to superimposed and dubbed versions, the old distribution contract provided we paid for them when we approved their making, but with the cost of them advanced by Loews and recouped from our share.

Alstock has also raised the question of Miscellaneous Distribution Costs. I do not think there will be any argument about following something like the UA schedule, as this was agreed to in Article 10 of the unsigned distribution agreement.

* * *

I think there may be a great deal of m ney [sic] to be obtained, in connection with commercial tieups and without such commercial tieups, from "GWTW" accessories to be sold to the public and also to exhibitors for giving away, in connection with the picture. I think these should be on an 80-20 basis.

I think that in addition MGM should agree to distribute thru its exchanges any accessories which we may, without cost to them, give them to place in their exchanges as advertising accessories, MGM receiving 2% for selling these. Also, we may want to place accessories in their exchanges for give-aways, which they should agree to distribute. We should also have them agree to list in their press books accessories of those types.

* * *

We should, of course, have complete protection on Loews' theatres and on theatres controlled or backed by Loews or its subsidiaries.

* * *

The television clause should be in accordance with what we worked out in Article 23 of the old contract.

* * *

dos:m

PAGE 62

Selznick International Pictures, Inc.
9336 Washington Boulevard Culver City, California
INTER-OFFICE COMMUNICATION

To: Mr. Selznick
From: Mr. Arnow
Date: Sept 12, 1938
Subject: Talent Hunt

Following you will find a further report on the talent hunt to date.

YOUNG STOCK PLAYERS—OTHER STUDIOS
M.G.M
Went through the entire contract list with Datig, saw several tests and the only likely possibility is Jack Hubbard who, in a pinch might be suitable for Ashley. Among the girls, Mimi Lilligren and Lana Turner might fit into smaller parts but are not right, or experienced enough, for any of the bigger roles in the picture. You saw the test of Hubbard and Lilligren which was made at R.K.O.

WARNER BROTHERS
Had a very attractive blonde young woman by the name of Irene Rhodes come in and gave her a dialogue scene. If she reads this well will have her see Mr. Cukor. No other suitable for the picture.

PARAMOUNT
After having a talk with Bagnall and Bottsford they thought the only people we would be interested in were the following:
Evelyn Keyes—is a De Mille protégé who is said to be a good young actress but who does not photograph as well as she should. She is in a picture now but they are going to send her to see me as soon as she has a day off as she seems to be on the order of "Scarlett."
Richard Denning—a young man of light complexion and hair, whom they feel might be a possibility for Ashley. They are sending us some tests which I will show you as soon as they arrive.
Louise Campbell—She is not a younger stock player but a contract player getting $1,000 a week. She is from the radio field in Chicago and has done only B pictures with the exception of the last, MEN WITH WINGS, in which she played opposite MacMurray and Milland. However she is more on the Melanie than the Scarlett type. The picture should be previewed in town this week and I will cover same.

20TH CENTURY FOX
Discussed the matter of stock players with Schreiber who says they have no one we would be interested in.

R. K. O.
Discussed matter with Rufus LeMaire who said they had no young players capable of doing these roles.

UNIVERSAL
Nothing on their list worthy of consideration.

COLUMNS

COLUMBIA
Nothing on their list worthy of consideration.

RADIO

KFI (NBC). Interviewed a group of several people and out of them selected an announcer by the name of James Frazier—a possibility for Ashley. Have given him lines and if he reads well will turn him over to Mr. Cukor.

Ellen Clancy. This young actress is finishing a contract with Warners and is now being represented by N.B.C. She is a fine young actress and, although not particularly suited for either Scarlett or Melanie, a good trouper. Possibly we can fit her into some other role if he thinks she is not right for Scarlett or Melanie.

KNX (C.B.S.). Interviewed several people but no possibilities there at all.

Within the next day or so these broadcasting companies will have photographs from their affiliated stations of people who might be of interest.

LITTLE THEATERS AND DRAMATIC SCHOOLS

MAX REINHARDT. Interviewed about 25 young people at the school. Only selected one girl, Mary Freeman, who may be a possibility for Melanie. She came here from the South a year or so ago. She is reading for me tomorrow and if okay will turn her over to Cukor.

EL CAPITAN COLLEGE OF THE THEATRE (Operated by Henry Duffy). Glen Langan, the boy mentioned in last week's memo, read the Ashley lines for me and did so beautifully. Will turn him over to Mr. Cukor tomorrow for his reaction. The boy has talent, and is a good actor. If we can ever photograph his face, he is worthy of consideration for Ashley and for other roles.

Also during the week covered the following Little Theaters: Footlights Theatre, Eda Edson and Ben Bard's players and in addition had the Bliss Hayden school send in their prospects. In the cases of the four above mentioned schools found nothing.

In addition to the above, interviewed quite a number of people during the week, many of whom were brought in by Agents. I will have two or three of these people ready for Mr. Cukor this week.

I am setting the auditions for Mr. Cukor for the middle of the week and immediately thereafter will take off for San Francisco which will require one day, or at the most, two days.

-3-

For your further information, have contacted the Music Corporation of America who have seven offices in the United States in big cities, including Atlanta and Dallas. They are contacting their representatives in these offices to line up any distinctive talent in the way of leading men and women, and upon my arrival at these various points will have the possibilities ready for me to see.

I hope to be able to leave by the end of the week. Before going, will see you to explain how the trip will be handled so that I may secure any suggestions or advice you may want to give.

MA

dc

PAGE 67

Selznick International Pictures, Inc.
9336 Washington Boulevard Culver City, California
INTER-OFFICE COMMUNICATION

To: Mr. David O. Selznick
From Miss Susan Myrick
Date: January 18, 1939
Subject: GONE WITH THE WIND Script
 Suggestions Pages 1 thru 44

Here are suggestions I have to offer on the GONE WITH THE WIND script through Page 44. I hope to get more of these to you during the day.

Copies of my report are going to various departments so that those concerned with production will be aware of these suggestions.

Page 5, Scene 7. "Gerald gallops into a pasture of blooded cattle." These cattle should be Jerseys or Guernseys. No Holsteins or Black Angus known in the South in the sixties.

Page 5, Scene 8. "Follow Gerald as his horse jumps across a narrow stream to a glade." Native Azalea would be in bloom at this time, and would add color about the stream. Also Red Bud is flowering at this time and might be near a stream.

Page 5, Scene 9. "—'snake fence' made of split logs." The "snake fence" showing sign might have Wild Honeysuckle climbing on it, as Wild Honeysuckle is very prolific in Georgia. It is not in bloom at this time, however.

The fence should look aged, and an occasional small weed or China Berry bush might show alongside since the Georgia roadside fence would not be neatly kept.

Page 6, Scene 12. "About them are dogwood trees full of blossom." Suggest Red Bud effective as shrub with Dogwood Trees. It would be blooming at the same time as Dogwood.

Page 10, Scene 19. Pork addressing Ellen: "He tuk on terrible at you runnin' out ter hulp dem w'ite trash…" The word "hulp" should be "hope" or "holp"

Page 10, Scene 19. Jonas Wilkerson speaks of plowing the "back 40 acres." The phrase "bottom land" is a typical southern phrase and could be substituted for "back 40 acres."

-2-

Page 14, Scene 33. "The O'Hara carriage—waiting in drive." Carriage dogs might be added to this scene.

Page 16, Scene 36. "Scarlett, leaving the room, takes a dish of olives with her."

I never saw an olive until I was about fourteen years old. On a Georgia plantation of the sixties, everything to eat that could be grown on the place was plentiful, but strange or imported foods were unusual. I, therefore, suggest that Scarlett take with her as more typical of Georgia two or three beaten biscuits. This is a very small, thin biscuit about an inch and a half in diameter, and probably a quarter of an inch thick.

Page 17, Scene 38. Change olives to "beaten biscuit."

Page 18, Scene 41. "The Wilkes' butler—offering tall frosted glasses." A small sprig of mint should show in the tops of these glasses to prove to southerners that this is mint julep.

Page 23, Scene 54. "—white-capped negro house servants are carving . . ." The negro man servant would not wear a white cap. Those who are carving the meat and working about the pits might be bareheaded, or they might wear dilapidated hats (Mr. Kurtz has described these in detail in his report).

The man servants who are waiting at tables would be bare-headed. The negresses who served would wear "head rags." Since these negro women

would be house servants, they would probably wear white head rags.

I am suggesting to Mr. Stacey a list of food which might be shown on the table at the barbecue.

Page 23, Scene 54. Three or four negro boys to fan the flies about the barbecue table, and three or four to fan the flies while the men are cutting the meat and serving would be appropriate.

-3-

Page 26, Scene 60. "—young ladies who are resting for the evening gaiety . . ." A nice touch here might be one or two small negro girls with palmetto fans keeping the young ladies cool while they nap.

Page 27, Scene 63. "—men grouped around punch bowl . . ." I should suggest it might be well to show in addition to the punch bowl, several decanters and glasses for drinking whiskey neat.

In a group of southern men, there would be many who would prefer straight whiskey to the finest punch known to man.

Page 28, Scene 66. "Stuart Tarleton savagely helps himself to another drink from the punch bowl." It seems to me that Stuart Tarleton, recently fired out of the University and a rather wild young man, would be more likely to take a straight drink.

Page 34, Scene 75. "Negro boys bring saddled horses; men mount to ride away." There would probably be four or five negro "body servants" who would ride away with their masters.

Page 38, Scene 85. The wedding reception. Somewhere in the group at the reception Mammy should be seen. No wedding, birth, or death in the south would be complete without Mammy's presence.

Page 40, Scene 87. Mammy speaks: "Ain't you any sentiment a-tall?" The word "any" should be changed to "no."

Page 42, Scene 90. Uncle Peter's second speech: "She's too young . . ." Drop the "'s" and have Uncle Peter say: "She too young."

Page 42, Scene 92. Uncle Peter's speech:—"You is as bad as Miss Melly . . ." Should read: "You's bad as Miss Melly."

Page 44, Scene 97. Decorations for Bazaar: There would be little ivy used for decorations at the Bazaar because Southern Smilax is very prolific and makes a very beautiful decoration. Mr. Kurtz has submitted a full report for decorations at the Bazaar, I believe.

SM:ek

Selznick International Pictures, Inc.
Culver City, California
INTER-OFFICE COMMUNICATION

To: Mr. David O. Selznick, Mr. George Cukor
From: Will Price and Susan Myrick
Date: January 19, 1929

In going through the Garrett script of January 16, 1939, we find that the script includes innumerable attempts at written southern accent for the white characters.

Both Miss Myrick and I strongly agree that this is extremely dangerous as it prompts the actors immediately to attempt a phoney southern accent comprised merely of dropping final 'ings' and consonants. A phoney southern accent is harder to eradicate than a British or western accent.

It is our opinion that the script should be retyped with all attempts at written southern accents taken out so that we may teach the accent from standard English. This, of course, excepts characters like Belle Watling who are written in dialect in the novel, and all negro characters as well.

WP:ek

copy

Mr. Cukor
CLARK GABLE
12/8/38

For your information, I am informed by MGM that Clark Gable refuses under any circumstances to have any kind of a southern accent.

I am very anxious to talk to you generally about this entire accent problem, and would appreciate it if you would make a note to take it up with me when you see me tomorrow.

DOS

dos:bb

—

Holman Hotel,
Athens, GA.
Oct. 9, 1936

Mr. David B. Selznick:
You are no doubt receiving many letters regarding the subject I am interested in to the extent of writing to you. Miss Mitchell's story of the South is wonderful! I am a Southern woman. Born of Southern parents. My father born and raised in Columbus, Ga. My mother in Oxford, Ga., fifty miles from Atlanta. My father was a Methodist minister in the North Georgia Conf. until his death. My mother's father was also a "Carrie Harris Circuit Rider." My grandfather owned slaves and gave four sons to the Southern Cause. The Southern people are very proud of the Southern background. We love our history and other parts of the U.S. are becoming more and more interested. Allow me to say, Mr. Selznick, you have a big job on your hands when you select the casting of this big picture. CLARK GABLE is perfect for RHETT BUTLER. But—please give SCARLETT's role to a woman who has the Southern dialect. Come South and study our dialect. I don't know your people as you do, but it cuts deep when we see our lovely old Southern life "hashed up." You have nothing like it in the world. The old South! How we love it. Go to Milledgeville, Ga. See and picture some of the beautiful old Southern homes, standing since the war. The old Capital. The Gov. Mansion. Perfectly intact. The red, red clay. Milledgeville has everything. You would be thrilled with your find. Look for the old Jarden farm. Jarden's Crossing. Six miles from Milledgeville. If you will come to Athens, Ga., Holman Hotel, I will take you there myself, as it is only a short ride by paved road, and I know every spa by heart! MARIAM HOPKINS is not bad for SCARLETT. Could be better looking. The southern people will never forgive you if you don't cast this as it should be. Please don't overdo the dialect and say "you all." You people just don't know the South. It would pay you to come or send and study it. Write to Mrs. Nellie Warmack Hines, Milledgeville, Ga. To give you some fine points.

You may consider this as none of my business, but believe me it is. And of every other true Southern woman or man.

My address and res. is the Holman Hotel, Athens, Ga. Famous Old Georgia!

Very truly,
Mrs. J. C. Stiles.

Selznick International Pictures, Inc.
9336 Washington Boulevard Culver City, California
INTER-OFFICE COMMUNICATION

To: Miss Barbara Keon
From: R. A. Klune
Date: November 5, 1938

Dear Bobby:

The space on the Forty Acres where we will construct Tara is presently occupied by a lot of old buildings. Instead of striking these buildings in the customary manner, we are burning them down and photographing such burning in Technicolor. In order to simulate actual Atlanta scenes, we are going to build profiles and false fronts and generally dope the set up to make it look genuine. We are going to shoot all of the medium long shots and long shots that are in the script, using doubles for our people. We plan the actual shooting for Saturday night, November 26. The thought occurred to me that some of the work which you may be doing on the story may concern the fire stuff. If there are any changes which we should know about, will you please let us know prior to the 26th. Mr. Selznick is familiar with what we are doing in this respect and approved it prior to his departure. I have gone into the above detail purely because I do not know whether you are familiar with what we plan to do, in respect to this fire stuff, (redundant—eh?) and so that you would know why it is important to let us know if any changes are made in it.

I hope you are enjoying—shall I call it—your vacation.

With kindest regards,
Ray

rak:cs

P.S. Cukor is so enthusiastic about the above bonfire—that in order to get greater scope we may burn down that part of Culver City where your house is located—is that alright?
Love

PAGE 81

WESTERN UNION
Night Letter
12/10/38

Mr. John Hay Whitney
Selznick International
230 Park Avenue
New York City

You have missed a great thrill. Gone With The Wind has been started. Shot key fire scenes at eight twenty tonight and judging by how they looked to the eye they are going to be sensational.

David

Chg. to Selznick International, Culver City, Calif.

PAGE 82
Mr. Ginsberg
"GONE WITH THE WIND" TESTS
12/12/38

I wish you would meet with Danny, Richards and George Cukor, and also Eric Stacey, and lay out the schedule of the remaining test of our principals for "WIND," which are much the most important that we have made. Scarlett will definitely be decided upon as a result of this next group of tests, which I hope we will be able to see by Monday or Tuesday of next week. The boys should be cautioned to keep things as confidential as possible.

I have had discussions with George this morning and he understands my desire that we test four candidates in three key scenes. The scenes should be the same, so that we have a basis of comparison. The scenes are:

(1) The scene in which Mammy is dressing Scarlett for the barbecue;
(2) The paddock scene in which Scarlett tries to get Ashley to run away with her;
(3) The drunk scene in which Rhett proposes to Scarlett.

The girls to be tested in these scenes are Miss Goddard, Joan Bennett, Jean Arthur and Vivien Leigh. Miss Goddard needs to make only the two scenes, since we have the paddock scene with her.

Rhett appears only in the trunk scene of these three, and I wish that you could make an attempt with Clark personally—or, if you think desirable, through Benny Thau—to have Gable work with at least one of the girls. It would be much more desirable if it could be arranged for him to make this scene with all of the girls, since we are down to our final selections and since we should have the benefit of seeing Gable with our final possibilities for Scarlett. I think it is worth a special trip on your part to see either Gable personally, or Thau, or both. I think it would be very helpful if you could so time it as to see Clark when Carole was with him, as I think Carole would be helpful in pointing out to him the importance of his doing this. . . . You may, however, decide to handle it through Thau, since we are, after all, entitled to have Gable report for he is actually on our payroll commencing this week.

The Mammy scenes should be made with our two principal candidates for this role, Hattie McDaniels and Hattie Noel. However, since the scene will be shot four times, it would be highly desirable to bear down at once on the other possible Mammy candidates and take advantage of this opportunity to see two others, one of whom I should like to be Louise Beavers—unless two other possibilities should emerge who seem better, in which case I should like to hear them read before we hear them in the tests. Even if there is only one other Mammy possibility that I have not seen, I should like to hear her read before being included in the test. We can save ourselves considerable money on testing for these roles if we include the best possibilities in the Scarlett tests instead of testing them separately later. I have already heard the best of the group they have been working with to date, and have selected and approved Miss McDaniels and Miss Noel as strong possibilities.

-2-

We should also take advantage of this opportunity to test our best Ashley possibilities by using them in the paddock scene. We have in these tests the opportunity to see three Ashleys. One of these should of course be Leslie Howard, if this afternoon he agrees to make another test. Please determine through Myron whether Lawrence Olivier [sic] will make a test for Ashley, and if so, include him in one of the tests, determining from the Goldwyn organization when he will have a day off. Because of his appearance in "WUTHERING HEIGHTS" he will be available only if Jean Arthur should be the final Scarlett selection and we should, as a consequence, be delayed a few weeks in starting.

The other Ashley selections are Joel McCrae [sic], Ray Milland and Lew Ayres. I will speak to Mr. Freeman at Paramount about Milland.

The next color test we make of Leslie Howard, if we make another, should be the occasion for making color tests of Miss Bennett, Miss Arthur and Miss Leigh (we already have color tests of Miss Goddard, of course), so that we do not have to go to the additional expense later of making a color test

of whoever looks to be the best for Scarlett from an acting standpoint. We might complicate ourselves terribly in making our final choice if we have not determined in advance that all possibilities will photograph well in color. The color test of Miss Bennett should probably be in a dark wig.

Doris Jordan is definitely out as a Scarlett possibility. She remains a likely candidate for Suellen, to be determined as soon as we have cast Scarlett.

Please make a note to discuss the Tallichet matter with me as soon as we have settled on Scarlett. Meanwhile, Danny might string along her lawyers and say that if he has about a week's time he can probably make a deal for her release, provided they boost the ante a little. Then next week we can decide whether we want her as Suellen and, if not, take whatever is the most we can get out of it.

Because of the amount of work with which I am swamped, I should appreciate it if you would get this whole thing organized in the most economical and efficient fashion.

DOS

dos:bb

PAGE 87

Selznick International Pictures, Inc.
9336 Washington Boulevard Culver City, California
INTER-OFFICE COMMUNICATION

To: Mrs. Rabwin
From: David O. Selznick
Date: 1-9-39
Subject: GONE WITH THE WIND—
 Talent search and casting

Please immediately get hold of Arnow and tell him we are going to be in serious trouble unless we cast Ellen, Jonas Wilkerson, Suellen, Carreen, Gerald and the Tarleton Twins within the next forty-eight hours in order to have their costumes ready for the possible starting date next Monday. Nothing should take priority with either him or me in getting these parts cast today and tomorrow.

Let me know definitely whether there is any truth in the report I hear that Mitchell may not be available for the role of Gerald, in which case, of course, we should not waste any money or time on testing him.

I want to check on my approval of the man we set for Big Sam so please have him come in.

What was the last letter to (or from) Walter White in reference to the technical advice on the negroes?

DOS

bk:gw

PAGE 92

Selznick International Pictures, Inc.
9336 Washington Boulevard Culver City, California
INTER-OFFICE COMMUNICATION

To: ~~Mr. Cukor~~, cc. ~~Messrs. Ginsberg~~, O'Shea, Arnow, ~~Klune,~~ Richards, ~~Stacey~~
From: Mr. Selznick
Date: 1/6/39
Subject: GONE WITH THE WIND

Following you will find a tentative set-up regarding the cast on G.W.T.W. Please keep this information confidential as we wanted no publicity whatsoever about the various people mentioned until such time as I give my approval thereto. Many of these people are not definitely set and we are negotiating with others on the list.

Rhett Butler—Clark Gable
Scarlett—Vivien Leigh
 (~~I would also like to hear Lucille Ball, Ruth Hussey and Geraldine Fitzgerald read for this role as soon as it can be arranged.~~)

Ashley—Leslie Howard
Melanie—To be selected
Miss Pitty—Laura Hope Crews
Gerald—Selection to be made between William Farnum [test] and Thomas Mitchell [test].
Pork—Oscar Polk (arr. 2-1)
Prissy—Butterfly McQueen
Mammy—Hattie McDaniels
Uncle Peter—Eddie Anderson (I would like to see film from "Jezebel" and "Green Pastures.")
Dr. Meade—Eddie Davenport
Belle Watling—To be selected (~~R. Johnson,~~ P. Shennor, Michael)
Frank Kennedy—To be selected (~~Rawley?~~) Conrad Hagel
Tarleton Twins—To be selected (Bigelow film)
Bonnie To be selected
Jonas Wilkerson—~~Edward Pawley~~
Ellen—~~Barbara O'Neil~~ (K. Alexander—see film, Peggy Wood, Jo Hutchinson—see film)

(If satisfactory financial deal arranged.) Otherwise our choice is between Frieda Inescourt, Peggy Wood, Katharine Alexander, Kay Johnson, and Gloria Holden. I also want to see a test of Edith Barret. Gail Petner

PAGE 94

January 7, 1939

Mr. Ed Sullivan
621 North Alta Drive
Beverly Hills, California

Dear Ed:

Vivian Leigh is by no means cast as Scarlett. There are three other possibilities. But should we decide on Miss Leigh for the role, I think the following answers your question:

1. Scarlett O'Hara's parents were French and Irish. Identically, Miss Leigh's parents were French and Irish.

2. A large part of the South prides itself on its English ancestry, and an English girl might presumably, therefore, be ~~much same welcome~~ as acceptable in the role ~~than~~ as a Northern girl.

3. Experts insist that the real Southern accent, as opposed to the Hollywood conception of a Southern accent, is basically English. There is a much closer relationship between the English accent and the Southern accent then there is between the Southern accent and the Northern accent, as students will tell you, and as we have found through experience.

4. I think it would be ~~outrageously~~ ungrateful on the part of Americans, particularly Americans in the film and theatrical worlds, to feel bad about such a selection in view of the English public's warm reception of American actors' portrayal of the most important and best-beloved characters in English history and fiction, ranging all the way from Wallace Beery in "Treasure Island," to Fredric March as Browning in "The Barretts," to Gary Cooper in "Bengal Lancer."

5. And, finally, let me call your attention to the most successful performances in the American theater in many, many years—those, respectively, of the American Helen Hayes as "Queen Victoria" and the British Raymond Massey as "Abraham Lincoln."

I feel that these are days when we should all do everything within our power to help cement British-American relationships and mutual sympathies, rather than to indulge in thoughtless, half-baked

and silly criticisms. As I have said, Miss Leigh is not set for the role, but if she gets it

-2-

~~it will be because she will have seemed~~ Miss Leigh seems to us to be the best qualified from the stand-points of physical resemblance to Miss Mitchell's Scarlett, and—more importantly—ability to give the right performance ~~for~~ in one of the most trying roles ever written. And this is after a two-year search.

And if she gets the role, I like to think that you'll be in there rooting for her.
Cordially and sincerely yours,
dos:bb

P.S. Incidentally, Just where do the carpers think the name "Georgia" came from, but from England? I suppose they'd also object to George Washington being played by an Englishman!

D.O.S.
Copy to Mr. Birdwell

—

Selznick International Pictures, Inc.
9336 Washington Boulevard Culver City, California
INTER-OFFICE COMMUNICATION

To: Mr. Selznick
From: Dorothy Carter
Date: Jan. 23, 1939
Subject: GONE WITH THE WIND FAN MAIL

Dear Mr. Selznick:
Following you will find a report on the GONE WITH THE WIND fan mail situation from Jan. 13th to Jan. 21st.

Total number of letters received	—189
California and vicinity	— 65
New York and vicinity	— 34
Midwest and vicinity	— 46
The South	— 43
New Zealand	1
	189

Vivien Leigh	Votes for 11	Votes against 193
Olivia de Havilland	1	24
Leslie Howard		17

Miss Leigh personally received 45 votes from her fans in favor of her playing role.

There were 64 threats of boycott.
1 chain letter to be organized.
Racial letters received 12 (included in the above total)

113 of the writers will not attend the theatre when the picture is shown.

The general tenor of the mail was in the nature of complaints against the non-American casting of an historical American picture. In voting against Miss Leigh the fans expressed a preference for the stars listed below.

Scarlett:

Miriam Hopkins	17
Bette Davis	16
Katharine Hepburn	12
Jean Arthur	12
Margaret Sullavan	9
Paulette Goddard	9
Tallulah Bankhead	4
Carole Lombard	4
Myrna Loy	4
Rosalind Russell	3
Barbara Stanwyck	3
Norma Shearer	2
Claudette Colbert	2
Gloria Swanson	2
Una Merkel	2
Frances Dee	2

Many others received 1 vote each

Melanie:

Janet Gaynor	3
Jean Parker	5
Helen Hayes	1

Ashley:

Phillip Holmes	3
Doug. Fairbanks Jr	2
Frederic March	1
Franchot Tone	1
Joel McCrea	1
Robert Taylor	1
Alexander Kirkland	1

dc

PAGE 95
POSTAL TELEGRAPH
S 49 NL=OCALA FLO JAN 18 1939

David Selznick=
Producer Gone With The Wind Culver City Calif=

Sir: Be it resolved that we, members of Dickinson chapter fifty six, United Daughters of the Confederacy protest vigorously against any other than a native born Southern woman playing the part of Scarlett Ohara in "Gone With The Wind" furthermore, we resolve to withhold our patronage if otherwise cast=
Mrs Raymond B Bullock President.

PAGE 97
copy
TDS Culver City, Calif Jan. 6, 1939

TO KB FROM DOS
Plunkett has come to life and turned in magnificent Scarlett costumes so we won't need anyone else. With further reference to Fredericks commencing to worry about the practicability of the idea. Would he send sketches or muslin patterns and just how would this work? Would he be willing to come out for a couple of days? The whole production is so complicated that I am trying to simplify the staff and the work so am anxious to get complete picture of the Fredericks situation in order to decide whether the whole idea is worthwhile. If we should go ahead with him is there any obligation as to credit and is there any obligation as to using any or all of his hats?

Sorry to seem so confused but everything is piling up in these last weeks.

PAGE 100
SAL42 TWS PAID 6
New York NY Dec 29 1938 442p
Selznick International Pictures
Culver City Calif

TO DOS FROM KB
In making my daily call to Erwin, happened to say that I had just seen Joe Platt, to which Hobe said the following:

That Joe Platt is not only his [peer] but in lots of ways exceeds him. He is a great designer, illustrator, painter, and diplomat. He will be able to handle the assignment beautifully and is one of Hollywood's best bets he is a natural for picture"

Do you want me to find out if Platt available? He will be very expensive.

INTER-OFFICE COMMUNICATION
Selznick International Pictures, Inc.
9336 Washington Boulevard Culver City, California
Office of the President

To: Mr. John Hay Whitney
Subject: GONE WITH THE WIND—Script
Date: 1/25/39 copy

Dear Jock:

Herewith the Sidney Howard script, the so-called Howard-Garrett script, and the script that we are shooting as far as we have revised it.

Don't get panicky at the seemingly small amount of final revised script. There are great big gobs that will be transferred from either the Howard script or the Howard-Garrett script, and it is so clearly in my mind that I can tell you the picture from beginning to end, almost shot for shot. I was about to say 'line for line,' but this I won't say because I want to match up the best things from the book and from Garrett and Howard, as well as try to make cuts.

The important thing to remember is that the creative work that remains to be done is not of the type that leads to trouble. We have everything that we need in the book and in the Howard and Howard-Garrett scripts. The job that remains to be done is to telescope the three into the shortest possible form. You can get a rough idea of exactly the process we are going to have to go through, and a rough idea of how much we are going to save in length by comparing the first 43 pages of the Garrett-Howard script with the equivalent scenes in the final incomplete shooting script, which you will note is a saving of 5 pages.

However, here again I want to caution you not to judge by pages, because the Garrett-Howard script, although longer in pages than the Howard script, is actually by Hal Kern's estimate almost 5,000 feet shorter than the Howard script. The reason for the extra pages is that the Garrett-Howard script is broken up so much more and contains so much more description, camera angles, etc.

The only thing that I can see that might get us into trouble would be for me suddenly to be run down by a bus, so you'd better get me heavily insured. As long as I survive the whole situation is well in hand: the whole picture in my mind from beginning to end; all the sets for the first six weeks of shooting approved in detail; all the costumes approved; the entire picture cast with the exceptions only of Belle Watling and Frank Kennedy, who don't work for some time; and generally the picture is, I assure you, much better organized than any picture of its size has ever been before in advance of production.

You must bear in mind that I am aware that I am in a terrific spot and that the company is in a terrific spot. Also that a picture of this size and importance cannot be created to the last inflection in advance of production,

-2-

and that there must be a certain leeway in production as we go along. Otherwise I could simply leave town and drop the picture into the lap of anybody to execute.

A couple of days ago I was sick with trepidation, but as of tonight—the night before we start shooting—I am filled with confidence and certain that we will have a picture that will fulfill all the publicity and will completely satisfy all the readers of the book as well. But you are going to have to bear with me for the next couple of months, which will be the toughest I have ever known—possibly the toughest any producer has ever known, which is the general opinion of the whole industry.

I think you will find the Garrett script infinitely better as to continuity and as to story-telling generally, but inferior to the Howard script as to each individual scene. Therein lies my job.

By the time you get here next Tuesday we will be able to show you three or four sequences and I think you will be completely happy. Certainly we ought to feel pleased that as small an outfit as ours is making the most important picture since sound came in—and, more astonishingly, that we have wound up with a cast that could not be improved if we had all the resources of all the big studios combined.

You have had faith in me to date, and I beg you to continue to have this faith until the picture is finished. I must refuse to be judged until the final result is in—at which time if the picture isn't everything that everyone wants, I not alone am willing, but am anxious to leave the whole goddam business.

DOS

dos:bk
Dictated but not read by David O. Selznick

249 CONTINUED (2)

Rhett (continued)
I liked to pretend that Bonnie was you—a little girl again—before the war had done things to you. I gave her the love you didn't want. When she went, she took everything.
Scarlett bursts into a paroxysm of sobs. Rhett looks at her for a moment, then offers her his handkerchief.

Rhett
Here, take my handkerchief. Never at any crisis, Scarlett, have I known you to have a handkerchief.

Scarlett (wipes her eyes; desperately)
But, Rhett—you loved me once. There must be something left for me now!
(then, however, looking up, she sees that he has left her. She totters to the front door, screaming wildly—)
Rhett! Rhett!
(she reaches the door, supporting herself against the jam)

250 EXTERIOR—STREET IN FRONT OF THE NEW HOUSE—DAY
From Scarlett's angle (over her shoulder if possible) Rhett can be seen as he gets into the carriage and drives off. A final cry from her.

Scarlett
Rhett!
Mammy appears beside her. She falls back against her for support. CAMERA GOES CLOSE as Scarlett turns to Mammy.

Scarlett
I'll go crazy if I think about this now! I'll think about it tomorrow!

Mammy
Never you mind tomorrow, honey. This here is today! There goes your man!
DISSOLVE TO:

251 EXTERIOR—DAY—RAILROAD STATION
A rattletrap of a train stands ready to pull out. Various people about, waving goodbye, etc. Rhett,

debonair as ever, his eyes on the future, enters, crosses to train and climbs aboard. He is followed by a darky carrying his grips.

252 INTERIOR—COACH—DAY
Rhett enters, finds a seat and settles down as the darky disposes of Rhett's luggage. The darky leaves. The train starts. As it does, Scarlett comes down the aisle, sits in the seat beside Rhett. Rhett doesn't look up, or express surprise.

Rhett (quietly)
It's no use, Scarlett.

Scarlett (bravely)
I've never been to London—or Paris—
 (she takes his hand in both of hers—)
Oh, Rhett! Life is just beginning for us! Can't you see it is? We've both been blind, stupid fools! But we're still young!—We can make up for those wasted years!
 (he tries to withdraw his hand—)
Oh, Rhett—let me make them up to you! Please! Please!
 He looks at her for a long moment, then down at the hands that hold his. Slowly, he lifts them to his lips, turns the palms upward and kisses them, as we —

FADE OUT.

THE END.
 —

Selznick International Pictures, Inc.
9336 Washington Boulevard Culver City, California
INTER-OFFICE COMMUNICATION

To: Mr. David O. Selznick
From: Val Lewton
Date: October 12, 1938

Subject: Suggested writers for "Gone With the Wind"

Naturally you understand that the field of good writers is limited, especially for an assignment of this sort. This is not so much an apology for the shortness of my list as for some of the choices, which at first blush, might strike you as rather odd.
 CLEMENCE DANE No one can quarrel with the worth of her dialogue and it is my feeling that she can give the character of Scarlett an intangible quality of life and fire. She's always been good with rebellion women characters. If you are going to Bermuda she could go straight there from England. The fact that she is an English woman should not deter you. "Abraham Lincoln," the best play ever written on an American historical character, was written by John Drinkwater. I think the English know and love our Civil War period even better than we do.
 BEN HECHT This seems the wrong assignment for him, but I think he can do anything he sets his mind to.
 THORNTON WILDER I don't know how much screen experience he has had, but he has a good quality of mind and it seems to me enough real intelligence, rare enough in writers, to be able to pick it up quickly from you. From all accounts he is a very pleasant person and I have a hunch that you might get on very well with him. His dialogue and its range over periods, peoples and countries, is exceptionally good.
 LOUIS BROMFIELD Here again I am not certain as to whether or not he has had enough screen experience. I know that he has had some, but how much I've been unable to find out in this brief time. He has nice structure sense and is such a good story teller that his limited experience as a screen writer might not count against him.
 LAURENCE STALLINGS His dialogue, to judge from his last picture, is pretty bad, but that may have been the fault of a collaborator or producer. He has a lot of feeling for this period and might work out, although I would not strongly recommend him to your attention; just a slight possibility.
 LYNN RIGGS He's good on dialogue, a little vague and poetical in his plays, but you might be able to keep this tendency in leash as you did in "Garden of Allah."
 O. H. P. GARRETT If only structural changes are needed, cuts of scenes and general rearrangement, he might be a good man. As to dialogue, much as I love the man, I, personally, wouldn't let him write dialogue for a "Mickey Mouse." I think visualization of scenes and general plot carpentry are his field and he excels in it.
Swerling?
Lillian Hellman?
 Val. (more suggestions to come.)

PAGE 104
 Over Shot Scott Fitzgerald

Mrs. Merriweather ~~Miss~~ Pitty Pat Hamilton, you are poor Charles aunt
Aunt Pitty ~~(ready to weep at the name)~~ (beaming) ~~Yes~~–poor Charles ~~got~~ yes, yes it is wonderful of her
Mrs. Merriweather His widow (side glance into booth) is visiting you and you're responsible for her. It hardly seem responsible–
Miss Pitty Yes, she's here. She would come I warned her–
 (Melanie comes into scene)
Mrs. Merriweather I was just saying it hardly seems–
Miss Pitty You can hardly see her back there
 (She stops intimidated)
Mrs. Merriweather (louder)–Appreciate
~~Mrs. Merriweather~~ Melanie Scarlett is here to serve the cause the rest of us Mrs. Merriweather. ~~We needed her help. I asked (Mrs. Merriweather backs down)~~
~~Miss Pitty Yes–She wanted to stay house. Or was it you Melanie. She was wearing her veil when she left the house. (to Melanie) It was Melanie who didn't want to come.~~
Mrs. Merriweather ~~I have spoken my mind, PittyPat Hamilton. Good evening, Melanie. We needed her help~~ when the McClure girls [illegible] Charles sister and I ~~begged~~ persuaded her to come. And I think I was a very [illegible] ~~thing for~~ of her. Charles would have understood and you may tell the ladies of Atlanta for me.

~~Miss Pitty~~ Mrs. Merriweather Of course if you feel that way, ~~Mrs. Hamilton~~
 (Mrs. Merriweather starts off)
[strike through illegible] ~~Of course it was~~
[strike through illegible]

Aunt Pitty I'll go and explain ~~to everybody~~. People will think we're fast.

PAGE 105
 Selznick International Pictures, Inc.
9336 Washington Boulevard Culver City, California
 INTER-OFFICE COMMUNICATION

To: Miss Katharine Brown

From: Marcella Rabwin
Date: 1/9/1939
Subject: GWTW—Negro Adviser

Dear Kay:

Mr. Selznick asked me to tell you about the situation which came about through his correspondence with Walter White who is Secretary of the National Association for the Advancement of Colored People.

Mr. White (who, as you probably know, is a white man sincerely interested in the Negro cause) wrote us about the desirability of having on the picture a Negro adviser who would be qualified to check on facts and errors concerning the race—since they felt the look had not presented the Reconstruction period in exactly the true proper light. DOS assured White that we would protect the race and would use an adviser during the filming of the picture.

However, we now find ourselves surrounded on all sides by advisers and one more will only confuse us.

So—

DOS asks if you will talk to Mr. White, so we will not be in the position of having broken a promise. He would like you to say to White that we have brought out Miss Susan Myrick—explaining who she is—so that we would be sure everything was right; and in view of this, he can be sure we will not turn out a Hollywood or NY conception of the Negro. Tell him, too, that we have made changes in the script so that even the famous Tax Scene involves a white man now and he is the real culprit while it is a Negro who saves Scarlett. We have eliminated the K.K.K. DOS would like you to try to make White happy with this arrangement.

We're so concerned about White because he is a very important man and his ill-will could rouse a swarm of bad editorials in negro journals throughout the country. It is even important enough for DOS to think Mr. Whitney might say "hello" to him.

Explain how sympathetic we are and tell him that the only negro characters in the picture now are: Mammy, who is treated very loveably and with great dignity; Uncle Peter, who is also treated in the same way; Big Sam, who saves Scarlett; Prissy, who is an amazing comedy character; and Pork, who is an angel. Assure him that the only liberties we have taken with the book have been liberties to improve the Negro position in the picture and that we have the greatest friendship toward them and their cause.

DOS is very anxious to avoid having a Negro technical adviser because we now have the two advisers, Myrick and Kurtz, and because such a man would probably want to remove what comedy we have built around them, however loveable the characters may be.

You can assure White that we have not characterized any of the Negroes as mean or bad and that they have nothing to worry about as far as a pro-slave angle or anything else is concerned, for the picture will be absolutely free of any anti-Negro propaganda.

Then, will you let the boss know what's what with White?

mbr

PAGE 109

Mr. George Cukor cc: Messrs. Plunkett,
 Westmore, Stacey
1/30/39

I feel very strongly that the hairdress we used on the twins makes them look grotesquely like a pair of Harpo Marx comics, even more so than was the case with Tommy Mitchell, because of the color of their hair. All feeling of a pair of young aristocrats of the period, which I worried about in the casting of the roles, is lost and they look like a pair of bohunks. This is almost entirely due, I think, to the hairdress but is also due in part to the size of one of the boys and to the way they wear their clothes. I think the boys should be encouraged to take off some weight before we use them again; and that corsets or whatever is necessary should be used to give them sleeker appearances when they are next used; that an attempt should be made to get them smarter looking in their next costumes.

Also, I think that their hair should be dressed attractively. I would like Mr. Westmore to re-dress their hair and I would like him to arrange with Mr. Plunkett for me to see them again in their next costumes and with their hair re-dressed before they work.

dos

dos*f

—

Mr. George Cukor
1/30/39

Since it is my strong feeling at the moment that we

will be forced to drop the twin scene, for length if for no other reason, and since further it is my feeling that even if we should eventually decide to keep it, we will re-take the one shot that we had with Miss Leigh, I feel that we should plan on using the white dress in the opening scene—which means that she should wear this dress in the scene with Gerald.

Plunkett feels very strongly that this would be the best plan.

If you have any different feelings, please call me.

dos

dos*f

PAGE 111

Mr. R. A. Klune cc: Mr. Lambert
Costumes
2/3/39

I was very disappointed by the costumes in the bazaar sequence during the dance. Much of the loveliness that this sequence could have had has been lost through the very ordinary costumes worn by the dancers. I am aware that we do not want to spend money building costumes for extras, but I think that we might have done much better if we had used a little more effort to get costumes worn by stars in other pictures, notably at M.G.M. Certainly costumes worn by Miss Shearer and Miss Rainer and Miss Crawford and all the other woman stars in various costume pictures could have given us a much more beautiful effect in this scene than the cheap looking extra costumes that we have utilized.

I am particularly concerned lest this be repeated in the interior of Twelve Oaks, in the barbecue scene, etc. I wish you would give your personal attention to the attempt to round up stars' former costumes from other studios, especially M.G.M. You must bear in mind that M.G.M. is our partner in this enterprise and if you ever have any trouble in securing their cooperation on such matters, you have only to ask help from Mr. Ginsberg—or in the final analysis from myself.

Plunkett feels that if we built ten or twelve costumes for the extras we could use them to advantage through the picture and estimates that these could be made at about an average cost of $80 or $90. In the first place, I dislike going into this expense unless it is necessary and in the second place, such costumes certainly could not be the equal of star costumes on which a great deal of money has been

spent. But in any event, I think something should be done so that we do not repeat the lack of beauty that is in the bazaar.

Incidentally, I think the men look awfully sloppy and I cannot understand why we cannot do a better job on uniform fitting throughout. Late in the picture we want the contrast of the seedy looking men against the brilliantly uniformed officers when the war begins. But with the men looking as they do in the bazaar sequence, there is no contrast possible. Also it seems to me that there should be a greater variety of uniforms of the men.

In short, I think that the whole flavor and color of the bazaar sequence, which should have been filled with brilliantly and smartly dressed officers and charmingly and beautifully gowned women, has been largely if not entirely lost because of a very cheap, ordinary and thoughtless costuming job on our super-numeraries.

dos

dos*f

PAGE 112

Selznick International Pictures, Inc.
9336 Washington Boulevard Culver City, California
INTER-OFFICE COMMUNICATION

To: Mr. Selznick
From: R. A. Klune
Date: February 6, 1939
Subject: Costumes

Your memorandum concerning costumes in the Bazaar Sequence brings up a number of important points that should be given consideration immediately, the principal one concerning authenticity, and another, to what extent Mr. Cukor's approvals may be considered final by Mr. Lambert and Mr. Plunkett. 105 of the dresses on women in the Bazaar were manufactured by Western Costume Company from scratch in accordance with sketches and specifications as to color and material as submitted by us. Samples of the dresses were in each case shown to Mr. Cukor for his approval. In all cases Miss Myrick felt that we were dressing the women much too nicely for Atlanta of that day. However, both Lambert and Plunkett went very much further than she said was permissible in attempting to make the gowns lovely. It would have been just as easy and not much more expensive to have gone to

more picturesque dresses because of having completely manufactured so large a number. While on a production rental basis we are paying much less, some of these manufactured dresses have cost as much as $75.00 to make. It seems a shame now that they are not what you wanted. Lambert and Plunkett both took your instructions literally when you suggested that they accepted Mr. Cukor's approval on the wardrobe for bits and extras, and of course feel very badly now that they have missed giving you what you wanted in the sequence.

The uniforms worn by the men in most cases were made to measure. The sloppiness of which you complain does not result from ill-fitting as much as from the fact that in all but a very few cases they were worn by men not accustomed to carrying themselves as army officers. Van Opel's men would have carried themselves like officers and gentlemen for $16.50 a day, as against the $8.25 a day we paid most of the men extras on that set. Here again, we were advised by our technical people that after two years of war the officers of the South would not have possessed the immaculateness and trimness that West Point men might display.

I believe that you should immediately clarify to Mr. Cukor and Mr. Plunkett and Mr. Lambert to what extent authenticity is to be disregarded, and license with respect to the general beauty of the picture is to be taken.

rak

—

Messrs. Cukor, Mensies, Wheels, Lambert,
 Plunkett cc: Mr. Klune
Authenticity
2/8/39

There is no question in my mind but that to date we have seriously hurt the beauty of our production by letting authenticity dominate theatrical effects. There is such a thing as carrying authenticity to ridiculous extremes and I feel that in our sets and in our costumes in the future, where authenticity means a loss of beauty, we should take liberties, and considerable ones, with the authenticity. The first people to complain about the lack of beauty will be the Southerners that we are trying to satisfy with authenticity.

dos

dos*f

PAGE 116

INTER-OFFICE COMMUNICATION
Selznick International Pictures, Inc.
9336 Washington Boulevard Culver City, California
Office of the President

To: Mr. John Hay Whitney
Date: February 10, 1939

Herewith the syndicated article and editorial on GONE WITH THE WIND in which we are attacked by the Negroes. I think this could become widespread and dangerous, and I feel it particularly keenly because I think it might have repercussions not simply on the picture, and not simply upon the company and upon me personally, but on the Jews of America as a whole among the Negro race. This is one reason why I should appreciate your intervention and careful handling of the matter, as well as because it involves the company's public relations, and also because I can ill afford the time that should be devoted to it to handle the matter properly. If you do not have this time to spare, then I should be grateful if you would let me know, so that I can either handle it personally or turn it over to someone else.

I send you also a letter which Marcella drafted for me to send to William White, and a note from Shapiro.

I am not sure that seeking Mr. White's help is wise. If we put him on the spot, he might find it necessary to find fault with the things in the picture which otherwise would not be objectionable, with consequent considerable difficulty and expense to us. It seems to me the smart thing to do might be to engage a prominent Negro editor as a public relations man with the Negroes of this country. An investment of as much as perhaps fifteen hundred or two thousand dollars in such services would, I think, be warranted, and I feel that this amount of money could probably buy for us the services of whoever we discover, after investigation, is a highly respected editor of one of the leading Negro journals. Or, if it is felt that engaging one editor might antagonize other editors, or might subject us to attempts of others also to get on the payroll, then a smart thing to do might be to engage the president of one of the leading Negro universities, or some other such important Negro, for the job, It would much as that Mr. White heads, for I am fearful that he would find it necessary to go to such extreme, in defense of his

own position, as to completely rob the picture of even its Negro flavor.

If and when we engage such a man—or if and when you decide on some other course of action—you might send for Bobby Keon, who can prepare for you a report showing the extreme to which I have gone in the preparation and casting of the picture, particularly the preparation, to avoid offending Negro sensibilities; to avoid any derogatory representation of the Negroes as a race or as individuals; and to eliminate the major things in the story which were apparently found offensive by Negroes in the Margaret Mitchell book. There is also on file an exchange of correspondence between Miss Mitchell and myself in which I explained to her why I was eliminating the Ku Klux Klan, and in which Miss Mitchell expresses her entire sympathy with this change. This material would, I think, be invaluable in public relations on the picture with Negroes. Presumably we would have to secure Miss Mitchell's permission to use

-2-

her letter; but even if she declined its use, and I doubt that she would, my own letter would demonstrate our attitude.

You might also consider the advisability of having O'Shea address legal letters of warning to the authors of such articles as I append hereto, but against this should be weighed the possibility that this would simply antagonize them further.

May I suggest that you call Danny O'Shea into consultation on this together with Shapiro? I really feel very deeply about this matter, as I think these are no times in which to offend any race or people. I feel so keenly about what is happening to the Jews of the world that I cannot help but sympathize with the Negroes in their fears, however unjustified they may be, about material which they regard as insulting or damaging.

In case you do not know it, this is not the first instance, by any means, of attacks of this kind. We have had literally hundreds of letters from individual Negroes and from Negro associations, and we have had wide-spread threats of boycott and other troubles. I personally think it most important that we should go after prominent space in all the Negro journals, both local and national, to not merely obviate the possibility of further trouble or further resentment, but to contradict anything that has been said in the past and to cure any impression that presently exists (an impression which I am sure is very wide-spread) that GONE WITH THE WIND is to be an anti-Negro picture; and that this company and I personally are enemies of the Negroes.

If we are to do anything on this I think we should do it at once, as the impression is probably spreading widely every day.

DOS

dos:bb

PAGE 118

Dear ——:

Your letter about "Gone With the Wind" has been referred to my attention by Mr. Selznick, who has asked me to let you know that your fears concerning our treatment of the Negro characters in our forthcoming production of "Gone With the Wind" are entirely unnecessary.

We have been in frequent communication with Mr. Walter White, of the Society for the Advancement of Colored People, and have accepted his suggestions concerning the elimination of the word "nigger" from out picture. We have, moreover, gone further than this and have portrayed important Negro characters as loveable, faithful, high-typed people—so picturized that they can leave no impression but a very nice one.

That section of the book which deals with the Ku Klux Klan has been deleted in deference to the ideals of all advanced people.

You will find confirmation of these efforts on our part to live up to the expectations of Negroes in America in the February eighteenth edition of the Pittsburgh Courier, in which Mr. Earl Morris says:

"In an exclusive interview with this writer, Monday, the Publicity Department of the Selznick Studios informed me that the objectionable word 'n——r' has been deleted from the film script of Margaret Mitchell's 'Gone With the Wind.' Also deleted will be the Ku Klux Klan sequence. The department has assured me that nothing offensive to the Negro race will be used in the picture."

Again on February 25th, Mr. Morris wrote:

"Thanks to Selznick Studios for their invitation to visit and see the photographing of the film to assure these fair-minded Americans and 'Black America' that nothing objectionable will be in the film."

We sincerely believe that your apprehensions concerning our treatment of the Negro characters in Miss Mitchell's book are unwarranted; and we are sure that you will heartily approve of our film when it is completed.

Sincerely yours,

m

—

WESTERN UNION

Feb. 13, 1939

Mr. David Selznick

Is it true that objectionable epithets referring to negroes used in Gone With The Wind have been removed from the script of the motion picture production. Please wire answer collect.

The Pittsburgh Courier
Pittsburgh Pennsylvania

—

WESTERN UNION

February 13, 1939

Pittsburgh Courier
Pittsburgh, PA.

It is true that objectionable epithets are not in script Gone With The Wind, also no Ku Klux Klan sequence appears and nothing in film will be objectionable to negro people. Regards.

Victor M. Shapiro
Publicity Director

PAGE 123

Mr. George Cukor
February 8, 1939

Dear George:

You will recall that before we started the picture we had a long discussion concerning my anxiety to discuss with you in advance the points that I personally saw in each scene. We had both hoped that we would have a period of rehearsals and that we would have a chance to see the whole script rehearsed. This, for many reasons, was impossible. Then we discussed seeing each scene rehearsed, and this idea was in turn lost sight of in the pressure of many things.

Now the idea becomes more important than ever, because we have little or no opportunity in most

cases even to discuss each rewritten scene before you go into it. I therefore would like to go back to what we discussed, and to try to work out a system whereby I see each block scene rehearsed in full before you start shooting on it. I am worried as to the practicability of this and as to whether it would lose too much time, but I should appreciate it if you would give some thought to it, as it might even save time in the long run. Also, it would avoid the necessity of my coming down on the set at any other time; any feeling on my part that I ought to go down to make sure a point we had intended has been made clear to you; would avoid projection room surprises to me; and, conceivably, would be of considerable service to you. Therefore, unless you see something in the way of the plan, I'd like, commencing immediately, to be notified when you are rehearsing each block scene. If this means I have to get in at the same time as the rest of you, so much the better—I'll get home earlier and Irene will appreciate it!

<div align="right">D.O.S.</div>

dos:bb

PAGE 124

<div align="center">Conf. File
Patsy Ruth Miller</div>

Mrs. I guess I can tell you anything you want to know.

B: There are so many different stories, I'd like to get one final story and clear the whole matter up.

~~Mrs.~~

MRS: Well, as far as I know the facts of the case are that the reason they stopped production was because of a little script trouble. So David Selznick came to Victor Fleming and John—you see Victor and John work together so much—Vic takes over a picture and John doctors it up and then Victor goes on with it, but John doesn't get screen credit. Victor and John are going away tonight to Palm Springs. They're going to have to re-write pretty nearly—well, I don't know exactly, but I'd say half of it. I can't say much about the script—John has such a high ethics about those things—he says he can salvage some of it—there's some very good stuff.

B: Is Mr. Selznick going with them?

MRS: Yes, I think so.

B: Where did you say they're going?

MRS: I don't know exactly—somewhere in the desert I think. They're going to stay for ten days or two weeks.

B: That long?

MRS: Well, they have to get enough stuff ready for Victor to start shooting.

B: ~~Mob~~ Mahin will be on the picture right along then?

MRS: Yes.

B: So there's going to be a lot of work on the picture before they start again?

MRS: That's the way looks now. David hopes there will not be that much, but I'm afraid there will be that much.

B: So they found the script in pretty bad shape?

MRS: Well, the main trouble is it's much too long.

B: Does that mean an editing or re-writing job?

MRS: When a script is in 250 pages and you want it in 150, you can't just edit, you know. You have to re-write whole scenes in order to tell what you want to say in just one scene. Another thing, I suppose Victor, who is a great admirer of Cukor, still has different views on it.

B: I heard there might be a lot of re-writing to do.

MRS: John says there is no such thing as putting a book on the screen. What you do is to translate the book in terms of the screen—it's like the difference between a painting and the statue. You can't follow a book literally. John says that what is good in reading, isn't good to hear in dialogue. John claims you have to translate it into your own terms.

B: Sidney Howard and that other man—

MRS: Oliver H.P. Garrett.

B: Oliver Garrett?

<div align="center">-2-</div>

MRS: Yes.

B: I heard they followed the book.

MRS: Yes, that's the thing. They followed the book exactly, literally—and John says he thinks the spirit is more important than the printed word.

B: Then they'll have to change the script and get ready to start shooting again?

MRS: Yes. It's hard to explain. I don't know

whether you ever saw "Captains Courageous." John kept the spirit of Kipling so well—everyone said "Oh, you kept the spirit of Kipling so well!"—but it wasn't at all … it wasn't the book … you couldn't use Kipling's dialogue today … but the spirit was there and you got the impression that you saw exactly what Kipling wrote.

B: Do the changes Mr. Mahin and Fleming have in mind—is David Selznick in agreement with those changes?

MRS: Yes, having tried it the other way, I guess he realizes it was wrong, so that's why they're doing it all over.

B: I was reading in the Hollywood trade papers this morning that Mr. Mahin had been holding conferences with Mr. Mayer and Fleming. Is MGM making the picture?

MRS: No, but MGM has a terrific interest because of Gable. They're handling the release too, aren't they?

B: Yes, I think they are.

MRS: The conference were [sic] because John was reluctant to take it over because of the time element. He's not what you call a fast worker.

B: I read that he didn't like the idea of doing the script day by day.

MRS: I think that's awfully hard for a writer, don't you?

B: Is that the way they work at Selznick studios?

MRS: Yes—there's that awful feeling of the overhead going on every day … that might make it a little tough. But they agreed he'd have time to do it.

B: I heard that Selznick held out to follow the book literally as much as possible. What would happen if the producer didn't agree with the writer and director?

MRS: I suppose that always comes up, but they're thrashing that out among themselves. I don't think they'll have much trouble from what John tells. David tried to get him originally for it, you know, and MGM wouldn't let him go because he was pretty busy and they wouldn't let him go. John has great respect for the book and loves it and doesn't intend to change it in the slightest.

B: One thing is not quite clear—just who is going to be in charge of the picture now.

MRS: Selznick is still in charge. He says he's not going to do anything else until this is finished. If he makes another picture, he'll get someone, one of his assistants or something, to supervise it. As far as I can gather, he is still in complete charge, though. The only reason MGM is on it is because they're handling the release and have two—no three people on it.

~~You~~ I don't think Mr. Mayer is going to interfere in any way in the actual shooting of it, as far as I can gather.

-3-

MRS: John is on the Hedy LeMarr picture, you know—

B: The—?

MRS: They're shelving the old one—so there was a discussions [sic] as to whether to tkae [sic] him off this to loan him to David. That's the reason for all the conferences. After all, the La Marr [sic] picture means a lot to MGM—

B: I should think so—

MRS: So that there was quite a to-do about that.

B: I understand Selznick is going to hold out for following the book almost literally.

MRS: David says, and Victor and John agree, that to try to change a book so widely read~~y~~ would be like changing the Bible. You can't put a happy ending to the story of Jesus Christ, you know. They're not going to change the story a bit.

B: What would happen if Selznick didn't agree with them?

MRS: I guess he will, or he wouldn't have been so anxious to get them.

B: He's the one who wanted them?

MRS: Oh, yes! David Selznick asked for them—he was very anxious to have them. I'll tell you who was very anxious to have them—to have Victor particularly— was Gable because Vic directed "Test Pilot." Gable gave such a good performance in that picture! John rewrote that picture, you know, but of course he doesn't get any credit for that.

B: I heard that Cukor was let out because Gable wanted Fleming.

MRS: I don't think it was entirely that. I think it was more because they couldn't agree on the script. Cukor was shooting the script as it was and it wasn't working out just write [sic].

B: Could you say that the script that Howard and the other man did is in such shape that they're going to lose most of it?

MRS: That's a tough one for me to answer.

B: Have you read the script?

MRS: Yes—but I don't think I should say anything about that. I heard John tell someone last night, after he decided definitely to do it, that he thought quite a bit could be salvaged. But I don't know—I'm only the wife, you know!

B: Ha-ha! I heard that some of the film will be thrown away, if not all of it. I'm wondering if Mr. Fleming and Mr. Mahin can save much of it.

MRS: I don't think they're going to throw away any of the big shots—only the closer more intimate stuff.

B: That would be about half of it, wouldn't it?

MRS: I don't know—I haven't seen it so I don't know.

-4-

B: Oh. I heard Gable wanted Fleming instead of Cukor.

MRS: Clark worked with Victor before and John re-wrote a great deal of Test Pilot unofficially, so Gable's glad abou [sic] this combination—but I don't think he actually was instrumental in getting rid of Cukor.

B: Has Mr. Mahin seen all the film to date?

MRS: Yes, he has seen it but he thinks he can save some of it.

~~MRB~~ B: Do you think I can reach Mr. Mahin someplace today?

MRS: He's trying to finish up the La Marr [sic] thing and is trying to get it ready so someone can take it over.

As far as I can make out myself, the whole trouble lay in not the cast or in the direction or anything—but the whole trouble was in the script. That's as nearly as I can figure. When they came to shoot it, it wasn't as shootable as they hoped it would be. So Mr. Selznick and Mr. Cukor apparently had some differences of opinion as to how it was to be changed. That's as near as I can figure it out. They saw they would have to re-write

the script and it was in the re-writing that they didn't quite agree. So I guess David figured if he could get John to re-write it—he has always liked John—and then get Victor to work with John, because they work so well together—that, er–(pause)

B: Is Miss Leigh out of the picture?

MRS: I haven't heard anything about that. From the conversation I heard, the cast is perfectly okay.

B: Can I quote you or Mr. Mahin on part of what you have said?

MRS: John wouldn't talk nearly as much as I do, you know. He's like a Doctor or something. He feels very strongly about one writer ever criticizing another writer. Personally I don't mind because I have a great deal of wifely pride in him—he's—but he has to—he would feel badly if he thought I had said too much. So please be very careful how you say it.

B: I imagine you're pretty sick of the whole subject.

MRS: I think it's just dreadful. They overpublicized it so that is why John and Vic were afraid to take it over. There was so much publicity that now no matter how good a picture it is, it's hard to live up to what the public expects. It's sort of turned into a Frankenstein.

I've never known anyone so earnest about anything as David Selznick—he's really giving his heart's blood to it. Not only his money, which is considerable—but everything. John was very impressed by his sincerity and desire to make a good picture.

PAGE 127

February 15, 1939

"GONE WITH THE WIND"
SCRIPT NOTES

Mr. Selznick
Mr. Fleming
Mr. Mahin

1. Give Scarlett more right to believe in her own heart, the minute she does the unconventional thing of telling Ashley she loves him, he will

immediately accept her in spite of his rumored engagement to Melanie.

2. Possibly draw a parallel between Ashley's scene in the Dining Room in his talk to the men (showing his fear of losing what is through war) and his talk to Scarlett in the Library. In other words he might feel he doesn't want to marry Scarlett because he will also lose there.

3. Dining Room scene should contain polite clash between Ashley and Rhett. That is, both disagree with the other men but have different reasons.

4. Establish reason for Rhett to be at the Barbecue where he seems so obviously unwelcome and out of key.

5. In connection with the above, dramatize Rhett as a terrific duelist and mention his calling out and killing the brother of the girl he took buggy riding.

6. Instead of showing marriage of Hamilton and Scarlett, show scene after the marriage when Hamilton and Ashley are leaving with their troop in uniform. Marriage of both couples can be easily planted in the dialog and such a scene of goodbye lends to more poignancy and size.

7. Go to Montage of the South beating hell out of the North and end with the first battle of Bull Run, shooting over the parasols of the Northern ladies who have come out to watch the battle in their carriages.

8. Belle must have some reason to give Melanie the money at the bazaar. Melanie should be established as head of the bazaar committee.

9. Whole Bazaar Scene needs work. Rhett should be physically connected with the end in some manner.

10. Bazaar Scene to be re-written so that Scarlett takes Rhett as a means to lift her out of her doldrums and give her a good time again. She even excuses his relationship with Belle, she is that selfish. The subsequent Bonnet Scene is Rhett's misinterpretation of her attitude.

m:gw

—

Miss Barbara Keon
3/3/39

Please remind me at our next script conference about placing the "think about that tomorrow" line several times in the course of the script and keep reminding me of it as we progress with the script changes.

 DOS

dos*f

—

Mr. Henry Ginsberg
Immediate
2/28/39 (Dictated 2/27/39)

Nobody seems to be paying any attention to the accent problem during this all-important interim period. We know that Leslie Howard has made little or no attempts in the direction of accent and since he is on our payroll there is little excuse for this.

I mentioned to Gable today the necessity of his doing a little work on it and I think this should be followed up.

I am particularly worried about Vivien Leigh since she has been associating with English people and more likely than not has completely got away from what was gained up to the time we stopped.

I wish you would have somebody keep an eye on this whole question, especially since I have occasional worries as to whether we are safe in turning this over to Myrick instead of continuing with Price.

In any event, somebody ought to take the responsibility of watching this since Mr. Fleming is less likely to be interested in it than was Mr. Cukor.

May have some word from you on this?

 DOS

dos*f

PAGE 141
"GONE WITH THE WIND"
3/2/38

Notes for discussion: Barbeque Sequence:
Discuss Jonas Wilkerson thing in place where it is in book—while girls saying goodbye to Ellen.
 Characterizations of Suellen and Carreen.
Very anxious, if possible, to characterize Carreen's unusual sweetness the one or two times we see her.
 Who drives the O'Hara carriage?
Possibility of Gerald riding alongside on horseback.
 Long cardboard boxes in carriage—see them also in 12 Oaks bedroom.
 L.S. 12 Oaks: possibility of kids playing on lawn (book p. 94)
 Describe barbeque as on pg. 93, book.

Costume notes: Parasols for girls; fawn and grey trousers for men.
 Possibility of combining Honey and India, so that Chas. Hamilton is India's beau.
 Be sure India's relationship is very clear.
 Do we have Melanie complimenting Scarlett? (as on pg. 102, book)
 Have we retained line re Kennedy: "If I couldn't get a better beau than that old maid in britches!"
 Scarlett, when gathering together her men, might use stock phrase repeatedly: (pgs. 97 and 98) "Now you wait right here"—etc.
 Describe (pg. 100, book) the high rosewood ottoman on which Scarlett sits.
 Use "Fiddledeedee" from Scarlett at least once in barbeque sequence.
 I think we should have some action during dialogue of boys trying to get closer to Scarlett as on pg. 102, with Chas. Hamilton close to her and the twins trying to disclose him—this maneuvering for position going on thru dialogue.
 Possibility, when Scarlett looks over and sees Ashley and Melanie, even if it means forgetting angle I described today, of seeing Melanie either picking at her food or turning down food, as an even better cue to Scarlett's "I guess I'm not as hungry as I thought."
 I think probably the google-eyed Carreen, sitting at one end of the table, is the only one of the girls who is not furious with Scarlett: she lets out big sigh as indicated on pg. 103, book.
 Rhett smiles as Scarlett looks at him.
 When Scarlett looks over at Rhett and says "Who's that?," cut back to Rhett laughing and staring at her (pg. 103, book)
 Possibility of one line re Rhett, instead of the background about Charleston telescoping right down to following from one of the boys with all the rage of a Southern gentleman: "Why, I understand he took a girl out one afternoon

Mr. R.A. Klune cc: Mr. Fleming
3/13/39

A brief visit to the set this afternoon disappointed me in the costumes of the four girls walking down the great staircase. The costumes have no real beauty, especially as to color. I discussed this with Plunkett and Lambert and found that the technicolor experts

have been up to their old tricks of putting all sorts of obstacles in the way of real beauty.

The costumes of the picture, and the sets also, should have dramatized much more than we have done to date, and much less than I hope they will do in the future, the changing fortunes of the people with whom we are dealing. The first part of the picture—especially the sequences at Twelve Oaks—have been so neutralized that there will be no dramatic point made by the drabness of the costumes through the whole second half of the picture. We should have seen beautiful reds and blues and yellows and greens in costumes so designed that the audience would have gasped at their beauty and would have felt a really tragic loss when it saw the same people in the made-over and tacky clothes of the war period. The third part of the picture should, by its colors alone, dramatize the difference between Scarlett and the rest of the people—Scarlett extravagantly and colorfully costumed against the drabness of the other principals and of the extras.

I am hopeful that this will be corrected in such things as the bazaar re-take. I am aware that the former scene at the bazaar looked like a cheap picture postcard in its color values—but this was because we were foolish enough to overdress the set so that it looked cheap and garish, instead of neutralizing the set as to its color values, so that it was obviously an armory and playing against this the beauty of the costumes which gave us a marvelous opportunity for beautiful colors against the set which obviously gave us no opportunities. The shots that Mr. Fleming has in mind on the waltz will fulfill their complete promise of beauty only if the costumes are lovely and colorful—so that Scarlett's black is a complete contrast and so that the colors of the costumes of the others are a complete contrast with the neutral colors that we should see as the war goes on, and in fact throughout the entire picture Twelve Oaks and the bazaar were, and to a degree still are, our only opportunities for beautiful color for the entire race of people we are portraying in the entire film. In the last part we have only the opportunity of Scarlett.

We should have learned by now to take with a pound of salt much of what is said to us by the technicolor experts. I cannot conceive how we could have been talked into throwing away opportunities for magnificent color values in the face of our own rather full experience in technicolor, and in the face particularly of such experience as the beautiful color values we got out of Dietrich's costumes in "The Garden of Allah," thanks to the insistence of Dietrich and Dryden, and despite the squawks and prophesies of doom from the technicolor experts. The color values of the costumes that she wore in the picture itself, and in some

-2-

of the sequences which had to be eliminated for dramatic reasons (not for color reasons), in such scenes as the honeymoon dissolve, have not been equaled by any of our costumes that I have seen on the screen or in sketch form, despite the fact that the period of the opening sequences of "Gone With The Wind," and of Scarlett's costumes in the last part of the picture, gives us much greater opportunity than did the costumes of the "Garden of Allah." Further, the color values of "The Garden of Allah" had no comparable dramatic significance, whereas the proper telling of our story involves a dramatic and changing use of color as the period and the fortunes of the people change.

Examine the history of color pictures: The one thing that is still talked about in "Becky Sharp" is the red capes of the soldiers as they went off to Waterloo. What made "Cucaracha" a success, and did so much for the technicolor company, were the colors used by Jones for his costumes. The redeeming feature of "Vogues" was the marvelous use of color in the women's styles. The best thing about the "Follies" was the beautiful way in which colors of sets and costumes were blended, as in the ballet.

I am the last one that wants in any scene a glaring and unattractive riot of color—and I think I was the first to insist upon neutralizing of various color elements, particularly of sets, so that the technicolor process would not obtrude on dramatic scenes, but I certainly never thought that this would reach the point where a sharp use of color for dramatic purposes would be completely eliminated; nor did I ever feel that we were going to throw away the opportunity to get true beauty in a combination of sets and costumes.

Presumably Bill Menzies is sufficient of an artist to so blend the colors that the scenes won't look like Italian weddings and so that where we use striking color it will be used as effectively as Dietrich's costumes against the drab sand, or as the Zorina ballet. If we are not going to go in for lovely combinations of set and costume and really take advantage of the full variety of colors available to us, we might just as well have made the picture in black and white. It would be a sad thing indeed if a great artist had all violent colors taken off his palette for fear that he would use them so clashingly as to make a beautiful painting impossible.

Neutral colors certainly have their value, and pastel colors when used properly make for lovely scenes, but this does not mean that an entire picture—and the longest picture on record—has to deal one hundred percent in neutral colors, or pastel shades. This picture in particular gives us the opportunity occasionally—as in our opening scenes and as in Scarlett's costumes—to throw a violent dab of color at the audience to sharply make a dramatic point.

I know from talking to Walter Plunkett that no one feels as badly about the

-3-

limitations that have been imposed upon him as he does. But if we are going to listen entirely to the technicolor experts, we might as well do away entirely with the artists that are in our own set and costume departments and let the technicolor company design the picture for us. The result will be the cheap and unimpressive pictures that have been made in color by contrast with new and startling color combinations such as we achieved in "The Garden of Allah" and such as I had hoped we were going to vastly improve upon in "Gone With The Wind."

I wish you would take steps immediately to give Menzies, Wheeler and Plunkett more liberty as to their color combinations. I have previously indicated that I want Menzies to be responsible for the color values of the picture and I hope that he will have more courage in this regard and will go after color combinations that are superior to those obtained so far.

I planned on sending copies of this note to the various department heads involved, but I think it would be preferable for you to call a meeting, to be attended also by the technicolor experts, and read this memo. I have tried for three years now to hammer into this organization that the technicolor experts are for the purpose of guiding us technically on the stock and not for the purpose of dominating the creative side of our pictures as to sets, costumes, or anything else.

DOS

dos*f

PAGE 142

Mr. Richards, Mr. Klune

3/9/39

I mentioned to Charlie Richards this morning the obvious desirability of having pretty girls and attractive young men on our sets, particularly in such sequences as the exterior of Twelve Oaks, the exterior of the barbecue, the bazaar, etc. Richards told me that he was doing this—but when I mentioned it to Mr. Fleming, I found that he was also unhappy about the unattractive people he had on the set, stating in particular that he had a complete shortage of pretty girls. I don't see any excuse in the world for this and wish Mr. Klune would get together with Mr. Richards on this and correct it immediately, even if we have to spend a few dollars extra to correct it.

DOS

dos*f

PAGE 149

"Gone With The Wind"
Notes
2/21/39

Following Barbecue and Scarlett's marriage or alternate:
MONTAGE covering two years of War.
SCARLETT IN WIDOW'S WEEDS: New scene getting over Scarlett is going to Aunt Pitty's in Atlanta.

DISSOLVE TO:

EXT. BAZAAR

DISSOLVE TO:

INT. BAZAAR
Starting on closeup [of] basket in man's hands into which are being dropped pieces of ladies' jewelry … follow basket as it is passed around until a gold cigar case is dropped into it. Man's voice says "Thank you, Captain Butler" and camera pans up to show that it is Rhett who has just donated his case for the 'Cause.'
Rhett is standing on a balcony over the main floor of the Armory where the Benefit bazaar is in progress. A full shot of the room is seen in back of him.
Rhett looks down an one of the booths:
Scarlett—rear to camera, is leaning on counter of her booth, her feet tapping in time to the music.
Back to Rhett—smiling.

Cut to Scarlett—Melanie—Pitty Pat in booth, Pitty scolding Scarlett for putting in an appearance in public, and Melanie defending Scarlett. Pitty: (gesturing off) "The eyes of Atlanta are on you. I can't stand it … I think I shall faint …"
Cuts of scandalized dowagers.
Scarlett promises to behave.
Pitty exits.
Melanie puts her arm around Scarlett, comforting.
Scarlett looks up, dismayed, as:
Rhett comes to Scarlett and Melanie. "I hardly hoped you'd remember—"
Greetings. (Shortening present version; Rhett already knows status of Melanie and Scarlett—ab't their marriages and bereavement, etc.)
Basket passed to Melanie and Scarlett.
Melanie drops in her wedding ring. "You're a courageous little lady, Mrs. Wilkes."
Scarlett donates her wedding ring.
Melanie, with tears in her eyes, exits from Rhett and Scarlett.
Rhett-Scarlett: short scene, talk about blockade running. Rhett confesses he is not the hero he is thought to be—he is actually making a great deal of money from the blockade. Tells Scarlett he half expected to find her here when he came back to town. Work up to quarrel between them, and to Scarlett saying in effect: "Get out of here. You're hateful!"

PAGE 150

Mr. Victor Fleming

4/12/39

Dear Vic:

If and when you get a moment when you are not a wreck and haven't got nine million other things to do, I should appreciate it if you would take a look at the plate of the dance and have a talk with Bill Menzies about what we can do to get more effective shots, and perhaps two or three of them, of the waltz, than are promised by this plate—which I frankly think is terrible. I have already had a discussion of it with Menzies and Cosgrove.

As we have previously discussed many times, I think it is terribly important to our love story that we romanticize this waltz. Maybe the plate is satisfactory for that section of the waltz which has the dialogue in it—but in any event, we certainly need at least two or three extremely effective silent shots

of the waltz, and I am prepared to go to the extreme of getting back extras and other dancers to stage this properly in order that the dance may be worthy of the picture, and in order that it may be at least as good as what they have had in other pictures in the way of waltz shots.

I should be grateful if you could find the time to have a little chat about this, perhaps over lunch one day, and if you would discuss it with me.

DOS

dos:bb

—

Mr. Fleming—cc: Messrs. Menzies, Klune, Haller, Kern, Lambert
Plunkett and Forbes
3/20/39

I am still worried about the waltz and am still hopeful that you will be able to get something comparable in quality with some of the shots you got in THE GREAT WALTZ—even though we don't go in for anywhere near the variety of shots. I realize you haven't got the possibilities in the set the you had in THE GREAT WALTZ, but we have things that you did not have in that picture—two infinitely more interesting personalities; color; Scarlett's black dress against the color of the others; etc.

I feel that the last time we shot this we leaned so strongly toward the side of authenticity, as we did in other things, that we robbed the waltz of a large part of its charm through holding to what would have been the actual tempo of a waltz danced in the South at this time. But Rhett is, after all, a widely traveled man and we might get something very exciting if he actually went into a Viennese waltz against the less interesting waltz of the other dancers—or, if the tempo of the music makes it impossible for his waltz to be basically different from the waltz of the other dancers, and if the Viennese tempo and style of dancing make for something more attractive than the actual waltzes danced in the South, I'd certainly take the license in order to get the most stunning and romantic effect. Without a little theatricalism we are never going to get what we want here.

I realize that we have some dialogue during the dancing, which hampers you somewhat, but I should appreciate it if you would think about how to get a few silent shots with perhaps something of

the accelerated tempo that you got in THE GREAT WALTZ so that the dance mounts to a really romantic climax. I think we could have some silent dancing shots both before the dialog starts and after Scarlett's last line—before the roll of the drums and Dr. Meade's speech.

It may be that we have the wrong dance director. Certainly we have judging by the effect we got last time. Maybe it's too late to change, but I wish Ray Klune would, immediately upon receipt of his copy of this note, check with you as to whether there is somebody who worked with you on THE GREAT WALTZ that you'd like to get over, either as a substitute and/or in addition to the man we have.

The costumes of the other dancers should also be selected for the most effective contrast with the black costumes of Scarlett and Rhett. The uniforms of the men should be brilliant and varicolored, including Zouaves and officers of other regiments that would give us a variety in the officers' uniforms, and the costumes of the women should be as colorfully contrasting as possible with Scarlett's black.

And, finally, photographically I hope we will be able to get lighting that will give us a sense of shadows and the mood that is obtainable if we can capture the feeling of the illumination of the period. Do you think we might get anything out of an angle that would give us both the dancers and their shadows on the wall?

 DOS

dos:bb

—

Selznick International Pictures, Inc.
9336 Washington Boulevard Culver City, California
INTER-OFFICE COMMUNICATION

To: Mr. Chas Richards cc. Mr. Klune
From: Eric Stacey
Date: March 10, 1939
Subject: BAZAAR

In the new bazaar sequence, there is a character known as "Basket Carrier." Mr. Fleming wishes, if possible, to get an actor who has only one arm. I suggest you work on this immediately, and if there are no one-armed actors, we will, of course, have to resort to trickery. Please start working on this right away. We will possibly get to the bazaar sequence around Wednesday or Thursday of next week.

Also, notice in the new script coming out today that the character of Uncle Peter is back in with quite a lot of dialogue, possibly necessitating recasting. Would you please advise whether we are to plan on continuing to use Jessie Clark, who was not particularly good, although no complaints have reached me.

 Eric Stacey

es:ls

PAGE 155

INTER-OFFICE COMMUNICATION
Selznick International Pictures, Inc.
9336 Washington Boulevard Culver City, California
Office of the President

To: Messrs. Lambert, Plunkett, Richards cc: Messrs. Fleming, Klune, Stacey, Kurtz
Subject: Gone With The Wind
Date: 3/13/39

In deciding the proportion of men to women in ordering our extras for the sequences in Atlanta, care should be taken that we clearly have many more women than men and a decreasing number of men as the picture progresses and as we get deeper and deeper into the war in our Atlanta sequences.

Thus, for instance, the scene of the news of Gettysberg being received should have infinitely more women than men. Also, such males as there are, should for the most part be old men and adolescents. There should, of course, also be the usual proportion of children.

Probably, too, such men as there are, particularly any men of fighting age, would be in uniform as being either soldiers or on leave or Home Guard. Probably, also, there would be wounded or convalescent soldiers.

Similarly, there should be an increasing percentage of mourning costumes as the picture progresses, with a great deal more black being worn by the women and such mourning as would be worn by men.

I think that Mr. Kurtz should supply to the casting and costume departments, details on the above matters on each sequence of the script that calls for mobs or even for comparatively small number of extras.

 DOS

bk

PAGE 156

Mr. Klune—cc: Mr. Ginsberg
BIT PLAYERS, ETC. * G.W.T.W.
4/7/39

Dear Ray:
While, believe me, I am not unappreciative of attempts at economy, I think we must be awfully careful not to spoil scenes that cost many, many thousands of dollars by an economy of a few dollars, or even of a few hundred dollars on actors. Scenes such as the individual bits at the Examiner Office are totally unusable because of the amateurish performances by the bit players, and we will have to either retake them or do without these pieces entirely. The scene at the Railroad Depot is a disappointment insofar as the bit action, and the long shot which caused so much trouble and took so much time is comparatively worthless and may never be used because a bit action gives us nothing, again due to bad and amateurish playing. I am informed that at the Railroad Station there was a limit of $25.00 for each of these bits. Had we used $100.00 actors for five or six of the small bits we would have had a scene that we could use and that would mean something to the picture.

I have always felt that it is the falsest kind of economy to save on bit actors. The time that cheap and inexperienced actors cost through the director's inability to get performances out of them, alone more than makes up the difference between their salaries and the salaries of good actors; film shot with cheap actors for a picture requiring the perfection of GONE WITH THE WIND obviously cannot be used, where the cheap actors fail to deliver what is demanded of them; and even if the cheap actors should work quickly and should give adequate performances, it is still bad economy because nothing is as important on the screen as the actor. To save money on actors and spend it on sets is silly—the audiences are looking at the actors, not at the sets, if our action means anything. And while a bit actor is on the screen, if it is for only two seconds, he is as important as the star. I should appreciate it if you would always bear this in mind, so that we don't come in for any more shocks such as we had on the exterior of the Examiner Office, the exterior of the Railroad Station, and such as I have just had with the officer in charge of the black troops.

 DOS

dos:bb

March 16, 1939

EXAMINER OFFICES—Extra People
(as discussed with Mr. Kurtz)

Based on a total		
of 350 people:	26	negro men and boys
	72	white men (civilians)
	30	men in uniform
	128	Total

	14	colored women and girls
	14	well-dressed women
	154	medium dressed women
	40	poor char. women
	222	Total

MEN

7 negro coachmen for private carriages.
1 negro driver of mule-cart filled with
 cotton bales.
1 negro driver for cab.
1 negro driver for long seated hack.
1 negro driver for covered army wagon.
12 negro porters and laborers carrying parcels
3 negro boys
26 Total

16 civilian men—well-dressed.
34 middle class men—merchants, clerks, etc.
7 men—riff-raff
3 men—train crew—engineer, fireman—
 wood passer
4 men—printers from Examiner offices
2 men—bakery men with bread baskets
4 men—mechanics from roller mill
1 man—Catholic clergyman
1 man—Episcopal clergyman
72 Total

8 soldiers (Provost guard) from Atlanta garrison,
 with rifles
5 divisional headquarters officers
17 convalescent officers and men
30 Total

WOMEN

3 colored mammies—riding in carriages with
 white children
8 " women—carrying parcels
3 " girls, children with mother
14 Total

14 well dressed women in carriages
154 medium dress women
40 poor class women, all ages, character
 (suggested a toothless old hag with cob pipe)
208 Total

NOTE: Mr. Kurtz suggested that about one third of the women would be in mourning of various stages, and according to their stations.

"Gone With The Wind"
Notes
2/22/39

After Ashley's departure back to War:
Pick up Int. Hospital (Book 203)—full shot of wounded men crowding cots, doctors, nurses, etc.

Scarlett is nursing one of the wounded. Some violent bit of atmosphere—such as man crying out in pain because he is being operated without anesthetic, or etc. Perhaps he lets out a fearful xxxxxx cry and falls back dead.

Above or alternate—leads into Scarlett running out on her duties. She is sick at her stomach, disgusted, fed up—goes to closet, grabs her hat and coat just as shells are heard bursting in street. Tells someone she is going home.

STREET

As Scarlett runs out—wartime activity in street—citizens refugeeing—wagons crowded with wounded pouring through city—retreating Confederate soldiers straggling through a-foot, thirsty and weary.

Scarlett runs for home—meet BIG SAM (Book 306) in a detachment of negroes on their way to dig trenches for the white folks.... He tells her the news of Tara—her father sick, the girls down with typhoid, etc. (No mention of Ellen ill).

At the end of Scarlett's scene with Big Sam she hears Rhett call to her—looks over. He is driving by in his carriage—offers her a lift. (Book 303, 336,

CARRIAGE SCENE starts with Scarlett telling Rhett she is going home to her mother at Tara, working in news that Melanie is to have baby in few weeks.

This leads into proposition from Rhett: Why doesn't Scarlett let him take care of her—they will get away from all this blood and this idiotic Cause and go to Paris and have the time of our lives.

He explains to Scarlett that city is under siege and

explains what a siege is.... Yankees will soon be in the city. The Cause is ended.

Scarlett furious when she realizes Rhett hasn't been proposing marriage to her—but wants her for his mistress... says she will have no part of him. "You varmint! I want to get home to Tara!"

Rhett: "What about Mrs. Wilkes? You can't take her on that journey, can you?" Perhaps this is not necessary in view of following scene with Meade.

They have arrived in front of Aunt Pitty's house. Scarlett jumps out of Rhett's carriage in a huff—and he goes off.

EXT. AUNT PITTY'S: Pitty and Aunt Peter about to refugee—getting into carriage. Dr. Meade is there, having just been to visit Melanie and saying goodbye to Pitty. Scarlett runs to them—distraught—she is going with them!

Meade, however, tells her Melanie cannot be moved—the journey might lead to a miscarriage. Scarlet, furious, reminded of her promise to

THE KLAN RIDES AGAIN

June 28, 1939
Mr. R. A. Clune
Production Manager
"Gone With the Winds"

Dear Sir:

I have just returned from the National Convention of the Ku Klux Klan at Atlanta (Georgia). I was questioned on numerous occasions, in hotels, business houses, Klan meeting and Masonic Lodges as to intention of the producers of "Gone With the Winds," as regards the treatment of the Klan subject. All seemed to agree that if the Klan part of the pictures were distorted or deleted the South would be insulted and that millions of Klanspeople would consider it a personal affront.

From cold, hard business judgment, I would say that there is a probability that the boxoffice receipts would suffer if proper attention is not given to the Klan part of the picture.

As Grand Dragon and King Kleagle of the Realm of California (State Head), and as having been an officer in the Klan since 1923, I believe I may be of material assistance to you, as Production Manager, and to Selznick International Picture in assisting as technical advisor, as regards signs, symbols and actions of characters in Klan regalia.

Enclosed, please find, newspaper account of the Convention.

With every wish that the picture may be a success, I am—

Very truly yours
GRAND DRAGON
Realm of California

CES:ld

COMMUNISM WILL NOT BE TOLERATED

PAGE 169

Selznick International Pictures, Inc.
Culver City, California
INTER-OFFICE COMMUNICATION

To: Messrs. Klune, Kern
From: Barbara Keon
Date: April 27, 1939
Subject: GONE WITH THE WIND

At the same time we make the Close Up of Ward Bond in the Klan Sequence in Melanie's Parlor with his new speech about the Provost Marshal, Mr. Selznick wants to make an additional Close Up of him reacting and looking around incredulously at the drunken act of the men.

BK

BK:ps

PAGE 171

Selznick International Pictures, Inc.
Culver City, California
INTER-OFFICE COMMUNICATION

To: Mr. David O. Selznick
From: Val Lewton
Date: April 26, 1939

Unfortunately, and because of the shortness of the time and difficulty of rounding up material quickly, we have not been very successful in our first assignment to carry out your new thought of using art and photography as an aid.

We could find no death bed or similar scene in the material at hand which might be of use to you, but I remember a picture called "The Return of the Prodigal," by one of the Dutch painters, possibly Van Der Meer, which might give you some ideas for Melanie's death bed and Scarlett's pose beside her.

As I remember the picture it is in a rather somber key and such light as there is flows down over the figure of the kneeling son and the still body of the mother in tones of cold, brownish-green. The pose of the son at the foot of the bed, with only a portion of his face visible and his back toward the beholder, might suggest the placing of Scarlett at Melanie's bedside. He kneels at the foot of the bed, his entire attitude one of agonized remorse, his face pressed against upraised forearms, his fists clenched above his head.

I am sure that if you mention the name of the painting to either Wheeler or Menzies that they will instantly recall it and possibly with more detail than that with which I have been able to describe it. Unfortunately we have been unable to secure a reproduction in the short time we have had.

I feel certain that as we get together a small library of material that we can work with much more efficiency than we have shown in this first failure.

Val

PAGE 173
Mr. Ginsberg—Mr. O'Shea
"GONE WITH THE WIND" [illegible]
4/14/39

We may soon have a serious worry to face that I think we should be prepared for if we are not going to be met with the possibility of again halting production. We should keep our worry confidential, but should be active on it none the less.

I have for some time been worried that Fleming would not be able to finish the picture because of his physical condition. He told me frankly yesterday that he thought he was going to have to ask to be relieved immediately, but after talking with his doctor was told that it would be all right for him to continue. However, he is so near the breaking point both physically and mentally from sheer exhaustion that it would be a miracle, in my opinion, if he is able to shoot for another seven or eight weeks. Since it would be difficult, if not actually impossible, for any substitute director to step in without taking the time to thoroughly familiarize himself with the book, the scripts and the cut stuff, I think we ought to start now selecting an understudy and familiarizing him with the material, so that he could step in on brief notice.

I have also discussed with Fleming the possibility of throwing in a substitute almost immediately for perhaps a week's shooting, to give him a chance to get a little rest and also to secure the benefit of his help on the script of the final part of the picture. As a matter of fact, this suggestion came from Fleming, and if we went through with it, it would have the double advantage of having another man familiar with the material and actually having shot on the picture, and consequently prepared to step in should Victor have to quit.

I'd like you to talk this over between yourselves, and then one of us, I think, should discuss it with MGM to see if we can get some help from them.

One of the best possibilities would be Bob Leonard, since Bob knows the book thoroughly and told me at the time Vic went on the picture that if we ever needed him to shoot any particular sequences on the picture he would be happy to step in and help out. Leonard is also unusually adept, and completely without any nonsense about stepping in, in a hurry. I once dragged him on "A TALE OF TWO CITIES" when Conway fell ill and he started shooting for me on twenty minutes notice. I think it might be wise for Henry to run the street and have a discussion with Mannix and Thau about the possibility of Leonard coming down and shooting for a while.

Another very good possibility would be Bill Wellman, if we could arrange to get Bill for a brief period in between his two pictures. I am sure Bill would do this as a favor for me, and I think Paramount owes it to us in payment of their promise to let us have a director in exchange for the Cukor loan.

DOS

dos:bb

PAGE 174
Mr. Schuessler
4/21/39

I will let you know about Lola Lane after seeing the Ona Munson test. I was enormously impressed with Miss Munson's reading for me yesterday and at the moment I feel that she is going to be our Belle. However, keep up your search until you hear from me and check with me again tomorrow or Monday, or whenever the test comes in. You might ask Hal Kern to keep you informed so that you could see it with me.

DOS

dos*f

NATIONAL HEADQUARTERS
AUXILIARY TO SONS OF UNION
VETERANS OF THE CIVIL WAR

Office of the National Secretary
Mrs. Maude B. Warren
14 Cary Street, Brockton, Mass.

Whereas: it is announced that the moving picture, Gone With The Wind, is to be shown in November, and that a Union Soldier wearing the uniform of our country is to be depicted as a "hideous" marauder attacking women; and

Whereas: it is further announced that Atlanta is to be pictured as being destroyed by General Sherman and being fired while citizens are still fleeing from the city; and

Whereas, the records of the Civil War show that the citizens had been humanely removed from Atlanta before any destruction was wrought; and

Whereas, the records further show that only that which was of military value was destroyed by Sherman's orders in Atlanta and that his orders to protect other property from destruction were so efficiently carried out, that the rebels were able to occupy the city after Sherman moved on; and

Whereas, much destruction was committed by Confederates and now attributed to Sherman, and

Whereas, all the military destruction wrought by Sherman's orders was for the purpose of aiding in the preservation of the Union and of putting down the Rebellion,

Be it Resolved, that the Auxiliary to Sons of Union Veterans of the Civil War protest against the false and injurious presentation of the Union Soldier as bestial and against the misrepresentation of the burning of Atlanta; and

Be it further Resolved, that the members of our organization be urged to absent themselves from any theatre picturing this defamatory film; and that movie censors where the film is to be presented be asked to forbid the presentation, because such presentation is an affront to all who wear our Country's uniform and would create disrespect for our Nation and its defenders and encourage those who advocate the righteousness of National destruction; and

Be it further Resolved, that copies of this protest be sent to Selznick, President Motion Pictures Producers; to Fannie Hearon, Commissioner of Motion Pictures, Department of the Interior; and to Dr. George W. Kirchway, Chairman, National Board of Reviews of Motion Pictures.

Passed by Delegates assembled in National Convention held at Pittsburgh, Pa. Aug. 29-31st, 1939.
Mrs. Maude B. Warren
National Secretary.

Selznick International Pictures, Inc.
Culver City, California
INTER-OFFICE COMMUNICATION
Office of David O. Selznick, President

To: Mr. O'Shea
Date: 6/10/39

Do anything you please about running the Evacuation scene for the Guild or anybody else that is necessary in the dispute about the extras.

The only thing that distresses me is the possibility that we will get still further publicity about the use of the dummies in this scene. Actually, I regret now that we used the dummies (except that as I recall it there was a shortage of extras and we would have had to use them regardless, which point, however, unfortunately has not been publicized: you might speak to Hebert about this).

It is a crime that with all the money we have spent on this picture, our biggest shot should be publicized as having been made with dummies and I would rather pay twice the saving than have it given further publicity. As it is, we have probably spoiled this shot for the critics and will spoil it for the public too if the controversy goes further.

DOS

dos*f

Selznick International Pictures, Inc.
Culver City, California
INTER-OFFICE COMMUNICATION
Office of David O. Selznick, President

To: Mr. Klune—cc: Mr. Menzies and Mr. Kern
Subject: G.W.T.W.
Date: 5/26/39

Before we go out on the retake of the Oath I would like to see not merely the test of the double, as discussed this morning, but also sketches to be worked on by Mr. Menzies and Mr. Kern showing exactly where we will cut in the close shots of Miss Leigh, and how we will light these.

In addition to the close-ups of her previously discussed, such as the one in which she gets sick at her stomach, and the one of her lying on the ground in which we get the slow transition from defeat to determination, we also ought to plan on following her with the camera from this last shot as she rises, and staying with her as she delivers the oath in a close shot. We could then cut back to quite a long shot of her standing and with fist raised, or in whatever other posture we decide is best, using the double, and pull all the way back as originally planned.

After we have this all laid out and I have had the meeting with Messrs. Menzies and Kern on it (which I wish Mr. Kern would arrange with Mrs. Rabwin), we should have a further meeting with Mr. Fleming or Mr. Wood, according to which one is going to direct the close shots.

DOS

dos:bb

Mr. Sam Wood
5/31/39

Dear Sam:

I have just sent Schuessler down to see you because I think there is a much better job to be done in the differentiation along the lines that you just spoke of—that is, that the fine sensitive types, the Southern aristocrats, are those that are in faded and somewhat patched clothes—and the horrible types are the well-dressed Yankees. Also, I suggest that you talk with Kurtz and Schuessler about any bits that you may want of the Yankees trying to pick up Scarlett, making cracks at her, etc. and if you need any better type or higher priced bit people for these characters, please don't hesitate to order them.

DOS

dos*f

Selznick International Pictures, Inc.
Culver City, California
INTER-OFFICE COMMUNICATION

To: Val Lewton
From: Mr. Selznick
Date: June 7, 1939.

Increasingly I regret the loss of the better negroes being able to refer to themselves as niggers, and other uses of the word nigger by one negro talking about another. All the uses that I would have liked to have retained do nothing but glorify the negroes, and I can't believe that we were sound in having a blanket rule of this kind, nor can I believe that we would have offended any negroes if we had used the word 'nigger' with care; such as in references by Mammy, Pork, Big Sam, etc. It may still not be too late to salvage two or three uses, and I'd like to have a very thorough and clear picture of what we can and cannot do, without delay.

Incidentally, it can't be a code violation, judging by uses of the word "wop" in the Claudette Colbert-Jimmy Stewart picture "It's a Wonderful World" in a manner which probably won't offend any Italian any place, but which certainly at best is much more offensive than the way in which we would use the word 'nigger.'

Please try to let me know about this today if you can.

I suggest that you secure Mrs. Rabwin's help in looking up correspondence that Vic Shapiro and I myself had with various negro groups, and perhaps also secure the advice of some local negro leaders on the subject. Maybe even talk to some of the negro leaders yourself.

I suggest, for instance, that you look up the wonderful use of the term Uncle Peter on page 673, which is the most sympathetic and friendly-to-the-negroes piece possible, and which deals with Peter's reaction to the whites calling him a nigger; and also Big Sam's reference to trashy niggers on page 779; and Mammy's reference to niggers on her arrival in Atlanta when she sees the invasion of the black and white scum alike (page 553). I think you can feel free to discuss these specific pieces with important negroes and with Breen's office.

DOS

PAGE 213

Selznick International Pictures, Inc.
Culver City, California
INTER-OFFICE COMMUNICATION

To: Mr. Selznick
From: Val Lewton
Date: June 9, 1939
Subject: "NIGGERS"

Dear David,

After having spent some time with Joe Breen, having seen his files, and having spoken with several very intelligent negroes, including Mr. Williams, the famous architect, I can only come to one conclusion: that it would be extremely dangerous for you to use the word "nigger" on the screen. I know that you will lose a certain amount of dramatic value and that it is certainly a great loss of comic material, but I feel sure that if you had seen what I have seen and spoken to those whom I have spoken to, you would come to exactly the same conclusion.

The word "nigger" is like a red flag in front of a bull, so far as the colored people of the United States are concerned. Mr. Breen pointed out to me, when I used the argument that we only had negroes calling other negroes "niggers," that the intelligent negro might understand this subtlety and that he is certain that by dint of persuasion we could get one or another of the negro societies to endorse this view of the matter, but that no one could answer for the rank and file who threw bricks at the screen in Chicago, Washington, Baltimore, New York and Los Angeles when "The House of Connelly" was shown and inadvertently Lionel Barrymore was allowed the use of the word "nigger."

Mr. Williams subscribes to this same view and says that despite the humorous use of the epithet by negroes, that they abhor it and resent it as they resent no other word.

Also, insofar as I could gather from glancing over our own correspondence with negro societies, we have repeatedly promised them, under the names of various persons here, that the word "nigger" would not be used in the picture.

VAL LEWTON

vl:lb

PAGE 214

October 20, 1939
Mr. Will H. Hays
Motion Pictures Producers & Distributors
 of America, Inc.
28 West 44th Street
New York, N.Y.

Dear Mr. Hays:

As you probably know, the punch line of "Gone With the Wind," the one bit of dialogue which forever establishes the future relationship between Scarlett and Rhett, is, "Frankly, my dear, I don't give a damn."

Naturally I am most desirous of keeping this line and, to judge from the reactions of two preview audiences, this line is remembered, loved and looked forward to by the millions who have read this new American classic.

Under the code, Joe Breen is unable to give me permission to use this sentence because it contains the word "damn," a word specifically forbidden by the code.

As you know from my previous work with such pictures as "David Copperfield," "Little Lord Fauntleroy," "A Tale of Two Cities," etc., I have always attempted to live up to the spirit as well as the exact letter of the producer's code. Therefore, my asking you to review the case, to look at the strip of film in which this forbidden word is contained, is not motivated by a whim. A great deal of the force and drama of "Gone With the Wind," a project to which we have given three years of hard work and hard thought, is dependent upon that word.

It is my contention that this word as used in the picture is not an oath or a curse. The worst that could be said against it is that it is a vulgarism, and it is so described in the Oxford English Dictionary. Nor do I feel that in asking you to make an exception in this case I am asking for the use of a word which is considered reprehensible by the great majority of American people and institutions. A canvas of the popular magazines shows that even such moral publications as Woman's Home Companion, Saturday Evening Post, Collier's and the Atlantic Monthly, use this word freely. I understand the difference, as outlined in the code, between the written word and the word spoken from the screen, but at the same time I think the attitude of these magazines towards "damn" gives an indication that the word itself is not considered abhorrent or shocking to audiences.

I do not feel that your giving me a permission to use "damn" in this one sentence will open up the flood-gates and allow every gangster picture to be peppered with "damns" from end to end. I do believe, however, that if you were to permit our using this dramatic word in its rightfully dramatic place, in a line that is known and remembered by millions of readers, it would

-2-

establish a helpful precedent, a precedent which

would give to Joe Breen discretionary powers to allow the use of certain harmless oaths and ejaculations whenever in his opinion they are not prejudicial to public morals.

Since we are trying to put "Gone With The Wind" into the laboratory this week, I should appreciate your taking this matter under immediate consideration. Mr. Lowell Calvert, our New York representative, has a print of the scene referred to which will take you, literally, only a few seconds to view. It is not a Movietone print, and must be exhibited with a dummy head, and therefore Mr. Calvert will have to arrange a room that is so equipped for you to see it. However, you may feel it possible to give the consent without viewing the film.

The original of the line referred to is on page 1035 of the novel, "Gone With The Wind," and you might have your secretary secure it for you.

We have been commended by preview audiences for our extremely faithful job on "Gone With The Wind," and practically the only point that has been commented on as being missing is the curious (to audiences) omission of this line. It spoils the punch at the end of the picture, and on our very fade-out gives an impression of unfaithfulness after three hours and forty-five minutes of extreme fidelity to Miss Mitchell's work which, as you know, has become an American Bible.

Thanking you for your cooperation in this,
Cordially and sincerely yours,
dos*f
Blind copies to Mr. Whitney, Mr. Calvert

PAGE 215
GONE WITH THE WIND LEWTON

xxxxxxxxxxxxxxxxxxxxxxx
"——Frankly, my dear, nothing could interest
me less——" Bowie
, I don't care——" Anon.
, it leaves me cold——" Ibid.
, it has become of no concern to me——" Ibid.
, I don't give a Continental——" Ibid.
, I don't give a hoot!" Ibid.
, I don't give a whoop!" Ibid.
, I am completely indifferent——" Ibid.
, you can go to the devil, for all of me——" Ibid.
, you can go to the devil for all I care——" Ibid.
, I'm not even indifferent——I just don't
care——" L.

, I've come to the end——" Millington
, I just don't care——" L.
, I don't give a straw
, It's all the same to me
, it is of no consequence
, the devil may care——I don't
, I've withdrawn from the battle
, the whole thing is a stench in my nostrils
, it makes my gorge rise

PAGE 223
GONE WITH THE WIND
May 12, 1939
Colleen Traxler

<u>Outline showing the attitude of the south
toward Scarlett as business woman and
associate of Yankees</u> (from novel)

Scarlett's becoming a business woman is the signal for the great deal of more or less silent disapproval to become exceedingly vocal, and the last straw is her marriage to Rhett. From then on she is no longer a member of the Southern society into which she had been born. The members of the society consider that she has deliberately defied their traditions and her own: she is not only unwomanly but unworthy, and hasn't the cultural sense to "shake the tramps off" when she gets what she wants, and foolishly allows them to drag her down to their level.

When Scarlett buys the mill with money 636-643
Rhett loaned her, Frank and all the
rest of Atlanta think she has "unsexed"
herself by going into business.

None of the men she knows wants to 664-6
work for her, they would rather work for
themselves and besides, she has "a hard
way of looking at things."

Atlanta is scandalized at Scarlett's 668-671
business dealings with the Yankees. 674-675
Even Uncle Peter tells her that it won't
do her any good to stand high with the
Yankees and white trash if her own folks
don't approve of her.

The penalty for getting the money she 678-680
wants so badly is loneliness.

Rhett tells Scarlett that one reason 683-4
the ladies of Atlanta don't approve of
her is because her conduct may cause
the neck-stretching of their sons and
husbands.

Grandma Fontaine tells Scarlett they 719
have heard of her didoes in Atlanta
with the Yankees.

Ashley tells Scarlett she has shouldered 726
a man's burdens.

Frank forbids Scarlett to lease the con- 742
victs when she first mentions this idea.

When she does lease the convicts the 759-760
town expresses disapproval for her 763-764
hardness and inhumanity.

Rhett tells not only what he thinks of 768-775
her way of doing business but, by infer-
ence, what everyone else would think:
she is a woman quite without honor and
he shouldn't have expected fair dealing
from her, knowing her as he does.

Scarlett is accused of putting the 794-5
Klansmen's lives in danger by riding 798
around town by herself

-2-
and what happened to her that
afternoon was only what she deserved.

When Scarlett and Rhett's engagement 839-846
is announced a storm of bitter gossip
arises because of the Klan incident,
because of the impropriety of the
'unseemly' haste, and most of all,
because of Rhett's Carpetbagger and
Scallawag cronies.

Rhett tells Scarlett that they will be 859-877
lucky if the decent society of Atlanta
doesn't spit on them. Scarlett definitely
becomes a member of the new Atlanta
society of Yankees and Republicans
and is banned by the real society of
the town. Only Melanie stands by

her and even she refuses to meet the Republican governor. Scarlett's lack of discrimination is painfully evident.

Even her children are not socially 898–904
acceptable.

Melanie protects Scarlett from gossip 946–954
over the episode with Ashley at the mill.

Scarlett wishes for the comfort of old 1002-3-4
friends but they have all slipped away.

PAGE 230

Selznick International Pictures, Inc.
Culver City, California
INTER-OFFICE COMMUNICATION
Office of David O. Selznick, President

To Mr. Raymond A. Klune
Subject: Gone With The Wind
Date June 22, 1939

One of the reasons we had so much difficulty with Leslie Howard on the extremely hard and trying paddock scene was because of the number of people that were on the set. Please give strict orders that on the retake of this scene the set is to be closed to every person who is not absolutely vitally necessary to the shooting of the scene, including our own employees who are not on the picture, and including members of the press.

Please tell Hebert that he can have visitors on any day but this one.

Also, please station an extra policeman to make sure that we have a tighter rope around the stage on this day than we customarily have and make clear to the assistant director and the police that this rule goes even for our own employees.

DOS

dos:ro

PAGE 240

Messrs. Klune, Stacey, Lambert, Westmore
6/5/39

If and when we re-take the scene on the porch, I will want Scarlett in a white dress and made up exactly the same way she was in the scene in the hall on the introduction of Ellen—and I want her looking as youthful as possible.

If we have time, the last day we are shooting, we should plan the re-take of Scarlett in the prayer scene and since she will be in the same make-up and costume as the porch scene, it should be made the same day as the porch scene and probably immediately following it.

DOS

dos*f

PAGE 243

Western Union
June 27, 1939

Mr. John Hay Whitney
630 Fifth Avenue
New York, N.Y.
<u>PERSONAL DELIVERY</u>

Sound the siren. Scarlett O'Hara completed her performance at noon today. Gable finishes tonight or in the morning and we will be shooting until Friday with bit people. I am going on the boat Friday night and you can all go to the devil. We are trying to keep Vivien's arrival in New York Thursday a secret. Hebert will accompany her and will look you up. Vivien is expecting a call from you so if you can arrange one evening or Sunday for her and Larry I think it would be a nice thing to do. Please tell Margaret Mitchell what she can do to herself.

David

PAGES 248–249

"Gone With The Wind"
PREVIEW QUESTIONNAIRE

MEMBERS OF THE PREVIEW AUDIENCE:
"GONE WITH THE WIND" is still in unfinished rough form and your opinions about it will be of great benefit to us in the final editing. Will you please be good enough to give us your answers to the following questions?

—

1. *How did you like the picture?*
Very very much. Whoever has the final editing of "Gone with the Wind" will certainly have a gigantic task. It is perfect, it seems to me, as we saw it, and will be a sacrifice to cut any of it. It is the finest adaption from a book I have ever seen, and the cast is perfect, especially the principles.

Noteworthy too, are the grand performances of Mammy and Prissie. The filming in Technicolor has greatly enhanced the charm of the picture, the fire scenes in particularly standing out with breathtaking naturalness.

2. *Was the action of the picture entirely clear? If not, where was it confusing?*
I had no difficulty following the sequence at any time.

3. *Was the sound entirely clear and could you understand the dialogue? If not, do you recall which parts were not audible?*
The only place I recall wasn't entirely clear was where Scarlett and the twins were talking in the very beginning of the picture. This may have been due to the fact that we had not heard Scarlett talk and had to become accustomed to her way of speaking—or to the excitement of at last seeing this much discussed picture. This was the only place and the fault was probably ours.

4. *Did any parts seem too long? If so, what parts?*
The only part that seemed to drag in the least was shortly after the intermission, where their work-a-day toil is shown is such detail. I thoroughly enjoyed every minute of the three hours and forty minutes and this is not a criticism, but if it does have to be cut I believe that would be the logical place.

5. *Do you think that any battle scenes should be added to the picture, or any fuller portrayal of the Civil War, its causes and development?*
No. I think you have shown cause and effect very well, and at this particular time of unrest, the hospital scenes should prove an object lesson to our youth who can only see the glamour of war.

6. *Have you any other suggestions to make?*
I can't think of a single thing that would improve what you have already done, but I do know that I shall never forget "Gone with the Wind" and want to thank you for allowing we folk in Riverside the privilege of seeing it first. May we have more of your pictures? Thank you.
(One intermission made it very enjoyable and enabled us to stretch a bit. It came at a high point of interest that made us eager for more)

7. *Please check one: Do you think the picture should be played*
With no intermissions?
With Two intermissions?
× With one intermission?

Name: Dora Neuber Wahle
Address: 4277 – 6th Street
City: Riverside

—

1. *How did you like the picture?*
Best picture I've seen this years so far, and believe that this picture be admired by the millions in near future to come.

2. *Was the action of the picture entirely clear? If not, where was it confusing?*
Yes. I do believe the action of the picture was very clear.

3. *Was the sound entirely clear and could you understand the dialogue? If not, do you recall which parts were not audible?*
Conversation between Scarlet and dying Mrs. Wilkes should be made little louder.

4. *Did any parts seem too long? If so, what parts?*
No.

5. *Do you think that any battle scenes should be added to the picture, or any fuller portrayal of the Civil War, its causes and development?*
I should think adding of more clear battle scenes would make "Gone with the Wind" stand out better, such as "Battle of Gettysburg"

6. *Have you any other suggestions to make?*
I would like very much to hear more of the songs by the darkies.

7. *Please check one: Do you think the picture should be played*
With no intermissions?
With Two intermissions?
× With one intermission?

Name: Kazuo Muramoto
Address: 2145 John St.
City: Arlington, Calif.

—

1. *How did you like the picture?*
I consider it the finest picture I have ever seen outside of the Ziegfeld picture. I consider I had the pleasure of a very rare treat. Had debated whether we would go to the theatre or not and when we found what the preview was we were thrilled.

2. *Was the action of the picture entirely clear? If not, where was it confusing?*
I think it was very clear.

3. *Was the sound entirely clear and could you understand the dialogue? If not, do you recall which parts were not audible?*
Good, and we saw in the first balcony.

4. *Did any parts seem too long? If so, what parts?*
The only part I would consider too long was the scene were Mammy was telling about the death of the child, it played on the emotions too much. May be would not affect anyone who had not had children. I have had five.

5. *Do you think that any battle scenes should be added to the picture, or any fuller portrayal of the Civil War, its causes and development?*
No, I think there were just enough.

6. *Have you any other suggestions to make?*
I would not want to change it a bit. The characters were all wonderful. I have never cared very much for Clark Gable but he won me completely over in his portrayal of the part Sat. night. Miss Leigh was excellent, so was Leslie Howard (one of my favorites anyway), Olivia de Haviland wonderful and Mammy I think just about played the best I have ever seen her.

7. *Please check one: Do you think the picture should be played*
With no intermissions?
With Two intermissions?
× With one intermission?

Name: Eleanor J. McClaskey
Address: 3364 Walnut Street
City: Riverside
Member of the Riverside Motion Picture Council

—

1. *How did you like the picture?*
Very much. It was as though I were seeing the same scenery, characters, and actions I had imagined as I read the book two years ago.

2. *Was the action of the picture entirely clear? If not, where was it confusing?*
The actions was wonderful. I sincerely believe it could not possibly be better. I also enjoyed the unusual number of close ups.

3. *Was the sound entirely clear and could you understand the dialogue? If not, do you recall which parts were not audible?*
The sound was very clear and I don't remember even once not being able to hear very distinctly.

4. *Did any parts seem too long? If so, what parts?*
For adults this picture is so complete and balanced so perfectly that no part is too long. I wish the public in general might have the chance to see it in this form.

5. *Do you think that any battle scenes should be added to the picture, or any fuller portrayal of the Civil War, its causes and development?*
Please don't add any more battle scenes, what you have is entirely sufficient, not to be monotonous and yet giving one a thorough understanding of the horrors of war—at any period.

6. *Have you any other suggestions to make?*
No suggestions—just Congratulations. In my estimation it is definitely the greatest picture ever made and is worth sitting though any length of time. The story deserved your effort.

7. *Please check one: Do you think the picture should be played*
With no intermissions?
With Two intermissions?
× With one intermission?

Name: Nancy Anne Carter
Address: 202 Longstaff
City: Elsinore, Calif.

—

1. *How did you like the picture?*
The picture in every way more than truthfully told Margaret Mitchell's story. It is a grand picture.

2. *Was the action of the picture entirely clear? If not, where was it confusing?*
The whole action was perfectly clear and if it isn't an academy picture I will be very much surprised.

3. *Was the sound entirely clear and could you understand the dialogue? If not, do you recall which parts were not audible?*
Yes.

4. *Did any parts seem too long? If so, what parts?*
No.

5. *Do you think that any battle scenes should be added to the picture, or any fuller portrayal of the Civil War, its causes and development?*
The story is complete with the battle portrayed. No more is needed.

6. *Have you any other suggestions to make?*
I think the slavery question was pushed too far in the background. That after all was the cause of the war.

7. *Please check one: Do you think the picture should be played*
 With no intermissions?
 With Two intermissions?
 × With one intermission?

 Name: Margaret Livingston
 Address: 4291 Westmoreland Ct.
 City: Riverside

—

1. *How did you like the picture?*
 Swell but too many unnecessary parts. Now is a good time to play up the hospital scenes and results of the war as hopeless.
2. *Was the action of the picture entirely clear? If not, where was it confusing?*
 More explanation about Carpetbaggers
3. *Was the sound entirely clear and could you understand the dialogue? If not, do you recall which parts were not audible?*
 I thought the sound was good.
4. *Did any parts seem too long? If so, what parts?*
 The whole picture had too much detail.
5. *Do you think that any battle scenes should be added to the picture, or any fuller portrayal of the Civil War, its causes and development?*
 More battle scenes and more about causes of the war and the result.
6. *Have you any other suggestions to make?*
 In some scenes you would see a distant shot a close up, then distant shot and this last distant shot would be a lot brighter.
7. *Please check one: Do you think the picture should be played*
 With no intermissions?
 With Two intermissions?
 × With one intermission?

 Name: Lyndon Harp Jr.
 Address: 4434 Lemon St.
 City: Riverside

—

1. *How did you like the picture?*
 Gone With The Wind fulfilled my every expectation. I fully enjoyed each minute of it. Having read the book, I appreciated the fact that the picture followed so closely the original story.
2. *Was the action of the picture entirely clear? If not, where was it confusing?*
 The action was exceptionally clear for a story involving a large number of roles and characters.
3. *Was the sound entirely clear and could you understand the dialogue? If not, do you recall which parts were not audible?*
 The sound was entirely clear but seemed very loud, especially at the front of the theater. I had no trouble in understanding the dialogue.
4. *Did any parts seem too long? If so, what parts?*
 The length of all parts seemed very well gauged and if cut down would endanger the clarity of the story.
5. *Do you think that any battle scenes should be added to the picture, or any fuller portrayal of the Civil War, its causes and development?*
 The course of the Civil War as portrayed in the picture seemed entirely clear. Those scenes showing the wounded of the war carried with them a full realization of its horror without showing actual battle scenes.
6. *Have you any other suggestions to make?*
 My only suggestion would be that the picture be left just as it is. Despite the fact that it is considered still in rough form. It would seem that cutting it or condensing it any more would detract from the picture.
7. *Please check one: Do you think the picture should be played*
 With no intermissions?
 With Two intermissions?
 × With one intermission?

 Name: Jean Hall
 Address: 3616 Bandini Ave.
 City: Riverside, Calif.

PAGE 252
Mr. David O. Selznick
Miss Katharine Brown
Nov. 14, 1939
Atlanta Attitude—Premiere

Dear David:
I think it might be encouraging to Mr. Gable and to Miss Leigh to let them know that the people in Atlanta do not consider their visit as a personal appearance. At least certain persons of importance do not. They want Gable and Leigh to feel that they are coming to an historic event, and that they will not be exploited to their personal discomfort.

Peggy works in queer ways, but she is bound and determined that Leigh won't be torn to bits, and that Gable will have a good time. Already John Marah has talked with one of the editors of one of the three papers and requested a campaign to be started to treat these celebrities like human beings. Just how much they can do is questionable, but the papers down there do wield a tremendous power. How far the fan in the street will be guided by the campaign is something that none of us knows.

Anyway, for what it's worth, it's now going on and it might reassure Mr. Gable.

As near as I can determine from the conferences that were held with the vice-president of the Coca Cola Corporation, who is the sub rosa sponsoring the ball, this event is not only going to be gala, but really great fun, and I think with luck you and Gable and the others should have a good time. The auditorium has an enormous stage. They're covering up this stage with a backdrop of Twelve Oaks. On either side of the proscenium on the floor will be replicas of sections of the Bazaar Scene. The main portion of the hall will be cleared for dancing with about 1,000 chairs on the floor for resting purposes. They are building a special tier of boxes on either side of the proscenium back and above the bazaars in which our company, Metro, and the stars will be placed. If these boxes look too near for comfort, we will place the governors in them, and our official party upstairs. I don't want to run any risk of any disaster from the whirling crowd.

The League has already sold at $10. a seat every box seat, which is some 250 seats. It is pretty safe to assume that they will have between 5,000 and 7,000 people there.

I am writing to Irene today, as they want to have her act as a patroness, and I am very anxious that she do so along with Joan.

Sometime during the day I want to find a minute to draw a diagram of the rooms I have taken for you.
KB:do
Orig. by airmail
Confirmation copy by regular mail

—

Excerpts from memorandum received by
 Katharine Brown from David O. Selznick
11/27/39

As I have wired you, I hope you are discouraging any idea of an earlier arrival in Atlanta.

However, if you still want to try to get an earlier arrival after reading this letter, which I hope will not be the case, please have Mr. Dietz or Mr. Ferguson or someone at MGM take care of it, since I feel it is both unnecessary and an imposition on Gable.

You must bear in mind that Gable has been opposed to this whole trip from the outset. He is still squawking about the ball, claiming that going to the opening is bad enough, but that selling thousands of tickets because of personal appearance by him at a ball [is] a little thick. I understand his viewpoint, especially since he is very self-conscious and shy with crowds and obviously is going to have an uncomfortable time. Strickling assures me that the ball will be all right, since he is sure Clark will go through with it once it is clear to him that it is for charity, etc., and once we have him in Atlanta.

As far as arrival festivities' involving time, it would be helpful if someone would explain to me why, even if the airport is thirty minutes outside of town, it is necessary to arrive any earlier than three-thirty in the afternoon to have these festivities and still be at the ball. I grant you that the plane might arrive late.

I don't want to miss the opening, and the only thing that worries me is not that we will be late, but that there won't be any planes taking off at that time of year for one reason or another. And I am seriously considering coming by train—to be sure I will be there in time for the opening.

I think the chances of having secrecy at Nashville are absolutely nil. A special plane carrying Clark Gable as its cargo has not a chance on earth of having anything in connection with its schedule kept secret.

However, all of the above is my own feeling. You can do as you please through MGM, as to earlier arrival, stopping at Nashville, etc., provided MGM approves.

I want you to understand that getting Gable to Atlanta is not the whole battle. He is still going to have to be happy when he gets there, and even if we get him through the whole trip successfully, I don't want his coming back to Hollywood claiming that he has been taken advantage of, or having any justification for saying that we trapped him into this or that festivity.

What do you think about having the arrival in town a complete secret from the public, with a dramatic entrance of Gable and Leigh at the ball?

In all of this I haven't mentioned Miss Leigh. No mention is necessary. You know her as well as I do, and she's not going to be exactly Pollyanna about what we put her through. But in her case I feel that she owes it to herself, to herself and the picture. In Clark's case I feel that whatever he does for us is in the nature of a great favor, and that we should regard it as such. He doesn't need Atlanta and he doesn't need us and he doesn't need these festivities. He is the biggest star in the world, and any time he wants to show his face for three minutes he can get a fortune for it.

Accordingly, I am doing nothing whatsoever about that particular wire of yours which deals with the earlier arrival and if there is anything you want done please take it up with Mr. Ferguson, simply keeping me informed as to what you are doing.

PAGE 253
AAF13 TWS PAID (DEL FRI A M)
 TDS CULVERSITY CALIF NOV 30 1939
Mr. Howard Dietz
Metro Goldwyn Mayer
1540 Broadway
New York NY

Southerners here think Legare Davis is nuts concerning use of Negroes in program. However, if there is any question it may be best to play safe. But in any event I think that New York and particularly Hollywood editions should include Mammy. Maybe safest thing to do is to forget all portraits on the back and simply use original sketch of Tara you had for this purpose or something comparable. Certainly for Hollywood would infinitely prefer having no portraits to omitting Mammy as I think there will be bitter resentment of this and would not be surprised if same were true in New York. Therefore if you should decide to omit Mammy from the whole thing or from southern edition please give us for Hollywood and New York either a separate edition without any portraits, or separate edition with her if you possibly can. Sorry to be such a nuisance on this point but in these increasingly liberal days (thank goodness) I hate to be personally on the spot of seeming ungrateful for what I honestly feel is one of the great supporting performances of all times, which is that of Mammy. Everyone who has ever seen picture is in unanimous agreement that one of her scenes which is very close to end of picture is easily the high emotional point of the film and I think she is going to be hailed as the great negro performer of this decade.

 David.

—

2177 West 31st Street
Los Angeles, Calf.
Dec. 11, 1939

Mr. David O. Selznick
9336 Washington Boulevard,
Culver City, California.

Dear Mr. Selznick:
On the eve of your departure for Atlanta, Ga., to attend to world premiere of "Gone With The Wind," I am writing to thank you for your very kind letter and for the opportunity given me to play the part of Mammy in the epochal drama of the old South.

I have nothing but the highest praise for the co-operation extended by my fellow-players and the entire studio staff. I am sure that the picture will live up to every expectation of the producer and preview critics and I hope that Mammy, when viewed by the masses will be the exact replica of what Miss Mitchell intended her to be.

Thanking you for the privilege of having a part in the screen's greatest undertaking, I am,
 Gratefully yours,
 Hattie McDaniel
HMD/g

PAGE 263
 POSTAL TELEGRAPH
NA104 119 DL = F Atlanta GA 20 1239p
Miss Katherine Brown =
Selznick International Pictures 630 Fifth Ave NYC

Have scheduled contest with Consitution and Junior League for debutante who most nearly approximates Vivien Leigh's measurements to wear the best of the Scarlett O'Hara's gowns you will make available to us. Need to know at once, therefore which gown it shall be so that we can start planning art of this gown. Kindly advise us as soon as possible which of the gowns will be available for this purpose. I think if you merely describe the gown to me I

can pull the necessary art out of the files. Would also like to obtain this gown at least a week in advance to put on display in one of the local windows. Please advise on this also. Best regards.

Bill Hebert.

PAGE 278

3/5/40

Hattie McDaniel's speech in the short was as follows:

"Academy of Motion Picture Arts and Science, fellow members of the motion picture industry and guests: this is one of the happiest moments of my life and I want to thank each of you who had a part in selecting me for one of the Awards, for your kindness. It makes me feel very humble, and I shall always hold it as a beacon for anything I may be able to do in the future. I sincerely hope that I shall always be a credit to my race and to the motion picture industry. My heart is too full to express just how I feel, so may I say thank you and God bless you." (business with a handkerchief)

(This is exactly what she said at the Dinner except for the reference to you and Mr. Mickeljohn.)

ILLUSTRATION CREDITS

All the illustrations in this book are housed in the Ransom Center's David O. Selznick collection, the John Hay "Jock" Whitney collection, the Film Stills collection, or the *New York Journal-American* Photographic Morgue.

Images requiring additional permissions are listed below.

ACKNOWLEDGMENTS

There are many people I'd like to thank for their help with this exhibition and catalog. I want to start with the many students and volunteers who spent hours reading, copying, and arranging the thousands of documents and photographs related to *Gone With The Wind* in the Selznick and Whitney collections: Amayeli Arnal-Reveles, Selene Arrazolo, Bridgette Balderson, Lucy Barber, Elana Barton, Jessica Brickey, Ashley Butler, Bailey Cain, Gabriele Caras, Ashley Carter, Eric Cartier, David Castaneda, Sophia Cathcart, Claire Cella, Alison Clemens, Mark Cooper, Carly Dearborn, Alicia Dietrich, Erin Donohue, William Vanden Dries, Leslie Ernst, Arcadia Falcone, Nicole Feldman, Madeline Fendley, Marc Flores, Barbara Galletly, Candice Gallion, Stacey Helmerich, Shannon Hildenbrand, Tirzah Johnson, Bridget Jones, Katherine Kapsidelis, Kathryn Kramer, Karen Kremer, Jo Lammert, Julie Liu, Daniela Lozano, Cynthia Mancha, Nicole Marquis, Kristen Marx, Marcia McIntosh, Betsy Nitsch, Laura Jean Norris, Kathleen O'Connell, Jenise Overmier, Rachel Panella, Ashley Park, Emily Perkins, Kevin Powell, Kathryn Puerini, Amy Rees, Hallie Reiss, Jessica Reneau, Jim Rizkalla, Michelle Roell, George Royer, Elizabeth Salazar, Margaret Schafer, Erin Schuelke, Alissa Simmons, Caitlin Smith, Sarah Sokolow, Sarah Sundbeck, Angela Swift, Coleman Tharpe, Brian Thomas, Stephanie Tiedeken, Laura Treat, Nicole Villarreal, Laura Vincent, Mary Wegmann, Lakeem Wilson, Brin Winterbottom, Alexis Wolstein, Melissa Wopschall, John Wright, Sandra Yates, and Justine Zarate.

I'd also like to thank my friends and colleagues who provided feedback and assistance: Tom Best, Barbara Carr, Alicia Dietrich, Jennifer Edwards, Wyndell Faulk, Roy Flukinger, Bob Fuentes, Bryan Garcia, Ken Grant, Chris Jahnke, Alex Jasinski, Han Kim, Carlos King, Ancelyn Krivak, Christine Lee, Cheryl McGrath, Peter Mears, Linda Briscoe Myers, Emily Osborn, Olivia Primanis, Lisa Pulsifer, Sonja Reid, Pete Smith, Jonathan Tamez, Jen Tisdale, Tracy Tran, Alan Van Dyke, Apryl Voskamp, Keith Walters, Mary-Jane Warren, John Wright, and Daniel Zmud.

Thanks also to the members of the faculty advisory committee, whose advice and feedback were invaluable: Daina Ramey Berry, Caroline Frick, Steven Hoelscher, Coleman Hutchison, Randy Lewis, Thomas Schatz, Shirley Thompson, and Jennifer M. Wilks.

A special thanks to donors from around the world who graciously contributed more than $30,000 to support the conservation work that will enable the Ransom Center to display three original costumes worn by Vivien Leigh in the film. And thanks to Cara Varnell, Jill Morena, Nicole Villarreal, Mary Baughman, Jim Stroud, and Catherine Williams for their incredible work conserving these costumes.

Thanks to Frances and Robin Thompson for their generous gift toward the publication of this book.

At UT Press, my gratitude goes to Dave Hamrick, Robert Devens, Jim Burr, Lynne Chapman, Sarah Rosen, Regina Fuentes, Nancy Bryan, and most of all Derek George, whose brilliant design made this book better than I ever dreamed it could be.

I'd like to thank Genevieve McGillicuddy, Robert Osborne, Pola Changnon, Britta Couris, and the staff of Turner Classic Movies for their support of and enthusiasm for this project.

Most of all I would like to thank my colleagues for their help and support with this book and exhibition: Megan Barnard, Stephen Enniss, Cathy Henderson, Margie Rine, Danielle Sigler, Tom Staley, and especially Albert A. Palacios.

And, of course, I must express sincere gratitude to Daniel Selznick for his long-standing interest in and support of the David O. Selznick collection and the Ransom Center.

INDEX

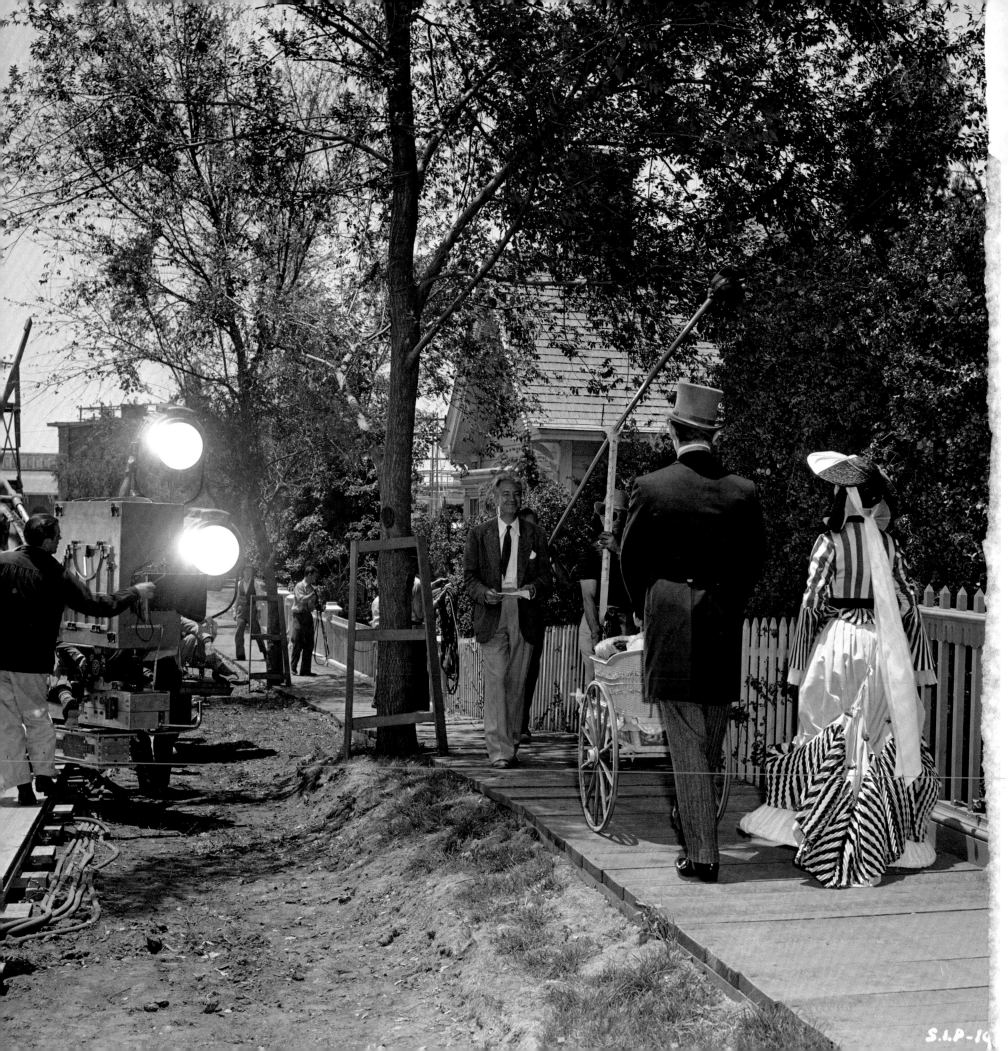

S.L.P-14